Matisse Radical Invention 1913–1917

Matisse

Radical Invention 1913–1917

STEPHANIE D'ALESSANDRO
JOHN ELDERFIELD

The Art Institute of Chicago
The Museum of Modern Art

Yale University Press,
New Haven and London

Matisse: Radical Invention, 1913–1917 was published in conjunction with an exhibition of the same title coorganized by The Art Institute of Chicago and The Museum of Modern Art, New York.

EXHIBITION DATES

The Art Institute of Chicago
March 20, 2010, to June 20, 2010

The Museum of Modern Art
July 18, 2010, to October 11, 2010

In Chicago, major funding is generously provided by The Harris Family Foundation in memory of Bette and Neison Harris, and Caryn and King Harris; and Emily Rauh Pulitzer. This project was partially funded by a grant from the Illinois Department of Commerce and Economic Opportunity, Bureau of Tourism.

 ILLINOIS. **MILE AFTER MAGNIFICENT MILE.**

In New York, the exhibition is made possible by

 AXA EQUITABLE
redefining / standards

 ALLIANCEBERNSTEIN **AXA** ART

Additional funding is provided by Jerry I. Speyer and Katherine G. Farley.

An indemnity for this exhibition has been granted by the Federal Council on the Arts and the Humanities.

First edition
Printed in Italy
Library of Congress Control Number: 2010900048
ISBN 978-0-300-15527-3 (cloth)
ISBN 978-0-86559-237-7 (paper)

Published by
The Art Institute of Chicago
111 South Michigan Avenue
Chicago, Illinois 60603-6404
www.artic.edu

Distributed by
Yale University Press
302 Temple Street
New Haven, Connecticut 06520-9040
www.yalebooks.com

Produced by the Publications Department of the Art Institute of Chicago, Robert V. Sharp, Executive Director

Edited by Gregory Nosan and Susan Weidemeyer

Production by Sarah Guernsey, Kate Kotan, and Carolyn Ziebarth

Photography research by Joseph Mohan and Kate Kotan

Designed by Daphne Geismar, New Haven, Connecticut

Typeset by Amy Storm, Island Pond, Vermont

Separations by Professional Graphics, Rockford, Illinois

Printing and binding by Conti Tipocolor, Florence, Italy

The Art Institute of Chicago and The Museum of Modern Art, New York, gratefully acknowledge the financial support of the Aaron I. Fleischman Foundation in the publication of this catalogue.

Directors' Foreword

Between 1913, when he returned from his last trip to Morocco, and 1917, when he left Paris to live and work in the southern coastal city of Nice, Henri Matisse pursued a radically new and inventive approach to artistic production. Earlier, he had gained notoriety with canvases that combined his love of rich color and arabesque line. Now, he relied upon geometric structures and a palette strong in blacks and grays, distilling his paintings to their essential elements and creating the most challenging, experimental, and abstracted works of his career. The exhibition *Matisse: Radical Invention, 1913–1917* explores the evolution of the artist's vision during this time, charting his innovative studio practices and his use of techniques across the media of painting, sculpture, printmaking, and drawing. In so doing, it reveals deep connections between works and demonstrates the importance of his development during this especially generative period.

Matisse himself acknowledged *Bathers by a River* (1909–10, 1913, and 1916–17) and *The Moroccans* (1915–16) as among his most pivotal works. These monumental paintings, in the collections of the Art Institute of Chicago and The Museum of Modern Art, New York, respectively, helped inspire the collaborative work of this exhibition and serve as major touchstones within it. The importance of these pictures, like that of Matisse's 1913–17 experiment more broadly, resides not only in their formal qualities—what Matisse called "the methods of modern construction"—but also in their physical nature. Each reveals the marks of its making, as the artist reexamined and revisited the canvas as if it were a sculpture, building, scraping, and carving into the layers of paint. It was in this way that Matisse explored the limits of his expression on the canvas itself rather than through separate preparatory studies, embracing the act of creation as a visible, vital subject.

We are grateful to Stephanie D'Alessandro, the Gary C. and Frances Comer Curator of Modern Art at the Art Institute of Chicago, and to John Elderfield, Chief Curator Emeritus of Painting and Sculpture at The Museum of Modern Art, for their conception of the exhibition and this catalogue, and for the impressive scholarship that they have brought to bear on Matisse's career. We are also thankful to the Matisse family for so generously facilitating Stephanie and John's research, and so enthusiastically supporting our institutions' endeavors. We are indebted to the many private and institutional lenders who have entrusted us with the care of their works during the course of this exhibition.

We acknowledge the generous donors who have made possible the organization of this exhibition. In Chicago, major funding was provided by the Harris Family Foundation in memory of Bette and Neison Harris, and Caryn and King Harris; Emily Rauh Pulitzer; and the Illinois Department of Commerce and Economic Opportunity, Bureau of Tourism. In New York, the exhibition is made possible by AXA Equitable, Alliance Bernstein, and AXA Art, with additional support provided by Jerry I. Speyer and Katherine G. Farley. Finally, we extend our sincerest thanks to the Dedalus Foundation for their support of this catalogue, and especially to the Aaron I. Fleischman Foundation, whose substantial underwriting helped bring this splendid, ambitious book into being.

JAMES CUNO
President and Eloise W. Martin Director
The Art Institute of Chicago

GLENN D. LOWRY
Director
The Museum of Modern Art, New York

Lenders to the Exhibition

Alan Christea Gallery, London

Albright-Knox Art Gallery, Buffalo

Allen Memorial Art Museum, Oberlin College

The Art Institute of Chicago

The Baltimore Museum of Art

Bibliothèque Nationale de France, Paris

The British Museum, London

Chrysler Museum of Art, Norfolk

The Detroit Institute of Arts

Fondation Beyeler, Basel/Riehen

Institut National d'Histoire de l'Art, Paris

Los Angeles County Museum of Art

The Metropolitan Museum of Art, New York

The Morgan Library and Museum, New York

Musée du Petit Palais, Musée des Beaux-Arts
de la Ville de Paris

Musée Matisse, Nice

Musée National d'Art Moderne/Centre de
Création Industrielle, Centre Pompidou, Paris

Museum of Art, Rhode Island School of
Design, Providence

Museum of Fine Arts, Houston

The Museum of Modern Art, New York

National Gallery of Canada, Ottawa

Philadelphia Museum of Art

The Phillips Collection, Washington, D.C.

Pierre and Tana Matisse Foundation,
New York

Saint Louis Art Museum

San Francisco Museum of Modern Art

Solomon R. Guggenheim Museum, New York

Städel Museum, Frankfurt

The State Pushkin Museum of Fine Arts,
Moscow

Statens Museum for Kunst, Copenhagen

And private collectors who wish to remain
anonymous

Matisse Research Team

Stephanie D'Alessandro
*Gary C. and Frances Comer Curator
of Modern Art*
The Art Institute of Chicago

John Elderfield
*Chief Curator Emeritus of Painting
and Sculpture*
The Museum of Modern Art

Wanda de Guébriant
Archives Henri Matisse, Paris

Kate Tierney Powell
Research Assistant
The Art Institute of Chicago

Lauren Mahony
Curatorial Assistant
The Museum of Modern Art

Claudine Grammont
Paris

Gregory Nosan
Associate Director of Publications
The Art Institute of Chicago

Jennifer Paoletti
Manager of Departmental Exhibitions
The Art Institute of Chicago

Francesca Casadio
*Andrew W. Mellon Senior
Conservation Scientist*
The Art Institute of Chicago

Inge Fiedler
Conservation Microscopist
The Art Institute of Chicago

Kristin Lister
Conservator of Paintings
The Art Institute of Chicago

Anny Aviram
Conservator of Paintings
The Museum of Modern Art

Michael Duffy
Conservator of Paintings
The Museum of Modern Art

Christopher McGlinchey
Conservation Scientist
The Museum of Modern Art

Lynda Zycherman
Conservator of Sculpture
The Museum of Modern Art

Robert G. Erdmann
*Assistant Professor, Department of Materials
Science and Engineering*
University of Arizona

Aggelos K. Katsaggelos
*Professor, Department of Electrical Engineering
and Computer Science*
Northwestern University

Sotirios A. Tsaftiris
*Research Assistant Professor, Department of
Electrical Engineering and Computer Science*
Northwestern University

Harry Abramson
Project Manager
Direct Dimensions, Inc.

Jessica Brodsky
Designer
Direct Dimensions, Inc.

Dan Haga
Designer
Direct Dimensions, Inc.

Mark Ludwig
Graphic Designer
Direct Dimensions, Inc.

Jeff Mechlinksi
Lead Industrial Designer
Direct Dimensions, Inc.

Glenn Woodburn
Industrial Designer
Direct Dimensions, Inc.

Acknowledgments

The organization of this, the first extensive project devoted to Henri Matisse's critical period of radical invention from 1913 to 1917, has been a challenging international effort. A five-year undertaking, it has included both substantial new research and the conception and execution of an exhibition and catalogue, all of which have involved the assistance and collaboration of many individuals. Colleagues in museums, universities, libraries, archives, government agencies, galleries, and auction houses, as well as others working independently, have contributed to this project in innumerable ways. From across Europe and the United States, more than forty museums, foundations, and private collectors graciously agreed to make works accessible for study and exhibition. We are profoundly indebted to all the lenders listed on the page preceding these acknowledgments for generously sharing their works with the public. We would like to extend our deepest gratitude to all those who have helped us.

A project such as this would be impossible without the collaboration of the artist's heirs. We are therefore especially fortunate for the commitment of Claude and Barbara Duthuit, Georges Matisse, and all the members of the Héritiers Matisse. Without their generous sharing of materials at the Archives Henri Matisse and Archives Georges Duthuit, Paris, their location of essential loans, and their enthusiasm for our research, publication, and exhibition, we could never have succeeded. We thank them most sincerely for all their efforts on our behalf.

We are acutely aware of the debt we owe to scholars who have devoted significant energies to Matisse's art. The endnotes and bibliography alone cannot adequately recognize the influences that have shaped our thinking over time, and we would like to recognize not only the original pioneers of Matisse scholarship, most particularly Alfred H. Barr, Jr., but also those who have contributed to this field of study more recently: Roger Benjamin, Catherine Bock-Weiss, Yve-Alain Bois, Ann Boulton, Katherine Butler, Christophe Cherix, T. J. Clark, Guy-Patrice and Michel Dauberville, Ann Dumas, Jay Fisher, Dominique Fourcade, John Golding, Claudine Grammont, Margrit Hahnloser-Ingold, Colta Ives, Albert Kostenevich, Peter Kropmans, Rémi Labrusse, Lisa Lyons, Isabelle Monod-Fontaine, Kasper Monrad, Pia Müller-Tamm, Jacqueline Munck, Steven Nash, John Hallmark Neff, Pierre Schneider, Oliver Shell, Hilary Spurling, Laurie Stein, Dominique Szymusiak, William Tucker, Margaret Werth, and Alastair Wright. In particular, we owe many thanks to Jack Flam, who, in addition to producing an important list of publications on Matisse, generously shared many resources with us for this project. Finally, we wish to acknowledge other scholars whose knowledge helped focus our work: Richard Cork, Elizabeth Cowling, Douglas Druick, Christopher Green, Gloria Groom, Cornelia Homberg, Marilyn McCully, John Richardson, Joseph Rishel, Richard Shiff, Kenneth Silver, Nancy Troy, Jayne Warman, and Matthias Waschek. We must also recognize here the indispensable earlier research of Judith Cousins and Courtney Donnell, which we depended upon as we began our project.

Like all those seeking a deeper understanding of Matisse, we have relied on the writings and correspondence that the artist left behind. Therefore we also owe our thanks to those individuals who helped us negotiate the complexities of primary documents, most especially Wanda de Guébriant of the Archives Henri Matisse, who was an enthusiastic and insightful collaborator, tirelessly confirming information and uncovering many new facts and pieces of correspondence that have immeasurably improved the research published here. We are happily in her debt, as we are to

staff at a number of other private and public institutions who provided materials to us at critical stages of our research: Margaret Zoller, Archives of American Art, Smithsonian Institution, Washington, D.C.; Katy Rawdon, Archives, Albert Barnes Foundation, Merion, Penn.; Bart Ryckbosch, Archives, the Art Institute of Chicago; Claudine Grammont, Archives Camoin, Paris; June Can and Moira Fitzgerald, Beinecke Library, Yale University; Bibliothèque Kandinsky, Musée National d'Art Moderne/Centre de Création Industrielle, Centre Pompidou, Paris; Marie-Dominique Nobébort-Mutarelli, Bibliothèque Littéraire Jacques Doucet, Paris; Dominique Versavel, Fonds de Photographie Moderne, Bibliothèque Nationale de France, Paris; Kevin Wilks, Center for Research Libraries, Chicago; Valentina Branchini, Library, George Eastman House, Rochester, N.Y.; Loisann Dowd White and Sarah Sherman, Getty Research Institute, Los Angeles; Nathalie Muller, Institut National d'Histoire de l'Art, Paris; Kristin Parker, Archives, Isabella Stewart Gardner Museum, Boston; Patricia McGuire, King's College, Cambridge; Michelle Harvey, Michelle Elligott, MacKenzie Bennett, and Tom Grischkowsky, Archives, The Museum of Modern Art, New York; Naomi Salwelson-Gorse, Arensberg Archives, and Susan Anderson, Archives, Philadelphia Museum of Art; Mary Portis, Pierre Matisse Gallery Archives, The Morgan Library and Museum, New York; and Accaccia Flanagan, Schlesinger Library, Radcliffe Institute, Cambridge, Mass.

An exhibition of this scope would have been impossible without the assistance of numerous individuals who helped us locate works, secure loans, and identify essential research and photographic materials. We are particularly indebted in this regard to Franck Giraud, who made great efforts on our behalf, shared his expertise, and enthusiastically supported the project at its inception. In addition, we owe a great deal to William Acquavella, who assisted us with many aspects of the project, and to Gordon Cook, Alan Cristea, Charles Moffett, Frederick Mulder, Laura Paulson, and Thomas Seydoux, who helped us secure important loans. Our gratitude also goes to Phyllis Hattis and Alexandra Schwarz. For their assistance in the study of specific objects in the exhibition, we are grateful to Clifford Ackley, Geneviève Bresc-Bautier, Phyllis Hattis, Helen Burnham, John Ittman, Colta Ives, Maya Joseph-Goteiner, Diana Kunkel, Brooke M. Lampley, Shelley R. Langdale, Lisa Dickinson Michaux, Patrick Noon, Alexey Petukhov, Carrie Pilto, Alexandra Schwarz, Kristin Spangenberg, and Rosemay Yin.

A variety of public institutions displayed remarkable generosity in making their objects available for loan to the exhibition. For their essential cooperation and enthusiastic support, we extend our thanks to the following colleagues, and especially those who made special concessions so that crucial works could be studied: Louis Grachos, Albright-Knox Art Gallery, Buffalo; Stephanie Wiles and Lucielle Steiger, Allen Memorial Art Museum, Oberlin College; Doreen Bolger, Jay Fisher, and Katy Rothkopf, The Baltimore Museum of Art; Pierre Vidal, Sylvie Aubenas, Celine Chicha, Marie-Cécile Miessner, Maxime Préaud, Bibliothèque Nationale de France; Neil MacGregor, The British Museum, London; William Hennessey and Jeff Harrison, Chrysler Museum of Art, Norfolk; Graham Beal and Mary Ann Wilkinson, The Detroit Institute of Arts; Samuel Keller and Ulf Küster, Fondation Beyeler, Basel/Riehen; Antoinette Le Normand-Romain, Dominique Morelon, and Nathalie Muller, Institut National d'Histoire de l'Art; Michael Govan, Stephanie

Barron, and Carol Eliel, Los Angeles County Museum of Art; Thomas Campbell, Gary Tinterow, Rebecca Rabinow, George Goldner, and Samantha Rippner, The Metropolitan Museum of Art, New York; Charles Pierce, The Morgan Library and Museum; Marie-Thérèse Pulvenis de Seligny, Musée Matisse, Nice; Alfred Pacquement, Agnès de la Baumelle, Cecile Debray, Brigitte Léal, Isabelle Monod-Fontaine, and Didier Ottinger, Musée National d'Art Moderne/Centre de Création Industrielle; Gilles Chazal, Musée du Petit Palais, Musée des Beaux-Arts de la Ville de Paris; Peter C. Mazio, Barry Walker, and Helga Kessler-Aurisch, Museum of Fine Arts, Houston; Glenn Lowry, Ann Temkin, Deborah Wye, and Connie Butler, The Museum of Modern Art; Pierre Thèberge, National Gallery of Canada, Ottawa; Alessandra Carnielli, Pierre and Tana Matisse Foundation, New York; Timothy Rubb, Joseph Rishel, and Michael Taylor, Philadelphia Museum of Art; Dorothy Kosinski and Eliza Rathbone, The Phillips Collection, Washington, D.C.; Hope Alswang and Maureen O'Brien, Museum of Art, Rhode Island School of Design, Providence; Brent Benjamin and Andrew Walker, Saint Louis Art Museum; Neal Benezra and Janet C. Bishop, San Francisco Museum of Modern Art; Richard Armstrong, Carmen Giménez, and Vivien Greene, Solomon R. Guggenheim Museum, New York; Max Hollein and Sabine Schulze, Städel Museum, Frankfurt; Irina Antinova, The State Pushkin Museum of Fine Arts, Moscow; Karsten Ohrt, Kasper Monrad, and Dorthe Aagesen, Statens Museum for Kunst, Copenhagen.

Research for this project was advanced by the expertise and dedication of many talented individuals. Foremost, we acknowledge the great contributions of conservators, scientists, and other colleagues at institutions with Matisse's works in their collections; their generous support of our research team and continued interest in the project made our work a great pleasure: Mary Sebera, The Baltimore Museum of Art; Mark Lewis, Chrysler Museum of Art; Alfred Ackerman, The Detroit Institute of Arts; Friderlicke Steckling, Fondation Beyeler; Lucy Belloli, The Metropolitan Museum of Art; Jacques Hourriere and Anne-Catherine Prud'hom, Musée National d'Art Moderne/Centre de Création Industrielle; Andrea di Bagno, Museum of Fine Arts, Houston; Suzanne Penn, Philadelphia Museum of Art; Elizabeth Steele, The Phillips Collection; Paul Haner, Saint Louis Art Museum; Carol Stringari and Hillary Torrence, Solomon R. Guggenheim Museum; Stefan Knoblauch, Städel Museum; and Kathrine Segal and Jørge Wadum, Statens Museum for Kunst. In addition, the exhibition and catalogue benefited from the imagination and intelligence of a number of scientists who have applied their interests to particular issues that concern our work: Don Johnson, Rice University; Rick Watson, Cornell University; and Sotirios A. Tsaftiris and Aggelos K. Katsaggelos, Northwestern University. Thanks also go to Glenn Woodburn, Harry Abramson, Mark Ludwig, Jessica Brodsky, Jeff Mechlinski, and Dan Haga of Direct Dimensions, Inc., who employed their remarkable technology in the service of this project. And most importantly, Robert G. Erdmann, University of Arizona, deserves special thanks for the remarkable amount of time and attention he gave to our project, an investment from which we have benefited immeasurably.

The partnership between the Art Institute of Chicago and The Museum of Modern Art began five years ago with our initial research on Matisse's *Bathers by a River*. We could never have realized *Matisse: Radical Invention, 1913–1917* without working together on every aspect of the research, project planning, and

securing of loans. We are grateful to the dedicated staff at both institutions for their enthusiasm, generosity, and support through the many years of preparations. Most particularly, we are honored and grateful to be part of a remarkable group of gifted, inventive museum professionals who comprise the Matisse research team (see p. 9). At the Art Institute of Chicago, these include Francesca Casadio, Inge Fiedler, and Kristin Lister, and at The Museum of Modern Art, Anny Aviram, Michael Duffy, Christopher McGlinchey, and Lynda Zycherman. In addition to the core research group for the project, a number of additional staff in our institutions' conservation departments were instrumental in supporting our work: at the Art Institute, Frank Zuccari and Suzanne Schnepp; and at The Museum of Modern Art, Jim Coddington and Cindy Albertson. The catalogue has benefited in particular from Ms. Lister and Mr. Duffy's ongoing contributions and suggestions, as well as those from research assistant Kate Tierney Powell and curatorial assistant Lauren Mahony. We offer additional thanks for historical and archival research to Claudine Grammont, James Glisson, Camran Mani, and Cheryl Carrier.

At The Museum of Modern Art, sincere thanks go to Glenn D. Lowry, Director, and Jennifer Russell, Senior Deputy Director for Exhibitions, Collections, and Programs, who steadfastly supported this project from its inception. We also wish to thank, in the Department of Exhibitions, Maria DeMarco Beardsley and Jennifer Cohen; in General Counsel, Patty Lipshutz and Nancy Adelson; in the Office of the Registrar, Ramona Bannayan and Jennifer Wolfe; in the Department of Art Handling and Preparation, Rob Jung and Sarah Wood; and in the Department of Exhibition Design and Production, Jerry Neuner, Peter Perez, and Michele Arms. We are especially grateful to Erik Landsberg, Robert Kastler, and Roberto Rivera in the Department of Imaging Services for facilitating the vast amount of new photography requested for this publication. We are also indebted to, in the Department of Education, Wendy Woon, Pablo Helguera, Beth Harris, Laura Beiles, and Sara Bodinson; in the Department of External Affairs, Michael Margitich, Todd Bishop, Mary Hannah, and Lauren Stakias; in the Department of Marketing and Communications, Kim Mitchell and Daniela Stigh; in Digital Media, Allegra Burnett; and in the Library, Milan Hughston, Jennifer Tobias, David Senior, and Lori Salmon. In the Department of Painting and Sculpture, in addition to Ann Temkin, we are especially grateful to Lauren Mahony, who assisted in various aspects of this project and contributed in significant ways to the catalogue, and to Sharon Dec, formerly in the department, who helped facilitate many elements of this project in its early stages. In addition, we thank Carla Bianchi, Jennifer Field, Vanessa Fusco, Delphine Huisinga, Cora Rosevear, and Anne Umland for their contributions to the exhibition and this publication. In the Department of Drawings, we are grateful to Kathy Curry and, in the Department of Prints and Illustrated Books, to Christophe Cherix and Emily Talbot for their assistance with research and for administering several loans to the exhibition.

At the Art Institute of Chicago, the project has benefited from extraordinary support, beginning with the encouragement of James Cuno, the President and Eloise W. Martin Director, who has himself written on Matisse and has been unstintingly enthusiastic in his embrace of the exhibition. Equally important and essential was the support of Dorothy Schroeder, Vice President for Exhibitions and Museum Administration. Special thanks are also due to Meredith Mack;

Julie Getzels and Jennifer Sostaric; Mary Jane Drews, Warren Davis, and Kevin Beck; and Jeanne Ladd.

In the Department of Medieval to Modern European Painting and Sculpture, Kate Tierney Powell worked imaginatively and relentlessly along with us, contributing in innumerable and essential ways to the research, exhibition, and catalogue to the very end. With efficiency, composure, and meticulous attention to detail, Jennifer Paoletti handled the many challenges of coordinating this exhibition and contributed in incalculable ways to what we will share with the public so proudly. Special thanks also go to Douglas Druick, chair of the department, for supporting this project at its earliest inception and fostering intellectual and institutional collaboration through all its stages; his insight and enthusiasm have been invaluable. Further, we gratefully acknowledge the assistance of colleagues Geraldine Banik, Gloria Groom, Adrienne Jeske, Marina Kliger, Christina Nielsen, George Sferra, Jill Shaw, and Martha Wolff, as well as departmental interns Caroline Neely, Keely Borland, and Anastasia Standa. Robert Burnier and Aza Quinn-Braun oversaw the installation with great care and finesse. In the Department of Prints and Drawings, we wish to thank Suzanne Folds McCullagh, Mark Pascale, Harriet Stratis, Martha Tedeschi, and Emily Ziemba; and in the Department of Photography, Elizabeth Siegel. In Conservation, we additionally thank Allison Langley, Jann-Nicole Trujillo, Kirk Vuillemot, Kelly Keegan, Claire Walker, and Charles Pietraszewski.

Supporting our research from the outset were Jack Perry Brown and the dedicated staff of the Ryerson and Burnham Libraries, especially Susan Augustine, Amy Ballmer, Melanie Emerson, and Nancy Ford. We are also grateful to Sam Quigley, Elizabeth Neely, Carissa Kowalski-Dougherty, Rafael Jaffey, Mariusz Czyz, and Gene Adams, who designed and supported a web module that enabled members of the Matisse team to share information regardless of their location.

The Publications Department brought great energy and dedication to the making of this book, and we are grateful both to Susan F. Rossen, former executive director, and her successor, Robert V. Sharp, for their support of the project. Most importantly, Gregory Nosan has led the extensive editorial enterprise with great intelligence, skill, equanimity, and good humor. We are extremely grateful for his diligent oversight and many valuable suggestions, as we are those of his gifted collaborator, Susan Weidemeyer. We must also acknowledge Jean Coyner for her sensitive translations of the words of Matisse, Georges Duthuit, and other important figures, and Lori Van Deman-Iseri for her excellent index. Sarah Guernsey, aided by Joseph Mohan, Kate Kotan, Carolyn Ziebarth, and Caelyn Cobb, has been indefatigable in her expert supervision of the catalogue's production, which has included the many hundreds of illustrations it contains. The book was beautifully and intelligently designed by Daphne Geismar, who showed remarkable creativity, sensitivity, and patience during a demanding process and met the challenges of presenting a great deal of textual and visual information in a clear and engaging format. The work of color specialists Pat Goley and Kirsti Monsen-Kellogg at Professional Graphics was also indispensable, as was that of the staff at Conti Tipocolor. We are thankful for the support of our colleagues at The Museum of Modern Art, in particular Christopher Hudson, Kara Kirk, and Norman Laurila, and our publishing partners at Yale University Press. Moreover, the willingness

of our lenders and their respective curators, collection managers, registrars, imaging specialists, and assistants to accommodate our requests for new photography has been remarkable.

For the design and construction of the installation at the Art Institute, for the wall texts and labels, and for the multitude of exhibition-related materials and outreach, we thank Bernice Chu, Yaumu Huang, Jeff Wonderland, Candice Wong, Carrie Heinonen, Erin Hogan, Chai Lee, Gary Stoppelman, Troy Klyber, Robert Eskridge, David Stark, and Jeffrey Nigro. The registrarial team, led by Patricia Loiko with Angie Morrow and Gregory Tschann, has, as usual, expertly coordinated the many and complex loans and attendant shipping arrangements. The exhibition benefited from a partial indemnification from the Federal Council on the Arts and Humanities. We recognize the support of Alice Whelihan of the National Endowment for the Arts.

We offer additional personal thanks to Francie Comer, Marie-Josée Kravis, Angelica Rudenstine, Emily Rauh Pulitzer, and James N. Wood.

And finally, an immeasurable degree of gratitude goes to our families and friends, who supported our work over these past few years with generous amounts of patience and enthusiasm—most especially David Rownd and Jeanne Collins.

STEPHANIE D'ALESSANDRO
JOHN ELDERFIELD

Note to the Reader

Organization

This catalogue is organized chronologically into three main parts, each of which contributes to the exploration of Matisse's radical artistic inventions from 1913 to 1917. The first part, "Defining a New Art," covers the years 1907 to 1913, documenting some of the early experiments that led to his later innovations; the second, "Changing Direction," focuses on 1913 and 1914, tracking his ambitious beginnings through the outbreak of World War I; the third, "Art as Experiment," pursues the extended moment during which, after some adjustment, his "methods of modern construction" enjoyed their greatest success. Every part contains a short chronology and a series of portfolio sections, each comprising a short introductory essay and in-depth entries on individual objects that primarily concern the production of the works themselves.

Illustrations

In documenting this period in Matisse's career, the works that appear in the exhibition are supplemented by details and conservation images and placed within the larger body of paintings, sculptures, and works on paper by Matisse and his peers. Works presented in the exhibition can be found in both the essays as well as in the object entries and are identified with the caption *In exhibition*. Works shown only at the exhibition's Chicago or New York venues are identified as such.

Within the text, works of art that are illustrated in this catalogue are called out in two different ways: those identified with both page and figure numbers are found in essays; those with a single number, or a number and a letter, are reproduced in an entry.

Titles of works

An effort has been made to provide the titles of works that Matisse first used in his correspondence, inventories, and exhibitions; additionally, the authors consulted discussions of titles in specific archival records, especially those of Alfred H. Barr, Jr., and Pierre Courthion. In the case of sculptures, prints, and illustrated books, titles typically follow those assigned in the catalogues raisonnés of these works.

Many works, such as *Back (II)*, contain a roman numeral as part of their title; for the most part, these numbers were not part of Matisse's original titles but were assigned by Barr to identify pairs or works in a series. In this catalogue, these additional titles appear in parentheses, which acknowledges both their commonly accepted status and their presence as products of a complex interpretation of the artist's working process; these issues are further addressed in the text that follows.

A number of titles—for example, *Bathers by a River*, first state—will be new to the Matisse scholar and general audiences alike, and are intended to identify a specific state of a work at a specific time, before its completion. This is a method of designation that was first used by Matisse himself for works such as *Jeannette*; it is adopted here in very specific instances in order to reconstruct the artist's working processes.

Places and dates of execution

Places of execution are listed with the name of Matisse's studio, as documented by our research, followed by the name of the city or town in which it was located.

Dates reflect research undertaken for this project and may differ from those published elsewhere; they are primarily based on the artist's correspondence and other historical records in combination with technical examination, and have been explicated in the text. Dates of execution are given by year, preceded by the season, in many cases by months, and sometimes even by days. When less certain about the date of a work, the designation *c.*, for *circa*, has been adopted; in a few cases, particularly speculative dates are followed by a question mark.

Dates for sculptures include those for the execution of the original clay or plaster; these are followed by those for casting, as recorded in the catalogue raisonné.

Media and dimensions

Information on media derives from the owners or custodians of the works; it has been confirmed by archival research as well as by physical study of the objects.

For drawings and prints, the nature of the paper is specified whenever possible; when confirmed, specific details of media and technique are also provided.

Dimensions are given in centimeters followed by inches in parentheses; height precedes width and, in the case of sculpture, precedes depth. For two-dimensional works with irregular dimensions, measurements are offered for the widest points. Unless otherwise specified, sheet sizes alone are given for drawings; image and plate or composition sizes are given for prints.

Inscriptions and locations

Signatures, annotations, and inscriptions are noted in the precise form in which they appear on the works, and their locations are indicated.

The following abbreviations are used: *l.l.* for lower left, *l.c.* for lower center, *l.r.* for lower right, *u.l.* for upper left, *u.c.* for upper center, and *u.r.* for upper right. In the case of sculpture, only general location information is provided for inscriptions; signature, inscription, and annotation information for prints is noted as pertains to subject of entries or essays.

In the text, *left* and *right* refer to the viewer's left and right, except when used to refer to the pictured figure's anatomy.

Collections

These are presented as requested by the owners or custodians of the works. In some cases, the text, notes, or captions will also identify former collections when the object in question previously belonged to a significant collector, was acquired in a particularly noteworthy way, or (in the case of works not made by Matisse) was owned by the artist himself.

Catalogues raisonnés

Depending on their medium, works included in the two existing catalogues raisonnés are identified by their catalogue numbers in one of the following

resources: for prints, Duthuit-Matisse and Duthuit 1983 (*Henri Matisse: Catalogue raisonné de l'oeuvre grave*); and for sculptures, Duthuit and de Guébriant 1997 (*Henri Matisse: Catalogue raisonné de l'oeuvre sculpté*). For ease of use, these works are identified simply with a *D* (Duthuit) number.

Archival sources

Throughout this project, our reliance on previously unpublished archival information has been critical. Most significant has been the essential source of the Archives Henri Matisse, Paris, noted in abbreviated form throughout this publication as *AHM*. Whenever possible, the source of all archival documents has been provided; previously unpublished material is cited with the permission of the institution in which it resides. Quotations from these sources have been translated from the French for this publication; unless otherwise noted, all translations are the work of Jean Coyner or the authors.

Standard sources

The standard sources for published writings by and on Matisse are, in the original French, Fourcade 2005 (*Écrits et propos sur l'art*) and, in English translation, Flam 1995 (*Matisse on Art*). These include some of the most important documents of the period, among them Matisse's *Notes of a Painter* of 1908 as well as his interview with E. Tériade in 1952.

Published collections of letters between Matisse and other artists can be found in Grammont 1997 (*Correspondance entre Charles Camoin et Henri Matisse*) and Grammont 1998 (*Matisse-Marquet: Correspondance, 1898–1947*); and Phéline and Baréty 2004 (*Matisse-Sembat correspondance: Une amitié artistique et politique, 1904–1922*). Other publications with rich resources of primary material include Duthuit 1992 (*Écrits sur Matisse*), Labrusse 1996 ("Esthétique décorative et expérience critique: Matisse, Byzance et la notion d'Orient"), and Labrusse and Munck 2005 (*Matisse, Derain: La verité du Fauvisme*).

Throughout this catalogue, citations are given to the original article, interview, letter, or other document, which was consulted whenever possible; unless otherwise noted, all English translations are the work of Jean Coyner or the authors, or those published in Flam 1995.

Within the texts that follow, sources quoted at length will be noted the first time with the bibliographic citation, with the understanding that quotations that follow, unless otherwise noted, belong to the same source. Bibliographic sources are cited in short forms through the texts and notes, with full references provided in the selected bibliography at the end of the book.

Provenance and exhibition history

These important aspects of the history of an artwork are included in the entries that follow only as they relate to the original title or presentation of the work. More complete information on ownership, exhibition, and bibliographic history of individual works is left to the many important Matisse publications that precede this study.

Contributors to the catalogue

This publication has depended on the expertise and deep collaboration of many individuals. Nearly every artwork presented in the exhibition was examined by Stephanie D'Alessandro and conservators from the Art Institute of Chicago and The Museum of Modern Art, as well as curators and conservators from host institutions. John Elderfield added to our knowledge of these objects with his long expertise in the field of Matisse studies and also contributed to new research on the works in the collection of The Museum of Modern Art. For the project research, paintings were typically unframed and examined in visible light on the front and back; in addition, works were examined with a binocular or stereoscopic microscope and/or ultraviolet, infrared, and X-radiographic technologies to elucidate the methods of a work's production as well as its connections to others included in the project. Detailed notes and visual documentation were compiled along with carefully annotated chronologies from primary sources. These materials were the basis of each object entry in this catalogue. The principal contributions of the staff at the Art Institute of Chicago and The Museum of Modern Art are noted below; the specific contributions of other essential members of the research project are noted in the acknowledgments and in the endnotes of specific entries.

STEPHANIE D'ALESSANDRO
Project director and exhibition co-curator; in addition to contents identified directly, authored chronology and entries 1, 2, 3, 4, 5, 6, 7, 8, 9, 10, 16, 17, 18, 19, 21, 22, 26, 27, 28, 29, 30, 34, 37, 45, 46, 47, 49, 54.

JOHN ELDERFIELD
Exhibition co-curator; in addition to contents identified directly, authored entries 11, 12, 13, 14, 15, 20, 23, 24, 25, 31, 32, 33, 35, 36, 38, 39, 40, 41, 42, 43, 44, 48, 50, 51, 52, 53.

KATE TIERNEY POWELL
Contributed to chronology and all essays and entries.

LAUREN MAHONY
Contributed to chronology and all essays and entries.

ANNY AVIRAM
Contributed to entries 7, 12, 14, 40.

FRANCESCA CASADIO
Contributed to entries 5, 10, 16, 21, 46, 54.

MICHAEL DUFFY
Contributed to entries 1, 2, 8, 15, 18, 20, 23, 24, 25, 27, 29, 30, 31, 32, 35, 36, 37, 39, 41, 43, 44, 49, 50.

INGE FIEDLER
Contributed to entries 5, 10, 16, 21, 46, 54.

KRISTIN LISTER
Contributed to entries 2, 3, 5, 6, 10, 16, 18, 19, 21, 23, 24, 26, 28, 29, 30, 37, 39, 41, 43, 46, 47, 50, 51, 53, 54.

LYNDA ZYCHERMAN
Contributed to entries 9, 11, 13, 17, 42, 45.

Matisse, 1913–1917, and the Methods of Modern Construction

STEPHANIE D'ALESSANDRO and JOHN ELDERFIELD

IN 1952 *ART NEWS ANNUAL* PUBLISHED "Matisse Speaks," a series of statements that the artist had made to E. Tériade in July of the previous year. It was designed to coincide with the most comprehensive retrospective of Matisse's art to date, which opened at The Museum of Modern Art, New York, in November 1951 and traveled to the Art Institute of Chicago as well as a number of other venues the following year.[1] The article comprises the fullest autobiographical statement in print that Matisse ever made, covering his entire career and referring to specific events and works that were obviously significant to him (fig. 1). At the age of eighty-two, Matisse was unusually primed for such recollections, having spent the past seven years answering a barrage of questionnaires from The Museum of Modern Art's founding director, Alfred H. Barr, Jr., that provided the foundations of the exhibition as well as his monograph *Matisse: His Art and His Public*. Matisse remained in a retrospective mood during his interview with Tériade, offering comprehensive thoughts on many aspects of his long career.

In recounting his initiation as an artist, Matisse noted his student practice of copying Old Master paintings, especially the seventeenth-century Dutch painter Jan Davidsz. de Heem's *A Table of Desserts* (1640) (35a) in the Musée du Louvre (fig. 2): "Among the pictures I copied at that time, I remember the *Portrait of Baldassare Castiglione* by Raphael, Poussin's *Narcissus,* Annibale Carracci's *The Hunt,* the *Dead Christ* of Philippe de Champaigne. As for the still-life by David de Heem, I began it again, some years later, with the methods of modern construction."[2] Matisse's comment on remaking his 1893 copy of *A Table of Desserts* seems almost an aside, yet it is of great significance to the present study, for it is the artist's only known characterization of his practice at the time. While the specific means by which he made his 1915 copy of the de Heem (35) are not at all the same as those he used for other objects from the period, his description is nonetheless instructive in relation to his overall production between 1913 and 1917. Indeed, most critical is Matisse's

fig. 1
The title spread of "Matisse Speaks," *Art News Annual* 21 (1952), pp. 40–41.

fig. 2
Page 47 of "Matisse Speaks," showing his 1893 copy (center right) and 1915 copy (bottom right) of Jan Davidsz. de Heem's *A Table of Desserts* (1640).

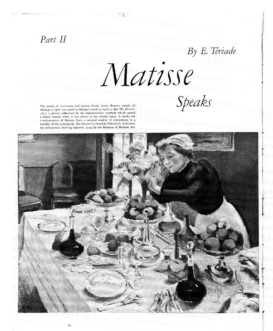

use of the phrase "the methods of modern construction" and, through it, his efforts to describe a specific, conscious approach to making modern art. This publication and the exhibition it accompanies aim to provide insight into Matisse's evolving understanding of his art at this moment by investigating his methods of modern construction themselves. The volume offers a detailed account of how the artist made his most important works, supplementing this understanding with information drawn from published and archival sources to illuminate as never before the cohesion and context of his artistic enterprise. Its subject, in short, is what Matisse's version of Modernism comprised and how it was variously developed, one work after the next, during the most radically inventive period of his long career.

Tériade's article was first published in English; although the interview was certainly conducted in French, to date no original French transcript has been found to determine the artist's precise words for "the methods of modern construction."[3] We can be relatively sure, however, that the phrase mirrored ones that had been in Matisse's arsenal since the first days of his public notoriety. For instance, his use of the French term *construction* and its cognates dates to his first published statement on his art, his 1907 interview with Guillaume Apollinaire in *La phalange*.[4] There the poet and critic clearly picked up on the artist's own terminology, describing his work by saying, "Henri Matisse erects his conceptions, he constructs his pictures using colors and lines, to the point where his combinations come to life, to the point where they are logical and form a closed composition from which one cannot take away either a color or a line without reducing the whole to the chance encounter of a few lines and a few colors." Matisse sometimes employed the term *composition* to suggest such an arrangement of parts; he used *construction*, however, to describe the production of a true compound in which the elements of a picture fit securely together like the parts of a house or human body. To his students at the Académie Matisse

Copying old masters at the Louvre

When he first came to Paris as a student, Matisse copied paintings in the Louvre, partly as training, partly to supplement his meagre allowance, as the generations bought such copies for French provincial museums. Above is his copy of Reynolds's *Tempête*, 1894, owned by Matisse's ex-pupil, Hans Purrmann of Berlin. Below is the copy of a De Heem still-life, 1893, and Matisse's own abstracted re-interpretation of this copy, painted in 1916, owned by Samuel A. Marx, Chicago. At the left, the artist is seen re-visiting the Louvre in 1952, photographed by Pierre Matisse.

in 1908, he lectured: "One must never forget the constructive lines, axes of shoulders and pelvis; nor of legs, arms, neck, and head. This building up of the form gives its essential expression. Particular characteristics may always heighten the effect, but the construction must exist first. . . . The mechanics of construction is the establishment of the oppositions that create equilibrium of the directions."[5] This was also the time when Matisse was looking to the work of Paul Cézanne to help him develop a new language of describing and making art, and the elder artist himself used the term *construction* in his writings, at least in one letter to Matisse's friend Charles Camoin, whom he advised, "What you must strive to attain is a good method of *construction*."[6] Hence, when Matisse referred to "the methods of modern construction," he was invoking this modern master as much as any other source.

Equally important is his use of the word *modern*, which has generally been understood as a reference to Cubism; this is supported by the artist's adoption of a doctrinaire Cubist style in his 1915 *Still Life after Jan Davidsz. de Heem's "La desserte."* But in the earlier part of the century, he may have meant the phrase "modern construction" in a broader sense, as suggested by Élie Faure's 1914 *Les constructeurs,* a book to which Matisse contributed a decorative vignette (fig. 3).[7] "I call Constructors," Faure wrote, "those who reveal that a work of organization is drafted in a society in ruins. Our descendents will know whether these are indeed the people to whom they owe a new intellectual order."[8] Faure described five revolutionaries who built different, new constructs of reality on the ruins of premodern culture, leading up to Cézanne, whose "architectural modeling" [*architecture plastique*] comprised "an early essay on the general, permanent architecture of the earth, a bit of it transported with all of its deep strata within the framework of a painting."[9] Such sentiments undoubtedly gained greater poignancy during the first year of World War I.

In this publication, we use the phrase "methods of modern construction" to represent Matisse's work between 1913 and 1917, when he resumed in full his efforts to devise a new approach to pictorial form. Like his art, the phrase draws upon the lessons and legacy of Cézanne; the developments of the Paris avant-garde art world of the second decade of the twentieth century, and most especially Cubism; and, as his description to Tériade suggests, the practice of returning to and reworking his own art. Matisse would focus on developing these means during this period, working synchronically on many projects, testing ideas in and across various media, and finding sometimes wildly divergent ways to pursue his objectives. He would start a number of canvases at the same time, test the solidity of his vision on both large- and small-scale works, and remove himself from practiced approaches to production. For Matisse this period was one of experimentation and flux as much as any solid sense of definition or unity. It was, in fact, his radical, unbridled, and ambitious invention, rather than any formal characteristic or subject, that defined his efforts.

Matisse: Radical Invention examines one of the artist's most significant periods of production, which began with his 1913 return to Paris from Morocco and concluded with his 1917 departure for Nice. This was a time unlike any other in his career, and commentators have long recognized its importance; surprisingly, however, they have spent little time adequately considering the works from these years as a cohesive whole. Indeed, the art Matisse made between 1913 and 1917 is among his most demanding and enigmatic. It is abstracted and rigorously purged of descriptive detail, often geometric and sharply composed, and dominated by the colors gray and black—built, as Barr said in 1951, with "austerity and architectonics."[10] It also displays an ambitious sense of passionate experimentation: we witness Matisse consciously setting aside earlier methods of making—looking to sculpture, for example, as a break before returning to his paintings—and forging new ones, as demonstrated by the singular impact of his bas-relief *Back* and by an exhilarating body of monotypes that he produced for the first and only time.[11] The artist restlessly experimented with various media, borrowing tools and techniques from one

fig. 3
Matisse's decorative vignette published in Élie Faure, *Les constructeurs* (1914), p. 149.

for use in another: he incised into paint, for example, like wax on an etching plate, and scraped it like plaster. He worked and reworked his paintings' surfaces with a near-sculptural handling and pushed himself to new levels of physical exertion as he made paintings and sculptures that were monumental in both scale and invention. The artist himself acknowledged the significance of this period when he identified two canvases, *Bathers by a River* (fig. 4) and *The Moroccans* (fig. 5), as among the most pivotal of his career.[12] The importance of this moment resides not only in the formal qualities of his works at this time, but also in the very ambition and cohesion of his project.

At the time these pieces were made, the singularity of Matisse's work from 1913 to 1917 was imperfectly understood, owing in part to disruptions in the public exhibition of art during World War I. Chief among these was the suspension of the spring and fall Salons that had been so essential to the reception of new art since early in the century. Apollinaire applauded the innovativeness of *Portrait of Madame Matisse* (p. 148, fig. 9) at the final prewar Salon d'Automne in 1913, but broad public debate on Matisse's work ended there. Moreover, with the Salons closed and the art market greatly contracted, there were no longer the same opportunities to display new work, with the result being that much of Matisse's production

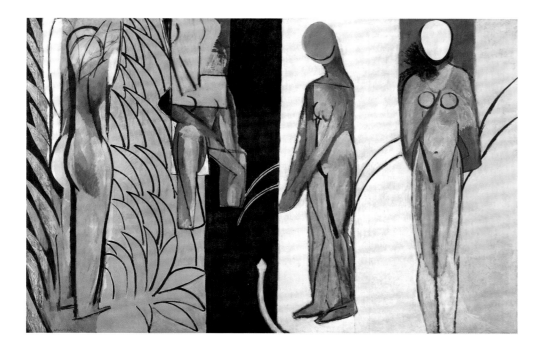

fig. 4
Bathers by a River, March 1909–10,
May–November 1913, and early
spring 1916–October (?) 1917
Oil on canvas
260 × 392 cm
(102 1/2 × 154 3/16 in.)
The Art Institute of Chicago,
Charles H. and Mary F. S.
Worcester Collection, 1953.158

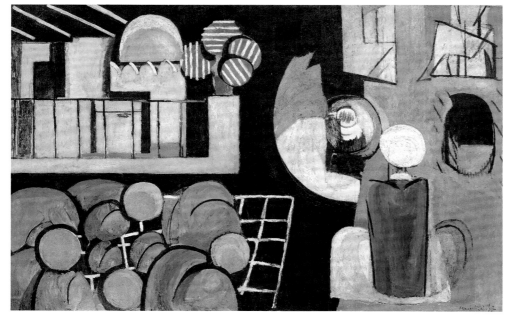

fig. 5
The Moroccans,
late 1915–November 1916
Oil on canvas
181.3 × 279.4 cm (71 3/8 × 110 in.)
The Museum of Modern Art,
New York, gift of Mr. and Mrs.
Samuel A. Marx, 1955

remained little known except to those artists, critics, and friends who encountered works in his studio, on a collector's wall, or in a dealer's storeroom. Therefore, only a small number of people saw such pictures as *Bathers by a River*, *The Piano Lesson* (43), and *The Moroccans* at the time; indeed, the first two paintings were not even exhibited until 1926.[13]

It was not until the mid-1920s that commentators began to consider works such as these as comprising a separate period with its own distinctive characteristics. Only in 1931, with Barr's first exhibition of Matisse, was the extent of their importance acknowledged, and even then the period itself was not widely discussed until after mid-century, following his second exhibition twenty years later.[14] At this time, formalist studies of Matisse's art emerged that were particularly sympathetic to the period's abstract qualities, and this view was bolstered by exhibitions such as the 1949 and 1966 Matisse retrospectives, which presented some of the greatest works from these years—for instance *View of Notre Dame* (23) and *French Window at Collioure* (29)—for the very first time.[15] Among the results of the expanded interest in Matisse that followed Pierre Schneider's centennial exhibition at the Grand Palais in 1970 was a proliferation of specialized monographs on the artist.[16] Some of these publications advanced understanding of the 1913–17 period, but a wider synthetic treatment than Barr's did not appear until 1986, nested within Jack Flam's larger survey of the artist's early career.[17] Throughout the years, there have been countless publications devoted to many other periods and aspects of Matisse's oeuvre, but the present volume and the exhibition it accompanies are the very first to be dedicated to a sustained investigation of this highly significant moment.[18]

This publication draws on earlier formalist studies in that its primary focus, mainly expressed in the entries on individual works and groups of works, is on Matisse's practice. How, when, and why, we ask, did he make these paintings, sculptures, drawings, and prints, and what are the connections between them? But this study is not formalist in the narrow sense of addressing only outward questions of style, construction, and chronology; rather, it is rooted particularly in the physical information provided by the objects themselves—what they tell us about the acts of their production and the artist's crafts of thinking, seeing, and making that lie within them. Matisse's studio practice, of course, was not solely self-motivated. He also interacted with the worlds of art and ideas, and was influenced by people and happenings in the wider world, including the deeply affecting events of World War I. These factors are discussed in the entries and, with a wider focus, in the portfolio essays that introduce them. Insofar as we begin with the art and move outward to questions of this sort, our approach is opposite to those that look from the social fabric to the art it produces. We have not been uninterested in how the social order is represented and endorsed—or not endorsed—by art and its institutions; to the contrary, we discuss how Matisse was actively engaged in the exhibition culture, gallery system, and network of private patronage typical of his day, all of which shaped his artistic practice. However, we are particularly intrigued by how these and other external events may be thought to have affected his art as it was materially as well as socially constructed.

In the essays and entries that follow, we give greater attention than previous studies to Matisse's involvement in avant-garde affairs and with the tastemakers and dealers who shaped the marketplace for art in this period. The names that appear most often are those of frequent visitors or correspondents; among these are Matisse's dealers, the former critic Félix Fénéon at Bernheim-Jeune and his competitor, Léonce Rosenberg; the Englishman Matthew Stewart Prichard and Frenchman Georges Duthuit, intellectuals with whom the artist discussed the Vitalist philosophy of Henri Bergson; and artists ranging from his old friend Charles Camoin to Juan Gris and the ever-watchful Pablo Picasso. Moreover, what Matisse was doing was disseminated by influential patrons like Marcel Sembat and Georgette Agutte, Sergei Shchukin, and Michael and Sarah Stein, and through the wide range of younger artists whom he met, from Albert Gleizes and Jean Metzinger to Diego

Rivera and Gino Severini, who came to watch him paint. Apollinaire, meanwhile, published five of Matisse's important works in his journal *Les soirées de Paris*, and Amédée Ozenfant published a number of his sketches in *L'Élan*.[19] Nonetheless, as we shall see, this limited, specialized, and largely sympathetic audience for Matisse's art did not open onto broader knowledge and discussion of it, such as it had for almost a decade before 1913. Striking evidence of this changed situation is that, after the six-day-long presentation of the artist's Moroccan paintings at the Galerie Bernheim-Jeune in April 1913, he had no solo exhibition in Paris until his first postwar show, which was held at the same gallery in May 1919. This display included two paintings from 1914 and one from 1916, but otherwise contained more recent, primarily Nice-based work; the writer Jean Cocteau complained about its conservatism.

Our project seeks not only to bring together Matisse's paintings, sculptures, drawings, and prints from 1913 to 1917 as a coherent body of work, but also to recognize their various, and sometimes conflicting, characteristics. Barr was the first to group works of this period together and to try to describe them: in 1931 he identified these particular years as ones of experiment with "austere form," "restrained color," and "abstract design."[20] Although expanded upon in his later monograph and qualified by others thereafter, these principles remain the foundation of our collective understanding of this era of Matisse's work.[21] Furthermore, Barr recognized in this period "a power of invention and an austerity of style scarcely equaled at any other time in his career," thereby setting it apart as a period of radical invention, an interpretation that was eventually adopted even by disapproving conservative critics and that we have clearly followed here. Unlike some of the previous commentators, however, we do not consider the works of these years as utterly isolated from those that preceded them, as if a very different artist had suddenly emerged. This was a time, as Barr noted, of "almost forbidding asceticism" that produced works like the near-monochrome *Woman on a High Stool* (25), although Matisse created the richly colorful canvas *Interior with Goldfish* (24) as well. We argue for a more varied analysis in which austerity and asceticism are a part of our understanding of Matisse's expressive means and earlier concerns. Indeed, we note not only his commitment to the extended revision of canvases that led to an increasing minimalism and abstractness, but also his persistent nostalgia for an earlier freedom and directness of creation, as can be seen in his two canvases on the subject of Notre Dame (23, 23d).

We also consider the multiple and sometimes contradictory issues of Matisse's relationship with avant-garde developments—most particularly, Cubism. Indeed, commentators have typically viewed Cubism as one of two sole causes that changed the character of his art, the other being the events of World War I. Again, Barr's 1931 catalogue noted, "He was influenced somewhat by the cubists, but he never destroyed the natural image to the same extent as did Picasso and Braque," thus opening one of the most crucial debates on the art of this era.[22] He suggested that Matisse used Cubism in different ways and with various degrees of accomplishment, criticizing *Head, White and Rose* (30) as "scarcely a complete success for the geometric cage seems somewhat superficially applied," while praising the "semi-abstract compositions on a grand scale"—*The Piano Lesson, The Moroccans*, and *Bathers by a River*—as among the "most magnificent achievements" of the artist's career, works that belie the frequent dismissal of "Matisse's experiments in abstract design . . . as 'unfortunate' or 'half-understood.'"[23] Barr's 1951 account was more nuanced, and later studies, in particular John Golding's 1978 *Matisse and Cubism*, further explored the development of the artist's Cubist engagements.[24] Nonetheless, while it is now broadly understood that Cubism was not a single, monolithic phenomenon, a tendency remains to treat it as such when considering its effect on Matisse. Here, however, we have sought a more inflected approach: we emphasize that in 1913 the artist had already been dubbed an "instinctive cubist" by Apollinaire—therefore understood not to be a complete outsider to the movement—and that, over the next few years, he was attracted to and practiced different Cubisms in a manner not so

distant from some of those whom we call Cubists without qualification.[25] Hence, in 1913 and 1914, he veered mainly toward Picasso's and Braque's Analytical Cubism; in 1914 and 1915, he was drawn also to the work of second-wave, more doctrinaire Cubists such as Gris and Metzinger, as well as to certain features of Cubist collage; and in 1916 and 1917, he used a collagelike approach that he drastically modified to make larger, more expansive paintings than any "true Cubist" produced. Then, as we shall also see, his turn away from Cubism in 1917 paralleled Picasso's dissatisfaction with what Cocteau called "the Cubist dictatorship" nurtured by, among others, Rosenberg and the poet Pierre Reverdy, both regular visitors to Matisse's studio. Throughout our account of these years, Cézanne's name recurs, for we argue that Matisse's "Cubism" was also a medium through which he could reengage and incorporate his earlier interest in that artist.

Along with Cubism, we aim to generate a greater, more complex understanding of Matisse's experience of World War I and how it shaped his art. For all his insights, Barr failed to consider the war except by noting, in his section on Nice, how "gradually a different feeling invades his work, caused perhaps by removal from the war-clouded atmosphere of the North aided by the sunlit climate of the Riviera."[26] Many writers have since published accounts that do not mention the war at all, and of those that do, most have shied away from even so reticent an analogy as paintings tinted by war clouds.[27] In 1966 Clement Greenberg famously celebrated the fact that Matisse's art was untouched by the events of the conflict, saying that he needed to be applauded, not condemned, for doing what artists should do, which is to make great art.[28] But this course of action was not Matisse's choice. Unhappily prevented from serving, he understood that his civic duty was to produce art. While isolated references to these complex issues abound in the literature, commentators have often treated his personal and artistic concerns in a disjointed manner, as aberrations or pauses within his development or as unique and singular responses to the war.[29] The manner in which Matisse behaved makes clear that he was deeply frustrated at not being in active service—he wanted to be involved in any way possible, and he saw his own artistic struggle as but a poor reflection of the military one, yet critical to pursue with maximum and continuous effort for that very reason. Matisse did not submit his art to the official service of the war—making posters, for example, like Raoul Dufy, or painting many scenes of battlefields, like Félix Vallotton. Indeed, he noted in 1951, "Despite pressure from certain conventional quarters, the war did not influence the subject matter of painting, for we were no longer merely painting subjects. For those who could still work there was only a restriction of means."[30] Matisse would react to the privations of the war period by making do with less in his art as well as in his life; this response, which was ethical as well as pictorial, only increased the intensity of what he acheived. Without changing the character of his work, however, Matisse did indeed put his art in the service of those at the front and behind enemy lines.[31] We recount examples in the following pages in order to suggest not only that his preoccupation with artistic struggle was a response to the endless round of battles—some so near to Paris that the gunfire could actually be heard there—but also that certain of his paintings do speak, albeit obliquely, of the troubled times in which they were made. Catherine Bock's 1990 study of *Bathers by a River* described the evolution of a once-Arcadian painting that ended up pessimistic and dystopian.[32] While we are not ready to see this or other works as actually allegorical of their temporal moment, we do argue that it was because he was faced by the awful events of the war that Matisse became so acutely aware of pushing painting to the limits of what it could depict.

Critical to our study is the effort to unite the works made with the methods of modern construction into some kind of coherent whole. Typically, this has been done in terms of style: in addition to the above comments, Barr characterized the 1913–17 works as investigative "experiments in abstract design," which soon became the common and accepted usage of detractors and admirers alike. It survives, for example, in Lawrence Gowing's 1979 definition of this moment as a time in which

the artist "experimented continually in the most various directions with uncertain success."[33] Although this terminology vividly invokes how Matisse was searching to an unprecedented and uninhibited degree, both approaches suffer from suggesting that the artist did not work speculatively in other periods, and that when he did so in this one it was solely to test some principle of abstract design. Conversely, Greenberg observed that Matisse's output at this time was a "'styleless' painting [that] does not fall easily into any of the established stylistic categories of the twentieth century."[34] This is to say, the continuity or coherence of the period is not that of a developing style, but rather of continually fresh approaches to common preoccupations. This, we will argue, is an exaggeration: we do track an overall stylistic evolution over the years 1913 to 1917, and it is one that proceeds in point and counterpoint between different expressive modes and is best understood in the context of the works' material nature and production.

In the pages that follow, we will see two broad and connected ways in which works of the period relate to one another. One is through stylistic alternation, the other through replication. Years later, Matisse would explain his turn away from austerity and asceticism in 1917 by saying, "A will to rhythmic abstraction was battling with my natural, innate desire for rich, warm, generous colors and forms."[35] This battle was also underway within the period itself. The opposing forces of abstraction and formal generosity complemented those of revision and spontaneity; the resistance generated as Matisse moved between these paired options was one of the principal forces that drove his development in this period. For example, his gradual surrender of extemporaneous creation and rich color in 1913, which led to *Portrait of Madame Matisse*, was followed in early 1914 by an attempt to recover it, an effort that soon collapsed into the highly revised and abstracted canvases that culminated in *Portrait of Yvonne Landsberg* (28).

We note, however, that these are not immovable poles. To complicate things, the artist sometimes combined rich color with revisionary abstraction, as in his second version of *View of Notre Dame*, and he occasionally found freedom and directness of expression in the use of subdued color, as in *Branch of Lilacs* (27). Matisse articulated these stylistic alternatives in the various Cubist and other avant-garde idioms he employed, using them to maintain freshness and directness in paintings such as *Still Life with Lemons* (26) and, more prominently, as tools for making extensively revised works, including the bas-relief *Back*, *The Moroccans*, and *Bathers by a River*. These multiple stylistic options have led us to agree with Greenberg and others that Matisse's search during this period was not itself stylistic—designed "to perfect a pictorial language," as Flam put it in 1986—but aimed at digging deeper and deeper into what the artist called the "truer, more essential character" of the subjects he painted.[36] What Matisse wanted, as Flam rightly argued, "could not be realized in a single picture; every image that he painted seems to have led him to other, very different images."[37]

It was in this way that the artist's stylistic alternations connect with his practice of replication, which is nonetheless a way of working from one artistic invention to another. Matisse's very first paintings (2a–b) were two variations of a still-life motif; as a student, he copied Old Master paintings, typically in a conventionally precise manner but sometimes in one more freely conceived. As a professional artist, he continued to find creative potential in this activity, producing pairs, series, and extended sequences of works as an important part of his practice well before 1913. These comprised both the traditional approach to related works—making a loose, spontaneous *esquisse* (sketch) and a more finished *tableau* (painting), as in the two *Le luxe* canvases (2.1–2)—as well as a more experimental approach, in which he treated the same subject at a similar level of finish, but in different styles, as in the two Spanish still-life paintings (p. 111, figs. 3–4). In the 1913–17 period, the artist drew on both approaches but intermingled them: for example, the first version of *View of Notre Dame* looks like an *esquisse*, but the second is an alternative treatment of the same motif, not—as we might expect—a more finished one.

Before 1913 Matisse also produced other kinds of sequences, some linked by a particular subject, others by format. *Bathers with a Turtle* (3), for example, belongs, by virtue of its subject, to a sequence of three-figure compositions of bathers that includes the two versions of *Le luxe, Game of Bowls* (5c), and other canvases. *Bathers with a Turtle* also belongs to a different sequence of paintings united in their format and size, which includes the interiors *Harmony in Red (The Red Room)* (p. 84, fig. 17), *The Pink Studio* (p. 113, fig. 5), and *The Red Studio* (p. 113, fig. 8). After 1913 Matisse both simplified and extended this approach. Between 1913 and 1914, he produced a sequence of canvases, all in the same format, that centered on the activities within his Paris studio (see 23–25, 27–28). He also continued with the *Back* relief, reprising his efforts from 1908 and 1909 to produce two additional revisions that he identified as states [*états*] of a single work.[38] The same is broadly true of the five *Jeannette* sculptures (11.1–2, 13.1–2, 42). In a somewhat different vein, the artist advanced his earlier sequence of bathers compositions, but did so solely in one work, returning to his 1909 *Bathers by a River* and reconsidering the canvas in a number of states through at least 1917. These complex sequences of invention and experimentation stretch through both this period and our account of it, affirming Matisse's studio practice as a process of reworking and revising a number of like images in a way that registered the passage of time in the appearance of the works themselves.

At its heart, *Matisse: Radical Invention, 1913–1917* aims to bring a new focus to some of the artist's most highly esteemed yet little-understood works. The project, which unites over 125 paintings, sculptures, and drawings in the exhibition and numerous others in this catalogue, offers new archival, art-historical, and technical information that allows us to delve beyond the surface of seemingly disparate images, revealing their deep, interwoven connections. Because three of the most important works completed in this period—the sequence of *Back* reliefs, *The Moroccans,* and *Bathers by a River*—were started earlier, our story also starts earlier, presenting the initial stages of these works and exploring other important paintings and sculptures that illuminate the unfolding of methods and themes that grew in significance later.

The works from 1913–17 characteristically bear the history of their manufacture: canvases show strata of reworked paint layers and a near-sculptural approach in scraping and incising. That few related sketches exist for many of the paintings indicates that Matisse was searching for a new way of working, as does his temporary break from making sculpture as a means of clarifying his painted compositions. Meanwhile, the improvisational and intimate nature of his prints, the speed and fluidity required for their creation, and the process of incising provide telling connections with his paintings and sculptures, as do his drawings, which are often composed of a network of erasure and stumping. Matisse frequently limited his exploration to single canvases or sheets. Indeed, we argue here that the high degree of visible reworking in the 1913–17 period demands that we reconsider the traditional term *pentimenti*. Though the artist could scrape, wipe down, or start a new canvas if work on a painting disagreed with him, he rarely exercised these options in this period.[39] Instead, many of these canvases and sheets, in their heavily worked and revised final states, indicate that his subject included the act of creation itself.

As suggested earlier, paintings from this moment are typically pared down and sober in both their coloring and their composition. Matisse did not give up entirely the vivid, prismatic colors of his Fauve or Moroccan periods, but he did mute their tones and contain them with the use of geometry. Over the course of the research on this project, conservators at the coorganizing and lending institutions treated well over twenty of the forty canvases presented in the exhibition; in every instance, this entailed the removal of varnish. In the case of *Bathers by a River*, the varnish was originally applied as a measure of protection. But while it may have possibly consolidated the fragile surface and safeguarded the canvas against general wear and tear, it also obscured Matisse's remarkable technical achievements.

When the coating was removed (figs. 6–7), his work with brushes and tools became more visible; lighter and brighter colors and ranges of blacks and grays were revealed; and a sense of depth, texture, and surface activity became evident as never before.[40] Just as critical was our survey and registration of Matisse's various ways of working—traces of incising, scoring, scraping, wiping, and other mark making. In doing so, we were able to recognize areas on a number of canvases previously assumed to be damage or loss; as conservators removed old, discolored, and inappropriate inpainting, the full effects of Matisse's efforts were revealed (figs. 8–9). These remarkable transformations led us to reassess our understanding of the artist's goals at this time and the overall character of his paintings in particular. This exhibition will mark the first time these works are shown together following this full-scale reconsideration and treatment. We believe it will be a revelation.

Considering the 1913–17 period afresh required an approach rooted in the physical information provided by the artworks themselves, amplified by new methods of scientific investigation and tested by archival documentation and art-historical findings. Our project originated in a multiyear study of *Bathers by a River* at the Art Institute of Chicago that employed new technologies and techniques; as detailed in the following pages, these have helped us to uncover evidence of the painting's evolution, as well as a number of unexpected links to other works. The Museum of Modern Art also investigated several objects in its collection, including *The Moroccans*, *The Piano Lesson*, and *Backs*. As a result of these collaborative efforts, new information about Matisse's media, experimental techniques, and compositional choices came to light, which led to an expansion of research beyond the holdings of the coorganizing institutions.

Critical to the success of our endeavor was the ability to document the changes that Matisse made to his works. For paintings, researchers used a variety of methods, ranging from direct visual examination to more specialized techniques,

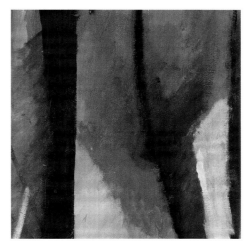

fig. 6
Detail of *Bathers by a River*, showing the left bather's lower back before varnish was removed.

fig. 7
Detail of the same area after treatment.

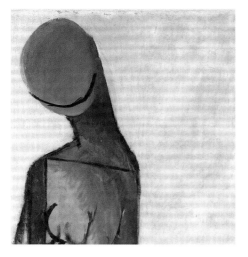

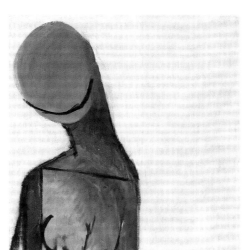

fig. 8
Section of the third figure's head in *Bathers by a River* before the old inpainting was removed.

fig. 9
Detail of the same area after treatment.

to reveal earlier stages, initial sketches, and supports. In the case of heavily worked canvases, X-radiographs often revealed—in addition to the extreme thickness of paint layers—the many stages of compositions as they were refined, abstracted, and sometimes completely reordered. Infrared reflectograms were used to disclose underdrawings and changes in paint layers, which are often missed in X-radiographs. Considered along with information gleaned from microscopic study of paint layers and examination under raking and ultraviolet light, these images were crucial to our efforts to chart Matisse's stylistic evolution and the previously unknown connections between his works.

Indeed, this publication presents and utilizes X-radiographs and infrared reflectograms of Matisse's paintings as never before. A specific challenge was the limited size of X-ray film and the often large—and, in the case of several works, monumental—size of the canvases involved. In the past, scholars and scientists have had to contend with individual sheets of film that were literally cut and pasted together; this method risked the loss of valuable information because of gaps and tonal variations between sheets. A case in point was *Bathers by a River*, which, when recorded in the 1970s (fig. 10), required as many as 122 separate sheets and produced an image that was intriguing yet challenging to interpret. The present project depends on a new kind of software that was designed to automatically assemble separate films into a digital composite X-radiograph that is corrected for any dimensional and tonal distortions (fig. 11); this, in turn, can be examined in high magnification as well as laid over other images (infrared reflectograms, photographs of earlier states of the composition, or the final work) for comparison.[41] These composite images also proved useful since they permitted the upper layers of the completed paintings to be digitally "peeled away," enabling us to read the lower layers more clearly.

Another key to charting the evolution of Matisse's works involved the acquisition of photographs of the artist's studio and, most importantly, of paintings and sculptures at the time of their production. In respect to *Bathers by a River*, for example, documentary photographs were used to produce critical information in two notable instances. The first effort involved a series of pictures, discovered only in 1992, that the American photographer Alvin Langdon Coburn took of Matisse as he worked on the canvas in late spring 1913.[42] Software was developed to reregister these images so that the details of the painting, which were documented at oblique angles or otherwise distorted, could be flattened and aligned onto the same plane; these were then stitched into a never-before-seen composite of the canvas at this critical stage (161). In the second effort, colorization algorithm software allowed

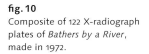

fig. 10
Composite of 122 X-radiograph plates of *Bathers by a River*, made in 1972.

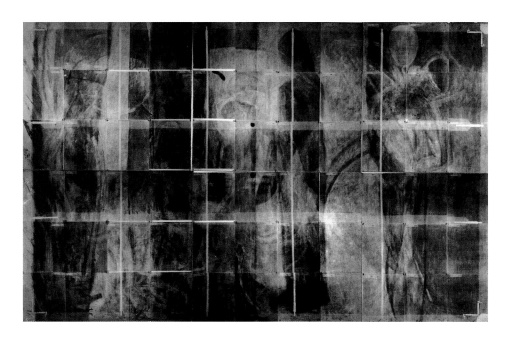

us to recolorize a photograph of *Bathers by a River* taken by Eugène Druet in November 1913. This new image (21c) demonstrates Matisse's dramatic transformation of this once-vivid painting and allows us to better understand and decipher its connections to the rest of his work at this time, as well as his working methods in general.

Digital technologies were also applied to the study of other works, most significantly to the *Backs*, Matisse's sequence of four large-scale bas-reliefs. The artist's work on the sculptural series has long been an area of great speculation, and as he made little else in this medium between 1913 and 1917, we were especially eager to study these works. Laser imaging technology allowed us to measure each of the *Back* sculptures in the collection of The Museum of Modern Art precisely and produce three-dimensional digital models that could be compared, overlaid, and even cross-sectioned, helping us to understand in great detail what areas the artist added and removed as he advanced the work through its various states.[43] Throughout the catalogue, individual entries detail these stages and include digitized overlays of present and past states in order to help readers appreciate Matisse's remarkable work in new ways.

Finally, this project depends on the careful accumulation of historic information from many sources, but most particularly from the Archives Henri Matisse, in order to carefully test and refine the information produced by our physical examinations and technological findings. Knowing the artist's travels, the content of his letters to friends and family members, his interactions with his dealers, and the amount of time and effort it took to complete his works has allowed us to not only propose a new sense of the order and depth of his production, but also suggest a coherence to the part of his oeuvre considered in this publication. Together, this combination of scientific and historical research has led us to a fundamental reassessment of both Matisse's experimental attempts at a radically new, modern pictorial approach and that approach's impact on the rest of his career.

This publication aims to demonstrate the cohesion and ambition of Matisse's "methods of modern construction." To that end, it is organized into three main parts, each introduced with a short chronology that precedes a set of portfolios devoted to specific phases of Matisse's exploration. Each of these portfolios begins with an introductory essay that is followed by entries on specific objects that detail their individual production, marrying archival, biographical, conservation, historical, and scientific material. Notable among these are entries that address the evolution of this period's most significant works—*Bathers by a River*, *The Moroccans*, and the

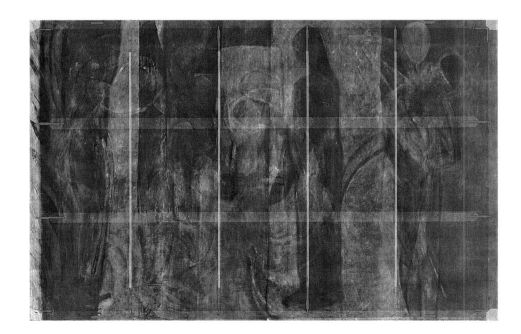

fig. 11
New digital composite of 122 X-radiograph plates of *Bathers by a River*, with dimensional and tonal distortions corrected.

Back reliefs—presented as they were documented at specific moments of progress and in conversation with other works from the time.

The first part of the book reviews the earlier period in which Matisse selected, refined, and rejected various approaches in his quest for the methods of modern construction. One portfolio section highlights seminal paintings and sculptures that demonstrate the artist's early working practices. Another considers the significance of Matisse's bathers compositions, both as a meaningful motif and as a ready-made theme for experimentation; and a third explores his process of building his compositions with color, particularly as it was affected by his travels to Spain and Morocco. The second part of the book explores Matisse's first efforts to break with his earlier work and devise a new vocabulary of pictorial construction. One portfolio focuses on his earliest efforts to reduce and refine his palette, producing a remarkable series of blue pictures, while another explores his prolific painting and printmaking in his new Paris studio, where he was clearly wrestling with the Analytical Cubism of Picasso and Braque, as well as the contributions of Gris, Severini, and other avant-garde artists. Finally, the third part features some of the greatest works Matisse made in the period—raw images, worked canvases, and monumental long-term projects that took a deep physical and emotional toll on the artist during the first half of World War I and that he used to synthesize the influences of others. Here portfolio sections focus on his struggles in late 1914 and 1915 to respond to the war personally as well as professionally; his trials in 1916 to resume his long-term works; and his later 1916–17 landscapes, portraits, and still lifes, which anticipate in some ways the end of this radical way of working and his imminent departure for Nice. A postscript considers the early reception of his 1913–17 works and their influence on his subsequent practice.

Immediately following this essay is a technical introduction that offers a short primer on some of the specific ways in which Matisse worked at this time, deploying various tools, materials, and techniques to produce his greatest experimental paintings, sculptures, and works on paper. It is also intended as a ready reference to the technical and scientific terms that appear in the body of the catalogue.

We hope this publication offers an example of a new kind of art history that fully integrates historical, scientific, and technical information, testing and challenging previous understandings to create a nuanced account that is supported by the material substance of the art itself. We also hope to shed new light on the career of Henri Matisse, an artist well recognized within the canon of modern art, but not always identified with the hungry spirit that motivated much of his work, certainly in this period. This project aims to offer a less monolithic, more carefully inflected account of an extended moment of radical invention that is, like the history of Modernism itself, full of more contradictions and subtleties than we sometimes allow. As we shall see, both Matisse's methods of modern construction—and the works he used them to make—are as diverse as they are similar.

1. Tériade 1952. The exhibition, *Henri Matisse*, was organized by The Museum of Modern Art and was on view at that institution from Nov. 13, 1951, to Jan. 13, 1952. It then traveled to the Cleveland Museum of Art, Feb. 5–Mar. 16, 1952; the Art Institute of Chicago, Apr. 1–May 4, 1952; and the San Francisco Museum of Modern Art, May 22–July 6, 1952. A smaller version of the exhibition continued on to the Los Angeles Municipal Art Gallery, July 24–Aug. 17, 1952; and the Portland Art Museum, Sept.–Oct. 1952. Alfred H. Barr, Jr.'s, publication, *Matisse: His Art and His Public*, functioned as a catalogue for the exhibition. This is in addition to a small catalogue that accompanied the exhibition, for which Matisse designed the cover.

2. Ibid., p. 42.

3. Presented as a straightforward transcript of a conversation in July 1951, some parts of the published article appear to be reprinted from 1929–31 interviews with the artist, as Flam 1995, p. 199, makes clear. None of these include the passage on copying in the Louvre or the phrase "the methods of modern construction."

4. Apollinaire 1907, p. 483.

5. Sarah Stein recorded the word *construction* in her notes from Matisse's lectures at his academy; see "Sarah Stein's Notes" (1908); Flam 1995, pp. 47–48. See Matisse 1908 for the artist's use of *composition*.

6. Cézanne to Camoin, Dec. 9, 1904, Camoin Archives; John Rewald, ed., *Paul Cézanne Letters* (Bruno Cassirer, 1941), p. 242.

7. Élie Faure, *Les constructeurs* (G. Crès et Cie, 1914). The author identified five individuals for his study—Jean-Baptiste Lamarck, Jules Michelet, Fyodor Dostoyevsky, Friedrich Nietzsche, and Cézanne—and included drawings by a number of artists, among them Pierre-Auguste Renoir, Cézanne, Pierre Bonnard, Albert Laprade, Albert André, Georges d'Espagnat, Albert Marquet, Francis Jourdain, Jean-Paul Lafitte, Charles Guérin, and Jean Puy. Matisse, too, contributed to the volume: he referred to it in a postcard to Marquet, who was in Tangier. In this correspondence, he enclosed a postcard from Faure dated Aug. 16, 1913, in which the author explained that he had asked Marquet to make a vignette for the chapter on Dostoyevsky but had not yet received a reply; see Matisse to Marquet, after Aug. 16, 1913, Wildenstein Institute, Paris. Matisse's drawing, on the motif of dance, appears at the opening of the chapter on Nietzsche (p. 149).

8. Ibid., p. xiv.

9. Ibid., pp. xv and 233. In 1920 Faure would write of Matisse as Cézanne's heir in not dissimilar terms; surely the artist would have been pleased to consider himself a modern *constructeur* in this distinguished tradition. See "Opinions," in Faure et al. 1920, pp. 5–17; Élie Faure, *L'art moderne*, Histoire de l'art 4 (G. Crès et Cie, 1924), pp. 458, 460, 462.

10. Barr 1951, p. 177.

11. For discussions of *abstraction* and *experiment*, see Gowing 1979, p. 124; Flam 1986, p. 360; and Elderfield 1992, p. 237.

12. This information comes from a May 23, 1985, interview of Katharine Kuh by Courtney Donnell concerning the acquisition of *Bathers by a River* by the Art Institute of Chicago. According to Kuh, Matisse "considered it one of his five . . . pivotal works." Later in the same interview, he also included *The Moroccans*. Curatorial files, Art Institute of Chicago.

13. These works were shown with *Branch of Lilacs* (27) at Galerie Paul Guillaume, Oct. 1–14, 1926. *The Moroccans* was first exhibited in a 1927 exhibition at Valentine Dudensing Gallery, New York. For more on the Guillaume presentation, Georges Duthuit's lecture at its inauguration, and the later reception of all these works, see pp. 350–55 in this publication. Diehl 1954, pp. 65–66, recognized this

14. The *Henri-Matisse Retrospective Exhibition* was held at The Museum of Modern Art from Nov. 3 to Dec. 6, 1931. Just three years later, Pierre Courthion published a study of Matisse that associated his work after 1914 with "pure painting"; see Courthion 1934.

15. The Musée des Beaux-Arts, Lucerne, hosted *Henri Matisse* from July 9 to Oct. 2, 1949. The University of California Art Council and University of California–Los Angeles Art Galleries organized *Henri Matisse Retrospective 1966*, which was shown at University of California Art Galleries, Jan. 5–Feb. 27, 1966; Art Institute of Chicago, Mar. 11–Apr. 24, 1966; and Museum of Fine Arts, Boston, May 11–June 26, 1966. Catalogues were published for both exhibitions; in the case of the 1966 presentation, the catalogue was written by Jean Leymarie, Herbert Read, and William S. Lieberman.

16. See Schneider and Préaud 1970; and Schneider 2002. Among these were the catalogues of the two collections richest in works of this period, The Museum of Modern Art, New York, and the Musée National d'Art Moderne, Paris (Elderfield 1978 and Monod-Fontaine 1979, respectively). The most complete and indispensable survey of the development of literature and exhibition history on Matisse is Bock-Weiss 1996.

17. See Flam 1986 and the subsequent Pompidou 1993.

18. Numerous shorter studies deserve mention here, including Lyons 1975; Elderfield 1978; and Isabelle Monod-Fontaine, "A Black Light: Matisse (1914–1918)," in Turner and Benjamin 1995, pp. 85–95.

19. In addition to the invaluable notes of Sarah Stein (n. 5) and countless articles by Apollinaire, Marcel Sembat's 1913 and 1920 publications deserve special note (see Sembat 1913 and Sembat 1920), as does Severini 1917.

20. Barr 1931, pp. 18–19.

21. Barr 1931, p. 18, describes a period that stretches "between the return from Morocco in 1913 and the first winter at Nice in 1917," thereby distinguishing it from the preceding and succeeding eras of "brilliantly successful experiments with clear, flat colors" and of "definite relaxation." After the publication of Barr's 1951 monograph, this periodization was gradually accepted, although in 1954 the eminent French critic Gaston Diehl wrote of 1910–17 as one period, albeit with the qualification that within it "an art of the mind" succeeded "an art of the senses." See Diehl 1954, chap. 4; Diehl 1958, p. 44. This is too rudimentary; nonetheless, it reminds us that there are features and concerns of Matisse's pre-1913 production that persisted in the years that followed.

22. Barr 1931, p. 18. Also published in 1931 is Zervos 1931, esp. pp. 246–49, which includes a consideration of Matisse and Cubism and utilizes the term *construction*.

23. Barr 1931, pp. 18–19. In his comments, he actually referred to *Music Lesson* and *Girls Bathing*, but since he identified them as in the collection of Paul Guillaume, he obviously meant *The Piano Lesson* and *Bathers by a River*. To these he added *Apples* (39.1) and *The Window* (37) as also "among his most magnificent achievements."

24. Golding 1978.

25. Apollinaire 1913a, pp. 83–84; Apollinaire 2004, pp. 83–84.

26. Barr 1931, p. 19.

27. On the opposite side, within the literature on wartime artists, Matisse is often given cursory attention, seemingly "excused" as being too old to fight and therefore little engaged, or only considered as far as his works made after his move to Nice represent an interest in tradition and therefore fit loosely into a more general return to order. The situation is indeed complicated by his production, which lacks any specific wartime themes or subjects, but integration is the key to a new understanding. While some questions cannot be answered without the identification of documents to ascertain more details of Matisse's activities at this time, this project seeks to set the works, merged with his wartime activities and statements, against the backdrop of the tragedy of the war. In doing so, we hope to suggest a more complex sense of Matisse's struggle—and even duty—to be a great artist during the war.

28. Clement Greenberg, "Influences of Matisse," *Art International* 17, 9 (Nov. 15, 1973), pp. 28, 39. The implicit comparison is, of course, with Picasso.

29. Two studies that stand apart from this characterization deserve mention here: Bock 1990 and Spurling 2005. In each case, however, the authors had different stated goals than solely Matisse and the war, and as such, their work leaves room for deeper focus.

30. Tériade 1952, p. 53.

31. Kenneth Silver is one of the few historians to recognize Matisse's activity in this regard; see Silver 1989, which does an excellent job of setting the artist's works within the larger interest in the return to order. For an earlier account, see Escholier 1956.

32. Bock 1990.

33. Gowing 1979, p. 127.

34. Clement Greenberg, "Matisse in 1966," *Bulletin: Museum of Fine Arts, Boston* 64, 336 (1966), p. 67.

35. Verdet 1978, pp. 124–25.

36. Matisse 1908, p. 736.

37. Flam 1986, p. 380.

38. In his 1951 monograph, Barr assigned numerical suffixes to the titles of these works (*Back I* and *Back II*, for example), as well as to others such as *Le luxe I* and *Le luxe II*. See pp. 16–17 in this publication for more on this subject. While some of these groups may have a sequential relationship, the designation is, in fact, misleading, especially in the case of many of his canvases. Matisse's original titles have been noted throughout this publication.

39. The only known example we have from this period is *The Moroccans*, which Matisse restarted on a larger canvas in 1916; see entry 44.

40. Of particular note here is the Detroit Institute of Arts's *The Window*, which has never been varnished and represents one of the most original and pristine surfaces from the time.

41. Other programs have been designed to serve similar purposes, such as that for The National Gallery, London; however, never before has it been possible to study large-scale paintings such as *Bathers by a River*.

42. These photographs were uncovered by Sharon Dec, formerly in the Department of Painting and Sculpture at The Museum of Modern Art, in preparation for the 1992 Matisse retrospective. One of these photographs (16e) was published in Coburn 1913. Coburn also took photographs of Matisse working on *Back* in 1913.

43. For this work, we were inspired by the landmark application of this technology for the 2007 exhibition *Matisse: Painter as Sculptor*, overseen by Ann Boulton and executed with Direct Dimensions, Inc.

Primer on Materials, Techniques, and Examination

The technical examinations undertaken for *Matisse: Radical Invention, 1913–1917* focused on twenty-six paintings and numerous drawings, prints, and sculptures from this four-year period; nine paintings from between 1907 and 1911; and a selection of other works in the collections of the Art Institute of Chicago and The Museum of Modern Art, New York. Our study revealed that, by and large, the artist's materials and tools were traditional ones that he sometimes altered and adapted as he developed his unique working methods. Matisse was a versatile, knowledgeable craftsman, and his studio practice was informed by a background that included the study of Old Master paintings and a knowledge of their construction; he also collected works, including Paul Cézanne's *Three Bathers* (p. 45, fig. 3) and Gustave Courbet's *The Source of the Loue* (p. 312, fig. 2), whose influence on his technique is evident. The artist's familiarity with different techniques provided the foundation for his bold technical experiments between 1913 and 1917.

The following pages introduce the concepts, materials, tools, and processes that Matisse drew upon as he worked through the various steps of constructing his paintings, sculptures, and works on paper; key terms are ordered generally as they would be used in the process of making a work. Also presented are the scope of our research team's findings and the examination techniques that were employed.

Traditional Terms

COMPOSITION
The arrangement of pictorial elements in a work of art. Matisse made many changes to his compositions as he worked, adjusting the size and shape of different areas in relation to one another and, in the case of paintings and works on paper, to the edges of the support.

ÉTUDE
A drawing or oil sketch from a model or from nature, often made with the idea that it will be incorporated into a larger work.

CROQUIS
A preliminary sketch done in pen, pencil, or crayon to set down the concept of a projected work (see p. 79, fig. 6).

ESQUISSE
A compositional sketch, painted or drawn, that represents the first worked-out idea for a finished painting. The *esquisse peinte* (painted sketch) played an important role in the French academic tradition of historical, mythological, and religious painting from the seventeenth century onward. Traditionally an *esquisse* was looser, smaller, and more spontaneous than the finished *tableau*; Matisse made such traditional examples early in his career, but by at least 1907 he insisted on the importance of the *esquisse* being the same size as the final work (p. 79, fig. 5).

ÉBAUCHE
The first laying in of the rough outlines and tones of a composition, often in a single color (5n), that is done on a full-size canvas with the idea that it will be carried forward to the completed painting; also known as underpainting.

CARTOON
A drawing used to transfer a composition to another surface, most traditionally by rubbing powder through a perforated cartoon to produce a dotted guide on the surface beneath. Matisse employed cartoons to transfer compositions to canvases, especially from around 1904 to 1907/08, and at least two of his transfer techniques are documented: rubbing charcoal on the verso of a full-scale drawing to transfer lines with a stylus (2d) and squaring up a cartoon (2–3) to redraw the image grid by grid (2.1–2); this method could also include resizing and transferring a small cartoon to a larger canvas.

STATE (*ÉTAT*)
A compositional shift made in the course of producing a work of art. Matisse sometimes documented a state of a painting (p. 82, figs. 13–14) or a sculpture (4), often engaging photographer Eugène Druet. After 1914 the artist also used prints to document states of paintings.

PENTIMENTO
Derived from the Italian word for repentance, this traditional term describes the unplanned reappearance of a previous or changed compositional element in a paint layer due to the increasing transparency of the oil paint layers over time. There are few traditional pentimenti in Matisse's works from 1913 to 1917, as he purposefully incorporated his reworking into the final work of art.

Painting

Materials and Process

SUPPORT
The structure on which a work is made. For the paintings in this period, Matisse used plain-weave, medium- to medium-fine weight linen. The canvas was mounted on a wooden stretcher, with its edges folded over the sides and tacked into place. Typically, a heavier canvas of thicker threads has a lower thread count and is used for larger paintings. However, our examinations indicate that this was not always the case with Matisse. *The Moroccans* (44), an unusually large work, was painted on one of the finer canvases the artist used; this is also the case for *Bathers by a River* (54), which, considering its extremely large size, was painted on a canvas of a not particularly heavy weight.

CANVAS SIZES
Commercially available canvases, already stretched, prepared with sizing (traditionally a glue-based layer), and primed with ground, came in a variety of standard sizes and in three different formats: the wide *figure*, the thinner *landscape*, and the

still-narrower *marine*. Examples of paintings with canvases of these three formats are *Nude with White Scarf* (6), *The Blue Window* (18), and *The Manila Shawl* (12), respectively. Larger canvases were not available in these ready-made formats. These include *Bathers by a River*, *Bathers with a Turtle* (3), *Le luxe (II)*, *The Moroccans*, *The Piano Lesson* (43), and *Still Life after Jan Davidsz. de Heem's "La desserte"* (35). Also noteworthy are five custom format canvases from this period: *Blue Nude (Memory of Biskra)* (1.3); *Fatma, the Mulatto Woman* (14.2); *Flowers and Ceramic Plate* (19); *Head, White and Rose* (30); and *Portrait of Auguste Pellerin (II)* (50).

GROUND
Also called *priming*, the paint layer—usually white—applied to a support to prepare it for subsequent painting. Matisse's canvases were primed in large pieces and later cut down to fit a desired stretcher. Exceptions exist in his oversize works, which were primed on their stretchers, as well as *Blue Nude (Memory of Biskra)*, *Music (Sketch)* (p. 81, fig. 10), *Portrait of Olga Merson* (12.2), and *Three Bathers* (3a).

For a number of paintings, including *Portrait of Yvonne Landsberg* (28) and *Bowl of Apples on a Table* (39.2), there is evidence that the artist applied a supplemental white ground to specific areas of the support in order to create a textural foundation. It is also possible that Matisse applied additional ground to *Portrait of Olga Merson* and *Head, White and Rose* to cover areas that had become abraded by his vigorous scraping, wiping, and reworking.

INITIAL SKETCH
Matisse usually sketched the contours of a composition directly onto the priming layer with fluid black paint (see 44o). He sometimes began with a pencil or charcoal drawing, and on occasion, as in the example of *Bather* (8e), we can see pencil or charcoal in the upper layers—and even on top of the paint—a reversal of the traditional art-making process. In other works, such as *The Moroccans*, Matisse sketched a painted border to outline the composition (see 36b), which suggests that he may have started the painting on an unstretched piece of primed canvas that was attached to a board (see overleaf, pp. 216–17) or the studio wall.

UNDERPAINTING
The preliminary layer or layers of paint used to establish both the form of the composition, traditionally known as an *ébauche*, and the preliminary color scheme, often by blocking in areas around the initial sketch (5n).

PIGMENTS
Finely powdered inorganic and organic colorants that are combined with a binder (oil or gum, for example) to make paint. Matisse typically purchased oil paint in a tube, squeezing it out onto a wood palette (see 10c). This type of paint contains a drying oil (such as linseed) mixed with finely ground pigments to provide a smooth consistency, which the artist sometimes modified by adding extra oil,

natural resin, or turpentine. Many pigments range in opacity and transparency, and Matisse selected them with these qualities in mind. The majority of his paints became available in the mid-1800s.

MEDIUM
The liquid nonevaporating component—traditionally a drying oil such as linseed—in which pigments are dispersed or ground to make paint. Judging from his finished works, it seems likely that Matisse occasionally added some kind of extra medium, including oil or natural resin, to his paint to achieve a fluid but full-bodied effect. On occasion, Matisse used other media including water-soluble paint such as *distemper*, an animal-glue-based medium that includes water-based binder and produces a quick drying, opaque, matte surface. Examples include *Interior with Aubergines* (p. 113, fig. 7), *The Moroccan Café* (15c), and *Le luxe (II)*.

CRAQUELURE/DRYING CRACKS
A network of cracks that sometimes develops over the surface of a picture due to the natural drying and aging of the paint film. The pattern and type of craquelure is dependent on the paint's chemical makeup, physical handling, and the exterior or ambient conditions present over a work's lifetime. Drying cracks occur quite rapidly, as the paint layer initially dries, shrinks, and slides over the one below, or the one below shrinks differentially, most commonly the result of lean over rich applications of pigment. These, like craquelure, are chance textural effects that Matisse accepted in his work: for instance, he could have easily painted over the cracked areas in *The Piano Lesson* (43d) or *Portrait of Auguste Pellerin (II)* (50f) but left them almost like a decorative patterning across the colored fields.

Techniques, Tools, and Effects

RESIST
A beading-up effect caused when liquid paint or ink is applied on top of a rich paint layer, often seen in Matisse's black lines (28g, 43h). This was likely the result of chance, but something that Matisse accepted and possibly encouraged as it is found in many canvases of the period.

HATCHING/CROSS-HATCHING
A method of applying paint in parallel strokes (hatching) and again in perpendicular strokes (cross-hatching). Originally the technique was used for tonal modeling and shading in etching, engraving, and tapestry weaving. Matisse used hatching to add texture and pattern to his paintings; to introduce subdued color; or to highlight, shade, or model forms (47c). He also introduced the parallel lines by scraping into the paint (31h).

IMPASTO
A thick application of paint with a brush or palette knife that stands in relief from the painting's overall surface, as in *Bowl of Oranges*, where both tools were used to create a light-toned impasto (38). The

artist often used dense paint such as lead white to build up texture, as he did with the turbaned head of the central figure in *The Moroccans* (44k).

PAINT INCLUSIONS

Small embedded fragments produced when Matisse vigorously scraped the surface or transferred partially dried paint from his palette to the canvas. When these have sharp edges, they are paint chips from areas on the canvas where the artist scraped off dried paint layers; when they are rounded, they are scrapings produced when Matisse cleared an area on his palette to mix a new color before applying it. *Bowl of Apples on a Table* (39.2) has many palette scrapings, especially in the fruit. Both types of inclusions are so pervasive in Matisse's paintings that we must assume that he accepted and incorporated their presence as chance elements that both invigorated the surface and drew attention to his techniques of construction (50e).

WET-INTO-WET

A technique of blending color directly on the canvas instead of the palette. A striking example of wet-into-wet application to blend color can be found in the right background of *Bowl of Apples on a Table* (39.2), where the colors shift from reddish to yellow with wet mixing to make orange, and then from yellow to black with wet mixing to produce green. The presence of this technique is sometimes used to identify parts of a picture that were painted at the same time.

SCUMBLE

A layer of opaque color that is applied so thinly that the color beneath shows through. In *Goldfish and Palette*, Matisse vigorously scumbled white paint over blue to describe the water in the bowl (31f).

WASHES AND GLAZES

Washes are watercolor-like applications of paint, usually thinned with turpentine and broadly applied. The color tends to vary in intensity as the turpentine evaporates and the paint is dispersed across the surface of the canvas (27). In glazes, color is diluted with a high proportion of extra medium, which results in a smoother paint with more consistent, transparent color, as in the right side of the scene outside the window in *Interior with Goldfish* (24). Matisse varied the degree to which he thinned paint with turpentine or another medium, even within a single work. The artist typically added only enough medium to create a more fluid paint. Spread thinly, it produced brushstrokes without impasto; applied more thickly, it resulted in a very smooth layer. We can also find chance drips from the artist's brush that he allowed to remain when he worked with such thinned colors.

DRY BRUSH

A technique of reworking paint that has already been applied, changing its texture, removing much of it (39f), or spreading and feathering it out. By removing paint only from the highpoints of an underlying brushstroke, dry brushing emphasizes the texture of the underlying paint (8f).

CHISEL

A steel tool with a flat, sharp cutting end traditionally used to carve plaster, wood, or other materials. Evidence of Matisse's employment of chisels on his canvases can be seen in marks with flat, not pointed, ends (28h). Presumably he could control the degree of paint removed by the angle at which he held the chisel (for example, in the left edge of *Bathers by a River* [54d], where all but the lowest layer was scraped away).

PALETTE KNIFE

A thin, flexible metal spatula with an end that is either flat and rounded or triangular and pointed. Artists typically use the knife to scrape paint onto and off of their palettes; to mix medium into their paint; and, like a trowel, to apply a ground layer onto the canvas. Matisse often employed this and other tools to rigorously scrape away passages of paint, revealing underlying colors and defining forms. The flexible blade of the palette knife can produce a line of varying width depending on the pressure and angle with which it is employed. A knife with a rounded end can be used to scrape off wet paint, and one with a pointed end to scrape away paint in broad, shallow strokes. Turned on its edge, it can also inscribe a thin, sharp line. Examples of Matisse's use of the palette knife can be found in *Flowers and Ceramic Plate* (19f) and *Portrait of Yvonne Landsberg* (28h).

SCRAPING

Matisse routinely scraped paint in order to change or emphasize elements of his composition. Sometimes the artist would scrape down large areas of already dried paint if he was dissatisfied with their appearance (see top of left figure in 16i); at other times he scraped into wet or soft paint, which redistributed the medium and left residue on the edges and end of a mark, often creating a repeating pattern. Matisse used scraping to reveal lower layers of paint, exposing earlier colors that could be reincorporated into the composition (50g). He also scraped around the contours of still-life elements to adjust their proportions.

INSCRIBING/SCORING/INCISING/SGRAFFITO

As he worked on his canvases during the 1913–17 period, Matisse frequently cut lines into wet or still-soft paint using a sharp instrument, including a quill or stylus, an etching or sculpting needle, the tip or edge of a palette knife, or perhaps a broken tool. This technique could sometimes echo that of his monotypes (22). The inscribed lines outlined forms (30g) and accentuated contours by revealing underlayers (37c). Sometimes the artist lightened a color by vigorously scoring and almost removing an area of paint (25g).

WIPING

Evidence suggests that when he needed to remove partially wet paint, Matisse sometimes would wipe it off, using turpentine if necessary (26c). Sometimes this abraded the ground or remaining paint layer slightly, exposing the canvas thread. The artist also used his fingers to wipe away paint, occasionally leaving a small fingerprint (27c). On the left side of *Still Life with Lemons,* Matisse scratched into the paler blue layer, then wiped a darker blue into the scratches to accentuate the texture of the paint (26c).

Prints and Drawings

Print Materials and Process

SUPPORT

In the 1913–17 period, Matisse executed almost all of his prints and drawings on substantial white or cream paper. Although no systematic study has yet been made, it appears that he preferred *wove paper,* with a smooth and uniform weave, to *laid paper,* which bears a pattern of crossing lines from the mold in which it is made. In occasional drawings, most notably in his portrait of *Eva Mudocci* (48.2), the artist expanded the original sheet with additional ones.

CHINE COLLÉ

Apart from lithographs, Matisse made virtually all of his prints on a press, using thin sheets of finely woven, opaque, matte China paper that were applied directly to a heaver support sheet in the so-called *chine collé* or *chine appliqué* technique. This is traditional for *intaglio printing*, since China paper accepts an impression more easily and carries detail better than regular paper, producing a richer print. Matisse also used it for most and perhaps all of his *monotypes*, probably as a way to capture their fine detail.

INTAGLIO PRINTING

In this general process, which includes *engraving, etching* and *drypoint*, the surface of a metal *plate* is cut into in a variety of ways; the parts removed from the surface register as the image when the recessed lines are inked and the plate is run through the press.

ETCHING

A metal plate is covered with a *ground,* a thin, acid-impervious coating, through which lines or other marks are drawn with an etching needle or another sharp instrument. Acid, applied to the plate, etches grooves into the exposed areas; the longer the acid remains, the deeper the *bite* and the stronger the line. Different effects can be achieved by using an acid-impervious varnish (*stop out*) on some lines and allowing the acid to bite others further. Matisse preferred the look of a spontaneous sketch for his etchings but he did occasionally accentuate the contours of a figure (22a) or heavily rework the whole image (22n and 33) with rebiting. As with his paintings, he sometimes accepted chance effects, including the unintended marks produced by wiping a plate insufficiently before etching, or by a *foul bite,* an error caused by a flaw in the application of the ground.

DRYPOINT

A metal plate is cut directly with an etching needle or other sharp instrument. When it is inked, the scratched furrows catch the ink and register as lines, as do the ridges of displaced metal, or *burr,* that are thrown up on each side. The burr catches the ink intermittently and in varying densities, according to how deeply the plate was scratched, producing dark, velvety accents at the edges of the line (18c), sometimes overtaking its entire width (48f). Matisse used drypoint to similar effect as the stuttering incisions in some of his paintings.

PLANOGRAPHIC PRINTING

A general process that includes *lithography* and *monotype*. The surface is not incised; rather an image is made onto the surface of a plate and then transferred to paper.

LITHOGRAPHY

Traditionally, a design is drawn or painted on the polished flat surface of a stone with greasy crayon or ink. The stone is flooded with water, which adheres to the bare stone and not the drawn areas; ink does the reverse, thereby reproducing the design when printed. With the exception of perhaps one work (21f), Matisse made *transfer lithographs,* in which he painted or drew with a lithographic crayon or paint on special paper and mechanically transferred the image to the stone for reproduction.

MONOTYPE

A technique in which a design is drawn into ink or paint on any smooth surface; while it is still wet, a sheet of paper is laid on top of the plate and then run through a press. As the image is not made with any permanent means, it results in only one good impression. Matisse made his monotypes on the same metal plates as his etchings. He covered the entire plate with medium and then scratched away the image, sometimes with an etching needle, sometimes with a broad, flat tool, possibly a pen (22p), the end of a brush, or even a palette knife. While some of these prints have dense fields of black, others reveal the chance effects such as uneven applications of ink onto the plate; still others demonstrate the intervention of the artist, who readjusted contours with his fingertip (22o) or forms with a brush (p. 227, fig. 11). A close connection exists between these prints and many of Matisse's 1913–17 paintings, not only in their black fields and inscribed drawing, but also as they appear to represent states or potential variations of works on canvas (22g–j, p–u).

Drawing Tools and Techniques

Matisse made various types of drawings in the 1913–17 period, using tools and techniques that were appropriate but not unique to each of them. While some have connections to paintings at the time, many display a high degree of experimentation and exist as independent works.

PENCIL/GRAPHITE

Matisse used pencil or graphite for studies of entire compositions (43a) as well as details of compositions (35g), drawing in outlines with little or no shading in order to establish the parameters of a scene quickly. At times he made many line drawings of portrait subjects in pencil with little or no shading; some were the result of a moment of relief during a painting session (28), some as preparation for a painting, or as an independent work.

CHARCOAL/CRAYON

Matisse's most ambitious drawings comprised works done in soft mediums such as charcoal and crayon, which allowed him to work the medium left on the paper in inventive and expressive ways. These dense substances also left traces of the artist's compositional changes (48.2): marks of an eraser used to efface or minimize earlier passages and signs of lines having been rubbed, wiped down, or blended either by fingers, a rag, or a *stump*.

INK

Matisse rarely used ink for his drawings in the 1913–17 period, except for compositional sketches in letters or on postcards (15a–b); here, he employed the pen and ink he was using for the correspondence itself.

STUMP

Also known as an *estompe*, a roll of leather or paper with a stubby conical or domed point at either end that is used to work the medium. The technique of *stumping* produces dramatic, shadowy effects (48.3).

Sculpture

Materials and Process

FREESTANDING SCULPTURE

A sculpture, with or without an attached base (1.1), that can be viewed from all angles.

BAS-RELIEF

A sculpture in which the forms are built from a flat background plane (4), different than a *freestanding sculpture*. Matisse made only eight bas-relief sculptures, including the four *Backs*. For his first state of *Back*, Matisse likely worked on a table, rolling out the soft clay into large sheets that he then firmly pressed onto a nail-studded board. The thickness

of the clay must have been sufficient for him to manipulate it with his fingers, producing the rolling topography of the background. The artist could easily have added clay to the figure to create the higher areas of the relief.

CLAY

Matisse made most of his early works first in clay (see pp. 57, 73), a soft material composed of mineral particles and water. Clay sculpture must be kept wet in order to keep working until it is completed; if allowed to dry out, clay without fillers has a strong tendency to crack.

PLASTER

Ground up and dehydrated gypsum; when water is added, the result is a pourable paste that hardens into a solid and can be carved when dry. Plaster is a more stable medium than clay for the long-term preservation of a sculpted form.

Back I, first state was cast into plaster in 1909 because Matisse was moving his studio and worried that the clay version might be damaged. The clay bas relief would have been molded with either plaster or gelatin to produce a negative impression of the relief (a *waste mold*). The original clay would have to be removed and scraped from the interior of the negative mold and would not have survived the process intact. Finally, fresh plaster was poured into the negative mold, which had been coated with a separating agent; the result was a positive copy. At this point, the new plaster could traditionally be used to make a bronze edition or, in the case of *Back (I–IV)*, Matisse could continue his reworking on the earlier form by rewetting the plaster and adding more plaster as well as cutting away form with a *chisel* or other tools.

BRONZE AND BRASS

Bronze is classically an alloy of copper and tin, while *brass* is an alloy of copper and zinc; lesser amounts of other metals may be added to either alloy to adjust their working properties. In modern times, the term *bronze* is used to refer to many copper-base alloys containing zinc and other elements in place of tin. Matisse's bronzes were cast in at least five foundries (Bingen-Costenoble, Godard, Rudier, Susse, and Valsuani), using two basic techniques. *Back (I) second state*, *Back (III)*, *Back (IV)* and *Jeannette (I–IV)* are lost wax casts. *Back (II)* is a sand cast.

Examination Techniques

Artworks can be studied by examining the thread count of a canvas; the chain patterns of paper; and the front, back, and edges of paintings and works on paper. These as well as sculpture can be examined under magnification and with raking and specular light, ultraviolet radiation, infrared reflectography, and X-radiography. In addition, various methods of scientific analysis and imaging techniques were developed specifically for this project.

RAKING, SPECULAR, AND TRANSMITTED LIGHT

Various lighting arrangements can highlight features on works that are not easily captured with normal illumination. To examine a painting in raking light, lamps are positioned at a low angle to a canvas, so the light travels from one edge of the object toward another, exaggerating the surface texture and deformities by enhancing their shadows (18f–g). To study a drawing, for instance, in specular light, lamps are positioned perpendicular to the surface of the sheet so the light is reflected directly back to the viewer, highlighting variations in surface sheen and planar deformities. Light transmitted through the front of a canvas accentuates thinly and thickly

painted passages, identifying unpainted areas in greater detail.

ULTRAVIOLET ILLUMINATION

Ultraviolet radiation is used to help characterize surface coatings, pigment composition, and reworkings or restorations. Artist's materials, including some pigments, exhibit specific fluorescence colors in response to ultraviolet radiation (8d), which aid in their identification.

INFRARED REFLECTOGRAPHY

Infrared imaging exploits the varied transmission and reflection properties of artists' materials and is used to distinguish pigments, inscriptions, underdrawings (particularly those done in carbon-rich materials such as charcoal and pencil over a white ground), and changes in a composition (3f) not visible to the naked eye.

X-RADIOGRAPHY

X-radiographs are obtained by exposing a painting to X-radiation and then capturing the image on film or digitally. Digital images can be manipulated with software designed to assemble individual X-ray films into a composite picture of the entire canvas and support (p. 29, fig. 11). X-radiography can reveal changes in the composition, the density of paint layers, and details in the support not visible to the naked eye.

Scientific Methods of Analysis

A variety of scientific techniques can be used to identify materials from a work of art. Individual pigments can be identified with polarized light microscopy or scanning electron microscopy coupled with energy dispersive X-ray spectroscopy. Paint samples that are mounted as a *cross section* reveal their layer structure when viewed with a reflected light/fluorescence microscope and can also be analyzed with SEM/EDS. In addition to pigments, the medium or binder from a paint layer can be identified by means of Fourier transform infrared microspectroscopy and gas chromatography-mass spectroscopy.

OVERLAYS

Digitized images of a painting—such as X-radiographs, infrared reflectograms, and photographs of earlier states—that are aligned over one another to determine how Matisse changed particular features of a work over time.

CROSS SECTIONS

A small sample of a painting that includes the surface, paint, and ground layers, usually from an area of loss or along the edge of the canvas, which is mounted in a silicone mold, sandwiched between two layers of hardened transparent resin, and ground and polished to expose all the layers of paint in one plane. Prepared cross sections (5g) can be examined and documented with a reflected light/fluorescence microscope equipped with a digital camera; this technique was employed to analyze the cross sections from *Bathers by a River*.

DIGITAL IMAGING TECHNIQUES

For this project, Dr. Robert Erdmann of the University of Arizona developed sophisticated software to unite multiple archival images that were taken from an oblique angle or otherwise distorted, aligning them into the same plane (16i). He used the same software to automatically unite individual films into composite X-radiographs (p. 29, fig. 11) and infrared reflectograms (26a) without distortions or tonal discrepancies.

RECOLORIZATION

Dr. Sotirios A. Tsaftaris and Dr. Aggelos K. Katsaggelos of Northwestern University developed a complex software protocol to recolorize a historic photograph of *Bathers by a River* (21c) in order to better understand Matisse's palette and working methods. They correlated black-and-white photographs with the color of the finished painting and spread the color information to as many pixels as possible using algorithms and equations based both on the grayscale intensities of the photograph and on the likely extent of hidden color areas (visible to researchers in cross sections, paint losses, and earlier areas of the painting that Matisse left exposed in his reworking).

THREAD COUNT AUTOMATION PROJECT

Dr. Rick Watson of Cornell University and Dr. Don Johnson of Rice University developed an automated software program for counting the threads and mapping the weave of a canvas from an X-radiograph so that canvases cut from the same fabric can be identified. The pair analyzed thread counts and canvas weaves from seventeen paintings by Matisse in this exhibition.

LASER SCANNING

The process of shining a laser line over the surface of an object in order to collect three-dimensional data. This data is captured by a detector, or camera, that is mounted in the laser scanner and records the line as it shines on the object. With knowledge of the location of both the origin of the laser and the detector, software triangulates the image of the laser line into accurate, dense, three-dimensional coordinates, or points. As the laser line passes over an object, tens of thousands of such points can be collected in seconds; these are later processed into a digital model that shows surface details and can be used for accurate comparisons of surface contours. The laser scanning for this project was performed by Direct Dimensions, Inc.

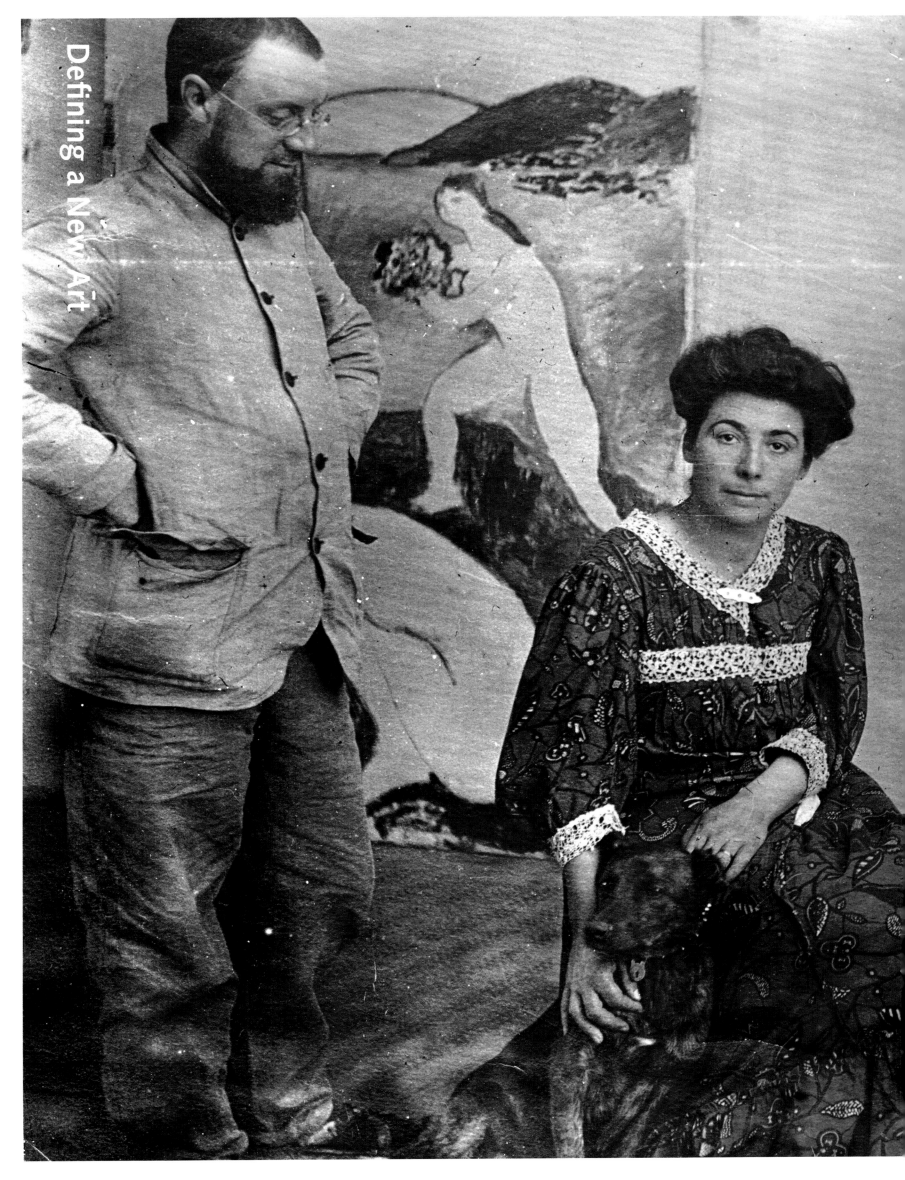

1907

Henri Bergson publishes *Creative Evolution*.

Daniel-Henry Kahnweiler opens his gallery in Paris.

EARLY JANUARY
In Collioure since early summer, Matisse begins work in the rented home of Marie Astié. Over the next two months, he will make the sculpture *Reclining Nude (I) (Aurore)* (1.2), a continuation of the theme initiated in *Reclining Nude with Chemise* (1.1) and the painting *Blue Nude (Memory of Biskra)* (1.3).

FEBRUARY 17
Writes from Narbonne to the artist Henri Manguin in response to his question about a frame for *Blue Nude*, which is nearly or already finished.

LATE FEBRUARY
Returns to Paris and works in his studio on the fifth floor of 19, quai Saint-Michel, near Notre Dame.

MARCH 1
Sells his first paintings to Galerie Bernheim-Jeune. Previously, he has sold work through the galleries of Eugène Druet; Henry Graves; Prath and Magnier; Ambroise Vollard; and Berthe Weill.

MARCH 20
Salon des Indépendants opens; it runs through April 30. Matisse exhibits two drawings, three woodcuts, and *Blue Nude* (under the title *Tableau No. III*), which is acquired by Leo and Gertrude Stein.

APRIL 22
Returns to Collioure.

SUMMER
Mécislas Golberg—poet, aesthetician, and critic—invites Matisse to write "an explanation of [his] aesthetics."

JUNE 17
Druet writes to Matisse to say he has photographed *Blue Nude*.

JULY 8
Matisse has completed a number of paintings, including *Three Bathers* (3a); *Music (Sketch)* (p. 81, fig. 10); *Madame Matisse, Red Madras*; and *La coiffure* (4i). He ships them to Félix Fénéon of Galerie Bernheim-Jeune.

JULY 14
Departs with his wife, Amélie, for Italy. On the way, they stop in Cassis, where they visit André Derain, to whom Matisse shows photographs of recent works. The couple also visits Georges Braque and Othon Friesz in La Ciotat, Henri-Edmond Cross in Saint-Clair, and Manguin in Saint-Tropez.

JULY 18
In Florence until July 29; they travel to Fiesole to visit Leo and Gertrude Stein and Walter Pach.

BEGINNING OF AUGUST
The Matisses visit Sienna, Arezzo, Ravenna, Padua, and Venice; Matisse is deeply moved by Giotto's Arena Chapel in Padua.

AUGUST 14
They return to Collioure; Matisse will soon resume work on *Le luxe (I)* (2.1) and possibly begin *Le luxe (II)* (2.2).

SEPTEMBER 1
In Paris Matisse works on *Le luxe (II)* and paints ceramics (3b) with André Metthey in Asnières.

Georges Desvallières asks Matisse to write an article on his work for *La grande revue*.

SEPTEMBER 10
Matisse submits materials to Golberg.

SEPTEMBER 26
Ivan Morosov purchases his first work by Matisse, *Bouquet*.

OCTOBER 1
Salon d'Automne opens at the Grand Palais; it runs though October 22. Matisse is represented by five paintings: *Madame Matisse, Red Madras*; *Music (Sketch)*; *Le luxe (I)*; two landscapes identified as *esquisses*; painted ceramics; and two drawings. He also tries to exhibit *La coiffure*, but it is rejected.

The Salon also includes a retrospective of Cézanne's many bathers compositions.

NOVEMBER–DECEMBER
Matisse probably sees *Les demoiselles d'Avignon* (p. 51, fig. 14) with Derain in Picasso's studio.

Exchanges with Picasso the paintings *Portrait of Marguerite* and *Pitcher, Bowl, and Lemon*.

EARLY DECEMBER
At the request of Sarah Stein, Hans Purrmann, and a group of young artists from the Académie Colarossi, Matisse teaches a private class.

Moves his studio to the Couvent des Oiseaux, 56, rue de Sèvres, where he will begin *Bathers with a Turtle* (3).

DECEMBER 15
Guillaume Apollinaire publishes the article "Henri Matisse" in *La phalange*, based on material from Golberg, who is gravely ill.

DECEMBER 24
A number of Matisse's paintings are shown at the Folkwang Museum, Hagen. The museum's founder, Karl-Ernst Osthaus, calls the artist "the true successor of Cézanne."

1908

EARLY JANUARY
Matisse opens the Académie Matisse with an initial group of about ten students, including Patrick Henry Bruce, Joseph Brummer, Bela Czobel, Oskar and Greta Moll, Carl Palme, Hans Purrmann, Annette Rosenstine, Sarah Stein, and Max Weber. The students draw, paint, and sculpt, with particular emphasis on working from the model. Matisse gives critiques of individual works but also lectures more generally.

FEBRUARY
Exhibition of International Society of Painters, Sculptors and Engravers opens at the New Gallery, London.

FEBRUARY 6
Through Purrmann, Osthaus begins discussions to acquire *Bathers with a Turtle*, which is also of interest to the Steins.

SPRING
Sergei Shchukin brings Morosov to Matisse's studio, where they see *Bathers with a Turtle*.

Couvent des Oiseaux is sold by the government; Matisse moves his studio and school, as well as family, to new quarters at the Couvent du Sacré Coeur, 33, boulevard des Invalides.

Matisse's friend Albert Marquet moves to Matisse's former studio at quai Saint-Michel.

MARCH 20
Salon des Indépendants opens; it runs through May 2. Matisse does not exhibit.

APRIL 6
Matisse has a solo exhibition of watercolors, drawings, and prints at Alfred Stieglitz's Little Galleries of the Photo-Secession (291) in New York; it runs through May 24. The exhibition is suggested by Edward Steichen, who met Matisse through Sarah Stein.

APRIL 18
Salon de la Toison d'Or opens in Moscow; it runs through May 24. Matisse exhibits three works, including *La coiffure* and *The Geranium*.

APRIL 20
American writers Gelett Burgess and Inez Haynes Irwin visit Matisse's studio, where they see his recent work, including *Bathers with a Turtle* and unfinished versions of *Decorative Figure* (4f–g) and *Back* (4). Burgess is interviewing artists, including Braque, Derain, and Picasso, for an article in *Architectural Record* (published as "The Wild Men of Paris" in May 1910).

MAY
Shchukin commissions Matisse for a painting like *Bathers with a Turtle*—this will be *Game of Bowls* (5c)—and a large panel (referred to as the "harmony in blue") to be installed with his six Gauguin paintings in the dining room of his Moscow home.

C. JUNE 12
Matisse travels to Germany for a week with Purrmann to see Heidelberg, Speyer, Munich, and Nuremberg.

JUNE 30
Shchukin acquires *Game of Bowls* after Matisse sends a photograph of the completed painting.

JULY 6
Druet makes an autochrome of the first state of the "harmony in blue" (p. 84, fig. 16).

AUGUST 6
Matisse writes to Shchukin about changing the palette of the "harmony in blue" to red (*Harmony in Red [The Red Room]* [p. 84, fig. 17]).

SEPTEMBER
Takes Shchukin to meet Picasso and see *Les demoiselles d'Avignon*.

OCTOBER
Camera Work publishes a statement on photography by Matisse ("George Besson Conducts Interviews on Pictorial Photography").

OCTOBER 1
The Salon d'Automne opens; it runs through November 8. Matisse is on the painting jury. He is the subject of a retrospective of eleven paintings, including *Statuette and Vase on an Oriental Carpet* and *Harmony in Red (The Red Room)*; thirteen sculptures, including *Reclining Nude (I) (Aurore)* and *Decorative Figure*; and six drawings.

Six of Braque's early Cubist paintings are rejected from the Salon.

OCTOBER 26
Vollard sells Matisse six watercolors by Cézanne.

BEFORE NOVEMBER 8
Desvallières invites Matisse to write what he describes as "a lecture of your beliefs."

NOVEMBER 26
Matisse proposes a painting to Fénéon that will become *Nymph and Satyr* (p. 79, fig. 4).

DECEMBER 11
Weill opens a group exhibition that includes Manguin, Matisse, Marquet, and Jean Puy; it runs through December 31.

DECEMBER 21
Matisse travels to Berlin with Purrmann to prepare an exhibition at the Galerie Paul Cassirer that runs through January. He sees his students the Molls and meets Max Liebermann and the architect Henry van de Velde. Visits Osthaus in Hagen and likely sees *Bathers with a Turtle* and his ceramic-tile triptych (5e) installed in Osthaus's museum.

DECEMBER 25
Matisse's "Notes of a Painter" is published in *La grande revue* and is illustrated by six paintings, including *Portrait of Greta Moll* and *Game of Bowls*. It will also be translated into German and Russian.

1909

JANUARY
The sale of the Couvent du Sacré Coeur is announced.

Around this time, Matisse begins *The Conversation* (p. 117, fig. 15), which he will continue to work on for some time.

JANUARY 12
Shchukin acquires *Nymph and Satyr*.

JANUARY 24
Salon de la Toison d'Or opens in Moscow; it runs through February 28. Matisse shows nine drawings and four paintings.

FEBRUARY 7
Matisse in Cassis for four weeks.

FEBRUARY 20
The Futurist Manifesto is published by F. T. Marinetti on the front page of *Le figaro*.

LATE FEBRUARY
In Paris Matisse begins an *esquisse* of *Dance* (*Dance [I]*) (p. 79, fig. 5).

MARCH
Matisse and Shchukin exchange letters regarding the commission throughout the month. Matisse will suggest the subjects of dance and bathers; Shchukin requests panels of dance and music.

MARCH 6
Shchukin writes to Matisse acknowledging the arrival of *Harmony in Red (The Red Room)* and *Nymph and Satyr*, and asks about the latest commission.

MARCH 11
The *esquisse* for *Dance* is complete.

MID-MARCH
Matisse begins *Nude with a White Scarf* (6).

C. MARCH 25
Begins a large bathers composition (*Bathers by a River*) (5n).

Charles Estienne interviews Matisse in his studio for *Les nouvelles* (published as "Des tendances de la peinture moderne: Entretien avec M. Henri-Matisse," April 12, 1909).

APRIL 9
Matisse and Shchukin are in agreement on the subjects for his decorative panels.

APRIL 26
Matisse begins correspondence with Madame Cocurat, who is the owner of 42 (later renumbered 92), route de Clamart, a house in Issy-les-Moulineaux, a suburb southwest of Paris, about renting the property.

JUNE
The Couvent du Sacré Coeur studio is sold.

JUNE 2
Matisse orders a prefabricated structure that will function as his studio on the grounds of the Issy-les-Moulineaux property.

JULY
Matisse and family in Cavalière-Sur-Mer, near Saint-Tropez, through August. He works outside with model Loulou Brouty and produces paintings and drawings related to his commission from Shchukin, including *Nude by the Sea* (7), *Bather* (8), and *Rose Nude* (7a).

SEPTEMBER
Matisse takes up residence at Issy-les-Moulineaux; he spends less time at the Académie Matisse.

SEPTEMBER 18
Signs a contract with Bernheim-Jeune for three years, which covers standard size format 6 through 50 canvases. This raises the prices of his works, which, along with Shchukin's patronage, makes him financially secure.

SEPTEMBER 27
The studio in Issy is completed. There Matisse will work on the sculpture *La serpentine*, resume work on *Back*, and begin the first panel of the Shchukin commission (*Dance [II]*) (p. 77, fig. 1)).

OCTOBER 1
The Salon d'Automne opens; it runs through November 8. Matisse exhibits two still-life paintings.

OCTOBER 30
Artists Marcel Sembat and his wife, Georgette Agutte, visit Matisse and look through the summer's work; they acquire *Rose Nude*.

C. MID-NOVEMBER
With *Dance* underway, Matisse begins *Music*. An *ébauche* is photographed by Druet (p. 82, fig. 13).

1910

JANUARY
Matisse begins portrait busts of Jeanne Vaderin (11.1–2), his neighbor in Issy.

JANUARY 10
Cézanne retrospective exhibition opens at Bernheim-Jeune; it runs through January 22. Matisse lends his painting *Three Bathers* (p. 45, fig. 3).

FEBRUARY 14
Exposition Henri-Matisse opens at Bernheim-Jeune; it runs through March 5. It includes ninety-one works from 1895 to 1910, among them sixty-five paintings such as *La desserte (after Jan Davidsz. de Heem)* (35b) and *Nude with a White Scarf*, and twenty-six drawings.

EARLY SPRING
Druet photographs *Music* in a further state of development (p. 82, fig. 14).

MARCH 18
Salon des Indépendants opens; it runs through May 1. Matisse shows a painted portrait of Vaderin, *Young Girl with Tulips* (11d). Reviews are mixed.

MARCH 26
Matisse in Collioure; visits Toulouse.

APRIL 18
Bernheim-Jeune exhibition *D'après les maîtres* opens; it runs through April 30. This is the first modern commercial exhibition of copies and is organized by Fénéon. It includes paintings by Cézanne, Gustave Courbet, Van Gogh, Jean-Auguste-Dominique Ingres, Édouard Manet, Odilon Redon, and Georges Seurat after Old Masters and modern artists such as Gauguin. Matisse is represented by a copy after Eugène Delacroix's *The Abduction of Rebecca* (p. 109, fig. 1).

MAY
Matisse ends his involvement at the Académie Matisse.

END OF MAY
Sends photographs of *Music* to Shchukin and reports on the progress of the commission.

SUMMER
Matisse works on *Dance (II)* and *Music* (p. 77, fig. 2) to the point of exhaustion.

JUNE 6
Henry McBride, Roger Fry, and Bryson Burroughs visit Matisse at the Issy studio and see *Dance (II)*.

FALL
Felius Elies (writing under the pseudonym "J. Sacs") interviews Matisse for *Vell i nou* and sees *Music* and "several seriated molds" of *Jeannette* (published as "Enric Matisse il la critica," November 1, 1919).

OCTOBER 1
The Salon d'Automne opens; it runs through November 8. Matisse shows two works: *Dance (II)* and *Music*. The themes of bathers, dance, and Arcadia are popular with many other artists at the Salon.

Cubist works are also shown in the Salon.

BY OCTOBER 3
Matisse has left for Germany. He goes to Munich with Marquet and is joined on the way by Purrmann. Visits the *Meisterwerken Muhammedanischer Kunst* exhibition, a display of Islamic art that includes over 3,500 objects and photographic reproductions. Meets Hugo von Tschudi, director of the Munich Staatliche Museen, and Matthew Stewart Prichard.

OCTOBER 14
Returns to Issy.

OCTOBER 15
Matisse's father dies in Bohain-en-Vermandois.

END OF OCTOBER
Matisse and Shchukin look at the commissioned panels together; Shchukin is initially unsure about them.

NOVEMBER 8
The Grafton Galleries, London, open *Manet and the Post-Impressionists*; it runs through January 15, 1911. The executive committee for the exhibition includes Fry. Matisse is represented by three paintings, eight sculptures, one painted vase, and twelve drawings.

NOVEMBER 11
Shchukin writes to Matisse about his commitment, despite his initial hesitation, to acquire the commissioned panels for the staircase of his Moscow home.

NOVEMBER 16
Matisse leaves for Spain. Visits Madrid, Córdoba, and Granada, seeing important Moorish monuments and works by Diego Velázquez and Francisco de Goya, among others. Francisco Iturrino travels and paints with him.

DECEMBER 11
In Seville, where he will paint *Seville Still Life* and *Spanish Still Life* (p. 111, figs. 3–4).

1911

WINTER–SPRING
Matisse paints *The Pink Studio* (p. 113, fig. 5).

JANUARY 5
Shchukin writes to Matisse, inviting him to Moscow.

JANUARY 17
En route to Paris, Matisse visits Barcelona and Toledo, where he sees paintings by El Greco.

LATE JANUARY
Returns to Paris and stays in Issy until May.

FEBRUARY
Paints *The Manila Shawl* (12.1), with Amélie as his model.

SPRING
Executes *The Painter's Family* (p. 113, fig. 6) for Shchukin.

APRIL 21
Salon des Indépendants opens; it runs through June 13. Matisse initially submits two figure paintings, *The Manila Shawl* and *Joaquina (Gitane)*, but substitutes *The Manila Shawl* with *The Pink Studio*.

A number of Cubist works are exhibited together in the Salon; the presentation causes a scandal.

APRIL 29
Matisse acquires Cézanne's painting *Fruits and Foliage* (p. 147, fig. 7) from Bernheim-Jeune.

MAY 1

Weill opens an exhibition of drawings and watercolors that will run for two weeks; the display includes works by Jean-Louis Forain, Manguin, Marquet, Matisse, Picasso, Redon, and Adolphe Willette.

Auction at Hôtel Drouot to benefit the construction of a monument to Cézanne by Aristide Malliol; Matisse donates *Carmelina* (p. 47, fig. 7) to the sale.

JULY 30

Matisse and his family travel to Collioure, where he will make a number of works, including the paintings *Portrait of Olga Merson* (12.2) and *Interior with Aubergines* (p. 113, fig. 7), and a sculpture of Olga (*Seated Nude [Olga]*).

OCTOBER

Stieglitz visits Matisse, Picasso, and Auguste Rodin in their studios and calls it a "tremendous experience."

Shchukin arrives in Paris and visits Matisse in his Issy studio, where he sees *The Pink Studio, The Painter's Family, Still Life with Aubergines,* and *Large Nude (Aurore)* (later destroyed). He will purchase *The Painter's Family* and may also commission *The Red Studio* (p. 113, fig. 8) at this time.

OCTOBER 1

Salon d'Automne opens; it runs through November 8. Matisse presents two works: *View of Collioure* (p. 114, fig. 10) and *Still Life with Aubergines*.

C. OCTOBER 13

Matisse returns to Issy.

NOVEMBER 1

Departs for Russia with Shchukin. In Moscow, Ilya Ostroukhov, a collector of old Russian painting, serves as Matisse's guide. Among his activities, Matisse visits Shchukin's and Morosov's collections as well as Ostroukhov's collection of icons, which greatly impresses him.

NOVEMBER 22

Arrives in Paris.

NOVEMBER 30

France enters a treaty with Germany that opens Morocco once again to French travelers. Matisse, who thinks of his Russian trip as an experience in "Asia," decides to spend the winter in Tangier, which he regards as "Africa."

DECEMBER

Matisse works on *The Red Studio*.

1912

JANUARY 29

Henri and Amélie Matisse, traveling from Marseilles, arrive in Tangier after a three-day journey by sea. Their room at the Hôtel Villa de France has views of the Grand Socco (large market), the Anglican church of St. Andrew's, the Casbah and the Medina (the oldest parts of the city), and the beaches along the Bay of Tangier. It rains for about fifteen days.

FEBRUARY 5

The Futurists' first exhibition in Paris opens at Galerie Bernheim-Jeune; it runs through February 12.

LATE FEBRUARY–MARCH

When the weather clears, Matisse acquires special permission to work in the gardens of the

Villa Brooks. Here he paints *Acanthus (Moroccan Landscape)* (p. 115, fig. 12), *Periwinkles (Moroccan Garden)* (p. 115, fig. 11), and *The Palm* (52b).

MARCH 14

An Exhibition of Sculpture—The First in America—and Recent Drawings by Henri Matisse opens at Stieglitz's Little Galleries of the Photo-Secession; it runs through April 6. The presentation is organized by Steichen and selected by the artist, and features six bronzes; five plasters, including three states of *Jeannette*; one terracotta; and twelve drawings.

MARCH 27–28

Matisse visits the Rif village of Tétouan.

MARCH 31

Amélie Matisse departs for France.

APRIL 1

Matisse corresponds with his family, saying that he has written to Shchukin and sent a sketch of the still life (*Basket of Oranges*) and two landscapes for Morosov, "the blue one" (*Landscape Viewed from a Window* [44c] or *Acanthus [Moroccan Landscape]*) and periwinkles (*Periwinkles [Moroccan Garden]*); he notes that they made a nice *croquis* triptych.

Writes to his family that Madame Davin, proprietress of the Hôtel Villa de France, has found a room where he can paint Zorah, a young Arab girl, without her being seen; the canvas he is working on will become *Zorah in Yellow* (14.1). At this time, he also paints *Amido* (14a).

APRIL 12

Writes to his wife about two ideas for new paintings, which later become *The Moroccans* (15) and *The Moroccan Café* (15c).

APRIL 14

Departs Tangier for Marseilles, then Paris. During this trip to Morocco, he may also complete *The Marabout* (15d).

MAY 1

Salon de Mai opens; it runs through May 15. Cézanne's *Madame Cézanne in a Yellow Chair* is exhibited.

SPRING–EARLY SUMMER

Back in Issy, Matisse begins an extremely productive period and makes a number of ambitious paintings, including two versions of *Nasturtiums with "Dance,"* *Corner of the Studio,* and *Goldfish*.

SUMMER

Matisse completes *Goldfish and Sculpture* (19a), *Interior with Goldfish* (19b), and *Purple Cyclamen*.

Ernst Goldschmidt visits Matisse in his studio for an article in *Politiken*; he sees *The Red Studio* and *Bathers* and *Back* in process (published as "Inroads to Art," January 5, 1913).

JUNE

Clara T. MacChesney interviews Matisse in his studio for an article in the *New York Times* (published as "A Talk with Matisse," March 9, 1913).

BY JULY 2

The Conversation (p. 117, fig. 15), which Matisse began in early 1909, is complete.

MID-JULY

Shchukin visits Matisse and purchases *The Conversation, Amido, Goldfish,* and *Nasturtiums with "Dance" (II)* (p. 116, fig. 13).

AUGUST

Stieglitz publishes a special issue of *Camera Work* with reproductions of works by Matisse (photographs by Druet) and Picasso, as well as "word portraits" of the artists by Gertrude Stein.

SEPTEMBER 18

Matisse renews his contract with Bernheim-Jeune for three years; it continues to include standard size 6 through 50 canvases.

SEPTEMBER 30

Leaves Paris for second trip to Morocco.

OCTOBER 1

The Salon d'Automne opens; it runs through November 8. Matisse is represented by two works: *Nasturtiums with "Dance" (II)* and *Corner of the Studio*.

OCTOBER 5

Second Post-Impressionist Exhibition, organized by Fry, opens at the Grafton Galleries, London; it runs through December 31. Matisse is represented by nineteen paintings, including *Dance (I), The Red Studio,* and *The Conversation;* eight sculptures, such as *Back* (plaster) and the first four states of *Jeannette;* and numerous works on paper.

OCTOBER 8

Matisse arrives in Tangier via Marseilles, bringing *Landscape Viewed from a Window* back with him. He intends to stay for only a short time.

OCTOBER 21

Writes to his artist friend Charles Camoin about his work on *Fatma, the Mulatto Woman* (14.2).

OCTOBER 25

Writes to Amélie about his continued thoughts for the Moroccan café and Casbah compositions.

END OF OCTOBER

Decides to extend his stay in Tangier.

NOVEMBER 2

Writes to Amélie about his continued work on *Fatma*.

NOVEMBER 22 OR 23

Amélie and Camoin join Matisse in Tangier.

DECEMBER 5

Debate over Cubism in the Chamber of Deputies, occasioned by the Salon d'Automne.

1913

FEBRUARY 17

Association of American Painters and Sculptors, International Exhibition of Modern Art (known as the Armory Show) opens in New York; it runs through March 15. Matisse presents eleven paintings, including *Le luxe (II)* and *Blue Nude;* three drawings; and one sculpture in plaster, *Back*.

BY FEBRUARY 27

The Matisses leave Tangier. By the end of this second trip, Matisse completes a number of works, including *Calla Lillies; Calla Lillies, Irises, Mimosas;* and *The Standing Riffian* (16l); and the three paintings of the Moroccan Triptych, *Landscape Viewed from a Window, On the Terrace,* and *The Casbah Gate* (44c–e). He also initiates *The Moroccan Café* (15c).

I feel very strongly the tie between my earlier and my recent works. But I do not think exactly the way I thought yesterday. Or rather, my basic thought has not changed, but it has evolved, and my means of expression have followed. I do not repudiate any of my paintings, but there is not one of them that I would not redo differently, if I had it to redo. My destination is always the same, but I work out a different route to get there.[1]

MATISSE'S INSISTENCE ON THE CONTINUITY of his art, and that change was required to maintain it, introduced his "Notes of a Painter" of 1908, his first published essay and the definitive statement of his artistic creed. By then he was a celebrated albeit highly controversial artist, but this statement not only explains how he got to that position—it also warns his readers that there will be changes to come. It explains that, for every work he made, he could envisage another version of it. Moreover, and just as importantly, it suggests how central the issue of reworking was to his practice: as a way of borrowing from and responding to art he admired, both past and present; revisiting familiar subjects in different compositions; and often improvising results not knowable in advance.

Matisse's artistic education was a protracted one, lasting until he was twenty-seven and culminating in study under Gustave Moreau, who sent his pupils to make copies after Old Master paintings in the Musée du Louvre. However, Matisse eventually became aware of Impressionist painting and, finally out of art school in 1897, the work of Van Gogh, one of whose drawings (fig. 1) he received as a gift.[2] Two years later, he found himself tempted to purchase one of Van Gogh's *Les Alyscamps* paintings (see fig. 2) from the dealer Ambroise Vollard, only to be discouraged by the price. Returning later to reconsider, he saw the small *Three Bathers* (fig. 3) by Cézanne, which made the Van Gogh seem posterlike in contrast.[3] "Vollard had acquired a considerable number of Cézannes," Matisse recalled. "They were everywhere; the walls were covered with them; there were even piles of them on the floor, one right next to the other, leaning up against the wall. He had managed to buy them at a low price."[4] However, he did not sell them cheaply, and the artist resisted. It was not until he had gone down to Toulouse, in the south of France, and seen local boys swimming in a river that he committed himself to the purchase.[5]

With this acquisition, Matisse was following the specialized taste of a group of discerning Impressionist painters, among them Camille Pissarro, who had introduced him to Cézanne's paintings on the occasion of Cézanne's first solo exhibition, comprising some 150 works, which Vollard organized in 1895.[6] It included the controversial *Bathers at Rest* (fig. 4), which the dealer cunningly displayed in the window of his gallery, with as many as ten bathers paintings inside.[7] Matisse was arrested by the "extraordinary qualities that were in these canvases, but at the same time somewhat shocked by the deformations or malformations that were unusual for that time."[8] These qualities were even more shocking to the public at large; however, the Impressionist artists were overwhelmed by the force of these works. As Pissarro wrote to his son Lucien on November 21, 1895, "My enthusiasm was nothing compared to Renoir's. Degas himself is seduced by the charm of this refined savage. Monet, all of us. . . . Are we mistaken? I don't think so."[9] The shock of these works' deformations was, in fact, one reason to like them; as the painter-critic Émile Bernard wrote in 1907, "Some time ago, at old man Tanguy's, the hardware dealer on the rue Clauzel, I saw a reclining female nude that, though decidedly very ugly, was a magnificent morsel; for its ugliness had the kind of inexplicable greatness that compels recognition and caused Baudelaire to write, 'The charms of horror intoxicate only the strong.'"[10] But, additionally, Cézanne had used the color-filled lightness of an Impressionist palette to create effects of breadth and solidity more customarily found in the somber, tonally shaded art of the Old Masters.

While Matisse learned from Cézanne not to be afraid of putative ugliness, he cited that quality as one of the reasons he prized his *Three Bathers.* After keeping it for thirty-seven years, even through periods of intense financial difficulty, he donated it to the Musée du Petit Palais, Paris.[11] He explained to the museum's

director, Raymond Escholier, the painting's importance to an understanding not just of Cézanne, but also of his own life and work:

Allow me to tell you that this picture is of the first importance in the work of Cézanne because it is a very dense, very complete realization of a composition that he carefully considered in several canvases which . . . are only the studies that culminated in this work. . . . It has sustained me morally in the critical moments of my venture as an artist; I have drawn from it my faith and my perseverance. . . . It is rich in color and surface, and seen at a distance it is possible to appreciate the sweep of its lines and the exceptional sobriety of its relationships.[12]

In this description, Matisse was clearly referring not only to *Three Bathers*, but also to his own practice of creating series of like works and to the pictorial clarity that he sought to achieve—both approaches that he had learned from Cézanne. At this moment, he also spoke of his student copies of Old Masters: "I started with David De Heem's *Desserte* [35a]. Then there was [Chardin's] *The Ray*, which I tried to paint schematically—Cézanne was the last."[13] While Matisse did not literally copy *Three Bathers*, as he did these other works, it was the rock to which his own, many bathers compositions remained firmly attached; they are unimaginable without it.[14]

Pissarro had said to Matisse, referring to the bathers canvases, "Cézanne is not an impressionist because all his life he has been painting the same picture," adding that an Impressionist such as Alfred Sisley "is a painter who never paints the

same picture, who always paints a new picture."[15] Reflecting upon this exchange, Matisse concluded: "A Cézanne is a moment of the artist while a Sisley is a moment of nature." He learned from Cézanne to view his art as self-expression more than as depiction and to pursue similar qualities in one canvas after the next. He also learned that he could be a modern artist while tackling the deeply traditional subject of multifigure compositions if he understood that expression was not a matter of depicting passionate gestures but rather of commanding the arrangement of the entire picture. As he would write in "Notes of a Painter": "Composition is the art of arranging in a decorative manner the diverse elements at the painter's command to express his feelings. In a picture every part will be visible and will play its appointed role, whether it be principal or secondary."[16] Hence, he remarked later to Gaston Diehl of *Three Bathers*, "It was the first time that I really noticed Cézanne's power. All was hierarchized . . . the hands, the trees, counted as much as the sky."[17] And the reason that Cézanne was thus able to make these nominally disproportionate components count equally was because of the "constructional laws" that shaped his work; as Matisse said to Jacques Guenne in 1925, "He had, among his great virtues, the merit of wanting the tones to be forces in a painting, giving the highest mission to his painting."[18] What Matisse would later call "construction by colored surfaces," whether the color be bright or subdued, became his mission, too; and he would often follow Cézanne's very procedure of aggregating and then combining ever more closely the units of color from which a picture was constructed.

While *Three Bathers* shaped Matisse's approach to composition, technique, and working method, it also provided him with a subject that he found compelling and that he returned to repeatedly for many years to come. Bathers pictures, which go back to antiquity, had evolved in two broad directions: one treated classical or biblical stories of forbidden looking at female bathers such as the goddess Diana or the faithful Hebrew wife Susanna; the other presented bathers in situations that sanctioned looking at them. The long-favored site of this second approach was an idyllic paradise—sometimes Eden but more often the classical version known as Arcadia, sometimes as the Golden Age—a mythical, usually pastoral place uncorrupted by civilization.

The weight and sobriety of most of Cézanne's bathers tells us that he was emulating the great earlier artists who had attempted this subject, notably Nicolas Poussin.[19] Matisse, following Cézanne, would look back to earlier artists as well. But he would also draw upon a variant of the Arcadian tradition that had emerged in the eighteenth century, namely the romanticized concept of the noble savage, whose colonialist and then primitivist connotations, both exotic and erotic, enlarged in the nineteenth century—the former to the delight of contemporary audiences, the latter to their dismay. Pissarro spoke of Cézanne as a "refined savage." Matisse would take over this title in due course. However, unlike Cézanne, and like Gauguin, of whose work he would become aware by the turn of the century, he would specifically create Arcadian settings for some of his most ambitious compositions and actually look to non-European arts for inspiration in making them.

Matisse would likely have known that Gauguin was the first owner of the vividly colored but classically sober still life on the easel in Maurice Denis' *Homage to Cézanne* (fig. 5), which shows representatives of the artistic association influenced by Gauguin, the Nabis, gathered with Vollard in his gallery. The Cézanne whose critical reputation quickly grew after the 1895 Vollard retrospective was not only a painter of bathers, but first and foremost of landscapes and still lifes. Indeed, many artists thought his most exemplary creations were works like the one on the easel in this picture. Prior to purchasing his Cézanne, Matisse had himself followed this trend, as shown by his *Still Life with Oranges (II)* (fig. 6). But once he owned *Three Bathers*, things began to change, and within three years, he had painted a model named Carmelina as if the left-hand figure of *Three Bathers* had come into his quai Saint-Michel studio, bringing her towel with her (fig. 7).[20] As with the Cézanne, the model is frankly constructed from unblended patches of pigment, the

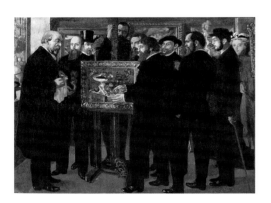

fig. 5
Maurice Denis
(French, 1870–1943)
Homage to Cézanne, 1900
Oil on canvas
180 × 240 cm (70⁷/₈ × 94¹/₂ in.)
Musée d'Orsay, Paris,
gift of André Gide, RF 1977 137

body weighty and limbs boldly articulated. Moreover, all the parts of the painting are "hierarchized": the background is made to count as much as the foreground and the setting as much as the model; across the surface, everything is worked with the same level of density.

Matisse loaned his *Three Bathers* to the retrospective of Cézanne's works at the 1904 Salon d'Automne.[21] He himself had fourteen canvases and two sculptures in the exhibition, attracted the attention of the American expatriate collector Leo Stein, and was fast becoming recognized as the strongest artist of his generation.[22] He had also developed interests in artists other than Cézanne. He unquestionably had seen the large Gauguin memorial exhibition at the 1903 Salon d'Automne; the gallery devoted to the Symbolist painter Pierre Puvis de Chavannes, famous for his pale-colored Arcadian murals, at the 1904 Salon; and the galleries at the spring 1905 Salon des Indépendants devoted to Georges Seurat and Van Gogh, to which he loaned one of his drawings.[23] At the 1905 Salon des Indépendants, moreover, he displayed his own first bathers composition, *Luxe, calme, et volupté* (fig. 8), which did not follow Cézanne but was created in a version of the Neo-Impressionist style established by Seurat. Although it is an additive, constructional technique like Cézanne's, Seurat's Neo-Impressionism used small dots or flecks of vivid, unblended color, understanding that they would combine optically at a distance to produce more luminous mixtures than was possible by mixing them on a palette. However, his followers Paul Signac and Henri-Edmond Cross used larger block- or mosaic-like units of color. This blunter, more exaggerated approach gained favor around 1900 because it was far more accessible, seeming less a theoretical science of color than an adaptation of the more spontaneous, commalike Impressionist brushstroke as a vehicle for heightened colors. Back in 1899, Matisse had made paintings in such a style, and he returned to it in 1904, when Signac invited him to spend the summer in Saint-Tropez. *Luxe, calme, et volupté* was the result, a work whose look soon became dissatisfying to its creator but whose subject turned out to be virtually a manifesto for the future direction of his art.

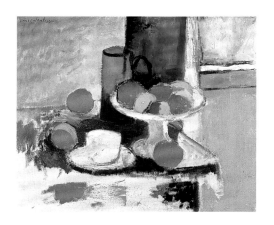

fig. 6
Still Life with Oranges (II), 1899
Oil on canvas
46.7 × 55.2 cm (18³/₈ × 21³/₄ in.)
Mildred Lane Kemper Art
Museum, Washington University,
St. Louis, gift of Mr. and Mrs.
Sydney M. Shoenberg, Jr., 1962

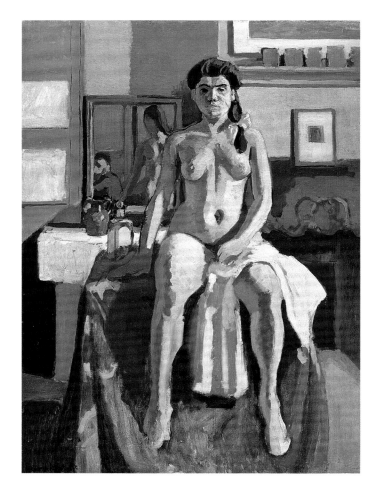

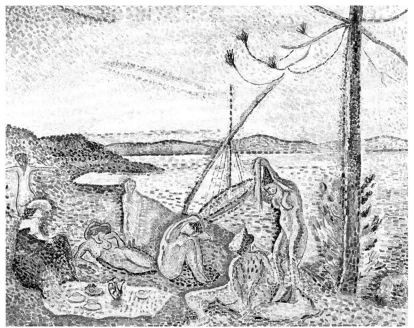

fig. 7
Carmelina, 1903
Oil on canvas
80 × 64 cm (31¹/₂ × 25¹/₄ in.)
Museum of Fine Arts, Boston,
Tompkins Collection—
Arthur Gordon Tompkins Fund,
RES.32.14

fig. 8
Luxe, calme, et volupté, 1904–05
Oil on canvas
98 × 118 cm (38⁵/₈ × 46¹/₂ in.)
Musée d'Orsay, Paris, DO 1985 1,
AM 1982 96

The title of the painting derives from Charles Baudelaire's poem "L'Invitation au voyage" and speaks of an invitation to an Arcadian world of harmony and sensual pleasure: "There, all was order and beauty, / luxury, calm, and voluptuousness."[24] It was based on a study of his wife and his son Pierre on the beach at Saint-Tropez, now joined by a group of female nude bathers; this improbable combination invokes a shift from the actual to the imaginary, which was precisely where his art was now going. The final picture was produced on the basis of a small oil study and a group of sketches, and worked out in detail on a full-size cartoon, now lost, probably the first time the artist had used this traditional device. *Luxe, calme, et volupté* was, in one respect, Matisse's attempt to outstrip his dependence on Cézanne, retaining his use of contours placed outside the edges of shapes but replacing his hatched brushstrokes with Neo-Impressionist bricks of much brighter color. He would soon chafe against the constraints of this style, complaining that it was "mechanical" and "limited by too great adherence to strictly logical rules," but its highly conceptual basis helped him to discover, among the techniques that came out of Impressionism, which was invented to deal with the perceptual world, a way of addressing the world of imagination at the same time.[25]

In May 1905, Matisse returned with his family to the south, this time to Collioure, where he would spend the first of several summers. There, working alongside André Derain, Matisse made his first so-called Fauve paintings: small, spontaneous oil studies and freely conceived works like *Landscape at Collioure* (fig. 9), using curls and strips of contrasting colors set against a white ground, and interiors that combine this approach with broad areas of color. Matisse effectively went back to the freedom of the oil study for *Luxe, calme, et volupté* and added to it memories of the Van Goghs that he had just seen at the spring Salon, not to mention the drawing that he owned and the flat, posterlike painting that he had almost bought (see figs. 1–2). Back in Paris, at the Salon d'Automne, he exhibited paintings made in Collioure plus a recent portrait of his wife, *Woman with a Hat* (fig. 10), his first attempt to use his newly liberated color palette to model volume in a Cézannist way. Derain's summer paintings were shown in the same room, as were works by Derain's friend Maurice de Vlaminck, plus those by Charles Camoin, Henri Manguin, and Albert Marquet, friends of and coexhibitors with Matisse since their time together in Moreau's studio. The paintings created a furor: "incoherents" and "invertebrates" were frequent charges; the president of the Republic, Émile Loubet, refused to open the Salon as he customarily did; even Leo Stein, who purchased the canvas, described *Woman with a Hat* as "a thing brilliant and powerful, but the nastiest smear of paint I have ever seen."[26]

Ten of Cézanne's paintings were also shown at the Salon, and one of them, the notorious *Bathers at Rest,* was widely noticed.[27] But Matisse was continuing to do what he knew Cézanne himself had recommended: "Defy the influential master."[28] After having defied Cézanne by returning to Neo-Impressionism and then to Van Gogh, Gauguin was next on his list, along with Puvis de Chavannes. Puvis' *Pleasant Land* of 1882 (fig. 11), or a work very like it, must have been one of the inspirations for the composition of *Luxe, calme, et volupté,* although obviously not its treatment, which was something that Matisse came to regret. Writing to Signac in the summer of 1905, he spoke of his dissatisfaction with how the character of the drawing and the color were so different as to be contradictory. He had been reading an article by Bernard that noted that Cézanne "believes that there are two *plastiques,* or methods of giving aesthetic form to things, one linear or sculptural, the other decorative or coloristic."[29] Matisse's conclusion was that his own broken form of color application "destroys the drawing whose eloquence comes solely from the contour," which was more prominent, of course, in the uncolored cartoon. "To color the cartoon," he had realized, "all that was needed was to fill in its compartments with flat tones, à la Puvis, for example."[30] Over the winter of 1905–06, working in his new studio in the Couvent des Oiseaux, Matisse made his largest painting to date, *Le bonheur de vivre* (fig. 12), "à la Puvis." However, while Puvis' classicized

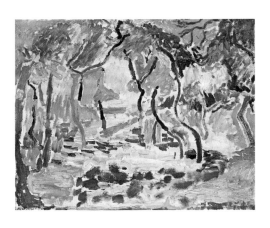

fig. 9
Landscape at Collioure, 1905
Oil on canvas
46 × 55 cm (18 1/8 × 21 5/8 in.)
Statens Museum for Kunst,
Copenhagen, J. Rump Collection,
KMS r 79

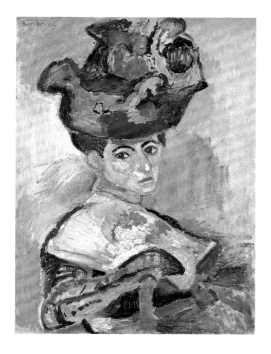

fig. 10
Woman with a Hat, 1905
Oil on canvas
80.7 × 59.7 cm (31 3/4 × 23 1/2 in.)
San Francisco Museum
of Modern Art, bequest
of Elise S. Haas, 91.161

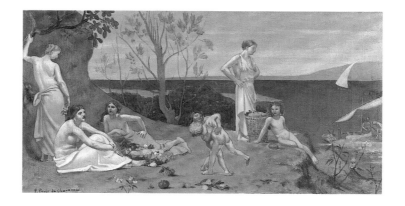

fig. 11
Pierre Puvis de Chavannes
(French, 1824–1898)
Pleasant Land, 1882
Oil on canvas
25.8 × 47.3 cm (10 1/8 × 18 5/8 in.)
Yale University Art Gallery,
The Mary Gertrude Abbey Fund,
1958.64

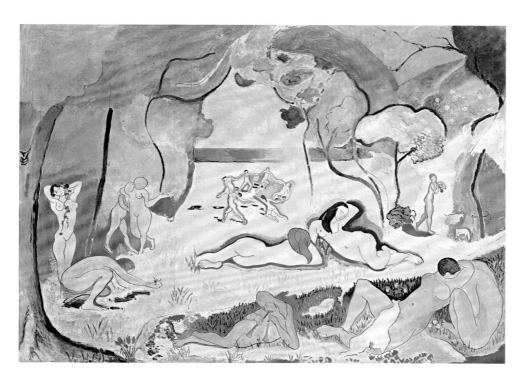

fig. 12
Le bonheur de vivre, 1905–06
Oil on canvas
175 × 241 cm (69 1/8 × 94 7/8 in.)
The Barnes Foundation,
Merion, Penn., 719

Arcadianism still tugged at Matisse, the distant, pale colors in which it was dressed hardly did, and he turned for inspiration to other artists who made linear compositions with flat-color infilling in more vibrant hues, from prehistoric cave painters and the creators of Greek vases to Gauguin.[31] For his setting, Matisse drew upon one of his Collioure landscapes (see fig. 9), which he remade with rudimentary figures in a small oil sketch whose drawing was simplified as it was enlarged in the final composition, thus setting the pattern for future transformations of spontaneously created full-size *esquisses* into more formalized compositions.[32] For the figures, Matisse drew heavily on Jean-Auguste-Dominique Ingres—"our most recently discovered master," as Denis had described him at the time of his retrospective at the 1905 Salon d'Automne—and specifically from *The Golden Age* (fig. 13), whose somnolent, classical tone as well as arabesque drawing infuses the composition.[33] Yet the drowsiness also comes from Gauguin's Tahitian figure paintings, whose "primitivist" connotations touch the picture in its seemingly crude, flat colors and heavy contours.[34]

The very multitude of sources for Matisse's new painting suggests that he was seeking to avoid dependence on one authority, Cézanne, by depending on many.[35] However, Cézanne is still very much present in *Le bonheur de vivre,* insofar as it is visibly composed of the addition of separate parts, each colored unit counting in its own way toward the effect of the whole. While *Luxe, calme, et volupté* is a composition of fragments joined together by figures of a uniform scale, here each figural group is a separate subject, sized according to its pictorial importance and joined only by serpentine rhythms that move the eye unceasingly from one part of the composition to the next. Although Matisse's urge to combine Cézanne's two *plastiques*, linear and coloristic, produced this picture, there is nothing quite like it in the older artist's oeuvre, largely because his follower employed color as a constructive element in a manner that the master never did. As Matisse told his own students in 1908, there are two principal ways of using color: "one considering color as warm and cool, the other seeking light through the opposition of colors."[36] Cézanne relied on the former method, using advancing warm colors, from red through yellow on the spectrum, against receding cool colors, from blue through green, in order to form volumes and shape spaces. Matisse also did so on occasion, but from the time of *Le bonheur de vivre,* he mainly used the latter approach, which he learned from Van Gogh and Gauguin, both of whom exaggerated the brightness of their colors, simplified their drawing, and stressed surface pattern at the expense of the illusion of depth. Cézanne would have hated the result; he had dismissed Gauguin's use of curving arabesque lines and unmodulated colors, saying, "All he did was make Chinese pictures."[37] Matisse would continue to owe more to Cézanne than to any other artist; his example had shown Matisse how the perception of nature need not only guide representation but also stimulate a direct and forceful statement of response to it. However, it was the example of Van Gogh and Gauguin that revealed to him how the most direct and forceful statement would mean giving greater priority to contrasts of color and pattern on the physical surface of the canvas than to resemblance, indeed the plausibility of pictorial illusion itself.[38]

Le bonheur de vivre created a sensation hardly less than the Fauve paintings had done when Matisse exhibited it at the 1906 Salon des Indépendants. His single submission was rightly understood to be a sort of manifesto, since Signac, whose Neo-Impressionism it very forcibly repudiated, was the Salon's president. Unexpectedly, he was enraged, writing, "Matisse, whose work I have liked until now, seems to have gone to the dogs. Upon a canvas of two and a half meters he has surrounded some strange characters with a line as thick as your thumb. Then he has covered the whole thing with flat, smooth colors, which—however pure—seem disgusting."[39] The influential critic Charles Morice castigated it as schematized and theoretical, but his complaint that Matisse had "thought less about the objects in his composition than about the means of execution" was not far from the point.[40] Leo Stein, maintaining his courageous approach of purchasing the works that at first he most

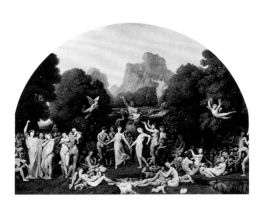

fig. 13
Jean-Auguste-Dominique Ingres
(French, 1780–1867)
The Golden Age, 1862
Oil on paper, mounted on
wood panel
46.4 × 61.9 cm
(18 1/4 × 24 3/8 in.)
Harvard Art Museums/Fogg
Museum, Cambridge, Mass.,
bequest of Grenville L. Winthrop,
1943.247

disliked, acquired the picture, which he would call "the most important done in our time."[41]

It was Stein and his sister, Gertrude, who introduced Matisse to Picasso at about this moment; soon the two began a highly competitive relationship that was initially fueled by the latter's envy of the *succès de scandale* surrounding *Le bonheur de vivre*.[42] Matisse played the elder statesman, lecturing Picasso and introducing him to African sculpture, while Picasso paid careful attention not to what Matisse was saying but to what he was doing.[43] At the 1907 Salon des Indépendants, the latter's *Blue Nude* (1.3), also bought by the Steins, irked Picasso: "If he wants to make a woman," he said, "let him make a woman. If he wants to make a design, let him make a design. This is between the two."[44] He may have picked up the quip from Vauxcelles's review of the exhibition, in which he observed, "I admit to not understanding. An ugly nude woman is stretched out upon grass of an opaque blue under the palm trees. . . . This is an artistic effort tending toward the abstract that escapes me completely."[45] But it did not escape Picasso; it changed the course of *Les demoiselles d'Avignon* (fig. 14), on which he was working, beginning its transformation into a much tougher painting. Neither did it escape Félix Fénéon, a critic formerly aligned with the Neo-Impressionists, who had begun working at Bernheim-Jeune the previous year and was starting to acquire Matisse's paintings for the gallery.[46] It also did not escape the young dealer Daniel-Henry Kahnweiler, who regretted that Bernheim-Jeune had got there before him and had to be satisfied with works by Braque, Derain, and Vlaminck instead.[47]

In fact, Derain's contribution to the Indépendants, *Bathers* (fig. 15), was as maligned as Matisse's, being described by Vauxcelles as "Cézannesque mottlings . . . dappled over the torsos of bathers plunged into horribly indigo waters."[48] Derain's work was primitivized by a masklike face, and Matisse's equally rough primitivism was also given exotic, colonialist connotations by its setting; nonetheless, both drew inspiration from Cézanne's bathers compositions. Vauxcelles, although recognizing that connection, observed that while "certain earlier Salons, in particular those of 1904 and 1905, could have borne as a banner . . . 'homage to Cézanne,'" now "the influence of Cézanne is on the wane."[49] This would seem an unaccountable statement, except that the critic, and others, had been viewing that influence as a matter of experiment in mottling color and bold drawing; hence, the turn to the sculptural in these works—literally in the case of *Blue Nude*—might be thought to be anti-Cézannist. However, both artists obviously had intended to join Cézanne's two *plastiques*, allying the freedom of his color construction to the sculptural vitality of his bathers compositions. Doing so created a new interpretation of Cézanne that was so surprising that critics did not at first recognize it for what it was.

Nor were Matisse and his fellow artists certain that this new, amalgamated Cézannism was the way to go. His two versions of *Le luxe* (2.1–2) show him beginning with a softened version of the *Blue Nude* approach, applied to a Puvis-like subject and ending in the arms of the decorative and coloristic. The first version was

fig. 14
Pablo Picasso
(Spanish, 1881–1973)
Les demoiselles d'Avignon,
June–July 1907
Oil on canvas
243 × 233 cm (95 5/8 × 91 3/4 in.)
The Museum of Modern Art,
New York, acquired through
the Lillie P. Bliss Bequest, 1939

fig. 15
André Derain
(French, 1880–1954)
Bathers, 1907
Oil on canvas
132.1 × 195 cm (52 × 76 3/4 in.)
The Museum of Modern Art,
New York, William S. Paley and
Abby Aldrich Rockefeller Funds,
1980

shown at the 1907 Salon d'Automne, and critics, even if they did not like it, seemed to grasp what the artist was doing. Hence Vauxcelles, while saying that this "unsettling" work showed a "hateful contempt for form," also observed: "I am, of course, well aware of the decorative merits that Matisse exhibits in his stunning panel of nudes."[50] The painter Félix Vallotton perceptively asked whether "the hypnotic and broken draftsmanship [was] adopted by M. Matisse as the only line that can record without betrayal the meanderings of his sensibility."[51] Perhaps this appreciation was aided by Matisse's return to somnolent Arcadianism, especially since the subject would have been recognized as an allegory of the birth of Venus from the ocean.[52]

That November, the first rudimentary history of Fauvism, written by the critic Michel Puy, was published in the journal *La phalange*; it placed Matisse at the movement's head, closely followed by Derain and then by their companions at the 1905 Salon d'Automne. Also included were the later arrivals Raoul Dufy, Braque, Othon Friesz, and Vlaminck, as well as recent converts such as Henri Le Fauconnier and Jean Metzinger.[53] But as the group was thus being memorialized, it started to fall apart; as Picasso's work began to garner attention as being more advanced, his relationship with Matisse deteriorated. At the Salon des Indépendants the following spring, the paintings by Braque and Derain demonstrated that they "had become Picassoites and were definitely not Matisseites," as Gertrude Stein put it, having become a Picassoite herself.[54] In the fall, the defection of Fauves was aided by the presence of two large, late bathers pictures (see fig. 16) in the great Cézanne retrospective at the Salon d'Automne, which was probably the most influential monographic exhibition of a modern artist in the twentieth century. Shown there for the first time, these works bred a colony of primitivized Cézannist bathers that included paintings by Derain and Friesz, while Braque began to emulate Picasso as well as Cézanne.[55]

As this shift was occurring, and perhaps as a consequence of it, Matisse agreed to a proposal from Leo and Gertrude Stein's sister-in-law, Sarah, and the young German painter Hans Purrmann to open the Académie Matisse in his studio at the Couvent du Sacré Coeur. There he completed *Bathers with a Turtle* (3), the largest and most ambitious figure composition he had made since *Le bonheur de vivre*. Cézanne, Matisse said that year, was "the father of us all"; this picture, painted so soon after his death, seems like an elegy.[56] It was purchased in late winter 1908 by Karl-Ernst Osthaus for his museum in Hagen.[57] With it, Matisse stepped away from Golden Age allegory with the help of Italian primitives like Giotto, arriving at something that seems almost precultural. This was the first of a trio of imaginary figure compositions that he painted that year, the others being *Game of Bowls* (5c) and *Nymph and Satyr* (p. 79, fig. 4), the latter completed in 1909. While working on it, he was also engaged with the first state of his relief *Back* (4), the sculpture *Decorative Figure* (4f–g), and the large painting *Harmony in Red (The Red Room)*

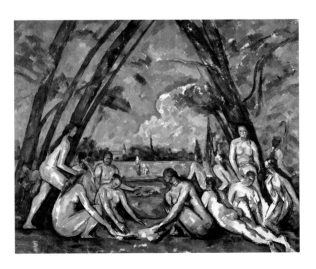

fig. 16
Paul Cézanne
Large Bathers, 1906
Oil on canvas
210.5 × 250.8 cm
(82 7/8 × 98 3/4 in.).
Philadelphia Museum of Art,
purchased with the W. P.
Wilstach Fund, 1937-1-1

(p. 84, fig. 17), which was shown in a retrospective exhibition of his work held at the 1908 Salon d'Automne.[58]

Responses were mixed, with the works arousing at once "disdain, anger, and admiration."[59] Critics recognized that the exhibition was as much an acknowledgment of Matisse's stature as those that had been given to masters of an earlier generation, including, of course, Cézanne.[60] Most noteworthy were the complaints by two commentators of Matisse's lack of a single direction; Charles Morice attributed this to the artist's "unhealthy state of mind, overworked by search and ambition," and Pierre Hepp to his treating each work as "an experiment that seems to be sufficient and unto itself."[61] For Matisse himself, however, the retrospective would have demonstrated that he did not, in fact, lack a single direction; he stated, "My destination is always the same, but I work out a different route to get there."

His critics would have read these words on Christmas Day 1908, when "Notes of a Painter" appeared in the prestigious literary journal *La grande revue*; this essay explained what he had concluded his destination to be.[62] Three years earlier, in the summer of 1905, Morice had sent out a questionnaire to a wide selection of artists and critics, inquiring where they thought new art was going.[63] The responses demonstrated that many felt that contemporary art was in a moment of transition, that the heritage of Impressionism was played out, and that reliance on ideas and feelings, rather than on nature, was most important.[64] Matisse was now ready to address these issues, and his putative reason for doing so was to respond to Mérodack-Joséphin Péledan's criticism of his Salon d'Automne retrospective, especially to the charge that he did not paint "honestly with respect to the ideal and the rules." The culmination of his response, "Rules have no existence outside of individuals," was preceded by a brilliantly argued statement of his artistic principles that drew, in part, upon earlier writers and artists, including Cézanne, but was not presented as a set of rules or general theory of art.[65] "Notes of a Painter" was, rather, a highly personal and practical mission statement based on past achievements and intended to be drawn upon for the future. In this workshop of ideas, three related ones are most relevant to Matisse's continuing pictorial processes.

First, Matisse stressed the importance of reworking.[66] Beginning a piece, he reported, he would often "record fresh and superficial sensations during the first session." To stop there, however, would be to register "the fugitive sensations of a moment that would not completely define my feelings and that I should barely recognize the next day." To persist might mean that he replaced fresh colors with those "less seductive to the eye." However, the artist must continue to "reach that state of condensation of sensations which constitutes a picture." Somewhat like the influential philosopher Henri Bergson, whose *Creative Evolution* had been published the previous year, Matisse conceived of objective existence as a flux of sensations, a continuum from which he could discover an essential reality.[67]

Second, the artist explained what reworking comprises. "A new combination of colors will succeed the first . . . I am forced to transpose until finally my picture may seem completely changed." One change causes another, and yet another, because "the entire arrangement of my picture is expressive: the place occupied by the figures, the empty spaces around them, the proportions, all of that has its share." This is perhaps Matisse's most critical point in defining his single direction. Two decades later, in 1929, when he was still working out different routes to get there, he offered a pithy summary: "Here are the ideas of that time: Construction by colored surfaces. . . . To be noted: the color was proportioned to the form. Form was modified, according to the reaction of the adjacent areas of color. For expression comes from the colored surface that the spectator perceives as a whole."[68]

Third, Cézanne was critical to all this precisely because he wanted "the tones to be forces in a painting," meaning that painting had to bring together competing coloristic forces in a dynamic equilibrium.[69] There was no one way of doing this, which meant that there had to be change. Nonetheless, while "an artist must recognize, when he is reasoning, that his picture is an artifice . . . when he is painting,

he should feel that he has copied nature. And even when he departs from nature, he must do it with the conviction that it is only to interpret her more fully." Matisse thus recapitulated Cézanne's assertion that painting was a matter of both *optique* and *logique,* "the eye by looking at nature . . . the mind by the logic of organized sensations, which provide the means of expression."[70] However, Matisse tipped the balance from *optique* to *logique*; he departed from nature and recognized that his painting was an artifice in a way that would have made his master uncomfortable. He spoke not only of emulation, but also of using it to stimulate his own invention— of Cézanne's influence as one to be absorbed and challenged.

After the great Cézanne retrospective of 1907 closed, the critic Guillaume Apollinaire engaged Matisse on this subject of influence, and the artist replied:

I have never avoided the influence of others. I would have considered this cowardice and a lack of sincerity toward myself. I believe that the personality of the artist develops and asserts himself through the struggles it has to go through when pitted against other personalities. If the fight is fatal and the personality succumbs, it is a matter of destiny.[71]

He obviously was speaking of Cézanne, whom he would describe as "a sort of god of painting," but whom he would also praise for having said, "Defy the influential master," because to be influenced also means that "we are obliged to create a new language."[72] As we have seen, with Cézanne—and with other artists besides—that is precisely what Matisse had already set out to do.

—JOHN ELDERFIELD

1. Matisse 1908, p. 733. Remembering this remark late in life, Matisse rephrased it slightly: "I have searched for the same things, which I have perhaps realized by different means"; Luz 1952, p. 66.

2. He received this work as a gift from the Australian painter John Peter Russell; see Spurling 1998, pp. 138–39; and Colta Ives, Alyson Stein, Sjraar van Heugten, and Marije Vellekoop, *Vincent van Gogh: The Drawings*, exh. cat. (Metropolitan Museum of Art/Van Gogh Museum, 2005), pp. 202–03.

3. The story of the purchase, told many times, derives from Courthion 1941, pp. 46–47, and is also recounted in Barr Questionnaire IV and summarized in Spurling 1998, pp. 180–82.

4. Verdet 1952, p 67.

5. See n. 3.

6. See "*Baigneurs au Repos, III*," in Rewald, Feilchenfeldt, and Warman 1996, vol. 1, pp. 179–80, cat. 261; and Christian Geelhaar, "The Painters Who Had the Right Eyes," in Krumrine 1990, pp. 275–303. For more on the 1895 exhibition, see Robert Jensen, "Vollard and Cézanne: An Anatomy of a Relationship," in Rabinow 2006, pp. 29–35.

7. *Bathers at Rest* had been recently refused by the French state from the bequest of the painter and patron of the Impressionists Gustave Caillebotte. It was the only bathers picture by Cézanne that had already been exhibited, shown at the Third Impressionist Exhibition in 1877, when Matisse was eight years old. That was the last time that Cézanne's paintings had been seen in Paris, apart from three works shown without his knowledge in group exhibitions.

8. Matisse's recollections are recorded by Courthion 1941; the one mentioned here is from Courthion, as interviewed by Jack Flam in Dec. 1979; Flam 1986, p. 51.

9. Pissarro to Lucien Pissarro, Nov. 21, 1895, Ashmolean Museum, Oxford, England; John Rewald, *Camille Pissarro, Letters to His Son Lucien* (MFA Publications, 2002), p. 275.

10. Émile Bernard, "Souvenirs sur Paul Cézanne et lettres inédites," *Mercure de France* 69, 247–48 (Oct. 1 and 16, 1907), pp. 607–08.

11. Pierre Matisse to Matisse, Aug. 2, 1927, Pierre Matisse Papers, Morgan Library and Museum, New York. In fact, Pierre Matisse recounted that when his father proposed selling it during World War I, it was his children who prevented him, feeling that it had become a part of their family; see Spurling 2005, pp. 176–77.

12. Matisse to Raymond Escholier, Nov. 10, 1936; Escholier 1937, pp. 17–18; Flam 1995, p. 124.

13. Pierre Courthion, "Rencontre avec Matisse," *Les nouvelles littéraires* (June 27, 1931), p. 7; Flam 1995, p. 105.

14. On Matisse's copies, see Benjamin 1989.

15. Barr Questionnaire IV.

16. Matisse 1908, p. 735.

17. Diehl 1954, p. 18.

18. Guenne 1925, p. 5.

19. For more on Cézanne's bathers, see Krumrine 1990.

20. This painting was preceded by a lengthy, changing interpretation of the sculptural in Cézanne's art that began in 1900 with paintings such as *Male Model* (c. 1900; The Museum of Modern Art, New York) and continued thereafter, exemplified by Matisse's work on the sculpture *The Serf* (1900–04; D6), which extended from 1900 to around 1906.

21. The exhibition contained three other bathers pictures besides Matisse's.

22. Vollard's first exhibition devoted to Matisse, in June 1904, featured 45 works from 1897 to 1903 and received positive reviews. A number of these works were likely exhibited again at the 1904 Salon d'Automne. See Rebecca Rabinow, "Vollard and Matisse," in Rabinow 2006, pp. 134–36.

23. He exhibited two works at the 1903 Salon, both for sale: *Dévideuse picarde* and *Tulipes* (nos. 386 and 387, respectively).

24. Charles Baudelaire, "Les fleurs du mal," *La revue de deux mondes* (June 1, 1855). For more on *Luxe, calme, et volupté*, see Elderfield 1978, pp. 36–39; Bock 1981, pp. 65–78; Flam 1986, pp. 114–21; Elderfield 1992, pp. 33–37; and Yves-Alain Bois, "Cézanne and Matisse: From Apprenticeship to Creative Misreading," in Rishel and Sachs 2009, pp. 108–10.

25. Matisse 1935, p. 238.

26. Stein 1947, p. 158. Oddly, and perhaps owing to

a confusion of names, a conventional, Italianate bust of a child by Albert Marque had been placed at the center of the room; Louis Vauxcelles, never short of words and possibly thinking of Daniel in the lion's den called it "Donatello chez les fauves" (Donatello among the wild beasts), and thus christened, indeed invented, the Fauve movement. See Tériade 1952, p. 43.

27. For more on this critical response at the Salon, see Jack Flam, "Le fauvisme, le cubisme et la modernité de la peinture moderne," in Suzanne Pagé, Juliette Laffon, et al., *Le fauvisme ou "l'épreuve du feu": Éruption de la modernité en Europe*, exh. cat. (Paris-Musées, 1999), pp. 90–103; for Cézanne at the 1907 Salon d'Automne, see ibid., pp. 94–98.

28. Matisse 1950.

29. Émile Bernard, "Paul Cézanne," *L'Occident* (July 1904), pp. 17–30; Doran 2001, p. 38. Matisse asked Signac to send him copies of "the two paragraphs by Cézanne where the two *plastiques* are mentioned," in his July 14, 1905, letter to Signac on the inadequacies of *Luxe, calme, et volupté*.

30. Matisse to Signac, July 14, 1905, Archives Signac, Paris. There had been an exhibition of Puvis's and Cézanne's work at the 1904 Salon d'Automne.

31. For more on these sources, see Barr 1951, pp. 88–92; Elderfield 1978, pp. 36–39; and Werth 2002, pp. 145–220.

32. Jack Flam, "*Le bonheur de vivre (The Joy of Life)*," in Wattenmaker and Distel 1993, pp. 226–35.

33. Maurice Denis, "La peinture," *L'Ermitage* 2, 11 (Nov. 15, 1905), p. 315; Barr 1951, p. 63.

34. Signac compared it to the work of Paul Ranson. See Signac to Charles Angrand, Jan. 14, 1906, Archives Angrand.

35. Elderfield 1992, pp. 54–56.

36. "Sarah Stein's Notes" (1908); Flam 1995, p. 52.

37. Bernard (n. 10), p. 400; Dorin 2001, p. 63.

38. See the introduction to Greenberg 1953, whose position is modified here.

39. Signac to Angrand (n. 34); Barr 1951, p. 82.

40. Charles Morice, "Le XXIIᵉ Salon des Indépendants," *Mercure de France* 61 (Apr. 15, 1906), pp. 535–37.

41. Conversation, Maurice Sterne and Alfred H. Barr, Jr., 1950; Barr 1951, pp. 82, 532 n. 9.

42. For conflicting accounts of the artists' early relationship, see Cowling 2002, p. 362.

43. On Matisse's relationship to African art, see Jack Flam, "Matisse and the Fauves," in Rubin 1984, pp. 216–17. Matisse himself recalled: "In rue de Rennes, I frequently passed a shop called 'Le Père Sauvage' belonging to a dealer in exotic curios. And late one afternoon, I went in to buy a seated figure, a little man sticking out his tongue. Then I went to Gertrude Stein's in rue de Fleurus. Picasso arrived as I was showing her the statue. We chatted about it. It was then that Picasso noticed the Negro sculpture."

44. Pach 1938, p. 125.

45. Vauxcelles 1907a; Flam 1988, pp. 65–66.

46. For more on Fénéon's early dealings with Matisse at Bernheim-Jeune, see Judi Freeman, *The Fauve Landscape*, exh. cat. (Los Angeles County Museum of Art/Abbeville Press, 1990), p. 105.

47. In a letter to Kahnweiler of Apr. 22, 1907, Matisse agreed to sell him one of the drawings exhibited at the Salon; Isabelle Monod-Fontaine, Claude Laugier, and Sylvie Warnier, *Daniel-Henry Kahnweiler*, exh. cat. (Centre Pompidou, 1984), pp. 95, 102.

48. Vauxcelles 1907a; Flam 1988, pp. 65–66. Matisse must have looked closely at Derain's painting: that artist's difficulty with the right-hand figure may have started Matisse thinking about the problems of representing a back, which he may have addressed in his first *Back* relief (4).

49. Vauxcelles 1907a; Flam 1988, pp. 65–66.

50. Vauxcelles 1907b, p. 1; Flam 1988, pp. 66–67.

51. Félix Vallotton, "Le Salon d'Automne," *La grande revue* 44 (Oct. 25, 1907), pp. 916–24; Elderfield 1976, p. 136.

52. For more on this significance, see Elderfield 1998.

53. See Michel Puy, "Les Fauves," *La phalange* 2 (Nov. 15, 1907), pp. 450–59; Flam 1988, pp. 69–70.

54. Gertrude Stein, *The Autobiography of Alice B. Toklas* (Modern Library, 1993), p. 87.

55. See Elderfield 1976, pp. 97–139.

56. Max Weber attributed this statement about Cézanne to Matisse; Barr 1951, p. 87; and Elderfield 1998, p. 36.

57. See entry 3 and p. 76 of this publication for more information on this work.

58. The exhibition included eleven paintings, six drawings, and thirteen sculptures, all produced since the turn of the century. For Inez Haynes Irwin's comments on *Bathers with a Turtle*, which she saw in Matisse's studio on Apr. 20, 1908, see p. 67 of this publication.

59. Georges Desvallières, introduction to Matisse 1908, p. 731; Flam 1988, pp. 75–76.

60. For more on the retrospective, see Flam 1986, pp. 232–34; Benjamin 1987, esp. pp. 151–57; and Labrusse and Munck 2005, pp. 316–20.

61. Charles Morice, "Revue de la quinzaine: Art moderne," *Mercure de France* 71 (Nov. 1, 1908), p. 161; Flam 1988, pp. 73–75. Pierre Hepp, "Le Salon d'Automne," *Gazette des Beaux-Arts* 40 (Nov. 1, 1908), p. 389; as discussed in Benjamin 1987, pp. 152–53, 308 nn. 6–9.

62. Matisse 1908, p. 733.

63. Niamh O'Laoghaire, "The Influence of Van Gogh on Matisse, Derain, and Vlaminck, 1898–1908" (Ph.D. diss., University of Toronto, 1991), pp. 163–64, 476–90; and Elderfield 1976, p. 32.

64. Guenne 1925, p. 4.

65. These writers include Paul Signac, Georges Desvallières, Maurice Denis, Jacques-Émile Blanche, Charles Guerin, and Émile Bernard, whom Matisse mentioned in his "Notes on a Painter"; see Matisse 1908, p. 732. See also Benjamin 1987, pp. 167–68. For Péledan's criticism, see Péledan, "Le Salon d'Automne et ses retrospectives. Greco et Monticelli," *La revue hebdomadaire* 12 (Oct. 17, 1908), p. 373; Benjamin 1987, p. 157.

66. Matisse 1908, p. 735.

67. Bergson's influence on "Notes of a Painter" is discussed in Benjamin 1987, pp. 188–90.

68. Tériade 1929.

69. Guenne 1925, p. 5.

70. For Cézanne's *optique* and *logique*, see Léo Larguier, *Le dimanche avec Paul Cézanne: Souvenirs* (L'Edition, 1925); Doran 2001, p. 17. The phrase appears in a set of forty-two aphorisms that Larguier claims he collected in 1902; if that is correct, they would likely have been in circulation soon afterward. The remark about the eye and the mind is among the celebrated "Opinions de Cézanne" in Bernard (n. 29).

71. Apollinaire 1907, p. 483.

72. Matisse's description of "a sort of god of painting," is in Guenne 1925, p. 5; for "Defy the influential master" and "We are obliged to create a new language," see Matisse 1950.

1.1 Reclining Nude with Chemise
Collioure, summer 1906

Bronze, cast c. 1930; 14 × 30.2 × 14.9 cm (5 1/2 × 11 7/8 × 5 7/8 in.)
Signed and numbered on base: *HM 5/10*;
inscribed on base: *Cire–C. Valsuani–perdue*
The Baltimore Museum of Art,
gift of Mr. and Mrs. Albert Lion, Jr., BMA 1955.164

IN EXHIBITION

1.2 Reclining Nude (I) (Aurore)
Collioure, January–February 1907

Bronze, cast c. 1912; 34.3 × 50.2 × 28.6 cm (13 1/2 × 19 1/4 × 11 in.)
Signed and numbered on base: *Henri Matisse 4/10*;
inscribed on base: *F. Costenoble Fondeur, Paris*
Collection Albright-Knox Art Gallery, Buffalo, New York,
Room of Contemporary Art Fund,
1945, RCA1945:3

IN EXHIBITION

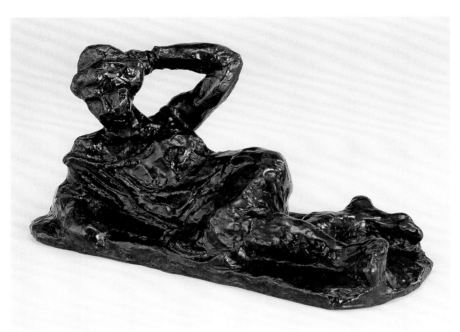

1.1

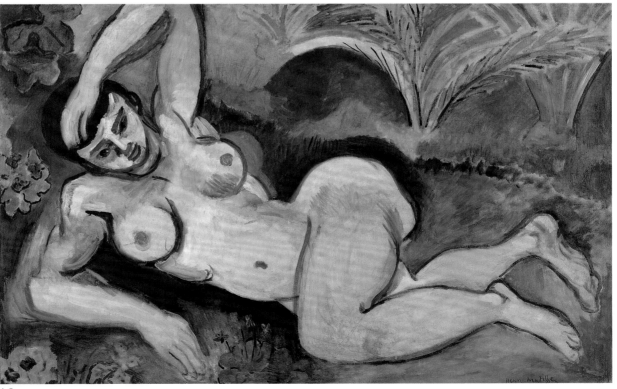

1.3

1.3 Blue Nude (Memory of Biskra)
Collioure, mid-January–February 1907

Oil on canvas; 92.1 × 140.4 cm (36 1/4 × 55 1/4 in.)
Signed l.r.: *Henri-Matisse*
The Baltimore Museum of Art, The Cone Collection, BMA 1950.228

IN EXHIBITION

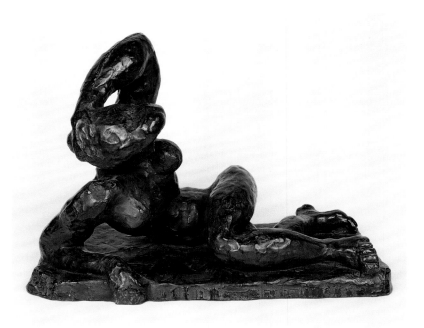

1.2

MORE THAN HALF the sculptures Matisse made during his entire career date from 1900 to 1909.[1] Critical to his early practice, these small figural works, modeled in clay, treat mostly female subjects and generally relate to his paintings.[2] As the artist himself recalled to Pierre Courthion in 1941:

I made sculptures because what interested me in painting was to organize my thoughts. I changed my means; I took up clay to have a rest from paint, with which I had done absolutely everything I could for the moment. What this means is that it was always a question of organization: putting order to my sensations so as to seek the method that absolutely suited me. When I had found it in sculpture, it served me for painting. The point was to possess my thoughts, to possess a kind of hierarchy of all my sensations, one that would lead me to a conclusion.[3]

While Matisse worked on these sculptures, he was also beginning to explore the subject of Arcadia, the imagined setting of much pastoral poetry and a powerful symbol of an idyllic Golden Age.[4] For the artist and his peers, this paradise could be found in the south of France, in such sun-soaked coastal towns as Saint-Tropez and Collioure, where he traveled to paint in the early years of the 1900s and which provided artistic inspiration for his first major paintings, *Luxe, calme, et volupté* (p. 47, fig. 8) and *Le bonheur de vivre* (p. 49, fig. 12). From these canvases, he produced, in turn, at least seven figures in the round. *Reclining Nude with Chemise* [**1.1**] is one example, made while he summered in Collioure in 1906.[5] The pose relates to that of the reclining woman in *Luxe, calme, et volupté* and the center-right figure of *Le bonheur de vivre*. In her posture and classical dress, the subject of *Reclining Nude (I)* also recalls the ancient *Sleeping Ariadne*, a wax copy of which [**1a**] Matisse may have seen in the galleries of the Musée du Louvre during the time that he copied paintings by Nicolas Poussin, Jean-Baptiste-Siméon Chardin, and other Old Masters as a student.[6] In its final form, the sculpture reveals few traces from his working process, save for the raised left arm and the notched wrist [**1b**], which was possibly the result of a studio mishap or of Matisse's decision to reposition or extend the limb with additional material. Instead, the antique garment, which is connected to the base, lends coherence and unity to the figure, while its surface—enlivened by fluid arabesques and inflected by tool marks and rough additions of material—offers a sense of animation to the whole.

Matisse typically used such sculptures to serve his painted ideas—"to organize my thoughts"—and clarify his means before returning to the canvas.[7] When he went back to Collioure in December 1906, however, he was unprepared for an incident that would bring about a significant change in this established working method.[8] During the winter of 1906–07, he began a new, related sculpture that was first exhibited as *Woman*

1a

1b

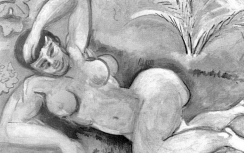

1c

1d

1e

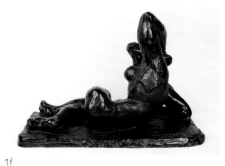

1f

1a
Attributed to Corneille van Clève (French, 1645–1732). *Copy of "Sleeping Ariadne," or "Cleopatra,"* 1665–1700. Wax; 29.2 × 54.9 × 20 cm (11 1/2 × 21 5/8 × 7 7/8 in.). Musée du Louvre, Paris, bequest of Jacques-Edouard Gatteaux, 1881, R.F. 415.

1b
Detail of the left wrist of *Reclining Nude with Chemise*, showing a possible repair or addition of material.

1c
Infrared reflectogram of *Blue Nude (Memory of Biskra)*, showing the lowest layers of the composition, especially the underdrawing.

1d
Detail of the right shoulder of *Blue Nude*.

1e
Detail of the right foot of *Blue Nude*, showing pencil underdrawing and adjustments in thinned blue, black, and red-brown paints.

1f
Reclining Nude (I) (Aurore) seen from the back, illustrating the addition of clay to the back of the left shoulder, possibly to reinforce a repair to the arm.

Resting on Arm. Known today as *Reclining Nude (I) (Aurore)* [**1.2**], it continues the same motif as *Reclining Nude with Chemise* but is twice its size and devoid of classical references.[9] Looking back in 1941, the artist recounted that his early labor on the sculpture was particularly demanding—"my mind was so taken up by the sculpture"—and was so engrossing that during one working session he was unable to pull himself away and missed several trains to nearby Banyuls to visit the sculptor Aristide Maillol.[10] On another occasion, however, his work was forcibly interrupted:

One morning when I was hard at work on it, the base it was sitting on ended up slipping off the turntable, and everything landed on the floor, with—of course—the clay figure crushed underneath. The cry that I let out and the noise of the crash brought my wife quickly upstairs . . . where she found me still speechless from the accident. . . . The next day I rescued the work, straightening it out enough to be able to continue. But before that, my confidence in what it had left behind in my mind was so complete, that I took out a large canvas and painted.[11]

In other words, Matisse altered his practice and started a canvas before he had completed the sculpture. In fact, he initiated this painting, known today as *Blue Nude (Memory of Biskra)* [**1.3**], in order to resume his work on the sculpture: its earliest layers tell us of the artist's efforts to record the clay figure's form before its fall.[12] A recent infrared reflectogram [**1c**] reveals the complicated network of lines that Matisse generated as he worked from memory and blocked in the silhouette on the canvas. He continued to adjust forms with pencil on the priming layer, adding thin layers of pale pink and blue pigment over areas of the pencil, and still further pencil over the dried paint. Also visible is a set of reworked contours executed in thinned blue, black, and red-brown paints [**1e**].

Part of the completed work's formidable presence derives from its surface of vibrant blue color, repeated arabesque forms, and contrasting layers of thin and thick paint. Physical examination reveals two distinct strata of paint, which relate to two working campaigns: the first is represented by initial sketches and underdrawings for the figure and foliage. Matisse painted these forms thinly, as the infrared image demonstrates. Certain elements, such as the position of the right hand or pose of the legs, did not change with further work on the canvas. The infrared is not only a record of Matisse's first steps in painting *Blue Nude*, but also a document of *Reclining Nude (I)* prior to damage. A comparison of the infrared and the completed sculpture makes it clear how, when the artist resumed the sculpture, he moved it toward a much more dynamic composition: the hefty left arm rises from a bulging, newly powerful shoulder; the left hand rests its weight on and pushes down the foreshortened head;

the nipped-in torso moves off the base, twisting into the hips; and the left leg lifts, almost disjointed, from the pelvis. The right hand grips the edge of the base, anchoring and redistributing weight back into a right hip that appears to be submerged [**1f**], as if the figure were reclining in a shallow river or stream.[13] Furthermore, the artist treated the evidence of his work on the sculpture as an integral part of its final form: for example, we can see what appear to be repairs in the clay on the left side of the figure's back and under the shoulder, where he added material to reinforce the arm but did not subsequently smooth over the surface.[14]

Some time within a month of the accident, Matisse resumed *Blue Nude*.[15] Just as that painting served his return to the sculpture, *Reclining Nude (I)* now served his new campaign on the canvas.[16] The infrared image shows how the second layer of paint, applied selectively over the first, reinforces earlier contours for the face, arms, hips, and sides of the torso. It also records the areas of greatest change and densest paint—the angle of the head, direction of the gaze, position of the breasts, contours of the arms and torso, and thrust of the raised left hip—that follow the final form of *Reclining Nude (I)*. Given the connections between these two works and the unusual influence each exerted on the other's making, Matisse's use of media is noteworthy, especially the manner in which his application of paint parallels that of clay and his brushwork echoes his modeling. For instance, the daubs of paint that he employed to adjust the contour and volume of the nude's right shoulder [**1d**] recall reflections on the bronze surface of the sculpture's right arm.

Soon after its completion, Matisse exhibited his canvas at the Salon des Indépendants as *Tableau III*. Scholars have suggested a number of possible reasons for this choice of title, including the work's place as the artist's third in a series of imaginative paintings after *Luxe, calme, et volupté* and *Le bonheur de vivre*, which were shown previously at the Salons.[17] Given the deep connections between *Blue Nude* and the two sculptures, however, the title may also refer to the work's unique genesis as the third representation of this particular figure. *Reclining Nude (I)* held a special status as well: Matisse returned to the work many times in his career, including it in a number of still-life paintings (including 19a–b and p. 265, fig. 6) and even reprising the motif for an entirely new sculpture series in the 1920s.[18] Most importantly, with the completion of *Reclining Nude (I)* and *Blue Nude,* Matisse had begun to produce his paintings and sculptures in a new manner, reworking them in a way that was at once simultaneous and mutually influential. As we shall see, he drew upon this experience more fully in the second decade of the twentieth century, even translating techniques and tools across media as he continued to clarify his artistic concerns.

1. Monod-Fontaine 1984; see also Kosinski, Fisher, and Nash 2007, which brought groundbreaking technical and analytic tools to the study of the artist's sculptures.

2. Other examples include *Madeline (I)* (1901; D8), *Study in Blue* (c. 1899; Tate Modern, London), *The Serf* (1900–04; D6), and *Male Model* (c. 1900; The Museum of Modern Art, New York).

3. Courthion 1941, p. 66. Since Matisse looked to the advice of older artists and sought to link his work with that of the past (if only to break with it), his words are worth considering in the context of Degas's own: "The only reason that I made wax figures . . . was for my own satisfaction, not to take time off from painting or drawing but in order to give my paintings and drawings greater expression, greater ardour, and more life." This statement was first published in 1921 by François Thiébault-Sisson, but Degas's ideas may have been transmitted earlier to Matisse through Ambroise Vollard; see Richard Kendall, *Degas: Beyond Impressionism*, exh. cat. (National Gallery Publications/Art Institute of Chicago/Yale University Press, 1996), pp. 254–55; and Fernande Olivier, *Souvenirs intimes: Écrits pour Picasso* (Calmann-Lévy, 1988), p. 170. Vollard later published his own appraisal of Degas (Vollard 1937) a few years before Matisse's interview with Courthion. Another important painting-sculpting practice is represented by Matisse's teacher, Gustave Moreau, who modeled in clay and wax as a means to study a figure for his compositions; see Lacambre 1999, p. 160. In his interview with Courthion, Matisse made no specific mention of the practice of either artist nor that of the two sculptors he discussed at greatest length, Aristide Maillol and Auguste Rodin.

4. On Matisse's engagement with these themes, see especially Puttfarken 1982; Werth 2002; and Wright 2004.

5. Other female figures derived from or inspired by *Luxe, calme, et volupté* and *Le bonheur de vivre* include *Upright Nude with Arched Back* (1904; D14); *Seated Nude with Arms on Head* (1904; D15); *Woman Leaning on Her Hands* (1905; D17); *Standing Nude* (1906; D20); *Standing Nude, Arms on Head* (1906; D22); and *La vie (Torso with Head)* (1906; D23).

6. For many years, and certainly during the time Matisse made his copies at the Louvre, the sculpture was thought to be by Poussin; it has been in the Louvre's collection since 1881. Thanks to Geneviève Bresc-Bautier, Musée du Louvre, for providing information on the history of this particular work. For more on Matisse's copies, see Barr 1951; Tériade 1952; Benjamin 1987; Schneider 2002; and esp. Benjamin 1985 and 1989; and Louvre 1993, pp. 72, 147–48, 348–55.

7. Courthion 1941, p. 66.

8. Matisse signed the lease on a property in Collioure for the winter 1906–07 season on Dec. 13, 1906; see Matisse and Derain 2005, pp. 42 n. 59, 291.

9. The sculpture was first known as *Femme couchée se soulevant sur bras* when it was exhibited in the 1908 Salon d'Automne; in 1913 it had a different title, *Figure couchée (Resting Figure)*, when it was included in Matisse's 1913 solo exhibition at the Galerie Bernheim-Jeune. Matisse cast bronze, terracotta, and possibly colored plaster examples of the work. For more information on its intriguing history, see Duthuit and de Guébriant 1997, pp. 72–77; Stein 1998, p. 54; and Kosinski, Fisher, and Nash 2007, esp. pp. 78–79, 84–85, 93 n. 39.

10. Courthion 1941, p. 67.

11. Ibid., p. 68. The incident probably occurred in mid-Jan. This is based on a letter in which Michael Stein commiserated with the artist about the accident but did not yet know its final outcome: "They say also that a misfortune also came to your sculpture but I hope it was not something irreparable." Stein to Matisse, Jan. 25, 1907, AHM.

12. The title *Blue Nude (Memory of Biskra)* was first published in 1931, on the occasion of the Galerie Georges Petit exhibition and was used that same year at The Museum of Modern Art's retrospective following Margaret Scolari Barr's interview with the artist; see Barr 1951, pp. 94, 533 n. 2.

13. Matisse's interest in giving the work a sense of weight and stability is further suggested by the point of view of a photograph taken at his request and direction by Eugène Druet; see D30 and Elsen 1972, p. 75. Before working with Matisse, Druet was the principal photographer for Rodin, and his images were exhibited in the Salon d'Automne of 1904. He also became a dealer, showing the work of Matisse's friends and fellow painters Georgette Agutte and Charles Camoin, among others. Druet's relationship to Matisse and the key role his photographs played in the work of many French artists are rich topics still to be fully explored.

14. See Oliver Shell's insightful comments on this work in Kosinski, Fisher, and Nash 2007, pp. 152–56.

15. Alastair Wright carefully examined the issues involved in Matisse's relationship to and representation of the non-Western in *Blue Nude*; see Wright 2004, esp. chap. 5.

16. On Feb. 17, 1907, Matisse wrote to a friend, the artist Henri Manguin, about a frame for the painting, which was nearly or already complete (Archives Jean-Pierre Manguin, Avignon).

17. Matisse exhibited *Luxe, calme, et volupté* at the 1905 Salon des Indépendants (no. 2771); *Le bonheur de vivre* premiered at the 1906 Salon des Indépendants (no. 2289). See esp. Flam 1986, p. 196; Elderfield 1992, p. 57; Flam 2001, p. 40; and Labrusse and Munck 2005, p. 282. For a critical consideration of the shifting language of aesthetic debate and terms of engagement in the 1890s and beyond, see Groom 2001.

18. For this series, see D69, 71. The figure would also appear on a number of ceramic tiles that Matisse painted in c. 1907; see Neff 1974, figs. 28, 30–31.

2.1 **Le luxe (I)**
Collioure, summer 1907

Oil on canvas; 210 × 138 cm (82 5/8 × 41 3/8 in.)
Signed l.l.: *H.M.*
Musée National d'Art Moderne/Centre de Création
Industrielle, Centre Pompidou, Paris, AM 2586 P

2.2 **Le luxe (II)**
Collioure or Couvent des Oiseaux, Paris,
summer–fall 1907

Distemper on canvas; 209.5 × 138 cm (82 1/2 × 54 3/8 in.)
Signed l.r.: *HENRI-MATISSE*
Statens Museum for Kunst, Copenhagen, KMSr76

IN EXHIBITION

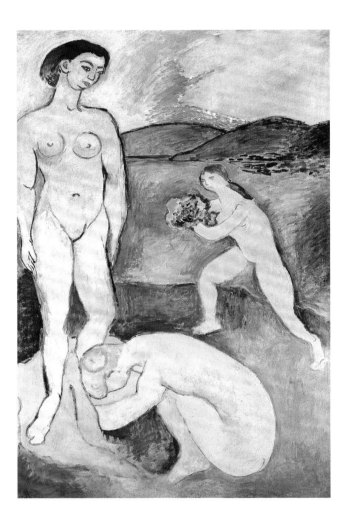

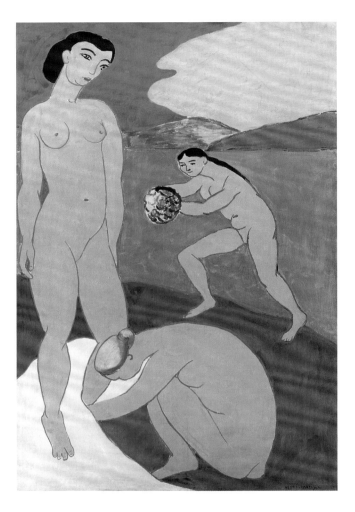

2.3 Study for "Le luxe"
Collioure and Couvent des Oiseaux, Paris, summer–fall 1907

Charcoal on paper; 225 × 137 cm (109 × 54 15/16 in.)
Musée National d'Art Moderne/Centre de Création
Industrielle, Centre Pompidou, Paris, AM 1976-279

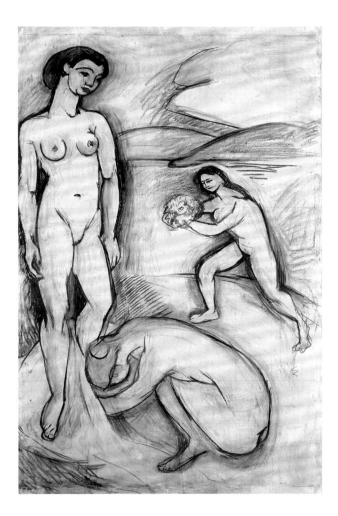

FROM THE EARLIEST moment of his career, Matisse found great creative potential in reusing subjects. Indeed, his very first pictures were two related still-life paintings made while convalescing from an illness at his parents' home in Bohain-en-Vermandois [2a–b]. Later, as a student in the atelier of Gustave Moreau, the artist built on this experience, making copies of Old Master paintings in the Musée du Louvre as part of his artistic instruction. Over a ten-year period, he produced works after many artists, including Jan Davidsz. de Heem [35b], Jean-Baptiste-Siméon Chardin, and Jean-Honoré Fragonard. This practice encouraged students to avoid direct invention and to follow instead the elements of composing and painting a picture devised by older masters. As Matisse recalled in 1941, "We looked to see how it was painted: the objects, the glazing, the passages from light to shadow. We studied it with a magnifying glass."[1] Such exactitude prevented personal interpretation; Matisse and his friends worked "according to the letter and not the spirit." This approach was required, especially if they hoped that the French government would acquire their copies.[2]

When it came to his own works, Matisse continued to find great creative potential in repeated motifs, whether remaking a figure from one medium into another [1.1–3] or returning in the same medium to a particular subject, such as a studio still life [19a–b] or view from a window [23b, 23d]. Reworking an already familiar subject—like a bathers scene—in which the initial invention of the figures and their poses was complete could free him to focus on other issues: to continue to pursue the essence of a form, search for still simpler means of making, or move the piece as a whole in a new direction.[3] The challenge in reworking a familiar subject was the preservation of the original feeling, or "expression," as Matisse called it.[4]

The paintings Matisse made of Le luxe [2.1–2] represent a particular kind of reworking that would become increasingly important in his 1913–17 period: the practice of producing two versions of the very same subject in the same dimensions and format.[5] Le luxe (I) is loosely and dryly painted in oil, with many adjustments to color: the blue horizon, for instance, was once pink. Le luxe (II) is more fully finished, a canvas painted in distemper with evenly filled, colorful forms and a markedly synthetic appearance.[6] While we call these works Le luxe (I) and Le luxe (II) today, the artist did not refer to them in this way.[7] Rather, he exhibited them with the respective titles Le luxe (Esquisse) and Le luxe, which connect them to the nineteenth-century academic tradition of making a freely painted, preparatory work (an esquisse, or sketch) and a second, more finished picture (a tableau) of the same subject. As utilized by his teacher

2a 2b

2c

2d

2a
Still Life with Books, June 1890. Oil on canvas;
21.5 × 27 cm (8 1/2 × 10 5/8 in.). Musée Matisse, Nice.

2b
Still Life with Books, 1890. Oil on canvas;
38 × 45 (25 × 17 3/4 in.). Private collection.

2c
Port of Abaill, Collioure, 1905. Oil on canvas;
60 × 148 cm (23 5/8 × 58 1/4 in.). Private collection.

2d
Study for "Port of Abaill, Collioure," 1905. Ink on
brown paper; 60.3 × 148.3 cm (23 3/4 × 58 3/8 in.).
Private collection.

2e
Collioure, Young Woman with a Parasol, 1905.
Oil on canvas; 46 × 38 cm (18 1/8 × 14 15/16 in.).
Musée Matisse, Nice, 63.2.14.

2e

Moreau and others, the *esquisse* and *tableau* were traditionally of different dimensions, the *esquisse* being smaller; Matisse broke with this tradition, however, as a way to preserve the expression of the first painting.[8] As he explained in a 1912 interview with the American reporter Clara MacChesney:

I always use a preliminary canvas the same size as for a finished picture, and I always begin with color. With large canvases this is more fatiguing, but more logical. I may have the same sentiment I obtained in the first, but this lacks solidity and decorative sense. I never retouch a sketch: I take a new canvas the same size, as I may change the composition somewhat. But I always strive to get the same feeling, while carrying it further. A picture should, for me, always be decorative. While working I never try to think, only to feel.[9]

Much has been written on the potential artistic sources for the two *Luxe* paintings, but far less has been devoted to the particular method of their making and their connection to a related charcoal drawing [2.3] that is of roughly the same dimensions.[10] Because of its close resemblance to the *Luxe* canvases, this has reasonably been identified as a cartoon since its first publication in the 1970s. Sometimes Matisse did indeed employ drawings to transfer his compositions to canvas, particularly a number of Divisionist—or post-Divisionist—works inspired by those of Paul Signac. For example, to make *Port of Abaill, Collioure* [2c], he used an ink cartoon the same size as the painting [2d], likely transferring the composition to the canvas by running a stylus over the main lines of the sheet, whose verso he had rubbed with charcoal. He also probably employed the same technique for *Luxe, calme, et volupté* (p. 47, fig. 8) and *Le bonheur de vivre* (p. 49, fig. 12), although the specific cartoons he used are not known today.[11] At other times, the artist used a grid as a means to transfer a drawing to a canvas: in *Collioure, Young Woman with a Parasol* [2e], we can see a light charcoal pattern on the surface of the canvas, which indicates that the artist probably enlarged the composition following a smaller, squared-up drawing.

Study for "Le luxe" is approximately the same size as the two paintings, and it has a grid: a twenty-by-twenty-centimeter orange squaring pattern that is visible today but documented most clearly in a photograph taken prior to its mounting on canvas [2f].[12] Visual examination of the first painting reveals evidence of vertical charcoal lines that run through the crouching figure's shoulders, upper left thigh, and back [2i]. The grid in the drawing matches the pattern of lines in *Le luxe (I)*: a digital overlay of both works with grids aligned demonstrates the nearness of their compositions [2g]. Some forms in the painting do not match those of the drawing; these include the jawline, right hip, and left foot of the standing figure; the contours of the crouching figure's back, buttock, and leg; and the striding figure's face, back, and

limbs. Many of these variations appear as changes to the drawing, forms lightly drawn or blended in, which indicate that the composition continued to evolve after the painting was begun.

The drawing also contains a number of contours—some reinforced, others submerged in areas of shading—that correspond to *Le luxe (II)*. We can find evidence of a grid on all four edges of this canvas: small pencil marks on the margins that match the drawing's grid and that Matisse connected with red chalk lines to create the squared intervals.[13] The marks are visible where the ground is exposed. Another digital overlay [2h], which matches the grids of the drawing and painting at the top of the compositions, establishes several shared contours, including part of the striding figure's upper back and the back of the neck and jawline of the standing figure. As with *Le luxe (I)*, a number of contours match ones that Matisse later erased or adjusted on the drawing. Others, such as the crouching figure's head, do not. Microscopic and infrared examination identify evidence of a charcoal underdrawing—for instance, on the neck of the standing figure, where paint does not cover the ground—but like the water-soluble chalk grid line, it was largely dissolved when Matisse began to paint the composition in distemper, which contains water.

It is likely, then, that Matisse used the drawing to produce both his *esquisse* and *tableau,* altering and revising it between paintings. This process is supported by the events of summer 1907. On July 14, he traveled with his wife from Collioure to Italy. The day after their return home, on August 16, the poet and critic Mécislas Golberg wrote to the artist, wishing that his "trip through Duccio, Giotto, Donatello will manifest itself in beautiful works that will complete, in an exquisite fashion, the one already drafted [ebauchée]."[14] Matisse had already sent a number of completed works to Paris before his trip, so Golberg was likely referring to *Le luxe (I)*, which can be seen in an unfinished state (ébauchée) in a photograph from the same moment [2j].[15] After he arrived back in Collioure, the artist would have had just a few weeks to complete his painting before the early September registration for the Salon d'Automne, where he presented it as *Le luxe (Esquisse).*[16] While we know that the term belongs to a specific practice of making a composition, scholars have also noted that Matisse might have used it for this and the other four works identified as *esquisses* at the Salon as a way to deflect critics' expectations about their styles or finishes.[17] In this case, however, the artist's choice of title might also indicate that a second painting was already on his mind— or even on canvas. With *Le luxe (I)* unavailable until the

end of the Salon, Matisse would have had to rely on the drawing to initiate *Le luxe (II),* which might account for the unusual and intriguing parity between the two paintings.[18]

The experience, however, must have ultimately been dissatisfying for him. Having viewed the work of Giotto during the summer and that of Cézanne at the Salon d'Automne, Matisse would soon be faced with summarizing his goals in his essay "Notes of a Painter." There he clearly cautioned against simply copying because of its potential loss of expression:

Expression, for me, doesn't reside in the passion seen ablaze on a face or indicated by a violent movement. It is everywhere in the arrangement of my paintings: the space occupied by bodies and the empty space around them, the proportions, all those play a part. Composition is the art of arranging in a decorative manner the various elements the painter has at his command to express his feelings. . . . Composition must aim for expression, [and] it is modified according to the surface to be covered. If I take a sheet of paper of any given size, the drawing I make on it will necessarily relate to its format. . . . I wouldn't be satisfied with enlarging it to transfer it to a sheet of paper of a similar shape, but ten times larger. . . . The artist who wants to transfer a composition from one canvas to a larger one, must—if the expression is to be preserved—conceive it anew, modifying its very appearance and not simply working to the square.[19]

Matisse would continue to rework subjects in repeated paintings, but his process of remaking and its final result would soon become increasingly free, generated and guided by the work itself.

1. Courthion 1941, p. 19.

2. Tériade 1952, pp. 41–42. For its lack of originality, Matisse ranked this kind of copying as a low form of artistic achievement: "The works most successful with the purchasing commission were those done by the mothers, wives, and daughters of museum guards. Our copies were only accepted out of charity, or sometimes when [art critic] Roger-Marx pleaded our case. I would have liked to be literal, like the mothers, wives and daughters of the guards, but couldn't."

3. Among the notable examples of earlier artists Matisse possibly looked to for working in series or variations (Gustave Caillebotte, Degas, Van Gogh, Monet, Camille Pissarro, Georges Seurat), he was surely influenced in this regard by Cézanne and inspired by his own small *Three Bathers* by the artist (p.45, fig. 3). For more on Cézanne's exploration of this theme, see Krumrine 1990.

4. In his 1907 interview with Guillaume Apollinaire, Matisse described his process of finding a voice, looking first to ancient and then modern masters, and then back to his own works. He commented that, while this at first seemed "to be monotonous repetition," it was instead the manifestation of his intent, his "personality, that appeared the same no matter what different states of mind I passed through." He discussed this desire to "express" himself through his artistic materials "with purity," developing this idea of expression the following year in his seminal "Notes of a Painter." See Apollinaire 1907, p. 482.

5. Matisse began this process very early in his career (see, for example, *Still Life with Oranges [I]* [1899; The Baltimore Museum of Art] and *Still Life with Oranges [II]* [p. 47, fig. 6], of the same dimensions and format, but varied handling). To this early group, though not in the same dimensions, also belong *Still Life with Purro*

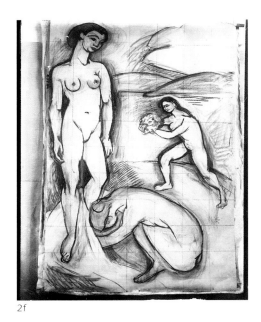

2f

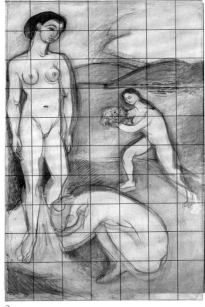

2g

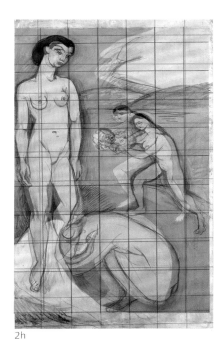

2h

2i

2f
Study for "Le luxe" possibly resting atop *Le luxe (I)*,
n.d., as photographed before lining.

2g
Digitized overlay of *Study for "Le luxe"* and *Le luxe (I)*,
matched to the grid: contours of figures correspond
to many existing lines in the painting and a number
that Matisse later rubbed out in the drawing.

2h
Digitized overlay of *Study for "Le luxe"* and *Le luxe (II)*,
matched to the grid: here far fewer lines correspond
between compositions, demonstrating Matisse's deci-
sion to carry the design further in the second painting.

2i
Detail of the crouching figure in *Le luxe (I)*, showing
a charcoal line visible under the paint.

2j
Henri Matisse with his wife, Amélie, and daughter,
Marguerite, summer 1907; *Le luxe (I)*, possibly unfin-
ished, appears in the background. Note in particular
the areas of difference with the finished canvas:
the hilltop on the left, the sky above the mountains,
and the area directly below the crouching figure's
feet at bottom.

2k
In this detail of *Le luxe (II)*, a vertical red-chalk grid
line is visible under the foot of the crouching woman,
where the distemper does not completely cover the
ground.

2j

2k

(I) (summer 1904; The Phillips Collection, Washington, D.C.) and *Still Life with Purro (II)* (summer 1904; National Gallery of Art, Washington, D.C.), and even the sculptures *Madeline (I)* (c. 1901; D8) and *Madeline (II)* (1903; D10), although they were apparently made a few years apart. Matisse's copying and related serial working would become lifelong creative practices. See Tanaka and Amano 2004; and Jeffrey Weiss, "The Matisse Grid," in Kahng 2007, pp. 173–93.

6. The Statens Museum for Kunst analyzed six samples of the medium of *Le luxe (II)*; results confirm that Matisse painted the composition in distemper. We are grateful to conservator Kathrine Segel for her generous assistance in this regard; the results of her analysis will be published in Kathrine Segel and Ole Nørregaard, "*Le Luxe (II)* by Henri Matisse," *SMK Art Journal* (forthcoming, 2010).

7. While there are instances of Matisse using numbers to identify works, the way that we know many of these numbered "painted pairs" today originated with Barr in 1951; the fascinating tale of the process he undertook to catalogue Matisse's work is told through his questionnaires to the artist, now housed in the MoMA Archives.

8. Moreau generally used detailed cartoons to enlarge details or figures for a final painted canvas, but he did not make an *esquisse* the same size as the canvas for a *tableau*. He did make large, detailed *esquisses* of particular figures in compositions to transfer to canvas, and these were often squared for transfer; see Lacambre 1999.

9. MacChesney 1913.

10. There is an additional strip on the top and bottom of the sheet that adds an extra fifteen centimeters to the dimenisons of this work. See Flam 1986; Monod-Fontaine, Baldassari, and Laugier 1989, pp. 32–35; Schneider 2002; and Wright 2004.

11. See Christian Zervos, "Notes sur la formation et le développement de l'oeuvre de Henri Matisse," *Cahiers d'Art* 5–6 (1931), p. 240. Yve-Alain Bois and Jack Flam noted Louis Vauxcelles's review of *Le bonheur de vivre* at the 1905 Salon des Indépendants: "When one executes a work, one must leave nothing to chance; to enlarge a lovely sketch by squaring is an error." Bois convincingly proposed that since Vauxcelles and Matisse knew one another, it was likely that the critic saw the sketch for the painting in the artist's studio; see Bois 1990, p. 266 n. 45; and Flam 1986, p. 489 n. 7. Flam reported that the major elements of *Le bonheur de vivre* were set initially in charcoal prior to painting and then reinforced with a thin black paint; see "*Le bonheur de vivre (The Joy of Life)*," in Wattenmaker and Distel 1993, pp. 231, 307 n. 15. Matisse also painted an *esquisse* for *Le bonheur de vivre* (1905–06; San Francisco Museum of Modern Art), which is much smaller (41 × 55 cm) than the finished work (175 × 241 cm).

12. Examination of the sheet under magnification reveals no holes in the surface over which, as has previously been suggested, Matisse would have pounced loose pigment to transfer the image to the canvas. As the drawing is now lined with canvas, it is not possible to verify the presence of charcoal for transfer on the verso. The following comments are based on visual examination of the surface only. Thanks to Anne-Catherine Prud'homme, Musée National d'Art Moderne, Paris, for examining the grid, as well as to Douglas Druick for his careful visual review of the work; Claudine Grammont located the uncropped photograph of the drawing.

13. An infrared reflectogram of the canvas shows evidence of the marks as well as a few instances of charcoal underdrawing. Again, thanks to Kathrine Segel for her intelligent, insightful examination of *Le luxe (II)*. Segel also noted in her visual examination of the standing figure's face that the eyebrows were left in reserve and painted after the flesh, which supports the belief in Matisse's use of an initial sketch.

14. Golberg to Matisse, Aug. 16, 1907, AHM. For a thoughtful examination of this interchange and a significant interpretation of *Le luxe (II)*, see Yve-Alain Bois, "A De Luxe Experiment: *Le Luxe, II*," in Aagesen 2005, pp. 108–30.

15. On July 13, Matisse sent six paintings by train to Félix Fénéon but *Le luxe (I)* was not among them; the shipment included *Baigneuses (Le bain)* (3a) and *La musique (Esquisse)* (p. 81, fig. 10); Labrusse and Munck 2005, pp. 290–91.

16. In a letter of Aug. 28, Fénéon wrote to Matisse about which of the six works sent in July would be exhibited in the Salon and if there were any new ones to be included (AHM); ibid., p. 292. See also Bois (n. 15).

17. The four works identified as *esquisses* were: no. 757bis, *La musique (Esquisse)*; 758, *Le luxe (Esquisse)*; and two unspecified landscapes (759 and 759bis). For more on Matisse's decision to use the term *esquisse* for *Le luxe*, see Benjamin 1987, pp. 110, 202, 322, no. 162; and Monod-Fontaine, Baldassari, and Laugier 1989, p. 34. For the artist's use of *esquisse* as opposed to *ébauche*, *étude*, *pochade*, and *croquis*, see also Elderfield, "Matisse in Morocco: An Interpretive Guide," in Cowart 1990, pp. 212, 236 n. 43.

18. Visual examination of the sheet indicates that the orange grid may be, in fact, both over and under the charcoal lines, which suggests that Matisse reworked the drawing to begin *Le luxe (II)*. (Microscopic analysis of the drawing was not possible for this study.) In addition to *Study for "Le luxe,"* there are two small contemporaneous Conté crayon sketches in the collection of the Musée National d'Art Moderne, Paris: *Study for "Le luxe I"* and *Study for "Le luxe I"*; for illustrations of these works, see Monod-Fontaine, Baldassari, and Laugier 1989, pp. 156–57. Matisse also made a woodcut of the *Luxe* composition (1907; D320).

19. Matisse 1908, pp. 733–35.

3 Bathers with a Turtle
Couvent des Oiseaux and Couvent du Sacré Coeur, Paris,
December 1907–February 1908

Oil on canvas; 179.1 × 220.3 cm (70 ½ × 87 ¾ in.)
Signed and dated l.r.: *Henri-Matisse-08*
Saint Louis Art Museum, gift of Mr. and Mrs. Joseph Pulitzer, Jr., 24:1964

IN EXHIBITION

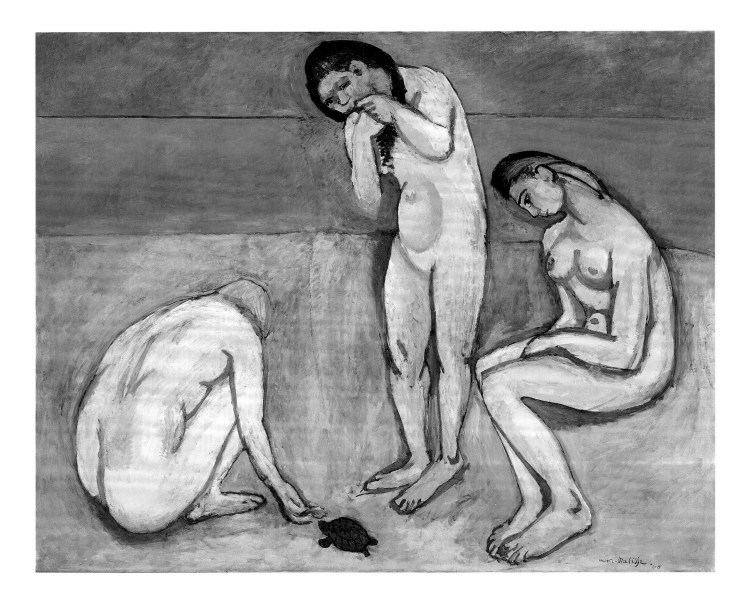

Masterpiece —a collection of three figures on a background of blue sky and sea. One is feeding a tortoise and the other chews her own fingers. I forget what the third is doing—probably crouching. One of them always crouches.[1]

SUCH WAS THE impression of the American author Inez Haynes Irwin, who saw the finished *Bathers with a Turtle* [**3**] during her visit to Matisse's new studio at the Couvent du Sacré Coeur on April 20, 1908.[2] Irwin was no doubt weary from touring the Salon des Indépendants as well as the various Stein collections, but her assessment is nonetheless astute. *Bathers with a Turtle* marked a fresh direction for Matisse, one in which he drew upon his practice of repeating motifs in different paintings and sculptures and forged a new approach predicated on an exceptional degree of reworking, now on the same canvas.

Matisse first painted this group on a much smaller canvas, initially titled *Le bain*, but known today as *Three Bathers* [**3a**], which he made before his trip to Italy in the summer of 1907; he reprised and synthesized it for *Le luxe (I)* and *Le luxe (II)* [**2.1–2**], produced after his return.[3] In these and *Bathers with a Turtle*, the artist employed the same three figures, repeating their standing, crouching, and sitting (or striding) poses with small variations even as he moved the overall composition toward greater simplification. The women in *Bathers with a Turtle*, however, are all but divorced from any narrative—gone is the recognizable landscape of earth, sea, and sky of the earlier paintings as well as the bouquets, clouds, drapery, hills, sailboats, and towels that suggested a leisure or vaguely Golden Age subject.[4] Their gestures do not communicate a specific purpose, and the turtle itself exists as an enigmatic, unsettling element that calls attention to the nearby crouching bather, but for no clear reason.[5] The figures are stripped and starkly bared against three plain horizontal bands, firmly separated from the traditional pastoral context in which it would have been permissible to view them.

As Irwin observed, Matisse did indeed include bending and squatting figures in many other compositions at this time, including *Luxe, calme, et volupté* (p. 47, fig. 8); *Le bonheur de vivre* (p. 49, fig. 12); *Pastoral* (July 1906; Musée d'Art Moderne de la Ville de Paris); *Music (Sketch)* (p. 81, fig. 10); and the lithograph *Large Nude* (21f). In fall 1907, he decorated ceramics with similar figures in the Asnières atelier of André Metthey [**3b**].[6] The following year, the artist explored the pose further in a series of small sculptures [**3c–e**], in which he reworked the motif each time, modeling the clay directly with his hands and eliminating progressively more detail.[7] This process culminated in a tightly bound mass without a head or limbs, a figure that likely informed the crouching woman in *Bathers with a Turtle*.[8] Matisse's repetitive practice

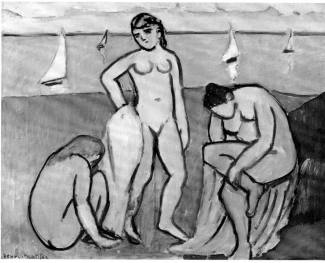

3a

3b

3a
Three Bathers, summer 1907. Oil on canvas; 60.3 × 73 cm (23 3/4 × 28 3/4 in.). Minneapolis Institute of Arts, bequest of Putnam Dana McMillan, 61.36.14.

3b
Three Bathers, 1907. Tin-glazed ceramic; diam. 34.9 cm (13 1/4 in.). The Metropolitan Museum of Art, New York, the Pierre and Maria-Gaetana Matisse Collection 2002, 2002.456.117.

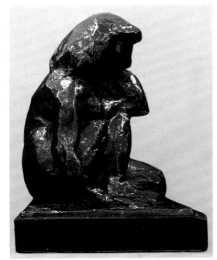

3c

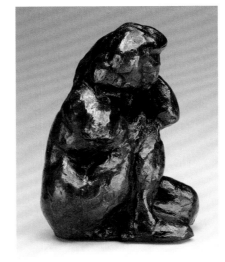

3d

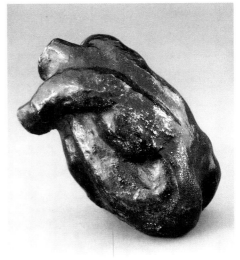

3e

3c
Small Crouching Nude with Arms, 1908. Bronze;
13.6 × 9 × 10 cm (5⁵/₁₆ × 3¹/₂ × 3¹⁵/₁₆ in.). Museo
Thyssen-Bornemisza, Madrid, Colección Carmen,
CTB. DEC 1722.

3d
Small Crouching Nude without an Arm, 1908. Bronze;
13.7 × 6.1 × 9.2 cm (5³/₈ × 2⁵/₈ × 3⁵/₈ in.). The Art
Institute of Chicago, gift of Emily Crane Chadbourne,
1932.1145.

3e
Small Crouching Torso, 1908. Bronze; h. 7.8 cm
(3¹/₁₆ in.). Musée Matisse, Nice, D78.1.54.

3f
Infrared reflectogram of *Bathers with a Turtle*,
showing how Matisse adjusted the poses of the
figures as he worked.

3g
X-radiograph showing how the artist used heavy
brushwork to construct and revise the contours
of each figure.

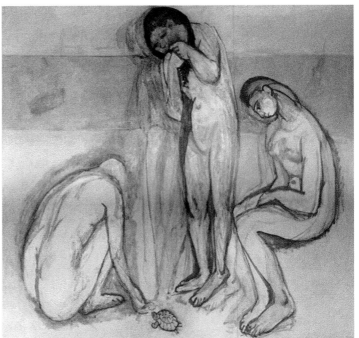

3f

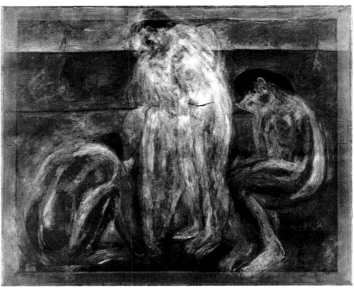

3g

served his goal of paring his forms down to their most pure and meaningful state, or what he called in "Notes of a Painter," published later that year, "a truer, more essential character."[9] This way of working also extended beyond his own creations, as he consistently revisited a range of poses and subjects that he gleaned both from mass-produced photographs of models and from paintings by a diverse array of artists including Cézanne, Camille Corot, Gustave Courbet, Gauguin, Giorgione, Jean-Auguste-Dominique Ingres, Pierre Puvis de Chavannes, Pierre-Auguste Renoir, and Titian.[10] In summer 1907, Matisse added to this list the work of artists he studied while visiting Italy: most significant for *Bathers with a Turtle* were Duccio's *Maestà* (1308–11; Museo dell'Opera del Duomo, Siena); the frescoes of Giotto's Scrovegni Chapel (1303–06) in Padua; Piero della Francesca's San Francesco (c. 1466) in Arezzo; and Andrea del Castagno's Sant'Apollonia (c. 1447–49) in Florence.[11] By repeatedly reusing these artistic resources, Matisse sought to mine—or rather, drain—forms of specific meaning to achieve a greater, more universal vocabulary of expression. "When I see the Giotto frescoes at Padua," he explained in his "Notes of a Painter," "I do not trouble myself to recognize which scene of the life of Christ I have before me, but I immediately understand the feeling that emerges from it, for it is in the lines, the composition, the color. The title will only serve to confirm my impression."[12]

In the early winter of 1907–08, back from his Italian sojourn and with the exhibition of *Le luxe (I)* and the production of *Le luxe (II)* behind him, Matisse set out to paint what must have been the culmination of his work on this particular subject.[13] He chose a large canvas of nonstandard size—almost the dimensions of *Le bonheur de vivre*, which possesses a similar summarizing quality.[14] An infrared reflectogram of *Bathers with a Turtle* [**3f**] demonstrates how close the artist's first version of the composition was to its predecessors: Matisse initially painted sailboats in the upper-left and upper-right quadrants, as in the 1907 *Three Bathers*; he likewise included drapery or a towel to the left of the standing figure. An X-radiograph [**3g**] further reveals the earlier presence of clouds at the upper left and undulating hills at the upper right that are similar to those in *Three Bathers*, *Le luxe (I)*, and *Le luxe (II)*. Both the infrared and the X-radiograph document not only the relatively unchanged placement of each figure on the canvas, but also Matisse's continual readjustment of their poses. The latter specifically identifies thick areas of paint that he built up following the contours of each figure; the lightest values signify the greatest density.

Visual and technical examination reveal the process of Matisse's reworking—pursuing the continual, repeated revision of the same forms on the same canvas almost as a process of evolution. For example, the crouching figure at left was first shown with her head in profile, lower than it is at present. Her right arm, now reaching toward the turtle, was once closer to her torso, while her right knee extended beyond her arm, much like the right arm and leg in *Small Crouching Nude with Arms* [**3c**]. Although Matisse reworked the pose, he retained the brilliant yellow hair seen in *Three Bathers* and both *Le luxe (I)* and *Le luxe (II)*; in fact, microscopic examination confirms that he used the same golden hue that appeared in the earliest version of the head, which now exists below the green paint near the top of the present right arm. Where we now see small patches of green under loose scumbles of peach and pink paint, we can identify Matisse's numerous enlargements and alterations of the woman's hunched back. The artist added volume by skillfully combining scraped-back contours, adjacent tracks of paint that he left only partially blended, and areas of thinly brushed ground that read as highlights on the skin of the lower back [**3k**]. To this he added thin black contour lines on the arm, lower torso, legs, and feet, complementing these with alizarin crimson and brown contours on the upper back and shoulders that lend a subtle weight to the whole.

Just to the right of this figure is the turtle, which Matisse must have included from the beginning, as it is painted directly onto the ground. Near the outstretched hand, the infrared image shows a short, double-curved outline that echoes the top of the present turtle's head and shell. We can find evidence of scraped black lines and brown paint in the hand, and microscopic analysis demonstrates that the bottom of the shell and legs now extend over the green background. Together, these details reveal that the artist moved the animal down and to the right, incorporating the scraped form into part of the offering that the woman extends to the turtle [**3l**].

Further examination with the microscope reveals that Matisse had earlier included loose white drapery between the crouching and standing women, as the pattern of folds are visible in both the X-radiograph and the infrared. It appears that he also shifted the standing figure from left to right, since below the present green surface there exists a complex series of terracotta and pink flesh layers brushed over and under the white of the drapery and the green of the background. The infrared image demonstrates how the artist changed the presentation of the figure from a side view to a frontal one, and finally to the current treatment, which enabled him to eliminate several repositioned sets of breasts. While Matisse kept the left arm in more or less the same position, he repeatedly readjusted the right one as he shifted the figure toward a more erect posture. The artist made similar changes in a related sheet [**3m**], leaving earlier arm and leg positions visible in the finished drawing.[15] Perhaps the most remarkable area in which Matisse reworked earlier forms occurs in the face, which he painted over in gray and scraped back to the original flesh colors in certain areas. He then painted in specific places, building highlights and volumes with lightly brushed passages of orange and pink, and defining the eyes with a thin black line of paint [**3h**]. The resulting image suggests the shadow on a downturned face, especially in contrast to the brilliant hues of the figure's left shoulder.

Matisse approached the seated figure in a similar way, building her final form from the revised contours of her head and body, which was originally turned to the side. Here he melded various layers of paint and scraping to suggest the volume and heaviness of the pose. The artist produced a particularly striking sense of weight through heavy contour lines in black paint. Visible in the infrared, these start at the top of the figure's head and reach down her back to under her left knee, also running from between the right arm and torso to the lower legs. Here these areas appear as cancelled sketch lines hatched over in a repeated fashion; on the surface, however, we can see how Matisse carefully painted over the black, using alizarin crimson between the enclosed forms of the body [**3i**] and green on the outside contours. What results is a sense of weight and vibration that resonates with the painting's overall vocabulary of pulsating, rhythmic brushstrokes and ghostly, hovering forms. What might have traditionally been called pentimenti can only be seen here as an integral part of the finished composition.[16] The extent to which Matisse orchestrated these effects can even be seen in the tripartite, abstracted background, in which he punctuated interwoven veils of dark blue, turquoise, and pale green with dense passages of more intense blues and greens [**3j**].

Whatever subject Matisse may have initially envisioned for this composition, its final form suggests something entirely new, transformed by the making of the work itself.[17] The artist seemingly acknowledged this when he spoke to Felius Elies in an interview not long after he completed the painting:

I believe only in Instinct. It is the purest, most invulnerable thing, the true lifespring of artistic activity.... not only do I seek instinctual ferment before the spectacle of the world but the most instinctive way of expressing it as well; often a Titanic task, because our conventional education and our conventional ancestralism weigh terribly on me. Often one of those apparently simple works of mine is preceded by long and copious labor; often behind one of these works a dozen more have been undergoing evolution, or, if you wish, involution, from objective vision to the sensationalist idea that engendered it.[18]

3h

3i

3j

3k

3l

3h

Detail of the face of the standing figure, demonstrating how Matisse used lower layers of paint as the basis for his final forms, scraping unblended patches of flesh-colored pigment and painting black lines on the surface.

3i

Detail of the seated figure, showing an area between the lower legs that Matisse initially painted in black and later layered with alizarin crimson to intensify the color and surface effect.

3j

Detail of upper left, showing how Matisse interwove layers of pale and dark green paint (at top) and dark and light blue paint (at middle), introducing passages of vivid blue at center.

3k

Detail of the back of the crouching figure, showing interwoven layers of scraped-down contours, built-up passages of sometimes unblended paint, and areas held in reserve that together produce form and volume.

3l

Detail of the area around the turtle's head, showing the previous position of the head above and to the left; this element, painted in brown and black paint, was later scraped down and incorporated into the present image.

In the context of Matisse's various explorations with ways of reworking repeated motifs and compositions, *Bathers with a Turtle* is a striking example of his incorporation of visible change throughout an entire composition to generate and determine its final form. The implications of this picture, and of Matisse's embrace of the concepts of evolution (and involution) in his working process, would become an increasingly significant aspect of his artistic experimentation in the second decade of the twentieth century.

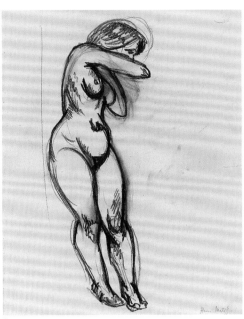

3m

3m

Standing Female Nude, Twisting toward Her Back, 1908. Graphite with stumping on tan wove paper, laid down on cream wove paper, laid down on ivory wove paper; primary support: 30.9 × 23.6 cm (12 1/8 × 9 1/4 in.). The Art Institute of Chicago, Alfred Stieglitz Collection, 1949.894. In exhibition.

1. Inez Haynes Irwin, typescript of diary, Apr. 20, 1908, A-25, box 2, vol. 22, folder 1, p. 106. Inez Haynes Gilmore Papers, 1872–1945, Schlesinger Library, Radcliffe Institute, Harvard University, Cambridge, Mass. Irwin was in Paris to accompany Gelett Burgess, who was interviewing Matisse as well as Braque, André Derain, Othon Friesz, Auguste Herbin, and Picasso for an article later published in *Architectural Record* 27 (May 1910), pp. 400–14. Thanks to Accacia Flanagan, Schlesinger Library, for making these materials available.

2. We do not know what Matisse called the painting, but the first published title was *Mädchen am Strande* (*Girls at the Beach*) in Wilhelm Niemeyer, *Malerische Impressionen und koloristischer Rhythmus. Beobachtugen über Malerei der Gegenwart* (À Bàgel, 1911), and a year later, *Drei Frauen am Meer* (*Three Women by the Sea*) in Freyer 1912. For more on this history, see Stein 1998.

3. See Matisse to Félix Fénéon, July 8, 1907, AHM. According to Wanda de Guébriant, AHM, the artist wrote on the verso of a photograph of *Three Bathers*: "Composition: Étude pour la peinture 'Les Femmes à la tortue.'" See Bois 1998b, p. 19 n. 1.

4. For information on the continuation of idyllic painting, see Werth 2002, esp. pp. 223–31.

5. Many scholars have focused on the work's iconography and narrative significance, relating it to various classical themes of Venus or religious scenes of the Expulsion, among other ideas. See in particular Rousseau 1991; Bois 1998b; and Elderfield 1998.

6. For more on Matisse's ceramic work with Metthey, see Musée Matisse 1996; and Rebecca Rabinow, "Vollard and the Fauves," in Rabinow 2006, pp. 125–28.

7. Also related to this group is the somewhat larger bronze sculpture *Seated Figure, Right Hand on Ground* (1908; D42).

8. As Isabelle Monod-Fontaine showed, the first of these sculptures is also related to a contemporary photograph; Matisse's process of reducing this form from the first crouching figure to the last was hastened by an accident in which the arm was broken off. See Monod-Fontaine 1984, pp. 15–16, pl. 29–32a.

9. Matisse 1908, p. 736.

10. For more on Matisse's photographic sources, see Monod-Fontaine 1984; and McBreen 2007. Among the many contemporary sources of inspiration, one of the most relevant is Cézanne's *Large Bathers* (p. 52, fig. 16), which was shown in the special exhibition at the 1907 Salon d'Automne, where Matisse also exhibited works, including *Le luxe (I)* (2.1). For more about Cézanne's impact on Matisse, see Bois, "Cézanne and Matisse: From Apprenticeship to Creative Misreading," in Rishel and Sachs 2009, pp. 103–20.

11. Henri and Amélie Matisse were in Florence by July 18, where they visited Sandro Botticelli's *Birth of Venus* and Titian's *Portrait of a Woman*; their tour also included Siena, Ravenna, Padua, and Venice. They returned to Collioure on Aug. 14. For more on Matisse's time in Italy, see Labrusse and Munck 2005, pp. 291–92.

12. Matisse 1908, p. 741.

13. For the date of Matisse's work on *Bathers with a Turtle*, I am indebted to Laurie Stein, who generously provided her original research on the painting, including correspondence between Matisse, Karl-Ernst Osthaus, Hans Purrmann, and Bernheim-Jeune around the acquisition. Among these important documents is a letter from Félix Fénéon to Osthaus, Jan. 28, 1908, Karl-Ernst Osthaus Museum, Hagen, that states, "This painter has been working on a huge canvas for ages, and we have not a single work by him to show to those interested in his work, who ask to see something." For more on the acquisition and early presentation of the painting, see Stein 1998; additional chronological information can be found in Labrusse and Munck 2005, p. 306.

14. It is worth noting that the largest works Matisse had produced since *Le bonheur de vivre* were the two *Le luxe* compositions, which are close in height to *Bathers with a Turtle*.

15. Matisse selected this drawing for exhibition at Stieglitz's 291 Gallery, New York, from Feb. 23 to Mar. 8, 1910, an early display of his work in the United States. Given the importance of this event to the artist's continued patronage and career, we should take special note of the "finish" Matisse wanted to present.

16. Pentimenti are defined as the visible evidence of an alteration to a painting or drawing that traditionally suggests a change of mind on the part of an artist. The term can also refer to such effects when they are not a deviation, but rather part of the alteration of a composition as an artist worked. In the context of Matisse's various explorations with ways of reworking repeated motifs and compositions, *Bathers with a Turtle* marks a mindful practice of incorporating change throughout a composition into the generation and final form of a painting.

17. Both Henri Bergson's concept of *durée* and Cézanne's practice of mark making should be understood in this context; see Benjamin 1987; and Mark Antliff, "The Rhythms of Duration: Bergson and the Art of Matisse," in Mullarkey 1999, pp. 184–208.

18. Matisse's interview with J. Sacs (Felius Elies) was published in *Vell i nou* in 1919 but was probably conducted by fall 1910; see Sacs 1919, p. 403.

4 Back (I), first state
Couvent du Sacré Coeur, Paris, by April 1908–June 1909

Clay; dimensions unknown
Signed l.l.: *Henri Matisse*
No longer extant

Back in progress, photographed by Eugène Druet, spring 1909

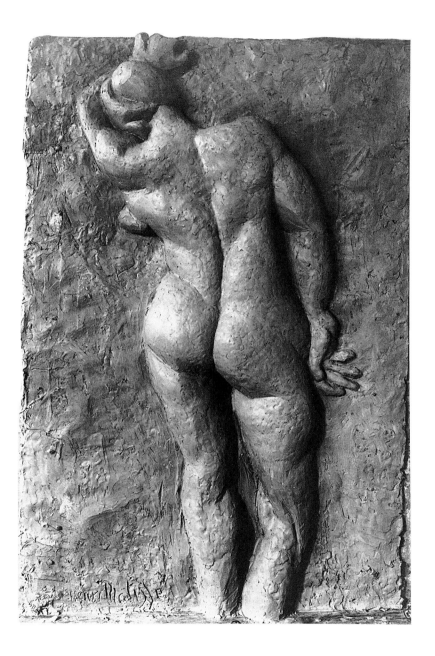

4a
Auguste Rodin (French, 1840–1914). *Despair*, c. 1889.
Plaster; 30.5 × 18 × 15 cm (12 × 7 1/8 × 5 15/16 in.).
Musée Rodin, Paris.

4b
Photographic plate 214 of *Étude académique*,
August 15, 1906.

4c
Standing Female Nude Seen from the Back, 1900/01.
Charcoal on wove paper; primary support:
33 × 21.4 cm (13 × 8 7/16 in.). The Art Institute
of Chicago, Alfred Stieglitz Collection, 1949.890.
In exhibition.

4d
Nude, Back View, 1907–09. Graphite on paper;
31.5 × 24.4 cm (12 7/16 × 9 5/8 in.). Private collection,
Switzerland.

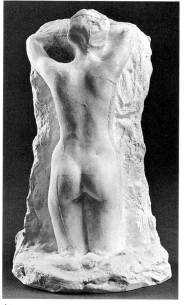

4a

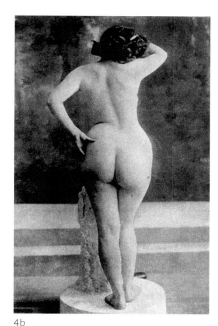

4b

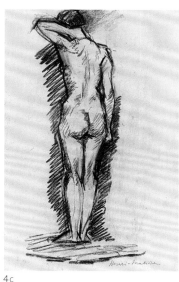

4c

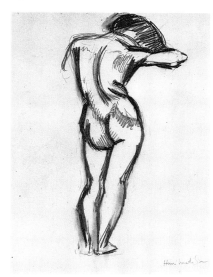

4d

ALMOST WITHOUT EXCEPTION, Matisse made his early sculptures in clay. He did not cast them in bronze—or, less typically, in terracotta or plaster—until sometimes much later, when they were requested for exhibition or purchase.[1] He made changes to works such as *Reclining Figure with Chemise* [**1.1**] and *Reclining Nude (I) (Aurore)* [**1.2**] by modeling the clay with his fingers or tools, which required keeping it wet between sessions until the sculpture was complete and could be dried.[2] His bas-relief *Back* [**4**], however, would prove to be a significant departure, influencing his methods of reworking in all media.

The artist's earliest efforts on *Back* can be traced to spring 1908, when Gelett Burgess and Inez Haynes Irwin visited him at the Couvent du Sacré Coeur studio. Irwin's diary recounts that on April 20—the same day they saw *Bathers with a Turtle*—she and Burgess glimpsed "two stunning things in clay, one a bas-relief, the back view of a huge figure, a hand up against the wall; the other a huge figure coiled to repose [*Decorative Figure*, **4f–g**]."[3] "For the first time," Irwin admitted, "I get the sense of the power of Matisse." Based on her entry, we must date the genesis of *Back* to at least April 1908—more than eight months earlier than the generally accepted date of 1909.[4]

Much has been made of the artist's sources for this sculpture, which range from his own Cézanne, *Three Bathers* (p. 45, fig. 3) to works by Gustave Courbet, Paul Gauguin, and Auguste Rodin [**4a**].[5] Matisse also studied contemporary publications of artists' photographs [**4b**] and undertook sessions with a model; numerous variations of the motif can be found in his mature drawings from as early as 1900 [**4c–d**].[6] His early sculptures display a similar interest, and it is noteworthy that a large number of works from 1907 and 1908 focus on the issues of anatomy he discussed with his students at that time, including the balance of relaxation and tension in the back as the spine and attached muscles are twisted or extended [**3c–e**], or the look that flesh takes on when it is pressed against a rigid surface [**4e–g**].[7]

Surprisingly, however, we can find in Matisse's paintings almost no standing figures with their backs turned to us, and certainly none who twist and raise their arms in the same way; the closest appears in *La coiffure* [**4i**]. As we know, the artist worked in "clay to have a rest from paint...putting order to my sensations so as to seek the method that absolutely suited me. When I had found it in sculpture, it served me for painting. The point was to possess my thoughts, to possess a kind of hierarchy of all my sensations, one that would lead me to a conclusion."[8] He might have produced *Back*, then, as an independent exploration following the recently completed *Le luxe* paintings. In this context,

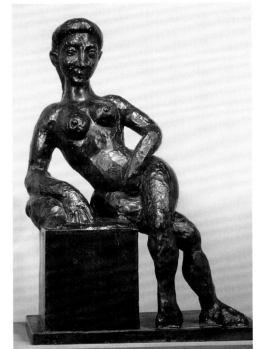

4f

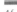

4h

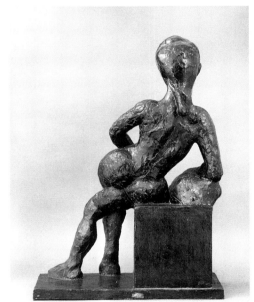

4g

4e

Two Women, 1907–08. Bronze; 46.6 × 25.6 × 19.9 cm
(18³/₈ × 10¹/₈ × 7⁷/₈ in.). Hirshhorn Museum and
Sculpture Garden, Smithsonian Institution,
Washington, D.C., gift of Joseph H. Hirshhorn,
66.3456.

4f–g

Decorative Figure, 1908. Bronze; 72.1 × 51.4 × 31 cm
(28³/₈ × 20¹/₄ × 12¹/₄ in.). The Art Gallery of Ontario,
Toronto.

4h

Standing Nude, 1908. Bronze; h. 22.9 cm (9 in.).
The Art Gallery of Ontario, Toronto.

4i

La coiffure, 1901. Oil on canvas; 95.2 × 80.1 cm
(37¹/₂ × 31⁹/₁₆ in.). National Gallery of Art,
Washington, D.C., Chester Dale Collection,
1963.10.165.

the small *Standing Nude* of 1908 [**4h**], which is directly related to the central figure in both canvases of *Le luxe*, should be considered an initial idea for the larger bas-relief.

Back was the largest sculpture Matisse had yet made, towering over the majority of earlier examples in his oeuvre.[9] Issues of size and scale may well have motivated him to begin the work, which is quite similar in size and format to *Le luxe (I)* and *Le luxe (II)*. Scholars have pointed to connections with the monumental canvas *Dance (I)* of spring 1909 (p. 79, fig. 5), and this is certainly warranted, given the familiar twisting pose of the dancing nude on the far left. But if *Back* was indeed underway in April 1908, we might consider whether the clay influenced the oil, its low-relief quality facilitating Matisse's move from *Le luxe (II)* to *Dance (I)*, with its merging of figure and ground. Alternatively, we might look to *Bathers with a Turtle* [**3**], which the artist had completed by April 1908. The rhythmic, overlapping brushwork that describes the bathers resembles the repeated modeling marks on *Back*'s figure and in the area that surrounds it. *Back* undeniably functioned as a bridge between these dual modes as it evolved over the months leading up to Matisse's commission of *Dance (II)* and *Music* (p. 77, figs. 1–2) from Sergei Shchukin.

In spring 1909, Matisse learned that the building in which his atelier was located would be sold, and he began plans to pack and relocate to a new home in Issy-les-Moulineaux, a southwestern suburb of Paris. It was at about this time that Eugène Druet photographed *Back* [**4**].[10] Albert Elsen, who first identified this image, asserted that it and the signature in the lower-left corner of the sculpture were evidence that Matisse considered the work finished.[11] The artist's daughter, Marguerite, attributed the need for a photograph to his fear that the clay might be damaged en route to Issy.[12] Indeed careful, Matisse cast the relief in plaster prior to leaving the Paris studio. While the move may have precipitated the signature, photograph, and casting, it may also be the case that Matisse was ready to rework *Back* and simply wanted to document it before he continued.[13] As we shall see most dramatically in the case of the paintings related to the Shchukin commission, he often recorded the progress of his works, and a signature would be expected—although not required—to properly document the bas-relief. In either case, the plaster casting of *Back* necessarily destroyed the clay, and Druet's photograph is now the only evidence of this first stage of exploration. The artist would return to the bas-relief in the fall, still in pursuit of its "conclusion."

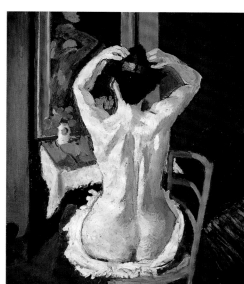

4i

Matisse could have worked on the piece after it had been cast in plaster and before it was cast in bronze; for more on the history of this sculpture, see Elsen 1972, pp. 25–44.

3. Inez Haynes Irwin, typescript of diary, Apr. 20, 1908, A-25, box 2, vol. 22, folder 1, p. 107. Inez Haynes Gilmore Papers, 1872–1945, Schlesinger Library, Radcliffe Institute, Harvard University, Cambridge, Mass.

4. In support of this dating, see Flam 1986, p. 495, no. 36; Monod-Fontaine, Baldassari, and Laugier 1989, p. 326; Elderfield 1992, p. 121; and Schneider 2002, p. 544.

5. For more on Matisse's sources, see Elsen 1972, pp. 176–80; Elderfield 1978, pp. 74, 193; and Flam 1986, p. 269. The artist also explored this motif in earlier, more decorative forms, including the tin-glazed ceramic *Green and White Vase with Nude Figures* (c. 1907; Musée d'Art Moderne de la Ville de Paris); and *The Dance* (1907; D35), a three-dimensional work of carved wood that owes much to Gauguin.

6. See Monod-Fontaine 1984; Briggs 2007; and McBreen 2007.

7. *Decorative Figure* is the second clay Irwin mentioned in her notes of Apr. 20, 1908. Matisse's concerns about constructing the human figure can be read in "Sarah Stein's Notes" (1908); Flam 1995, pp. 44–52.

8. Courthion 1941, p. 66.

9. The artist produced approximately forty sculptures by the end of 1908. *Back* would remain the largest work in his oeuvre; the second largest was *Decorative Figure* (4f–g), with the majority from 1900–09 around five inches tall.

10. Flam 1986, p. 265.

11. Elsen titled the photographed clay *Back (0)* to signify that it comprised a completed stage predating *Back (I)*, rather than a first state of *Back (I)*, as suggested here; see Elsen 1972, pp. 183–85.

12. Marguerite Duthuit believed that the clay had no armature; see ibid., p. 182; and Duthuit and de Guébriant 1997, p. 384 n. 20.

13. Matisse's process of reworking was already well in place by Apr. 1908. As Irwin (n. 3) noted, "Matisse tells Gelett that whenever he makes any correction of detail in the clay, he has to go over all the whole figure."

1. Duthuit and de Guébriant 1997, p. 250.

2. One of Matisse's earliest sculptures, *The Serf* (1900–04; D6), may be an exception to this process:

BY THE BEGINNING OF 1909, Matisse had formed relationships with a number of important and supportive collectors: there was the expatriate Stein family, both Leo and Gertrude as well as Michael and Sarah (47.2, 47a), the latter of whom had been particularly helpful in establishing the Académie Matisse the year before; Ivan Morosov, a "Moscow importer of Eastern textiles" known for his decorative commissions to the Nabi painters Pierre Bonnard and Maurice Denis, who began acquiring the artist's works in 1907 through Bernheim-Jeune; and the German collector Karl-Ernst Osthaus, who in 1908 commissioned a ceramic triptych from Matisse (5e) and purchased *Bathers with a Turtle* (3) for his Hagen museum.[1] However, in terms of the sheer number of works acquired, probably no patron was greater than Russian businessman Sergei Shchukin. Indeed, he was essential to Matisse not only for his generous financial support, but also for the exceptional creativity and freedom he afforded the artist—especially as it related to what would become the pinnacle of his early career, the monumental paintings *Dance (II)* (fig. 1) and *Music* (fig. 2), which debuted at the Salon d'Automne in October 1910. The experience of making those works, as well as a number of related canvases (6–8), particularly *Bathers by a River* (5, 10), would leave an indelible impression on Matisse's continuing evolution and development throughout the 1913–17 period.

Shchukin began to collect French art in 1897 and, within a few short years, had amassed an ambitious representation of paintings by such Impressionist and Post-Impressionist artists as Cézanne, Degas, Gauguin, Van Gogh, and Monet.[2] In the middle of the first decade of the new century, he began to focus on a younger generation of contemporary artists, most especially André Derain, Matisse, and Picasso. In May 1906, he sought Matisse's address from Ambroise Vollard and paid him a visit, acquiring *Dishes on a Table* (1900; The State Hermitage Museum, St. Petersburg). The artist recalled:

He noticed a still life hanging on the wall and said: "I'll buy it, but I'll have to keep it at home for several days, and if I can bear it, and keep interested in it, I'll keep it." I was fortunate in that he held up under this first ordeal easily, and that my still life didn't tire him too much. So he came back and commissioned a series of large paintings to decorate his Moscow house.[3]

Matisse appreciated his new patron and even helped to facilitate relationships with other artists: in September 1908, for example, he took Shchukin to the Bateau-Lavoir to meet Picasso and see *Les demoiselles d'Avignon* (p. 51, fig. 14), thus sparking a rivalry for the collector's attention for years to come. By 1914, when World War I forced Shchukin to stop purchasing art, he had amassed thirty-eight paintings by Matisse, including *Path in the Bois de Boulogne* (fig. 3), *View of Collioure* (p. 114, fig. 10), *Still Life with Blue Tablecloth* (1909; The State Hermitage Museum, St. Petersburg), *The Conversation* (p. 117, fig. 15), *The Pink Studio* (p. 113, fig. 5); *Goldfish* (1912; The State Hermitage Museum, St. Petersburg); six Moroccan paintings (including 14a, 15c, 16l), and *Portrait of Madame Matisse* (p. 148, fig. 9). His collection boasted fifty works by Picasso.[4]

The roots of the commission for *Dance (II)* and *Music* go back to the spring of 1908, when Shchukin brought Morosov to Matisse's studio to introduce him and saw *Bathers with a Turtle*, which was already reserved for Osthaus.[5] Seemingly fixated on the canvas, which he called *Mer* (Sea), the collector asked Matisse to make a similar canvas that he referred to as *Bathers*. On June 2, he inquired about its progress:

As for the *Bathers*, I am very happy to learn that you are thinking of beginning them again. I still think of your admirable *Sea*, still seeing this picture in front of me. I feel that freshness, the magnitude of the Ocean and the feeling of sadness and melancholy. I will be very happy to have something striking the same note. Perhaps you might send me a photograph of the *Bathers*?[6]

At the end of the month, after reviewing the photograph, Shchukin confirmed his offer for the "very interesting" canvas and requested its express delivery. The ensuing correspondence about the work, known today as *Game of Bowls* (5c), clari-

fies the artist and patron's mutual understanding of process and need for creative liberty as well as their habit of introducing and identifying potential new works. Shchukin's letters demonstrate a businesslike pace: while complimenting the artist's work, he quickly moved the discussion to the next matter at hand—in this case, his desire for more paintings.[7] For his part, Matisse offered patient latitude for Shchukin's acceptance of completed works and, at the same time, tested his interest in potential future ones. On July 6, for instance, he drafted a letter to his patron about *Game of Bowls*, which he soon sent after deleting the sections shown here:

I handed over the picture of the three bathers to Mr. Sheiter. If it does not please you, or when it stops pleasing you, I expect you to return it to me. ~~I send it to you only on the condition that you send the picture back to me if it does not please you anymore.~~ I ask you please to consider it as an *esquisse*. I think it is honest and expressive. Its expression is pure, although less powerful than that of the large canvas ~~of bathers~~ that you liked so much. [. . .] Please be good enough, dear sir, to tell me very briefly if you are happy with the new pictures that you have from me, as well as Bathers.[8]

In response, Shchukin confirmed his pleasure in (and implicit acquisition of) the painting and then inquired about progress made on other works he had ordered.

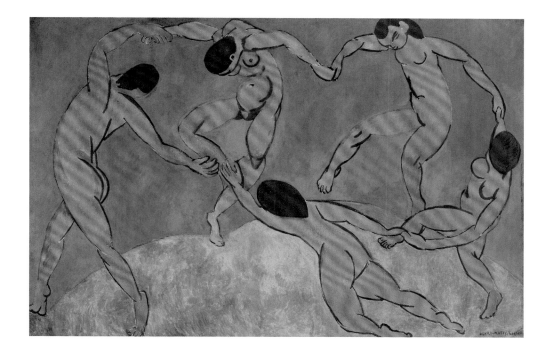

fig. 1
Dance (II), summer–fall 1910
Oil on canvas
260 × 391 cm (102 3/8 × 154 5/16 in.)
The State Hermitage Museum,
St. Petersburg, 9673

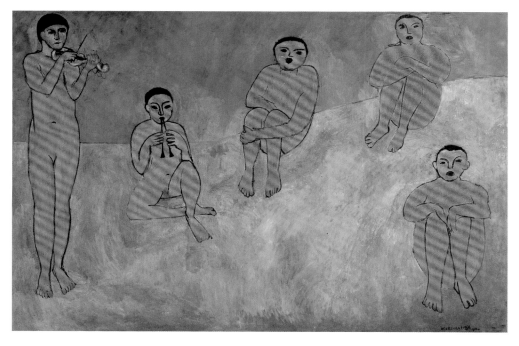

fig. 2
Music, winter–fall 1910
Oil on canvas
260 × 389 cm (102 3/8 × 153 1/8 in.)
The State Hermitage Museum,
St. Petersburg, 9674

fig.3
Path in the Bois de Boulogne, 1902
Oil on canvas
63 × 80 cm (24 13/16 × 31 1/2 in.)
The State Pushkin Museum
of Fine Arts, Moscow, 3300

Although Matisse made—and Shchukin purchased—additional paintings in summer and fall 1908, this Arcadian composition clearly spurred both artist and collector: by the end of the year, Matisse proposed a related picture that would eventually become *Nymph and Satyr* (fig. 4) to Félix Fénéon, and Shchukin purchased it in January, a full month before its completion. Together, the canvases would undoubtedly influence the subject matter for the *Dance* and *Music* commission, though records specifically documenting the introduction of the project have yet to be located. Based on the 1908 correspondence, however, we can assume that it too began in the same organic manner as other works of that time, especially given the seed that Matisse planted by referring to *Game of Bowls* as an *esquisse*.

What is certain, as detailed in the entries that follow, is that Matisse and Shchukin met in his studio at the end of February 1909 and discussed the commission. Before the meeting—whether to introduce the idea to the collector or to begin to explore it for himself—Matisse stretched a canvas larger than any he had yet painted and started to lay in the outlines of a composition. After the visit, archival records make it clear that a commission for decorative panels for the staircase of Shchukin's Moscow home was firmly in place, although the exact subjects and number of panels ordered would be a matter of discussion for weeks to come (see p. 89). The eventual result of this discussion, which was carried on in letters between the artist and patron, would be *Dance (II)* and *Music*. The nature of their relationship and ways of working, as well as the method of their correspondence, left a degree of uncertainty about the exact subjects and size of the commission until April 9, when it became clear that the canvas known today as *Bathers by a River* would not be part of the project.

Earlier, on March 11, Matisse reported to Shchukin that the *esquisse* for the first subject of the commission, known today as *Dance (I)* (figs. 5–6), was complete: "The canvas that you saw without color [*blanche*] is finished and will remain the *esquisse* of the painting I'm about to undertake."[9] His description suggests that the collector had seen the composition as an *ébauche*, or the first stage of blocking in a painting with a light contour sketch, the same way the artist would initiate *Bathers by a River* just a short time later (5n). When it was finished, according to Matisse, the canvas engendered a great deal of interest from potential buyers: "Many people greatly like the *esquisse* (of 4m) and I've had two offers to sell it." This was not surprising. The themes of Arcadian existence and pleasurable pursuits (such as dancing, music making, and relaxing in nature) were ones that Matisse had successfully considered many times previously, most particularly in his first large-scale paintings of *Luxe, calme, et volupté* (p. 47, fig. 8) and *Le bonheur de vivre* (p. 49, fig. 12)—indeed, his frolicking weightless female dancers are nearly the same as the figural group in the background of the latter canvas, though reduced in number.[10] Here, at nearly four meters in length, the canvas gave Matisse the opportunity to synthesize his evolving interest in a language of harmonious color, delicate paint application and surface, energetic and organic arabesques, and flat, overall design—formal qualities celebrated in Art Nouveau (fig. 7)—and combine this with the tradition of painted *décorations*, pictures of historical or mythical subjects intended to evoke tranquility and uplift.[11] The decorative paintings popularized by Bonnard and Denis (figs. 8–9)—and commissioned by Morosov—often focused on a classical form of myth that merged the French Mediterranean with the ideals of harmony, balance, and purity. Matisse mindfully drew upon these connections for his *esquisse* and would do so again in the summer of 1909, when he traveled to Cavalière-Sur-Mer to make easel paintings (7–8) and drawings in preparation for the work ahead. By going to the Midi, he made clear his intention to locate Shchukin's entire decorative program (*Dance* and *Music*, as well as the rejected *Bathers*) within this mythical, pastoral paradise and to satisfy the contemporary taste for *décoration*. Furthermore, the artist identified the palettes of these works—like that of the *esquisse* for *Dance*—with the sun, sea, and pines of the mythic south. In fact, when he shared his summer paintings with his friends, the artist Georgette Agutte and her husband, Socialist politician and writer Marcel Sembat, back in Paris, he explained, "I wanted to convey my total impression of the Midi."[12]

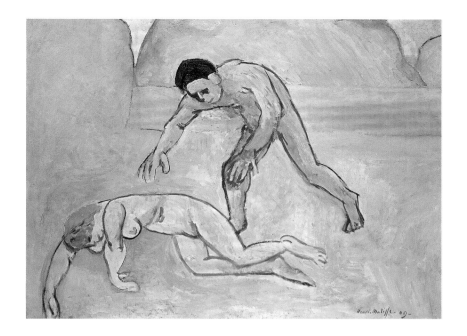

fig. 4
Nymph and Satyr,
November 1908–
early February 1909
Oil on canvas
89 × 116.5 cm (35 1/16 × 45 7/8 in.)
The State Hermitage Museum,
St. Petersburg, inv. no. 9053

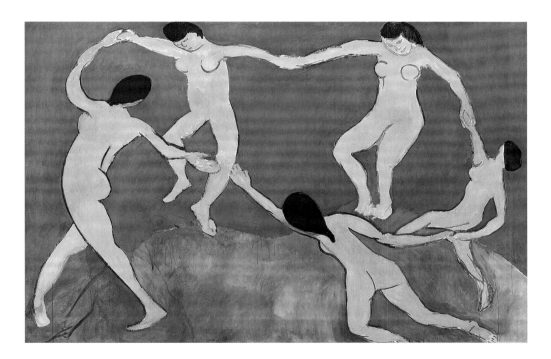

fig. 5
Dance (I) (Dance [Esquisse]),
February–March 1909
Oil on canvas
259.7 × 390.1 cm (102 1/2 × 153 1/2 in.)
The Museum of Modern Art, New
York, gift of Nelson A. Rockefeller
in honor of Alfred H. Barr, Jr., 1963

fig. 6
Composition No. I,
c. March 11, 1909
Watercolor on paper
21.9 × 32 cm (8 5/8 × 12 1/2 in.)
The State Pushkin Museum of
Fine Arts, Moscow, 10449
In exhibition

Soon after Matisse's return, he received a letter from his patron, thanking him for news of his summer preparations and mentioning that he hoped to come to Paris for the Salon d'Automne. "My *décorations* 'Dance' and 'Music,'" Shchukin wrote, "interest me very much. I am sure that this will be a big victory."[13] Shchukin's expectations were clearly high, as were the artist's, and soon after he settled into his new studio in Issy-les-Moulineaux around September 27, he started on the commissioned panels.[14] Back in March, Matisse had told his patron that he would use the *esquisse* (*Dance [I]*) and "a new canvas to execute this painting."[15] Now the artist set to work transferring the composition to a new canvas, although the exact method he used cannot be determined at this time.[16] A photograph taken by Henri Manuel, who visited the artist in the fall (fig. 12), shows him at work on a composition that is either *Dance (I)* or an early version of the new canvas, known today as *Dance (II)*, looking very much like the earlier *esquisse*.[17] In the late fall, Matisse shared a photograph of *Dance (II)* with the art historian Bernard Berenson, who responded enthusiastically: "Today I received the photography of your 'Dance.' How good of you to send it to me! The composition charms me and I fix my eyes on the empty spaces and feel the rhythm all through my body. . . . I have no fear for you for I believe that you are entirely in possession of yourself."[18] *Dance (I)*, or even this first state of *Dance (II),* also appears in *Still Life with "Dance"* (10d), which Matisse may have envisioned as a proud proclamation of the hard work underway.[19]

Work on *Music* would prove a more demanding process. As far as we know, Matisse did not produce a compositional drawing or *esquisse* for the panel. Instead, he may have started from an earlier painting made in Collioure during the summer of 1907 and exhibited in the Salon d'Automne as *Music (Esquisse)* (fig. 10). There we see a standing violinist and seated figure in a similarly generalized landscape, although the female dancers would be excluded from the panel.[20] He also developed figures for the composition in Cavalière-Sur-Mer (fig. 11). The first record of Matisse's work on a canvas can be found in a fascinating photograph taken by Druet (fig. 13) that has traditionally been dated to 1909–10. This is assumed to have been taken during a season when foliage is on trees, which we can see at the top of the image, through the window above the canvas.[21] While we do not have the photograph of *Dance (II)* that Matisse sent to Berenson, it was likely taken by Druet, since Matisse regularly hired him to record his works in process and at completion.[22] If this is true in this case, both works might have been documented together around the middle of November. Regardless of date, the photograph shows us Matisse's earliest thinking for the composition of *Music*: we see four male musicians atop a rolling hill: the one on the left plays a flute, the next blows a double-pipe, and three open their mouths in song. This, too, is recorded as the beginning of the *ébauche* stage, with the figures starting to be distinguished by heavy patches of shading laid in behind them. Compared to the figures in *Dance (I)*, the musicians are far more weighted and solid, each nestled into the surrounding earth.

Another photograph of *Music* taken by Druet (fig. 14) probably dates from some time in the early spring.[23] Here we see that Matisse adjusted the composition, moving the flutist and the two singers in the upper half of the canvas up and to the right; he has also made their poses more tense and rigid. In striking ways, he advanced *Music* beyond *Dance (II)*: we see narrative details (flowers, plant forms, and a sleeping dog) that are altogether absent in the companion panel, as well as a roughened, "primitivizing" description of the figures that is reminiscent of contemporaneous Expressionist prints and paintings of the Brücke group in Germany (fig. 15). Druet's photograph also shows us the many compositional adjustments already visible below the densely painted surface. It is worth noting, too, the many points of overlap between the states of *Music* and *Bathers by a River* (10), suggesting that the bathers composition was still in process at this time.

At the end of March, Georgette Agutte, who, with Marcel Sembat, had purchased one of the Cavalière paintings, visited Matisse's studio and saw *Music*, probably in a state close to what Druet recorded in his second photograph. Her thoughts, written to the artist while he was on break in Collioure, deserve note as a record of the progress of his work:

fig. 7
Félix Vallotton (French, born Switzerland, 1865–1925)
Three Bathers, 1894
Woodcut on paper
Composition: 18.2 × 11.2 cm
(7 3/16 × 4 7/16 in.);
sheet: 24.9 × 16 cm
(9 13/16 × 6 5/16 in.)
The Museum of Modern Art, New York, gift of Heinz Berggruen, 1951

fig. 8
Pierre Bonnard (French, 1867–1947)
Water Game (*Voyage*), 1906–10
Oil on canvas (part of a decorative ensemble for the dining room of Misia Natanson Edwards)
250 × 300 cm (96 1/8 × 118 1/8 in.)
Musée d'Orsay, Paris, RF 1996 18

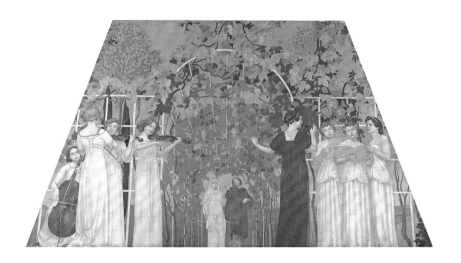

fig. 9
Maurice Denis (French, 1870–1943)
Cantata, 1910
Oil on canvas
218 × 362 cm (85 7/8 × 142 1/2 in.)
Petit Palais, Musée des Beaux-Arts de la Ville de Paris, inv. 3740

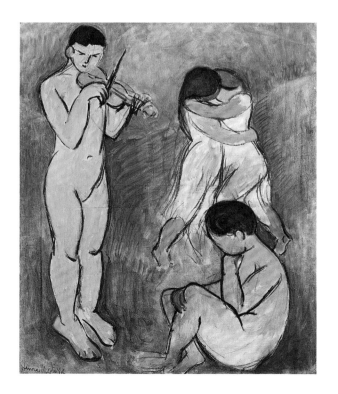

fig. 10
Music (Sketch), summer 1907
Oil and charcoal on canvas
73.4 × 60.8 cm (29 × 24 in.)
The Museum of Modern Art, New York, gift of A. Conger Goodyear in honor of Alfred H. Barr, Jr., 1962

fig. 11
Pipers, c. 1909–10
Pencil and ink on paper
29.6 × 24.4 cm (11 11/16 × 9 5/8 in.)
Private collection

I went to your place in Clamart Wednesday . . . I was able to see the beautiful third *esquisse*, of musicians. I like it very much, the sitting figure who is playing two flutes I think and who is seated in the middle and is the most ambitious, seems to me superb in its line and I like the intensity of the flesh tones, but will that not force you to stress the intensity of the flesh tones of the dancers if the panels are placed side by side? I nevertheless would regret to see the range [of color] in the first large *esquisse* transformed, it is so beautiful as it is. The whole of this third panel is very beautiful, I am certain that Marcel will be very taken with it.[24]

His friend touched on what would start to become a growing problem for Matisse with *Dance (II)* and *Music*, namely how to keep the compositions and their intensity of color, form, energy, and mood at a point that would satisfy both the expectation of *décoration* and his own imperative, published in "Notes of a Painter," concerning expression. Visitors to his studio at this time would recall the artist's near-obsession with the painting. The collector Leo Stein wrote years later:

Once Matisse was working on a picture . . . in a position like that which it was to have in a palace in Moscow. Matisse and I were sitting below, talking, while his mind ran partly on the picture. Several times he mounted the ladder and slashed at the picture with big brushes, making big changes in it. Once, after a long pause and some silent meditation, he climbed the ladder and altered the line on the neck of one of the figures, flattening just a little bit a line a couple of inches long. When he came down, I said, "I've understood everything you did before this last change, but I don't see the point of that." He replied, "I'm not surprised, because I've decided to change entirely the orientation of the figures."[25]

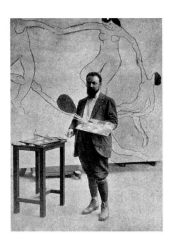

fig. 12
Henri Manuel, "Henri Matisse working on *Dance*," fall 1909. Published in Roland Dorgelès, "Le prince des Fauves," *Fantasio* (Dec. 1, 1910), p. 299.

fig. 13
Music, in process, late fall 1909, photograph by Eugène Druet.

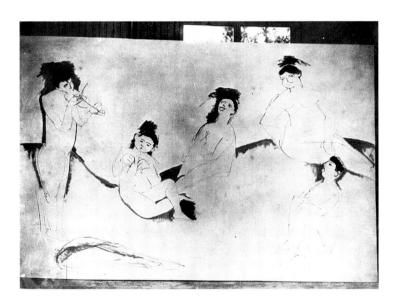

fig. 14
Music, in process, spring 1910, photograph by Eugène Druet.

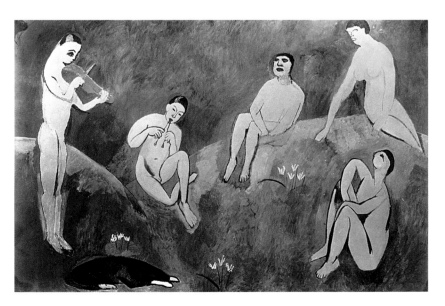

Hans Purrmann recounted a moment soon after Matisse had yet again altered *Music* from the state recorded in Druet's second photograph:

He kept rearranging the limbs of the . . . figures represented, and manipulated the entire group as though it were one single figure. . . . If he deranged only one line in an arm, the whole fell into disorder and the balance had to be restored at some other place. But Matisse complained to me at this, "Notice that large green mound the figures are sitting on; I should have loved to paint flowers in there but I can't manage them. They would have no organic meaning to me, they do not apply; and painful as it is, I must renounce them!"[26]

Purrmann also described a visit by Bonnard, who inquired about the uniform and likely intensifying color of the figures, which he felt was too far from nature. Matisse, according to Purrmann, justified his choice by explaining, "I know that the sky throws a blue reflection on an object, and that a meadow throws a green one, but why all these dreadful complications? It adds nothing to my picture and interferes with my expression."

By the end of May, the artist had almost completed his initial work on *Music* but confided to his old friend and fellow artist Jean Biette that it had been "an immense effort, which has exhausted me, so much so that I'm feeling a bit drained and could use a month's rest, which I can't take."[27] Still, he felt confident enough in the composition to send Druet's now outdated photograph to Shchukin at the end of May, noting that the composition was still changing: "It is a pity that you cannot see the harmony of color, which is very complete and will surely be to your taste. Several days ago I abandoned the panel in order to attack *Dance*. . . . After this panel I shall, of course, take up *Music* again . . . I think you will be completely satisfied . . . this work occupied me much of this winter and will take me almost all the summer."[28]

Work on *Dance (II)* proceeded quickly. In a matter of weeks, Matisse had begun to transform the palette of the canvas from that of the *esquisse* to something in line with *Music* and then moved beyond it to even more intense red, blue, and green.[29] For some, it was a shock. On June 6, the critics Henry McBride and Roger Fry and the artist Bryson Burroughs visited the studio and were surprised to see the state of the canvas. "There was great uncertainty in my mind," McBride wrote two days later, "whether the huge canvas, 12 ft. by 14 ft., with dancing figures, life size, painted on flat brick red, against a flat chrome green hill, and a flat cobalt sky, was meant as a joke or as a serious attempt at something beautiful."[30] Despite this reaction, Matisse was undeterred. Earlier in his relationship with Shchukin, during the summer of 1908, he had faced a similar, potentially major reworking of another, smaller decorative panel, *Harmony in Red (The Red Room)* (fig. 17), which was ordered as a pendant to a group of paintings by Gauguin that hung in Shchukin's dining room.[31] The artist had initially painted the canvas in a palette of overall blues, likely wanting to complement the Gauguin works, but after studying the painting, he decided to dramatically revise his initial plan and paint the whole over in brilliant red. The artist had been confident in that decision, in spite of the positive responses to the blue composition from Vollard and Druet, who even offered to photograph it in color at his own expense. Matisse enthusiastically sent the color print (fig. 16) to Shchukin at the same time that he announced his revisions.[32] The successful acceptance of *Harmony in Red* in 1908 contributed to the commission of *Dance (II)* and *Music* the following year.

As the summer of 1910 progressed, Matisse might well have wondered if he would finish the panels in time for the Salon d'Automne. In July the surface of *Dance (II)* became less uniform, revealing instead the flat, repetitive marks of the artist's brush as he reworked the palette and activated the broad expanses of intensifying color. The dancers, too, became more energized, with greater articulation of musculature and a solidity far removed from the insubstantial figures of *Dance (I)*. These changes forced the artist to rework *Music* yet again. In addition to dramatically altering the palette to fully meet *Dance (II)*, Matisse would change the composition. He radically revised the poses of the figures, turning each away from the other to face the viewer, their forms now closed off and compact. Here, too, Matisse

fig. 15
Ernst Ludwig Kirchner
(German, 1880–1938)
Bathers Throwing Reeds, 1909
Color woodcut
Composition: 20.2 × 29.3 cm
(7 15/16 × 11 9/16 in.); sheet:
40.3 × 54 cm (15 7/8 × 21 1/4 in.)
The Museum of Modern Art,
New York, Riva Castleman
Endowment Fund, The Philip
and Lynn Straus Foundation
Fund, Frances Keech Fund, and
by exchange: Nina and Gordon
Bunshaft Bequest, gift of
James Thrall Soby, Anonymous,
J. B. Neumann, and Victor S.
Riesenfeld, Lillie P. Bliss
Collection, and Abby Aldrich
Rockefeller Fund, 1997

activated the surface with the repeated adjustments of figures and color, as well as the many former positions of the musicians that are still visible from below.

In early September, the artist registered *Dance* and *Music* as entries for the upcoming Salon, each as a *panneau décoratif*, though, with little time before the opening, he was still apparently working on the panels.[33] Late in September, he wrote again to Biette, updating him on his work and his late-stage revisions: "I told you that I myself was sorely tried by my *décorations*, which I had the stupidity (perhaps) to return to once they were finished, believing I had to do better. The Salon opens the 29th. I feel tired and preoccupied by how close the deadline is. So much so that I cannot sleep which hardly puts me in good form the next day."[34] By the time Matisse finished, he was exhausted by the physical demands of completing both large-scale works and confided to Agutte weeks later that he did not have "the courage to go to vernissage." He left Paris and by October 3 was in Munich for a major exhibition of Islamic art with Albert Marquet and Purrmann, and would not return until October 14, the day before his father died in Bohain-en-Vermandois, which took him away from Paris again.

Matisse was grateful for the distractions, since he was aware that the two works that had occupied the majority of his attention for so long and had required so much physical work, particularly over the summer, had not met with overwhelming acceptance at the Salon but had instead become the subject of immediate derision and scorn. Critics described his figures as "crayfish-men . . . frolicking among spinach" painted with a "brutality" of "ferocious blue . . . no less violent green" and as "red beings moving about agitatedly: it's apparently a bacchanal of flayed or sinister puppets."[35] The canvases were parodied as uncivilized offenses to beauty and examples of the effects of alcohol (figs. 18–19). Worse, they were identified as "simplification carried to its extreme limits" and a heartless "wallpaper image . . . deliberately established with the aid of science, but no charm."[36] The problem seemed to lie in the exact border Matisse had already been aware of crossing—the point between the requirements of traditional decorative painting and his own for composition, line, and color to be in the service of expression. In a Salon dominated by an overwhelming number of decorative paintings—Denis's grand-scale *Cantata*, for example, was among the works exhibited and praised by critics—and many more easel pictures on the themes of dance, music, and other idyllic pastimes, Matisse's monumental paintings boldly trod the limits of acceptability. As Henri Pellier wrote:

The shock that one receives is not precisely in the order of artistic emotions. The organizers no doubt wanted it like that to accustom the eye at a single stroke to the brutalities of form and color that it would be likely to encounter. . . . All of that is dominated by two enormous compositions by M. Henri-Matisse that call themselves decorative panels representing Dance and Music . . . so far removed from all we have considered for centuries as the beauty of line and the harmony of color . . . M. Maurice Denis . . . also wanted to represent Dance and Music. Well! If one compares this with the work by M. Henri-Matisse, one will see which side grace and harmony are on, which side knowledge of color and charm of composition. . . . In our opinion, it is impossible to admire at the same time both the compositions of M. Maurice Denis and the fantasies of M. Henri-Matisse.[37]

Charles Morice put it most directly, "He dares to describe as 'decorative,' and which he entitles Dance and Music. It is not even folly. It is no longer anything appreciable, no longer anything with regard to which one could speak of Painting, nor of Music, nor of Dance . . . it is nothing."[38] The only critic who stood in praise of Matisse was Apollinaire, whom the artist disliked for his enthusiastic praise of Denis at the Salon in addition to that of his own works.[39]

Matisse and Shchukin would not meet to look at the panels together until the end of October, and the committed patron hesitated in his acceptance of them, considering first—at Bernheim-Jeune's urging—a decoration by Puvis that his dealers presented in Matisse's studio after he left for Spain. En route back to Moscow,

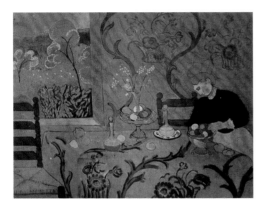

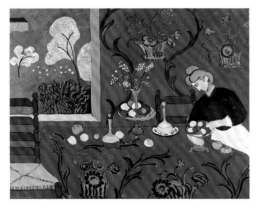

fig. 16
Harmony in Red, in process, July 6, 1908, photograph by Eugène Druet.

fig. 17
Harmony in Red (The Red Room), spring–August 1908
Oil on canvas
180 × 220 cm (70 7/8 × 86 5/8 in.)
The State Hermitage Museum, St. Petersburg, 9660

Shchukin regretted his decision and upon his return sent a full apology to the artist, even requesting new paintings. On November 11, he wrote:

Dear Sir! During the trip (two days and two nights), I reflected a lot and I am ashamed of my weakness and of my lack of courage. It is not necessary to abandon the battlefield without endeavoring to fight. For this reason, I am resolved to exhibit your panels. There will be shouts, there will be laughter, but as it is my conviction that your way is just, perhaps time will be my ally and in the end the victory will be mine.[40]

Shchukin would take some time to come to appreciate the true importance of the panels. Matisse needed even more to move beyond the reactions of colleagues and critics, and the problems caused by his dealers, although his feelings about his patron were strengthened and confirmed by the ordeal.[41] Still in Spain in January 1911, he wrote to Biette:

I myself had been so upset about my *décorations* since the fall Salon that I no longer knew what I was doing. It seemed to me that the sun would do me good, someone suggested that I come here and I left. But I did not leave my worries in Paris completely. I needed several days here to calm down; two weeks after my trip to Spain, I developed complete insomnia (I slept one or two hours a night), which made me very irritable. That lasted until barely a week ago. . . . My fatigue came from that last effort I made to finish the two large panels and to finish them in full consciousness. You know that I've had them in my head for 2 years, and as they were commissioned, I needed to finish them. Then I had to move heaven and earth to give them their final expression. (I managed to do so.) The commission is more a horrible than a desirable thing for certain temperaments. When you accept one, you must do it—and I myself would have felt disgraced if I had broken down. At last it is finished and in place. The customer is happy, but what rage from almost everyone, critics and colleagues alike. Maybe I'd be left in peace if these panels had not been bought for Russia; but as this country is regarded as full of excellent buyers, it is feared that these panels and my paintings in general will divert or check a part of the Gold Mine coming to France. Then I wonder if these panels are really important enough to motivate all this aggression, by which I am still astonished and perhaps will not always be able to bear. I feel unwilling to do new pictures to explain the preceding ones, I have never done it, but [want] to do canvases that capture my emotions of the moment. I therefore find my independence under attack and I do not believe I can work fruitfully in the greatest liberty.[42]

It would be more than two years before Matisse would return to the remaining canvas connected to the commission, his now-abandoned bathers composition.

Others took away different lessons from the experience: Picasso, who likely knew the works from his visits to Matisse's studio, would, according to John Richardson, react with envy.[43] He himself had recently formalized a commission to decorate the library of American painter, critic, and collector Hamilton Easter Field—a job no doubt accepted in a spirit of competition with Matisse (and to gain Shchukin's attention as well). Picasso's commission would require him to make fourteen 185-centimeter-tall paintings, nine narrow verticals, and five horizontals as much as 300 centimeters wide. He had struggled over the summer of 1910 to complete just one single painting for Field (fig. 20), recognizing in Cubism a fundamental dilemma: the scale and working method that he and Braque had invented

fig. 18
"This year, at the Salon d'Automne, woman triumphs in all her beauty." Published in *Paris-journal* (Oct. 1, 1910), p. 1.

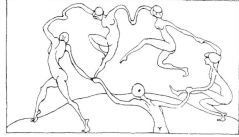

HENRI MATISSE : *Avant.*
(Deux affiches pour vin constituant).
HENRI MATISSE : *Après.*

fig. 19
"Henri Matisse: Before—Henri Matisse: After." Published in *La vie parisienne* 48, 41 (Oct. 8, 1910), p. 742.

fig. 20
Pablo Picasso
(Spanish, 1881–1973)
Nude Woman, summer 1910
Oil on canvas
187.3 × 61 cm (73³/₄ × 24 in.)
National Gallery of Art,
Washington, D.C., Alisa Mellon
Bruce Fund, 1972.46.1

was inimical to large compositions. Seeing *Dance (II)* and *Music*, Picasso must also have realized that the dimensions of Matisse's canvases were not only affirmed by their vast areas of fierce color but also multifigure, quasi-narrative subject— something he and Braque had earlier abandoned in their development of Cubism. Just a year later, with this lesson in mind, Picasso would attempt the largest of the panels ordered, choosing as his subject "a stream in the middle of town with some girls swimming." We must wonder whether he had heard about—even seen—the large bathers composition that still remained unfinished in Matisse's studio at the end of his two-year-long effort on the Shchukin commission. As we shall see, Matisse would look to Picasso when he finally resumed his monumental painting in 1913. In the fall of 1910, however, the two artists could hardly have been further apart.

—STEPHANIE D'ALESSANDRO

1. For more information on the Steins, see Museum of Modern Art 1970; on Morosov, see Monrad 1999; on Osthaus, see Stein 1998. One could also include André Level, who through his syndicate of collectors known as the Peau de l'Ours, started to acquire the artist's canvases in 1904. By the time of the collection's sale in 1914, he had purchased ten works by Matisse. This is a slightly different case, however, since these works were acquired with the intention of being sold. The description of Morosov is Matisse's; Tériade 1952, p. 47.

2. Among the highlights of Shchukin's collection were sixteen works by Gauguin, a number of which were installed together in his dining room. For more on Shchukin, see Kean 1983; Kostenevich and Semyonova 1993; Monrad 1999; and Kostenevich, "Russian Clients of Ambroise Vollard," in Rabinow 2006, pp. 243–56.

3. Tériade 1952, p. 49.

4. For more on Matisse's Moroccan works, see Cowart 1990. Two additional works, *Woman on a High Stool* (25) and *Interior with Goldfish* (24) were reserved for Shchukin, but the arrival of the war meant that the agreement was not formalized and the works were not delivered to his collection. See John Klein, "Objects of Desire and Irresistible Forces: Matisse between Patrons, Collectors, and War," in Monrad 1999, pp. 11–23.

5. For more on Osthaus's acquisition, see the discussion of *Bathers with a Turtle* (3) in this publication as well as Stein 1998 and Labrusse and Munck 2005.

6. Shchukin to Matisse, June 2, 1908, AHM.

7. During summer 1908 and winter 1909, Shchukin acquired at least five other paintings from Matisse, which featured still-life and figure subjects.

8. Matisse to Shchukin, draft letter, July 6, 1908, AHM.

9. Matisse to Shchukin, Mar. 11, 1909, AHM. On Mar. 12, Matisse sent a watercolor of the completed canvas (p. 79, fig. 6) to update Shchukin on his thoughts for the commission; see entry 5 in this publication.

10. Much has been made of the potential origin of Matisse's composition in the history of art, tracing the subject to such works as Greek red-figure pottery and the paintings of Andrea Mantegna, Nicolas Poussin, and Pierre Puvis de Chavannes. In addition, Matisse's interest in the folk dances of the *farandole* and *sardagne* has been mentioned. The literature on this subject is vast: see Barr 1951, Neff 1974, Elderfield 1978, and Flam 1986. For more recent studies on the currency of Arcadian themes in modern times, see James Herbert, *Fauve Painting: The Making of Cultural Politics* (Yale University Press, 1992); Kenneth Silver, "New Spirits and Sacred Springs: Modern Art in France at the Turn of the Century," in *Voyage into Myth: French Painting from Gauguin to Matisse from the Hermitage Museum*, pp. 17–43 (Museum of Fine Arts, Montreal/Art Gallery of Ontario, 2002); Werth 2002; and Wright 2004.

11. For more on the fascinating history of *décoration* as it pertains to late-nineteenth- and twentieth-century

France, see Nancy Troy, *Modernism and the Decorative Arts in France: Art Nouveau to Le Corbusier* (Yale University Press, 1991); and Groom 2001.

12. Sembat 1913, p. 191. Years later, Matisse would also recall the experience in a series of letters to the Russian critic Alexander Romm; see Alpatov 1969, pp. 130–34.

13. Shchukin to Matisse, Sept. 3, 1909, AHM.

14. According to Wanda de Guébriant, the new atelier was in place by this date. It was constructed by the Compagnie des Constructions Démontables et Hygièniques, Paris.

15. Matisse to Shchukin (n. 9).

16. Detailed technical examinations of *Dance (II)* and *Music* were not possible for this study, given their fragile states. Based on Matisse's method of transfer for the large-scale composition *Le luxe*, we might consider whether a similar solution was employed and the transfer medium wiped off before painting. Given his changing techniques at this same time, however, we cannot be certain without further study.

17. This photograph has traditionally been thought to be by Edward Steichen, but it is identified in Roland Dorgelès, "Le prince des Fauves," *Fantasio* (Dec. 1, 1910), p. 299, as "Henri Matisse working on Dance, P(hoto) Manuel." The Manuel Frères was a well-known photography company at the turn of the last century. Henri Manuel also photographed a number of Matisse's friends and colleagues, including Auguste Rodin, Georgette Agutte, and Marcel Sembat.

18. Berenson to Matisse, Dec. 9, 1909, AHM.

19. It is worth noting that this painting would be acquired in the spring of 1910 by Shchukin's rival, Morosov.

20. Matisse would later tell Alfred Barr, Jr., that he made the painting in Collioure without thought of a decoration; see Barr Questionnaire V. For more on the painting, see Elderfield 1978, pp. 52–54.

21. One of these remarkable photographs (the second state of *Music*) was first published in Sembat 1920; the first state of *Music* appeared in Barr 1951.

22. In fall 1910, the writer Felius Elies visited Matisse's studio; his impressions would later be published in 1919 under the pen name "J. Sacs" in the Catalan publication *Vell i nou*. Most fascinating for this discussion is his description of Matisse showing him photographs from Druet that illustrated "the process of several of his works" that "transformed progressively by means of successive omissions and deformations"; Sacs 1919, p. 403. A full exploration of Matisse's early use of photographs and interest in documenting the progress of his work is still yet to be undertaken.

23. In 1920 this photograph was published in Sembat's monograph *Henri Matisse*, among reproductions of artworks as *La musique (Premier état)*, which was mistakenly dated 1911.

24. Agutte to Matisse, Apr. 2, 1910, AHM. It is worth noting that Agutte used the term *esquisse* for the

5n

5f
X-radiograph of *Bathers by a River* with a diagram of the first state, showing locations of cross sections.

5g
Cross section showing the lower and middle pinks and turquoise of the waterfall. The ground layer is not present in this sample. Original magnification: 500x [x888].

5h
Cross section of the light yellow-green foliage of the background. (The light yellow-green layer—second from the bottom—is directly over the ground layer.) Original magnification: 200x [x882].

5i
Cross section with the tan riverbed (light brown layer directly above the white ground). Original magnification: 200x [x1055].

5j
Cross section of the bright yellow snake, with distinctive splintery black particles present above the white ground layer. Original magnification: 200x [x1061].

5k
Cross section of the warm pink head of the bather directly above the white ground. Original magnification: 200x [x846].

5l
Cross section showing the medium yellow hair of the third figure, seen here in the bottom-most layer. Original magnification: 100x [x1114].

5m
Cross section of the blue sky painted directly above the white ground layer. Original magnification: 200x [x849].

5n
Matisse posing in front of a very early stage of *Bathers by a River*, c. March 25, 1909. Archives Henri Matisse, Paris.

crouching pose, its bent legs visible behind Matisse's elbow. At the edge of the knee, we also can make out sweeping lines that define the water's edge. While the author of the photograph is unknown, we should consider the possibility that it was taken at the time of Estienne's interview, perhaps for publication. Like other documents, it makes clear that *Bathers by a River* was not only part of Matisse's original concept for the Shchukin commission, but also was initiated well before the paintings that would finally go in Shchukin's staircase—*Dance (II)* and *Music* (p. 77, figs. 1–2), which the artist would not begin until the fall. Indeed, we can be certain that it was painted soon after *Dance (I)*, and the nearness of their dimensions corroborates this.

An X-radiograph of *Bathers by a River* reveals much of the early composition [**5**]. Matisse's subsequent adjustments and alterations have occluded some details, but on the left we can make out a standing bather turned from the viewer who bends with a raised arm. Her pose is reminiscent of the Osthaus ceramic as well as a drawing for the bas-relief *Back* [**4d**]. A second woman crouches in profile by the edge of the waterfall, while another is immersed in the stream, her back to the viewer; these figures look much like those in the previous *Bathers by a River* sketches. A fourth bather stands at right, lifting her arm over her downturned head and possibly holding a towel; the position of her head echoes that of the standing figure in *Game of Bowls*, and her torso and arms recall the contemporary *Nude with a White Scarf* [**6**]. Microscopic examination and cross-section analysis of precise locations [**5f**] have determined the original painting's palette, which was remarkably similar in color to the watercolor Matisse sent to Shchukin on March 12. The foliage was light green [**5h**], and the sky at the very top was a deep blue [**5m**]. Matisse painted the waterfall pink and turquoise [**5g**], and the riverbed was tan [**5i**]. He modeled the figures in a warm pink [**5k**]. Immersed in water, the third bather is distinguished from the others by her golden hair [**5l**], much like her counterparts in the preceding *Le luxe* and *Bathers with a Turtle* compositions. Departing from the watercolor, Matisse added a snake, which he initially painted yellow [**5j**], fairly early on in his creation of the painting.

Freed from his patron's demands, Matisse continued to work on the large composition, although likely keeping in mind the need to move it to his new studio by the summer. He completed his initial work in time to roll and transport the canvas in June but, as we shall see, his interest in the project continued over the summer, even while he was away from the painting itself.

1. See in particular the seminal works of Neff 1975; Flam 1986; Bock 1990; and Kostenevich 1990.

2. Barr Questionnaire VI. Barr noted the date of the commission differently.

3. Shchukin to Matisse, Mar. 6, 1909, AHM. Some important historical points should be noted when reviewing the Shchukin–Matisse correspondence. First, the Russian calendar differed from the Western calendar at this time by thirteen days. This study follows the French dates. According to Wanda de Guébriant, AHM, Shchukin often double-dated his correspondence to account for this difference, and every attempt has been made to confirm the dates of all existing letters and drafts noted here. In this case, Shchukin dated the letter *21 Fev/4 Mar*, mistaking the number of days in the month. The correct date in the French calendar would be Mar. 6. Second, Kostenevich and Semyonova 1993, p. 106, noted that at the time of the commission, letters sent from Russia took three to four days to arrive in Paris.

4. Matisse to Shchukin, draft letter, Mar. 11, 1909, AHM.

5. Flam 1986, p. 495 n. 22.

6. Matisse to Shchukin (n. 4).

7. No letter or draft can be found in the AHM; this information is inferred by Shchukin's letter of Mar. 16 thanking Matisse for the watercolors he sent on Mar. 12. While variations of the title *Bathers by a River* are documented in a number of photographic and archival records, nothing dating from Matisse's earliest work on the picture gives any indication of a title beyond the watercolor's, *Composition No. II*; thus, the present-day title has been retained in this discussion.

8. Shchukin to Matisse, Mar. 16, 1909, AHM.

9. Shchukin's unrelated letter was dated Mar. 19; if it was sent the same day, it would have arrived at Matisse's home about four days later (see Kostenevich and Semyonova 1993, pp. 103, 106). Thanks to Albert Kostenevich for bringing this invaluable document to the attention of the Art Institute.

10. Shchukin to Matisse, Mar. 27, 1909, AHM; Shchukin referred to Matisse's "letter of 23 March." See Kostenevich and Semyonova 1993, p. 164, for full text of the correspondence.

11. Shchukin to Matisse, telegram, Mar. 28, 1909, AHM.

12. Estienne 1909; the interview was published on Apr. 12 but likely took place before Mar. 28, the date on which Matisse's daughter, Marguerite, underwent a serious operation. In a letter dated Apr. 4 or 5, Matisse wrote to Albert Marquet that he missed the opening of the Salon due to Marguerite's condition. For more information on the potential date of the interview, see Neff 1974, p. 180 n. 164; and Flam 1986, p. 495 n. 24.

13. Shchukin to Matisse, Mar. 31, 1909, Pierre Matisse Gallery Archives, Department of Literary and Historical Manuscripts, MA5020, box 187, folder 15, Morgan Library and Museum. The telegram Shchukin mentioned is his from Mar. 28 (n. 11).

14. Matisse to Shchukin, draft letter, Apr. 9, 1909, AHM. The "idea in [Shchukin's] hands" is surely the watercolor *Composition No. II*. Thanks to Wanda de Guébriant for sharing this important document and confirming its date.

6 Nude with a White Scarf
Couvent du Sacré Coeur, Paris, c. March–May 1909

Oil on canvas; 116.5 × 89 cm (45⅞ × 35 in.)
Signed and dated l.r.: *Henri-Matisse 09-*
Statens Museum for Kunst, Copenhagen, KMSr81

IN EXHIBITION

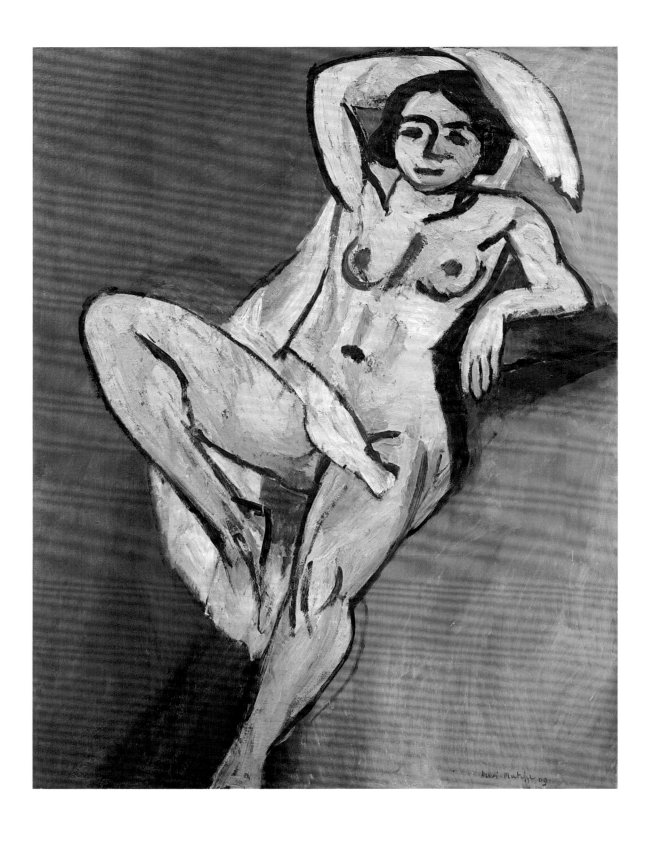

6a

6b

6a
Detail of the bather at far right in *Composition No. II* (5a), showing ink sketches of reclining, seated, and rising poses.

6b
Edmé Bouchardon (French, 1698–1762). *Sleeping Satyr* (copy of the Barberini Faun), 1726–30. Marble; 194 × 142 × 119 cm (76 1/4 × 55 2/3 × 46 2/3 in.). Musée du Louvre, Paris, M.R. 1921.

ACCORDING TO GALLERY records, Matisse sold *Nude with a White Scarf* [**6**] to Bernheim-Jeune on June 2, 1909.[1] Although he did not date the canvas itself, he most likely worked on it as he considered the decorative commission for Shchukin, beginning around mid-March 1909 and continuing through the end of May. Given its June date of acquisition, the work would have been among the last that Matisse completed in his Couvent du Sacré Coeur studio, just weeks before he departed for a summer painting trip to the southern coastal town of Cavalière.[2]

The connections between *Nude with a White Scarf* and the Shchukin commision — and the large bathers composition in particular — are more than chronological. The female model's pose is remarkably similar to one of three sketched for the figure on the far right of the watercolor *Composition No. II* [**6a**]. Related postures are especially familiar in Matisse's repertoire of bathing figures and can be traced from countless studio drawings to the momentous canvases *Le bonheur de vivre* (p. 49, fig. 12) and *Blue Nude (Memory of Biskra)* [**1.3**], and to the sculptures *Reclining Nude (I) (Aurore)* [**1.2**] and *Decorative Figure* [**4f–g**]. The modified recumbent pose can also be found in a number of works from which Matisse might have drawn inspiration, most especially the Barberini Faun, a copy of which had resided in the Musée du Louvre since 1892 [**6b**].[3] For the painting, he propped up the figure's body and raised her knee and foot to produce a more open, engaged effect than the watercolor.

The two works share similar backgrounds. In the watercolor, the bather poses on or in front of a gently sloped hill. In the oil, the setting is less specific, but it is traced in the gray-black line that curves down to the figure's left hip and then continues from her right foot to the bottom left of the canvas. The woman rests on her arm, hip, and raised foot, which is partially sketched with dry-brush contours and appears almost as if it has become submerged within—indeed, transformed into—the gauzy folds of her scarf. It is in the background that we can find a deeper connection between the oil and watercolor. In the former, there are hints of a deep blue color between the thick passages of white and red paint; these appear along with a number of related lighter tones, especially in the area surrounding the figure's raised foot [**6h**]. Two cross sections taken in the lower left of the painting confirm that there is indeed blue paint under some areas of red. However, Matisse may not have uniformly applied this as a distinct layer—he may even have painted over the blue while some of it was still wet, mixing it into the pink paint that appears under the top layer of red.[4] Nonetheless, the idea that he may have initially envisioned this nude as a related bather, perhaps with her

6c

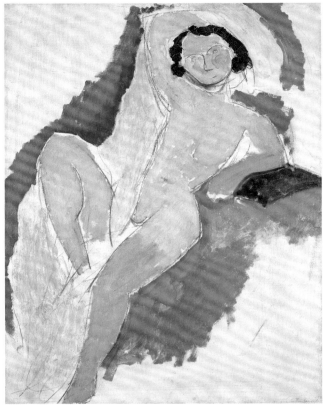

6d

6c
X-radiograph of *Nude with a White Scarf*, revealing the progressive changes to the figure, which began with a foreshortened left hand, a hunched shoulder, crossed legs, and a right arm and hand more tightly wrapped around the head.

6d
Seated Nude, c. 1909. Oil on canvas; 115.5 × 89 cm (45 9/16 × 35 in.). Courtesy of the Pierre and Tana Matisse Foundation, New York.

6e
Detail of *Nude with a White Scarf*, showing how Matisse built form by scraping down black paint on the top of the forearm.

6f
Detail showing the rhythmic brushwork that echoes a change in the contour of the figure's left shoulder and arm.

6g
Detail showing how Matisse built form by applying thick tracks of unmixed paint on the torso.

6h
Detail of the lower left, showing an earlier layer of blue paint below the white scarf and red background.

panels, though she might have been using the term less to identify sketches than the panels of a decorative ensemble. Her identification of *Music* as the "third panel" may suggest continued activity on *Bathers by a River*.

25. Stein 1947, p. 122.

26. Hans Purrmann, "Aus der Werkstatt Henri Matisses," *Kunst und Künstler* 20, 5 (Feb. 1922), p. 172. Matisse's comments on the renounced flowers must postdate Druet's photograph that includes tulips in the foreground. The following anecdote about Bonnard is also from Purrmann.

27. Matisse to Biette, n.d. [end of May 1910], AHM.

28. Matisse to Shchukin, n.d. [end of May 1910], AHM.

29. It is worth noting that one of the paintings Matisse made after receiving the commission, but before traveling to Cavalière for the summer, was *Nude with a White Scarf* (6), with its own intense red background, perhaps an early consideration of the palette that would later be chosen for *Dance (II)* and *Music*.

30. McBride to Otto, June 8, 1910, McBride Papers, Yale Collection of American Literature, Beinecke Rare Book and Manuscript Library, Yale University. Thanks to June Can, Beinecke Rare Books and Manuscript Library, for making this letter available.

31. Matisse would exhibit *Harmony in Red (The Red Room)* at the 1908 Salon d'Automne (no. 898) as *Panneau décoratif pour salle à manger*.

32. See correspondence between Matisse and Shchukin, July 6–Aug. 6, 1908, AHM. Of particular note is Druet's push to photograph the work in color at his own expense (July 6, 1908).

33. Matisse to Henri Manguin, postcard, Sept. 10, 1910, AHM.

34. Matisse to Biette, n.d. [in response to letter from Biette, dated Sept. 19, 1910], AHM.

35. "La potinière: Nos grands barbouilleurs," *Fantasio* 102 (Oct. 15, 1910), p. 214; André Fontinas, "Le Salon d'Automne," *L'Art moderne* (Oct. 15, 1910), pp. 329–30; Robert Lestrange, "Prenez garde à la peinture, s.v.p. Salon d'Automne," *Le tintamarre* (Oct. 16, 1910), p. 2; and Henri Pellier, "Le Salon d'Automne," *La petite république* (Sept. 30, 1910), p. 4.

36. Henri Bondou, "Le Salon d'Automne," *Gazette des beaux-arts* 3rd ser., 44, 641 (Nov. 1910), p. 370; Fontinas (note 35).

37. Pellier (note 35).

38. Charles Morice, "Art moderne—Le Salon d'Automne," *Mercure de France* 321 (Nov. 1, 1910), pp. 155–56.

39. Apollinaire's reviews can be found in "Vernissage d'automne," *L'Intransigeant* (Oct. 1, 1910), p. 1; and "Le Salon d'Automne," *Poésie* 6, 37–39 (Autumn 1910), p. 74.

40. Shchukin to Matisse, Nov. 11, 1910, AHM.

41. See Matisse's description of his first weeks in Spain in 1911 and thoughts about Shchukin in Courthion 1941, p. 106.

42. Matisse to Biette, Jan. 9, 1911, AHM.

43. For more on Picasso's reaction and his commission, see Richardson and McCully 1996, p. 170; and Elderfield's entry in Cowling 2002, pp. 142–43.

5 Bathers by a River, first state
Couvent du Sacré Coeur, Paris, March–May 1909

Oil on canvas; 260 × 392 cm (102 1/2 × 154 3/16 in.)

X-radiograph of *Bathers by a River* with a diagram showing the composition
of the first state of the painting.

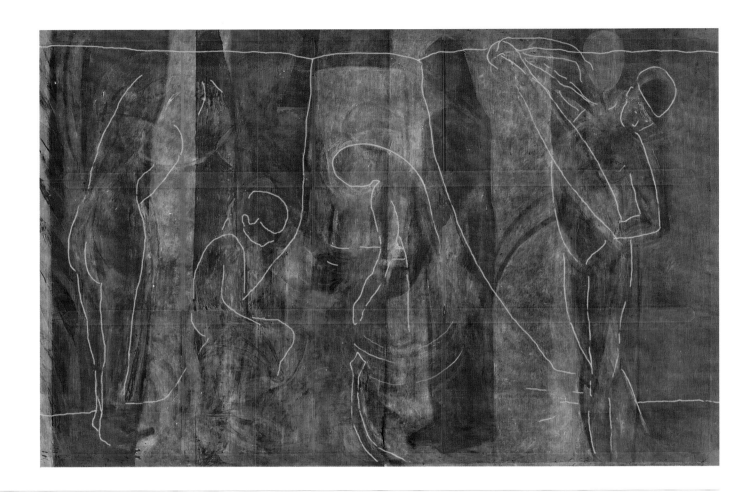

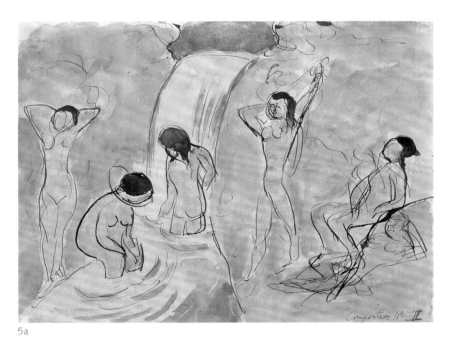

5a

5b

5a
Composition No. II, c. March 11, 1909. Watercolor
on paper; 21.9 × 29.5 cm (8 5/8 × 11 5/8 in.). The State
Pushkin Museum of Fine Arts, Moscow, 10308.
In exhibition.

5b
Drawing on verso of letter, c. March 1909. Ink on
paper. Archives Henri Matisse, Paris.

THE EARLY HISTORY of Matisse's *Bathers by a River* is directly connected to Sergei Shchukin's 1909 commission of decorative panels for his Moscow home. Indeed, new research demonstrates that a composition devoted to the theme of bathers was central to the artist's original scheme. Given the amount and complexity of the commentary on this picture, a careful review of the history is necessary in order to understand the work's precise relationship to the commission.[1] Planning for the project began in at least early winter 1909, since we know that by the end of February, Shchukin visited the artist in his Couvent du Sacré Coeur atelier. There he saw the beginnings of a work Matisse would later call *Dance (Esquisse)* (p. 79, fig. 5). According to Matisse's recollections, he and the collector discussed the commission afterward at the restaurant Larue.[2] On March 6, Shchukin wrote for more information about the work, which was likely drawn in but not colored during his visit: "I've been thinking a great deal of the large painting. Perhaps you could send a sketch [*croquis*] in color. It seems to me that it will be very beautiful ! and that I must take it. In any case, I trust you and I am sure that the large painting will be a beautiful *décoration* for my staircase."[3] A week later, the artist reported back that the "grand tableau" Shchukin saw in Paris was now fully underway: "This means that the canvas that you saw without color [*blanche*] is finished and will remain the *esquisse* of the painting I'm about to undertake. I'm very happy with it and that is why I'm using a new canvas to execute this painting. . . . Many people greatly like the *esquisse* (of 4 m) and I've had two offers to sell it; but I want to keep it for myself."[4] Along with the letter, Matisse apparently sent a drawing of the work, which he probably traced from a photograph of the painting taken by Druet.[5] The artist asked to confirm the number of works for Shchukin's home and suggested two or three subjects that would result in a feeling of absolute repose. He mentioned the second subject: "I made you a color sketch [*croquis*] indicating my idea for the second part to give you an idea of the atmosphere that could be created by the decorative ensemble of your staircase."[6] The following day, he sent along two watercolors of the panels, which he annotated *Composition No. I* (p. 79, fig. 6) and *Composition No. II* [**5a**], and it is here that we find the very first image of the design that eventually became *Bathers by a River*.[7] The image presents five women relaxing near a waterfall, nestled within a verdant, hilly landscape. Two bathe in the water, which Matisse described in blue with pink highlights, like that in *Luxe, calme, et volupté* (p. 47, fig. 8) and *Le bonheur de vivre* (p. 49, fig. 12). Initial ink lines that Matisse sketched but later abandoned allow us to trace his working thoughts for the figures,

whose poses recall those he used in earlier works. For example, the standing woman at left echoes the woman with flowers on the same side of *Le bonheur de vivre*; her crouching companion repeats those in *Music (Sketch)* (p. 81, fig. 10), *Game of Bowls* [**5c**], and the seated figure in *Bathers with a Turtle* [**3**]. To the right of the waterfall, the standing woman with an outstretched arm mimics one who lifts her hair in *Luxe, calme, et volupté*; and the reclining bather at right is related to a number of figures in *Le bonheur de vivre* as well as to the nymph in the now lost *Nymph and Faun* [**5d**] of early 1909. The figure standing in the water is a similar, although reversed, version of that in Cézanne's *Three Bathers* (p. 45, fig. 3), which Matisse owned.

The artist's watercolors would have arrived at Shchukin's home around March 16, and the collector immediately replied that while they were "very beautiful and very noble in color and in line,"

I cannot at present put a nude in my staircase. After the death of a relative, I took three little girls (8, 9, and 10 years old) into my household, and here in Russia . . . one simply cannot display nudes to little girls. Do the same *ronde* but with the young women in dresses. The same with composition no. 2. The staircase has two walls for the panels. . . . If I had no little girls in my house, I would have risked defying public opinion, but for now I have to respect Russian customs. Perhaps you will find a way of creating the same dance, but with girls in dresses? . . . I hope you will find a way of decorating my staircase with two large panels (of 4 meters) but without the *nudes*.[8]

It is important to note that Shchukin did not reject the subjects Matisse proposed. Probably around March 23, the artist responded to his patron's requested revisions on the reverse of one of Shchukin's unrelated letters.[9] On this page [**5b**], he redrafted the composition by dressing the two flanking figures in loose drapery, turning the woman in the stream fully away from the viewer and reducing the total number of bathers from five to four. We can infer from Shchukin's next letter of March 27 that Matisse sent a sketch of this revised composition, although the letter is not known to us today.[10] He responded, stating clearly, "For my staircase I need only two decorative panels. Only I wish to avoid nudes as a subject." In fact, he offered Matisse the opportunity to make the picture in a different format and for a more private area of his home. The next day, however, he telegrammed the artist: "Cancel all reservations expressed in my letters—request you give me priority for two panels on staircase—telegraph if accept firm order panel *La danse* for fifteen thousand—for second panel please do music as subject—write with price second panel."[11] That even near the end of the month the pair had not decisively agreed upon the panels' subjects is important to note for the genesis of *Bathers by a River*.

On March 25—after Matisse's revised proposal, yet before Shchukin's response—the

Salon des Indépendants opened. It was likely on this occasion that Charles Estienne interviewed Matisse for *Les nouvelles* as part of a series on modern art. In explaining his work, the artist proudly mentioned a commission "to decorate a staircase" and three subjects of dance, music, and repose (the bathing scene), which strongly suggests that he had not yet received Shchukin's most recent letter and telegram, or preferred to hope in some way that he would persuade his patron to follow his plan:

It has three floors. I imagine a visitor coming in from the outside. There is the first floor. One must summon up energy, give a feeling of lightness. My first panel represents the dance, that whirling round on top of the hill. On the second floor one is now within the house; in its silence I see a scene of music with engrossed participants; finally, the third floor is completely calm and I paint a scene of repose: some people reclining on the grass, chatting or daydreaming.[12]

On March 31, perceiving silence on Matisse's part, Shchukin wrote apologetically:

I find such nobility in your panel *Dance* that I have decided to ignore our bourgeois opinion and put a subject with nudes in my staircase. At the same time I shall need a second panel, where Music would be a good theme. I was very happy to have your response: firmly accept orders for dance panel fifteen thousand and music panel twelve thousand confidential price. I thank you very much and hope to have an *esquisse* of the second panel soon. In my house there is a great deal of music making (Bach, Beethoven, Mozart). The music panel should to some extent express the character of the house. I trust you completely, and am convinced that Music will be as successful as Dance. I ask you please to give me news of your work. All my reservations in the two preceding letters are canceled by my telegram last Sunday. Now you have my definitive order for the two panels.[13]

But while Matisse had envisioned panels on dance and music for Shchukin's staircase, he had also by this time become firmly committed to a bathers composition. Indeed, he responded on April 9, "[I] agree to the dance and music panels. At this moment, I am working on the composition for the panel of *esquisse* no. 2, you have in your hands the idea for it. I started it before your letter. Thus, I will finish it and then begin the composition of *Music*."[14] A photograph [**5n**] documents this early stage of the canvas: in it, we can see the artist seated in quarter profile, dressed in a smock and with a palette and brushes in hand; behind him, and looming large on the stretched canvas, is a loosely painted sketch for the bathers composition. At left we can see the ends of feet and the dynamic contours of a standing figure who turns her back to us; she swings one arm up and around her head, like the nymph in the left section of a ceramic triptych [**5e**] that Matisse made for Karl-Ernst Osthaus in 1907. Directly behind the artist's left shoulder, we can see a second figure, with its head in profile and a face somewhat similar to that of the standing bather in the *Luxe* compositions [**2.1–3**]. This bather assumes a

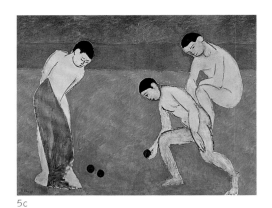

5c

5d

5c
Game of Bowls, spring 1908. Oil on canvas; 113.5 × 145 cm (44⅝ × 57⅛ in.). The State Hermitage Museum, St. Petersburg, 9154.

5d
Nymph and Faun, early 1909. Oil on canvas; dimensions and location unknown.

5e
The Osthaus Triptych, 1907. Painted ceramic; left to right: 58.5 × 39.5 cm (23 1/16 × 15 9/16 in.); 56.5 × 67 cm (22 1/4 × 26 3/8 in.); 57 × 38 cm (22 7/16 × 14 15/16 in.). Osthaus Museum, Hagen.

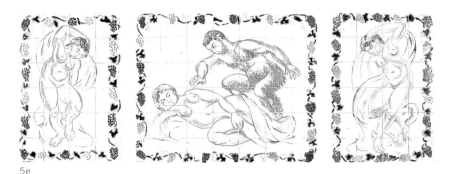

5e

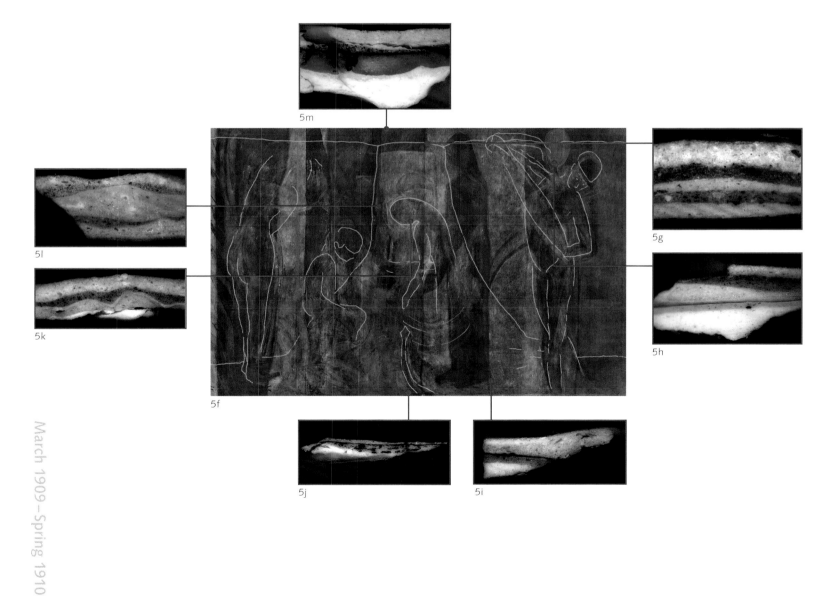

5m

5l

5k

5g

5h

5f

5j

5i

foot immersed in water, can be supported by a letter to Shchukin of April 9, in which Matisse stated that he was working on a painting first introduced with the watercolor *Composition No. II.*[5]

During the time Matisse was painting *Nude with a White Scarf*, he was also in the first stage of work on *Back* [4], and both the painting and the bas-relief exist as similar explorations of depth and flatness, weight on flesh. Like her counterpart in *Back*, the subject here is nestled into an indeterminate space that the artist built up by layering hatched, rhythmic patches of paint [6f]. Matisse's evolving approach to the figure's placement on the canvas is demonstrated in an X-radiograph [6c] that shows a more compressed initial pose similar to a related canvas of the same dimensions and time period [6d].[6] In the finished work, the woman's body is pressed into the background, seemingly splayed across the surface. Matisse built her form with thick trails of unblended peach, pink, tan, yellow, green, and gray pigment [6g] and overlapping veils of scraped or wiped paint [6e]. He employed this simultaneously additive and reductive process not only in oil paint but also with plaster, as he continued to push the evolution of the figure in *Back*.

6e

6f

6g

6h

1. Receipt no. 97 for *Nu à l'écharpe blanche*, 1000 francs, dated July 12 and stamped paid July 13; see Dauberville and Dauberville 1995, vol. 1, pp. 460–61, cat. 92.

2. The studio was sold in June. On Apr. 26 and May 1, Matisse wrote to Madame Cocurat about renting a house at no. 42, route de Clamart in Issy.

3. Edmé Bouchardon's copy of the Barberini Faun (225 B.C.; Glyptothek, Munich) was displayed in the Parc Monceau and various places around Paris before it entered the Musée du Louvre's collection in 1892. For more on the sculpture's connection to *Nude with a White Scarf*, see Elderfield 1995, pp. 31–32, n. 61.

4. Cross sections (KMSr81 338a and 338b) were taken and analyzed by the conservation department of the Statens Museum for Kunst, Copenhagen. Many thanks to conservator Kathrine Segel for her important contribution to the study and presentation of this work.

5. See entry 5 in this publication.

6. The fact that *Seated Nude* is simpler and more thinly painted than *Nude with a White Scarf*, and that the pose of the figure mimics the earliest in the X-radiograph, suggests that it may be an earlier version or *esquisse*, in a manner similar to *Le luxe (I)* and *Le luxe (II)* (2.1–2). For an alternate reading of the relationship between *Seated Nude* and *Nude with a White Scarf*, see Monrad 1999 and Margaret Werth, "Nude with a White Scarf: A Thick and Full Material," in Aagesen 2005, pp. 133–58. However, as *Seated Nude* is apparently unfinished, it is difficult to draw firm conclusions about the exact relationship between these works.

7 **Nude by the Sea**
Cavalière-Sur-Mer, July–August 1909

Oil on canvas; 61 × 50 cm (24 × 19⁵/₈ in.)
Signed l.r.: *Henri Matisse*
Private collection

IN EXHIBITION

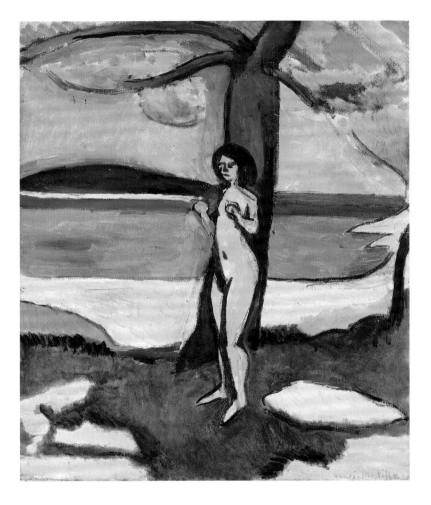

7a

7b

7a
Rose Nude, summer 1909. Oil on canvas;
33.5 × 41 cm (13³/₁₆ × 16 in.). Musée de Grenoble,
MG 2207.

7b
Nude by the Sea, Cavalière, summer 1909. Oil on
canvas; 46.5 × 29 cm (18⁵/₁₆ × 11⁷/₁₆ in.).

7c
Nude in Sunlit Landscape, summer 1909. Oil on
canvas; 41.9 × 32.4 cm (16¹/₂ × 13 in.). Solomon R.
Guggenheim Museum, New York, 84.3252.

IN JULY 1909, Matisse and his family went to Cavalière-Sur-Mer, a small village on the southern coast of France, to prepare for his work on Shchukin's decorative panels, which were not yet painted. By traveling to the Midi, the site of Arcadian inspiration for French artists for centuries—and to a place just east of Saint-Tropez, which was the ultimate source for *Luxe, calme, et volupté* (p. 47, fig. 8) —the artist made clear his intention to locate the setting of the scenes of *Dance (II)* and *Music* (p. 77, figs. 1–2) in a mythical, pastoral paradise. The paintings he made in Cavalière feature nymphlike figures in the forest or on

7c

a shore. In addition to *Nude by the Sea* [**7**] and *Bather* [**8**], there are at least three other paintings that Matisse is known to have produced during his nearly three-month stay in the south: *Rose Nude* [**7a**]; *Nude by the Sea, Cavalière* [**7b**]; and *Nude in Sunlit Landscape* [**7c**]. These works share similar palettes as well as abbreviated forms that suggest the artist's particular interest in the brilliant Mediterranean sun's dissolving effect on solid form and its unifying power on color and space, features he sought to capture in his monumental canvases for Shchukin. These three Cavalière paintings also share the subject of bathers; this, while certainly connected to the pastoral theme also associated with dance and music, relates more immediately to the recently completed state of *Bathers by a River* [**5**].

In order to start his preparations for *Dance (II)* and *Music*, Matisse brought along his trusted model Loulou Brouty, who sat for *Nude with a White Scarf* [**6**]. Brouty was accustomed to the artist's rigorous schedule and was willing to pose nude outdoors, two requirements that might have prevented Matisse from finding a local model quickly.[1] Given that at least four of the known Cavalière

paintings are of standard size formats, it seems that Matisse might also have brought ready-stretched canvases in order to set to work without additional delay.[2]

Although not specifically pictured, the sun is a major presence in these works; Matisse captured its powerful ability to drain variations in color from illuminated areas and heighten the contrast of shady places outside its reach. He also suggested its ability to thwart viewers' perception of detail in figures and landscapes, causing a flattening of form and a loss of depth consistent with contemporary painted *décorations*. To describe these effects, the artist employed a palette of intense pink, blue, and green, which he applied with small touches in a layered, hatched pattern that recalls the Neo-Impressionist brushwork of *Luxe, calme, et volupté*. This decorative, tapestrylike surface was something that Marcel Sembat noted when he saw *Rose Nude* upon Matisse's return to Paris at the end of the summer. Looking at the canvas along with his wife, the artist Georgette Agutte, at the Matisses' new home in Issy, he recalled, "Little by little its real character emerged for us: the impossibility of restricting one's eyes to any particular spot in isolation—the figure, for example, or the shadows, or the pale greenery at the top; the necessity of having it strike your eyes and your soul all at once, the total shock of the thing as a whole. This work was in the highest sense indivisible and *synthetic*."[3] The lack of emphasis on particulars and the harmonious overall impression was, as Sembat noted, Matisse's ultimate goal: "I didn't want to paint a woman . . . I wanted to convey my total impression of the Midi."[4]

But if Sembat was correct, what are we to make of the deviations in *Nude by the Sea*— the rigid black outlines painted on the figure, the visible pencil and painted underdrawing, and other changes—that keep it from achieving a more unified, synthetic and decorative effect? *Nude by the Sea* is far more worked than its companions: Matisse continuously adjusted the figure's silhouette, trying to contain her form within that of the tree. He incised and scratched away paint, scraped layers, and painted over earlier forms with a heavy brush. Such alterations suggest the continuing challenge that the artist set for himself in describing soft flesh in relation to a fixed surface. Visual examination, in fact, reveals that Brouty was originally depicted in profile on the left side of the tree, and that Matisse revised this pose as a more frontal one, a change that he echoed in *Bather*, also made that summer.

Nude by the Sea provides us with clear evidence that Matisse had begun a process of rethinking that, in the following months, would come to affect Shchukin's *Dance (II)* and *Music* panels as well as *Bathers by a River*.

With his work completed at summer's end, he wrote to his patron about his painting trip, reporting, "After two, almost three months by the sea I am returning to Paris satisfied with the health of my family and the work I have done here. I have finished with the model and bring documents that will be very useful for your decorations."[5] While the artist did, practically speaking, paint subjects related to the compositions, his process of working, the sturdiness of his figures and painted surfaces, and the palette of his canvases registered a change brought on by the time away.[6] Indeed, as Sembat wrote in 1913, these paintings were "new works in embryo" that would later affect *Dance (II)*, *Music*, and *Bathers by a River*.[7]

1. Brouty also sat for *Nude, Black and Gold* (1908) and *Lady in Green* (1909), both now in the State Hermitage Museum, St. Petersburg. For more on Brouty and Matisse's other models at this time, see Spurling 2005, pp. 27–30.

2. *Nude by the Sea* is a number 12; *Bather* is a number 30; and *Rose Nude* and *Nude in Sunlit Landscape* are number 6. The verso of *Nude by the Sea* is stamped *12/F/1/2 FINE*. As he did with *Bather*, Matisse also inscribed the verso on Apr. 25, 1935, mistakenly dating the work to summer 1908.

3. Sembat 1913, p. 190 (emphasis in the original). Sembat echoed Matisse's own statement of his goals in his 1908 "Notes of a Painter," pp. 733–34.

4. Sembat 1913, p. 191.

5. Matisse to Shchukin, Aug. 9, 1909, AHM. Matisse listed among the "documents" numerous drawings of musicians and of Brouty in a crouched pose. An additional sign of the importance of *Nude by the Sea* to Matisse's work on *Bathers* is that the work was not sold until the 1930s. Although exhibited in the 1912 Grafton Galleries exhibition, *Nude by the Sea* (no. 24) was, like the plaster *Back*, not for sale.

6. Matisse himself acknowledged this effect when he sold the painting to its first owner, noting that it was "very worked" and that he "valued it greatly." Matisse to Hermann Rubin, Apr. 25, 1935, AHM.

7. Sembat 1913, p. 191.

8 **Bather**
Cavalière-Sur-Mer, July–August 1909

Oil on canvas; 92.7 × 74 cm (36 1/2 × 29 1/8 in.)
Signed l.r.: *Henri-Matisse*
The Museum of Modern Art, New York, gift of Abby Aldrich Rockefeller, 1936

IN EXHIBITION

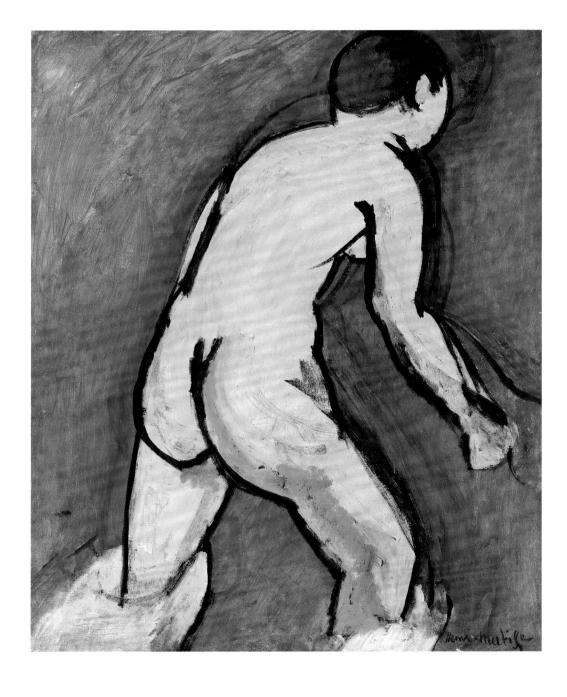

8a

8b

8a
X-radiograph of *Bather*: the dark lines show how Matisse scratched down into the paint layer to fix the figure's position on the canvas.

8b
Detail of *Composition No. II* (5a), with ink lines that indicate the repositioning of the figure.

IT IS LIKELY that this canvas [**8**] first appeared to the public in the 1936 exhibition *Henri Matisse, "La Danse": Sketch for the Moscow Decoration*, along with sixteen other paintings, photographs, and related materials for the 1909 commission for Sergei Shchukin.[1] Identified as *Bather*—a theme not represented by *Dance (I)* (p. 79, fig. 5), *Dance (II)* (p. 77, fig. 1), or *Music* (p. 77, fig. 2)—it was the only work related to the subject that the artist first proposed in the watercolor *Composition No. II* [**5a**], and that Shchukin rejected. The palette of *Bather* is similar to that of *Dance (I)*, with its deep blue, Giottoesque background and the use of pale, contrasting colors for the figure; the painting also shares the heavily outlined forms and some of the worked surface of *Dance (II)* and *Music*. Its greatest connections, however, are to Matisse's early plans for *Bathers by a River* [**5**].[2]

The bathing woman, who submerges her lower legs in the rushing water, is almost a mirror image of the middle figure in *Composition No. II* [**8b**]. There she is nestled within a series of upward-running curves; while these are reminiscent of waves or ripples, they are most likely earlier placements of buttocks that remained as Matisse initially moved the figure both to the left and right of the waterfall before settling on its present position.[3] He integrated similar working marks into the final image: for instance, the heavy ink line running along the left side of the woman's face was once the profile of a smaller, foreshortened head; the inner contour of her thick right arm served to define an earlier, slimmer version; and various lines running along the sides of her torso are abandoned contours of standing and turning poses.

It is noteworthy that approximately four months later, during his summer in Cavalière, Matisse reprised many of the watercolor's repositionings and reworkings in this oil painting, moving the figure across the canvas, shifting the pose from a side- to a back-turned position, altering the fragmentary breast form, and even changing the contour of the extended arm.[4] An X-radiograph of *Bather* [**8a**] shows how deeply Matisse scratched into the paint as he adjusted the figure's form. Examination with infrared reflectography makes the artist's adjustments in pencil and dark blue and black paint even more clear [**8c**]. Here we can see at least five variations of the right leg, as the bather initially had a wider stance; her left leg grew heavier and then slimmer as Matisse worked toward its final tapered form; and her hunched back was reshaped at least four times.[5] We can also observe the changing description of the head. Beginning with a profile view and a longer hairstyle like the figure in *Composition No. II*, Matisse opted for a back-turned pose, rendering the hair with a simple notation that recalls the first figures in *Bathers by a River* [**5**].[6]

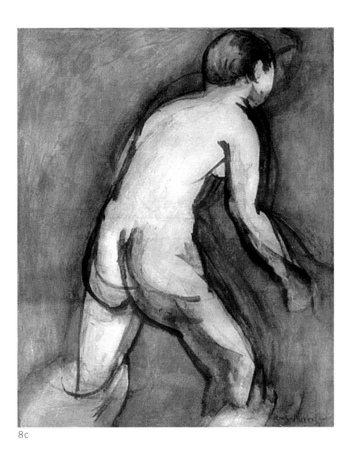

8c

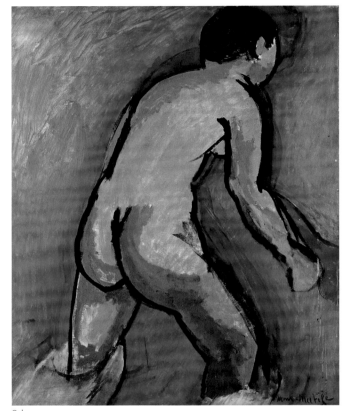

8d

8c

Infrared reflectogram of *Bather*, revealing the many adjustments to the figure's head, back, and legs.

8d

Bather seen under ultraviolet light. Areas of consolidated value show different successive layers—and campaigns—of paint.

8e

Detail of *Bather*, showing how Matisse employed scraping to create volume in the figure's right hip. Note the pencil marks from his additional considerations of the figure's pose after the paint was dry.

8f

Detail illustrating the use of dry brushwork to construct volume in the right upper thigh.

8g

Detail indicating how Matisse incorporated the blue background to suggest volume and depth on the back of the right thigh.

As he repositioned the bather, the artist worked old contours with long, repeated brushstrokes, modeling the body's volumes just as he would when adding clay to a sculpture. An image of the work viewed under ultraviolet light [**8d**] emphasizes the successive layers of paint that Matisse applied over the initial figure as he reduced the torso and limbs on one side and built up the other. This process of adjustment was, in fact, almost sculptural at times—it involved working the material on the canvas to produce alternatives to more traditional means of describing volume. Matisse suggested the shape of the bather's abdomen and the angle of her body, for instance, by scraping into layers of blue and black paint [**8e**]; in another example [**8f**], he used a light, dry brushstroke of black over pink paint to define the contour of the upper thigh and suggest volume in shadow. It is also worth noting the dual method he employed for contour shading, often in the same area of the canvas. On the undersides of the figure's jaw, outstretched arm, and right thigh [**8g**], we can see how Matisse reused the dark blue background under the adjusted forms, allowing it to show through the loose net of pale pink brushstrokes as the darkest point of shadow; in other areas, he introduced a thick track of gray paint on top of the pink. In neither case did he blend these layers to render shadow naturalistically, but the cumulative optical effect—like an added touch of plaster or clay on a bas-relief—works in concert with the other traces of adjustments to produce the total image, a record of making as a form of growth, modeled from the two-dimensional plane of the canvas. Matisse worked with his model Loulou Brouty on this canvas, but he may have also, as some scholars suggest, worked from memory, and the images in his mind may well have been the figures in *Bathers by a River* and *Back* [**4**]. Indeed, the background of the latter may represent the agitated surface of water. Just as he drew on the experience of making these works as he painted *Bather*, Matisse would likewise fix this recent working session into his memory before he returned to Issy and focused his attentions again on the bathers panel and the bas-relief.

8e

8f

8g

1. Aside from a 1933 auction, no other public presentations of the work have been identified before the one held at the Pierre Matisse Gallery, New York, from Oct. 27 to Nov. 21, 1936. The checklist, with a preface by Pierre Matisse, identifies *Bather* as cat. 4.

2. In summer 1907, Matisse visited the Arena Chapel. In "Notes of a Painter," he discussed his experience of Giotto's frescoes as "the immediate feeling that emerges"; Matisse 1908, p. 741. *Bather*, like *Bathers by a River*, is also clearly influenced by Cézanne's *Three Bathers* of 1879–82 (p. 45, fig. 3), which Matisse had purchased in the summer of 1899.

3. The figure is female: when the painting was sold at Hôtel Drouot in 1933, it was titled *Jeune fille sortant au bain*, and in 1945 Matisse identified the work as

Baigneuse. See Barr Questionnaire I. Most significantly, Matisse wrote to Amélie in 1926 during the sale of *Bathers by a River* to Paul Guillaume, identifying this canvas as "the nude done with Brouty that was hung on the wall of the large studio, 30 canvas"; Matisse to Amélie Matisse, Sept. 14, 1926, AHM. It is likely that Matisse sold *Bather* to Guillaume at this point as well.

4. For issues of memory, imagination, and the source of this image, see Elderfield 1978, p. 60; and Flam 1986, p. 261. Spurling noted an additional source of inspiration: Matisse's own activities in the water, diving, bathing, and teaching Brouty to swim. In Aug. he wrote to Henri Manguin that he could "dive and swim underwater. . . . I can even pick up a *sou* from the bottom four meters below." Matisse's interest in submerged figures and the transparency of water was also evidenced in the many humorous sketches of himself included in letters to friends back home; see Spurling 2005, p. 28, for Matisse's letter to Manguin as well as examples of his sketches.

5. For example, Matisse fashioned the sliverlike left arm from the vestige of an earlier bent back. He used pencil both under and over the paint to plan the bather's form; see, for instance, the repeated set of marks on the outside of the right buttock.

6. The short hair has led some commentators to describe the figure as male, but as the conservation examination and archival documents demonstrate, Matisse painted her from the start as a female bather. In addition to this information, it is important to note that Matisse used this short hairstyle for other female figures from this time, including those painted in the first state of *Bathers by a River*.

9 Back (I), second state
Issy-les-Moulineaux, fall 1909

Plaster, cast in bronze c. 1950; 188.9 × 113 × 16.5 cm (74 3/8 × 44 1/2 × 6 1/2 in.)
Signed l.l.: *Henri Matisse*; inscribed l.r.: *H. M. / 2/10 / 1909 / Cire—C. Valsuani—perdue*
The Museum of Modern Art, New York, Mrs. Simon Guggenheim Fund, 1952

IN EXHIBITION

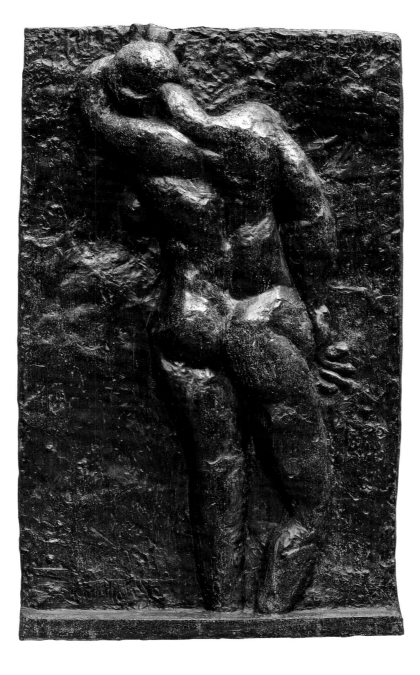

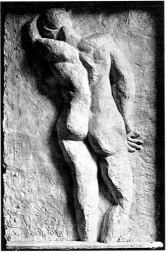

9a

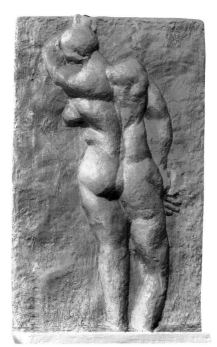

9b

9c

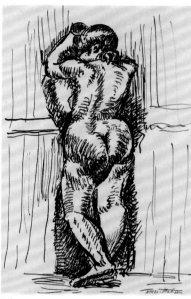

9d

9a
Back (I) in plaster, c. 1912. Walt Kuhn Papers, Archives of American Art, Smithsonian Institution, Washington, D.C.

9b
Digitized overlay of the 1909 photograph of the clay and the final state of *Back (II)*, in blue, showing the reductive changes made to the plaster version.

9c
Standing Woman Seen from Behind (Study for "The Back [I]"), fall 1909. Pen and ink on paper; 26.6 × 21.9 cm (10 1/2 × 8 5/8 in.). The Museum of Modern Art, New York, Carol Buttenweiser Loeb Memorial Fund, 1969. In exhibition.

9d
Standing Woman Seen from the Back, fall 1909. Pen and ink on paper; 28.8 × 18.6 cm (11 3/8 × 7 3/8 in.). National Gallery of Canada, Ottawa, purchase 1974, 17924. In exhibition (Chicago).

AS WE HAVE seen, just before Matisse packed up his Paris studio and departed to Cavalière for the summer, he cast his clay *Back* [**4**] into plaster in a waste-mold process that necessitated the destruction of the original. In September, when the artist started work in his new studio in Issy, he also resumed work on the plaster. This undertaking now involved several new aspects. The first was a different colored surface: the gray or tan clay was now replaced by white plaster, something more akin to a primed canvas or a blank sheet of drawing paper. The second involved a revised approach to sculpture making: whereas Matisse modeled the earlier *Back* in clay—which, if kept moist, would respond to his fingers as well as wire and wood tools—the present cast required him to add fresh plaster to an already-set, rewetted surface and to remove hardened forms with chisels, hammers, and rasps.[1] Third, and most important, was the embrace of a new kind of reworking and serial exploration: the artist would return to this figure over the course of twenty-one years, each time beginning with a new plaster cast of the previous version.[2] In this way, the various *Back* states are, as Matisse's daughter, Marguerite, suggested in 1976, one sculpture that passed through several stages of evolution.[3]

Bearing these issues in mind, we can appreciate the way in which Matisse's new working method affected the plaster. Comparing Eugène Druet's spring 1909 photograph of the clay *Back* [**4**] and a photograph of the plaster from around 1912 [**9a**], we can see how the figure's fleshy modeling was made increasingly solid and rigid. The artist cut away the roll of hair, the left edge of the neck, and the left hip and leg to produce more angular, sharply defined forms; he added material to submerge and straighten the once gently curved spine and to construct thick muscles on the back that move out in axial directions. He enlarged the breast and cut the form of the buttocks to give the idea of the figure stiffly pressed against the background. Various body parts, in particular the right side of the torso, were trimmed; others, including the right thumb and the contour behind the right knee, were radically sliced away. These more angular and hard-edged contours are visible in an overlay [**9b**] of the clay version and the present-day bronze [**9**], and echo studio drawings that Matisse made after a live model, whom he posed against the bead-board interior of his new studio. In the first sheet [**9c**], the artist described the figure with a supine curve of the back and soft contours on the hips and thighs; here pen-and-ink hatchings seem to foretell areas to which he would turn his attention on the plaster, cutting away softer lines for a firmer effect. The second example [**9d**] shows a more voluminous figure, and the hatching is used less to mark areas of

reduction than to produce highlighted forms that give the figure its rigid volume and structure.[4] Echoing the format of the bas-relief itself, the sheet also shows the model holding her weight on one leg, her right foot hidden, seemingly submerged in the floor.

It is generally accepted that Matisse stopped work on *Back* at the end of 1909, although no documentation has been found to confirm this.[5] We know more securely, however, that the artist first showed it to the public at the *Second Post-Impressionist Exhibition*, organized by Roger Fry and held in London between October and December 1912. There he titled it *Le dos: Plaster Sketch*. The piece was then sent on to the *International Exhibition of Modern Art*, more commonly known as the Armory Show, which traveled in 1913 from New York to Chicago and Boston; in this venue, the work was called *A Back (Sculpture)*.[6] In both instances, it was not annotated with a number, as it is today, but identified singly and—in the case of the London exhibition—as an *esquisse*, or sketch.[7] As we have seen, this term had specific meaning for Matisse at around the time of *Back*'s genesis in 1908 and 1909; by 1912 and 1913, however, after the experience of Morocco, his use of the word had likely shifted, although he always employed it to suggest an object's association with another related work.[8] Given this, it is possible that by fall 1912 Matisse had already returned to work on the relief, or at least intended to do so. In that case, the plaster he exhibited, known today as the bronze *Back (I)*, would have been the *esquisse* for *Back (II)* [**17**].

1. Marguerite Duthuit confirmed that her father worked in "soft plaster" to effect his changes; see Elsen 1972, p. 183.

2. This study proposes that Matisse cast two plaster *Backs* when he was ready to start a new stage: one to keep as a record of his progress, and the other to begin a new stage of work.

3. Marguerite Duthuit to John Elderfield, Apr. 26, 1978; Elderfield 1978, p. 194, no. 6.

4. See Dauberville and Dauberville 1995, vol. 1, p. 426, cat. 77, where it is identified as *Nu vu de dos, 1907*.

5. Since Matisse considered *Back* to be an ongoing project, it would stand to reason that he would not tell friends or otherwise document its "completion."

6. J. Chenue to Walter Pach, Dec. 30, 1912, and Jan. 28, 1913, Walt Kuhn Family Papers and Armory Show Records 1859–1978 (bulk 1900–1949), Archives of American Art, Smithsonian Institution, Washington, D.C. *Back* was published in Roger Fry, *Vision and Design* (Chatto and Windus, 1920), opp. p. 8, 10, and Zervos 1928, p. 278, but it was not shown to the public again until 1949. This provides further evidence for the idea that this was an intermediary state of a continuing work, one that, by the late 1940s, Matisse was considering casting in bronze. See Matisse to Henri Laurens, Nov. 4, 1949; Duthuit and de Guébriant 1997, no. 30.

7. This suggests that the clay *Back (I)*, first state (4) was not an independent state: if it had been, it would be the *esquisse* for the present work. See Elderfield 1978, p. 74.

8. See MacChesney 1913; and Elderfield, "Matisse in Morocco: An Interpretive Guide," in Cowart 1990.

10 **Bathers by a River,** second state
Issy-les-Moulineaux, fall 1909–spring 1910

Oil on canvas; 260 × 392 cm (102 1/2 × 154 3/16 in.)

X-radiograph of *Bathers by a River* with a diagram showing the composition of the second state of the painting.

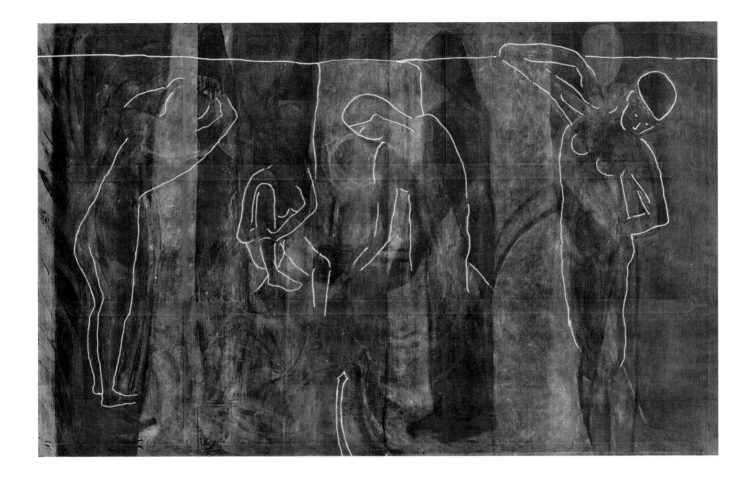

10a

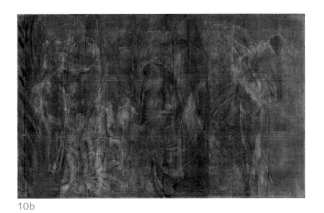

10b

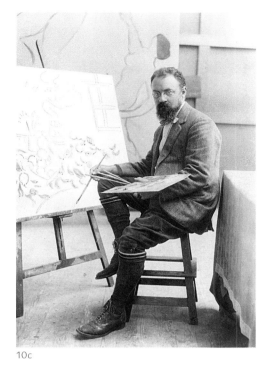

10c

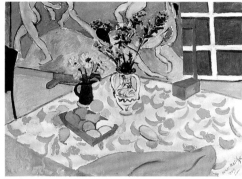

10d

10e

10f

10a
Plan of Matisse's studio in Issy-les-Moulineaux, with the positions of *Bathers by a River* and *Back* noted.

10b
X-radiograph of *Bathers by a River* with the upper paint layers suppressed.

10c
Matisse painting *Still Life with "Dance,"* fall 1909, photograph by Edward Steichen.

10d
Still Life with "Dance," fall 1909. Oil on canvas; 89.5 × 117.5 cm (35 1/4 × 46 1/4 in.). The State Hermitage Museum, St. Petersburg, 9042.

10e
Bathers by a River, as recorded by Pierre Matisse, c. 1910. Archives Henri Matisse, Paris.

10f
Seated Female Nude, Holding One Knee, with Sketch of Foot, August 1909. Reed pen and black ink on white laid paper, laid down on cream wove paper, laid down on ivory wove card; primary support: 23.6 × 29.9 cm (9 5/16 × 11 3/4 in.). The Art Institute of Chicago, gift of Mrs. Emily Crane Chadbourne, 1926.1533. In exhibition.

IN SEPTEMBER 1909, Matisse returned from Cavalière to settle into his new home and atelier in Issy-les-Moulineaux, in the southwest suburbs of Paris. With funds from Sergei Shchukin, and on the recommendation of photographer Edward Steichen, he had purchased and installed a prefabricated studio on the northwest corner of the home's grounds. This building was approximately thirty-three feet square and, unlike the Couvent du Sacré Coeur atelier, provided the artist with ample space for making paintings and sculptures in the same location. Its interior was faced with beadboard and punctuated with light from a double-paned window on the south, a long set of windows on the north, and a pitched roof whose northern portion was glazed [**10a**].[1]

It was here that Matisse would unroll and restretch *Dance (I)* (p. 79, fig. 5), as we can see in Steichen's fall 1909 photograph [**10c**] of the artist at work on a new canvas, *Still Life with "Dance"* [**10d**]. In the background of both images, we can see a large painting behind and to the right, turned to the wall and held on what appears to be an eight-member stretcher. This monumental painting may well be *Bathers by a River*: its location against the west wall corresponds to Pierre Matisse's recollections, and it is also likely that the artist would have placed it in this area of the studio in order to take advantage of the daylight from the northern windows.[2] While no known photographs exist that date work on the painting to fall 1909 and beyond, a watercolor made by one of Matisse's sons [**10e**], replete with flowers in the foreground, suggests the presence of the canvas in the new studio and the likelihood of Matisse's continued attention to it. Technical examination and physical evidence strongly indicate that the artist did indeed continue it during his first year in the new studio, doing so in concert with, and in response to, the panels for Shchukin.

An X-radiograph of *Bathers by a River* with its upper, later paint layers suppressed shows some of Matisse's reworkings at this time [**10b**]. However, his subsequent alterations—scraping down abandoned forms in certain areas and covering some with lead white—make it difficult to interpret with current technology, and we are able only to point to a small constellation of changes to the composition that date to this moment in the painting's evolution. There is evidence that Matisse repositioned the figure to the left of the stream, raising her to a little above the midpoint of the canvas. He altered the pose from the previous side-turned crouch, turning the bather toward the viewer with legs bent and head facing down to the running water. Indeed, the posture is similar to that in a drawing that he made of Loulou Brouty while in Cavalière-Sur-Mer [**10f**] and provides

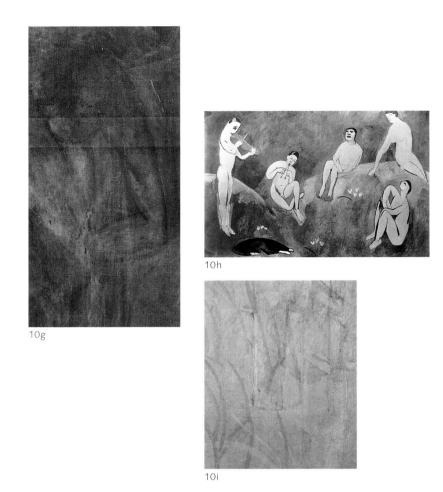

10g

10h

10i

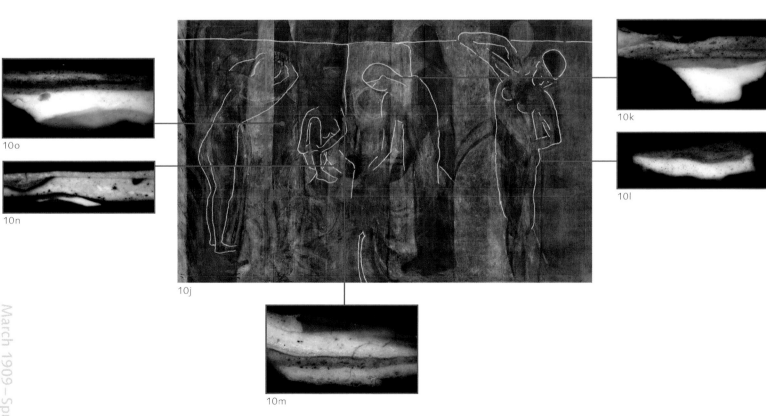

10o

10n

10j

10k

10l

10m

10g

Detail of the X-radiograph of *Bathers by a River*, showing the articulated musculature of the fourth figure's left arm.

10h

Music, in process, spring 1910, photograph by Eugène Druet.

10i

Raking-light image of the second bather's right foot.

10j

Diagram of *Bathers by a River*, second state, showing the locations of the cross sections.

10k

Cross section of the third bather, showing its yellow hair. The yellow layer is just above the thin turquoise and thicker pink waterfall layers. Original magnification: 200x [x1110].

10l

Cross section of the fourth bather's left arm. Although this sample is incomplete, it shows the thin dark reddish-orange layer that corresponds to a change in palette by Matisse. This layer is over a lighter pink skin tone. Original magnification: 200x [x893].

10m

Cross section of the second bather's pink left arm. Original magnification: 500x [x887].

10n

Cross section of the second bather's left foot, showing the fairly thick warm pink layer. Original magnification: 100x [x1040].

10o

Cross section showing the dark green background. Original magnification: 200x [x901].

evidence of his continued thinking about this picture during the summer of 1909. The artist shifted the position of the figure on the right side of the waterfall, too, lifting her head and straightening her back, while keeping her immersed in the water. He adjusted the pose of the fourth figure as well, although the exact changes are difficult to extract from the tangle of revisions visible in the X-radiograph. It is certain, however, that Matisse tightened the pose and strengthened the limbs in response to the stiffer, more powerfully built figures of *Dance (II)* (p. 77, fig. 1), which he would have been working on in the fall, and a detail from the X-radiograph of the fourth bather's left arm [**10g**] shows a similar articulation of muscle.

Cross sections of specific locations on the left arms of the fourth and second figures [**10l–m**] demonstrate a corresponding change in palette: Matisse altered the flesh tones of the bathers, making them more intense. He modified the hair of the third figure [**10k**]— although still yellow, it became a comparatively lighter shade—and shifted the foliage and background to a darker, richer green [**10o**]. It is important to note that despite these color changes, physical examination of *Bathers* has not confirmed that Matisse transformed the palette to the degree of the completed *Dance (II)* and *Music* (p. 77, fig. 2) panels. However, some elements, visible on the painting's surface in raking light, correspond to a second stage in *Music*'s evolution, documented by Eugène Druet [**10h**].[3] For instance, near the middle left, Matisse revised the second bather's right foot [**10i**] in a similar, thickly outlined style that has a heavier effect than the figures' feet in *Dance (I)*.[4] It may also be that Matisse painted flowering plants, possibly tulips, much like those that appear in Druet's photograph of *Music* and the c. 1910 watercolor, but no evidence for this has thus far been found. The photograph shows a sleeping dog who was perhaps initially a companion to the snake in *Bathers by a River*, although it was abandoned in the final version.

While we cannot fully document Matisse's progress on *Bathers by a River* between fall 1909 and 1910, these correspondences suggest that he may have finished in early spring, before Georgette Agutte visited his studio on March 31 and later worried to Matisse about the intense colors in which he had repainted *Music*.[5] Perhaps the artist planned to continue *Bathers by a River* after completing Shchukin's panels, but by the end of May they were not yet finished, and he was exhausted. "I could do with a good month's rest, which I can't take," he told the artist Jean Biette. "If you only knew how I long to get away from here."[6] As we know, the artist's hard work on *Dance (II)* and *Music* would not immediately be recognized: the panels met with a

negative response at the Salon d'Automne and—initially at least—from Shchukin. Given *Bathers by a River*'s connection to this commission, it is not unreasonable to assume that Matisse left Issy without resuming work on the canvas, as its recent reworkings were connected to the other panels.[7] Indeed, it was likely a full three years before he felt the freedom to return to the canvas.

1. For more on the studio, see Elderfield 1978, pp. 86–89, 198–200, and esp. figs. 62, 64.

2. Elderfield confirmed the location of *Bathers by a River* in the Issy studio with Pierre Matisse; see ibid., p. 198. See also Flam 1986, p. 272, for the possible identification of *Bathers by a River* in *Still Life with "Dance"* (10d).

3. This photograph was first published in Sembat 1920. The circumstances in which Druet took this and an earlier photograph of *Music* are not fully known, but given the growing evidence of Matisse's desire to record his progress on many works at this time, we can assume that he engaged the photographer specifically for this purpose, as well as to have something to send to Shchukin.

4. As additional evidence of Matisse's detailed focus on revision from *Dance (I)* to *Dance (II)* and *Music*, as well as *Bathers by a River*, we should note the sculpture *Study of a Foot* (D43), possibly dating to fall 1909.

5. Agutte to Matisse, Apr. 2, 1910, AHM.

6. Matisse to Biette, n.d. [May 1910], AHM.

7. We know, for example, Matisse's thoughts immediately after the ordeal. He wrote from Spain to Jean Biette, saying that he was "unwilling to do new pictures to explain the preceding ones"; Matisse to Biette, Jan. 9, 1911, AHM. For a fuller quotation of this letter, see p. 85 in this publication.

FOR THE BETTER PART OF 1910, MATISSE'S MOST important project was his commission from Sergei Shchukin for the two big decorative panels *Dance (II)* and *Music* (p. 77, figs. 1–2), but this did not prevent him from working on other things. Among them was the painting *Young Girl with Tulips* (11d), which was the only piece he sent to the Salon des Indépendants in mid-March, perhaps because that exhibition followed on the heels of his big retrospective at the Galerie Bernheim-Jeune, during which, Guillaume Apollinaire noted, the press had treated the artist with "an unusual violence."[1] Among the most hostile of the critics was Charles Morice, who was even nastier than he had been about Matisse's 1908 retrospective, complaining that his gifts as a colorist were erased "by the incoherence of the directions he follows, by the bizarreness of his experiments, by the bad taste . . . by the lack of proportion of his compositions."[2] In short, Matisse had "misjudged the teachings of Cézanne and wasted his own gifts." Of course, he had done no such thing; he had been pursuing the direction, first announced in *Le bonheur de vivre* (p. 49, fig. 12), of using flat areas of intense, contrasted hues to advance Cézanne's basic message of additive color construction. Soon, however, he would begin to alternate this approach with the use of rich decorative patterning, developing the impetus of his *Harmony in Red (The Red Room)* (p. 84, fig. 17); he would juggle these two methods until, working outdoors in Morocco in 1912 and 1913, he found himself moving much closer to Cézanne's teachings.

A more troubling complaint against the artist was the critic Louis Vauxcelles's comment, in his report on the 1910 Salon des Indépendants, that Matisse was having a bad effect on his mostly foreign followers, a statement that reflects how opposition to him among Parisian critics and admiration of him among foreign critics and artists were growing reciprocally.[3] It did not help that all of the students at the artist's academy were foreigners, as were his major patrons, and that, in the years just after the infamous Dreyfus Affair, most of his clients and many of his friends were Jewish.[4] In the meantime, though, Matisse did have his defenders, among whom Apollinaire remained the most eloquent. "No man is a prophet in his country," he wrote on the occasion of the Salon, "and while the foreigners who acclaim him are at the same time acclaiming France, France is getting ready to stone to death one of the most captivating practitioners of the plastic arts today. . . . He strives not to imitate nature but to express what he sees and what he feels through the very materials of painting, the way a poet uses the words of a dictionary to express the same nature and the same feelings."[5] Matisse's February 1910 retrospective at the Galerie Bernheim-Jeune was his largest yet, but given its date, proportionally not much larger than his Vollard and Druet retrospectives of 1904 and 1906.[6] It was unusual for a dealer's show to include only ten paintings that could be purchased, but Matisse must have wanted to demonstrate the long unfolding of his art to its present radical position, and the gallery had good reason to want to demonstrate, in turn, that his work was in demand.[7]

The earliest work in the exhibition was Matisse's student copy of Jan Davidsz. de Heem's *A Table of Desserts* in the Musée du Louvre (35a), and the display also included a much freer pen-and-ink drawing after Eugène Delacroix's *The Abduction of Rebecca*, also in the Louvre (fig. 1). Félix Fénéon, now the gallery's manager, must have realized that this demonstration of a radical artist dealing respectfully with the past was good for business, for the latter work reappeared in mid-April at Bernheim-Jeune in the first-ever commercial exhibition of copies, made by artists from Jean-Auguste-Dominique Ingres and Édouard Manet to Cézanne and Odilon Redon, which he organized. The presentation was widely and enthusiastically reviewed by both conservative and progressive critics, especially, as the forward-looking J. F. Schnerb put it, for those works that "capture, perhaps more than the original works, the true character of the translators, who had sought out a guide in their researches, who certified a place of common ground, or who simply asked . . . for a theme for variations."[8] This speaks of a wish to see the present joined to the past in a way that is vital, not "sad like the museum of copies at

the École des Beaux-Arts," as Schnerb said, and also of a validation of the new based upon its grounding in tradition.

Matisse would continue to seek ways to draw upon the past in a vital way; indeed, that fall he would extend the range of his references to include the art of Islam. Moreover, the theme-and-variation approach to copying was not too distant from what had been a part of his aesthetic from the very beginning, starting with the first two paintings that he made, the second based on the first (2a–b). In winter and early spring 1910, he maintained that practice by making, one after the other, two sculptures of the head of Jeanne Vaderin (11.1–2), the model for *Young Girl with Tulips*, and then extended the practice by making two more (13.1–2), probably later the same year or in 1911. These additional sculptures form a pair of works themselves and, with their predecessors, comprise one of the artist's first extended, serial developments of an individual subject. As such, the *Jeannettes* exemplify commitment to the development of a single key image over a long period of time. In 1910, the same year he started these works, Matisse stressed the labor-intensive nature of his practice in a conversation with the writer Felius Elies, saying, "Often one of those apparently simple works of mine is preceded by long and copious labor; often behind one of these works a dozen more have been undergoing evolution, or, if you wish involution, from objective vision to the sensationalist idea that engendered it."[9] While saying this, he was showing his visitor photographs of his works produced by Eugène Druet, who usually documented pieces when they were completed but sometimes recorded stages in their evolution, as in the photographs that the artist showed Elies.

Earlier, Elies had compared Matisse's art to that of the Cubists and, asking how Matisse went about making his works, boldly suggested that he neglected intelligence. To this, the artist coolly replied, "Quite so. . . . I believe only in Instinct. It is the purest, most invulnerable thing, the true lifespring of artistic activity. As a result, not only do I seek instinctual ferment before the spectacle of the world but the most instinctive way of expressing it as well."[10] Matisse had enlarged the discussion, in his 1908 "Notes of a Painter," of his need to rework his canvases, which had largely focused on making color transpositions. Expanding on that text in a 1909 interview with Charles Estienne, he emphasized how making a picture is "a long process of reflection and amalgamation . . . a slow elaboration."[11] Now, a year after that, his stress on the instinctiveness of the process suggests that he made his intuitive reactions to his works in progress the single most important factor in determining how they would be developed. This meant observing his reactions just as much as the picture and following the momentum that a train of reactions produced.[12] As he would say later, "The reaction at each stage is as important as the subject."[13]

This closed-circuit approach to his own creative practice brought with it an increasing tendency toward introversion and self-engrossment. In the fall of 1910, after the debacle of the Salon and its aftermath, Matisse deliberately withdrew from close contact with the Paris art world, one in which the Cubists and their supporters were gaining prominence. Despite the many disappointments of this period, his most important reason must have been a need to maintain the impetus of his work in the special terms that he now understood that it required. It was at this moment of readjustment that he discovered a manner of composition that allowed him to represent a succession of separate stages within a picture and to tie them together at the same time. In early October, he traveled to Munich, accompanied by Albert Marquet and joined on the way by Hans Purrmann, to visit the *Meisterwerken Muhammedanischer Kunst,* a major exhibition of Islamic art.[14] Waiting for them in Munich was Matthew Stewart Prichard, an English intellectual and student of Oriental and Byzantine art, who was "dazzled by the splendour and brilliance" of Matisse's works at the Bernheim-Jeune retrospective.[15] His advocacy of Islamic art reinforced the enthusiasm felt by Matisse, who was particularly impressed by the bronzes, ceramics, and textiles but also looked closely at the illuminated miniatures. "Persian miniatures," he recalled, "showed me all the possibil-

fig. 1
Copy *after "The Abduction of Rebecca,"* c. 1902–05
Pen and ink on paper
26.2 × 18.7 cm (10 5/16 × 7 3/8 in.)
Private collection, New York

ities of my sensations. I could find again in nature what they should be. By its properties this art suggests a larger and truly plastic space. This helped me to get away from intimate painting."[16]

By "intimate painting," Matisse seems to have meant works that produce effects of spatial enclosure, such as still lifes and interiors, which had already become sparse in his production, giving way to highly synthetic, flat, vividly colored portraits and paintings of Arcadian subjects. Despite their small size, miniatures (fig. 2) suggested a way to depict a larger world of observed reality: their composition of separate spatial cells, or compartments, demonstrated how a single painting after nature did not require a single, "intimate" focus but could combine separately observed features, thereby unfolding serially, almost cinematically, for the viewer. Matisse's most important recent compositions—notably *Dance (II)* and *Music*—had encouraged the viewer's gaze to roam almost untethered around the figures and the large, undefined, and unlocatable spaces in which they were set. Thanks to his "revelation . . . from the Orient," Matisse was able to gain a comparable effect, ambition, and authority in the depiction of actual, not only imaginary, places.[17] At first, the artist made a pair of pictures, his two Spanish still lifes of 1910 (figs. 3–4), that show views of the same space from two different viewpoints and distances at two successive moments in time. Unlike recent pairs of pictures, for example the *Le luxe* compositions (2.1–2), these do not comprise a preparatory *esquisse* and a more finished *tableau*, but exist as works of a similar style and degree of finish—equal partners. Then Matisse learned to present different spaces within a single picture as if viewed separately, notably in four large canvases of approximately the same size, painted in 1911, which have come to be known as the Symphonic Interiors (figs. 5–8).[18]

This was of profound thematic importance, allowing the artist to turn from the painting of privileged events without a location to the painting of privileged locations without an event.[19] But it also changed Matisse's pictorial means. As the Spanish still lifes demonstrate, the experience of Islamic art offered the artist a decorative alternative to the use of flat areas of color, namely areas of profuse ornamentation. Then it led him, in the Symphonic Interiors, to use geometry to at once separate and unify spaces within a picture, an approach that he would develop further in the 1913–17 period. The austere geometry of his art in those years has seemed to some viewers to be unlike anything he had done before, as if a different artist had suddenly appeared. But what happened between 1910 and 1913 not only formed the triumphant conclusion of Matisse's fixation on construction through color, but also laid the foundations for the strength of what followed, and for certain very specific preoccupations that accompanied it.

One of these preoccupations was a desire to express a quality of growth, or becoming, in the very means of figural representation. The arabesque of the tree forms in *Le bonheur de vivre* reflected those of sinuous Art Nouveau decorations, and, since making *Harmony in Red (The Red Room)* (p. 84, fig. 17) in 1908, Matisse had found inspiration in *toile de Jouy*, using this fabric's organic patterning as a way to achieve the quality he was looking for.[20] But he also found confirmation of his search in the writings of the philosopher Henri Bergson, who had been giving well-attended lectures at the Collège de France since 1900, and whose *Creative Evolution* (1907) was a huge popular success, becoming part of the period's intellectual currency. We have no direct evidence that Matisse read Bergson himself, but from Prichard's correspondence, we know that they unquestionably discussed his ideas together. Prichard admired the philosopher greatly and would have felt a rapport with at least four of the most important of Bergson's principles.

First, Bergson placed enormous importance on intuition, now the single working principle in which Matisse professed to believe. Second, he associated it with an understanding of reality as in constant flux, as duration (*durée*) itself, a "radical becoming" of constant movement and change inaccessible to analysis and only to be grasped by intuition.[21] Matisse would have recognized a similar principle in his own understanding of his creative process (see pp. 70–71). Third,

fig. 2
The First Meeting between the Prince Houmay and the Princess Houmayoun, c. 1430–40
Iran, Timurid dynasty,
Herat school
Tempera on cardboard
29 × 17.5 cm (11 3/8 × 6 7/8 in.)
Musée des Arts Décoratifs, Paris,
n. 3727

Bergson emphasized the primal, organic character of the life force, the *élan vital*, that suffused duration. The artist would, therefore, have felt confirmed in his belief that using organic, arabesque forms answered more than merely a stylistic imperative, but expressed in the very composition of a work the instinctive growth of the idea that produced it. And fourth, Matisse would also have responded with recognition to Bergson's insistence that duration, given its fluid nature, cannot be grasped in a single image, but that "many diverse images . . . may, by the convergence of their action, direct the consciousness to the precise point where there is an intuition [of duration] to be seized."

Two such images were the Seville still lifes, which Matisse made in the Andalusian capital at the end of a two-month stay in Spain, which lasted from mid-November through mid-January 1911. The main interest of the trip was to extend his recent enthusiasm for Islamic art, which led him to visit the great, ornamented Moorish monuments at Córdoba, Granada, and Seville.[22] These works reflect the experience of the monuments he had just seen, for they animate his previously somewhat heavy use of organic patterning in the *toile de Jouy* paintings, which almost overrides the identities of objects and furnishings.

Matisse took fabrics from Seville with him when he returned to Issy and posed his wife in one of them to paint *The Manila Shawl* (12.1), exhibiting it at the Salon des Indépendants, which opened on April 21. Two days after installing his painting, he replaced it with the just-completed *Pink Studio* (fig. 5) to a chorus of complaints of favoritism from other exhibitors.[23] This, and the large number of entries by Fauve artists, meant that too little notice was paid to yet another gallery; there, as if forming a manifesto, were Cubist paintings by Robert Delaunay, Henri Le Fauconnier, Albert Gleizes, Marie Laurencin, Fernand Léger, and Jean Metzinger.[24] Cubism had begun effectively as a private movement, the creation of Picasso and Braque in 1908 and 1909; of interest mainly to their friends and supported by a few collectors; and only seen, but not often, at the galleries of Ambroise Vollard and the German dealers Daniel-Henry Kahnweiler and Wilhelm Uhde. This presentation at the 1911 Salon initiated a second phase of the movement, created by artists who were interested not only in geometricized form but also in using it to idealize contemporary subjects, at this point largely rural ones, as with Le Fauconnier's Arcadian painting, *Abundance* (fig. 9). However, by the time of the group's second outing at the Salon d'Automne, its membership had enlarged with Roger de la Fresnaye and the Villon brothers, Jacques and Marcel (Duchamp), and its subjects were definitely moving from the Golden Age to modernity. One critic, likely with last year's *Dance (II)* and *Music* on his mind, reported that visitors had commented that these Cubists had turned "against the 'colored debauchery' of Matisse."[25] It is ironic, then, that it would be from members

fig. 3
Seville Still Life, 1910
Oil on canvas
90 × 117 cm (35 3/8 × 46 1/8 in.)
The State Hermitage Museum,
St. Petersburg, 6570

fig. 4
Spanish Still Life, 1910
Oil on canvas
89.5 × 116.3 cm (35 1/4 × 45 3/4 in.)
The State Hermitage Museum,
St. Petersburg, 9043

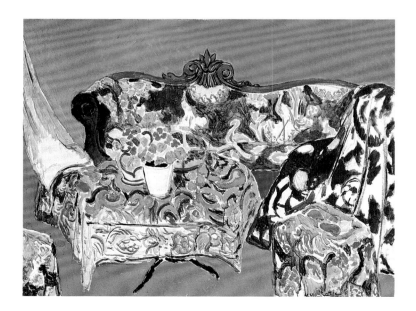

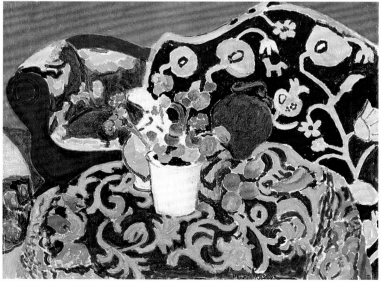

of this circle, just as much as from Picasso, that the artist would learn of Cubism in the years ahead.

In 1911, however, there is no evidence that Matisse showed the slightest interest in this sort of work.[26] Instead, he was in the process of following up *The Pink Studio* with his three other Symphonic Interiors. The first, *The Painter's Family* (fig. 6), was a commission from Shchukin, initiated while Matisse was in Spain. In early December, his patron sent him a photograph of Cézanne's *The Card Players* (1890–92; Musée d'Orsay), suggesting that the artist paint a picture of his own family after its example.[27] Matisse responded, however, by reprising the patterned surfaces and separated spatial cells of Persian miniatures. Just left of center on the canvas, surrounded by Matisse's wife, Amélie, and daughter, Marguerite, we can see his sons, Pierre and Jean, playing checkers on a board whose grid recapitulates those of the carpet below and of the overall geometric composition. But, unlike the rest of the painting, this area is drawn in linear perspective. The creation of different spaces within a picture encouraged Matisse to give one space, and sometimes more than one, a different style and character from the rest. It also spurred him to build strong overall scaffoldings in order to integrate and relate what he had separated.[28] As in all four of these compositions, Matisse shaped much of the geometry on one of the most basic materials of his art: the format of the canvas and the shape of the stretchers to which it was attached. In this case, however, he did so to an unusual extent. The sequence of narrow horizontal bands in the background follows that of the striped canvas, possibly made of mattress ticking, while the pilasters on each side of the fireplace repeat the vertical bars of the sturdily constructed stretcher behind them.

Interior with Aubergines (fig. 7), which Matisse painted in Collioure in the quick-drying medium of distemper on canvas, which he had used for *Le luxe (II)*, was the apogee of his preoccupation with the ornamental.[29] But the patterns are no longer animated tendrils, like those in the Spanish still lifes; they are akin to samples of stenciled fabric and wallpaper. Braque saw this work while visiting Collioure, and its collagelike qualities may well have influenced his invention of *papiers collés* the following year.[30] Finally, in the fall came the radically spare *Red Studio* (fig. 8). In the summer of 1912, the Danish painter Ernst Goldschmidt encountered this painting in the Issy studio and would later publish an account of his visit:

"You're looking for the red wall," Matisse said to me. . . . "That wall simply doesn't exist. Where I got that red from I couldn't say. But in a little while we'll take a walk in the garden, and maybe then things will seem clearer to you." . . . Once in the garden, Matisse enthused, "Isn't that flower bed more beautiful than the finest antique Persian rugs? Look at the colors. . . . In fact, compared to the colors here, my paintings aren't much better than those reproductions [in horticultural catalogs]."[31]

If Persian miniatures were showing Matisse how to find in nature "all the possibilities of my sensations," it would seem that nature itself was showing him how to find something more beautiful than art alone could provide. At the same time, the very geometry of the pictorial support was again used to cohere the separate parts and to provide a point of visual stasis. All of these elements—spatially disconnected parts, varied treatment of the parts, and strong overall scaffolding to both distinguish the parts and integrate them—would continue to inform Matisse's art in the 1913–17 period, as would the subject of the studio and domestic interior. Additionally, the Symphonic Interiors offer a strong sense of privacy, separating themselves from the seemingly more public decorative figure compositions that preceded them: the figure compositions depicted settings that convey an impression of distant, Arcadian solitude; the 1911 interiors demonstrate that Matisse could do something similar with contemporary subjects that represent retreats for the artist and his family.

As the year advanced, though, he seemed to be looking to give landscape a greater role. In the summer, Matisse painted two landscapes, including *View of*

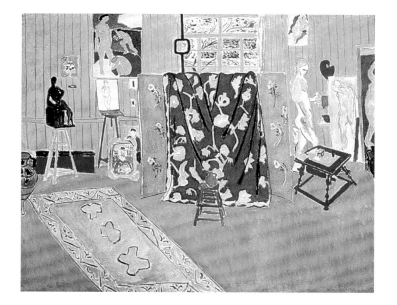

fig. 5
The Pink Studio, 1911
Oil on canvas
179.5 × 221 cm (70 5/8 × 87 in.)
The State Pushkin Museum of
Fine Arts, Moscow, 3295

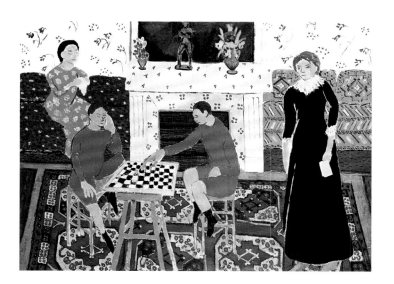

fig. 6
The Painter's Family, 1911
Oil on canvas
143 × 194 cm (56 1/4 × 76 3/4 in.)
The State Hermitage Museum,
St. Petersburg, 8940

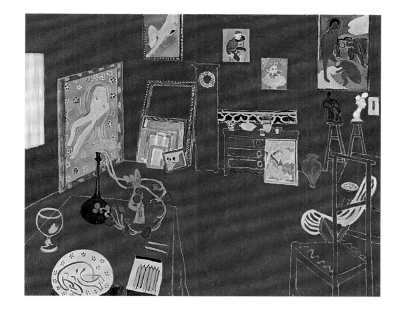

fig. 8
The Red Studio, 1911
Oil on canvas
181 × 219.1 cm (71 1/4 × 86 1/4 in.)
The Museum of Modern Art,
New York, Mrs. Simon
Guggenheim Fund, 1949

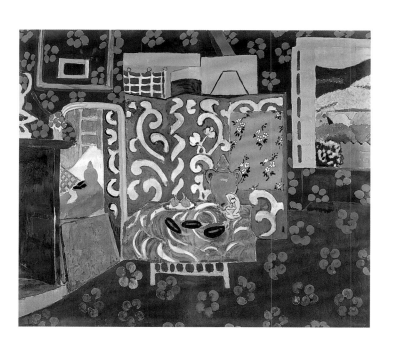

fig. 7
Interior with Aubergines, 1911
Distemper on canvas
212 × 246 cm (82 3/8 × 96 7/8 in.)
Musée de Grenoble

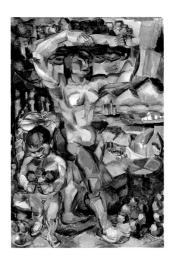

fig. 9
Henri Le Fauconnier
(French, 1881–1946)
Abundance, 1910–11
Oil on canvas
193 × 121 cm (76 × 47 ⁵/₈ in.)
Gemeentemuseum, The Hague

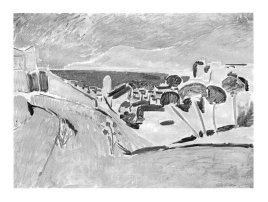

fig. 10
View of Collioure, summer 1911
Oil on canvas
90.2 × 118 cm (35 ¹/₂ × 46 ¹/₂ in.)
Private collection

Collioure (fig. 10), which baffled critics when they saw it at the Salon d'Automne. "Let's be frank, there is almost nothing there," the exasperated Vauxcelles complained. "If this goes on, Matisse will soon be giving us a white canvas."[32] As we have seen, this Salon presented a new generation of Cubists in force. Matisse's work displayed a "total absence of forms" and "the very opposite of cubism," Apollinaire wryly observed.[33] Matisse did not exhibit until many years later a very different painting that he also made in Collioure, the *Portrait of Olga Merson* (12.2), a work marked with structural reinforcements so much more prominent than those of *The Manila Shawl* that they have been attributed to the influence of Cubism. In fact, this painting introduces a new method of representing a Bergsonian sense of flux and becoming, namely, allowing the process of becoming an image to show in the final appearance of the painting.

One month after the Salon opened, the artist was on a train to Russia in the company of Shchukin, who wished to discuss future projects and gain the artist's advice about the installation of his pictures. This was the first time Matisse had viewed Shchukin's collection, and he was delighted to see the great Cézannes, Gauguins, and Van Goghs, in numbers rarely found in French collections, as well as many of his own works.[34] Matisse also visited Ivan Morosov and saw his collection; he, too, was interested in acquiring new works from the artist. And Matisse toured the collection of Ilya Ostroukhov to see Russian icons, which deeply moved him with their use of brilliant colors and simplified drawing. "They are really great art," he said. "I am in love with their moving simplicity which, to me, is closer and dearer than Fra Angelico."[35] By no means did all the Russian critics think that Matisse made great art: Cubism was also sweeping Moscow and, to some, Matisse seemed an old-fashioned decorator.[36]

Almost immediately upon his return, the artist and his wife left for Morocco, arriving in Tangier on January 29, 1912, and staying until April 14. The Franco-German crisis of 1911, which had taken French troops into Fez and a German cruiser into the Bay of Agadir, was finally resolved to France's advantage while Matisse was in Moscow, opening the country again to travelers. Nonetheless, Matisse decided against a visit to Fez because of rumors of unrest there, and he seems to have only left Tangier for an overnight visit to the scenic Rif village of Tétouan.[37] He had considered a visit to Tangier two years earlier, while in Spain, so he was finally fulfilling that plan.[38] By now his interest in profuse ornamentation was fading, but not his desire to see Morocco, as he remembered that Eugène Delacroix, whose work he had copied, had visited eighty years earlier. He also went there, he said, "because it was Africa."[39] His only previous taste of the continent had been just two weeks spent in Algiers in 1906, but years later he would recall them as fruitful, as they had spawned *Blue Nude* (1.3), the final point on the path from his Fauvist work of 1905–06 to something grander and more synthetic. "The voyages to Morocco," he remarked, "helped me accomplish this transition, and make contact with nature again better than did the application of a lively but somewhat limiting theory, Fauvism." His description is reminiscent of what he said of the influence of Persian miniatures; his work in Morocco, in fact, comprises the second chapter in the return of Matisse from being a painter of imaginative compositions to one mainly of perceptual experience.

Nonetheless, most of the canvases that Matisse produced on his first Moroccan trip—for instance, as seen with *Zorah in Yellow* (14.1)—were made using the same careful preliminary drawing and color infilling that he had used for his imaginative compositions and the Symphonic Interiors. But something had changed, and now it may fairly be said that the artist had indeed found in nature what he previously had to imagine. It would be going too far to say that Matisse had discovered in Morocco a real Arcadia; we know from his letters that he was not blind to the squalor in Tangier and the brutishness of some of its inhabitants. Only four days after arriving, he sent Gertrude Stein a postcard of female charcoal carriers, writing, "A country where feminists are completely unknown—unfortunately

because the men abuse the women."[40] But the landscapes were extremely beautiful, "just as they had been described in the paintings of Delacroix and in Pierre Loti's novels," the artist recalled. Insofar as Morocco was a wishful memory come true, it could be thought to be a kind of Arcadia, and Matisse did not object when his friend Marcel Sembat wrote that he had transformed the Moroccan landscape into a terrestrial paradise.[41]

It was, therefore, reasonable that he should use the technique of his imaginative compositions for landscape paintings such as *Periwinkles (Moroccan Garden)* (fig. 11), as well as figural works. However, as this watercolor-like landscape reveals, it led him to accept the freedom found in an *esquisse* but for a work that would not lead to a *tableau*. Indeed, Matisse needed access to the actual scene, not merely to a preparatory *esquisse*, if he were to realize a subject after constantly changing nature.[42] And the more variable the natural landscape, the more it resisted the spontaneous *esquisse* approach alone, as is shown by a work like *Acanthus (Moroccan Landscape)* (fig. 12), composed under the ever-changing, pearlescent blue-violet, late-afternoon light of a Tangier garden. That trembling, dusty light did not make nonsense of Matisse's preplanning, or of beginning with *esquisse*-like freedom, but it required him to make extended revisions of the surface, during which he scumbled and glazed layer upon layer of thin, transparent and translucent pigment, so that color finally came to seem suspended in some almost lacteal medium. Such a lengthy process, in which design would inevitably change along with color, was reminiscent of Cézanne; so was Matisse's application of pigment, "considering color as warm and cool" rather than "seeking light through the opposition of colors," as he had been doing since painting the Cézannist *Blue Nude* five years earlier.[43]

The extended revisionary process of works like *Acanthus (Moroccan Landscape)* meant that Matisse's closed-circuit conception of the creation of a work of art produced even more extended sequences of action and reaction. "To give yourself completely to what you're doing while simultaneously watching yourself do it—

fig. 11
Periwinkles (Moroccan Garden),
winter–spring 1912
Oil, pencil, and charcoal
on canvas
116.8 × 82.5 cm (46 × 32 1/2 in.)
The Museum of Modern Art,
New York, gift of Florene
M. Schoenborn, 1985

fig. 12
Acanthus (Moroccan Landscape),
1912
Oil on canvas
115 × 80 cm (45 1/2 × 31 1/2 in.)
Moderna Museet, Stockholm,
NM 2070

that's the hardest of all for those who do work by instinct," he wrote to his wife before returning from his first trip to Morocco.[44] Nonetheless, this process, and the new understanding of the pictorial surface it had produced, persisted in the paintings the artist made back at Issy in the late spring and summer of 1912, an extremely productive period in which he created a number of ambitious canvases, many dominated by blue. Some of these, such as *Goldfish and Sculpture* (19a), have a watercolor-like quality similar to some of the Moroccan paintings and likewise reveal that they were drawn first and then filled with loosely applied color, the brushstrokes showing. Others, however, reveal far denser, more homogenous blue grounds, like *Nasturtiums with "Dance" (II)* (fig. 13), which was prepared first as an *esquisse* (1912; Metropolitan Museum of Art), and *The Conversation* (fig. 15). Both are visibly reworked, and Matisse allowed the changes to show in a way that drew attention to the temporal process of painting.[45] In the latter, the combination of different treatments recalls the Symphonic Interiors, as does the geometry, but the dislocated right arm of the seated figure reveals an unprecedented acceptance of the display of alteration. The subject of *Nasturtiums with "Dance" (II)* is a rhythmic study of Bergsonian duration in the human and plant worlds, but Matisse went so far as to fake alteration, creating false pentimenti around the figures, thereby tying the temporal movement of the subject to that of the painting process. In so doing, the painting functions as a hinge between Matisse's older method of expressing duration through his subject matter and his newer one of revealing it through technique.

While back in France, Matisse likely followed what was happening in the Paris art world. We do know that during his first Moroccan trip, he received a letter from Georgette Agutte reporting on the Futurist exhibition at the Galerie Bernheim-Jeune. Of this event, which included major works by Giacomo Balla, Umberto Boccioni, Carlo Carrà, and Gino Severini, and made Futurism an important new avant-garde movement, she remarked:

There are among our friends some who are furious at the success of this with the press and the public. As for Druet, he is beside himself, [as] he had Valloton [*sic*] at the time [and] his exhibition was better than the others. I don't like it, but one has to be fair. You understand, it's true that it's comical what publicity can do! I find it amusing on the contrary and it should in no way be damaging for true artists.[46]

It is reasonable to assume that, during the summer at Issy, he may have asked Fénéon to show him Futurist paintings at the gallery. He probably saw Gleizes and Metzinger's book *Du "cubisme,"* which had just been published, and certainly Salmon's *La jeune peinture française*, with its sneering criticism of him.[47] "His real gifts are gifts of skill," the critic wrote, "flexibility, prompt assimilation, of an exact science, but one quickly acquired—feminine gifts." Matisse's taste has been greatly praised, but it is second rate: "It is a *modiste*'s taste, whose love of color equals the love of chiffon." Matisse cannot be ignored; he has a place in history. "But whom to follow: Matisse or Picasso?" Salmon asked, leaving no doubt as to his answer. This unpleasant text, more than any other, put into currency the idea that Matisse was a merely hedonistic painter; it is, of course, ironic that it appeared on the threshold of the least hedonistic period of his career.

In October 1912, Matisse returned to Tangier, where he soon received news from Agutte of the improbable debate over Cubism in the French parliament. In the Chamber of Deputies, a Socialist, Jules-Louis Breton, protested against the "artistic scandal" of the recent Salon d'Automne, which he found even more heinous because it was held in a national gallery, the Grand Palais.[48] In fact, the young Cubists were becoming obsessed by their place in the national tradition, situating themselves within a stream of influence that began in early French painting but whose course had been decisively reshaped by Cézanne.[49] As for the parliamentary debate, Marcel Sembat, Agutte's husband and Matisse's friend, who was also a Socialist deputy, quashed the protest, saying, "My dear sir, when a picture displeases you, you have one undeniable right: and that is not to look at it, and go and look at others. But

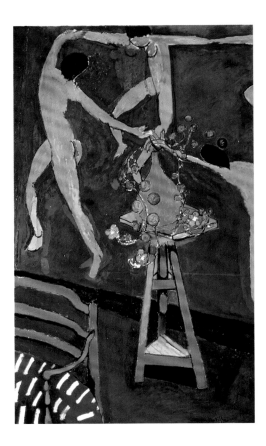

fig. 13
Nasturtiums with "Dance" (II), 1912
Oil on canvas
190.5 × 114 cm (75 × 44 7/8 in.)
The State Pushkin Museum of Fine Arts, Moscow, 3301

you don't call out the police."[50] As the many published parodies of this incident suggest, Cubism was still popularly viewed as a source of fun—for example, as tipsy figures painted by presumably drunken artists (fig. 14).[51]

Even as Matisse followed this adventure from Morocco, he was hard at work. He had decided to return there even before leaving for France at the end of his first trip. Indeed, he had then written to his wife, "Two ideas for paintings came to me, which I plan to carry out when I get back."[52] Shortly after returning, he wrote of developing these ideas, which would eventually produce *The Moroccan Café* (15c) and *The Moroccans* (44), but he did not immediately do so.[53] Instead, he took up where he left off, making figure paintings and landscapes. The scumbled, layered surfaces that had begun to appear during the first trip grew in prominence, overtaking even decorative figure paintings like *Fatma, the Mulatto Woman* (14.2). The light airiness of works like *Acanthus (Moroccan Landscape)* remained, but the outcome was more substantial, reflecting the progress that Matisse had made over the summer. The most developed manifestation of this approach is the so-called Moroccan Triptych (44c–e), whose thin layers of pigment, one above the other, are visible. The trio of identically sized canvases show different views of Tangier, like a set of picture postcards. As such, they extend the approach of Matisse's pair of Spanish still lifes, or of his four Symphonic Interiors, in shaping a small series of diverse images that, by the convergence of their subjects, direct us in a Bergsonian sense to the understanding of a single reality in flux. Presiding at the center of the triptych, the figure of Zorah, which has visibly grown in size, focuses the apprehension of duration within the process of painting itself.

But something critical had changed. In the Symphonic Interiors, color, shaped and apportioned, created form. In the Moroccan Triptych, the induced and enhanced spatiality of color substituted for form: images of built settings, like those of the earlier interiors, are seen as if under stretched gauze, inaccessibly veiled. The last of the Moroccan paintings, *The Moroccan Café*, retains that veiled effect, but this time produced with matte distemper to subdue bright color as well as to simplify. The field of gray-green celadon, a color associated with Asian pottery, covers reds, blues, and yellows in addition to eliminating the faces of the figures and a row of slippers along the base of the composition.[54] Sembat noted these changes on the occasion of Matisse's exhibition of Moroccan paintings and assorted sculptures at Bernheim-Jeune (fig. 16).

Sembat reported, quoting the artist, that Matisse had sought "peace of mind" in this picture, concluding that he had realized his persistent aim of achieving a "harmony of feeling."[55] In private, some people found this pretentious; hence, Charles Angrand wrote sarcastically of *The Moroccan Café* to Maximilien Luce, "These—Moroccan—allusions: I seem to see them: a large blank space [*espace blanc*],

fig. 14
Joseph Hémard, *Cubist Painting*, published in *Le rire* 508 (Oct. 26, 1912)

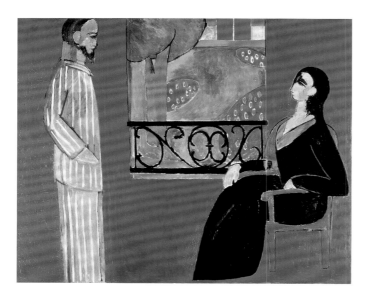

fig. 15
The Conversation, 1908/12
Oil on canvas
177 × 217 cm (69 5/8 × 71 3/8 in.)
The State Hermitage Museum, St. Petersburg, 6521

fig. 16
Installation view of *Exposition Henri-Matisse: Tableaux du Maroc et sculpture*, Galerie Bernheim-Jeune, Paris, April 14–19, 1913. Visible from left to right are *The Serf* (1900–04; D6), a Moroccan drawing; and the Moroccan Triptych, comprising *Landscape Viewed from a Window*, *On the Terrace*, and *The Casbah Gate* (44c–e). Photo Archive, The Museum of Modern Art, New York.

the canvas—and that's the Casbah—a ragged strip of blue, that's the infinite sky."[56] However, the published reviews were generally favorable. Apollinaire wrote that Matisse was "a great colorist," that his "line is purely instinctive, expresses the most subtle and refined sensuality found in any artist today," and that "*The Turkish Café* [*The Moroccan Café*] and *Gate to the Casbah* are among the very few acceptable works inspired by contemporary North Africa."[57] René Jean was the most enthusiastic, writing,

M. Henri Matisse is a colorist of remarkable refinement and subtlety, sensitive to the least nuances; he juxtaposes with boldness the most violent and the softest tones, to the point of attaining a sort of colored music that goes to the outermost limits of the pictorial domain. The canvases he brought back from Morocco are expressive and evocative. They are comparable to notes in pen and ink, done in sure, synthetic line and to sculptures whose systematic, voluntary deformation aims to emphasize the expression of faces or bodies.[58]

The terms of approbation used by these critics are sadly inadequate to the commanding vigor of Matisse's Moroccan paintings, being merely on the positive end of the same understanding of the artist that had produced Salmon's negative evaluation of him as an artist of "feminine gifts" with a "*modiste*'s taste." His reputation as a colorist had created this understanding, and the artist's own statements, from "Notes of a Painter" onward, had been complicit in its propagation. But this was about to change. Indeed, not long after the Bernheim-Jeune exhibition had closed, Matisse abruptly altered direction, and formal structure began to gain the upper hand over construction by means of color.

—JOHN ELDERFIELD

1. Apollinaire, "Prenez garde à la peinture! Le Salon des Indépendants," *L'Intransigeant* (Mar. 18, 1910); Apollinaire 1972, p. 65.

2. Charles Morice, "À qui la couronne?," *Le temps* (Feb. 22., 1910); Flam 1986, p. 281.

3. Louis Vauxcelles, "Review of Salon des Indépendants," *Gil Blas* (Mar. 18, 1910). The following year saw the publication of Wassily Kandinsky's seminal *Concerning the Spiritual in Art*, with its encomium on Matisse's importance. See p. 145 in the present publication for more about Kandinsky and Matisse.

4. The division in French society created by the Dreyfus Affair in the 1890s and early 1900s had not simply disappeared with the reinstatement in the French army of Alfred Dreyfus in 1906; indeed, chauvinism and anti-Semitism would increase in the years leading up to the outbreak of World War I in 1914. For more on the aftermath of the Dreyfus Affair in the second decade of the twentieth century, see Silver 1989.

5. Apollinaire (n. 1); Apollinaire 1972, pp. 65–66.

6. The 1910 exhibition showcased sixty-five painting and twenty-five drawings; the 1904 and 1906 shows contained forty-five and fifty-five paintings, respectively.

7. Matisse had signed a three-year contract with Bernheim-Jeune the previous September, offered to him by Félix Fénéon; his prices had been raised, so it made more sense to showcase the range of his art than to risk not sustaining the new prices by having too many works on sale. Fénéon was proving as astute a dealer as he had been a critic, paving the way for a total of five contracts between Matisse and Bernheim-Jeune, lasting until 1926.

8. J. F. Schnerb, "Petites expositions: 'D'après les maîtres,'" *La chronique des arts et de la curiosité* 17 (Apr. 23, 1910), p. 131.

9. Sacs 1919, p. 403.

10. Ibid.

11. Estienne, "Des tendances de la peinture moderne: Entretien avec M. Henri-Matisse," *Les nouvelles* 12 (Apr. 1909), p. 4.

12. For an eloquent account of this process and its implications, see Gowing 1979, pp. 106–07.

13. Tériade 1936, p. 3.

14. The exhibition—which included textiles, tiles, ceramics, metalwork, manuscripts, and coins—was organized by a committee headed by Hugo von Tschudi, the director of the Munich Staatliche Museen, whom the group met there.

15. Prichard to Matisse, Dec. 13, 1912, AHM; Cauman 1991, p. 3.

16. Matisse 1947a, p. 23. On Matisse's trip to Munich and the broad issue of the influence of "Oriental" art, see Duthuit 1997.

17. Matisse 1947a, p. 23.

18. The name was coined in Barr 1951, p. 151.

19. Of the Symphonic Interiors, only *The Painter's Family* depicts an event in a location.

20. For more on Matisse's interest in fabric, see Spurling 1998, pp. 78–79, 364–65; and Spurling and Dumas 2004.

21. Bergson 1911. The discussion of Matisse's debt to Bergson that follows is indebted to those in Flam 1986, pp. 243–44; and Flam 1995, pp. 33–34.

22. Matisse had journeyed first to Madrid, where he found the Prado "marvelous," citing his admiration of works by Francisco de Goya, El Greco, Diego Velázquez, and Tintoretto. Matisse to Marquet, Nov. 19, 1910, AHM.

23. André Salmon, "Courrier des ateliers," *Paris-journal* (Apr. 25, 1911), p. 4, announced Matisse's replacement of *L'Espagnole* by a very large canvas, *Interieur*. In a subsequent report, Salmon published what purported to be a letter to the editor, signed "Un groupe d'exposants," complaining of the favoritism of the officials of the Salon des Indépendants in having allowed this to happen; Salmon, "Courrier des ateliers," *Paris-journal* (Apr. 27, 1911), p. 5. See Elderfield 1992, pp. 70–71 n. 36.

24. The large number of Fauves showing in two of the galleries prompted sarcasm from some critics: Franz Richard's review was subtitled "Two Kilometers between the Fauves," while André Salmon, a card-carrying Picasso supporter, noting the presence of numerous Matisse students, sneered, "I would not be

surprised if the evening newspaper informed me of the election of M. Matisse to the Académie des Beaux-Arts." See Richard, "Le vernissage des Indépendants, deux kilomètres entre les fauves," *Gil Blas* (Apr. 21, 1911), p. 2; Salmon, "Le 27e Salon des Indépendants," *Paris-journal* (Apr. 20, 1911), p. 5. On this group, known as "the Salon Cubists," see Green 1976.

25. For this article, see *Paris-Midi* (Sept. 30, 1911).

26. Matisse did not participate in the Salon of the Cercle des Indépendants, which featured works by Le Fauconnier, Gleizes, Metzinger, Laurencin, and Léger. See André Salmon's discussion of this situation in "Courrier des ateliers," *Paris-journal* (May 26, 1911), p. 4.

27. Shchukin to Matisse, first half of Dec. 1910, AHM.

28. Elderfield 1992, cat. 282. These two aspects of a later painting, *Harmony in Yellow* (1928; private collection), are well described in Bridget Riley, "Painting Now," in Robert Kudielka, *The Eye's Mind: Bridget Riley; Collected Writings, 1965–1999* (Thames and Hudson, 1999), pp. 208–09.

29. Matisse may have chosen this medium for large works that had to be transported, presumably rolled, back to Paris because it was quick drying.

30. Flam 1986, p. 314.

31. Goldschmidt 1913.

32. Vauxcelles, "Le Salon d'Automne," *Gil Blas* (Sept. 30, 1911); Flam 1986, p. 314.

33. Apollinaire, "Le Salon d'Automne," *L'Intransigeant* (Oct. 12, 1911); Apollinaire 1972, p. 185.

34. Matisse was unhappy, however, to see that his works had been glazed and hung at a steep angle. While Shchukin altered the installation to please Matisse, he did not remove the patch of red paint that now covered the genitals of the flutist in *Music*. For more on Shchukin's collection and Matisse's visit to Russia, see Kostenevich, "A Visit to Russia, Autumn 1911," in Kostenevich and Semyonova 1993, pp. 23–36. See also Christopher Lyon, "Prelude to Morocco: Matisse in Moscow, 1911," *MoMA* 2, 5 (Summer 1990), pp. 8–15.

35. "U Matissa," *Ranee utro*, Nov. 8 (Oct. 26), 1911; Yu. A. Rusakov, "Matisse in Russia in the Autumn of 1911," *Burlington Magazine* 117, 866 (May 1975), p. 287.

36. In fact, a gibe attributed to Picasso had followed him there: "Matisse is a *cravate* – a colored necktie"; see ibid., p. 289.

37. See Elderfield, "Matisse in Morocco: An Interpretive Guide," in Cowart 1990, p. 217. For further information on Matisse's time in Morocco, see Cowart 1990, pp. 257–62; Duthuit 1997; and Benjamin 2003, esp. chap. 7, pp. 159–90.

38. In his letter to Marquet of Dec. 13, 1910, he stated that he had abandoned the idea of visiting Morocco, explaining, "The storm is not my element." He was probably complaining about the weather, as he often did, but he may have been referring to the colonial dispute.

39. Courthion recalled , in interviews with Jack Flam in Dec. 1979, that Matisse associated *Blue Nude* with Africa; see Flam 1986, p. 324. For "the voyages to Morocco," see Tériade 1952, p. 43.

40. Matisse to Stein, Feb. 22, 1912, Gertrude Stein and Alice B. Toklas Papers, Yale Collection of American Literature, Beinecke Rare Book and Manuscript Library, Yale University; Elderfield, "Matisse in Morocco: An Interpretive Guide," in Cowart 1990, p. 227.

41. Sembat 1920, p. 10.

42. Hence, Matisse felt compelled to take *Acanthus (Moroccan Landscape)* (fig. 12) back to Tangier with him on his second visit, since he was not convinced it was complete. See Cowart 1990, pp. 68–69, cat. 5.

43. Matisse explained the two systems to his students in 1908. See "Sarah Stein's Notes" (1908); Flam 1995, p. 52. See p. 50 in this publication for a discussion of these systems. However, whereas the cool blue surrounding that nude tends to recede in contrast to the warmer beige tones of the figure, the nominally cool blue-violet of the garden in *Acanthus (Moroccan Landscape)* does not recede because it is warmed by the pink layer beneath it; rather it clings to the surface, at once flattening and dematerializing it. An exception to the Cézannist approach, which formed a partial prototype for *Acanthus (Moroccan Landscape)*, is *View of Collioure and the Sea* of summer 1911 (private collection); see Elderfield 1992, cat. 142.

44. Matisse to Amélie Matisse, Mar. 31, 1912, AHM; Spurling 2005, p. 115.

45. The artist began *The Conversation* in the winter of 1908–09, not so long after the similarly painted *Bathers with a Turtle* (3). Unlike the majority of the 1911 interiors, it represents an event in a specific place. In other interiors completed in the summer of 1912, Matisse reintroduced narrativity by including representations of figural works of art—through images of the painting *Dance (II)* and the sculpture *Reclining Nude (I)* (1.2), as if he were seeking to conflate the subjects of the interior and of the figure composition, which is to say the principal subjects of 1909–10 and 1911. In 1911 he had turned from stories to places; now, in 1912, it seems that he was interested in stories in places.

46. Agutte to Matisse, Feb. 18, 1912, AHM.

47. Gleizes and Metzinger 1912. Salmon, "Les fauves," in Salmon 1912, pp. 15, 19.

48. Agutte to Matisse, Oct. 28, Nov. 12, and Dec. 8, 1912, AHM.

49. See Green 1976, p. 48.

50. Daix and Rosselet 1979, p. 285; and Cowling 2002, p. 367. This account comes from the *Journal officiel* of Dec. 3, 1912.

51. There was also a comedy film made in 1912 by Pathé starring a parody of a Cubist painter, George Monca's *Rigadin, peintre cubiste*. These parodies are discussed in Weiss 1994, pp. 199–200, 317 n. 128.

52. Matisse to Amélie Matisse, Apr. 12, 1912, AHM; Schneider, "The Moroccan Hinge," in Cowart 1990, p. 43.

53. Matisse to Amélie Matisse, Oct. 25, 1912, AHM.

54. Examination confirms that, while *The Moroccan Café* was drawn prior to painting in a form close to that of Matisse's sketch (p. 134), the artist altered and simplified it as it developed. This means that *The Red Studio* was the last ambitious preplanned composition that he completed by color substitution and without significant changes in the drawn layout.

55. Sembat 1913, p. 192; Flam 1988, pp. 147–48.

56. Angrand to Luce, lundi soir [mid-Apr. 1913]; Angrand, *Correspondances, 1883–1926* (F. Lespinasse, 1988), p. 250.

57. Apollinaire, "La vie artistique: Henri Matisse," *L'Intransigeant*, (Apr. 17, 1913), p. 2; Apollinaire 1972, p. 306.

58. René Jean, "Exposition Henri Matisse (Galerie Bernheim)," *La chronique des arts et de la curiosité (Supplément à la gazette des beaux-arts)* 16 (Apr. 19, 1913), p. 125.

11.1 Jeannette (I)
Issy-les-Moulineaux, January–March (?) 1910

Plaster, cast in bronze 1952 (LACMA), c. 1930 (MoMA);
32.7 × 27.9 × 27.9 cm (12 7/8 × 11 × 11 in.) (without base) (LACMA);
33 × 22.8 × 25.5 cm (13 × 9 × 10 in.) (without base) (MoMA)
Signed and numbered: *HM 4* (LACMA); *0/10 HM* (MoMA)
Inscribed on the base: *Cire – C. Valsuani – perdue* (LACMA, MoMA)
Chicago venue: Los Angeles County Museum of Art, gift of
the Art Museum Council in memory of Penelope Rigby, 68.3.1
New York venue: The Museum of Modern Art, New York,
acquired through the Lillie P. Bliss Bequest, 1952

IN EXHIBITION

11.2 Jeannette (II)
Issy-les-Moulineaux, January–March (?) 1910

Plaster, cast in bronze 1952 (LACMA), c. 1930 (MoMA);
26.7 × 30.5 × 27.9 cm (10 1/2 × 12 × 11 in.) (without base) (LACMA);
26.2 × 21 × 24.5 cm (10 3/8 × 8 1/4 × 9 in.) (without base) (MoMA)
Signed and numbered: *HM 5* (LACMA); *2/10 HM* (MoMA)
Inscribed on the base: *Cire – C. Valsuani – perdue* (LACMA, MoMA)
Chicago venue: Los Angeles County Museum of Art, gift of
the Art Museum Council in memory of Penelope Rigby, 68.3.2
New York venue: The Museum of Modern Art, New York,
gift of Sidney Janis, 1955

IN EXHIBITION

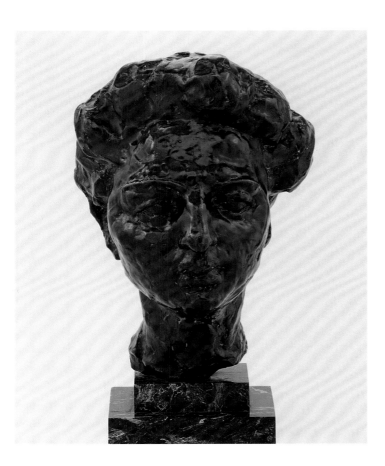

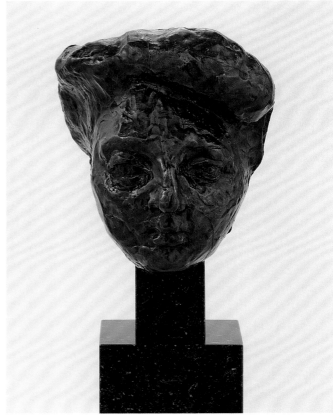

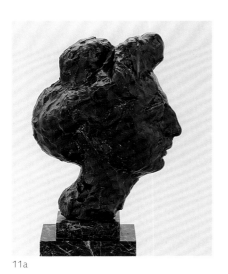

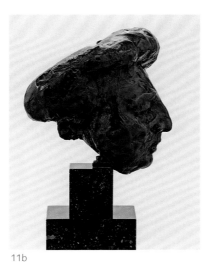

11a
Profile view of *Jeannette (I)*.

11b
Profile view of *Jeannette (II)*.

11a

11b

MATISSE'S FIRST TWO *Jeannette* sculptures [**11.1–2**], which were initially titled *Portrait of a Young Girl* and *State* [État] *of the Portrait of a Young Girl* (see p. 128) — and then both simply *Bust of a Woman* — were, as Amélie Matisse later recalled, made from life in 1910.[1] The sitter was Jeanne Vaderin, a young woman who was convalescing from an illness at a nearby house in Issy. She also posed for another pair of works: the vividly observed charcoal drawing *Girl with Tulips* [**11c**] and the decoratively schematic painting *Young Girl with Tulips* [**11d**], which was exhibited at the 1910 Salon des Indépendants, which opened in mid-March.

As *Jeannette (I)* was only Matisse's second life-size bust — the first, created in 1900, portrayed an old woman — he may have found it difficult to arrive at the psychological density and richness of articulation that he had

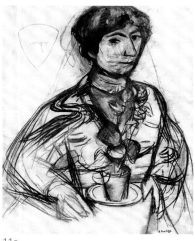

11c

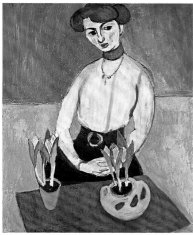

11d

11c
Girl with Tulips (Jeanne Vaderin), 1910. Charcoal on paper; 73 × 58.4 cm (28 3/4 × 23 in.). The Museum of Modern Art, New York, acquired through the Lillie P. Bliss Bequest, 1970.

11d
Young Girl with Tulips, 1910. Oil on canvas; 92 × 73.5 cm (36 1/4 × 29 in.). The State Hermitage Museum, St. Petersburg, 9056.

achieved in the smaller heads that he had been making with such immediacy since around 1903, and very productively in 1906 and 1907.[2] Indeed, he had remarked to Sarah Stein in 1908, "A sculpture must invite us to handle it as an object; just so as the sculptor must feel, in making it, the particular demands for volume and mass. The smaller the bit of sculpture, the more of the essence of form must exist."[3] Conversely, the larger the sculpture, the more difficult it is to shape the volumes and masses with the fingers and hands, and *Jeannette (I)* tells of clay having been pushed and mounded around a continuously modeled surface to form a cranial volume that is taken as a given, rather than as something to be found in the making. Perhaps it was because Matisse was developing, or had developed, *Young Girl with Tulips* as a composition of analogous ovals that he treated the big oval shape of the face in *Jeannette (I)* and *(II)* almost as a pictorial field that he could articulate with embedded, somewhat graphic features. Matisse said that he turned to sculpture to put "order to my sensations so as to seek the method that absolutely suited me. When I had found it in sculpture, it served me for painting."[4] In this case, the sculpture is pictorialized, and yet the freedom with which the features are arranged causes these parts to begin to threaten the unity of the whole.

In the drawing *Girl with Tulips,* Matisse turned the face from a frontal to a three-quarter view; in the process, he slid the features, producing asymmetrical eyes that seem oddly unrelated. The drawing takes on a task beyond that of portrayal, suggesting an analogy between the growth of the tulips and the upward swell of the model's body. Yet Matisse was interested, while making both the drawing and the sculpture, in identifying, clarifying, and vividly articulating the salient features of Vaderin's appearance. A full oval face with a pointed chin, sloping in a steep angle down to her throat and neck, is matched by a sharply defined, somewhat Roman nose that forms a similar, reverse slope up her forehead, where it meets the thick cap of her hair. Very prominent, asymmetrical eyes, heavy eyebrows, and strong cheekbones together create large oval craters on each side of her nose. Speaking of the series of works, the sculptor William Tucker observed, "The subject is not the woman's head, but the *process of making the woman's head.* The head is the vehicle of perceptual continuity, of recognition, no more."[5] Looking at *Jeannette (I),* however, this is not yet apparent; but we know that we will be able to identify the model when we see her represented differently.

Jeannette (II) was made on a plaster cast of the preceding sculpture. The modeling shows far fewer impressions of the artist's fingers, suggesting that Matisse spread soft plaster on top of the plaster cast with a

spatula of some sort, inscribing the eyes with a tool. But we cannot rule out the use of added clay. In any event, he simplified what he began with, eliminating details in four critical areas. First, he lessened the linearity of the eyebrows and cheekbones, giving greater visual weight to the orbital cavity and the shaped lids of the eyes within it. Second, he spread and smoothed the face to emphasize the ovoid mass of the head, causing the hair to seem wrapped over it. Third, he pared down the aquiline bridge of the nose to create one long slope running from its point to within the overlapping hair, and took away the neck, compacting the chin in a way that did injury to the mouth and lower cheeks. Fourth, he sliced off the ears and cut away the hair at the back, producing what is almost a mask.

The result is a work that relates to the similar face in *Young Girl with Tulips* — and in the contemporaneous *Marguerite with a Black Cat* (1910; private collection) — even more closely than its predecessor did.[6] It is also rougher and more expressive than *Jeannette (I)*, with a finish that is clearly not based on a unity of style or surface, but on a working process that was carried to a point that seems at once complete and provisional, open to being realized in some new, different way as yet unknown.[7] But *Jeannette (II)* is also paired with — and, indeed, the consequence of — *Jeannette (I)*, related to it in the same way that *Le luxe (II)* [**2.2**] is to *Le luxe (I)* [**2.1**]. Much later, when Matisse made notes about the casting of his five *Jeannette* sculptures, he separated the first two as a pair from the three that followed.[8]

1. For more on these titles, see London, Grafton Galleries, *Second Post-Impressionist Exhibition*, Oct. 5–Dec. 31, 1912, and New York, Little Galleries of the Photo-Secession (291), *An Exhibition of Sculpture—First in America—and Recent Drawings by Henri Matisse*, Mar. 14–Apr. 6, 1912. For Amélie Matisse's recollections, see Barr 1951, p. 140; and Barr Questionnaire VII. Barr also noted there that Matisse believed he made at least four of the heads within a single year at Issy-les-Moulineaux. See entry 13 in this publication for more on this possibility.

2. For more on *Bust of an Old Woman* (1900; D5), see Elsen 1968c, p. 31. The tiny *Head of a Child* (1903–05; D13) opened a sequence of wonderful small heads that included four works in 1906 (D24–25, 27–28) and four more in 1907 (D31–34), most of which, significantly, are of children. It is noteworthy that Matisse turned in 1910 to a young woman — older than a child but not a mature adult — to increase the size of his sculptural portraits.

3. "Sarah Stein's Notes" (1908); Flam 1995, p. 50.

4. Courthion 1941, p. 66.

5. Tucker 1974, p. 96.

6. For an illustration of *Marguerite with a Black Cat*, see Flam 1986, cat. 278, p. 276.

7. Tucker 1974, p. 98.

8. See Duthuit and de Guébriant 1997, p. 385; and entry 13 in this publication.

12.1 **The Manila Shawl**
Issy-les-Moulineaux, February–mid-April 1911

Oil on canvas; 118 × 75.5 cm (46 3/8 × 29 3/4 in.)
Signed and dated l.l.: *Henri Matisse 1911*
Private collection

IN EXHIBITION

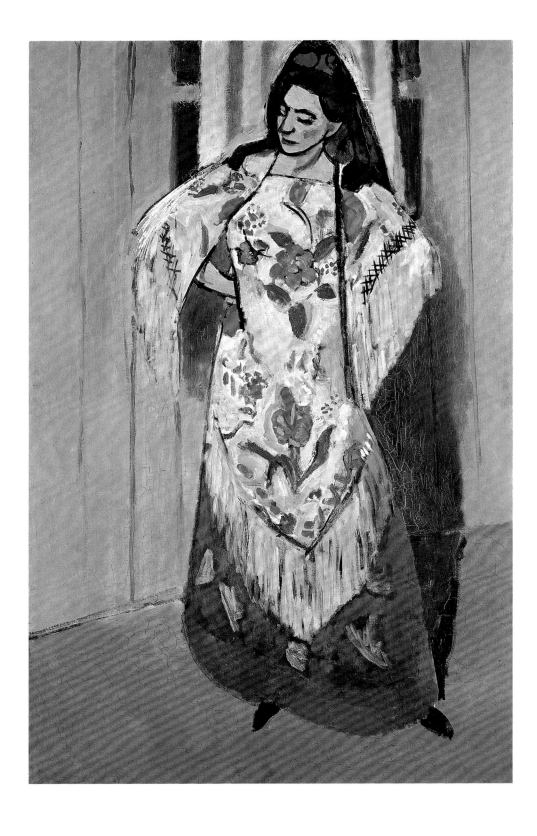

12.2 Portrait of Olga Merson
Collioure, July–mid-October 1911

Oil on canvas; 99.7 × 80.6 cm (39 1/4 × 31 3/4 in.)
Signed l.r.: *Henri-Matisse*
The Museum of Fine Arts, Houston, Museum purchase with funds
provided by the Agnes Cullen Arnold Endowment Fund, 78.125

IN EXHIBITION

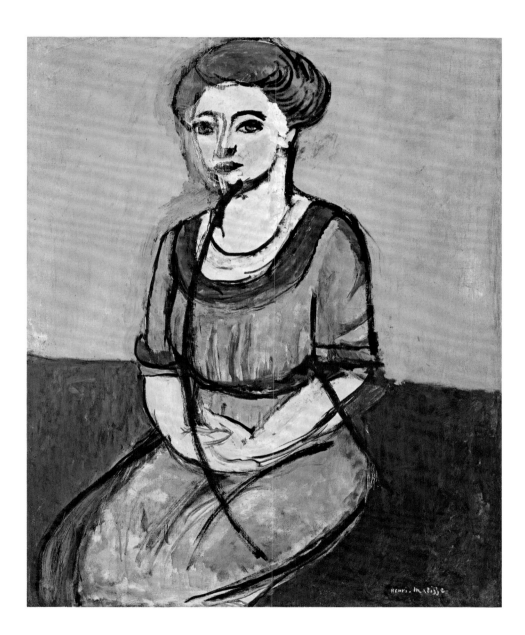

MATISSE PAINTED *The Manila Shawl* [**12.1**] after he returned in late January 1911 from a two-month trip to Spain, completing it before that year's Salon des Indépendants, which opened on April 21. In his review of the exhibition, Guillaume Apollinaire hailed the work, which was exhibited under the title *L'Espagnole,* as an "expressive and harmoniously painted Andalusian."[1] It is uncertain whether he realized that it showed Amélie Matisse dressed up in costume yet again, holding the pose of a flamenco *bailaora,* with arms behind her waist and one foot forward.[2] If the critic had visited Matisse's slatted-wall studio [**19g**], he would have known it had not been painted in Spain.[3]

The artist purchased the shawl in Seville, along with other textiles that run riot over a pair of interiors painted there (p. 111, figs. 3–4), works that mark the start of his reengagement with the decorative arabesque, which had formed a counterpoint to the stripped-bare figure compositions of 1908 and 1909 such as *Bathers with a Turtle* [**3**].[4] *The Manila Shawl* effectively blends the two modes, confining a sample of spreading pattern to a flat figural shape. The shawl itself is a painterly tour-de-force, elaborating the analogy of woman and flower—the theme of *femme-fleur*—in a manner both showy and tender, while the extraordinary shadow-shapes make space for the figure, as if setting it within a niche, and also corroborate its pasted-on appearance. Most dramatically, the tall shadow on the right—dark viridian over the pink floor, dark ultramarine over the cobalt wall—rises above the model's black shoe like a giant, flat exclamation point. Both of these aspects anticipate the large decorative interiors such as *The Red Studio* (p. 113, fig. 8) that would follow in 1911, and that properly form the principal context in which this painting has been studied.

Of particular interest here, however, are three other features, two of which have been less noticed. First—and already acknowledged—is the collagelike effect produced by a figure seemingly pasted upon the surface of the canvas. This suggests its influence on, and dialogue with, the work of Picasso and Braque, who began to use collage the following year.[5] Second, the figure is not, however, merely set flat against the surface: Matisse incised and scraped the contours around its head and right upper arm to excavate it from its surroundings [**12a**]. And third, he articulated the figure in relation to its setting through three strong, dark verticals that are hidden in plain view, one on each side of the torso and another running through the tall shadow at the right. Although both the scrapings and the verticals masquerade as representations of occluding edges, they are actually notational marks that represent the

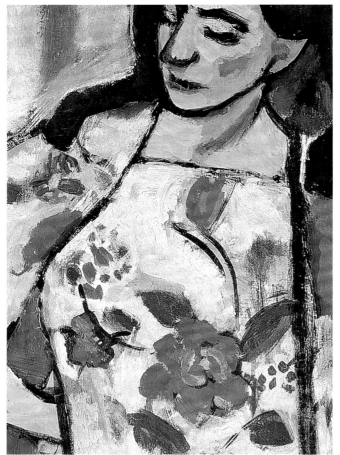

12a

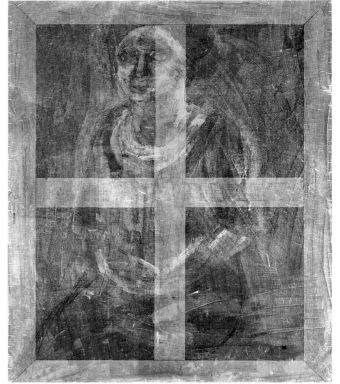

12b

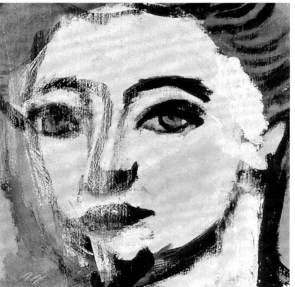

12c

12d

12a
Detail of *The Manila Shawl*, showing the dark verticals on either side of the torso and the incised and scraped contours around the head and right upper arm.

12b
X-radiograph of *Portrait of Olga Merson*, revealing the changes to the figure.

12c
Detail of *Portrait of Olga Merson*, highlighting the vertical tracks caused by paint scraped from the face on the left side; the right side shows how Matisse added paint to build the surface.

12d
Detail of *Portrait of Olga Merson*, showing the sharp-angled contour, scraped back, in the right hip.

movement of Matisse's hand in response to the model and to his canvas, discovering her precise posture within the vertical field.

These aspects associate *The Manila Shawl* with a painting made some six months later, *Portrait of Olga Merson* [**12.2**], which depicts a woman with whom Matisse had a complicated and ultimately unhappy relationship.[6] It draws on the format that the artist had used for *Young Girl with Tulips* of 1910 [**11d**], a *femme-fleur* motif set on a bisected ground of complementary colors, with the uppermost one close to that of the dress. But whereas the subject of the earlier portrait offers an illustration of growth and becoming, this one manifests those attributes through its own improvisatory creation. The image of Merson hovers against the thinned, grayed viridian and dense ultramarine background, her dress shaped from dabbed and dripped patches of viridian and chrome green interwoven with accents of burnt sienna and raw umber. Her flesh ranges from patches of exposed, bare ground to dense, pasty areas of pinkish and cream-to-ocher tones, many of them scratched, scumbled, and wiped.

Visible changes to the composition and signs of contours having been moved, overpainted, and repositioned are especially notable above the horizon line on both sides of the figure, more extensively at the left. X-ray examination [**12b**] confirms that the form was reduced in size and that the head, which had tilted toward the left, was straightened and moved to the right, the face extended by a patch of light gray over part of the hair and ear. And, very noticeably, Matisse scraped away paint as he scoured vertical tracks on each side of Merson's face and down her nose, as if wishing to bring these elements onto the same plane [**12c**]. In the process, he exposed, at the left side of the head, multiple contours that denote changed positions for the nose, mouth, and cheek, but no new, definitive boundaries. On the opposite side, however, Matisse covered the vertical track produced by scraped-off paint with separate patches of pigment, which reminds us that he also made a sculpture of Merson, *Seated Nude (Olga)* (1911; D49), whose surface is an aggregate of patches of clay. In the painting, they visibly lie on top of the pictorial surface, pulling Merson's neck and temple forward while distancing the scraped-down line of the cheek at the left.

The X-radiograph tells us that, in the lower part of the painting, the right hip was originally shaped in a more naturalistic curve. Matisse replaced this with a sharp-angled contour, only to scrape back the point of the angle a bit, lining it up with the elbow above [**12d**]. Across the painting, at lower left, he scraped away a long sliver of dress, reinstating it in a solid dark green within a reinforced external contour whose shape answers that of

the opposite thigh. These changes must have come late in the process, for they connect to the cat's cradle of scaffolding that wraps and shapes the figure. The parallel lines that define the outside and inside of the upper arms attach to the loop at the waist, which is crossed at one side by a line from the armpit to the hip. On the other side, a parallel, even more surprising line extends all the way from the chin, across the torso and lap, to the base of the thigh.[7] The former alone would have settled the figure's position; the latter reads somewhat as a mark of cancellation as well as of postural affirmation. Yet together, like the dark lines added to *The Manila Shawl,* they vitalize the figure, introducing the subtle suggestion that Merson has somehow floated up to the top of the pictorial rectangle. In both instances, additionally, they speak of Matisse's increasing willingness not merely to let the methods of his construction show, but to explicitly draw these methods to the viewer's attention. This fact was not noticed in contemporaneous reviews of *The Manila Shawl*, and *Portrait of Olga Merson* remained unexhibited until 1938. Hence, in the fall of 1911, Apollinaire could still speak of Matisse as "the master of powerful and mellow colors."[8] In retrospect, however, it is clear that Matisse was in the process of reshaping his art to make it even more powerful and far more than merely pleasant.

1. Apollinaire, "The Salon des Indépendants," *L'Intransigeant*, (Apr. 21, 1911). This painting was titled *The Manila Shawl* for Matisse's first retrospective exhibition in 1931; however, the artist was not deeply involved in that undertaking. The canvas was probably completed well before the Salon opened, because Matisse soon replaced it with the large, recently competed *Pink Studio* (p. 113, fig. 5). On Apr. 25, André Salmon wrote that the switch had been made on Sunday, which would have been Apr. 23; see Salmon, "Courrier des ateliers," *Paris-journal*, Apr. 25, 1911, p. 4, and Apr. 27, 1911, p. 5. There are a number of reasons why Matisse might have substituted the paintings: possibly because *The Manila Shawl* had been sold to an impatient collector; or possibly because it had already been favorably reviewed, and he wanted to gain additional notice for *The Pink Studio*. Spurling 2005, pp. 72–73, suggested that Matisse's strained relationship with his wife at the time caused him to withdraw it. The fullest account of this work appears in Flam 1986, pp. 296, 300.

2. Those who had regularly followed Matisse's work would have known that his wife had posed in costume for earlier paintings, including *Madame Matisse in a Japanese Robe* (1901; private collection); *The Guitarist* (1902–03; private collection); and *Madame Matisse, Red Madras* (1907; The Barnes Foundation, Merion, Penn.).

3. This work belongs to the mode of exotic costume paintings, which was how it would have been received, especially since it was exhibited with a canvas catalogued as *La gitane*, now known as *Joaquina* (1911; National Gallery, Prague), which was painted in Spain; see Schneider and Préaud 1970, p. 77, cat. 103. It belongs to a French tradition, stretching back to the eighteenth century, of representing Spanish dancers on stage, and may even draw upon Édouard Manet's notorious contribution to this tradition, *Lola de Valence* (1862–after 1867), whose entry into the Musée du Louvre with the Camondo bequest was finalized in 1911, though it was not

displayed until 1914; see Françoise Cachin, Michel Melot, Charles S. Moffett, and Julia Wilson Bareau, *Manet, 1832–1883*, exh. cat. (Metropolitan Museum of Art/ Harry N. Abrams, 1983), pp. 146–50, cat. 50. But *The Manila Shawl* also draws upon an understanding of Spain as "Moorish" and "Oriental"; the shawl itself, known as a *mantón*, reinforces this interpretation, since *mantónes* were made in Seville from Manila silk on the model of Chinese shawls. For more on Matisse's relationship to the exotic, see Philip Larson, "Matisse and the Exotic," *Arts Magazine* 49, 9 (May 1975), pp. 72–73; Pierre Schneider, "The Moroccan Hinge," in Cowart 1990, esp. pp. 25–32; Roger Benjamin, "Orientalist Excursions: Matisse in North Africa," in Turner and Benjamin 1995, pp. 71–83; and Claude Duthuit, "La luce nasce sempra dall'Est," in Duthuit 1997, pp. 23–79.

4. These are *Seville Still Life* (p. 111, fig. 3) and *Spanish Still Life* (p. 111, fig. 4), both painted in the winter of 1910–11. See Flam 1986, pp. 295–96; and Kosme De Baranano, "Matisse e Hurrino," *Goya* 205–06 (July–Oct. 1988), pp. 94–98. For a broad consideration of the artist's use of textiles in his paintings, see Spurling and Dumas 2004.

5. For more on this collagelike effect, see Flam 1986, p. 314; for more on *papier collé*, see the discussion following Christine Poggi, "Braque's Early Papier Collés: The Certainties of Faux Bois," in *Picasso and Braque: A Symposium*, ed. Lynn Zelevansky (Museum of Modern Art, 1992), pp. 153–55.

6. Matisse created this work in Collioure, where he stayed from July through Sept. 1911. Spurling 2005, pp. 85–86, noted that Amélie and her two boys returned to Paris in early Oct., while Matisse, his daughter, and Merson stayed on for a week, during which time the portrait may have been painted. We do know that Matisse was still in Collioure on Aug. 29, for Kostenevich and Semyonova 1993, p. 170, noted that there is a Sept. 3 letter in which Shchukin mentioned a letter from Matisse dated Aug. 29 and was pleased to hear that the artist was hard at work in Collioure. For more on Merson, see ibid., pp. 16–22, 74–97; and Flam 2003, pp. 73–74, 79, 85, 237–38. Given the relationship's unhappy end, the pair of crescent-shaped lines that run down the figure have been interpreted as both the artist's assumption of control over the sitter and his way of distancing himself from her; see Klein 2001, pp. 160–61, 268 n. 36.

7. Barr 1951, p. 131, related this to *Portrait of Yvonne Landsberg* (28): "It is as arbitrary as some of the linear devices which the Cubists were developing at that time. At one scimitar-like stroke it seems to break the image, to remove it from ordinary visual conventions both of reality and of previous figure drawing. The effect is challenging, literally iconoclastic, though cruder than similar but more organic devices in some of Matisse's later portraits such as Yvonne Landsberg of 1914."

8. Apollinaire, "Le Salon d'Automne," *L'Intransigeant* (Oct. 12, 1911). *Portrait of Olga Merson* appeared in New York, Wildenstein & Co., *Great Portraits: Impressionism to Modernism*, Mar. 1–29, 1938, no. 25, as *Olga*, dated 1910. See Wildenstein & Co., *Great Portraits: Impressionism to Modernism*, exh. cat. (Wildenstein & Co., 1938), p. 30, cat. 25.

13.1 **Jeannette (III)**
Issy-les-Moulineaux, April–September
1910 or February–mid-July 1911

Plaster, cast in bronze 1952 (LACMA), c. 1930 (MoMA);
59.7 × 30.5 × 30.5 cm (23 1/2 × 12 × 12 in.) (LACMA);
60.3 × 26 × 28 cm (23 3/4 × 10 1/4 × 11 in.) (MoMA)
Signed and numbered: *HM 4* (LACMA); *HM 5/10* (MoMA)
Inscribed on the base: *Cire – C. Valsuani – perdue* (LACMA, MoMA)
Chicago venue: Los Angeles County Museum of Art, gift of the
Art Museum Council in memory of Penelope Rigby, M.68.48.1
New York venue: The Museum of Modern Art, New York,
acquired through the Lillie P. Bliss Bequest, 1952

IN EXHIBITION

13.2 **Jeannette (IV)**
Issy-les-Moulineaux, April–September
1910 or February–mid-July 1911

Plaster, cast in bronze 1951 (LACMA), 1931 (MoMA);
61 × 27.9 × 27.9 cm (24 × 11 × 11 in.) (LACMA); 61.3 × 27.4 × 28.7 cm
(24 1/8 × 10 3/4 × 11 1/4 in.) (MoMA)
Signed and numbered: *HM 4* (LACMA); *5/10 HM* (MoMA)
Inscribed on the base: *Cire – C. Valsuani – perdue* (LACMA, MoMA)
Chicago venue: Los Angeles County Museum of Art, gift of the
Art Museum Council in memory of Penelope Rigby, M.68.48.2
New York venue: The Museum of Modern Art, New York,
acquired through the Lillie P. Bliss Bequest, 1952

IN EXHIBITION

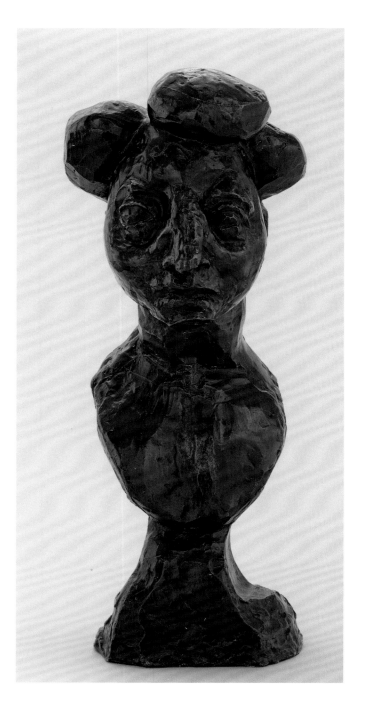

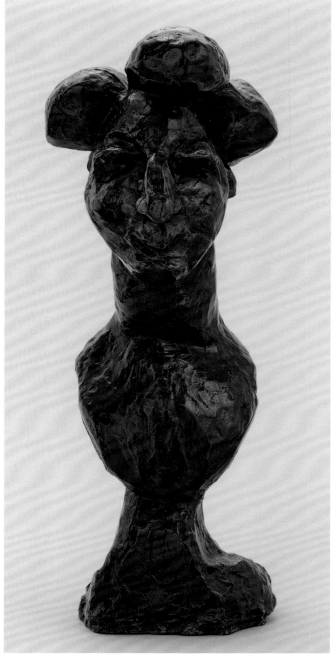

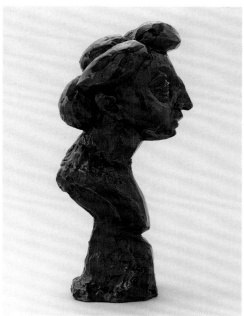

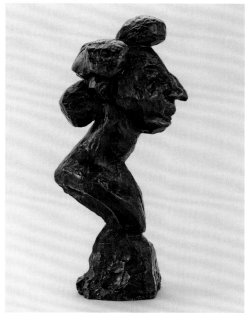

13a

13b

THE COMPLEX CHRONOLOGY of *Jeannette (III)* and *(IV)* [**13.1–2**] is worth exploring, both for the insight it offers into Matisse's serial practice and because the ultimate date of these works in large part determines what the artist may have set out to accomplish. In 1951 he twice told Alfred H. Barr, Jr., that he made the first four—and perhaps all five—heads within a single year; however, he later remarked that he might have made *Jeannette (V)* afterward.[1] Nonetheless, learning that only the first two were done directly from the model, Jeanne Vaderin, and knowing that Matisse's memory for dates was often unreliable, Barr concluded that the remaining three "were done later as variations on a theme, but how much later is uncertain."[2] One difficulty in evaluating this assessment is that we cannot be sure precisely when the first two sculptures were made. We do know that Matisse had completed a painting of Vaderin by mid-March 1910, but it is uncertain whether she also posed for *Jeannette (I)* and *(II)* [**11.1–2**] around that time or later in the year. On balance, the former seems most likely.

The writer Felius Elies visited Matisse's studio, most likely in early November 1910; using the pseudonym J. Sacs, he later reported that there "were scattered about several seriated molds of a bust of a woman in the course of despiritualization; the last of these sculptural states is not yet the definitive one and yet it already provoked a strange, unknown horror, something akin to the image of the cadaver of reason, the decomposing corpse of Intelligence."[3] Since "several" and "last" presumably refer to more than two objects, Elies's article suggests that Matisse had completed *Jeannette (III)* by then, and possibly also *Jeannette (IV)*. However, precisely because they appear to comprise a pair, *Jeannette (III)* may well have been "the last of these sculptural states" that Elies saw, since Matisse also told him that he had not yet made "the definitive one," which at that point could only have been *Jeannette (IV)*.[4] Because Elies's account was not published until 1919, he might easily have encountered "several" *Jeannettes* at a later date, misremembering that he had actually seen in 1910 only the first two works, or possibly more than one plaster cast of each. Indeed, the sculpture that he describes as being the last of these states—akin to a cadaver or a decomposing corpse—could very well be *Jeannette (II)*, and less plausibly *Jeannette (III)* or *(IV)*.[5]

At the very least, we can be certain that *Jeannette (III)* and *(IV)* were completed by the end of October 1911, and likely before Matisse left for Collioure on July 30, returning in mid-October, since a plaster of *Jeannette (IV)* appears in *The Red Studio* (p. 113, fig. 8), painted immediately upon his return. That same October, before leaving Issy for trips to Russia and Morocco that would keep him

13a
Profile view of *Jeannette (III)*.

13b
Profile view of *Jeannette (IV)*.

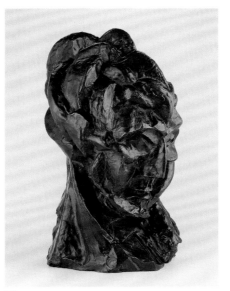

13c

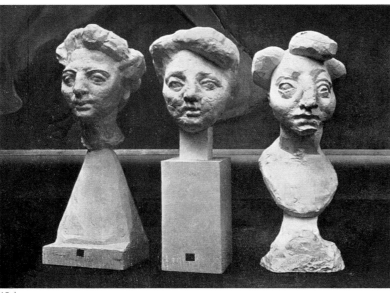

13d

13c
Pablo Picasso (Spanish, 1881–1973). *Head of a Woman (Fernande)*, fall 1909. Bronze; 40.7 × 20.1 × 26.9 cm (16 1/8 × 9 7/8 × 10 9/16 in.). The Art Institute of Chicago, Alfred Stieglitz Collection, 1949.584.

13d
Photograph from the catalogue for the *Second Post-Impressionist Exhibition*, Grafton Galleries, London, 1912, showing plaster casts of *Jeannette (I)–(III)*.

13e
Photograph reproduced in the catalogue for the *Second Post-Impressionist Exhibition*, showing a bronze cast of *Jeannette (IV)*.

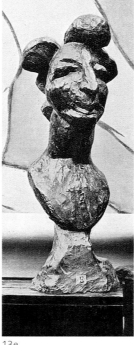

13e

away until April, Matisse arranged for plasters of the first three *Jeannettes* to be sent to an exhibition in New York that opened in mid-March of 1912.[6] There the first was shown as *Portrait of a Young Girl* and the second and third as *State (État) of the Portrait of a Young Girl*. However, it was clear that the artist then considered *Jeannette (IV)* as the culminating work of the series, for he held it back from the display so that it could be cast in bronze.[7] This bronze was later shown, along with the earlier three plasters [**13d–e**], in Roger Fry's *Second Post-Impressionist Exhibition* in London in October 1912, as the first through fourth states of *Bust of a Woman*.[8]

This series of four works, however, is not a strict progression from the least to the most definitive. Just as *Jeannette (I) and (II)* comprise more restrained and more expressive versions of the same subject, so do *Jeannette (III) and (IV)*. Moreover, insofar as these two works derive from the pair that preceded them, Matisse built his series not iteratively but reiteratively: not simply from a string of single works, each one the consequence of its predecessor, but from pairs of works, the first sculpture in the second pair looking back to the first of the opening pair, even as it succeeds its immediate predecessor.[9]

Speaking in 1912 of making the second of a pair of paintings, Matisse said, "I always strive to give the same feeling, while carrying it further."[10] This was also true for making the second works in each pair of busts. Additionally, though, the second pair, as a whole, carries further the feeling of the first pair, moving it into a more extreme direction. Much later, Matisse explained his process to E. Tériade: "The reaction of each stage is as important as the subject. . . . At each stage, I reach a balance, a conclusion. At the next sitting, if I find that there is a weakness in the whole, I make my way back into the picture by means of the weakness—I re-enter through the breach—and I reconceive the whole."[11] In the case of *Jeannette (III)* and *(IV)*, Matisse surrendered his earlier notion of the head as a unitary whole with a continuously modeled surface; instead, he chose to separate, and thereby privilege, its component parts.[12]

After the minimal, masklike *Jeannette (II)*—a work "without ears, hair truncated at left rear," as Matisse characterized it—*Jeannette (III)* is about rebuilding.[13] The artist described this sculpture as "with neck and partial bust; face thrust forward, base integrated with sculpture," and, indeed, there is so much new about it that only the profile view reveals its origin in the preceding work. But even there, Matisse used a knife or another tool to cut into the mass of plaster that was his starting point, excavating sets of crisply articulated volumes for the facial features and, most conspicuously, for the hair.

That process involved some rebuilding, either with plaster or clay. As for the unquestionably new parts—everything from the jawline down—he must have made a neck, partial bust, and base, almost certainly built onto an armature, and set onto it the reshaped head. Hence, having reduced the portrait to a mask in *Jeannette (II)*, Matisse more than reversed himself, forming *Jeannette (III)* from three big volumes of head, bust, and base. What was before a monolith now became a pile of monoliths of roughly similar heft, composing a tripartite column, with the head gaining new force by virtue of its topmost position. The three analogous clusters that mark the eyes and mouth, pulled away from the huge axial nose, recall the organization of the sculpture as a whole, as do the three aggregated, analogous volumes for hair, visible from the front.

The amazing nose, now longer and hooked, attaches well in front of the eyes, and the slope from nose to brow penetrates the overhanging hair. From the ears, a similar slope moves down to the chin, which has somewhat of an upward hook [**13a**]. All of this gives the head, in profile, a big triangular shape, "the face thrust forward," as Matisse said. Within it, the orbital sockets frame lidded eyes that are set back into, and protrude from, the skull. The lower cheeks are now weighted against the upward lift of the hair. Apparent throughout is Matisse's vivid awareness of how matter can be aggregated, lumped, and visually shaped. As a painter, he registered volume and concavity in the tonal shifts across a face. In *Jeannette (III)*, we can see how, as a sculptor, he manipulated his materials in order to produce such tonal shifts in the viewer's perception. In doing so, he recognized that these simplified, physically separated forms would be perceived not as a deconstructed anatomy but rather as the components of a clearly constructed image.

Matisse did not imagine a monolith behind the broken surface, a mere clustering of separated volumes around an implied core. This fact makes the work's precise date of more than archival interest, for the question arises as to whether he could have seen Picasso's *Head of a Woman (Fernande)* of fall 1909 [**13c**], which fits such a description, and to which he may have responded. The artist might have encountered this work in Picasso's studio, but he would certainly have seen it after Ambroise Vollard purchased it in 1910, arranged for it to be cast, and exhibited it at his gallery from December 20, 1910, to February 1911, with four other sculptures by the artist.[14] Moreover, Vollard featured it in the front window or inside his gallery over the next several years, where it had a profound impact on sculptors from Alexander Archipenko and Umberto Boccioni to Raymond Duchamp-Villon and Henri Laurens, who saw

it in 1911 and 1912.[15] Hence, if *Jeannette (III)* and *(IV)* were not made until 1911, they may certainly be viewed as a response to Picasso's work. Whereas in *Head of a Woman*, Picasso applied the faceting of 1909 Cubist painting to the surface of a preconceived volume, in *Jeannette (III)*, Matisse rejected preconceived volumes: dispersing as well as gathering as he built, he placed volume next to volume, reunifying the parts in a newly discovered object.

In *Jeannette (IV)*, he developed the volumes independently, seeming hardly to connect them to the real Jeanne Vaderin—and only barely to each other. Matisse described this sculpture as "Same as 3rd, but mass of hair more simplified, the face more angular."[16] This suggests that, working on a plaster cast of *Jeannette (III)*, he cut into the hair to produce the series of plumed, rhyming growths that extend from midway down the neck to in front of the brow, and generally reduced the bulk of the head as he shaped a new, gangly, elongated appearance. To that end, he thinned and lengthened the neck, pushing upward the newly narrowed head; he also further smoothed the path from the hairline to the tip of the nose, which now ends in a beaklike protrusion. This, together with the chevron smile and the lifted chin, creates the look of a smirking Pulcinella [**13b**]. Deep crevices appear on both sides of the nose because the artist added clay or plaster to fill in the orbital sockets; this obliterated the earlier eyes, which Matisse replaced with hooded gashes. The jaw, cheeks, and chin are composed of cut, faceted planes, which confirms that Matisse, by this point, had a blade among his sculpting tools. This emphasis on the process of making, which increased through the series, culminates in *Jeannette (IV)*: everywhere, the surface looks built, pushed, molded, smoothed, carved, and scraped. We do not merely picture a figure made from a particular material; first we notice the material, which we then see has been worked into a semblance of a figure whose uneasy, plangent affect comes from our seeing how very far it now is from a surrogate person.

1. Barr 1951, pp. 140, 538 nn. 7–8. Barr's note reads that Matisse was questioned twice (Barr Questionnaires V and VI), and Amélie once (Barr Questionnaire VII). Barr Questionnaire V raises questions about the dating of the *Jeannettes* but does not back up the statement that four or all were made in the same year. Barr Questionnaire VI reads: "All from the same year; succession correct; painting in Moscow—Tschoukine: *Jeune fille aux tulipes*; done with ordinary means." Regarding the possibility that *Jeannette (V)* was created later, Barr Questionnaire VI reads: "After 1912? [. . .] It's possible, but I couldn't say." Barr Questionnaire VII reads: "Done after 1912? [. . .] M: That is possible, but I can't say—H.M."
2. Barr 1951, p. 140.
3. Sacs 1919, p. 403. Sacs referred to standing with Matisse in his studio in front of *Music* (p. 77, fig. 2); if this was so, this must have been after the Salon d'Automne (where this painting was shown), which closed on Nov.

8, and prior to Nov. 16, when the artist, having dispatched the painting to Shchukin, left for Spain. This is not to say, however, that Matisse had necessarily been working in the fall of 1910 on the sculptures that Sacs described.
4. It is inconceivable that Matisse had already imagined making what would become the sculpture's final state, *Jeannette (V)* (42), which he would not turn to for at least another three and perhaps six years.
5. Matisse's schematic drawing of *Jeannette (II)* in his record of its casting history bears the title *Jeannette Masque* (42c).
6. The exhibition was held at 291 Gallery, Mar. 14–Apr. 6, 1912, and was organized by Edward Steichen and selected by the artist with Steichen.
7. Dauberville and Dauberville 1995, vol. 2, cat. no. 794: "*Buste de femme*" (*Jeannette [III]*); Sculpture en bronze, épreuve n° 1 sur 10. Déposée par Henri Matisse à MM. Bernheim-Jeune le 16 janvier 1912, prix de vente: 400 fr."
8. The exhibition was held at Grafton Galleries, Oct. 5–Dec. 31, 1912. The sculptures are referred to as follows (although not listed in this order): *Buste de femme (Plâtre. Première état)*; *Buste de femme (Plâtre. 2me état)*; *Buste de femme (Troisième état)*; and *Buste de femme (Bronze)*. Matisse would not include *Jeannette (IV)* with the first three plasters in his 1913 Bernheim-Jeune show in Paris or his 1915 Montross Gallery exhibition in New York.
9. This recapitulative method of advancement will become explicit with *Jeannette (V)* (42), which is literally built on a plaster of *Jeannette (III)* rather than on its immediate predecessor.
10. MacChesney 1913.
11. Tériade 1936.
12. Gowing 1979, p. 89, commented that Matisse engaged "the capacity of modelling to endow physical forms with a separate life, so that they grow and gather of their own accord a rhythmic coherence that is recognized as the hermetic life of art."
13. Matisse, undated manuscript notes, AHM.
14. Matisse was in Spain when the exhibition opened but was back in Paris before it closed.
15. See Valerie J. Fletcher, "Process and Technique in Picasso's *Head of a Woman (Fernande)*," in Jeffrey Weiss, ed., *Picasso: The Cubist Portraits of Fernande Olivier* (National Gallery of Art, Washington, D.C., 2003), pp. 171–72, 181–83.
16. See Matisse (n. 13).

14.1 **Zorah in Yellow**
Tangier, first half of April 1912

Oil and pencil on canvas; 81.3 × 63.5 cm (32 × 25 in.)
Signed l.l.: *Henri-Matisse*; inscribed and dated on verso:
Tangier 1912. Marocaine en jaune
Private collection

IN EXHIBITION

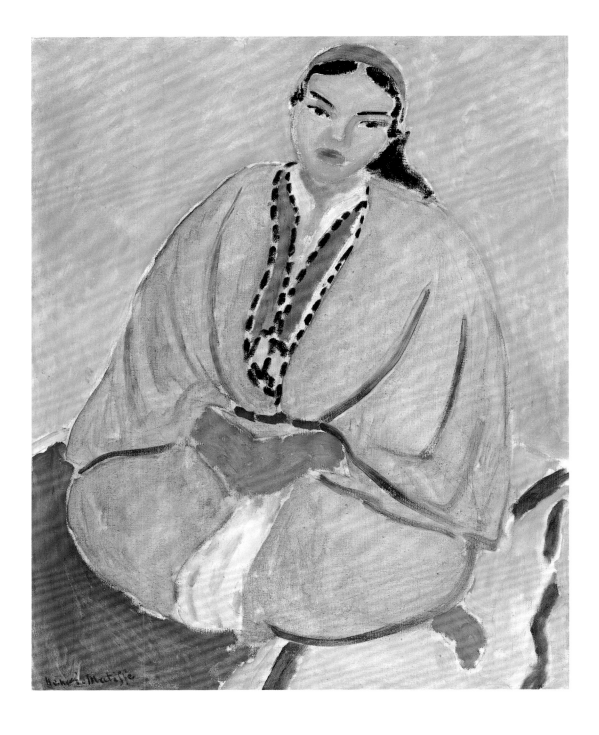

14.2 Fatma, the Mulatto Woman
Tangier, mid-October–early November 1912

Oil on canvas; 146 × 61 cm (57 1/2 × 24 in.)
Private collection

IN EXHIBITION

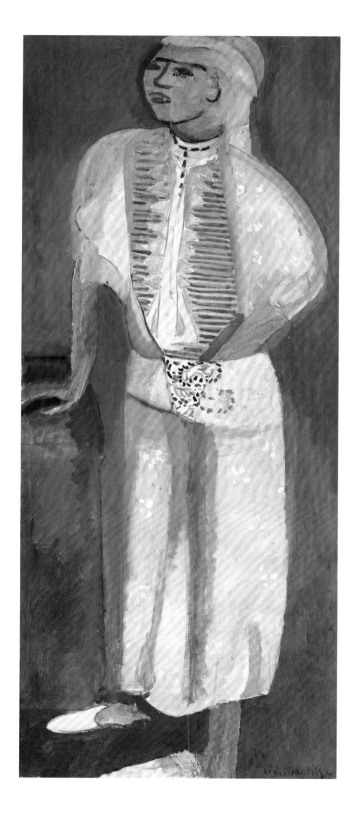

on the first of his two trips to Morocco, which lasted from January 29 to April 14, 1912. He began about a week after his arrival in Tangier but was forced to work inside because of the rain, which plagued him intermittently throughout his stay.[1] By mid-February, the weather had cleared enough for him to start exploring the city, but it was not until March that he began to settle into his work. The principal task he had set himself was to fulfill a commission to make two landscapes for his Russian patron Ivan Morosov and a still life for Morosov's wife, and by the end of March he had discharged that obligation.[2]

The artist had also promised Sergei Shchukin a "souvenir de Tanger," and presumably because Shchukin had purchased *Dance (II)* and *Music* (p. 77, figs. 1–2), Matisse decided to make him a figure painting. Since he preferred to paint women rather than men, he set out to find a female model, only to run afoul of the law of the veil, from which only Jewish women and prostitutes were exempt. By April 1, however, he wrote to his family to say the proprietress of the Hôtel Villa de France, where he was staying, had found him a room where "the Arab girl" could come without being seen.[3] Five days later, the plan had unraveled: he had wanted to work with "the young girl," he wrote again to his family, but her brother was about and would have killed her. However, he reported, "The young bellhop at [the hotel] Valentina was free and might pose." This was presumably the subject of *Amido* [**14a**], which was therefore painted in early April. But the problem of the brother must have been solved quickly, because Matisse was soon able to paint Zorah, a very young prostitute.[4] *Zorah in Yellow* was done rapidly, certainly before April 14, when Matisse returned to Issy with the work in tow. While *Amido* went to Shchukin, the artist retained *Zorah in Yellow*, hanging it in his studio. We see it in *Interior with Goldfish* [**19b**], where it hangs on a wall along with two Arcadian images— *Seated Nude* [**6d**] and the sculpture *Reclining Nude (I) (Aurore)* [**1.2**]—as if to underscore how, as Marcel Sembat put it, Morocco had become for the artist "a terrestrial paradise."[5] It also served to remind Matisse of Zorah herself; when he returned to Tangier in October, he sought her out, and she became his favorite Moroccan model.[6]

As he worked on *Zorah in Yellow*, Matisse had his model assume a crouching pose commonly used by Moroccans, and which would have been familiar to him from studies Eugène Delacroix had made in that country.[7] It also recalls a posture that he himself utilized for *Music*, suggesting that he had, indeed, found in Morocco the kind of Arcadia that he had previously conjured up in his imagination. By extension, here and in his other Moroccan

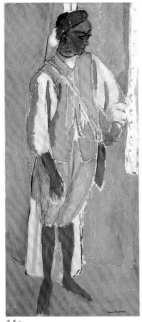

14a

14a
Amido, 1912. Oil on canvas; 146.5 × 61.3 cm
(57 5/8 × 24 1/8 in.). The State Hermitage Museum,
St. Petersburg, 7699.

14b
Detail of *Fatma, the Mulatto Woman*, revealing the
adjustments to the contours and position of the head.

14c
Detail of *Fatma*, showing chest decoration.

14d
Detail of *Fatma*, displaying Matisse's use of overlapping
washes and dot-and-dash brushstrokes in the sash.

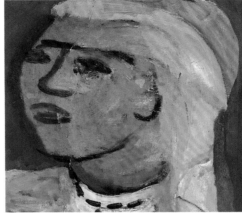

14b

14c

14d

paintings, the artist employed the two-part
method that he used to create most of
the Arcadian figure compositions: he estab-
lished the drawing first and then filled in
the compartments with color. Since, as he
put it, "the color was proportionate to the
form" (see p. 53)—that is to say, it looked
different according to the size and shape of
the area it occupied—great discipline was
required to develop a design that would
hardly change and then to fill it in without
having to transpose colors too much.[8] "This
all or nothing is very exhausting," Matisse
had complained in 1911 while executing the
similarly constructed *The Painter's Family*
(p. 113, fig. 6), and he did a lot of such com-
plaining in Morocco.[9]

The pencil drawing that established the
composition of *Zorah in Yellow,* which is visi-
ble beneath the painted surface, is not as
precise as that of some of the artist's other
Moroccan paintings, but it was obviously
guidance enough, because he appears to
have used it, unchanged, as the basis of his
painted outlines.[10] Before doing so, how-
ever, he applied his pigments to the drawn
template, using twelve discrete colors that
he modified by applying them in different
ways. In only four cases did he superimpose
them: he drew with alizarin crimson and
rubbed golden shading over the yellow ocher
robe; added touches of alizarin into the wet,
bluish gray paint below the hands; over-
painted areas of the face with a denser version
of the pink-orange beneath; and applied
touches of black, in the form of charcoal,
around the edges of the robe and to a few
places within it.[11] For the rest, the artist laid
each color carefully into its own compartment,
often leaving areas of ground between the
color and adjacent ones.

Matisse returned to Morocco on October
8, 1912, and eight days later wrote to his
wife at Issy that he had painted a Moorish
woman for Shchukin, which he thought was
not bad.[12] Since Matisse had been unable to
find Zorah immediately, this reference would
seem to be to *Fatma, the Mulatto Woman*
[**14.2**].[13] Matisse had not made up his mind
about the painting a week later, when he
wrote to Charles Camoin on October 21: "I
began a Moorish woman on a terrace as a
pendant to last year's young Moroccan boy
[*Amido*]; but a lot of wind and an irritating
model worked against me. Also, when I
thought I had finished, I brought the painting
home, and I haven't had the courage to turn
it around for fear of disappointment. . . . It is
a decorative canvas that I am required to do,"
he added, "and I think that will be it, but I
would have wanted more."[14]

In fact, that was not the end, for Matisse
reconsidered the painting and decided he
should keep going with it. Hence, on Novem-
ber 2, he wrote to his wife:

I have just finished my afternoon session with the Negress, which was the fourth, and it's going well so far. . . . I haven't yet started a canvas in the mornings, I make drawings that tire me less to save myself for the afternoon session because my canvas of the Negress interests me so much and I would like to give myself entirely to it. Work with her is not very convenient, and if Hamido [Amido] were not always there, I would really have a problem because she does not speak a word of French. She is always tired, she always wants money. I have already advanced her four sessions, and this afternoon she wanted 10 francs more. I only gave her 5, because she threatened not to come again, which would have really been a problem because the canvas is going so well. . . . Ten days for sure of good weather is predicted. I will take advantage of it to finish my Negress as I may well return after that.[15]

Sometime between November 8 and 12, Matisse included a sketch of the painting in a letter to his children, saying that it was "for Bernheim."[16] So it seems that he had finished it around that time and, having decided to place it with his dealers, was left to start afresh on a "decorative canvas" for Shchukin.

Fatma, the Mulatto Woman began with a drawn design, like *Zorah in Yellow* and *Amido*; the pale yellow and turquoise decoration down the chest was outlined and filled in [14c], and there are traces of pencil visible within the left shoulder and arm. It is obvious why this piece took time to complete, as it is much more dense and painterly than *Zorah in Yellow* and *Amido*, and Matisse built up both figure and ground by layering washes and glazes to create a sumptuously glowing effect. Indeed, *Fatma* is the richest of the Moroccan canvases in this respect and uncannily recalls *The Manila Shawl* [12.1]. The turquoise paint of the caftan was scumbled over the white ground, and white flowers were conjured from within and dispersed over it; the sash provides a dot-and-dash Fauvist flourish, simulating an embroidered panel and surrounded by overlapping, scumbled washes of cream and salmon [14d]. The caftan is connected to a similarly colored veil whose transparency Matisse evoked by applying turquoise glaze over the copper tone used for the head.

The same copper color, which also appears on the arms and legs, explicitly reveals Matisse's technique of overlapping luminous washes over a white ground. The head, which is denser than the arms, shows signs of having been enlarged and turned left as the artist worked on the composition [14b]. The left edge of the original contour is just visible, cutting through the right side of the mouth and the tip of the nose; Fatma's present left eye is where her right one was earlier, and an indication of her previous left eye can be discerned above her left ear. Matisse may also have shifted her gaze to the left in order to complement that of Amido, who looks to the right. But this choice might have been a consequence of his earlier decision to place at bottom left the great liquid feet—one unmoored, almost an empty slipper, the other a large,

scratched anvil. This difference accounts for the often-noticed fact that Fatma faces the observer but turns her face and feet to the side, like a figure in an ancient Egyptian wall painting or a Persian miniature.[17]

1. For more on the events of Matisse's first trip to Morocco, see Elderfield, "Matisse in Morocco: An Interpretive Guide," in Cowart 1990, pp. 210–16; Duthuit and de Guébriant 1997; and Institut du Monde Arabe 1999.

2. Matisse later changed his mind: he did not send the landscapes and still life to Morosov but fulfilled his commission with the so-called Moroccan Triptych (44c–e); see Cowart 1990, pp. 211–12, 214, 222, 229–31, cats. 5–6, 12–14.

3. Matisse to Amélie Matisse, Apr. 1 and Apr. 6, 1912, AHM.

4. In Barr's Questionnaire V, John Rewald revealed that Matisse had painted Zorah on his first trip to Morocco: "When he returned there on his second trip he could not find her until he learned that she was in a public house."

5. Sembat 1920, p. 10.

6. Matisse sold *Zorah in Yellow* to Bernheim-Jeune on Sept. 24 along with the now-lost *Moroccan Woman in Yellow,* just before he returned to Morocco; see Dauberville and Dauberville 1995, vol. 1, p. 512, cat. 124. This perhaps increased his interest in finding Zorah so that he might paint her again. Amélie joined the artist on this search and created an uproar by accompanying him to a brothel where the girl was known to have worked. See Cowart 1990, cat. 13 n. 4, cat. 9 n. 1, for images of Zorah that Matisse made on this second trip.

7. For examples of Delacroix's studies, see ibid., pp. 21, 23.

8. Tériade 1929.

9. Matisse to Michael Stein, postcard, May 26, 1911; Barr 1951, pp. 152–53.

10. See, for example, the very careful underdrawing of *Periwinkles (Moroccan Garden)* (p. 115, fig. 11), visible in an infrared photograph illustrated in Cowart 1990, p. 276. While there is no known preliminary compositional drawing, Matisse made some beautiful drawings of Zorah's head and what was in essence a large drawing on canvas in 1912/13; see n. 6.

11. These twelve colors seem to be viridian (background and beneath chin); pale ultramarine (fabric, lower right, and small areas at the bottom of dotted lines); ultramarine violet (the stripes within that fabric); brick red (fabric, lower left, and areas within dotted lines); brick red mixed with yellow (hands and feet); yellow ocher (robe); gold ocher (shading within robe and beneath viridian below chin); bluish gray (beneath hands and, more densely, below chin); alizarin crimson (drawing over robe, dashes on bluish gray below hands, lips, and headband); orange-pink (face); dark brown (dotted lines, hair, eyes, and eyebrows); and black (charcoal at outer contours of robe and a few places within it).

12. Matisse to Amélie Matisse, Oct. 16, 1912, AHM.

13. Matisse was still searching for her when Amélie arrived in Tangier around Nov. 24; see n. 6.

14. Matisse to Charles Camoin, Oct. 21, 1912, Archives Camoin.

15. Matisse to Amélie Matisse, Nov. 2, 1912, AHM.

16. Matisse to his family, Nov. 8–12, 1912, AHM. The painting was sold to Bernheim-Jeune on Mar. 20, 1913, as *La mûlatresse Fatma, debout Maroc;* see Dauberville and Dauberville 1995, vol. 1, p. 514, cat. 126. It was included in Matisse's Apr. 1913 exhibition of his Moroccan paintings at Galerie Bernheim-Jeune, which sold it, probably three years later, to Josef Müller of Solothurn. The "decorative canvas" that Matisse painted for Shchukin was *Zorah Standing* (1912; The State Hermitage Museum, St. Petersburg); see Cowart 1990, cat. 16.

17. Rémi Labrusse compared *Fatma* and *Amido* to a fifteenth-century Russian icon of Saint Michael in Moscow; Duthuit 1997, p. 144, cat. 29. However, the torque of the body that distinguishes *Fatma* is actually closer to a figure at the lower right of a c. 1500 miniature from Iran, acquired in 1887 by the Musée des Arts Décoratifs, Paris, and illustrated in ibid., p. 367.

15 The Moroccans, first state
Tangier, April–October 1912

Compositional sketch for *The Moroccans* contained in an October 25, 1912, letter from Matisse to Amélie Matisse. Archives Henri Matisse, Paris.

15a

15b

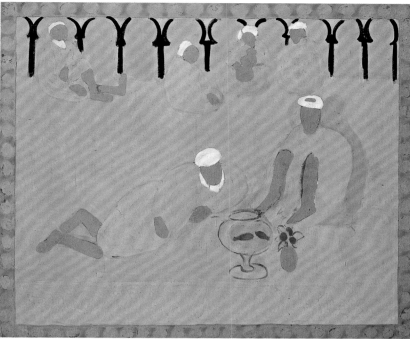

15c

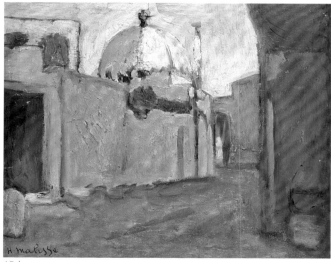

15d

15a
Letter from Matisse to Amélie Matisse, October 25, 1912, showing a compositional sketch of *The Moroccans*. Archives Henri Matisse, Paris.

15b
Letter from Matisse to Amélie Matisse, October 25, 1912, showing two compositional sketches of *The Moroccan Café*. Archives Henri Matisse, Paris.

15c
The Moroccan Café, 1913. Oil on canvas; 176 × 210 cm (69 3/8 × 82 5/8 in.). The State Hermitage Museum, St. Petersburg, 9611.

15d
The Marabout, 1912/13. Oil on canvas; 21.5 × 27.5 cm (8 1/2 × 10 13/16 in.). Private collection. In exhibition.

ON APRIL 12, 1912, before returning to Issy at the end of the month, Matisse wrote the final letter of his first trip to Tangier—with another Moroccan visit already in his mind. "Two ideas for paintings came to me," he declared to his wife, "which I plan to carry out once I get back."[1] These notions were in all likelihood the first glimmerings of what would become *The Moroccans* [**44**] and *The Moroccan Café* [**15c**], for on October 25, some two weeks into his second stay in the city, he wrote to Amélie again:

I am also hoping to do two large *panneaux* of Tangier like this. One represents the terrace of the Arab café and the Casbah with Arabs drinking and playing cards near the end of day with the city in the background…The Arab on the right is looking through binoculars. The others are chatting quietly or even silent, dreaming. The other panel will show a small Arab café where I sometimes go at the end of the day, around five o'clock, to have coffee. It's a quiet café where serious people go. It's on the path to the Casbah. Inside it's painted in oil paint with white arcades against a blue background, up to the height of the picture rail.[2]

Small compositional sketches [**15a–b**] within the letter confirm that Matisse was speaking of these works, which he conceived as a pair; the sketches also suggest that they were to be works of the same proportions and, probably, size.[3] The fact that there are two sketches for *The Moroccan Café*—one with an arcaded background and the other with a trellised one—tells us that the artist had not yet settled upon its design. However, Matisse may well have favored the second design because he also drew a sketch in the letter of a flowering trellis on the lower part of a wall in the medina [**15b**]. Different views of this same feature appear in a group of sketches depicting a small plaza located just outside the Bab el Aassa [**15e**], a rare, coherent sequence among the large number of topographic studies that Matisse made in Tangier.[4]

Other independent drawings show architectural features that Matisse brought together in his compositional sketch for *The Moroccans*. The most specific of these include a view of steps leading up to a terrace ringed by plant pots [**15f**]; another depicts the railing at left, with the dome of a *marabout*, or shrine, beyond it, and in front of it what may be melons scattered on the ground [**15g**]. The same terrace—but now paved—perhaps appears in the foreground of another drawing, which offers a vista down onto the city and a dome with a view of the bay beyond.[5] There also exist a beautiful, more finished close-up on a dome with a crenellated parapet [**15h**] and a topographical painting [**15d**], unique among Matisse's Moroccan images, that shows a distant view of the same feature. We may presume that the artist made these drawings, if not the painting, before he wrote to his wife, since the sketch in his letter summarizes their salient features. This must also

15e

15f

15g

15h

15e
Medina: Flowered Trellis, 1912/13. Pen and ink on paper; 19.4 × 25.5 cm (7 5/8 × 10 in.). The Metropolitan Museum of Art, New York.

15f
Medina Terrace, 1912/13. Pen and ink on paper; 19.7 × 25.5 cm (7 3/4 × 10 in.). Private collection. In exhibition.

15g
Medina Terrace and Dome, 1912/13. Pencil on paper; 16.2 × 9.5 cm (6 3/8 × 3 3/4 in.). Courtesy of the Pierre and Tana Matisse Foundation, New York. In exhibition.

15h
Casbah: The Marabout, 1912/13. Pen and ink on paper; 17 × 26 cm (6 11/16 × 10 in.). Private collection.

15i

15j

15k

be true of two additional drawings [**15i–j**], quick, eyewitness studies that show figures sitting and lounging on striped floor mats with slippers and glasses beside them. At the rear are extremely summary notations for distant figures who stand and walk on the level below the steps.

Despite these many preparations and against his announced intentions, Matisse did not immediately fulfill his aim of creating "two large panels of Tangier." But he did realize one of them, *The Moroccan Café*, which may well have been the last painting on which he worked in Tangier, possibly completing it back at Issy in early March 1913.[6] In any event, it was ready in time for the five-day exhibition of his Moroccan canvases that opened on April 14 at the Galerie Bernheim-Jeune [**15k**]. *The Moroccans was* not in that exhibition, for, as we shall learn, it had not yet been begun.[7]

1. Matisse to Amélie Matisse, Apr. 12, 1912, AHM. It is worth noting Matisse's description of how the subject of the canvas was painted in reality.

2. Matisse to Amélie Matisse, Oct. 25, 1912, AHM.

3. These recall Van Gogh's two well-known paintings of the exterior and interior of a night café: *The Night Café* (1888; Yale University Art Gallery, New Haven, Conn.) and *Terrace of a Café at Night (Place du Forum)* (1888; Kröller-Müller Museum, Otterlo).

4. Cowart 1990, pp. 141–43. This catalogue published for the first time a wide selection of Moroccan sketches.

5. See Institut du Monde Arabe 1999, p. 109, cat. 48.

6. For evidence that Matisse worked on *The Moroccan Café* in Tangier, see Camoin to Matisse, Apr. 12, 1913, AHM. However, if painted in Tangier, this work would be the only one to have been made of distemper, which raises doubts as to why Matisse would have taken these materials to Morocco and only made one work using them. Moreover, distemper produces an extremely fragile surface that easily suffers during transport, most especially if the canvas is large and rolled. These facts suggest that Matisse drew the composition in Tangier and did the actual painting back at Issy, perhaps choosing distemper because it dries much more quickly than oil and, therefore, would have allowed him to complete the work in time for his April exhibition at the Galerie Bernheim-Jeune. If that was the case, Sembat's well-known account of the changes that occurred in the painting may have been based on first-hand knowledge; see Sembat 1913. Previously, Sembat's comments had been questioned because he was not in Morocco. See Cowart 1990, p. 104, cat. 23; p. 106 nn. 3, 17. However, the certainty that one of Matisse's two other extant distemper paintings, *Interior with Aubergines* (p. 113, fig. 7), was made in Collioure, and that the other, *Le luxe (II)* (2.2), may have been, raises the possibility that the artist chose this medium for works that needed to dry quickly in order to be transported.

7. Although Matisse did not start the canvas for *The Moroccans*, he clearly had the intention of using his drawings for that purpose. Writing to Walter Pach from Tangier on plans for the Armory Show, he stated that he intended to make use of the drawings he had made in Tangier (Dec. 6, 1912, Walter Pach Papers, Archives of American Art, Smithsonian Institution, Washington, D.C.). Additionally, one of the photographs that Alvin Langdon Coburn took of Matisse in his Issy studio in May 1913 shows the artist seated on a divan in front of a large group of framed drawings made in Morocco. Moreover, Matisse brought back photographs of Tangier (20a–b), which he likely referred to in advancing his composition.

15i

Café (I), 1912/13. Graphite on paper; 26.5 × 21 cm (10 1/16 × 8 1/4 in.). Private collection. In exhibition.

15j

Café (II), 1912/13. Pen and ink on paper; 17.5 × 7.6 cm (6 7/8 × 3 in.). Private collection. In exhibition.

15k

Exposition Henri-Matisse: Tableaux du Maroc et sculpture, Galerie Bernheim-Jeune, Paris, April 14–19, 1913. *The Moroccan Café* is visible at center, flanked by the sculptures *Decorative Figure* (4f–g) and *The Serf* (1900–04; D6). Photo Archive, The Museum of Modern Art, New York.

1913

MARCH

Prima esposizione internazionale d'arte della Secessione opens in Rome; it runs through June. Matisse exhibits two works, *Place de Lices* and *Goldfish*.

Guillaume Apollinaire publishes *Les peintres cubistes*; Matisse is included as an "instinctive cubist."

EARLY MARCH

Henri and Amélie Matisse are back in Issy-les-Moulineaux.

MARCH 17

Félix Fénéon writes to Matisse and offers an exhibition of his Moroccan work at Galerie Bernheim-Jeune.

MARCH 19

Salon des Indépendants opens; it runs through May 18. Matisse does not exhibit.

MARCH 20

Bernheim-Jeune purchases *Fatma, The Mulatto Woman* (14.2).

MARCH 24

The *International Exhibition of Modern Art* (Armory Show) opens at the Art Institute of Chicago; it runs through April 16.

APRIL

Marcel Sembat writes an article, "Henri Matisse," which is published in *Les cahiers d'aujourd'hui*.

Ausstellung der Berliner Secession opens in Berlin. The exhibition causes a stir with pronouncements from Lovis Corinth and Max Beckmann, among others. Matisse is represented by four works, including *Dance (I)* (p. 79, fig. 5).

APRIL 14

Exposition Henri-Matisse: Tableaux du Maroc et sculpture opens at the Galerie Bernheim-Jeune; it runs through April 19. The checklist includes twelve Moroccan paintings and at least five drawings and thirteen sculptures, including earlier and later works. Many of the paintings presented have already been acquired by Sergei Shchukin (*The Moroccan Café* [15c]) and Ivan Morosov (the Moroccan Triptych [44c–e]). The exhibition generates much critical attention, especially from Apollinaire and René Jean.

APRIL 16

On the closing day of the Armory Show, students from the School of the Art Institute of Chicago demonstrate against Matisse, Constantin Brâncuși, and organizer Walter Pach.

APRIL 28

The Armory Show opens at Copley Hall, Boston; it runs through May 19.

MAY

Matisse works on behalf of Galerie Levesque to offer Gauguin's *Where Do We Come From? What Are We? Where Are We Going?* (p. 146, fig. 6) to Shchukin and then to Morosov; both decline.

MAY 1

Henri Matisse: Moroccan Paintings opens at Kunstsalon Fritz Gurlitt, Berlin; it runs through May 10.

MAY 13

Alvin Langdon Coburn visits Matisse in Issy and photographs him in his studio (16a–g, 45b–c); the artist is recorded reprising his work on *Bathers by a River* and *Back*.

SUMMER

Matisse paints *The Blue Window* (18) from his bedroom at Issy.

END OF JUNE

Shchukin visits Matisse in Issy to see activities in the studio; afterward, the artist intends to make a portrait of Amélie for his patron.

JULY

Matisse likely begins *Portrait of Madame Matisse* (p. 148, fig. 9).

Matisse and Picasso begin spending time together over the summer; the two artists go horseback riding together in the woods near Clamart.

Henry McBride, Gertrude Stein, and Mildred Aldrich visit Matisse's studio; McBride writes about the encounter in *The Sun* (November 16).

Matisse visits Collioure and Cassis.

JULY 5

Fénéon writes to Matisse concerning his contribution of an etching (he will change course and produce a lithograph instead) after a work by Cézanne for Bernheim-Jeune's forthcoming album on the artist.

AUGUST 14

Charles Camoin writes, inquiring about Matisse's bas-relief (*Back*) and painting of the beach at Tangier (*The Moroccans* [20]).

SEPTEMBER

Matisse begins *Flowers and Ceramic Plate* (19).

SEPTEMBER 2

Karl-Ernst Osthaus writes to congratulate Matisse on the completion of *The Blue Window*.

SEPTEMBER 4

Fénéon writes about plans for the album *Cézanne* and the possibility of a second lithograph from Matisse.

SEPTEMBER 15

Matisse writes to Camoin about his work on *Bathers by a River* and *Back*, and his struggles over *The Moroccans* (44), for which he has stretched a canvas that does "not suit the representation" he envisages for the subject.

SEPTEMBER 20

Marcel Sembat visits Matisse, finding him troubled by his work on *Portrait of Madame Matisse*.

SEPTEMBER 29

Fénéon writes again, asking about the status of the lithograph for the Cézanne publication.

OCTOBER 12

Post-Impressionist and Futurist Exhibition opens at the Doré Galleries, London; it runs through January 16, 1914. Matisse is represented by two paintings and five lithographs.

OCTOBER 13

Matisse is in Grenoble.

OCTOBER 27
Alfred Flechtheim writes to request photographs of paintings he is considering for his upcoming exhibition in Dusseldorf; the works include *Nasturtiums*, *The Red Studio* (p. 113, fig. 8), and a scene of bathers.

NOVEMBER
Camoin writes to Matisse to ask whether he will send his *Bathers by a River* to the upcoming salon.

Solo show at Kunstsalon Fritz Gurlitt, Berlin. The checklist comprises twelve works, including *Three Bathers* (3a) and *The Palm* (52b), both of which are owned by Oskar and Greta Moll, and a few drawings and lithographs.

BEGINNING OF NOVEMBER
Eugène Druet photographs *Bathers by a River* in the Issy studio (21).

NOVEMBER 4
Matthew Stewart Prichard writes to Isabella Stewart Gardner, reporting on Matisse's activities and stating that *Portrait of Madame Matisse* is complete and that the artist has made "some good etchings too."

NOVEMBER 6
Matisse makes three pencil drawings of Mabel Bayard Warren; Prichard observes.

NOVEMBER 9
Matisse writes to his daughter, Marguerite, that *Portrait of Madame Matisse* has taken a great physical and emotional toll.

NOVEMBER 15
Salon d'Automne opens; it runs through January 5, 1914. Sembat writes the preface to the catalogue. Matisse exhibits only one work, *Portrait of Madame Matisse*, which engenders enthusiastic praise from Apollinaire.

AFTER NOVEMBER 15
Matisse writes to Camoin that "painting is a thing of great disappointment." He reports that he hired a model and did a nude study (this will become *Gray Nude with Bracelet* [22k]): "This morning, 2nd session and concern begins." Matisse likely hired Germaine Raynal, wife of the art critic Maurice Raynal, to pose for the painting; she is also the subject of a new series of lithographs and intaglio prints at this time.

NOVEMBER 26
Fénéon writes to congratulate Matisse on his new painting, *Flowers and Ceramic Plate*; Bernheim-Jeune will purchase it the next day.

NOVEMBER 27
Matisse ships *The Blue Window* to Osthaus for the Folkwang Museum in Hagen, Germany.

DECEMBER
Galerie Flechtheim opens an inaugural exhibition; it runs through early January. Matisse is represented by four paintings, including *Nymph and Faun* (5d), *Nasturtiums with "Dance,"* and *The Red Studio*; three sculptures; five prints; and several drawings.

DECEMBER 5
Bernheim-Jeune sends a receipt to Matisse for recent prints the gallery has purchased: two figure studies (*Three Figures [Académies]* [22f]) as well as *Bell Flower (Campanule)* (18c), *Half-Length Nude* (22e), and *Nude Lounging* (22d).

DECEMBER 15
Portrait of Madame Matisse is illustrated in *Les soirées de Paris*.

BY DECEMBER 25
Henri and Amélie Matisse consider traveling south for the winter, finally settling on Tangier as their destination. Their bags are packed when Matisse visits Albert Marquet in his former fifth-floor studio at quai Saint-Michel and learns that the flat below him is available. He abandons plans for Morocco and rents the Paris studio instead.

C. DECEMBER 26–28
Matisse brings his mother to Menton and returns to Paris.

LATE 1913
Robert Rey visits Matisse in Issy for an article in *L'Opinion*. He is introduced to the artist's collection of works by Cézanne, Gauguin, and Odilon Redon, as well as African art; in the studio he sees a portrait (*Gray Nude with Bracelet*), a Moroccan figure, plaster states of *Jeannette*, and *Bathers* in process (published as "Une heure chez Matisse," January 10, 1914).

LATE 1913 OR EARLY 1914
Matisse purchases a small hand etching press.

1914

Bernheim-Jeune publishes the album *Cézanne*.

JANUARY 1
Henri and Amélie Matisse move to the apartment at quai Saint-Michel. The artist sets up the press in his new studio, where he will make drypoints, etchings, and monotypes.

AFTER JANUARY 1
Reviving a familiar subject, Matisse begins work on two views of Notre Dame from his studio window.

JANUARY 10
William King records a conversation between Matisse and Prichard on *Gray Nude with Bracelet* (see p. 143). It is possible that *Woman on a High Stool* (25), the subject of which is also Germaine Raynal, is under way at this time. Prichard and Matisse also discuss the difficulty of painting *essence* ("life itself") as embodied by the goldfish in his studio.

BY JANUARY 13
Matisse begins work on *Interior with Goldfish* (24), which is designated for Shchukin (the war will prevent its later acquisition).

JANUARY 29
Fénéon begins publishing a series of bimonthly art news bulletins at the Galerie Bernheim-Jeune. In the first, he announces the upcoming Peau de l'Ours auction (March 2) and lists the artists in the catalogue, including Matisse.

FEBRUARY 17
Sembat writes in his diary about Matisse's two Notre Dame paintings: one (23d), he states, is "very beautiful, which everyone will understand and admire," while the other (23) is "a work of genius, which will not be understood by anyone. Nevertheless for us this is the more

beautiful one of the two, the most inspired, the one in which Matisse is more personal."

FEBRUARY 18
Prichard writes to his friend Georges Duthuit that "Matisse has now begun five paintings but has finished none."

END OF FEBRUARY/BEGINNING OF MARCH
Carlo Carrà travels to Paris with fellow Futurists Giovanni Papini and Ardengo Soffici, who are guests of Serge Férat and Baroness Hélène d'Oettingen, codirectors with Apollinaire of the journal *Les soirées de Paris*. Apollinaire will bring Carrà to Matisse's studio.

SPRING
Gino Severini visits Matisse's studio.

Walter Pach negotiates with Matisse on behalf of the Montross Gallery, New York, for a solo exhibition.

Matisse paints *Branch of Lilacs* (27) and a number of portraits of his daughter, Marguerite, including *The Rose Hat* (30a).

MARCH
Still Life with Lemons (26), *The Rose Hat*, and *Tulips* (p. 181, fig. 5) are photographed by Bernheim-Jeune. Shortly after *Still Life with Lemons* is complete, Juan Gris and Jean Metzinger visit Matisse and praise the painting privately for its "extraordinary concordance."

MARCH 1
Bernheim-Jeune announces *Les estampes d'Henri Matisse* in its *Bulletin*. There are thirty-three works in the series, twenty-nine identified as nudes.

MARCH 2
Sale of the Peau de l'Ours, a collection that André Level has assembled, since 1904, from the work of such artists as Gauguin, Van Gogh, Matisse, and Picasso. The auction, held at the Hôtel Drouot, includes ten Matisse paintings, which are sold with great success.

MARCH 3
Matisse sells *Acanthus (Moroccan Landscape)* (p. 115, fig. 12) to dealer Léonce Rosenberg.

MARCH 10
Shchukin writes to ask about the shipment of *Portrait of Madame Matisse* and congratulates the artist on the Peau de l'Ours auction, adding, "I am sure that the demand for your paintings will continue to increase."

MARCH 11
Bernheim-Jeune notifies Matisse about the interest in a commission from the family of Yvonne Landsberg.

MARCH 21
Matisse attends the Fête Van Dongen with Camoin and Marquet; press covering the costume party describe the friends as "three archimandrites transformed into carnival wrestlers."

MARCH 25
Gustave Coquiot publishes *Cubistes, futuristes, passéistes*, which includes a chapter on Matisse.

APRIL
Matisse meets Landsberg to make a commissioned portrait drawing (28a); before the meeting, Matisse spends the morning creating drawings of magnolia flowers and buds.

APRIL 4
Bernheim-Jeune purchases *Still Life with Lemons* and *Tulips*.

BEGINNING OF MAY
Matisse completes the portrait drawing of Landsberg and asks if he can paint a more ambitious portrait. Her family agrees, with the understanding that Matisse will be free to paint what he wishes, and they will have the option—but no obligation—to buy the picture.

MAY 1
Exposition internationale 1914 opens at the Musée des Beaux-Arts, Lyon; it is scheduled to run through November 1 but will be cut short by the outbreak of war. Matisse shows one painting, *Joaquina*.

MAY 2
Prichard writes to Duthuit about "a veritable Matisse cult" among their acquaintances.

MAY 15
Apollinaire publishes in *Paris-journal* an announcement for the upcoming issue of *Les soirées de Paris*, in which there will be reproductions of paintings and drawings: "The marvelous artist who spent the winter in Paris, produced in his studio on the quai Saint-Michel a series of pictures full of freshness, power and sensitivity. Never have his qualities as a colorist been so obvious."

Exposition d'art français du XIXe siècle opens at the Musée Royal, Copenhagen; it runs through June 30. Matisse is represented by four works.

Les soirées de Paris publishes reproductions of works by Matisse: five paintings, *The Blue Window*, *Woman on a High Stool*, *Interior with Goldfish*, *Tulips*, and *Still Life with Lemons*; and two untitled drawings.

SUMMER
Sommerschau 1914 opens at Neue Kunst Hans Goltz, Munich. Matisse is represented by three paintings, including *Nude with a White Scarf* (6), and one sculpture.

EARLY SUMMER
Troubled by increasing international tensions, the Matisse family stays in Issy; they will also keep the studio at quai Saint-Michel.

JUNE
The installation of the 1911 bequest of Isaac de Camondo to the Musée du Louvre is opened to the public. The collection comprises over eight hundred objects, including the arts of China and Japan, and works by artists from the Middle Ages to the present, including Pierre Bonnard, Cézanne, Camille Corot, Degas, Maurice Denis, Jean-Honoré Fragonard, Van Gogh, Jean-Auguste-Dominique Ingres, Édouard Manet, Matisse, Monet, Camille Pissarro, Paul Signac, and Édouard Vuillard.

JUNE 4
Bernheim-Jeune sells *Tulips* to Fritz Gurlitt.

JUNE 8
Le paysage du Midi opens at Bernheim-Jeune; it runs through June 16. Matisse is represented by two works, including *Nude in Sunlit Landscape* (7c).

Prichard and friends come to watch Matisse paint *Portrait of Yvonne Landsberg* (28); over the course of the month, many visitors will drop in to see the painting develop. Matisse will make many drawings and etchings of his subject during his work (28i–t).

JUNE 15
Shchukin sends Matisse 6,000 francs for *Portrait of Madame Matisse*.

JUNE 26
Prichard writes to Gardner that Matisse has made a portrait etching of him.

JUNE 28
Curt Glaser visits from Germany to organize a large Matisse retrospective for Kunstsalon Fritz Gurlitt, Berlin. Hans Purrmann and Matisse persuade Michael and Sarah Stein to lend nineteen paintings; Sembat refuses, probably due to escalating hostilities in Europe.

Juan and Josette Gris are in Collioure.

Assassination of Archduke Franz Ferdinand, heir to the Austro-Hungarian throne, in Sarajevo.

JULY 1
Shchukin writes about the payment for *Portrait of Madame Matisse* and that he is thinking of works that Matisse might still paint for his drawing room; he also writes of plans to visit Paris in July.

JULY 12
Matisse finishes *Portrait of Yvonne Landsberg*; soon afterward, the sitter and her family will leave France for Brazil.

MID-JULY
Henri Matisse exhibition opens at Kunstsalon Fritz Gurlitt. Works include *Young Sailor (I)*; *Portrait of Madame Matisse (The Green Line)*; and *La coiffure* (4i).

JULY 28
Bernheim-Jeune purchases *View of Notre Dame* (23d).

Austria-Hungary declares war on Serbia, marking the outbreak of World War I. Russia, bound by treaty to Serbia, announces mobilization of its vast army in Serbia's defense.

JULY 30
Bernheim-Jeune acquires *Gray Nude with Bracelet*.

JANUARY 10, 1914
*Dialogue between Matisse and Matthew
Stewart Prichard, 19, quai Saint-Michel, Paris.
Recorded by William King.*

HM: I'm waiting for a young man from Munich who wants to take lessons. I can't give him a direction. I can only erect barriers in front of him to exercise his muscles.

MSP: But if one paints, isn't it necessary to choose between two sorts of expression, one of which is practiced through space (that of the École des Beaux-Arts, which doesn't take phenomena into account) whereas the other would be evocative?

HM: I will say to him, "Paint anything, for example, those fish . . . if you are not happy with those fish, continue with another object and then go see Cubists, Bouguereaus, Moreaus, all kinds of works, and train yourself in that way."

MSP: The student will tell you that if he chooses this first form of expression, he will first of all have to kill the fish because they are in motion.

HM: I will stop him immediately, for those fish are life.

MSP: Thus you admit that there are two kinds of expression, one of which looks at life and the other which only deals with dead things.

HM: I admit it.

MSP: So, you will have something to teach him.

HM: Yes, but the Beaux-Arts student analyzes the fish, I myself dissected a thing to better understand it. He knows all that but if you ask him to make a drawing using a continuous line, he's incapable of it. A child draws a train with the engine leaning forward, and the thing works. At the age of thirteen, show him that the machine is vertical in his construction and he'll have trouble drawing it. At the same time, he will lose his ease in expressing movement. Much experience and conviction are necessary to redevelop the type of expression observed in childhood, but that's what one needs to learn.

MSP: You are communicating the reality of the model, whereas the Beaux-Arts student only sees the spatial details (extensive, spread out).

HM: But I also take into account the space of the form, etc.

MSP: But nevertheless, this chair...

HM: Yes, but when I paint it, I see it in relation to the wall, in relation to the light of the room in which it is enclosed, in relation to the objects that surround it. It would be different if I wanted to buy it; my first impression might be of its beauty, but then I would look to see if it was sturdy, etc.

MSP: In the first case, you would feel it in its nonextensive reality, in the second, your interest is the same as that brought to the chair by the Beaux-Arts student.

HM: Yes, that's right.

MSP: Your painting would thus be a bridge between reality and the *percipient*.

HM: I don't see the distinction between reality and the painting.

MSP: Just about the same distinction that one might make between your thoughts and the words that express them when you write a letter, the same way that musical notes link the soul of the composer to the soul of the person who hears them.

HM: Spiritualists or realists, everyone was interested in my drawing of Mrs. Warren, thus the image acts as a bridge between them.

MSP: Yes, but one can also be interested in it as an object. Spiritualists do something more, as the spiritualist can understand it also as an object, whereas feeling is a closed book to the realist.

MSP: So, one has to have a philosophy.

HM: Yes. Probably is it easier to belong to a philosophy, a religion, a family...there is a sweetness in finding oneself supported by an organization.

MSP: Bergson said that there was only one philosophy.

HM: Yes, I can also conceive of that possibility.

HM: (*speaking of his drypoint etchings*): I am not conscious of whether, while I am executing them, my thought evolves, I look at the object and I transmit my impression with a continuous line. While I paint a picture, I am conscious of the continual development that transpires through my action on the canvas. The conditions are different for a painting, implying much more complicated work than those necessitated for a drypoint. Formerly, I analyzed my paintings and I noted that, once the design was established, the color values followed, but now, I look at the canvas as a whole, without states. I can only paint in the presence of the model; I am quite close to it and look at it all the while I work. All that I put into the painting, I find in the model. I cut off the color in this painting (*a female nude seated in a chair*) [22k], because I found that the colors interfered with the plastic values, which are very tender.

MSP: There were Japanese painters like Sesson and Sesshiu who gave up using color for similar reasons, because they found that it was too intrusive.

HM: My model is a young eighteen-year-old girl from Montmartre, but very simple and pure; there is an air of innocence about her; I found that color conflicted with that feeling.

HM: I made a lithograph in that book on Cézanne, the one after his *Pèches* [*Fruits and Foliage*, p. 147, figs. 7–8]. I had to simplify the painting, and by the way I made my choices, Matisse appeared. All the other lithographs are neither by Cézanne nor by the copyist. Cézanne always looked to render Poussin's vision of nature. He recommended that every young artist should go to the Louvre and, having found the master with whom he had the greatest affinity, endeavor to bring the vision of this master to life.

Portfolio Contents

fig. 1
Installation of *Exposition Henri-Matisse: Tableaux du Maroc et sculpture*, Galerie Bernheim-Jeune, Paris, April 14–19, 1913. Visible from left to right are *Zorah Standing*, *The Standing Riffian* (16l), and *Fatma, the Mulatto Woman* (14.2); a plaster cast of *Jaguar Devouring a Hare* (1899–1901; D4); and drawings of Zorah on either side.

fig. 2
Installation of *Exposition Henri-Matisse* featuring *Arums*; *The Seated Riffian* (16l); and *Calla Lilies, Irises, Mimosas*, complemented by plaster casts of *Jeannette (III)* (13.1) and *(I)* (11.1).

MATISSE'S RETURN FROM MOROCCO WAS marked by an exhibition at the Galerie Bernheim-Jeune that was organized within a month of his arrival home in March.[1] *Exposition Henri-Matisse: Tableaux du Maroc et sculpture* ran for just six days in mid-April and featured twelve paintings and at least five drawings made during the artist's two recent visits to Morocco, as well as thirteen sculptures from all periods of his career.[2] Archival evidence suggests that Matisse was probably involved in both selecting and installing the works, which were presented as units—single canvases such as *The Moroccan Café* (15c) or groups of three like *Zorah Standing* (1912; The State Hermitage Museum, St. Petersburg), *The Standing Riffian* (16l), and *Fatma, the Mulatto Woman* (14.2)—flanked by a drawing or bronze sculpture at each end (fig. 1).[3] Documentary photographs show how plaster sculptures were arranged within the smaller units (fig. 2): in the case of *Arums* (1912/13; The State Hermitage Museum, St. Petersburg), *The Seated Riffian* (1912/13; Barnes Foundation, Marion, Penn.), and *Calla Lilies, Irises, Mimosas* (1913; The State Pushkin Museum of Fine Arts, Moscow), the pale-colored busts of *Jeannette (I)* (11.1) and *Jeannette (III)* (13.1) augmented the overall presentation and echoed the light gray frames that Matisse specified for a number of the paintings.[4]

The installation demonstrated Matisse's intense exploration of the power of North African light to dissolve form and to reconstruct space into vaporous, mutable, interwoven layers of ethereal color. The effect was not lost on critics. Marcel Sembat wrote a virtual paean: "He is forty-four, and is already the subject of legend. Paleographers imagine that to discover mythical beings, one needs to excavate Antiquity. Wrong! Here is a contemporary who is a figure of legend."[5] Both Guillaume Apollinaire and René Jean acknowledged Matisse principally as a "great colorist" of subtlety and refinement.[6] The display even prompted Jean, perhaps in the spirit of the concurrent ideas of Wassily Kandinsky's synaesthetic approach to art making or Robert Delaunay's colorful Orphic paintings (p. 179, fig. 1), to identify in Matisse's new work "a sort of colored music that goes to the outermost limits of the pictorial domain."[7]

Following such artistic and critical exuberance, it may be hard to imagine how the artist returned to Issy after Morocco and so radically changed direction. Yet the work he produced during the remaining seven months of 1913 would be the result of a difficult process of transition in which the concern for formal structure and the physical nature of media—issues that Matisse would push to the fore in the following year—began taking hold. Indeed, in the period immediately after he arrived back in Issy, he would chart the course of a difficult struggle and redirection toward what would eventually become his "methods of modern construction."

In fall 1913, Matisse hesitantly recognized the slow results of this change, writing to his friend Charles Camoin, "I am tired and need to drive all worry from my mind. . . . All the same, I think I've taken a step and it is always hard."[8] Evidence of the challenge to discover a new path can be seen in the relatively few works—only three new paintings—that he would complete between May and

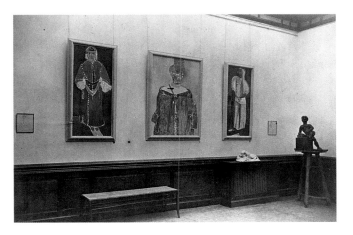
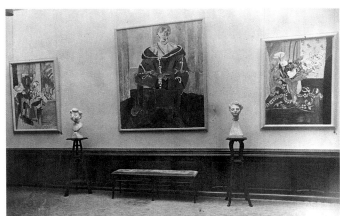

December, and his continued endeavors on earlier projects such as his monumental canvas *Bathers by a River* (16, 21) and bas-relief *Back* (17, 45). Together, they represent diverse and yet related efforts to move away from the spatiality of color he had explored in Morocco and toward a new kind of formal construction. In fact, the new canvases—*The Blue Window* (18), *Portrait of Madame Matisse* (p. 148, fig. 9), and *Flowers and Ceramic Plate* (19)—comprise a loose series related by date and subject. They reflect Matisse's immediate surroundings (the view from his bedroom, his wife, and the interior of his studio) and suggest just how focused and self-reflective he became in his pursuits. The three pictures are also dominated by the color blue. They continue a line of earlier explorations of a single color (blue or red) in such diverse canvases as *Male Model* (c. 1900; The Museum of Modern Art, New York), *A Glimpse of Notre Dame in Late Afternoon* (23b), *Harmony in Red (The Red Room)* (p. 84, fig. 17), *The Red Studio* (p. 113, fig. 8) and *The Conversation* (p. 117, fig. 15), to the more recent Moroccan works of *The Marabout* (15d) and *The Moroccan Café* (15c).[9] We can also trace Matisse's interest in color to the many ceramics and other art objects he was inspired to collect by his fascination with the arts of Islam and the East (fig. 3).

The culmination of this growing exploration of the color blue, however, can be found in the Moroccan Triptych (44c–e)—three paintings of similar dimensions that were not made at the same moment or even initially conceived as a group, but which came to be united by the time they were completed through a diversified, luminous palette of blues. The three pictures Matisse made in Issy in 1913 are not of the same dimensions, and no evidence yet uncovered suggests that he planned to unite them as a group.[10] However, placed into the order in which archival records suggest they might have been made, *The Blue Window, Portrait of Madame Matisse,* and *Flowers and Ceramic Plate* share striking similarities in organization, subjects, and forms with the Moroccan Triptych. They demonstrate another instance of the productive potential for Matisse of serially reworking themes and motifs—and, during the Moroccan period especially, of working in twos and threes, something he reinforced in the installation of the Bernheim-Jeune exhibition.[11] Most significantly for this discussion, however, the three pictures demonstrate the continuation of what has been called, clearly in contradistinction to Picasso, Matisse's own "blue period."[12]

By the time he painted these works, the color blue had a ready set of artistic associations: in the late nineteenth and early twentieth century, color had a central place in the formulation of theories of expressive equivalences as well as in scientific attempts to codify their properties in physical laws. These interests are reflected in the exhilarating developments of the Impressionists and Post-Impressionists, especially in the work of such artists as Van Gogh, Monet, and Georges Seurat.[13] Early in his career, Matisse had studied the color theories of Paul Signac and others, and later, as a teacher, he lectured on them at his school.[14] Blue had firmly established associations with interiority and mystical, psychological content thanks to the work of such Symbolist artists as Gauguin and Odilon Redon.[15] In the summer of 1900, in fact, just a year after acquiring his Cézanne *Three Bathers* (p. 45, fig. 3), Matisse purchased canvases by both Gauguin (fig. 4) and Redon (fig. 5), perhaps attracted to their broad passages of nocturnal, otherworldly blue. At the time of the artist's return from his Moroccan travels, blue also played a significant role in Kandinsky's recent treatises on the association of colors with the senses. The Russian artist's synaesthetic approach to art making was summarized in his 1912 *Blue Rider Almanac*, which included a discussion of Matisse's work and illustrations of *Dance (II)* and *Music* (p. 77, figs. 1–2), as well as his 1911 essay "Concerning the Spiritual in Art," in which the "heavenly color" was connected to the sound of a flute, double bass, or organ, depending on its changing value and tone.[16] Although Matisse was likely not interested specifically in the moody or spiritual associations of the color blue for his own work at this time, its connotations of an intense inner focus and reduction to the most significant, symbolic, and abstract might indeed have appealed to him.[17]

fig. 3
Fragment of a late-sixteenth-century ceramic panel from Iznik, Turkey (Formerly in Matisse's collection)

fig. 4
Paul Gauguin
(French, 1848–1903)
Young Man with a Flower, 1891
Oil on canvas
46 × 33 cm (18 1/8 × 13 in.)
Mavromatis Collection, New York
(Formerly in Matisse's collection)

fig. 5
Odilon Redon
(French, 1840–1916)
Death of the Buddha, c. 1875–80
Pastel
49 × 39.5 cm (19 5/16 × 15 1/2 in.)
Private collection
(Formerly in Matisse's collection)

The artist was also reminded of these associations directly in May when, on behalf of the Galerie Levesque, he wrote to both Sergei Shchukin and Ivan Morosov concerning the availability of Gauguin's extraordinary painting *Where Do We Come From? What Are We? Where Are We Going?* (fig. 6).[18] Neither patron would act on the offer, but the immediate experience of the large-scale, predominantly blue, and highly symbolic canvas might have spurred Matisse to consider the potential of undertaking a more monochromatic or tonal painting himself.[19] In addition, during the summer of 1913, he would reestablish his friendship with Picasso: we should not discount the possible example of Picasso's Blue Period canvases as well as his more immediate Analytical Cubist paintings, similarly reduced to a palette of grays and tans. For the Cubists, working in a restrained range of colors allowed them to fully focus on the construction—or deconstruction—of pictorial form. Their canvases, composed of rhythmic touches of muted tones, explore the

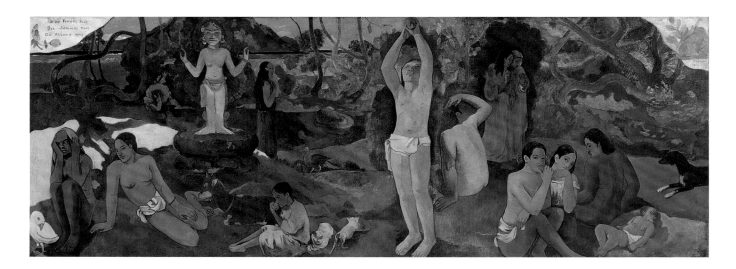

fig. 6
Paul Gauguin
Where Do We Come From? What Are We? Where Are We Going?, 1897
Oil on canvas
139.1 × 374.6 cm
(54 3/4 × 147 1/2 in.)
Museum of Fine Arts, Boston, Tompkins Collection—Arthur Gordon Tompkins Fund, 36.270

fragmentation of objects and space, presenting them as faceted, overlapping planes that are semitransparent and almost atmospheric. For Matisse, working in blue might have offered the same kind of formal focus that the Cubists found in their rejection of color, while allowing him to avoid direct comparison with their inventions.[20] As Marcel Sembat would recall in 1920:

He looked at Cubist canvases with unconcealed sympathy. He liked the effort involved, he welcomed them, he listened to them. Picasso and he were once friends. Here is something that was repeated to me: Whether said by Matisse, or said by Picasso, I do not know, and it is of little importance to me. "We are both searching for the same thing through opposite means." It was supposed that a charmed Matisse would adopt the Cubist circles. This shows poor knowledge of the man. The cry would go up: "He's captured! He's ours!" Not at all! Matisse belongs to himself alone![21]

Matisse spoke little at the time about the specific significance of blue on his work, although we do know that he lectured to his students about Cézanne's careful use of it in his compositions: "Cézanne used blue to make his yellow tell," Sarah Stein noted in 1908, "but he used it with the discrimination, as he did in all other cases, that no one else has shown."[22] Matisse had, of course, an intimate knowledge of the artist's use of blue from observation of the *Three Bathers* as well as the six landscape watercolors he purchased in 1908 and a small canvas entitled *Fruits and Foliage* (fig. 7), which he acquired in 1911. Two years later, during the time that he was painting his three blue pictures in Issy, Matisse made *Fruits and Foliage* the subject of sustained study when he began work on a print after it for Bernheim-Jeune's forthcoming publication on Cézanne.[23] His graphic translation (fig. 8) demonstrates his careful understanding of Cézanne's use of blue in the painting, to suggest both depth (what Cézanne identified as "sufficient blues to make one feel the air") and form.[24] To produce the black-and-white image, Matisse suppressed most of the

blue-colored depth in the painting, untangling it from the surrounding colors and forms, but recorded many of its blue-hatched, form-giving strokes. From correspondence with Fénéon, we know that he originally intended to make an etching of the image but later decided on a lithograph instead.[25] The change to a technique that can produce a softer line and more subtle surface may reflect Matisse's reconsideration of the substance of Cézanne's work, its layered volumes and the materiality of its surface—qualities also potentially harder to translate into the intaglio medium, especially as Matisse was just starting to make prints again after a six-year hiatus.

Matisse's new canvases from the summer and fall of 1913 demonstrate an awareness of the form-giving potential of Cézanne's blues, which he used in *The Blue Window* to tamp down color in order to focus on inner geometric structure, and in *Flowers and Ceramic Plate* to build atmosphere through the rhythmic application of visible daubs of paint. In the fall, however, when faced with the decision of what he would send to the Salon to represent his most recent work, he chose *Portrait of Madame Matisse* (fig. 9).[26] Much has been made of the similarity of this portrait to those of Cézanne's wife, in particular his *Madame Cézanne in a Yellow Chair* (1888–90; Fondation Beyeler, Basel/Riehen), which was exhibited in the 1912 Salon de Mai.[27] In trying to find his new artistic path, Matisse looked to Cézanne for the portrait, but beyond simple pose to something more fundamental, as he had in his study of the Old Masters at the Louvre. He explained this in regard to his copy of *Fruits and Foliage*:

I did a lithograph in this book on Cézanne . . . I had to simplify the picture and, listening to my choices, it became a Matisse. All the other lithographs are neither Cézanne's nor a copyist's . . . Cézanne always tried to convey Poussin's vision of nature. He recommended that every young artist go to the Louvre and, having found the master with whom he had the greatest affinity, try to convey the vision of this master in life.[28]

Furthermore, while Matisse and Cézanne's portraits share some formal characteristics, we might also look to a more recent potential source, the May 1913 photograph of Matisse and Amélie that Alvin Langdon Coburn took for his publication *Men of Mark* (16h). Coburn sent a set of proofs to the artist in mid-June, close to the time that Matisse would have begun painting the portrait.

Regardless of sources, the process of painting the portrait was painstakingly slow and extremely difficult. When Walter Pach admired the completed canvas in 1914 and remarked on the apparent ease of its production, he recalled the artist admitting that it had taken over one hundred sittings.[29] Indeed, the surface of the painting is a record of just how much Matisse reworked the composition, scraping down forms and repainting them, moving his wife's figure up the canvas, and changing the position of her arms many times. Even the seemingly simple chair back was repeatedly readjusted: its final mottled-looking surface is the product of numerous scraped-down and repainted placements on the canvas. As the artist reduced and

fig. 7
Paul Cézanne (French, 1839–1906)
Fruits and Foliage, c. 1890
Oil on canvas
29 × 29 cm (11⁷/₁₆ × 11⁷/₁₆ in.)
Private collection
(Formerly in Matisse's collection)

fig. 8
Fruits and Foliage (after Cézanne),
plate 5 from *Cézanne*, 1914
Lithograph on paper
Image: 20.5 × 21.2 cm
(8¹/₁₆ × 8³/₈ in.);
sheet: 28.5 × 37.6 cm
(11¹/₄ × 14¹³/₁₆ in.)
The Museum of Modern Art,
New York, purchase, 1953
In exhibition

scratched away contours in many places, he also began to use his incising tool to conjure forms such as Amélie's left arm and hand (fig. 10) from simple lines scratched into the heavily worked surface. A recent X-radiograph (fig. 11) demonstrates how deeply he dug into the painted surface in certain places, almost carving his wife's silhouette into the canvas. Most striking is his reworked palette: we can trace Matisse's reduction of the form of his once-naturalistic portrait in the thick strata of blues and grays that cover the pinks, greens, and ochers below.

Some of this reworking was a natural part of the artist's creative method, but the heavily revised surface and endless painting sessions also tell of the transition he was trying to enact in his work as a whole. The surface of the canvas bears the evidence of this struggle, as do the numerous testimonials of his friends and the artist's own letters. On September 22, for example, Sembat recounted a visit to Issy, writing in his journal, "Saturday, saw Matisse demented! crying! By night he recites Our Fathers! By day, he quarrels with his wife."[30] And probably on November 16, Matisse wrote to his daughter, Marguerite, about the palpitations, high blood pressure, and constant drumming in his ears exacted by the portrait. "My painting, the portrait of your mother, is in the show at the Salon and is a success. I worked hard for it: I can say when showing it, 'This is my flesh and my blood' . . . A great success with the portrait of your mother—widespread success, aside from a few slow starters led by Vauxcelles, it is spoken of as a masterpiece. Its success is due to my hard work, for this painting gave me so much trouble."[31]

Despite his struggle, the portrait was well recognized by the critics, and most especially Apollinaire, who proclaimed it "the best thing in the Salon [and] the artist's masterpiece."[32] He also noted the symbolic content of Matisse's blues:

Never before, I believe, has color been endowed with so much life. Internal art, which is the art of today, after affecting an austerity that had not been seen in the arts since [Jacques-Louis]

fig. 9
Portrait of Madame Matisse,
July–October 1913
Oil on canvas
146 × 97.7 cm (57 1/2 × 38 1/2 in.)
The State Hermitage Museum,
St. Petersburg, 9053

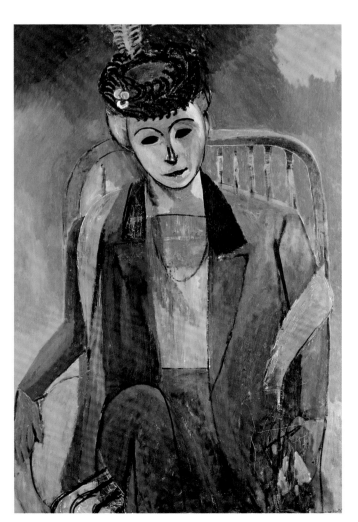

fig. 11
X-radiograph of *Portrait of Madame Matisse,* showing the dark lines of deeply incised contours.

fig. 10
Detail of contour of the figure's left arm and hand in *Portrait of Madame Matisse,* constructed by etching into many layers of paint.

David's reforms, no longer disdains to appear agreeable, and the orphism of certain painters is a holy, admirable intoxication with color. Henri-Matisse has always had a hedonistic conception of art, but he has also raised Gauguin's teaching to new heights. He has not remained a slave to resemblance, and as much as anyone understood the necessity, as proclaimed by the South Seas recluse, of a double deformation, both objective and subjective. Matisse's great merit and the characteristic trait of his personality is that, apart from the symbolism of his colors, there is no trace of mysticism in his work. . . . The portrait he is exhibiting here, full of voluptuousness and charm, marks, in a sense, a new period in Matisse's art, and perhaps in contemporary arts as a whole: until now, voluptuousness had almost completely disappeared from contemporary art, and was to be found almost nowhere except in the magnificent sensual paintings of the aged Renoir.

But the glowing praise that Matisse would receive from his submission to the Salon was no consolation, as he wrote to Camoin soon after the opening: "The truth is that Painting is a thing that disappoints greatly. By chance, my painting (the portrait of my wife) has had a certain success among those with advanced views. But I find scant satisfaction in it, it is the beginning of a very painful effort."[33]

By then Matisse had expanded his search for new methods of working beyond his blue paintings, although he would continue to consider the color—as well as Apollinaire's reception of his portrait—for some time (pp. 178–79). He had, however, since Coburn's visit in May, rethought the possibility of painting his composition for *The Moroccans* (20) and was steadily working on *Back* (17, 45) and *Bathers by a River* (16), the canvas he had put aside following the disappointing debut of his *Dance (II)* and *Music* at the Salon d'Automne in 1910. Over the summer and into the fall, he would subject the canvas to its own radical transformation, slowly changing the once-colorful palette to one that was increasingly gray, a choice perhaps inspired by working in the near-monochrome of blue. He also subjected the rounded forms of the bathers and their surroundings to a more reduced and geometric style, possibly the result of Picasso's renewed presence in his life. Indeed, the hieratic figures and austere monochrome of the *Bathers by a River* canvas (fig. 12) parallel Picasso's own abandoned decorative panel on the subject of "a stream in the middle of town with some girls swimming" for Hamilton Easter Field (fig. 13). In the years leading up to this moment, Picasso had labored under a disadvantage, trying to alter the internal scale of his Cubist paintings to meet the needs of the large-scale panels, eventually abandoning the project.[34] Matisse's *Bathers by a River*, as well as his reprised *Back* (17, 45), demonstrate a more angular, abstracted, Cubist approach to form making on a grand scale that would continue for the next number of years.

By December the artist was exploring still other avenues of inspiration, returning to printmaking and, paralleling the November 1913 state of *Bathers by a River* (21), beginning *Gray Nude with Bracelet* (22k), a new painting made

fig. 12
Matisse's *Bathers by a River*, photographed by Eugène Druet in the artist's Issy studio, November 1913.

fig. 13
Picasso in his studio at 11, boulevard de Clichy, fall 1911. At top left is an unfinished large-scale canvas, later destroyed by the artist, that was to be the centerpiece of an ensemble of works commissioned in 1909 by Hamilton Easter Field for the library of his Brooklyn home.

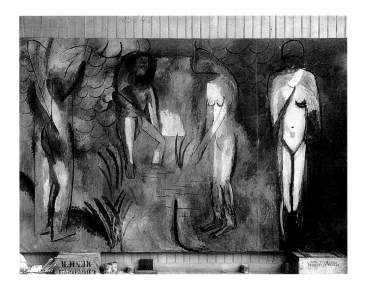

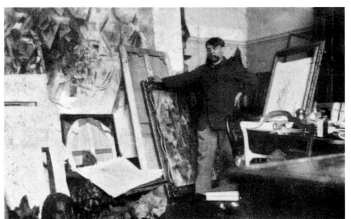

completely in grays and black. As he wrote to Camoin, none of these avenues yet held a solution: "Aside from today, it has been a long time since we have seen the sun. All last week the sky was gray and heavy and it was enough to make you disgusted with life. I had not worked for at least two weeks and in order not to get gloomy, I got back to it last Sunday. I got a model and did a nude study. This morning, a second session and here is where the worries begin."[35] His restless search would also extend to his plans for the winter of 1913–14, which even until the end of December apparently included the possibility of a return to Morocco. As we shall see, the end of Matisse's successful but worrisome transition would come with a new atelier, a great surprise in many ways, even for the artist himself.

—STEPHANIE D'ALESSANDRO

1. The exhibition was organized by Félix Fénéon and ran at Bernheim-Jeune from April 14 to 19.

2. The catalogue lists twelve paintings, most of which were owned by Ivan Morosov (noted in the catalogue as *M. I. S.*) and Sergei Shchukin (*M. S. S.*); the idea for the exhibition, in fact, was introduced by Fénéon as a way to show Matisse's latest work before it was sent to its new Russian owners (Fénéon to Matisse, Mar. 17, 1913, AHM). At least one change was made in the month leading up to the exhibition: according to available installation photographs, *View of the Bay of Tangier* was substituted for a second painting of *Fatma, the Mulatto Woman* (14.2) (cat. 4, listed as in the collection of *M. M. S.*, presumably Michael Stein). Only three paintings were available for purchase.

3. For more on the installation, and in particular the effect of the sculptures in the exhibition, see Oliver Shell, "Seeing Figures: Exhibition and Vision in Matisse's Sculpture," in Kosinski, Fisher, and Nash 2007, esp. pp. 58–61.

4. Matisse instructed Morosov on the installation of the Moroccan Triptych as well as the frame color: "The frames have been designed for the paintings and are gray—they are painted in distemper. If they have finger traces, the spots could be removed by wiping them softly with a slightly moistened sponge; if this should not be possible, any decorative painter would repaint them after having removed the gray paint, with water, from the frame, down to the white base. This gray is made from *blanc d'Espagne*, or another white in powder, some black, some ultramarine, and some gelatin as glue." The artist's careful attention to how the frames could be cleaned strongly suggests that he expected them to remain on the works permanently; see Matisse to Morosov, Apr. 19, 1913, Archives Morosov, Moscow; Kostenevich and Semyonova 1993, p. 184. He also specified the framing of other Moroccan works in the exhibition; see Fénéon to Matisse, Mar. 19, 1913, AHM. Photographs of the exhibition suggest that many of the works were similarly framed in light gray with a matte finish.

5. Sembat 1913, p. 185.

6. Apollinaire's review, "La vie artistique: Henri Matisse," was published in *L'Intransigeant* (Apr. 17, 1913), p. 2; Apollinaire 1972, p. 306. It is also worth noting that exactly a month earlier Apollinaire published *Les peintres cubistes*, in which he identified Matisse as an "instinctive cubist."

7. René Jean, "Exposition Henri Matisse," *La chronique des arts et de la curiosité* 16 (Apr. 19, 1913), p. 125.

8. Matisse to Camoin, Sept. 15, 1913, Archives Camoin.

9. It should be remembered that *Harmony in Red (The Red Room)*, while primarily red in its finished state, was first primarily blue; see pp. 83–84 in this publication.

10. Recently accessed evidence helps confirm the dates and order of production of these works; previously, they were not dated to the same year: Barr 1951, for example, dated *Flowers and Ceramic Plate* to 1911.

11. For more on Matisse's interest in triptychs and diptychs at this time, see Pierre Schneider, Jack Cowart, and Laura Coyle, "Triptychs, Triads, and Trios: Groups of Three in Matisse's Paintings of the Moroccan Period," in Cowart 1990, pp. 270–74.

12. Kostenevich and Semyonova 1993, p. 121.

13. For more on this topic, see John Gage, *Color and Culture: Practice and Meaning from Antiquity to Abstraction* (Little, Brown, 1993), esp. chap. 11.

14. Ibid., p. 211; and Flam 1986, p. 223.

15. Much of this was based on the color theories developed in the 1880s, especially those of Charles Henry, who proposed that each color had a corresponding psychological effect—that blue, for example, was a "sad" color whereas red was "happy." The Symbolist aesthetic of tonal coloring—using one to two colors to produce subtle, evocative canvases—is also worth noting. For more on Symbolist style and color, see Sharon L. Hirsh, *Symbolism and Modern Urban Society* (Cambridge University Press, 2004), pp. 2–8. Flam 1986, p. 223, stated that Matisse discussed the work of theorists Michel Chevreul, Hermann von Helmholtz, and Ogden Rood with his students.

16. Wassily Kandinsky, *Concerning the Spiritual in Art*, trans. M. T. H. Sadler (Dover Publications, 1977), p. 38. The two artists corresponded about a contribution to the almanac in 1911. See "A History of the Almanac," in *The Blaue Reiter Almanac* (1912; repr., edited with an introduction by Klaus Lankheit, Da Capo, 1989), pp. 11–48. For more on this, see Jonathan Fineberg, *Kandinsky in Paris* (UMI Research Press, 1984), pp. 49–50.

17. In northern Europe, painting predominantly in blue tonalities became particularly popular for the feeling, mood, or sense of musicality it was thought to inspire. For more on blue, especially in the work of Edvard Munch and Eugene Janssen, see Roald Nasgaard, *The Mystic North: Symbolist Landscape Painting in Northern Europe and North America, 1890–1940*, exh. cat. (Art Gallery of Ontario/University of Toronto Press, 1984). As he studied with Gustave Moreau, Matisse's awareness of Symbolist aesthetics was significant and should not be discounted. For a brief exploration of these connections, see Dore Ashton, "Matisse and Symbolism," *Arts Magazine* 49, 5 (May 1975), pp. 70–71.

18. See letters from Shchukin to Matisse, May 14, and Matisse to Morosov, May 25, 1913, AHM. Matisse also had direct experience with Gauguin's blue canvases in the collection of two of his patrons, Karl-Ernst Osthaus, whose *Contes barbares* (1902; Folkwang Museum, Essen) Matisse would have seen when he visited in 1908; and Sergei Shchukin, whose ensemble of blue paintings was the inspiration for his commission of *Harmony in Red (The Red Room)* (formerly painted in blue) in 1908, which the artist would see during his 1911 visit to Moscow. For more on Matisse's interest in the work of Gauguin, see Xavier Girard, "Gauguin et Matisse," in *Rencontres Gauguin à Tahiti* (Papeete, 1989), pp. 88–93.

19. Gauguin's painting was also surely an inspiration for his 1913 return to *Bathers by a River*.

20. Working in blue would also be a precursor to Matisse's continued reduction of color: to gray in late 1913 and 1914, and to black in the 1914–17 monotypes.

21. Sembat 1920, pp. 10–11.

22. "Sarah Stein's Notes" (1908); Flam 1995, p. 52. See p. 50 for a discussion of Matisse's lectures to his students on color and its two systems.

23. Matisse purchased the painting on Apr. 29, 1911; see Bernheim-Jeune to Matisse, AHM. The book was intended to raise funds for a monument by Aristide Maillol. Other artists who contributed to the publication include Pierre Bonnard, Maurice Denis, Ker-Xavier Roussel, Paul Signac, Félix Vallotton, and Édouard Vuillard; four of the seven works made after Cézanne's own were of bathers, both single and in groups. No correspondence suggests why Matisse, who owned *Three Bathers*, did not copy it for the publication and chose instead to do *Fruits and Foliage*, although it may be that his work on *Bathers by a River* was enough for him at this time.

24. Cézanne to Émile Bernard, Apr. 15, 1904, Courtauld Institute; Doran 2001, p. 29.

25. During the summer, Bernheim-Jeune's correspondence about the print mentions an etching and later, in early fall, the possibility of two lithographs. However, by the end of Sept. it seems clear that Féneon expected only one lithograph from the artist; see letters from Féneon to Matisse, July 5, and Sept. 4 and 29, 1913, AHM.

26. Evidence suggests that Matisse had also considered *Flowers and Ceramic Plate*; see Oct.–Nov. letter from Georgette Agutte to Matisse in which she encouraged him to do no more work on the canvas and send it to the Salon. The dates of Matisse's work on *Portrait of Madame Matisse* are determined by two letters (one written probably at the end of Oct. to his mother, Anna, and the other written Nov. 4 from Prichard to Gardner stating that it was complete; AHM). Matisse stated in the first that he had been working on the portrait for three months; if indeed the legend that the picture took one hundred sittings has a kernel of truth, three months of work would mean at least one sitting per day.

27. The Art Institute of Chicago's *Madame Cézanne in a Yellow Chair*, sometimes identified as the portrait Matisse saw at the exhibition, was not included in the 1912 Salon de Mai. Thanks to Dorota Chudzicka and Jane Warman for their assistance in confirming this information.

28. Matisse, as quoted in conversation with Prichard by William King, Jan. 10, 1914, Isabella Stewart Gardner Museum Archives, Boston, and Archives Duthuit. It is worth noting that Matisse's quoting of Cézanne was first recorded in 1904 by Camoin, who exchanged letters with the artist and was in regular correspondence with him at this time.

29. Pach 1938, p. 219. Coincidentally, Cézanne is said to have had over one hundred sittings for his portrait of Ambroise Vollard (1899; Petit Palais, Paris).

30. Sembat, in his daily notebook under the heading for "Monday, 22 September"; Sembat 1985, p. 34.

31. Matisse to Marguerite Matisse, undated [probably Nov. 9, 1913], AHM.

32. Apollinaire 1913b, p. 6.

33. Matisse to Camoin, after Nov. 15, 1913, Archives Camoin.

34. According to records, the large painting languished in storage for at least a year, after which it presumably was destroyed. "Le grand paneau pour l'America" was last heard of in an inventory of unfinished, stored works in a letter from Picasso to Daniel-Henry Kahnweiler, June 5, 1912, Archives Kahnweiler-Leiris, Paris; Rubin 1989, p. 66.

35. Matisse to Camoin (n. 33).

16 Bathers by a River, third state
Issy-les-Moulineaux, May 1913

Oil on canvas; 260 × 392 cm (102 1/2 × 154 3/16 in.)

X-radiograph of *Bathers by a River* with a diagram showing the composition
of the third state of the painting.

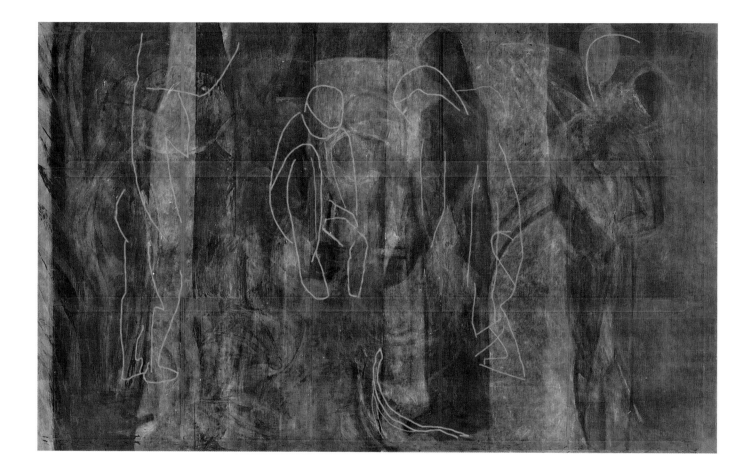

16a

16b

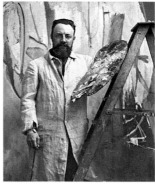

16c

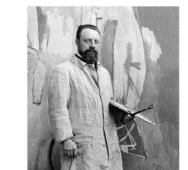

16d

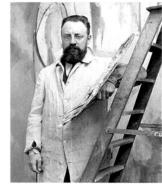

16e

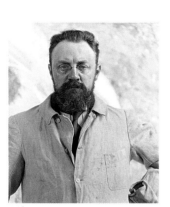

16f

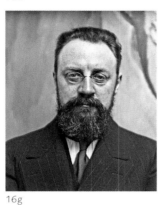

16g

16a–g

Henri Matisse painting *Bathers by a River*, May 13, 1913, photographs by Alvin Langdon Coburn. Archives, International Museum of Photography at George Eastman House, Rochester, New York.

16h

Henri and Amélie Matisse in front of *Bathers by a River*. May 13, 1913, photograph by Alvin Langdon Coburn. Archives, International Museum of Photography at George Eastman House, Rochester, New York.

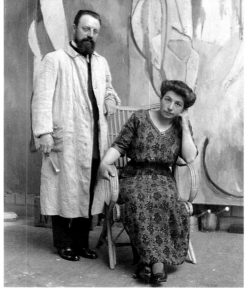

16h

BY EARLY MARCH 1913, Matisse returned home to Issy from Tangier. On March 17, Félix Fénéon wrote to the artist, offering him a show of his Moroccan work at the Galerie Bernheim-Jeune, which he accepted. In anticipation of the exhibition, Marcel Sembat wrote an enthusiastic article for *Cahiers d'aujourd'hui*, in which he attempted to bring renewed attention to Matisse after his time away and counter the persistent and often negative assessment of his work that followed the debut of *Dance (II)* and *Music* (p. 77, figs. 1–2) at the 1910 Salon d'Automne. In his appraisal, Sembat singled out the recently completed *The Moroccan Café* [**15c**] for its process—the physical sign that Matisse had moved "by instinct from the concrete to the abstract":

Those sprawling figures, all in the same nuance of gray, such a restful gray, and whose faces are represented by an ocher-yellow oval, the fellow on the left, that's how he was painted. Look! Up there that fellow on the left—he was red! The other one, next to him—he was blue, and the other was yellow. The faces had features—eyes, a mouth. . . . By examining the bottom of the painting, you discover traces of what used to be a row of Turkish-style slippers. . . . Why . . . has all that melted away? Because, for Matisse, to perfect one's self is to simplify![1]

The article did much to restore Matisse's critical reception and self-confidence.[2] It is perhaps no surprise, then, that he also returned to *Bathers by a River* around the same time, simplifying and changing the composition in a similar way. The artist may even have resumed work on the canvas just after completing *The Moroccan Café*, if he indeed finished the latter painting in Issy.[3]

On May 13, through the introduction of Gertrude Stein, the American photographer Alvin Langdon Coburn visited Matisse in his studio, where he made a number of portraits of the artist alone and one with Amélie for his forthcoming publication *Men of Mark* [**16a–h**].[4] The majority of these images present Matisse armed with a large palette and brushes, standing on a ladder while he paints the monumental scene. The photographs also record his working practice and process for revisions: by correcting distortions and digitally stitching together the glimpses of the painting that the prints provide, we can reconstruct the state of *Bathers by a River* on the date of the photographer's visit [**16i**].[5] Looking past the distorted silhouettes of the artist that result from the digital reconstruction, we can see a canvas that is clearly in transition and that demonstrates the degree to which Matisse's Moroccan experience had influenced his work. For instance, we can see that the standing figure at left is stiffly posed, floating against a dark background that recalls the composition of *Fatma, the Mulatto Woman* [**14.2**]. We can discern part of the bather's earlier posture—perhaps one that

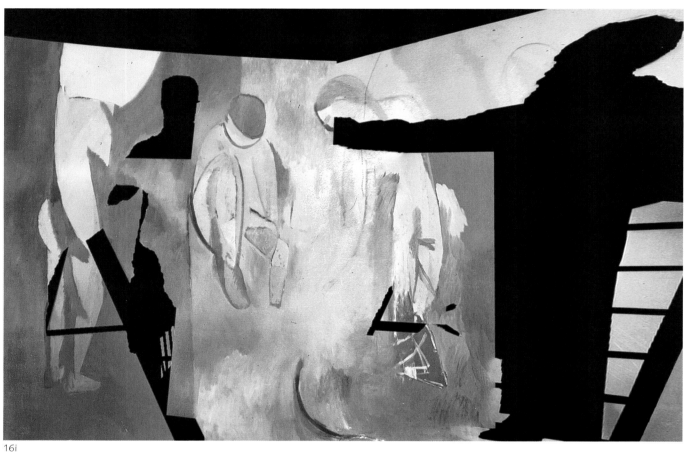

16i

16i
Digitally stitched and corrected reconstruction
of *Bathers by a River* derived from Alvin Langdon
Coburn's photographs.

16j
Face and Two Nudes with Gourds, 1912–13. Pen and
ink on chine on quadrille paper; 20.6 × 26 cm
(8 1/8 × 10 1/4 in.). Musée National d'Art Moderne/
Centre de Création Industrielle, Centre Pompidou,
Paris, AM 1984-40.

16k
Backs and Scene of Tangier, 1912/13. Pen and reed
and ink on paper; 32 × 33 cm (12 5/8 × 8 3/4 in.).
Private collection. In exhibition.

Matisse painted between 1910 and 1913—by looking at the area of the back, where a broad, sweeping arc runs from the left shoulder to right buttock indicating her forward-looking pose.[6] The artist transformed this once-graceful stance into a more rigid, upright one by blocking out the pink flesh of earlier limbs and musculature with dark gray, wedge-shaped forms; this was much like the carving that he used to transition the form of his bas-relief *Back* [**17, 45**]. This exaggerated modeling suggests the dramatic effect of highlights and shadows that he witnessed in the light of Morocco, and his heavy brushwork echoes the hatched shading he employed on the body of the left figure of the Moroccan-period sheet *Face and Two Nudes with Gourds* [**16j**] as well as the right one in *Backs and Scene of Tangier* [**16k**]. It appears that Matisse executed a different type of blocking in at the top of the canvas in preparation for the same bather's head: here a pale turquoise, half-oval shape covers the previous green background [**16p**], while the earlier head, slightly lower and to the right, was scraped away in a large circular area that is visible in the X-radiograph. The abstract form and pale color anticipate the kinds of forms the artist would devise for the figures in his final version of *The Moroccans*.

Many of the artist's adjustments are contained within groups of vertical lines. They establish the construction of the standing figure at left, where they appear near the upper part of the torso and run from the shoulders to the heels on both sides of the body.[7] Matisse used a similar framework for the next bather, who remained in generally the same position as before, but with a new right leg and foot, and adjusted arms, left leg, and foot. Near the left leg, we can see a number of intersecting lines that Matisse used to reposition and then build out the limb. He also painted vertical lines near the back, at the top of the head, and adjacent to the left arm; forming a kind of network, these helped him set the figure into the space of the composition, a practice he may have begun in such Moroccan paintings as *The Standing Riffian* [**16l**].

Matisse made most of these revisions within the color palette already established in the previous stages of the composition: for example, he painted new adjustments to the bathers' bodies—including the right leg and foot of the second bather—in a pink color similar to the one he had already used for flesh [**16o**] in the 1909 and 1910 states of the painting. But he also executed dramatic revisions of forms in colors not yet seen on the canvas: for instance, he chose a dark gray to cut into and build the new torso and legs for the first bather. Similarly, he employed new colors to establish a fresh pose for the third figure, which, as we can see in Coburn's

16j

16k

16l

16l
The Standing Riffian, 1912. Oil on canvas; 146.5 × 97.7 cm (57 5/8 × 38 1/2 in.). The State Hermitage Museum, St. Petersburg, 9155.

16m
X-radiograph of *Bathers by a River*, third state, with a diagram showing the locations of cross sections.

16n
Cross section of the lower tan riverbed, which Matisse covered with black before sketching new legs in pale gray. Original magnification: 500× [×836].

16o
Cross section showing the pink color of the second bather's knee, which was painted above the original dark blue edge of the waterfall. Original magnification: 200× [×885].

16p
Cross section showing the pale turquoise paint over the green background. Original magnification: 200× [×896].

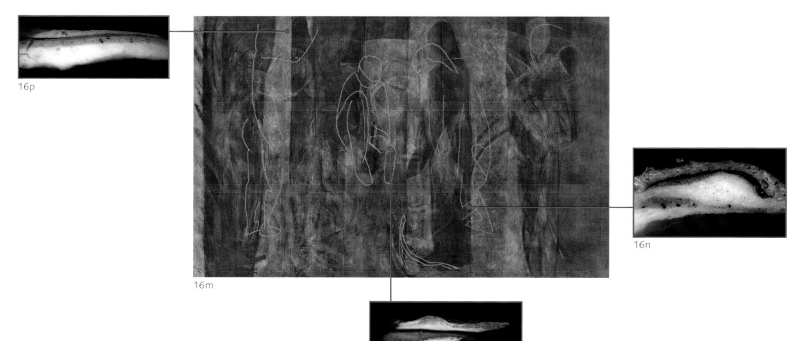

16p

16m

16n

16o

photographs, was in an early stage of transition. Here the artist retained the torso but moved the legs and feet to a standing position outside the waterfall, in an arrangement that recalls the middle figure in *Backs and Scene of Tangier*, as well as numerous studies related to *Back* [**4, 17**]. To build the limbs, Matisse covered the earlier pink and turquoise waterfall and tan riverbank with black and then sketched new legs and feet with pale pink paint [**16n**].[8] This approach recalls the impression of a black ink monotype printed on pale paper, a technique the artist would soon begin to explore. Finally, throughout the digitally reconstructed painting, we can also find examples of the reverse of this process, in which Matisse painted dark, hatched outlines around light-colored forms. The artist made use of this technique for the second figure's left arm and right foot; it was another means to build volumes on the otherwise flat and increasingly worked canvas.

Unfortunately, the composite image does not include much information about the bather on the right. The reason may be that Coburn preferred the left side of the canvas; that Matisse chose it because the right side was not as advanced; or simply that the lighting in the Issy studio was uneven.[9] Regardless, this reconstruction gives us the sense that Matisse may have approached different parts of the painting in distinct ways: he painted a vertical line to separate the first bather from the next two, recalling the diptych and triptych compositions he produced during his two trips to Morocco.[10] The backgrounds of these areas appear different in the reconstruction: the left side is painted in various shades of gray and green, while the central portion is in passages of light grays and greens, much like those in *Fatma*. Whatever his reason for partitioning the canvas, by June 16, Matisse had received proofs of the photographs from Coburn and wrote back to say that he found them "completely rare."[11] They must have proven to be intriguing counterpoints over the next few months and into the fall, as he continued to work on the canvas and watched as forms, in Sembat's words, "melted away" into others.

1. Sembat 1913, p. 191. Sembat even brought up *Dance (II)* and *Music*: "*Dance* made people scream by the magnificent audacity of its design, *Dance* compelled everyone's recognition through the wild leap of movement that carries it away! After *Music*, he regretted that *Dance* was not more sublimated, more restful, more nobly calm! And I know of a charcoal of *Dance* as he sees it now, where the movement is sweepingly solemn."

2. We know, for example, that Matisse sent a copy of the article to both Sergei Shchukin and Ivan Morosov. To the latter, he described the essay as "the best that has been written about me." Matisse to Morosov, May 25, 1913, Archives Morosov, Moscow; Kostenevich and Semyonova 1993, p. 185. Shchukin purchased *The Moroccan Café* by at least the end of the summer, if not sooner. On Sept. 15, Matisse wrote to Camoin (Archives Camoin), reporting the sale of the painting. For more on

the acquisition, see Cowart 1990, pp. 266, 269 nn. 75–76.

3. For more on this possible production date, see entry 15 in this publication; and Rémi Labrusse, "L'Epreuve de Tanger," in Institut du Monde Arabe 1999, p. 49.

4. Coburn wrote in his text for *Men of Mark*, "A journey to Paris gave me the opportunity of meeting and photographing Matisse, and I was glad to include the portrait of so able and interesting an artist"; Coburn 1913, p. 29. Coburn dated the text May 27, 1913, and took his photographs of Matisse at the very end of the process of compiling the book, which came out in Oct.

5. This reconstruction (as well as the majority of digital infrared images and X-radiographs in this publication) is the work of Prof. Robert G. Erdmann of the University of Arizona. The exhibition and publication benefited immeasurably from his important contribution.

6. We should consider that since *Bathers by a River* remained in Matisse's studio between 1910 and 1913 and had been the focus of innovation and experimentation during the production of the Shchukin panels, it is possible that the artist worked on the canvas to some degree before May 1913. Its presence in the studio also might have inspired other paintings: for example, the central pair of bathers in the Chicago canvas recalls the central figures of the artist's sons, Pierre and Jean, in another large-scale Shchukin commission of these years, *The Painter's Family* (p. 113, fig. 6).

7. Matisse would also use this vertical structuring for his work on *Back (III)* (45), which he was likely focusing on concurrently.

8. The technique is similar to one Matisse used for the left elbow of the second figure in the later, completed painting; see entry 54 in this publication.

9. For more on the studio, see entry 10.

10. Pierre Schneider, Jack Cowart, and Laura Coyle, "Triptychs, Triads, and Trios: Groups of Three in Matisse's Paintings of the Moroccan Period," in Cowart 1990, pp. 270–74.

11. Matisse to Coburn, postmarked June 16, 1913, Archives, International Museum of Photography at George Eastman House, Rochester, New York. Thanks to Valentina Branchini, Andrew W. Mellon Fellow, George Eastman House, for her assistance with materials related to Coburn and Matisse.

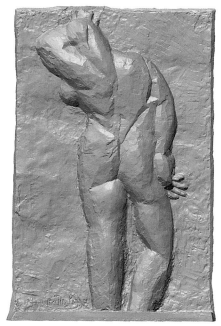

17 Back (II)
Issy-les-Moulineaux, 1911 (?)–early March or April 1913

Plaster, cast in bronze 1956; 188.5 × 121 × 15.2 cm (74 1/4 × 47 5/8 × 6 in.)
Signed l.l.: *Henri Matisse*; inscribed l.r.: *HM / 2/10*
The Museum of Modern Art, New York, Mrs. Simon Guggenheim Fund, 1956

IN EXHIBITION

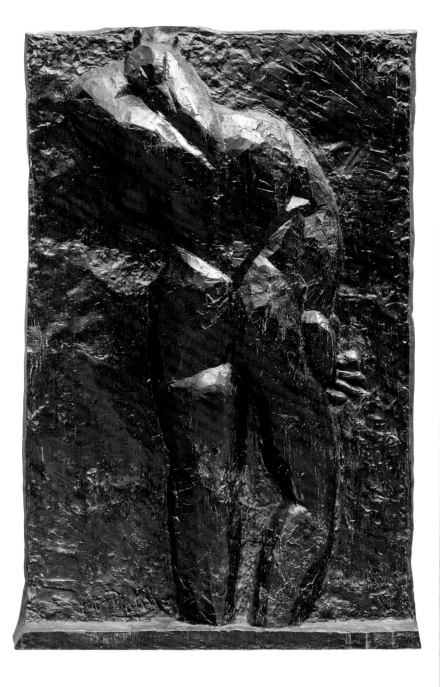

17a

17a
Grayscale three-dimensional digital model of *Back (II)*.

17b
Female Nude, 1912–13. Pen and black ink on paper;
31.7 × 22.1 cm (12 3/8 × 8 3/4 in.). Trustees of the British
Museum, London, 1931.1114.10. In exhibition.

17c
Study for the Back (II), c. 1913. Ink on lined paper;
20 × 15.7 cm (7 7/8 × 6 1/4 in.). The Museum of Modern
Art, New York, gift of Pierre Matisse, 1971.
In exhibition.

17d
Female Nude Lying Facedown on a Table, 1912–13.
Pen and black ink on tan wove paper, laid down on
cream Japanese paper; primary support: 24 × 31.5 cm
(9 1/2 × 12 3/8 in.). The Art Institute of Chicago,
Alfred Stieglitz Collection, 1949.893. In exhibition.

17b

17c

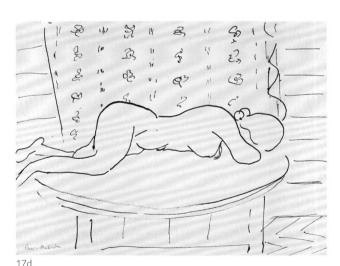

17d

IT IS GENERALLY accepted that Matisse began the second state of his bas-relief *Back* [**17**] when he returned to Issy in spring 1913 and resumed work on his other long-term project, *Bathers by a River* [**16**]. As is the case with *Back (I)* [**9**], however, we have no way to firmly document the full production dates of the sculpture, and over the years it has been variously ascribed to 1910–13, c. 1913–14, and c. 1914.[1] Complicating matters further are the circumstances of its exhibition and casting: while the plaster of *Back (I)* was first shown in London in 1912, according to the catalogue raisonné two of the three subsequent states— the plasters of *Back (III)* and *(IV)*—were not shown until 1949, when they were misidentified as *Back (II)* and *Back (III)*.[2] The plaster of *Back (II)*, however, was never exhibited during Matisse's lifetime and was seemingly forgotten: indeed, it was only discovered in the artist's Nice studio in 1955, the year after his death.[3] Because of this, the casting dates of the *Back* sculptures are different: the first bronzes of *Back (I, III,* and *IV)* were made in 1950, while the first bronze version of *Back (II)* was not cast until 1956.[4]

While historical documents that might help firmly date the work are lacking, a number of factors suggest that both Matisse's approach to the sculpture and the timeline of his efforts were themselves rather fluid. For example, a representation of a plaster *Back* can be found on the far right of the artist's 1911 painting *The Pink Studio* (p. 113, fig. 5), propped up against the wall next to *Dance (I)*. Painted in the same white and shadowy gray, blue, and green as the plaster cast to its left, the sculpture is similar to *Back (I)* but with a few notable differences: the version in *The Pink Studio* has a thicker waist, a straighter spine, and a wider-legged pose; if this representation is accurate, it suggests that we may be witnessing *Back (I)* early in its voyage to becoming *Back (II)*.[5] Two drawings related to Matisse's work on *Back (II)* [**17b, d**] show a fabric-covered screen similar to that in the painting, and although this does not mean that they, too, date to 1911, it may suggest the shape of Matisse's thinking about *Back* during the time of his Symphonic Interiors and prior to his first trip to Morocco.[6] In addition, as previously noted, Matisse exhibited *Back (I)* in the 1912 *Second Post-Impressionist Exhibition* at London's Grafton Galleries as *Le dos (Plaster Sketch)*, a title that implies the idea of a subsequent version, if not its actual presence at this time.[7] These factors do not necessarily change the potential end date of the work but rather suggest a longer gestation that may have begun either in 1910; during Matisse's long period in Issy from late January to June 1911, when he also would have been working on *Jeannette (III)* and *Jeannette (IV)* [**13.1–2**]; or possibly from June to September 1912, between his trips to Tangier. Indeed, con-

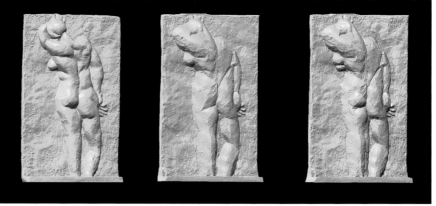

17e

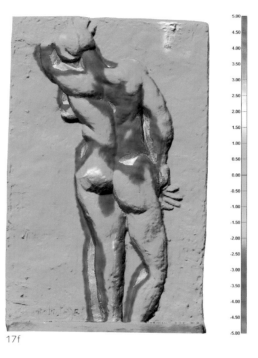

17f

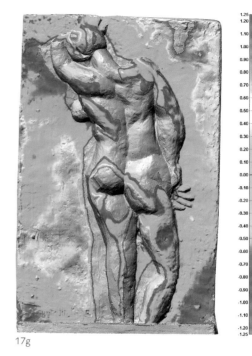

17g

17e
Three-dimensional digital models of *Back (I)*, second state, in blue, and *Back (II)*, in yellow, shown separately and, at right, overlaid.

17f
Overlay of *Back (I)* and *Back (II)* with differences of up to 5 centimeters identified; gray areas indicate more than 5 centimeters of difference.

17g
Overlay of *Back (I)*, top, and *Back (II)*, bottom, with differences of up to 1.25 centimeters identified; gray areas indicate more than 1.25 centimeters of difference.

17h
Comparison of the lower-left corners of *Back (I)*, top, and *Back (II)*, bottom, showing small changes in the surface and signature.

17i
Comparison of the upper-right corner of *Back (I)* and *Back (II)*, showing Matisse's diagonal marks on the surface of the latter.

17j
Small casting irregularities, noted on the digital model of *Back (I)*, top, are repeated on *Back (II)*, bottom, demonstrating that Matisse relied on a cast of *Back (I)* to begin his new work.

17k

Superimposed vertical cross section of *Back (I)*, second state, in blue, and *Back (II)*, in yellow, 8 centimeters from the left edge of the two works, demonstrating little variance between the two backgrounds.

17l

Overlaid horizontal cross sections of *Back (I)* and *Back (II)*, 83 centimeters from the bottom, showing relatively minimal change through the buttocks of the figures.

17m

Overlaid vertical cross sections of *Back (I)* and *Back (II)*, from the left ankle to the top of the head, showing how, despite changes to form, the depth remained approximately the same.

17n

Horizontal cross section of the head in *Back (I)* and *Back (II)*, indicating the great changes in form and depth that Matisse exacted.

17o

Horizontal cross section through the lower part of the legs of *Back (I)* and *Back (II)*, revealing the general pattern of the artist's adjustments to the figure, shifting the forms to the left.

final *e* became slightly occluded, possibly by some light plaster, while he added a dot on the *i* that had been missed in the first. However, a vertical cross section from the left side of the two superimposed models [**17k**] shows just how close the two background surfaces are and confirms that Matisse did not focus his attention on major alterations here. One area of exception is in the upper-right corner [**17i**], where the artist chiseled down the surface, leaving prominent, repeated marks that fan out and up from the right side. This area also demonstrates one of the ways that he worked on *Back (II)*, marking the surface in a manner that recalls the hatched patterns he used to describe volumes both in another related study of the sculpture [**17c**] and in *Bathers by a River*, as photographed in 1913 [**16a**]; we can see traces of these patterns elsewhere on *Back (II)* where he adjusted the figure's form.

Matisse added material to the figure, although, as we can see in horizontal and vertical cross sections [**17l–m**], its overall form changed minimally and the depth stayed about the same. There was, however, a good deal of material added to bulk the figure: a comparison of the right hand demonstrates that the artist built upon the first state with its casting irregularities to make it fleshier, adding a bulbous mass of plaster [**17j**]. The most remarkable area of change can be appreciated with a horizontal cross section of the space near the top of the head [**17n**], which Matisse rendered far more massive and abstract, removing anecdotal details of the hair, head, neck, and shoulders. A final horizontal cross section [**17o**], this time taken through the lower part of the legs, also reveals a general pattern of the artist's adjustments to the figure, shifting it to the side, as he had those in many paintings, including *Bathers with a Turtle* [**3**] and *Bather* [**8**].

These comparisons demonstrate that Matisse, in his work on *Back (II)*, was primarily focused on reformulating the style of the figure, attempting to remove the curving, S-shaped spine and the relatively soft, relaxed flesh in *Back (I)*. Instead, he sought to create an increasingly solid, stocky figure with a more angular and geometrically built form that anticipated the direction he went on to take with the other works that he completed over the summer in Issy. *Back (II)*, possibly finished soon after Matisse returned from Morocco in March 1913, would be critical to his efforts to refine and abstract as he searched for a new form of pictorial construction.

1. Various attempts at dating *Back (II)* outside 1913 include Barr, "Painting and Sculpture Acquisitions July 1, 1955 through December 31, 1956," *Museum of Modern Art Bulletin* 24, 4 (Summer 1957); Tucker 1969; Legg 1972; and Gowing 1979.

2. According to Duthuit and de Guébriant 1997, p. 384, no. 20, the 1949 presentation at the Musée des Beaux-Arts, Lucerne, was the first time these three works were shown together. The catalogue for the exhibition published only two works under the heading "Sculptures en bronze": *Nu de dos I* and *Nu de dos II*, the first of which was illustrated in what appears to be bronze. See *Henri Matisse* (Musée des Beaux-Arts, Lucerne, 1949), p. 50; Maison de la Pensée Française, *Henri Matisse: Chapelle, peintures, dessins, sculptures*, exh. cat. (Maison de la Pensée Française, 1950), which identifies and illustrates *Back (IV)* as *Nu de dos, 3e état* (p. 24 and n.pag.); and Barr 1951, pp. 11, 29.

3. Barr's notes in preparation for the 1951 exhibition and his monograph, made in consultation with the artist and his family, note only three bas-relief *Back* sculptures. In Barr Questionnaire VII, the three sculptures noted are *Back (I)* (1909, with the date c. 1910 crossed out); *Back (II)* (*Back [III]*, dated 1929); and *Back (III)* (*Back [IV]*, also dated 1929).

4. Duthuit and de Guébriant 1997, pp. 162–63, cat. 57, p. 374 n. 20. The first instance of all four bronzes being exhibited together is at the Kunsthaus Zurich, from July 14 to Aug. 12, 1959, cats. 38, 48, 50, and 63. See *Henri Matisse: Das plastische Werk* (Kunsthaus Zurich, 1959), pp. xi, opp. 10, 16, 20, 22, opp. 22, and 26.

5. The tan color of the figure's body suggests that Matisse might have depicted his real working process: a traditional technique of painting plaster forms with slip as a way to better recognize removals (areas carved away would register as white marks from the clean plaster below); see entry 45 in this publication for more information on this process. A potentially earlier date for *Back (II)* suggests an intriguing connection with the dramatic black curves that the artist painted through Olga Merson's body for her 1911 portrait (12.2).

6. For more on the Symphonic Interiors, which also include *The Painter's Family*, *Interior with Aubergines*, and *The Red Studio* (p. 113, figs. 6–8), see Barr 1951, p. 151. *The Pink Studio* was the first large-scale painting Matisse had made since *Dance (II)*, *Music*, and *Bathers by a River*, a work directly related to this similarly scaled canvas.

7. The plaster of *Back (I)* is listed in *Second Post-Impressionist Exhibition, Grafton Galleries, Oct. 5–Dec. 31, 1912*, exh. cat. (Ballantyne, 1912), p. 23, cat. 1. This catalogue has an introduction by Roger Fry and essays by Clive Bell and Boris von Anrep.

8. This technology was previously used by The Baltimore Museum of Art, Dallas Museum of Art, and the Nasher Sculpture Center, Dallas, in an important study that compared different casts of Matisse's works from the same edition in order to identify differences between various casting processes. For the current project, this software was employed to compare different states of the same sculpture. A similar study of the five states of *Jeannette* still remains to be undertaken.

18 The Blue Window
Issy-les-Moulineaux, June–August 1913

Oil on canvas; 130.8 × 90.5 cm (51 1/2 × 35 5/8 in.)
Signed l.l.: *Henri-Matisse*
The Museum of Modern Art, New York, Abby Aldrich Rockefeller Fund, 1939

IN EXHIBITION

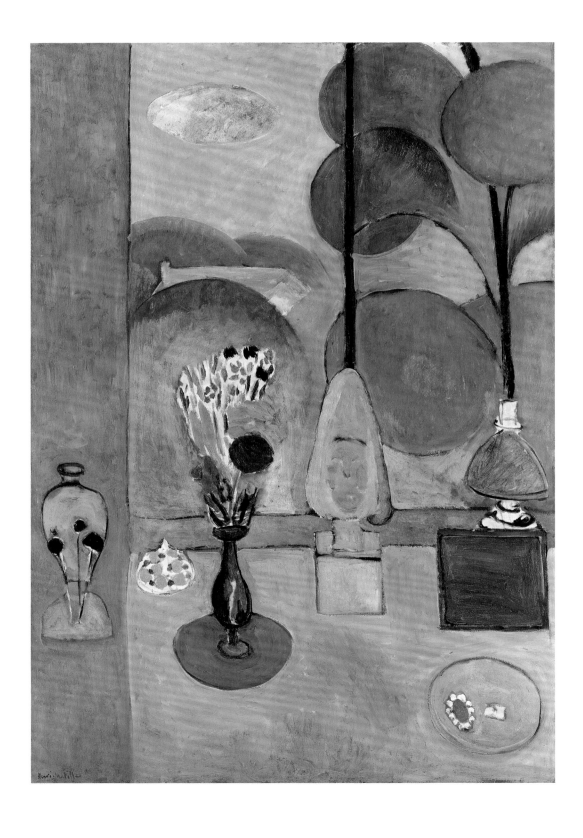

WHEN IT WAS first published in the May 1914 edition of *Les soirées de Paris*, the painting known today as *The Blue Window* [**18**] was given the title *La glace sans tain*, or "the mirror without silvering," a phrase that refers to what is more commonly called a Claude mirror or black glass.[1] This title may suggest something of the genesis of the picture: during a 1941 interview with Pierre Courthion, Matisse recalled an experiment from the early 1900s in the Bois de Boulogne, in which he used a view-finding device to focus on a woodland scene, employed a plumb line to orient the trees, and established a horizontal with a paintbrush. To further harmonize dissonant features, he made use of a blackened mirror. He explained:

I wanted to work within fixed elements, with unchanging things. I took a little black mirror and I looked at the landscape in my mirror. This black mirror has the property of removing all sensation of coloring, like a vermilion red that, when you're not looking at it with the mirror, always comes at you as if it were outside the plane; it's a trumpet in the landscape, and that didn't suit me.[2]

If, as we have seen, the artist revisited subjects as a means of furthering his experiments, he may also have reused a device—particularly one that had helped him reduce and synthesize a composition so successfully. *The Blue Window*'s cool, harmonious palette mimics the effects achieved with a black mirror, and on the right side of the picture, among the still-life elements on the table is a square, red-framed mirror.[3] Its dark surface, which bears no discernible reflection, strongly suggests its identity as a Claude mirror, very possibly the one that Matisse employed to paint this canvas or used as an inspiration for its optical effects.

The Blue Window is even more geometrically organized than the related Moroccan-period *Landscape Viewed from a Window* [**44c**] from the Moroccan Triptych: Matisse structured the composition into vertical and horizontal bands that form the view from his bedroom window at Issy, looking out to the studio.[4] On the left, he painted a vertical band that runs the length of the canvas, which may represent a curtain, an empty space at the edge of the table, or a shadow cast upon its surface. The artist's adjustments to the composition demonstrate his concern for greater simplicity and geometry. Comparison of the infrared reflectogram and X-radiograph [**18a–b**] with the finished painting reveal that Matisse changed the trees, eliminating branches and individual clumps of leaves, and creating rounder, more uniform silhouettes. He balanced other elements, modifying the shape of the distant studio gable from an elongated rectangle to a more symmetrical diamond. He also recast the mirror from a rectangle to a square; adjusted the sculpture and lamp with overlapping brushstrokes in the background in order to align them with

the verticals of the window and tree, respectively; and moved the side of the table to the left to match the left edge of the window.

Matisse reinforced these increasingly simple shapes: he painted black lines around the trees and incised the lines of the studio roof, cloud, and red flower. His choices relate to the 1913 drypoint *Bell Flower* (*Campanule*) [**18c**], which includes an image of the typically blue-colored flower and two sketches of a window view.[5] If we imagine these scenes in reverse—oriented as Matisse would have seen the plate as he worked—we realize that they are directly related to the canvas, recording how the artist successively reduced the number of trees and added still-life elements [**18d–e**].[6] Indeed, in *The Blue Window*, he produced painted lines with a look similar to that of the ink in the drypoint's burr. This is especially true in the area between the bottom of the window and the top of the table and tree trunks, where the overlapping edges of green and black create velvety lines that seem to hover between strokes of cool blue paint. Matisse also paid acute attention to other edges, too, especially the white cloud in the sky outside the window. Here, under magnification, it becomes apparent that he built up the cloud in layers of ocher, pink, green, and blue paint, incising the shape and then scraping into the dried surface to make the simple oval form. Uniform tool marks on the bottom edge of the cloud [**18f**] suggest that the artist used something like a mezzotint rocker to work the contour.[7] His near-sculptural handling produced a kind of shallow bas-relief: in fact, the cloud's surface exists on a different level than the surrounding sky, and the edges of its form are so pronounced that they cast shadows when viewed in raking light [**18g**].

That Matisse used a Claude mirror is also suggested by the color shifts that he made as he worked on the painting. Microscopic examination demonstrates that he tried many layers of varied color, primarily greens, ochers, and pinks, often scraping back a layer before applying a new one.[8] Some of the changes can still be seen between blue brush marks in the vertical band at left, on the tabletop, and in the forms outside the window. A number of objects on the table that had been painted red were covered over with ocher; others first painted in ocher were scraped and repainted red.[9] It may be that the muted tones the artist saw in his Claude mirror were instrumental in leading him to narrow his palette to a few main colors and to repaint the overall composition in a harmonious range of blues, from cobalt to ultramarine. A letter to Matisse from Karl-Ernst Osthaus, the first owner of this work, suggests that the artist had been explicit about using the mirror. Upon receiving the painting, Osthaus wrote, "The beauty and novelty of

18a

18b

18a
Infrared reflectogram of *The Blue Window*.

18b
X-radiograph of *The Blue Window*.

18c

18c

Bell Flower (*Campanule*), 1913. Drypoint on vellum; plate: 14.8 × 9.8 cm (5 $^{13}/_{16}$ × 3 $^{7}/_{8}$ in.); sheet: 32.5 × 42.2 cm (12 $^{13}/_{16}$ × 9 $^{1}/_{2}$ in.). The Museum of Modern Art, New York, William Kelly Simpson (in memory of Abby Aldrich Rockefeller) and Jeanne C. Thayer Funds, 1993. In exhibition.

18d

Detail of *Bell Flower (Campanule)*, showing the scene at upper left; it appears in reverse, as Matisse would have viewed it as he worked on the plate. The artist made this version first.

18e

Detail of the scene at the upper right, in reverse; this is the second version of the composition.

18d

18e

the harmony in your painting made a vivid impression on me, and I am very happy to be able to place this work among the paintings in my gallery. Your description was very useful for me for, while feeling the vision behind the objects, the idea of a mirror absolutely did not occur to me. Thank you, too, for the small engraving which very much interested me."[10] Matisse achieved the overall harmony with blue, which he modulated with varying degrees of black, the most traditional color of printmaking; these, he noted in a June 1912 interview with the American reporter Clara MacChesney, produce a cooler tone.[11] He continued to examine the effect of blues, both warmed and cooled by other colors, in a small group of works executed over the summer and fall.

18f

18g

18f
Detail of the upper edge of the cloud form. Note the darkly shadowed diagonal line on the right side, which is produced by raking light over the edge of the deeply incised form.

18g
Raking-light detail, showing the bottom edge of the cloud form. Note the regularized marks made by Matisse's tool.

1. The Claude mirror, also called a Claude glass, black glass, or black mirror, was named after the French landscape painter Claude Lorrain. It is slightly convex and often made of blackened glass. While the most common color for such mirrors is black, others—from different silver values to green—produce varied effects in different weather conditions. Artists including Édouard Manet and Degas were familiar with the device, whose shape could help them focus on the forms and perspective of the image reflected. For more on the history and application of the Claude mirror, see Arnaud Maillet, *The Claude Glass: Use and Meaning of the Black Mirror in Western Art* (Zone Books, 2004), esp. chaps. 1, 10.

2. Courthion 1941, p. 133. The painting Matisse produced is *Path in the Bois de Boulogne* (p. 78, fig. 3).

3. For identifications of specific objects, see Barr 1951, p. 166; Elderfield 1978, p. 90; and Flam 1986, p. 362. A similar Claude glass, covered in red velvet, is in the collection of Transylvania University, Lexington, Ky. Examination of the X-radiograph of the painting in this area shows that this object was originally rectangular but that Matisse adjusted the shape. Claude glasses were known to be rectangular or round.

4. This subject, a view through a window, was already familiar in Matisse's repertoire. He identified this particular scene in 1945 in response to Barr's question about the historical details of the work; the artist stated that the painting was not easy to produce and that the "picture was painted for the couturier Jacques Doucet, who refused it as it was too advanced for him" (Barr Questionnaire I). Evidence also suggests that the painting was made directly for Karl-Ernst Osthaus. See the letter to Matisse of Sept. 2, 1913 (AHM), presumably from Osthaus, that states: "I am very happy to learn that the painting you have executed for me is finished. I would very much like to ask you to send it to me immediately, but tomorrow I am leaving for Russia and will not return from there until the month of October. After my return, I am planning on going to Paris. It is for this reason that I wish to ask you to keep the painting until then, so that I can look at it in your presence [. . .] the 27th of September, I'll be going to Moscow where I very much hope to see your works." See also Sergei Shchukin's Oct. 10, 1913, letter to Matisse about Osthaus's visit, in which he wrote, "I talked with him about your blue still life, which you had done for him, and what a beautiful picture I found it" (Pierre Matisse Gallery Archives, Department of Literary and Historical Manuscripts, MA5020, box 187, folder 15, Morgan Library and Museum).

5. The bell flower, also known as the campanula, typically blooms in June and July, which supports the idea that Matisse may have started the painting in the summer. While bell flowers appear in white, they are best known for their blue variety, which offers another connection to the palette of *The Blue Window*.

6. That Matisse made the drypoint before the painting is confirmed by the fact that he did not yet include the sculpture of a head, which is located in the center of the painting.

7. Marks left on the bottom edge of the cloud are uniform in length (one centimeter) and regularized in spacing (about seven lines per centimeter).

8. He used pale green, peach, and pink in the sky; bright, dark, lemon, and turquoise greens in the trees; green and pale green for the studio roof; green, ocher, and turquoise on the bedroom wall; and green and pink for the table.

9. Matisse's color combinations and overall palette changes recall his experiments with *Harmony in Red (The Red Room)* (p. 84, fig. 17) and *The Red Studio* (p. 113, fig. 8), raising the possibility that he may have started *The Blue Window* earlier than 1913, perhaps even in 1911. The 1913 date, however, is supported by Matisse himself in his response to Barr's questionnaire, as well as in numerous letters between Matisse and Fénéon, Osthaus, and Shchukin.

10. Osthaus to Matisse, Dec. 12, 1913, AHM.

11. MacChesney 1913.

19 **Flowers and Ceramic Plate**
Issy-les-Moulineaux, September–October 1913

Oil on canvas; 93.5 × 82.5 cm (36 ¼ × 32 ½ in.)
Signed l.r.: *Henri-Matisse*
Städel Museum, Frankfurt am Main, SG 1213

IN EXHIBITION

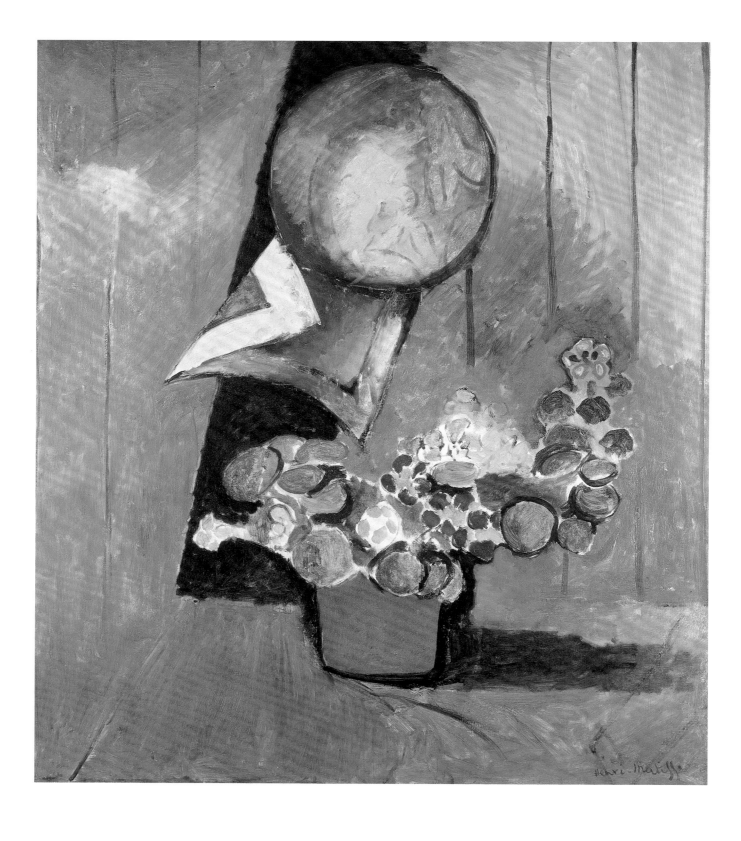

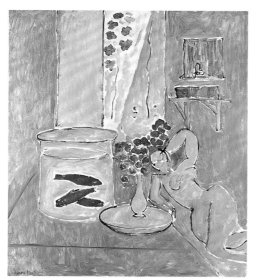

19a

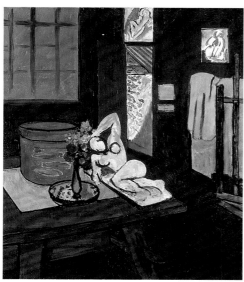

19b

19a

Goldfish and Sculpture, spring–summer 1912.
Oil on canvas; 116.2 × 100.5 cm (46 × 39⁵/₈ in.).
The Museum of Modern Art, New York,
gift of Mr. and Mrs. John Hay Whitney, 1955.

19b

Interior with Goldfish, 1912. Oil on canvas;
117.8 × 101 cm (46³/₈ × 39³/₄ in.). The Barnes
Foundation, Merion, Penn., 569.

ON NOVEMBER 26, 1913, Félix Fénéon wrote
to Matisse concerning his "new still life," *Les
capucines (Nasturtiums)*, known today as
Flowers and Ceramic Plate [**19**].[1] Probably
painted in September and October, the can-
vas likely followed *The Blue Window* [**18**],
which was still in the artist's possession while
its new owner, Karl-Ernst Osthaus, was visit-
ing Russia.[2] Both pictures are marked by blue
palettes and strong horizontals and verticals;
in the present work, the most evident of these
are the familiar wood panels of the interior
of Matisse's studio at Issy. Seen in tandem,
these two paintings demonstrate his evolving
interest in the nature of vision and sensory
experience, and his continuing efforts to trans-
late these explorations into the materials of
his artwork.[3]

Flowers and Ceramic Plate presents us with
an apparently simple still life centered on a
pot of nasturtiums and a small sheet of paper
that hangs below a decorative ceramic plate.
The plate, which seems to float incongruously
above the other two objects, originally bore
a red design of two seated figures facing one
another [**19c**]. Visual examination reveals that
the plate was once larger, extending on the
right beyond its present contours. The fig-
ures' poses are similar to others that Matisse
painted on ceramics around 1907, when he
was working in André Metthey's studio.[4] They
also recall a number of his earlier Arcadian
paintings and sculptures: for instance, the
figure at left is reminiscent of the woman on
the right of *Three Bathers* [**3a**]; related crouch-
ing figures [**3c–e**]; the man at the upper right
in *Game of Bowls* [**5c**]; and the bather to the
left of the waterfall in sketches for *Bathers by
a River* [**5a–b**]. The figure on the right side of
the plate is most closely related to the faun in
the now-lost painting *Nymph and Faun* [**5d**].[5]

Immediately below the plate is an object
that has been variously identified as a print or
drawing, possibly one of Matisse's own, with
its corner curled to expose what may be a
densely drawn or inked image with a generous
border.[6] If we compare its front and back,
we can see that the body is composed of the
same blacks, blues, and reds, and exhibits the
same white-gray border.[7] This treatment may
suggest that what we see is the verso of a
print marked by the pressure of a hand etching
press—or perhaps another object altogether,
one that is more transparent than opaque.[8]
Visual examination also confirms that Matisse
added this item late in the painting process,
and below the present form there are layers of
blue and green paint representing the gen-
eral background of the composition. To add
the object, it appears, he scraped off some
of the blue and used a palette knife to apply
color and then shape and smooth its surface.

Below is the pot of yellow and red flowers,
which sits atop a small table or stool. Here
Matisse used different approaches to suggest

depth and balance, and the contrast of light
and shadow: on the left, he carefully delin-
eated the edge where the highlighted surface
and the dark space behind it meet; to the
right, he painted the bottom ends of the pan-
els into the open space below the nastur-
tiums. In order to echo the main horizontal
surface and provide more balance to the
overall image, the artist extended the flowers
up and to the right of their original position.
These changes create a composition resem-
bling that of *The Blue Window*, with its table-
top at the bottom and still-life objects moving
up and into the depth of the painting. In this
work, however, we can see little beyond the
plate, hanging object, and flowers. Instead,
Matisse filled his scene with a light that is at
once tangible and transparent, and condensed
the shadow into the heavily painted diago-
nal black band at center, which is framed by
the repeating panels of the studio walls.[9]
This geometric description of intense outdoor
light and its penetration into the space of a
studio is reminiscent of his earlier interiors,
especially *Goldfish and Sculpture* [**19a**] and
Interior with Goldfish [**19b**].[10] However, what
Matisse produced in this work—perhaps as
the result of his experiment in *The Blue Window*
and *Portrait of Madame Matisse* (p. 148, fig.
9)—is a more totalizing experience of light and
atmosphere in the overall composition.

The exact location of this view, and pos-
sibly the identity of the objects and their
orientation, may be explained by a 1911 photo-
graph of the studio [**19g**] that shows a book-
case and a curtained window; it suggests
that what we see in the painting is a combi-
nation of these items, and even the curtain,
perhaps animated by a breeze. The painting,
nonetheless, remains notably ambiguous.
What is most significant is Matisse's desire to
record his fleeting visual impression of this
small corner of the world and evoke his con-
tinuing experience of its changes as the light
of day transforms objects and the atmosphere
around them. The artist's main tool in this
task was the color blue, which he had used to
similar delicate effect in the Moroccan
Triptych of 1912, which includes *Landscape
Viewed from a Window*, *On the Terrace*, and *The
Casbah Gate* [**44c–e**]. For *Flowers and Ceramic
Plate*, he built upon earlier green, pale blue,
pink, and violet paint with delicate layers of
darker, warmer blue [**19f**]. To suggest shifts
of light and changes in volumes, he varied his
brushwork from vertical strokes with a dry
brush that lifted away still-wet paint [**19d**] to
quick zigzags that fan out across the sur-
face.[11] The range of blues evokes a brilliant,
warm light that seems to radiate from within;
by contrast, the artist mixed black and other
colors into muted gray tones in areas of
shadow, thereby changing the temperature
and density of the light [**19e**]. The picture, as
Fénéon described it to Matisse on November

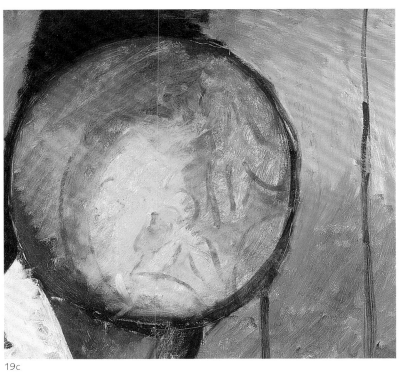

19c

19d

19e

19f

26, is one of "fullness and delicacy," amplified and extended by brushwork that builds light, air, and time itself, registering it mark by mark in colored pulses of paint. It is the perfect translation of Henri Bergson's notion of *durée* (see pp. 110–11). While Matisse may not have experienced this concept directly, he was certainly familiar with it through his growing friendships with Georges Duthuit, Matthew Stewart Prichard, and their friends, who attended Bergson's lectures at the Sorbonne during summer and fall 1913.[12]

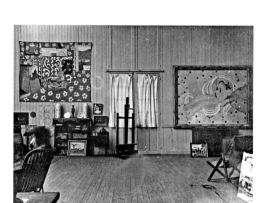

19g

19c

Detail of *Flowers and Ceramic Plate*, illustrating the figural composition on the plate and earlier adjustments to its placement.

19d

Detail of the upper right, illustrating Matisse's use of a dry brush to pull back still-wet paint.

19e

Detail of the flower pot, focusing on the horizontal shadow that the artist painted in shades of green cooled with gray.

19f

Detail showing, at left of still life, the lower layers of pink to which Matisse added small touches of blue atmosphere.

19g

Matisse's studio at Issy, 1911, showing the curtained window and, on the bookcase to the left, two ceramic plates propped up for display. Archives Henri Matisse, Paris.

1. Fénéon wrote to Matisse the next day, asking him to come by Bernheim-Jeune to sign the painting, thus readying it for sale; by mid-Dec., he reported that George Caspari of Munich had made an offer on the work. It appears, however, that the painting was not sold (perhaps due to the war) until 1917, when Robert von Hirsch acquired it for the Städtische Galerie, Frankfurt am Main. See Fénéon to Matisse, Nov. 26, Nov. 27, and Dec. 13, 1913, AHM; and Stephan Mann, "Erworben 1917, beschlagnahmt 1937, zurückworben 1962," in Bismarck and Gallwitz 1991, pp. 75–78.

2. We know that Matisse was in Cassis for some of Sept. In addition to Fénéon's letter of Nov. 26 (see n. 1), a letter from Matthew Stewart Prichard, Nov. 4, 1913 (Archives Duthuit), reports that "Matisse has finished another picture of nasturtiums, about a metre square with which his friends are very pleased." Also there is an undated letter from Georgette Agutte (AHM), who referred to the upcoming Salon, urging Matisse, "Don't work any more on the flower picture, send it to the Salon." She continued, "I am sure that it will be greatly liked, hang it on the picture rail and the beautiful portrait of Madame Matisse above. Believe me, I am quite certain that I am giving you good advice." For Osthaus's visit to Russia, see his letter to Matisse of Sept. 2, 1913, AHM (see p. 167 n. 4 in this publication).

3. The two works have even been proposed as pendants; see Flam 1986, p. 362.

4. The image on this plate does not relate to any known ceramic that Matisse made around 1907. For more on his work with Metthey, see Neff 1974, fig. 35; Xavier Girard, "Matisse: L'Oeuvre céramique," in Musée Matisse 1996, pp. 77–87; and Monery 2002. For more on Metthey, see Clouzot 1922.

5. This painting was known in 1913 as *Bathing Women*, and a noteworthy connection exists between it and another painting featuring nasturtiums, *Nasturtiums with the Painting Dance* (1912; The Metropolitan Museum of Art, New York); see entry 21 (p. 177 n. 6) in this publication.

6. Barr 1951, p. 154, identified the object as an engraving; and Flam 1986, p. 364, described it as a "sheet of paper—either a print or drawing." Barr did not include the work in his questionnaires, and Matisse, as far as we know, never commented on the identification of the objects in the still life.

7. Many of these grays were made with different color combinations: pale green mixed with pink, for instance, and pink and black.

8. It was not possible to study this painting with infrared or X-ray technology, and we are therefore unable to better determine the potential identity of this object and its relationship to the others in the painting; neither are we able to chronicle many of the changes Matisse made in order to arrive at the final image.

9. The diagonal was also a late addition to the canvas, perhaps even the final element for which Matisse scraped down the surface still further.

10. A similar treatment of light falling through open doorways or windows can be found in *Basket of Oranges* (38a) and certainly in earlier works as well.

11. Matisse also used a palette knife to work the surface, but its trace is not as immediately visible.

12. According to Spurling 2005, p. 152 n. 48, Matisse did not read Bergson, although he brought a copy of one of his books to Tangier. For more on Duthuit, William King, Prichard, and Camille Schuwer, see ibid., chap. 5, esp. pp. 148–52; see also Labrusse 1996. For more on Matisse and Bergson's philosophy, see Flam 1986, pp. 243–44; Benjamin 1987, esp. chap. 6; Antliff 1993, pp. 45, 49, 65, 102; Antliff 1999, pp. 184–207; and Dittmann 2008.

20 **The Moroccans, second state**
Issy-les-Moulineaux, September 1913

Compositional sketch for *The Moroccans* contained in an October 25, 1912,
letter from Matisse to Amélie Matisse. Archives Henri Matisse, Paris.

20a

20b

20a–b
Postcards, captioned "Tangier: Tombs of Saints
(*Marabout*)" and "Tangier: Casbah Gate," acquired by
Matisse during his 1912 or 1913 visits to Morocco.
Archives Henri Matisse, Paris.

WHILE IN TANGIER in October 1912, Matisse described and sketched his plans for two paintings that would become *The Moroccan Café* [**15c**] and *The Moroccans* [**44**]; he completed the former of these works by April 14 of the following year. Precisely four months later, Charles Camoin wrote him a somewhat puzzling letter, saying that he assumed that Matisse must have finished both his bas-relief and his painting of the beach at Tangier.[1] The former must be *Back (II)* [**17**], but whether the latter is a proposed beach-themed revision of *The Moroccans* or *Bathers by a River* [**16**] is impossible to know.[2] It is conceivable, however, that Camoin miswrote *plage* (beach) for *place* (square or plaza), for in a letter of September 15, 1913, presumably in reply to Camoin, Matisse summarized what he had been doing: "As for my large painting of Tangier, I have not begun it: the size of the canvas I stretched does not match the way I see the subject."[3] So, at that point, we can be sure that there was a stretched canvas for *The Moroccans* but no work worthy of mention yet done on it.

If this stretched canvas followed the proportions of the compositional sketch for the painting in Matisse's October 25, 1912, letter [**20**], it was a squarish horizontal, similar to the format of *The Moroccan Café,* which he conceived and sketched along with it. As realized, that work is close to a 180-by-220-centimeter canvas, Matisse's favored size for large compositions, and it would have made sense for him to begin another large painting of Tangier at those dimensions.[4] Was it a canvas of that size that he rejected in mid-September 1913? By looking ahead to the next mention of the painting, we can deduce two possibilities to explain what happened. On November 22, 1915, Matisse wrote to Camoin that he was "beginning again" a canvas of 180 by 220 centimeters, namely *The Moroccans.*[5] This suggests that either he had stretched a canvas of that size in 1913 but, after rejecting it in September, decided that it would suffice after all; or that he had stretched a canvas of some other size in 1913 and realized later that he had to replace it with one measuring 180 by 220 centimeters. What is uncertain is when, after writing to Camoin in September 1913, he settled on that size for his painting, and how much work—if any—he did before returning to it two years later.

It is worth noting that a November 1913 letter contained Matisse's announcement that, at the last minute, he had decided not to visit Tangier for a third time. He concluded, "You will probably be astonished to hear that I've made plans to spend a few months in Paris, subletting a studio in Montparnasse. Judging that my present task demands concentration and that a trip, a change of climate and the excitement of new things —whose first impact on us is always how picturesque they are—would lead my attention to be dis-persed, so that the excitement of Paris is sufficient for me for now."[6] *The Moroccans,* as first conceived in 1912, had been a picturesque genre scene. The representation that Matisse now envisaged for the subject obviously was not.

1. Camoin to Matisse, Aug. 14, 1913, AHM.

2. Elderfield 1978, p. 209 n. 2, suggested that Matisse's first conception of *The Moroccans* may have been as a beach scene; Flam 1986, p. 366, proposed that Camoin was referring to *Bathers by a River.* Both of these texts were written prior to the publication in Duthuit and de Guébriant 1997 of Matisse's Oct. 25, 1912, letter, which rules out the former suggestion but leaves open the possibility of a planned transformation of the setting of both *The Moroccans* and *Bathers by a River.*

3. Matisse to Camoin, Sept. 15, 1913, Archives Camoin.

4. Other paintings of this size include *Bathers with a Turtle* (3), *Harmony in Red (The Red Room)* (p. 84, fig. 17), *The Pink Studio* (p. 113, fig. 5), *The Red Studio* (p. 113, fig. 9), and *The Conversation* (p. 117, fig. 15).

5. Matisse to Camoin, Nov. 22, 1915, Archives Camoin. It is worth noting the potential inspiration at this time of the many postcards that Matisse acquired during his travels (20a–b).

6. Matisse to Camoin, Nov. 1913, Archives Camoin.

21 Bathers by a River, fourth state
Issy-les-Moulineaux, early November 1913

Oil on canvas; 260 × 392 cm (102 1/2 × 154 3/16 in.)

Photograph of *Bathers by a River* by Eugène Druet, showing the painting
as it was in November 1913.

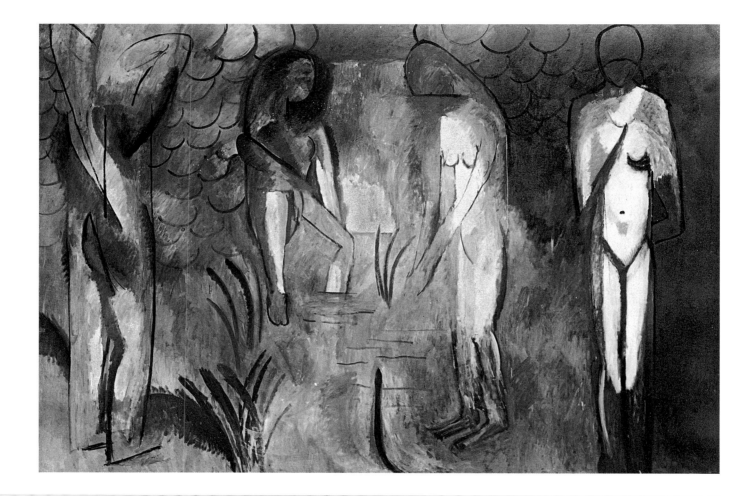

21a

21b

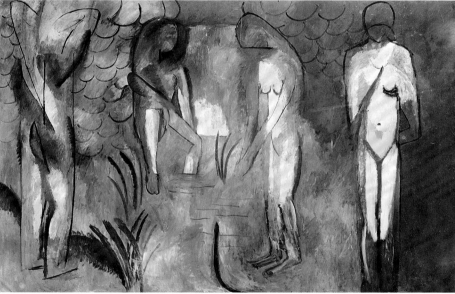

21c

21a
Eugène Druet's photograph of *Bathers by a River* in November 1913 overlaid with a diagram of the painting's state in May.

21b
Overlay of the final version of *Bathers by a River* and the state recorded in Druet's November 1913 photograph; areas that match are those retained in subsequent changes.

21c
Druet's November 1913 photograph of *Bathers by a River*, recolorized to represent the appearance of the painting at the time.

"I HAVE BEEN wanting to write to you for a long time," Matisse apologized to his artist friend Charles Camoin on September 15, 1913,

But I am preoccupied by my work. . . . When I have a moment, the ideas don't come to me—you know this ailment. At present I am tired and what I need would be to chase all concerns from my mind. Still I have worked on only a few things this summer, but I have advanced my large paintings of Bathers, the Portrait of my wife, as well as my Bas-relief.[1]

Matisse's assessment was, of course, an understatement: the transformation of *Bathers by a River* alone would prove to be a major effort that would demand equal measures of physical and mental endurance if it was to continue. Over the summer, he was preoccupied with a number of artistic and personal concerns: he had, for instance, been spending much time with Picasso, who was convalescing after "a little typhoid," as his companion Eva Gouel explained to Gertrude Stein.[2] Matisse visited his recuperating friend on several occasions in July and August, and in September even reported on their activities: "Picasso is an equestrian and we ride together, which astonishes many people! Why? Painting goes slowly but well."[3] Although the pair's conversations went undocumented, we can assume they touched on art. This may account in some ways for Matisse's sustained examination of his subjects in reduced, nearly monochromatic palettes reminiscent of the Analytical Cubist paintings of Picasso and Braque in 1909 and 1910—the blues and, increasingly, grays of *The Blue Window* [**18**], *Flowers and Ceramic Plate* [**19**], and *Portrait of Madame Matisse* (p. 148, fig. 9).[4] In addition, earlier in the summer he was working on behalf of the Galerie Levesque, offering— first to his patron Sergei Shchukin, then to Ivan Morosov—Gauguin's remarkable *Where Do We Come From? What Are We? Where Are We Going?* (p. 146, fig. 6), which must also have offered welcome inspiration as he contemplated work on his own monumental figure painting.

Matisse's progress on *Bathers by a River* was significant enough to prompt questions about his ultimate plans for the work. Camoin, in a letter possibly from November 1913, asked—no doubt responding to his friend's own comments—whether he would be exhibiting the painting in the upcoming Salon d'Automne.[5] Around the beginning of that month, Matisse himself had arranged for Eugène Druet to photograph the picture [**21**].[6] The formal nature of the image suggests that the artist identified this stage of the painting as worth documenting; in fact, his daughter, Marguerite, stated that he photographed his work when he felt he had taken something to a certain state of completion.[7]

In Druet's photograph, we see the painting, now identified with the title *Femmes nues, décoratif*, resting against the familiar

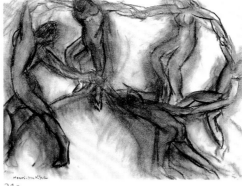

21d

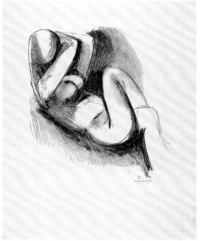

21e

21d
Detail of the bent knee of the second figure from left, showing scumbled layers of gray over the brighter colors of the earlier palette.

21e
Study after "Dance (II)," c. 1910. Charcoal on paper, mounted on cardboard; 48 × 63.5 cm (18 7/8 × 25 in.). Musée de Grenoble, MG 2213

21f
Large Nude, 1906 or 1913. Lithograph on white chine; composition: 28 × 26 cm (11 × 10 1/4 in.); sheet: 44.8 × 35.2 cm (17 7/16 × 13 7/8 in.) (AIC); composition: 28.3 × 25.1 cm (11 1/8 × 9 7/8 in.); sheet: 45 × 34.9 cm (17 11/16 × 13 13/16 in.) (MoMA). Chicago venue: The Art Institute of Chicago, Prints and Drawings Purchase Fund, 1955.1050. New York venue: The Museum of Modern Art, New York, gift of Abby Aldrich Rockefeller (by exchange), 1955. In exhibition.

21f

21k

21g

21h

21i

21j

21g
X-radiograph of *Bathers by a River* with a diagram of the fourth state, showing locations of cross sections.

21h
Cross section showing dark gray over the formerly pink waterfall. Original magnification: 200× [×898].

21i
Cross section showing light gray over the once-blue water and pink bather. Original magnification: 200× [×847].

21j
Cross section showing light gray over the earlier pink right leg of the figure on the right. Original magnification: 200× [×1050].

21k
Cross section showing dark gray over green foliage. Original magnification: 200× [×883].

bead-board paneling of the studio, propped up on two food crates with art materials gathered on the floor.[8] Comparing the state of the composition to that in the image digitally stitched from the photos Coburn took four months earlier [16i], we can begin to appreciate the major transformation that Matisse wrought even as he worked on *Back* and the portrait of his wife, among other pictures. We can discern vestiges of the May canvas: at the top, Matisse retained the high horizon, which is the source of the waterfall, as well as the general position of the four bathers and the snake, although in each case either moving them up or fixing them more solidly in place. Gone are the details of the figures' faces and hair; they are now more generalized, faceless women.[9] Also new are the details of the bathers' environment—the leafy parts of plants, rippling surfaces of water, and repeated round forms of the trees—elements, in fact, from Morocco and Issy [18] that Matisse merged to form a new kind of imaginary landscape.

Visual examination of the finished painting reveals the colors of this earlier composition; indeed, some are visible even today, since Matisse retained parts of the May 1913 version—especially the legs and torsos of the bathers—throughout later painting campaigns [21b]. Microscopic study and cross-section analysis confirm the range of light, medium, and dark grays that he used to cover the foliage, waterfall, and bodies [21g–k]. By employing new imaging technology developed specifically for this project, which has allowed us to colorize black-and-white archival photographs, we can reconstruct the palette of the canvas documented in Druet's photograph [21c].[10] This enables us to see that Matisse tamped down the earlier layers of pinks, greens, and blues and enveloped the whole in a palette of mottled grays. He shifted the color and mood of the picture dramatically by scumbling delicate layers of gray paint over the surface [21d], producing a pulsating rhythm that is echoed by the densely hatched brushwork found in other areas of the painting. The overall effect of outlined forms filled with thin, overlapping washes of gray is parallel to the drawing Matisse made after *Dance (II)* [21e], which Marcel Sembat noted in an article in *Les cahiers d'aujourd'hui*: "After *Music*, he regretted that *Dance* was not more sublimated, more restful, more nobly calm! And I know of a charcoal of *Dance* as he sees it now, where the movement is sweepingly solemn."[11] It was at this same time that the artist likely took up *Bathers by a River* again, three years after he brought it to some degree of parity with *Dance (II)* and *Music* before their debut at the Salon d'Automne in 1910. With the charcoal drawing, which he made after completing *Dance (II)*, Matisse seemingly resolved his concerns about the vividly colored

painting. The charcoal drawing, which he may have reencountered both in the article and on a visit to Sembat and his wife, the artist Georgette Agutte, would have stirred him to take *Bathers by a River* in a new direction—a process that we see beginning in Coburn's photographs of May 1913 and ending in Druet's of November.

These changes also relate to what may be Matisse's first lithograph of the period, *Large Nude*, a work traditionally ascribed to 1906 [21f]. With its abstracted human form and pose, the figure recalls the bather seated at the left side of the waterfall. It is unlike any other prints that the artist made in that he worked the image directly on the stone, scraping down and adjusting it much like he did the bathers on his large-scale canvas; moreover, he constructed the form out of a network of soft black and gray lines, and with an atmospheric shadowing that parallels the palette of the painting. With its modeling and broad shading, the work is unique among Matisse's lithographs, which share a linear, economical style.[12]

It is likely that the artist ended his work on *Bathers by a River* shortly after Druet's photograph. This is suggested not only by his engagement of Druet but also by the onset of cooler weather, which would have made his unheated studio inhospitable. In December, in fact, Robert Rey visited Issy; his impressions, recorded in a rare eyewitness account that was later published, describe a "deserted" and "frigid" studio. It was also here that Rey encountered a "scene in misty tones, highlighted with blue reflections, a strange scene where large figures can be made out, sketched in wide dark strokes."[13] This cool, reduced canvas, of course, was the once-idyllic, pastel-colored *Bathers by a River*, now dramatically transformed in mood and palette. Before the artist started a new stage of this monumental, demanding picture, he would play out its lessons in other works, reducing, abstracting, and yet building form—especially with the color gray—over the next months and at least into the spring of the following year.

1. Matisse to Camoin, Sept. 15, 1913, Archives Camoin.
2. Gouel to Stein and Alice B. Toklas, July 22, 1913, Gertrude Stein and Alice B. Toklas Papers, Yale Collection of American Literature, Beinecke Rare Book and Manuscript Library, Yale University. Gouel wrote: "Matisse comes often to ask for news about Picasso. And today he has brought Pablo some flowers and spent practically the afternoon with us. He is very agreeable."
3. Matisse to Stein, Sept. 3, 1913. On Aug. 29, Picasso likewise reported to Stein that he and Matisse went "for walks in the woods of Clamart with horses." Both letters are in the Gertrude Stein and Alice B. Toklas Papers, Yale Collection of American Literature, Beinecke Rare Book and Manuscript Library, Yale University.
4. In addition, as we know from Alvin Langdon Coburn's photographs of Matisse working on *Back (III)* (45), he was marking his plaster with varying

intensities of color—probably different dilutions of slip—before cutting away with his chisel and hammer. The monochrome effect of this sculpting process paralleled his canvases at this time.
5. Claudine Grammont assigned this undated letter to Nov. 1913; Camoin wrote to Matisse: "Have you sent *Bathers* [La baignade] to the Salon?" It is worth noting that Matisse called the painting *Baigneuse* in his mid-Sept. letter to Camoin, and that Camoin, in turn, gave it a slightly different title. While they relate to the same subject, the different titles may indicate that there was another painting about which Camoin had inquired.
6. This date was determined by the circumstances of Matisse's participation in Alfred Flechtheim's inaugural exhibition of Dec. 1913. There Matisse presented a number of paintings including *Femmes baigneuses* (known today as the lost *Nymph and Faun* [5d]), *Nasturtiums with the Painting Dance* (1912; The Metropolitan Museum of Art, New York), and *The Red Studio* (p. 113, fig. 8), as well as sculptures, drawings, and prints. By the end of Oct., Flechtheim was impatiently awaiting photographs of the works to include in his catalogue; these, the dealer reported in a letter of Nov. 4, 1913, were being taken by Druet. Today a set of Druet's glass negatives (Réunion des Musées Nationaux, Fonds Pompidou, Druet-Vizzavona) include the print of *Bathers by a River* as illustrated here, suggesting that he took the photographs to send to Flechtheim. See correspondence between Flechtheim and Matisse, Oct. 27–Nov. 11, 1913, AHM.
7. Elderfield 1978, p. 72, no. 6.
8. Annotated version of Druet's 1913 photograph, curatorial files, Art Institute of Chicago.
9. Robert Rey, who would visit Matisse at the end of the year and see the canvas, called the figures *personnages*, demonstrating the degree to which they had moved from their original identification as bathers.
10. This groundbreaking technology was developed by Sotirios A. Tsaftaris and Aggelos K. Katsaggelos of Northwestern University; it was intelligently employed by Francesca Casadio and Kristin Lister at the Art Institute of Chicago.
11. Sembat 1913, p. 193.
12. John Neff, following Barr 1951, p. 99, cat. 7, proposed that *Large Nude*, which is typically dated to 1906, be reassigned to 1913 based on the Mar. 1, 1914, edition of Bernheim-Jeune's *Bulletin* 3, n.pag. That publication lists a lithograph printed in an edition of fifty on Chine-Chine, and measuring 450 by 350 millimeters. Based on the known prints made by Matisse and published in Duthuit-Matisse and Duthuit 1983, p. 403, Neff's thesis, which includes the possibility that Matisse reworked the stone in 1913 from a 1906 composition, warrants serious consideration. See Neff, "Henri Matisse: Notes on His Early Prints," in Moorman 1986, p. 19, cat. 16. Working a lithographic stone years after it was made would have been a difficult task for an artist like Matisse, who made lithographs exclusively through transfer and did not print his own impressions until late 1913 and early 1914. The proposal here is simply that as Matisse began to look at printmaking as another possibility for exploration, he began this image, which he made on a stone in 1913. Thanks to Mark Pascale at the Art Institute of Chicago for his thoughtful advice on this issue.
13. Rey 1914, p. 60.

ON JANUARY 1, 1914, THE DAY AFTER Matisse's forty-fourth birthday, he and his wife moved into an apartment in Paris, taking with them their bed, piano, violin, maid, and a selection of their most prized paintings.[1] They were to stay for at least several months. The apartment was on the fourth floor of 19, quai Saint-Michel, looking down onto the Seine; it was across from the police headquarters and the Cathedral of Notre Dame, directly beneath the studio that the artist had occupied for more than a decade, from summer 1894 through fall 1907.[2] In a letter to his daughter, Marguerite, Matisse described what it comprised: "Main room with two windows opening on the quay, bedroom, dining room, kitchen, hall—well laid out—rent 1300 francs—so I took it, realizing at last that this is what I wanted—your mother, who found the idea extraordinary to start with, is quite happy now."[3]

This move was indeed a bit of a surprise to Amélie, as she and her husband had been planning to go back to Tangier for a well-deserved rest in the winter, having spent a difficult three months as Matisse completed *Portrait of Madame Matisse* (p. 148, fig. 9).[4] Yet the artist had been looking for a studio in Montparnasse before he learned of the quai Saint-Michel vacancy, already wondering whether it would be wise to revisit Morocco after all. It would be better, he wrote to Charles Camoin, to spend some months in Paris, "Judging that my present task demands concentration and that a trip, a change of climate and the excitement of new things—whose first impact on us is always how picturesque they are—would lead my attention to be dispersed, so that the excitement of Paris is sufficient for me for now."[5] Finding not merely a studio but an apartment in the city, Matisse took it. He knew, when he began his search, that he wanted to get away from the Issy studio, which had been the site of so many frustrations, in order to better focus attention on where his artistic exploration should go. When he found the studio at the quai Saint-Michel, he seems to have realized that he also wanted to revisit familiar themes and older ideas to help him move forward into new territory.

At least that is what happened: in just over six extremely productive months, he painted around a dozen pictures, six of them in the same standard size 80 format—approximately 146 by 97 centimeters—that he had used for his wife's portrait. Matisse may well have chosen this format because it was the largest he could comfortably work on in the small apartment. But he did recognize that he needed discipline to get through what was going to be a difficult period, and there is also something very systematic about working through a series of identical canvases.[6] These ambitious works comprise two paintings of the cathedral from the studio window, both titled *View of Notre Dame* (23, 23d); two still lifes in the studio, *Interior with Goldfish* (24) and *Branch of Lilacs* (27); and two portraits, *Woman on a High Stool* (25) and *Portrait of Yvonne Landsberg* (28). Together, the three pairs constitute a series in a new sense for the artist, encompassing variations on themes and recording his shifting focus on a rediscovered place.

Leaving Issy also enabled Matisse to avoid being confronted every day with figure compositions that went back years, namely the bas-relief *Back* (17, 45) and *Bathers by a River* (21), which were standing incomplete in the studio there. Conversely, he wished to extend his recent return to printmaking and installed a hand etching press in the new apartment, where he continued to create drypoints and etchings, and added a new technique, monotype, which he would pursue only during this period (22). Most urgently of all, he wanted to grapple with issues raised in making the tragically beautiful *Portrait of Madame Matisse*, which had marked a big change from the vivid blue interiors that joined it over the summer and fall. Indeed, the work had come at the cost of enormous effort and a sense that it had opened up a Pandora's box of difficulties. Although he wrote to Camoin that the painting had been well received among "those with advanced views," he also remarked, "I find scant satisfaction in it, it is the beginning of a very painful effort."[7] However, as Guillaume Apollinaire recognized, it was truly a turning point in Matisse's art; he proclaimed it to be the best work in the Salon d'Automne and, with the 1905 *Woman with a Hat* (p. 49, fig. 10), the finest of the artist's career.

If the paintings that Matisse made in the first six months or so of 1914 play out the consequences of *Portrait of Madame Matisse*, one of Apollinaire's remarks on that work offers a useful way of understanding the position from which he started. Understanding that grays and dark blues are as much colors as greens and oranges, the critic announced: "Never before, I believe, has color been endowed with so much life. Internal art, which is today's art, after affecting an austerity that has not been seen since [Jacques-Louis] David's reforms, no longer disdains to appear agreeable, and the orphism of certain painters is a holy and admirable intoxication with color."[8] This is an oblique reference to how avant-garde painting had surrendered the austerity exemplified by Picasso and Braque's increasingly hermetic Cubism to produce the Orphism of Robert Delaunay.[9] That artist had long been indebted to Matisse, retaining a Fauvist emphasis on contrasts of color as the key to pictorial construction. In the summer of 1913, he began his *Circular Forms* series (fig. 1); in these works, freed from the constraints of specific depiction and a Cubist grid, he placed yet greater emphasis on color contrasts to create visual sensations that were equivalent to those found in the sunlit world. Apollinaire clearly esteemed *Woman with a Hat* because it embodied just such a liberation of color and freedom from verisimilitude, and *Portrait of Madame Matisse* for showing how austerity did not preclude coloristic brilliance.

However, Matisse was uninterested in following Delaunay into an exploration of the harmonic movement of color unattached to the depiction of external reality.[10] Indeed, it may be that Apollinaire's praise, which emphasized color as a source of sensual pleasure, prompted Matisse to move in a different direction, drawing instead upon his memories of Cubism's earlier austerity. This may seem surprising, since he had spoken dismissively of the Cubist paintings at the 1913 Salon d'Automne, and many years later he explained to André Verdet, "I was entrenched in my pursuits: experimentation, liberalization, color, problems of color-as-energy, of color-as-light. Of course, Cubism interested me, but it did not speak to my deeply sensory nature, to the great lover that I am of line, of the arabesque, those bearers of life. For me to turn toward Cubism would have been to go counter to my artistic ideas."[11] "Nevertheless, Cubism brushed against you," Verdet tactfully replied. "Brushed against me, exactly," the artist agreed. It certainly did so in Apollinaire's *Les peintres cubistes*, where the critic described him as an "instinctive Cubist," and indeed, it is not unreasonable to apply that label to Matisse if Delaunay's now entirely nongeometric, soft symphonies of color were also to be described as Cubist paintings.[12]

It is striking that Matisse moved away from vivid color precisely when the Cubist avant-garde appeared to be embracing it: not only Delaunay, but also Roger de la Fresnaye, Albert Gleizes, Juan Gris, Fernand Léger, and Jean Metzinger were painting more frankly sensual, pleasurable pictures than Matisse now was, most of them prompted by the flat, bright color that appeared in the *papiers collés* of Picasso and Braque, works that may well have been originally influenced by Matisse's *Interior with Aubergines* (p. 113, fig. 7).[13] Picasso led the way to use *papier collé* as a license to introduce found decorative patterning, as in his *Pipe, Glass, Bottle of Vieux-Marc* of 1914 (fig. 2), and the paintings that he began making in June of that year initiated what Alfred H. Barr, Jr., called "Rococo Cubism" for its riot of decorative details.[14] We see this most ambitiously employed in his *Portrait of a Girl* (fig. 3), which looks like a collage but is actually a painted patchwork whose components include Pointillist dots, leaves, seemingly cut-out patterns, imitation basketwork, drawing paper, marble, and wallpaper. It displays a more fanciful and self-indulgent use of color and decoration than Matisse had ever allowed. Indeed, it comes as a shock to turn to what Matisse was painting at precisely the same time, *Portrait of Yvonne Landsberg* (28)—severe in its color, harsh in its distortions, its surface scraped and scratched, and not a hint of dissimulation in its means.

This painting is the final, culminating work in the sequence of canvases that played out the consequences of *Portrait of Madame Matisse*. It was begun in early June 1914 and completed by July 12, almost precisely five months after Matisse had

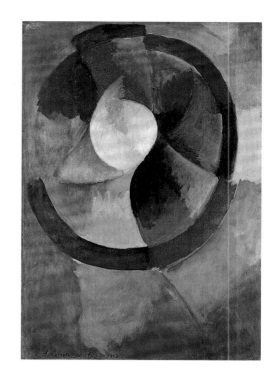

fig. 1
Robert Delaunay
(French, 1885–1941)
Circular Forms, 1913
Oil on canvas
100.3 × 68 cm (39 1/2 × 26 3/4 in.)
Musée National d'Art Moderne/
Centre de Création Industrielle,
Centre Pompidou, Paris, gift
of the Friends of the Musée
National d'Art Moderne, AM
3910 P

finished the first works in the sequence, the *esquisse* (23d) and final version (23) of *View of Notre Dame*.[15] The first of these, a limpidly delicate work that is refreshing in its light tonalities, is accentuated by areas of exposed canvas but nonetheless more conservative than comparable paintings of the preceding year, *The Blue Window* (18) and *Flowers and Ceramic Plate* (19). In the second, however, the artist carried forward the relatively dense yet aerated surfaces of these earlier blue canvases, only to strip back their geometric organization into bare scaffolding that suggests knowledge of such high Analytical Cubist paintings as Picasso's *La pointe de la cité* (fig. 4).

Other paintings were already underway by this time. In mid-January, Matisse may have begun the great canvas *Interior with Goldfish* (24) and possibly started a second, *Woman on a High Stool* (25).[16] The artist said that he hoped that he could paint the former work "directly and freely" only to find that it "had to be done and redone."[17] We may assume that the latter, which also shows signs of extensive revision, was begun in a similarly direct and free manner—therefore, that both were initially consistent with the Notre Dame pictures, which were begun in the early part of the year. Perhaps Matisse's overall aim, when starting to work in the Paris studio, was to avoid the extremely protracted revisions that had made his *Portrait of Madame Matisse* so difficult to complete. The canvases that we know Matisse had finished by March suggest that this was indeed the case.

On February 18, nine days after Sembat's visit, Matthew Stewart Prichard wrote to his friend Georges Duthuit, "Matisse has now begun five paintings but has finished none."[18] Some of the works that he completed by the end of the month were presumably among them, for they all seem quickly painted. *The Rose Hat* (30a) is one of a group of portraits of his daughter, Marguerite, that Matisse made that spring; all of these combine the lightness and spareness of the first version of *View of Notre Dame* with the flatly tinted color and tall vertical formats of some of Matisse's Moroccan figure paintings of 1912–13, resembling especially the more freely composed of such works, like *Amido* (14a). Related to this is the strangely forlorn *Tulips* (fig. 5), which likewise maintains the sketchlike quality of the first *View of Notre Dame* but not its incomplete coverage. The same is true of the more ambitious depiction of spring blossoms, *Branch of Lilacs* (27).[19] This painting, too, has

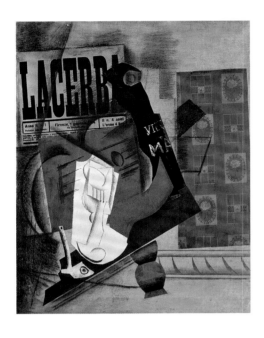

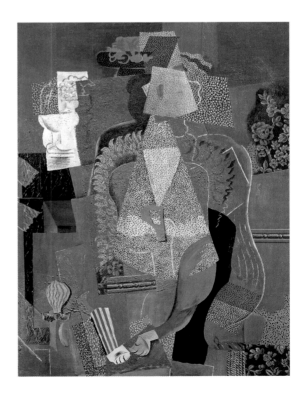

fig. 2
Pablo Picasso
(Spanish, 1881–1973)
Pipe, Glass, Bottle of Vieux-Marc,
1914
Paper collage, charcoal, India ink,
printer's ink, graphite, and
gouache on canvas
73.2 × 59.4 cm (28⁷/₈ × 23³/₈ in.)
Peggy Guggenheim Collection,
Venice, 76.2553 PG 2

fig. 3
Pablo Picasso
Portrait of a Girl, 1914
Oil on canvas
130 × 96.5 cm (51¹/₈ × 38 in.)
Musée National d'Art Moderne/
Centre de Création Industrielle,
Centre Pompidou, Paris, bequest
of Georges Salles, AM 4390 P

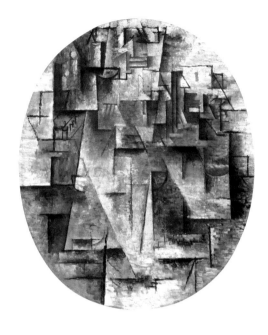

fig. 4
Pablo Picasso
La pointe de la cité, 1911
Oil on canvas
90 × 71 cm
(35 1/2 × 28 in.)
Private collection

fig. 5
Tulips, 1914
Oil on canvas
100.1 × 72.9 cm
(39 7/16 × 28 11/16 in.)
Private collection

the watercolor-like thinness of an *esquisse,* but Matisse found substance enough in its lightness to create a fully realized examination of the color gray in ranks of hatched brushstrokes that echo those of Cézanne.

Yet another painting completed by March was the smaller *Still Life with Lemons* (26), which seems an attempt on the artist's part to conflate his earlier method of flat color infilling, most recently used in the Moroccan paintings, with a Cubist design. Its tight focus on a small group of objects is reminiscent of Matisse's contemporaneous monotypes and of the close-up views of faces in his etchings (see 22a, v–w). In fact, as he was painting this work, he was also arranging with Bernheim-Jeune to announce, on March 1, the availability of "Les estampes d'Henri Matisse," an edition of thirty-three prints.[20] The focus of attention on this small corner of his studio, cropped out of space and time, recalls the previous year's *Flowers and Ceramic Plate*; but whereas the earlier painting invokes change in an observed moment, this offers the sense of a moment eternally suspended by geometry so as to make comparable Cubist collages look indulgent. Indeed, it gives priority to controlled order over empirical experience to such an extent that it left the Cubists Gris and Metzinger speechless when they saw it shortly after its completion.[21]

On March 24, Prichard wrote to Isabella Stewart Gardner that he had just seen two new pictures by Matisse, "of which I said to him that one would be a classical work, in the sense that it typifies a new formula."[22] By now, however, the artist was using virtually every new painting to introduce a new pictorial idea. This fact was made very apparent two months later, on May 15, when Apollinaire's journal *Les soirées de Paris* reproduced five of the artist's "recent" canvases to welcome his return to the avant-garde: *The Blue Window, Interior with Goldfish, Still Life with Lemons, Tulips,* and *Woman on a High Stool*.[23] The inclusion of the previous year's *The Blue Window* may have been the artist's acknowledgment of how that similar work anticipated the completed form of *Interior with Goldfish.*

In *Interior with Goldfish,* Matisse moved beyond light painterliness to compose with bold planes that were heavily worked, scraped, and incised, and a color range dominated by dark blue for the interior, with pinks, mauves, and creams outside. The interior space is nominally deeper than in any painting he had done since he had left his first studio at quai Saint-Michel nine years earlier, yet everything seems pulled up to the dense surface. The artist may have been looking at the use of contrasting vertical bands to open up space on the flat surfaces of Cubist collages such as Picasso's *Guitar* (fig. 6). If so, he reversed their function, using the alternating light and dark bands of the walls and window to make one plane of background and foreground. Matisse expanded this idea in a second version of this painting, *Goldfish and Palette* (31), making it a principal feature of a number of his most ambitious compositions over the next two years.

Woman on a High Stool is even more radical than *Interior with Goldfish,* but whether completed after or before it is unknown. In one respect, the artist followed the impetus of *Gray Nude with Bracelet* (22k), begun in December 1913, in which he allowed ambient space to eat into the solid form of the figure, something that Cézanne had done to embed volumes within the flat areas around them. Also like Cézanne, Matisse divided the form of the figure into planes, setting them parallel to the surface. However, this painting also looks back to the more angular gray bodies of *Bathers by a River* (p. 149, fig. 12): the sitter's elevated position recalls that of the second bather, who is seated up high beside the waterfall. The late-1913 stage of *Bathers* revealed a dual indebtedness to Cézanne, with its hatched brushstrokes and broken contours that afford a linkage, or *passage,* between volume and ground, and to Analytical Cubism, with its dialogue of opaque and transparent form. In *Woman on a High Stool,* the overlaid drawing and transparent effects recall Analytical Cubism even more; Matisse was interested in the breaking of "closed form" in works like Picasso's *La pointe de la cité,* which Daniel-Henry Kahnweiler claimed was the decisive advance that freed Cubism from the language of earlier painting.[24] At the same time, even Matisse's fully open forms, like the seemingly empty neck

or feet in his portrait, still serve the Cézannist mission of reinforcing rather than fracturing the identity of the figure.

When Matisse found his new studio at the end of 1913, he began work there by wanting to resolve what he felt were the shortcomings of *Portrait of Madame Matisse.* To that end, he attempted to work "directly and freely," avoiding the lengthy revisions that canvas had required, only to find himself once again making paintings that "had to be done and redone," and that led to *Portrait of Yvonne Landsberg,* truly the companion of *Portrait of Madame Matisse.* However, like *Woman on a High Stool,* the Landsberg portrait also draws upon *Bathers by a River,* particularly the standing figures, combining the mute frontality of the bather on the right end of the canvas with the arching, rhythmic lines of the one on the left, which Matisse recapitulated in the marks that he scratched into the surface of the portrait.

Indeed, it appears that the artist was using all of the individual paintings he had made thus far in 1914 not just to grapple with issues raised by *Portrait of Madame Matisse,* but also to explore the possibilities of *Bathers by a River.* He had done a similar thing just after starting that composition in 1909, when he reprised and reexamined the figural poses in separate canvases. Now he did the same for its technical means. He reviewed *Bathers by a River*'s superscribed drawing in the second *View of Notre Dame,* its delicate gray layers and hatched brushwork in *Branch of Lilacs,* and the idea of imposed geometry in *Still Life with Lemons.* He imagined new options for its organization in the light-and-dark banding of *Interior with Goldfish,* revisited a familiar way of setting a figure into a narrow, bandlike rectangular space in *The Rose Hat,* and attempted a newer method of doing so in *Woman on a High Stool* and *Portrait of Yvonne Landsberg.* Moreover, as this sequence of canvases unfolded, Matisse used his etchings and monotypes to aid his ability to work directly and freely, and to repeat and test his treatment of the same or similar forms. As the prints pulled him in the direction of clarity and simplicity, he sought these same qualities in his paintings through, as well as despite, the increasingly revisionary processes of their making. Conversely, the more that the artist relied upon revision, the more he kept turning to Cézanne, to the extent that *Woman on a High Stool* and *Portrait of Yvonne Landsberg* take on some of the strangeness of Cézanne's late compositions of bathers that had infused *Bathers by a River* the previous year.

fig. 6
Pablo Picasso
Guitar, after March 31, 1913
Cut-and-pasted paper and printed paper, charcoal, ink, and chalk on colored paper on board
66.4 × 49.6 cm (26 1/8 × 19 1/2 in.)
The Museum of Modern Art, New York, Nelson A. Rockefeller bequest, 1979

Matisse's expanded Cézannism of 1914 came in a year when Paris was often reminded of the artist's legacy. In June the 1911 Camondo bequest to the Louvre was finally put on view, bringing paintings by Cézanne into the museum's collection for the first time, among them *The Blue Vase* (fig. 7), which would have reminded Matisse of his own *The Blue Window*.[25] In May, Léger spoke of the artist in his second lecture at the Académie Wassilief, remarking that Cézanne's observation of "plastic contrast" in external reality was tempered by his living in a less dissonant period, one that now required a dynamic clash of nature and architecture.[26] Matisse may well have heard of this from friends in the Cubist circle, if he had not read the published version.[27] He must have known about the book on Cézanne that Vollard issued in September, no doubt in a spirit of competition with the Bernheim-Jeune volume; his own *Three Bathers* (p. 45, fig. 3) was among its illustrations.[28]

Being back in Paris meant that there were plenty of people with whom Matisse could discuss his interests and current projects, if he chose to. Among them were Prichard and those in his cosmopolitan group, including the Sorbonne student Duthuit, the Englishman William King, the Brazilian Albert Clinton Landsberg, and others who attended Bergson's popular lectures at the Collège de France and engaged the artist in discussions about the nature of perception and on questions of ontology relating even to the goldfish and chair in his *Interior with Goldfish*.[29] On the fringes were American collectors such as the Bostonians Gardner and Mabel Bayard Warren. Although Matisse's drawings were not well received in Boston—indeed, the artist remained controversial in the United States—this circle did what they could to advance his cause. Of this group, Prichard wrote to Duthuit on May 2, "There is a veritable Matisse cult, you see, and they are all trying to understand him, in order to explain him to the others."[30]

That spring, however, the Paris art world was most interested in the unfolding events of the sale of the Peau de l'Ours collection, one of many events at this time that registered Matisse's increasing prominence and the growing appeal of his work. This collection had been established in 1904 by a cartel of young collectors led by the writer and collector André Level, with the goal of acquiring works over a period of ten years and then selling them at auction, hopefully for a profit. The sale was a huge success, attracting dealers from Germany as well as France and generating great interest among artists, especially since twenty percent of the profit made on any work would go to its creator.[31] More than any other event, this sale encouraged the purchase of art for investment and would soon further heat up the market for Matisse's work. The Galerie Thannhauser of Munich purchased Picasso's *Family of Saltimbanques* for the astonishing sum of 11,500 francs, which prompted the critic Maurice Delacourt to see yet another example of a plot to destroy French art: "Well, a new proof of this German meddling is obvious. It's the sale of La Peau de l'Ours . . . since these 'considerable prices' were attained by the grotesque works, and given form by undesirable foreigners."[32]

Matisse was seeing a lot of foreigners—American, German, and Italian. In fact, in 1914, he mingled with the avant-garde to a far greater extent than in the previous year, when his circle of contact was tightly focused on Issy, and found growing appreciation among his younger colleagues. The Futurist Carlo Carrà, for instance, likely visited Matisse's studio sometime in March. He came to Paris with his colleagues Giovanni Papini and Ardengo Soffici, and all stayed with Serge Férat and Baroness Hélène d'Oettingen, codirectors with Apollinaire of *Les soirées de Paris*. They were there when the journal published its feature on Matisse, who was certainly aware of their sojourn and who met Soffici, if not the others. Although he had been conscious of the Futurists since their large group exhibition at the Galerie Bernheim-Jeune in 1912, it is possible that their presence in May 1914 affected the soon-to-be-painted *Portrait of Yvonne Landsberg*. As often observed, the incised lines that arch around the figure may refer to what the Futurists called *force-lines*. In the preface to their 1912 Bernheim-Jeune exhibition catalogue, *Les peintres futuristes italiens*, they claimed that "each object, by means of its lines, reveals how

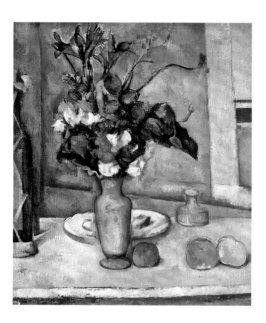

fig. 7
Paul Cézanne
(French, 1839–1906)
The Blue Vase, 1889–90
Oil on canvas
61 × 50 cm (24 × 19 11/16 in.)
Musée d'Orsay, Paris, RF 1973

it will be decomposed according to the direction of its forces . . . which follow the emotional law dominant in the painting."[33] This somewhat Bergsonian idea may well have appealed to Matisse. Another aspect of the Landsberg portrait may also owe something to external influence. On May 24, Matisse met Soffici in Picasso's studio, where *Les demoiselles d'Avignon* (p. 51, fig. 14) hung in a corner. This must have been an agitating experience for Matisse, who was blocked in his attempts to advance his own recent large composition, *Bathers by a River*. Yet it may also have been an instructive one, encouraging him to a greater extremism. We must wonder whether he remembered the blank eyes and primitivized faces of the right-hand two *demoiselles* while working on the head of the Landsberg portrait a few weeks later.[34]

The Cubists were no less present. In the month prior to this meeting, there opened at the Galerie André Groult an exhibition of the work of Raymond Duchamp-Villon, Gleizes, Metzinger, and Jacques Villon.[35] Gleizes and Metzinger had visited Matisse's quai Saint-Michel studio shortly before, and it is likely that he returned their interest. If so, he would surely have paid attention to Duchamp-Villon's relief *The Lovers* (fig. 8), which had been made while he was working on his bas-relief *Back* the previous year. For Matisse, however, this would have served as an example of what not to do: cut into a figure so much that it flies apart. The artist claimed that the incised arcs that spring from Landsberg's figure were "lines of construction that I put around the figure to give it greater amplitude in space."[36] But they also return to the body, preserving its figural wholeness.

In the late spring, Matisse was visited by the American critic Walter Pach, whose purpose was to negotiate a solo show for the following year on behalf of the Montross Gallery in New York, to which the artist agreed. Then, in mid-June, Curt Glaser arrived from Germany to ask Matisse to intercede with the Sembats, and especially with Michael and Sarah Stein, whose participation was critical to a solo exhibition planned for the Kunstsalon Fritz Gurlitt in Berlin. The Sembats refused to lend, probably because of the worsening political situation, but the Steins were reluctantly persuaded; they would lose nineteen paintings after the United States entered the war in 1917 (see pp. 321–23).[37] Bernheim-Jeune was supportive of both these projects and was doing very well indeed for Matisse, largely through the efforts of Fénéon, who was working on commission and naturally interested in seeing the prices rise.[38]

In retrospect, there were two especially notable sales in this period. The first was that on March 3 of *Acanthus (Moroccan Landscape)* (p. 115, fig. 12), to Léonce Rosenberg.[39] When the German dealer Kahnweiler, the principal representative of the Cubists, was forced to leave France upon the outbreak of the war, Rosenberg

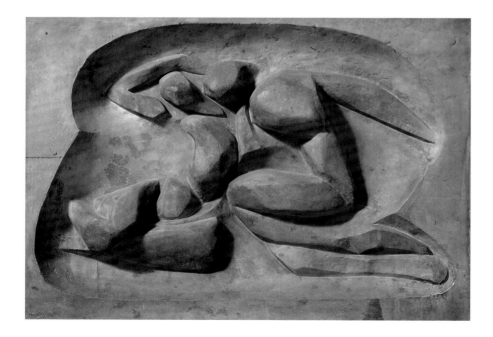

fig. 8
Raymond Duchamp-Villon
(French, 1876–1918)
The Lovers, 1913
Plaster
69.8 × 116.8 × 16.3 cm
(27 1/2 × 46 × 6 1/2 in.)
The Museum of Modern Art,
New York, purchase, 1939

set about engaging the Cubists and also worked very hard to get paintings from Matisse. The second notable sale was arranged but could not be realized, also because of the impending war. Matisse's most loyal patron, Shchukin, wrote to him on July 1 to confirm his payment for *Portrait of Madame Matisse,* adding, "I hope that you haven't forgotten my sitting room and that I'll be getting some paintings (there are still three lacking to finish the first row)."[40] He would eventually agree to purchase *Woman on a High Stool*, but time was running out, and the painting would never reach Moscow.[41] On July 28, Austria-Hungary declared war on Serbia, setting off a chain of events that would deeply affect Matisse's art and life.

—JOHN ELDERFIELD

1. Matisse to Marguerite Matisse, Dec. 26, 1913, AHM, mentions that the move would occur on January 1; see also Spurling 2005, p. 145.

2. Albert Marquet had then taken it over, and Matisse rented a larger space at the Couvent des Oiseaux, where *Le bonheur de vivre* (p. 49, fig. 12) was painted. It was Marquet who had told him that the fourth-floor apartment was available.

3. Matisse to Marguerite Matisse (n. 1); Spurling 2005, p. 145.

4. Apparently, they had considered traveling to the Corsican town of Ajaccio, Collioure, Barcelona, and Tangier, with a third trip to Morocco being the favorite possibility; Monod-Fontaine, Baldassari, and Laugier 1989, p. 38. It is not surprising that Amélie found the idea extraordinary, as the couple's marriage had entered a difficult period, and it must have been hard to think of moving from the villa at Issy into a crowded apartment that was also to function as a studio. For more on Amélie's reactions, see Spurling 2005, pp. 92–94, 140–42, 186–87.

5. Matisse to Camoin, after Nov. 15, 1913, Archives Camoin; this letter is dated Nov. 1913 in Grammont 1997, p. 57. It was certainly written after Nov. 15, since Matisse referred to looking for a studio, and must date to before the end of the year, when he rented the apartment at 19, quai Saint-Michel.

6. The tall, narrow canvases, traditionally used for figure formats, also relate to Matisse's use of an even narrower format for some of his etchings and the vertical format of his ongoing bas-relief, *Back* (17, 45). In all these cases, a figure-ground reciprocation is asserted by the shape of the support.

7. Matisse to Camoin (n. 5).

8. Apollinaire 1913b, p. 6; Apollinaire 1972, pp. 330–31.

9. This development had become evident to Apollinaire when he accompanied Delaunay to Berlin in early 1913 to see his *Windows* paintings at the Galerie der Sturm; he unashamedly promoted Orphism in his book *Les peintres cubistes,* published later that year. For more on Apollinaire, Delaunay, and the Cubist avant-garde in 1912 and 1913, see Green 1976, pp. 73–80.

10. In Delaunay's *Circular Forms,* the rhythmic flow of luminous color was intoxicating, not because it depicted the simultaneousness of experience in external reality, as the Futurists had pioneered, but because it exemplified a central tenet of Henri Bergson's philosophy in the harmonic movement of color itself; see ibid., pp. 74–75. Neither the Futurist nor the Orphist approach would be satisfying to Matisse: the former was tied too closely to the particularities of external experience, the latter too little.

11. Verdet 1978, p. 127.

12. Apollinaire 1913a, pp. 83–84; Apollinaire 2004, pp. 83–84.

13. For the influence of Matisse's painting on Picasso and Braque, see Flam 1986, p. 134. See also the discussion after Christine Poggi, "Braque's Early Papiers Collés: The Certainties of Faux Bois," in

Picasso and Braque: A Symposium, ed. Lynn Zelevansky (Museum of Modern Art, 1992), pp. 153–55.

14. Alfred H. Barr, Jr., *Picasso: Fifty Years of His Art* (Museum of Modern Art, 1946), p. 90. For a discussion of color, decoration, and Picasso's collages, see Cowling 2002, pp. 242–52.

15. Sembat, "Cahiers noirs," Feb. [17], 1914, cahier V, OURS, Paris; Phéline and Baréty 2004, p. 174.

16. We have no firm knowledge of *Woman on a High Stool* until its May publication in *Les soirées de Paris;* see pp. 201–03 in this publication.

17. Stein to Albert C. Barnes, Oct. 20, 1934, President's Files, Albert C. Barnes Correspondence, The Barnes Foundation Archives, Merion, Penn.; Stein 1950, p. 147.

18. Prichard to Duthuit, Feb. 18, 1914, Archives Duthuit; Labrusse 1996, p. 215, no. 217.

19. *Branch of Lilacs* appears to have been in Matisse's studio when Carlo Carrà visited sometime in March. According to Carrà, Apollinaire took him to the quai Saint-Michel studio of Matisse, whom he called the "grande fauve." Matisse was not there, but Amélie showed them everything. Carrà noted in particular "two still life paintings with fish, statuette, and other objects, and a delicate portrait of his wife"; Carrà, *La mia vita* (Rizzoli, 1945), pp. 196–97. Presumably, the two still-life paintings were *Interior with Goldfish* and *Branch of Lilacs.*

20. "Les estampes d'Henri Matisse," *Bulletin* 3 (Mar. 1, 1914), n.pag.; see p. 141 of this publication.

21. Barr Questionnaire VI.

22. Prichard to Gardner, Mar. 24, 1914, Prichard Papers, Isabella Stewart Gardner Museum Archives, Boston. Prichard may also be referring to the Notre Dame paintings or *Still Life with Lemons.* As Jack Flam put it, "Over the past few months Matisse had invented so many new formulas that Prichard might have been referring to quite a few of his paintings. None was meant to represent a style per se; all share imagery that reflects a search for an absolute, along with the assumption that an absolute can be realized only once"; Flam 1986, p. 380. On Mar. 28, Prichard wrote to Duthuit to say that Matisse had finished three or four glorious pictures (Archives Duthuit); he did not identify them, however, and currently available documentation does not determine precisely which these were. See Labrusse 1996, p. 215 n. 217.

23. Apollinaire 1914, pp. 253, 254, 264, 284.

24. Karmel 2003, pp. 13, 68.

25. *The Blue Vase* is often said to have influenced *The Blue Window;* however the Camondo bequest, although formally acquired in 1911, was not put on view until 1914. See Musée du Louvre, *Catalogue de la collection Isaac de Camondo* (Musées Nationaux, 1922).

26. See Léger, *Fonctions de la peinture* (Gonthier, 1965), p. 26.

27. "Les réalisations picturales actuelles," *Les soirées de Paris* 3, 25 (June 15, 1914), pp. 349–56.

28. Vollard, *Paul Cézanne* (Galerie A. Vollard, 1914), fig. 45, opp. p. 136.

29. For a useful summary of the Matisse–Prichard discussions, see Labrusse 1996, pp. 766–68; and Spurling 2005, pp. 148–52.

30. Prichard to Duthuit, May 2, 1914, Archives Duthuit; Labrusse 1996, p. 778.

31. Paintings by Gauguin and Van Gogh sold for around four thousand francs, and the ten Matisses went for prices ranging from six hundred to five thousand; the undisputed star, however, was Picasso's *Family of Saltimbanques* (1905; National Gallery of Art). For more on Level, see p. 86 in this publication.

32. Guy Habasque, "Quand on vendait la Peau de l'Ours," *L'Oeil* 12 (Mar. 1956), p. 22; E. A. Carmean and J. Carter Brown, *Picasso: The Saltimbanques*, exh. cat. (National Gallery of Art, 1980).

33. Umberto Boccioni, Carlo Carrà, Luigi Russolo, Giacomo Bella, and Gino Severini, "Les exposant au public," in Boccioni et al. 1912, pp. 1–14; *Archivi del futurismo*, vol. 1 (De Luca, 1958), p. 106; Green 1976, p. 42.

34. Soffici, "Fatti personali," *Gazzetta del popolo* (Feb. 9, 1939), p. 3.

35. See the exhibition at Galerie André Groult, Apr. 6–May 3, 1914, *Exposition de sculptures de R. Duchamp-Villon: Dessins, aquarelles d'Albert Gleizes, gravures de Jacques Villon, dessins de Jean Metzinger*, exh. cat. (André Groult, 1914).

36. Matisse to Barr, June 22, 1951, Alfred H. Barr, Jr., Papers, series 11, folder I A 9, MoMA Archives.

37. Conflicting accounts of precisely how the Steins lost their paintings exist; see Fiske Kimball, "Matisse: Recognition, Patronage, Collecting," *Philadelphia Museum Bulletin* 43, 217 (Mar. 1948), p. 35; Barr 1951, pp. 177–78, 540–41 nn. 4–6; Flam 1986, p. 394; Schneider 2002, p. 185 n. 43; Fourcade 2005, p. 470; and Annette Rosenshine, "Life's Not a Paragraph," unpublished memoirs, Bancroft Library, University of California–Berkeley, microfilm reel 68/144, typescript p. 96.

38. See Fénéon to Matisse, Nov. 5, 1914, AHM. In this letter regarding the Montross exhibition, Fénéon made suggestions about the works that Pach had requested for the presentation. See also Fénéon to Matisse, May 29, 1914, which expresses Fénéon's desire to keep the sale price of *Tulips* above what Gurlitt had offered for it.

39. In 1906 Rosenberg and his brother Paul took over the long-established Paris gallery of their father, Alexandre, only to split the business four years later. When Rosenberg purchased *Acanthus,* he was mainly a collector; however, before the year was over, he had returned to dealing. See Dauberville and Dauberville 1995, vol. 1, pp. 530–31, cat. 139.

40. Shchukin to Matisse, July 1, 1914, AHM.

41. Barr 1951, p. 180.

22 Prints
Issy-les-Moulineaux and quai Saint-Michel,
Paris, January 1914–17

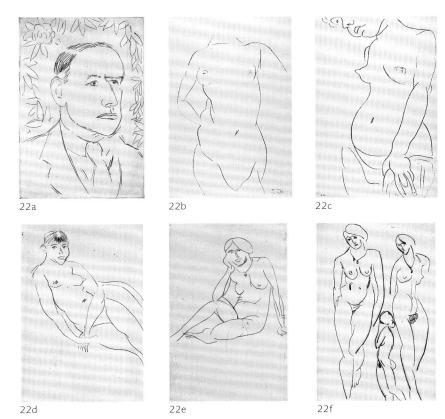

22a

22b

22c

22d

22e

22f

22a

Matthew Prichard, spring 1914. Etching on vellum;
plate: 18.2 × 12.2 cm (7³/₁₆ × 4¹³/₁₆ in.); sheet:
40 × 28.3 cm (15³/₄ × 11¹/₈ in.). The Museum of
Modern Art, New York, Stephen C. Clark Fund, 1951.
In exhibition.

22b

Torso, fall 1913. Lithograph on Japan paper; plate:
46 × 30 cm (18¹/₁₆ × 11¹³/₁₆ in.); sheet: 50.3 × 33 cm
(19¹¹/₁₆ × 13 in.). The Art Institute of Chicago,
gift of Mrs. Tiffany Blake, 1952.1072.

22c

Three-Quarter Nude, Head Partly Cropped,
fall 1913. Transfer lithograph on Japan paper;
composition: 50.3 × 30.5 cm (19¹³/₁₆ × 12 in.);
sheet: 50 × 32.9 cm (19¹³/₁₆ × 12¹⁵/₁₆ in.).
The Art Institute of Chicago, Alfred Stieglitz
Collection, 1949.928.

22d

Half-Length Nude, fall 1913. Drypoint on vellum; plate:
14.5 × 10 cm (5¹¹/₁₆ × 3¹⁵/₁₆ in.); sheet: 32.6 × 25.2 cm
(12¹³/₁₆ × 9¹⁵/₁₆ in.). The Museum of Modern Art,
New York, Stephen C. Clark Fund, 1951. In exhibition.

22e

Seated Figure–Nude, fall 1913. Drypoint on vellum;
image: 14.8 × 9.9 cm (5¹³/₁₆ × 3⁷/₈ in.); sheet:
32.5 × 25 cm (12¹³/₁₆ × 9¹³/₁₆ in.). Institut National
d'Histoire de l'Art, Paris, Bibliothèque, collections
Jacques Doucet, EM Matisse 27. In exhibition
(Chicago).

22f

Three Figures (Académies), fall 1913. Etching and dry-
point on vellum; plate: 14.8 × 10 cm (5¹³/₁₆ × 3¹⁵/₁₆ in.);
sheet: 33 × 25.5 cm (13 × 10¹/₁₆ in.). The Museum of
Modern Art, New York, Stephen C. Clark Fund, 1951.
In exhibition (New York).

IN THE FALL of 1913, after a six-year hiatus,
Matisse returned to the practice of making
prints. His output was more prolific than dur-
ing earlier periods, when he had created a
handful of drypoints, lithographs, and wood-
cuts.[1] Now, from late 1913 until early 1917, he
produced eight lithographs, sixty-six drypoints
and etchings, and at least sixty-nine mono-
types, creating the latter for the first and only
time in his career. The modest subjects of
these prints reflected the world around him—
everyday life in the studio (22g–j)and espe-
cially family and friends (22a)—but the format,
tools, and techniques he employed wrought
a far greater impact on his work overall
than we might at first expect.[2]

The first prints of this period coincided
with the artist's fall 1913 efforts on *Bathers
by a River* [**21**]. By mid-November he was
working with Germaine Raynal, a model who
later posed for *Woman on a High Stool* [**25**].[3]
Matisse made a group of lithographs that
present Raynal in a variety of seated and
standing poses; these works relate to his
efforts to simplify form, capturing essential
elements and describing them with a mini-
mal number of strokes. *Torso* [**22b**] and *Three-
Quarter Nude, Head Partly Cropped* [**22c**]
show Matisse at his most extreme, eliminating
the figure's head or limbs and manipulating
her torso on the rectangular page while still
preserving the kind of monumentality he had
achieved in *Bathers by a River*. At this moment,
he also resumed making drypoints, which
allowed him to pursue his reductive experi-
ments, but with different means and effect.
Unlike the freely drawn line of the lithograph,
the drypoint's is stiffer and more angular by
its very nature, as it is made with a sharp
metal tool scratched directly into the surface
of a copper plate. Matisse employed this
technique to give a firmness and solidity to
Raynal's body; the resistance his tool met on
the plate likewise encouraged him to sup-
press detail, leaving the form open [**22d–e**]. At
times, he also scratched deeply, producing
more burr on the plate and a printed line of
inky depth, density, and volume [**22f**]. His
early efforts were well received: correspon-
dence among the artist's friends documents
that, on at least one occasion, the atmosphere
in the Issy studio was "like an afternoon at
the Bon Marché," with enthusiastic, direct
sales to Georges Duthuit, Matthew Stewart
Prichard, Mabel Bayard Warren, and others.[4]

Matisse's resumption of printmaking coin-
cides with a number of factors, including
work on *Bathers by a River* and the completion
of *Portrait of Madame Matisse* (p. 148, fig. 9),
a demanding canvas that he recounted took
over one hundred sittings. In contrast, the
minimal effort and commitment required to
make prints must have been a welcome
"rest," as he had termed his similar transition
to sculpture from painting (p. 73). Graphic

22g

22g
Young Woman in an Interior with Fruits and Sculpture,
1914–15. Monotype on chine collé; image: 18 × 12.9 cm
(7 1/16 × 5 1/16 in.); sheet: 37.5 × 28.2 cm (14 3/4 × 11 1/8 in.).
Saint Louis Art Museum, gift of Mr. and Mrs. Joseph
Pulitzer Jr., 1951. In exhibition.

22h
Young Woman before a Table Garnished with Fruit,
1914–15. Monotype on chine collé; image: 12.8 × 18.8 cm
(5 × 7 3/8 in.); sheet: 27 × 34.2 cm (10 5/8 × 13 1/2 in.).
Lent by Alan Cristea Gallery, London. In exhibition.

22i
Interior, Young Woman Drawing Fruit, 1914–15. Mono-
type on chine collé; image: 9.7 × 15 cm (3 13/16 × 5 7/8 in.);
sheet: 27.8 × 36.9 cm (10 15/16 × 14 1/2 in.). The Museum
of Modern Art, New York, gift of Abby Aldrich
Rockefeller (by exchange), 1956. In exhibition.

22j
Still Life and a Statue, 1914–15. Monotype on
chine collé; image: 12.9 × 17.9 cm (5 1/16 × 7 1/16 in.);
sheet: 28 × 37.5 cm (11 × 14 3/4 in.). Private col-
lection, Germany. In exhibition.

22h

22i

22j

media's potential for monochromatic treat-
ment and compositional reduction also
complemented the path the artist would con-
tinue to take in his painting. Since he could
complete plates quickly and transport them
easily, printmaking would have been a prudent
choice up through the end of December,
when he was contemplating whether to return
to Morocco a third time.

As it turned out, Matisse decided to stay
and rent the quai Saint-Michel studio instead;
this led him to commit himself to a sustained
exploration of printmaking, and he even pur-
chased a hand etching press for his own use.
Indeed, printmaking came to have a special
place in his artistic practice: his daughter,
Marguerite, recalled that he often executed
prints at the conclusion of an arduous paint-
ing session; from eyewitness accounts, we
also know that he employed them during
breaks, as instruments of relief or synthesis
[**28**].[5] He likewise used prints to record dif-
ferent states of works, much like Eugène
Druet's photographs on other occasions,
including the November 1913 state of *Bathers
by a River*. During this time, the artist was
also at work on the canvas *Gray Nude with
Bracelet* [**22k**]. Under magnification, its surface
reveals a number of changes to the model's
form and pose—including a formerly pointed
chin and delineated right hip—that Matisse
recorded in the drypoint *Nude with a Bracelet*
[**22l**].[6] Increasingly over the next years, he
looked to his prints as a way to explore a pos-
sible change to a composition or to docu-
ment the end of a state before beginning
further alterations.

Matisse also used his prints—and especially
his etchings—to increase his ability to work
quickly and concisely, since they are made by
lightly drawing on a waxy ground and letting
acid do the work to mark the plate. Walter
Pach, who was in Paris in the fall of 1914 pre-
paring an exhibition of Matisse's work for
the Montross Gallery, New York, recalled the
artist's efforts in this regard.[7] At the end of a
meeting, Matisse asked if he might do an
etching of Pach, who had only a short time
before his next appointment and tried to
reschedule. Matisse offered,

"I'll do it in five minutes." And he took out his watch
and laid it on the table. . . . In five minutes, he had an
outline drawing on a plate and a few strokes to indi-
cate color and shading. "That isn't serious," he said as
he showed it to me, "I wanted to set down an impres-
sion of you then and there. But come on Sunday morn-
ing and we'll have time for a real one." I came on Sunday
morning and found the little plate he had sketched,
already nicely printed. There were some unimportant
spots of foul biting in it, but as Matisse said, "I did not
do those. God did. What God does is well done; it is
only what men do that is badly done." For three hours
he worked over one plate and then another—there may
even have been a third. Each time he took turpentine
and washed off the drawing so as to be under no temp-
tation, as he said of biting it in with the acid. The morn-
ing was a failure from the standpoint of results (it is

true that there were interruptions by friends in uniform
who had to be eased out); but then we looked at the
little five-minute etching, and it had just the life that
the more heavily worked things had lost. It is a delight-
ful piece of character and design—the best demonstra-
tion of the difference between quantity of work and
quality of work that I have encountered.[8]

Pach's portrait [**22v**], made with a plate that
was small enough for Matisse to hold in his
hand while working, demonstrates both the
intimate, improvisational nature of these
works and the pace and fluidity with which
he produced them. The artist also took
advantage of this readymade format, allowing
the natural sides of the tall, vertical plate—
and the final printed composition—to stand in
for the sides of Pach's face, furthering his
greater efforts toward simplification and
reduction.[9] Etching also allowed Matisse to
freely experiment, at times reusing abandoned
plates for new compositions and letting
chance take a hand in the production process.
Here the "foul bite" of the acid onto the
ground, possibly hastened by a fingerprint on
the surface of the wax that was etched, reads
as a shadow on Pach's face. His description
also reminds us of Matisse's practice of
reworking motifs—although in this case the
artist preferred his first attempt, in many
other instances he focused repeatedly on
the same subject, exploring form and line in
various and unexpected ways, as seen in his
studies of model Loulou Brouty [**22m**]. In the
case of the young Irène Vignier [**33g**], the
artist whittled down the details of a face
through a set of eight prints, working until
he had condensed it into an essential
"mask" [**22w**].[10]

All these elements came together in
Matisse's monotypes, a hybrid form of print-
making in which he applied ink to a copper
plate and then lightly scratched away with a
pointed tool to make an image that is printed
on Chine paper as a single, unique impres-
sion.[11] For these Matisse had to work quickly
while the ink was wet, running the plate
through the press smoothly since the image
was delicate, scratched only into the surface
of the ink and not the plate. Marguerite, who
often assisted her father in the studio, recalled
the importance of this process to the artist
and the "great moment of emotion when one
discovered the imprint on the sheet of
paper."[12] If monotypes further sharpened
Matisse's efforts to simplify outlines, suppress
details, and condense forms, they also offered
techniques and effects that he could trans-
late directly back to his canvases. The reverse
of a traditional print, in which inked lines sit
on an unprinted field, the monotype relies
on lines that read against a black field with
a brilliant crispness and physicality [**22n**].
Matisse could employ these to suggest deli-
cacy and softness [**22x**], or weight and solidity
[**22z**].[13] His experience of scratching—almost

189

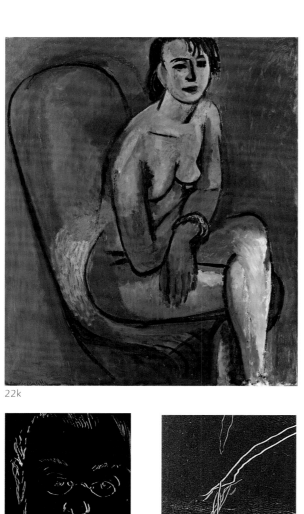

22k

22l

22m

22n

22o

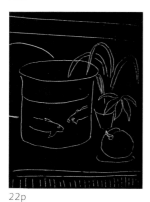

22p

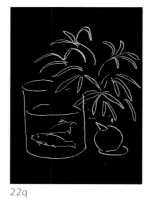

22q

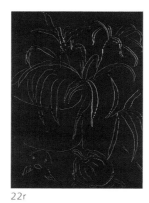

22r

22s

22t

22u

22k

Gray Nude with Bracelet, 1913. Oil on canvas; 75 × 61 cm (29 1/2 × 24 in.). Staatsgalerie Stuttgart, Steegmann Collection.

22l

Nude with a Bracelet, fall 1913. Drypoint on vellum; image: 14.9 × 9.9 cm (5 7/8 × 3 7/8 in.); sheet: 36 × 27 cm (14 1/8 × 10 5/8 in.). Jerry and Judy Polizzi Fine Art, Brooklyn, New York. In exhibition.

22m

Loulou, Study of Nape of Neck, 1914–15. Etching on paper; image: 18 × 12.7 cm (7 1/16 × 5 1/16 in.); sheet: 37.5 × 28 cm (14 3/4 × 11 in.). Private collection.

22n

Self-Portrait, 1914–15. Monotype on chine collé; image: 9 × 6.5 cm (3 9/16 × 2 9/16 in.); sheet: 27 × 17.5 cm (10 5/8 × 6 7/8 in.). Private collection. In exhibition.

22o

Detail of *Still Life with Goldfish (V)*, showing light fingerprints where Matisse tapped over the top of the bowl to adjust its shape and describe the effect of light on the glass.

22p

Still Life with Goldfish (I), 1914–15. Monotype on chine collé; image: 18 × 12.9 cm (7 1/8 × 5 1/16 in.); sheet: 37.5 × 28 cm (14 3/4 × 11 in.). Location unknown (D351).

22q

Still Life with *Goldfish (II)*, 1914–15. Monotype on chine collé; image: 17.8 × 13 cm (7 × 5 1/8 in.); sheet: 37.5 × 28 cm (14 3/4 × 11 in.). Private collection.

22r

Still Life with Goldfish (III), 1914–15. Monotype on chine collé; image: 17.9 × 13 cm (7 1/16 × 5 1/8 in.); sheet: 36.7 × 27.2 cm (14 1/4 × 10 11/16 in.). The Art Institute of Chicago, Mr. and Mrs. Robert O. Delaney Endowment Fund. In exhibition.

22s

Still Life with Goldfish (IV), 1914–15. Monotype on chine collé; image: 18 × 12.8 cm (7 1/8 × 5 1/16 in.); sheet: 37.5 × 28 cm (14 3/4 × 11 in.). Location unknown (D354).

22t

Still Life with with Goldfish (V), 1914–15. Monotype on chine collé; image: 17.5 × 12.6 cm (6 7/8 × 4 15/16 in.); sheet: 37.5 × 28 cm (14 3/4 × 11 in.). The Art Institute of Chicago, Mr. and Mrs. Robert O. Delaney Endowment Fund. In exhibition.

22u

Still Life with Goldfish (VI), 1914–15. Monotype on chine collé; image: 18 × 13 cm (7 1/8 × 5 1/8 in.); sheet: 37.5 × 28 cm (14 3/4 × 11 in.). Location unknown (D356).

22v

Portrait of Walter Pach, fall 1914. Etching on paper; plate: 15.9 × 5.9 cm (6 1/4 × 2 5/16 in.); sheet: 27.9 × 18.7 cm (11 × 7 3/8 in.). Lent by The Metropolitan Museum of Art, New York, Harris Brisbane Dick Fund, 1929, 29.89.15. In exhibition.

22w

Irène—Mask, 1914. Etching on paper; plate: 8.9 × 6.5 cm (3 1/2 × 2 9/16 in.); sheet: 28.1 × 18.7 cm (11 1/16 × 7 3/8 in.). The Metropolitan Museum of Art, New York, Harris Brisbane Dick Fund, 1929 (29.89.24).

22x

Standing Nude, Arms Folded, 1915. Monotype on chine collé; image: 17.6 × 12.8 cm (6 15/16 × 5 1/16 in.); sheet: 37.5 × 27.9 cm (14 3/4 × 11 in.). The Museum of Modern Art, New York, Frank Crowninshield Fund, 1945. In exhibition.

22y

Nude with Bangs (I), 1915. Monotype on chine collé; image: 15.4 × 5.8cm (6 1/16 × 2 1/4 in.); sheet: 15.8 × 6.1 cm (6 1/4 × 2 3/8 in.). Private collection. In exhibition.

22z

Nude with a Ring, 1914. Monotype on chine collé; image: 16.9 × 12.2 cm (6 5/8 × 4 13/16 in.); sheet: 37.5 × 28 cm (14 3/4 × 11 in.). Bibiliothèque Nationale de France, Paris, Department of Prints and Photographs, 81 C 105. In exhibition (Chicago).

22v 22w

22x 22y

22z

carving—into black, removing medium, and investing the inky field with a sense of volume, depth, and even illumination would be carried into his paintings. Indeed, it was in 1914—the same year the artist made his first monotype — that he fully employed black and incising on a canvas, an approach that reached its first dramatic culmination in *Portrait of Yvonne Landsberg* [**28**]. Matisse's translation of techniques from printmaking to painting, however, was not unreciprocal: although we do not know how much he reworked his prints, we can find instances of an inky finger tapped lightly over a reconsidered line on a plate [**22o**], or ink brushed on an impression to clarify a form (p. 227, fig. 11).[14] The physical nature of making a monotype satisfied his overall interest in surface and depth in his works, as well as his own ability to leave a trace of their evolution as a part of their final form.

Monotypes also present a fascinating window onto Matisse's working process: he could repeatedly explore a potential composition for a painting or isolate elements such as the small bowl in *Gourds* [**41**], reshaping and comparing their essential contours before proceeding with an adjustment in the painting. In a dramatic example, the six monotypes related to *Interior with Goldfish* [**24**] and *Goldfish and Palette* [**31**] demonstrate how keenly he examined individual objects, testing the details for elimination [**22p–r**] and studying the still life from various angles and distances, and in different intensities of light [**22s–u**]. In this period, Matisse's monotypes parallel the subjects of some of his most challenging paintings and were deeply connected to their making. This is likely the reason why in 1917, as he began to shift away from his experimental mode of working, he also stopped making monotypes, whose meaning and value to his practice at this time had been inestimable.

1. According to Duthuit-Matisse and Duthuit 1983, the artist made nine drypoints between 1900 and 1903 (cats. 1–9); sixteen lithographs between 1906 and 1907 (cats. 390–406); and four woodcuts between 1906 and 1907 (cats. 317–20). For more on his prints, see Jean Guichard-Meili's preface to Duthuit-Matisse and Duthuit 1983; Woimant and Guichard-Meili 1970; Hahnloser-Ingold 1982; and Fourcade 2005.

2. Of the 143 prints Matisse made over this period, approximately ninety were portraits; see ibid. For general information on Matisse's portraits, see Klein 2001.

3. For more on Raynal, see Hahnloser-Ingold 1988, pp. 30, 34; and John Neff, "Henri Matisse: Notes on His Early Prints," in Moorman 1986, pp. 19–21.

4. Prichard to Georges Duthuit, Nov. 4, 1913, Archives Duthuit; Spurling 2005, p. 150. Matisse was also very aware of this revival: on Jan. 29, 1914, Félix Fénéon wrote to the artist, thanking him for cataloguing his print production up to that point; this information would culminate in the Mar. issue of Bernheim-Jeune's *Bulletin* and the announcement of the sale of Matisse's prints from 1906, 1907, and 1913. See "Les estampes d'Henri Matisse," *Bulletin* 3 (Mar. 1, 1914), n.pag.

5. Albert Clinton Landsberg to Alfred H. Barr, Jr., May

30, 1951, Alfred H. Barr, Jr., Papers, series 11, folder I A 9, MoMA Archives.

6. Early on, the painting was called *Grisaille*, emphasizing its gray palette; see Georges Petit 1931, p. 18, cat. 30. It is noteworthy that as Matisse embarked on an exploration of the color gray in his paintings, he also began to make prints with chine collé, a process that lent an overall field of gray to his intaglios.

7. The Montross exhibition was held from Jan. 20 to Feb. 27, 1915; as a measure of Matisse's sense of the importance of his graphic work at this time, it included twenty-five prints. For more on the display, see Montross 1915, and pp. 224–25 of this publication.

8. Pach 1938, pp. 219–20.

9. This vertical format also recalls those of Asian prints and paintings; the Asian art dealer Charles Vignier might have been instrumental in sharing this world with Matisse, as was Prichard. For more on this subject, see Rémi Labrusse, "Henri Matisse: Un'estetica orientale," in Duthuit 1997, esp. pp. 379–87. Indeed, an Asian influence (in costumed figures, format, and titles) can be seen in a number of Matisse's prints at this time; see Duthuit-Matisse and Duthuit 1983, pp. 28–29, 56–57, cats. 27–29, 68.

10. Matisse specifically used the term *masque* to describe these etchings and monotypes; see ibid., pp. 26–27, 42–45, 54–55, 62–63, cats. 25, 48, 54, 65, 76. For general information on Matisse's portraits and various approaches to the concept of a mask, see Klein 2001; Alarcó and Warner 2007; and Rainbird et al. 2008.

11. When examined under magnification, some impressions reveal the use of a tool that, like the nib of a fountain pen, could expand and contract, leaving fine parallel lines on the inked plate. For more on Matisse's monotypes, see Metropolitan Museum of Art, *The Painterly Print: Monotypes from the Seventeenth to the Twentieth Century*, exh. cat. (Metropolitan Museum of Art, 1980), esp. pp. 206–11; Lebovici and Peltier 1994; Isabelle Monod-Fontaine, "A Black Light: Matisse (1914–1918)," in Turner and Benjamin 1995, pp. 85–95; and Cherix 2007.

12. Marguerite Duthuit to Riva Castleman, Mar. 7, 1978; Castleman, "The Prints of Matisse," in Moorman 1986, p. 8. According to Castleman, the activity of running the press was a family enterprise.

13. Both of these works show evidence of experimentation with a new technique: the black backgrounds were not printed uniformly and exhibit changing density, the result of an unevenness in either inking or printing.

14. See, for example, *The Gourds* (41l). For a thoughtful discussion of this issue, see Chicha 2003–04.

23 View of Notre Dame
Quai Saint-Michel, Paris, January–mid-February 1914

Oil on canvas; 147.3 × 94.3 cm (58 × 37 1/8 in.)
Signed l.l.: *H Matisse*
The Museum of Modern Art, New York, acquired through the Lillie P. Bliss Bequest,
and the Henry Ittleson, A. Conger Goodyear, Mr. and Mrs. Robert Sinclair Funds,
and the Anna Erickson Levene Bequest given in memory of her husband, Dr. Phoebus
Aaron Theodor Levene, 1975

IN EXHIBITION

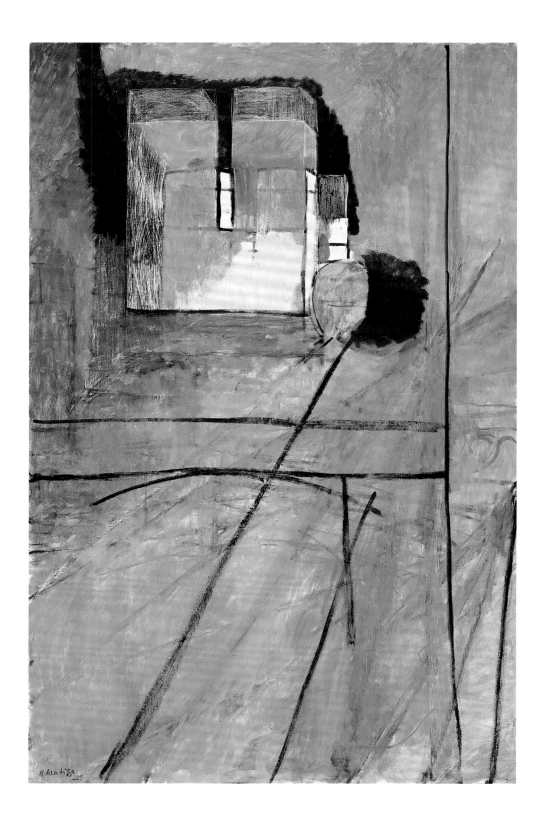

23a

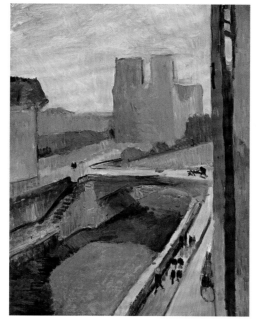

23b

23c

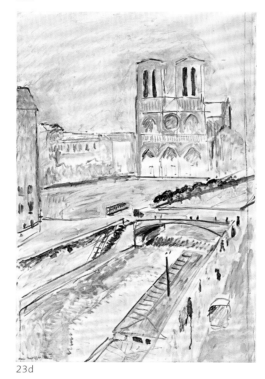

23d

23a
View of Notre Dame, 1914. Monotype on chine collé; image: 8.9 × 6 cm (3 1/2 × 2 3/8 in.); sheet: 28 × 18.7 cm (11 × 7 in.). Bibliothèque Nationale de France, Paris, Department of Prints and Photographs, 81 C 105. In exhibition (Chicago).

23b
A Glimpse of Notre Dame in Late Afternoon, 1902. Oil on canvas; 72.5 × 54.5 cm (28 1/2 × 21 1/2 in.). Albright-Knox Gallery, Buffalo, gift of Seymour H. Knox, 1927:24.

23c
Photograph of Notre Dame from the window of Matisse's studio at 19, quai Saint-Michel, Paris.

23d
View of Notre Dame, 1914. Oil on canvas; 147 × 98 cm (57 7/8 × 38 1/2 in.). Kunstmuseum Solothurn, Dübi-Müller–Foundation.

ON FEBRUARY 17, 1914, Marcel Sembat wrote in his journal of two paintings by Matisse of pont Notre Dame: one "very beautiful; everyone would understand and admire"; the other, "lopsided; no one would understand immediately."[1] The artist obviously agreed about the likely reception of these two works— the delicate painting now in the Kunstmuseum Solothurn [**23d**] and the radical *View of Notre Dame* discussed here [**23**]—for he did not include the latter among the recent works illustrated in *Les soirées de Paris* that May; indeed, he did not exhibit it until 1949, when it was "regarded as an unfinished sketch to which Matisse had unaccountably signed his name."[2] Twenty years after that, it would be celebrated as a presciently abstract work of art.[3]

It is not a sketch; neither is it an abstract painting, except in the sense that Matisse suppressed detail and condensed the scene as presented in the preceding composition— or, better, compositions. For, during his first tenure at the quai Saint-Michel, his studio from 1894 to 1907, the artist had painted several views from his two windows looking north onto the Seine and would do the same between 1914 and 1917.[4] Among earlier works that look right toward Notre Dame is a painting from 1902 [**23b**] that forms the compositional prototype for the pair of 1914 canvases. On January 26 of that year, presumably while working on this composition, Matisse wrote to his friend the painter Simon Bussy of being back on quai Saint-Michel, "where we have taken the apartment immediately beneath my old studio. . . . It is a great pleasure for us to experience new sensations in familiar surroundings. Here I work and do not regret not having left Paris."[5] These two views of Notre Dame must be the first paintings to have been completed in the new studio and, therefore, to respond to the regaining of a view that had been lost years before [**23c**].

The pictures join a long series of closely related pairs, which include Matisse's two versions of *Le luxe* [**2.1–2**] and two pairs of *Jeannette* heads [**11.1–2, 13.1–2**]. Not all of these pairs comprise an *esquisse*, or sketchlike first version, and a more developed second version (see pp. 61–63) but many, including these, do. In the Solothurn painting, the response to the regained view is of the pleasure of rediscovery. Although Matisse offers a sense of empathy with the peopled city that recalls the 1902 prototype, his thinly painted, light-filled rendering is a picture of immediacy, in sharp contrast to the earlier work's languorous, Symbolist treatment of blue-violet late afternoon light. In the companion work, he returned to blue tonalities, only now spreading them across the surface as if across the pane of a window. And yet he engaged the features of the scene, translating them into lines, brushstrokes, scratching, and scraping, and—visible beneath

23e

23f

23g

23h

23e
Detail of infrared reflectogram of *View of Notre Dame*, showing the arched forms at top that may represent clouds.

23f
Detail indicating how Matisse increased the size of the cathedral, accentuating it with highlights and shadows, and using color to achieve a sense of transparency.

23g
Detail showing the eliminated grillwork.

23h
Detail of the open surface at the center right, revealing how the artist painted over ochers, pinks, and tans, later scraping away to expose flashes of these colors beneath the blue.

23i
Detail showing how Matisse used a resist technique to soften lines.

23i

23j

23k

23j
Infrared reflectogram of *View of Notre Dame*, showing Matisse's repeated efforts to redraw the linear scaffolding.

23k
Infrared reflectogram overlaid on the finished *View of Notre Dame*, highlighting the changes to the composition.

the surface—into pentimenti and flashes of color. The artist's response here is one that captures the overflowing of remembered sensations into present ones, and vice versa.

Much of the painting's development is visible to the naked eye. However, infrared examination [**23j–k**] is helpful in revealing the extent to which the linear scaffolding was drawn and redrawn, rubbed and scraped back, and all but erased, yet still forms the sedimented memory of the work's creation. Matisse began by centering a smaller cathedral on the canvas rather than off to the right, as in the preceding painting. This arrangement corresponds to that of a contemporaneous monotype [**23a**] whose clouds he may have sketched out in the painting [**23e**], only to reduce them to generalized arched forms. In front of the cathedral, the artist tried several vanishing points for the perspective of the quai and several arcs for the underside of the bridge. To the left, he superimposed various buildings in too small a space, only to eliminate them all; he also added steps going down from the bridge to the side of the river. To the right, he kept repositioning what became the large green bush, changing its position in relation to the bottom of the building and the angle of the riverbank, and drew in the long vertical of the window frame and a fragment of the grillwork [**23g**]. Within this tangle of lines, small patches of underlying colors—grays, ochers, pinks, and tans—reveal how Matisse set down, suppressed, and then partially recovered a local description of the various features of the scene [**23h**].

Then he lightly painted over almost the entire surface with blue, minimizing the details he had drawn but leaving them visible enough to be able to choose from them in reconstructing a new, more simplified image. This approach to painting as palimpsest—as a new text written over an almost erased predecessor—calls to mind not only the processes of losing and recalling memories, including the philosopher Henri Bergson's idea that separate temporal moments actually exist within one continuum (see pp. 110–11), but also the temporal quality of building any work of art. This is especially evident with Notre Dame itself, which took more than a century to complete. It is, therefore, apt that Matisse, as he reconstructed his image, paid particular attention to the cathedral [**23f**]. Indeed, he chose to enlarge it in all directions, accentuating it with strong highlights, deep shadows, and multiple exposure lines along the bottom edge, which give it the appearance of rising upward in stages. Because of the distinct clarity of the light pinks and whites within it, and the diffuse darks around the edges, there is also a sense of transparency to the building, as if it is a window through to a celestial view beyond.

In this reworking, Matisse may well have consulted his monotype of Notre Dame, for he appears to have adapted the methods of intaglio printmaking to his painting through the addition of dense blacks surrounding the cathedral; the widespread instances of scratching, scraping, and incising, especially in the area of the building; and the occasional use of resist technique to soften sections of lines [**23i**]. In contrast to this detailed treatment, he turned to boldness and generalization for the scene around the cathedral, choosing from the underlying web only a few strong lines to carry across the blue field. These include three diagonals, one speeding across the painting from the bottom edge of the bush; two horizontals that extend the lines of the grillwork across the picture, doubling as signs for the top of the bridge; and a vertical that represents the window frame, running from top to bottom on the right. As a result, the picture combines vividness and immediacy with nuanced invocations of process, duration, and memory. Its quality of firm uprightness may reflect Matisse's own analogy, offered in advice to Sarah Stein in 1908, of architectural and painterly construction to the human body: "Everything must be constructed—built up of parts that make a unit...a human body like a cathedral."[6]

1. Sembat, "Cahiers noirs," Feb. [17], 1914, cahier V, OURS, Paris. The works next appear in a letter of Mar. 24, 1914, from Matthew Stewart Prichard to Isabella Stewart Gardner, in which Prichard referred to two paintings by Matisse that he had recently seen, "Of which I said to him that one would be a classical work, in the sense that it typifies a new formula." Prichard Papers, Isabella Stewart Gardner Museum Archives, Boston.

2. John Russell, "Art: A Key Matisse Joins the Modern," *New York Times*, Apr. 26, 1975, p. 17. Russell did not attribute this response to the 1949 Lucerne exhibition, but since it was the only time the painting was seen prior to the 1965–66 retrospective, he must have been speaking of that event or the period following it.

3. See, for example, Robert T. Buck, Jr., "The Ocean Park Paintings," in *Richard Diebenkorn: Paintings and Drawings, 1943–1976* (Albright-Knox Art Gallery, 1976), pp. 45–49; Clement Greenberg, "Matisse in 1966," *Bulletin: Museum of Fine Arts, Boston* 64, 336 (1966), pp. 66–76.

4. *Interior with Goldfish* (24) was painted from the left of the two windows and shows a view to the northwest. It is possible that *View of Notre Dame*, which looks to the northeast, was painted from the right window and that these two works were in process at the same time. For early paintings from both windows, see Elderfield 1992, pp. 119, 121–23, cats. 37, 39–42; and Jeanne Seigel, "Henri Matisse's View of Notre Dame, Spring 1914," *Arts Magazine* 54, 5 (Jan. 1980), pp. 158–61.

5. Matisse to Bussy, Jan. 26, 1914, Matisse–Bussy Correspondence, Bibliothèque Centrale des Musées Nationaux, Musée du Louvre, Paris.

6. "Sarah Stein's Notes" (1908); Flam 1995, p. 47.

24 Interior with Goldfish
Quai Saint-Michel, Paris, January–mid-March 1914

Oil on canvas; 147 × 97 cm (57⅞ × 38⅛ in.)
Signed l.l.: *Henri-Matisse*
Musée National d'Art Moderne/Centre de Création Industrielle, Centre Pompidou, Paris,
bequest of Baroness Eva Gourgaud, 1965, AM 4311 P

IN EXHIBITION

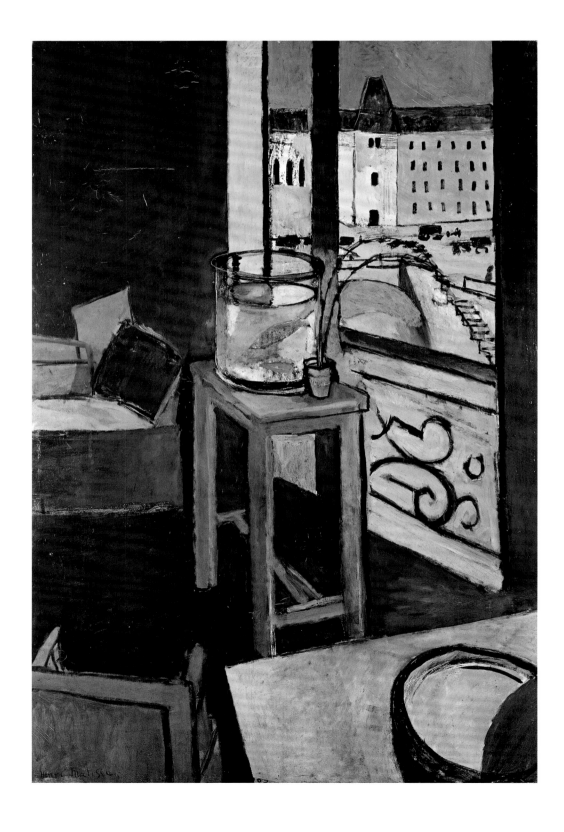

24a

24b

24a–b
Sketches on the verso of a letter from Josse Bernheim-Jeune to Henri Matisse, January 13, 1914, working out the composition of *Interior with Goldfish* or showing it in an early state of completion. Archives Henri Matisse, Paris.

LIKE THE SECOND version of *View of Notre Dame* [**23**], *Interior with Goldfish* [**24**] continues the impetus of the blue paintings that Matisse initiated in Issy, although now infused with a slate gray that he had begun to use toward the end of the previous year. The artist also incorporated even darker hues of blue to re-create the sensation of an interior in deep shadow, except for the light of a late winter afternoon, which is reflected from the outside. *Interior with Goldfish* shows the view to the left from the studio at 19, quai Saint-Michel, which Matisse had taken at the end of December and moved into on the first of the year. The painting was certainly in progress after mid-January, for the artist made two sketches, working out the details of the composition, or showing an early state of the work, on the back of a January 13 letter from Josse Bernheim-Jeune [**24a–b**]. Moreover, Leo Stein recalled running into the artist later that winter and being invited to come and see *Interior with Goldfish*, saying that Matisse "had hoped there would come a time when he could paint directly and freely, but this latest picture was as painful an effort, and had to be done and redone as often, as all that preceded."[1] It was completed in time for it to be reproduced, as *Les poissons*, in the May 1914 issue of *Les soirées de Paris*.

It is worth noting that while Matisse was aware of the need to revise a great deal while he worked, he desired to paint "directly and freely." In fact, the amount of reworking he required to complete a painting had been growing of late, and it would soon expand as a positive, creative process that became increasingly more evident in the appearance of his finished paintings. *Interior with Goldfish* is of particular interest because it was preceded, in 1912, by representations of the same subject that seem much more spontaneously painted [**19a–b**], and would be directly reprised in the fall by one of the most patently reworked pictures of this entire period, *Goldfish and Palette* [**31**]. Moreover, it is the first of four great compositions that Matisse made of this studio between 1914 and 1917, works that document the place as well as his continuing amendatory method of painting.[2]

Matisse liked the feeling of the apartment, remarking, "The low ceiling gave it a distinctive light, warmed by the reflection of the sun on the walls opposite (Préfecture de Police)."[3] Here the artist looked directly north to the tower at the corner of the quai des Orfèvres and the boulevard du Palais. He rendered in pale pink over cream the late afternoon light that falls on the building on the quai, to the left; in the upper part of the structure, where the light is most intense, he scraped the color down to the white ground. For the cooler, more shadowy boulevard side, to the right, he glazed over the pink with mauve gray and painted the sidewalk in a

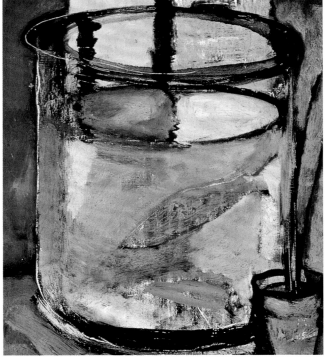

24c

24d

24e

24c
Detail of the goldfish bowl in *Interior with Goldfish*, which was enlarged substantially.

24d
Detail of the clay pot, showing how Matisse moved it forward and away from the window.

24e
Detail of the right cushion, revealing the artist's choice to scratch out the orange highlights on the edges.

complementary soft green of the same value, lightening it away from the building. In the coloring of the pont Saint-Michel, he reprised a similar palette in thicker paint, as if to prepare for the dense surfaces of the interior. All of this is so vivid that we can hardly believe that the upper part of the window is glazed. Indeed, upon seeing the painting that spring, Georgette Agutte was impressed by the treatment of the architecture, exclaiming, "You will never be able to put together again such a happy, quite *so* harmonious, whole—believe us!"[4]

Matisse brought touches of the rose and gray architecture inside, showing it reflected on the inside of the window frame, the divan at left, and the table in the right foreground, which holds a bowl whose inside echoes the green of the sidewalk. On these two horizontal surfaces, the artist invoked the varied temperatures of the entering light by scumbling glazes of blue and gray, leaving a dappled pink showing through. Otherwise everything is in blues and grays—except for the flashes of orange and red that describe the two floating goldfish and the transom across the window, which reflect a fiery light onto the edges of a cushion on the divan.

The painting seems to have darkened as Matisse worked on it. There are pinks, together with areas of pale blue and green, beneath the somber surface, some of them still easily visible at the edges of the furniture. The first sketch on the back of the Bernheim letter shows a painting on the left-hand wall; on the canvas, craquelure in the very dark paint reveals where that potentially enlivening feature was eliminated. Close examination suggests that the strip of wall to the right of the window was a lighter gray before Matisse changed it, too, to dark blue, enhancing the shaded, claustrophobic quality of the interior. Crowding the visible perimeter of the room with furniture further intensified this character. On the far left, the divan has a jumble of pillows on it: the artist drew one only summarily and shifted the position of the other, excavating the orange edges with scratching [**24e**]. At lower left is an object that, while at first indecipherable, resolves itself into a blue armchair. The same sketch suggests that Matisse had originally placed this chair further to the right, and an added section of pink tabletop beside it in the painting reveals where it was. As completed, the foreground furniture is pushed together in a way that suggests an audience eagerly crowding around the quiet drama that takes place on the table before the window; they also form a visual distraction from that drama, however, prompting us to look back and forth, reexperiencing the space of the painting over an extended period of time.

If we look closely, we can just see that the grillwork of the window was initially more ornate and tipped more steeply down to the right; in contrast, when Matisse adjusted the angle of the trestle of the table, he did not bother to conceal the original placement. In the area around the grillwork, there are pinks and creams within and below the blues, which indicate that the artist struggled before deciding to disregard appearances and suffuse the entire area with the color of the Seine. He also purged the area below the table of all details—including grillwork and a section of the pink sill—that would have distracted from the still life above. The fish bowl was originally smaller [**24c**], with its right edge reaching just to the mullion of the window; its left side aligned with the division between the light band and dark wall; and its top ending where the central black vertical line makes a visual hiccup just above the near edge of the rim. Enlarging the bowl, the artist vigorously incised around the new perimeter. Within it, the two scraped, bright orange ovals that represent goldfish seem momentarily suspended within the transparent cylinder, yet more capable of movement than anything else in this utterly still room. We can also see how Matisse moved the small clay pot away from the window, bringing it forward to where the right edge of the aquarium had been [**24d**]; this allowed him to draw the young, not-yet-budded shoots of the plant so that they rise to the left of the arch of the bridge, then merge with the steps leading down to the river, as if actually reaching through a window that seems open. The still interior is thus linked to the bustling exterior, with the delicate, about-to-blossom plant mediating the movement outward, even as light coming from outside irradiates the goldfish, before very selectively and tentatively reaching into the room.[5]

1. Stein to Albert C. Barnes, Oct. 20, 1934, President's Files, Albert C. Barnes Correspondence, The Barnes Foundation, Marion, Penn.; Stein 1950, p. 147.

2. The others are *Goldfish and Palette* (31); *The Painter in His Studio* (51a); and *The Studio, quai Saint-Michel* (51).

3. For more on Matisse and the quai Saint-Michel studio, see Courthion 1941, pp. 27, 103. On *Interior with Goldfish*, see Barr 1951, pp. 164, 168, 177, 179, 185, 188, 190, 203, 206; Theodore Reff, "Matisse: Meditations on a Statuette and Goldfish Bowl," *Arts Magazine* 51, 3 (Nov. 1976), pp. 109–15; Flam 1986, pp. 376–80, 397, 402, 505 n. 10; Monod-Fontaine, Baldassari, and Laugier 1989, pp. 38–40, cat. 9; and Pompidou 1993, pp. 350–51, 497–98.

4. Agutte to Matisse, spring 1914, AHM.

5. Of this activity, Matisse remarked, "On Sunday mornings, the activity on that riverbank was always quite fiendish. Barges were moored there; there were people who came to see the containers of books. And fishermen installed their little folding stools on the barges and sat there, immobile"; Courthion 1941, p. 27.

25 **Woman on a High Stool**
Quai Saint-Michel, Paris, January–April 1914

Oil on canvas; 147 × 95.5 cm (57⁷/₈ × 37⁵/₈ in.)
Signed l.l.: *Henri-Matisse*
The Museum of Modern Art, New York, gift and bequest
of Florene M. Schoenborn and Samuel A. Marx, 1964

IN EXHIBITION

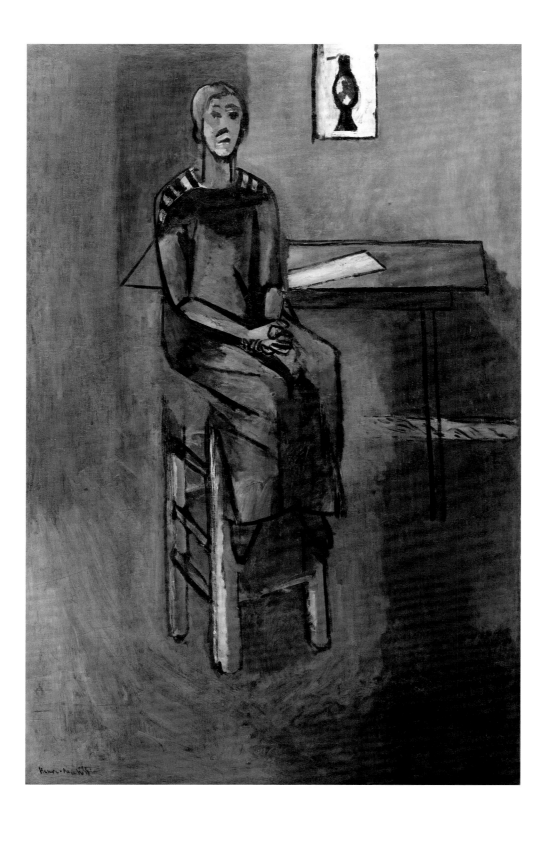

25a

25b

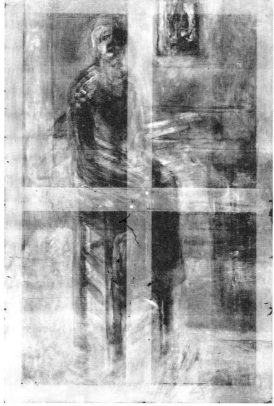

25c

25a
Juan Gris (Spanish, 1887–1927). *Portrait of Germaine Raynal*, 1912. Oil on canvas; 55 × 38 cm (21⁵/₈ × 15 in.). Private collection.

25b
Black Eyes, 1913. Transfer lithograph; composition: 45.3 × 32.6 cm (17¹³/₁₆ × 12¹³/₁₆ in.); sheet: 50 × 32.9 cm (19¹¹/₁₆ × 12¹⁵/₁₆ in.). The Museum of Modern Art, New York, gift of Mrs. Sadie A. May, 1932.

25c
X-radiograph of *Woman on a High Stool,* showing multiple changes to the composition.

MATISSE MADE *WOMAN* on a High Stool [**25**] in his new studio at 19, quai Saint-Michel. It was reproduced as *La femme assise* in the May 1914 issue of *Les soirées de Paris*, which was essentially a Cubist house journal whose editor, Guillaume Apollinaire, had previously been fulsome in praising *Portrait of Madame Matisse* (p. 148, fig. 9).[1] The painting has additional Cubist associations, as its sitter was Germaine Raynal, the nineteen-year-old wife of the critic Maurice Raynal, who was closely allied with the Cubists, and her portrait [**25a**] had been painted by Juan Gris in the summer of 1912.[2] Indeed, while there are earlier works by Matisse in which the influence of Cubism is felt, this is the first in which it may unhesitatingly be pointed to—particularly in the dispersion of flat, geometric planes in the background and the outlined, transparent angle and leg of the table. And yet Matisse's painting does not simply adopt Cubism, as Gris's portrait seems to do, enmeshing a naturalistic face within an orthogonal grid. Rather, it adapts it as a congenial result of Cézanne's austere simplifications of form and color, which are felt in the heavy contouring of the compositional elements and in the shaded, severe iron grays that bring this work together.[3]

As both unaided visual inspection and X-ray examination reveal, *Woman on a High Stool* went through many changes before taking on its final appearance [**25c**]. The drawing of a vase made by the artist's thirteen-year-old son, Pierre, visible on the back wall, was originally about a third larger on both the right and bottom sides.[4] The table was not as steeply angled at the left; its right side was adjusted more than once, placing the leg in different positions; and the orange-red tabletop was originally blue—so, most likely, was its skirt, before it, too, became orange-red and finally gray. There is also evidence of a rectangular shape, possibly a window, at the upper left, which may account for the light falling onto the figure's head, shoulders, and right forearm, and down onto the sides of the legs of the stool, where Matisse represented its reflection by scratching right down to the ground [**25g**]. Beneath the gray, the upper right of the painting reveals green—still visible in the patterned baseboard [**25h**]—while the lower right shows traces of orange and peach tones. The artist may have begun with a colored wall and floor, or have been following the traditional practice of underpainting gray with a prismatic color to give it substance.

It is the seated figure, however, that underwent the most alteration. As we know, Matisse made lithographs of Raynal [**25b**] around the same time as *Woman on a High Stool*; however, they bear little resemblance to her appearance in the painting. Here it appears that the sitter's original form was broader and taller: the artist revised the head several times—at one point, it reached as high

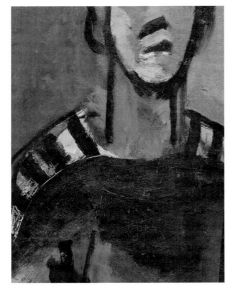

25d

25e

25f

25g

25h

25d
Detail of the neck and shoulders in *Woman on a High Stool*, showing how Matisse narrowed them with paint, scratching, and superimposed lines of paint.

25e
Detail of the reshaped torso and loose, segmented arms.

25f
Detail of the left hip and thigh, which Matisse adjusted by bringing the gray background across the stool, obscuring its top.

25g
Detail of the legs on the stool, showing how the artist created reflected light by scratching down to the ground.

25h
Details of the table legs and baseboard, revealing the green paint beneath the gray, which Matisse applied later.

as the midpoint of the drawing on the wall—and her feet once rested on the bottom rung of the stool. When Matisse eliminated the rectangular shape at the upper left, he trimmed back the head and the neck [**25d**], giving form to the latter only with a superimposed drawing that makes it seem as transparent as the corner of the table beneath it. He narrowed and sloped the shoulders, scratching into them severe bars or straps; he also reshaped the torso as a tall cylinder, which he angled with parallel lines akin to those of *The Manila Shawl* [**12.1**] and defined with segmented, loose-jointed arms, like a marionette's [**25e**]. Most radically, he cut into the figure's right hip and thigh by carrying the gray background across the stool [**25f**], which was narrowed as a result.

Speaking of *Gray Nude with Bracelet* [**22k**], which he made about a month earlier, Matisse said that the darkness of the painting closed of its own accord, without deliberate intervention on his part:

While I paint a picture, I am conscious of the continual development that transpires through my action on the canvas. The conditions are different for a painting, implying much more complicated work than those necessitated for a drypoint. Formerly, I analyzed my paintings and I noted that, once the design was established, the color values followed, but now, I look at the canvas as a whole, without states. I can only paint in the presence of the model; I am quite close to it and look at it all the while I work. All that I put into the painting, I find in the model. I cut off the color in this painting (*a female nude seated in a chair*) [**22k**], because I found that the colors interfered with the plastic values, which are very tender.[5]

This is one of Matisse's clearest statements of having abandoned the method of composition that had dominated his production from 1906 through early 1913, of drawing first and coloring afterward. Now, drawing and color were mutually informing, and they advanced together. It is not so much that the artist spontaneously flooded the canvas with gray, but rather that he built it up deliberately to *become* gray as he gradually realized that the sentiment of the subject required it; this is proven by a clear indication of grays, as well as other colors, that were allowed to dry before the final surface was laid down.[6] The dusk that resulted reveals a thin, miserable doll of a figure, anxiously wringing her hands as she begins to float upward, even as the complementary flashes of orange-red and blue-green appear to hold her in place.

Matisse esteemed this painting highly: after the outbreak of World War I precluded its delivery to Sergei Shchukin, who had reserved it, the artist hung it in his living room at Issy, where it is seen in *The Piano Lesson* [**43**]. It remained in his possession for the rest of his life.[7]

1. Apollinaire 1914, opp. p. 262; Apollinaire 1913b, p. 6.

2. According to John Neff, Maurice Raynal needed money, and Matisse, to help his situation, hired his wife to pose not only for this painting, but also for numerous lithographs and probably etchings as well. See Neff, "Henri Matisse: Notes on His Early Prints," in Moorman 1986, pp. 19–21.

3. In 1914 two major publications on Cézanne appeared in Paris: Bernheim-Jeune's *Cézanne*, with texts by Théodore Duret, Octave Mirbeau, and Léon Werth; and Ambroise Vollard's, *Paul Cézanne*. Matisse made a lithograph (p. 147, fig. 8) for the former, and his *Three Bathers* appeared in the latter.

4. The same drawing, but with a handle on the vase, appears in *Still Life with Lemons* (26). Barr 1951, p. 184 n. 8, was the first to identify this drawing as Pierre's.

5. Matisse, in conversation with Matthew Stewart Prichard, Jan. 10, 1914, as recorded by William King, Isabella Stewart Gardner Museum Archives, Boston, and Archives Duthuit. For more on this exchange, see p. 143 in this publication.

6. Matisse stated that he would never have dared to consciously create a painting like this, for he would never have thought it possible to construct a picture based on a neutral gray; Matisse, in conversation with Matthew Stewart Prichard, June 25, 1914, Prichard Papers, Isabella Stewart Gardner Museum Archives, Boston. See also Labrusse 1996, p. 769. He presumably meant that he would not have dared to set out consciously to create such a work, but only did so—and did so consciously—when it became clear in the process of painting that the subject required it.

7. See Barr 1951, pp. 179–80, 541 n. 8, which mentions that *Woman on a High Stool* was reserved for Shchukin, who, before he received it, agreed in Nov. 1914 to lend it to Matisse's 1915 exhibition at the Montross Gallery, New York. When it returned to France, the war and then the October Revolution precluded its delivery to Russia. See Kostenevich and Semyonova 1993, pp. 43–44.

26 Still Life with Lemons
Quai Saint-Michel, Paris, February–March 1914

Oil on canvas; 70.2 × 50.4 cm (27³/₈ × 19⁷/₈ in.)
Signed l.r.: *Henri Matisse*
Museum of Art, Rhode Island School of Design, Providence,
gift of Miss Edith Wetmore, 39.093

IN EXHIBITION

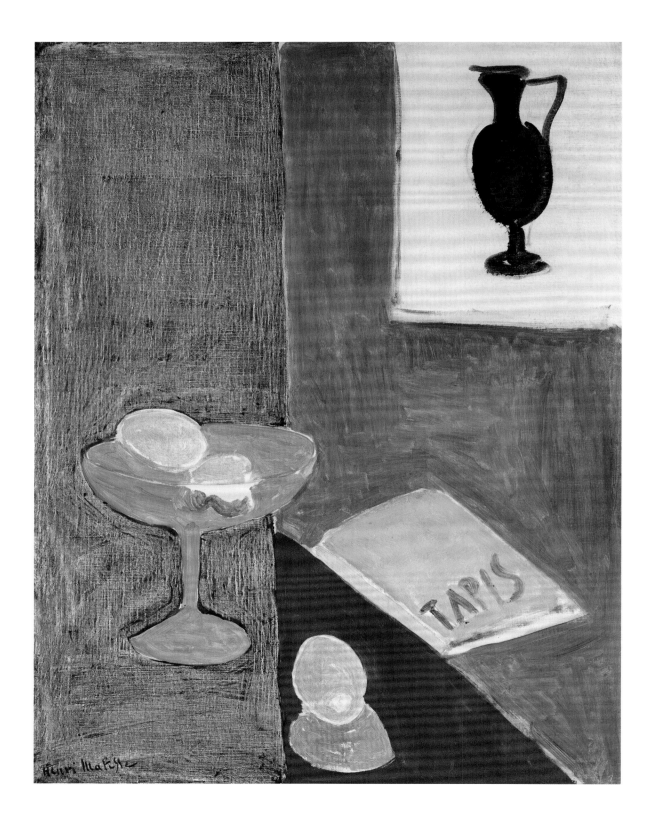

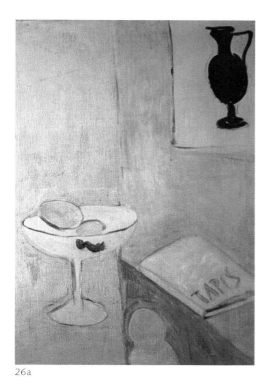

26a

26b

"APART FROM THE artists I have referred to in the preceding chapters," wrote Guillaume Apollinaire in his seminal publication *The Cubist Painters* (1913), "there are other living artists, whether in the movements before Cubism, in contemporary movements or among independent individuals, who are affiliated to Cubism, whether or not they like to admit it."[1] In this list, categorized by the critic as an "instinctive cubist," was Matisse.[2]

Made a year after Apollinaire's book was published, *Still Life with Lemons* (or *Lemons*, as it was first called) demonstrates not so much what Apollinaire found instinctual in the artist's work, but what Matisse was inspired in 1914 to pursue: a new type of composition explicitly engaged with the distinctive and familiar visual vocabulary of Cubism.[3]

That the artist clearly set out to do something different in this painting is evident first in its dimensions: not a standard size, it is smaller than many of the canvases he used at this time.[4] Second, unlike other works he made in winter and early spring 1914, it is not primarily monochromatic or constructed from a scaffold of patterned, interwoven brushstrokes or scraping. On the contrary, it is generally flat and boldly geometric, and the still-life elements resemble those in a stencil or a Cubist collage. In addition, Matisse's unusual addition of the French word *tapis* (carpet or rug)—although not a fragment— recalls Picasso's and Braque's *papiers collés* of 1912 and 1913. The divided structure, in particular the vertical band on the left and the triangle on the bottom, suggests the centrifugal Futurist compositions of Gino Severini [**26b**], who visited his studio by at least spring 1914.[5] The artist's engagement with avantgarde art circles is most evident, however, in the history of this work's title, which he revised in 1950 to *Still Life with Lemons Which Correspond in Form to a Drawing of a Black Vase on the Wall*.[6] The change was prompted by Matisse's recollection to Alfred H. Barr, Jr., that, soon after the work was made, Jean Metzinger and Juan Gris visited his studio and saw the painting, but did not comment on it. Only later, Matisse explained, did he hear that they had found its "concordance of forms" extraordinary.[7] The fact that he remembered the incident (and his own disappointment) years later indicates his extreme desire to engage these colleagues directly with his new work.

Based on the comparatively small amount of reworking on the canvas, the artist appears almost to have conceived the painting's final forms from the start, making minor changes as he progressed. Matisse began the composition with an initial detailed sketch that he may have made first in charcoal but then enhanced with a light wash of black paint. Infrared reflectography [**26a**] shows this initial stage, and we can see the original taut lines

26d

26c

26e

26c
Detail of lower-left corner of *Still Life with Lemons*, showing the marks left by wiping blue paint away from the contour of the bowl and edge of the red triangle.

26d
Detail of the dish and lemons, showing the shadows and highlights described with wash and unpainted ground.

26e
Detail of the lower-right corner, illustrating how the artist turned his brush quickly, pulling back the wet paint and exposing the layers below.

of the triangulated composition. On the surface of the picture, we can make out how, as he added color, he was careful to follow the lines of the sketch, leaving a slim border of unpainted ground or a lower layer of paint. It was this decision that produced the hovering, stencil-like effect of the final forms, whose separateness is underscored by the varied qualities of the paint and brushstrokes. Matisse laid in color carefully, rarely moving beyond the contours for objects he devised in the sketch. He painted a vertical band of yellow ocher on the right side of the canvas and a band of dark blue on the left, holding the still-life elements and drawing on the wall in reserve. The artist then applied a rosy tan to the spine of the book and an initial layer of color to the table, covering the latter in red and adding a thick coat of green to the background. In some cases, his quickly turning brush pulled back the wet paint, revealing lighter ocher and tan colors below [**26e**]. At this point, Matisse adjusted the composition, further dividing the ocher band into a burnt orange triangle and an irregular green shape that stand for the table and wall behind; he also painted the white rectangle on the right, giving each component an independently colored background. On the right side, he applied green paint thickly with rapid turns of the brush, producing a distinct, irregular pattern. On the left, he removed the blue paint in a network of fine, densely packed scratches and then wiped more on and over the surface, as a printer would ink a plate. Close inspection also reveals both the path of this wiping [**26c**] and the care he took to pull pigment back from the edge of the red triangle.

As he painted the yellow lemons, he played off the initial layer of ocher, adding a bright spot in the central portion of the composition. He balanced this with the bright white of the drawing, which also hangs in *Woman on a High Stool* [**25**] and was apparently made by his son Pierre.[8] The artist juxtaposed the solid contrast of the black vessel against the white sheet with the more liquid relationship of the lemons in the dish. Here Matisse played with the viewer's sense of space, fusing the inside and outside of the glass, and painting the shadow below the lemon in pale black wash, leaving the area above in reserve to suggest a volume that has been brightly illuminated [**26d**]. He used more white—this time a thick dollop of paint—to stand in for the light that reflects off the lemon onto the red table and set the whole composition spinning by adding even more to the drawing and the pages of the book.

The canvas was illustrated in the May 15 issue of *Les soirées de Paris*, along with six other works.[9] To publicize the volume, Apollinaire printed a note in the *Paris-journal* that must have pleased Matisse. Of these paintings, he wrote: "This marvelous artist who

passed the winter in Paris, produced in his quai Saint-Michel studio a series of pictures full of freshness, force and sensitivity."[10] Despite his friends' lack of response to *Still Life with Lemons*, both its publication and Apollinaire's praise demonstrate Matisse's successful efforts to meld the popular vernacular of Cubism with his own visual sensibility. Indeed, in his final comment on the new paintings, the critic recognized that the artist had not deviated from his original path, acknowledging, "Never are his abilities as a colorist not evident."

1. Apollinaire 1913a, pp. 83–84; Apollinaire 2004, pp. 83–84.

2. The Futurist artists Umberto Boccioni, Filippo Tommaso Marinetti, and Gino Severini were also included in Apollinaire's list.

3. Writing about the recent purchase of *Still Life with Lemons* [no. 20256] and *Tulips* (p. 181, fig. 5) [no. 20255], Bernheim-Jeune asked: "Which are the prices of the frames for the canvases that we took this morning? We will give them the titles 'Tulips' and 'Lemons.' Do you like these titles or do you have others in mind?" Bernheim-Jeune to Matisse, Apr. 3 and 4, 1914, AHM.

4. While the painting does not fit the exact dimensions of a standard size canvas, it may have been one initially. Of the paintings that Matisse was likely working on or would soon begin when he painted *Still Life with Lemons—View of Notre Dame* (23), *Interior with Goldfish* (24), *Woman on a High Stool* (25), *Branch of Lilacs* (27), and *Tulips*—all are standard size 80 canvases, roughly double its dimensions.

5. The exact circumstances of their friendship are difficult to ascertain, as there is little documentation of Matisse and Severini's encounters before the war.

6. Barr Questionnaire VI; Barr to Heinrich Schwarz, July 9, 1951, collection files of the Museum of Art, Rhode Island School of Design. In the latter, Barr explained, "This page is one of a series taken to Matisse by John Rewald on my behalf. Matisse is quite impatient ordinarily with answering specific questions of any kind, but he apparently was quite interested when he saw the reproduction of your picture . . . Matisse was so stirred up by his recollections that he proposed a change in title. He and Rewald stumbled over it a bit and finally came out with the title which is written on the sheet [of the questionnaire]."

7. Matisse told Barr that this occurred during the war; however, *Still Life with Lemons* would have already been in the possession of Bernheim-Jeune about four to five months before France entered the conflict. See Dauberville and Dauberville 1995, vol. 1, p. 534–35, cat. 142, which notes that the work was purchased from Matisse on Apr. 4, 1914, and documented with a photograph (no. 429) in Mar.

8. Barr to Schwarz (n. 6).

9. These were *The Blue Window* (18), *Interior with Goldfish*, *Woman on a High Stool*, *Tulips*, and two untitled figure drawings.

10. Apollinaire, "Les arts: Henri Matisse," *Paris-journal* (May 15, 1914), p. 3.

27 Branch of Lilacs
Quai Saint-Michel, Paris, mid-March 1914

Oil on canvas; 146.1 × 96.5 cm (57 1/2 × 38 in.)
Signed l.r.: *Henri Matisse 14*
Lent by The Metropolitan Museum of Art, New York,
The Pierre and Maria-Gaetana Matisse Collection, 2002, 2002.456.4

IN EXHIBITION

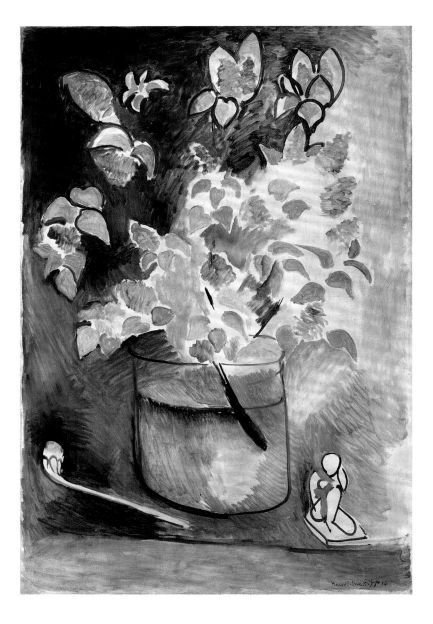

27a

27b

27a
Detail of *Branch of Lilacs*, showing how Matisse used
a loaded brush to build up form, working until it
was dry. Note the thinness of the paint for the lilac
in contrast to the thickness of the nearby leaf.

27b
Detail illustrating the lower layers of flowers and
leaves with darker, dense outlining on top.

27c
Detail showing the hatching and zigzagging patterns
of Matisse's brush, as well as the artist's fingerprint
in the once-wet paint of the clay pipe.

27d
Detail demonstrating the fluid quality of the paint,
which the artist directed with a rag, brush, and
perhaps the brush handle.

THE YEAR 1914 found Matisse exploring a number of different artistic paths, forging new vocabularies as well as returning to familiar themes in new and sometimes contradictory ways. For instance, there is great variation in his approach even within the small group of *Woman on a High Stool* [**25**], *Branch of Lilacs* [**27**], and *Portrait of Yvonne Landsberg* [**28**]—all made in the spring of that year on the same standard-size (number 80) canvas and all marked by a predominance of dark grays and blacks. Certainly the most delicate of these, both in terms of subject and construction, is the still life, a close-up view of springtime blossoms in a glass vase, accompanied on the left by a clay pipe and, on the right, by Matisse's own sculpture, *Small Crouching Nude with Arms* [**3c**].[1]

Just the summer before Matisse painted this work, he wrote from Versailles to his friend the artist Albert Marquet, remarking, "Here the weather is rather cold and somewhat gray, but what a delicious gray and what exquisite air when I think about Tangier, where the air is so depressing."[2] His words perhaps signal that he was retreating from the experiments introduced by the intense color and light of Morocco but also beginning a

new kind of construction inspired by a reduced gray light. In this regard, he joined such artists as Camille Corot, Camille Pissarro, and especially Cézanne, who had examined the special qualities of gray light in painting with color, limiting their palettes to a narrow scale of tonal values in order to reproduce the intensity of hues.[3] Such experiments were not new for Matisse: it is likely, for example, that he used a Claude mirror to adjust the tonalities in the palette for *The Blue Window* [**18**], and Pierre Schneider even proposed that he made *Branch of Lilacs* from the reflection in an ordinary mirror.[4] In addition, we know that, during winter and spring 1914, the artist spent time with a group of young men, including Georges Duthuit and Matthew Stewart Prichard. In January he spoke at length with Prichard about the nature of his recent work *Gray Nude with Bracelet* [**22k**] and suggested that by painting in gray he "cut off color" in order to preserve the delicacy and tenderness of a subject.[5] For Matisse, whether literally observing the light around him or figuratively creating it from his palette, painting in "delicious gray" was another way to continue his experiments with expression and construction.

Unlike the portraits of Germaine Raynal and Yvonne Landsberg, *Branch of Lilacs* was executed quickly. The artist began the composition with a painted sketch that is barely detectable at the base of the sculpture and on the stems of the pipe and branch. For the space around the still-life elements, he laid in thin passages of green, violet, blue, and then gray paint, overlapping them with shifting, zigzagging brushwork to produce a transparent, washlike effect. In the center, which he had left in reserve, Matisse added blooming lilacs. He painted the petals with alizarin crimson that he loaded on his brush and ran in continuous, returning lines until the bristles were dry [**27a**]. In contrast, he added the leaves in a more opaque green, which he applied in various densities to suggest both depth and illumination. The play of paint—thick and dense in some areas, and thin and transparent in others—produces a sense of depth that the artist furthered by keeping some parts of the canvas unpainted, so that they register as both the thinnest level of the surface and the brightest points of illumination. To further this sense of space and light, Matisse contrasted the thinner layers of light-colored paint on the right with the thicker layers of more opaque grays and blacks on the left. In the darker gray space on the left and top, he outlined the lilac leaves and petals with black paint, sometimes making these borders larger than the forms they enclosed and sometimes overlapping them, as if they had misregistered in printing [**27b**]. The effect suggests two planes, closely spaced and parallel to the canvas, that sometimes

merge and sometimes remain distinctly apart. As he worked to reduce the depth and space of the composition, Matisse also moved closer to the subject, adjusting the size and shape of the vase on the left.

Matisse used a fluid oil paint that he possibly thinned with turpentine, working the colors by wiping the edges with a rag or quickly blending them with a dry brush. This rapid technique demonstrates his control of the medium. In the bowl of the clay pipe, we can find the artist's fingerprint [**27c**], which suggests he might have used his fingers in addition to a brush and rag to execute the painting. In other areas, there are drips of pigment (and perhaps even traces of turpentine) left on the surface [**27d**].

The composition of *Branch of Lilacs* is one of contrasts: the pale palette and delicate brushwork on the right side and the darker, more heavily painted left side; the alternating areas of unpainted canvas and opaque pigment; and the inanimate, firmly planted sculpture as a counterpoint to the fragile cut lilac. On the canvas, Matisse used his watery medium to capture the dematerialization of substance in light, the transience of time, and even the fragility of vision itself, as he struggled to record the still life as it changed before his eyes.

27c

27d

1. The clay pipe was a still-life element that Matisse first painted in his 1893 copy of Jean-Baptiste-Siméon Chardin's *Pipes and Drinking Pitcher* (c. 1737; Musée du Louvre). Coincidentally, he found the painting difficult to copy because of its blue color, recalling the experience years later; see Courthion 1941, pp. 17–18.

2. Matisse to Marquet, Aug. 16, 1913, Wildenstein Institute, Paris.

3. Cézanne's interest in gray light was particularly significant in this regard: in Sept. 1914, Ambroise Vollard published his luxury monograph on the artist, which reproduced the *Three Bathers* owned by Matisse. Vollard told how Cézanne would visit and say, "Mr. Vollard, I have good news to tell you; I am so satisfied with this afternoon that if the weather tomorrow provides a pale gray light I think that our session will go well." Vollard, *Paul Cézanne* (Galerie A. Vollard, 1914), p. 94; Doran 2001, p. 9. For a review of this and other accounts of Cézanne's statements about gray light, see ibid., pp. 9, 225 n. 3.

4. Schneider 2002, p. 350, proposed this intriguing idea based on the appearance of the painting.

5. Matisse, in conversation with Prichard, Jan. 10, 1914, as recorded by William King, Isabella Stewart Gardner Museum Archives, Boston, and Archives Duthuit; see also Labrusse, 1996, p. 767. The full transcript of this conversation can be found on p. 143 of this publication.

28 Portrait of Yvonne Landsberg
Quai Saint-Michel, Paris, June–mid-July 1914

Oil on canvas; 147.3 × 97.5 cm (58 × 38 3/8 in.)
Signed l.l.: *Henri Matisse 1914*.
Philadelphia Museum of Art, The Louise and Walter Arensberg Collection,
1950, 1950-134-130

IN EXHIBITION

28a

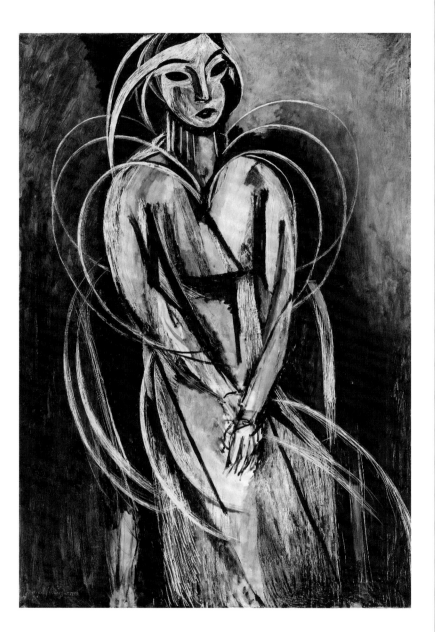

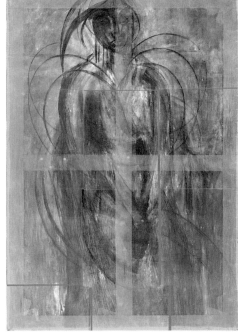

28b

28a
Yvonne Landsberg, April 1914. Pencil tracing. Archives,
The Museum of Modern Art, New York.

28b
X-radiograph of *Portrait of Yvonne Landsberg*, showing
changes to the composition.

28c
Detail of *Portrait of Yvonne Landsberg*, showing the
variety of incised "lines of construction" near the
figure's right shoulder.

28d
Detail of the right side of the sitter's head; note the
score marks on the right side of the scraping.

28e
Detail of the figure's right arm, showing lines carved
into black paint and forms constructed through its
removal.

28f
Detail of the arms, showing thin blue-gray and tan
washes; on the tan wash of the sleeve are visible the
darker sketch lines of the next stage and, atop those,
thicker, pale blue-gray paint.

28g
Detail showing the "resist" effect on the fingers, which
was made as black lines crossed the underlayer.

28h
Detail near the hands, showing the trace of the tool
used to remove pigment from the canvas.

28c

28d

28e

28f

28g

28h

STARTLING AND UNFAMILIAR to this com-
mentator—and even to its maker—the *Portrait
of Yvonne Landsberg* [**28**] is one of the most
extraordinary of Matisse's canvases from the
spring and early summer of 1914. A complex
orchestration of technique and construction,
the portrait clearly reflects the artist's under-
standing of the fragile yet profound subject
of perception and human experience, and it
emerged from his continuing desire to find
an appropriate equivalent—whether demonic
or angelic—in his art.

The account of how Matisse came to make
this painting has been well described by
scholars and best documented by the sitter's
brother.[2] According to Albert Clinton Lands-
berg, he and Yvonne were part of a group of
friends—including Georges Duthuit, William
King, Matthew Stewart Prichard, and Camille
Schuwer—who regularly attended the lectures
of the philosopher Henri Bergson at the École
de France. The artist was drawn into this cir-
cle of young enthusiasts and, at Prichard's
urging, Albert secured him a commission for
his sister's portrait.[3] This initially took the
form of a spare, naturalistic pencil drawing
that Matisse completed by the beginning of
May; today we know that image only from a
tracing [**28a**] that Albert made in 1951 for
Alfred H. Barr, Jr.[4] Once the portrait was fin-
ished, Matisse proposed to do another in
oil, which the Landsberg family would have
the option to purchase upon completion.

With their consent, he began the present
work by early June, and it was soon well
under way.[5] Albert acted as his sister's chap-
erone and often brought along friends, who
likewise documented the portrait's approxi-
mately two-month gestation. Prichard wit-
nessed the painting's evolution over many
sittings and called it "extraordinary." On
June 22 he told Duthuit that the collector
"Alphonse Kahn [Kann] has admired the paint-
ing and the Landsbergs are already making
overtures for its acquisition, which awakens
Matisse's amusement, as they could have
begun by giving the order. They will find it
hard to let the picture go, and Matisse, who
already considers it his best work, won't let
it go cheaply."[6] On July 12, he reported that
the work was complete, and he marveled at
the radical transformations through which
Matisse had carried the canvas during each
sitting. "My friends have seen it in a later
stage than it had reached when I left Paris,"
he wrote,

28i 28j 28k

28l 28m

28n 28o 28p

28i
Mlle Landsberg (Large Plate), summer 1914. Etching and drypoint on vellum; plate: 20 × 11 cm (7⁷/₈ × 4⁵/₁₆ in.); sheet: 45 × 31.5 cm (17¹¹/₁₆ × 12³/₈ in.). The Museum of Modern Art, New York, gift of Mr. and Mrs. E. Powis Jones, 1956. In exhibition.

28j
Yvonne Landsberg, Profile, July 1914. Black ink on cream woven paper; 28 × 21.7 cm (11 × 8 ⁹/₁₆ in.). Philadelphia Museum of Art, gift of Jacqueline Matisse Monnier, 2003-53-1.

28k
Yvonne Landsberg, July 1914. Graphite on wove paper; sheet: 28 × 43.2 cm (11¹/₈ × 17 in.); mount: 52.1 × 45.4 cm (20¹/₂ × 25³/₄ in.). Philadelphia Museum of Art, gift of Jacqueline Matisse Monnier, 2003-53-2.

28l
Yvonne Landsberg, July 1914. Pen and ink on paper. Dimensions and location unknown.

28m
Yvonne Landsberg, 1914. Black ink on wove paper; sheet: 50.8 × 65.4 cm (20 × 25³/₄ in.). Philadelphia Museum of Art, gift of Jacqueline Matisse Monnier, 2003-53-3.

28n
Yvonne Landsberg, 1914. Ink on paper; sheet: 50.2 × 32.7 cm (19³/₄ × 12⁷/₈ in.). Private collection.

28o
Yvonne Landsberg, July 1914. Ink on paper; 65 × 50.2 cm (25⁵/₈ × 19⁷/₈ in.). The Museum of Modern Art, New York, Alva Gimbel Fund, 1968.

28p
Yvonne Landsberg, July 1914. Steel pen and black ink on paper; 66 × 31.8 cm (26 × 12¹/₂ in.). Inscribed: *à Mlle Yvonne Landsberg/hommage respecteux/Henri-Matisse Juillet 1914.* Private collection.

and a later stage means a completely new result. You think the picture is finished and next time find a completely new one. Nothing is the same except the feeling, composition, color, drawing all new. While creating he works with lightning rapidity in that way, starting with something, which is a likeness and going then farther and farther from the likeness into evocation and returning a little toward likeness at the end. Every stage is convincing.[7]

Albert Landsberg also recounted that Matisse "entirely repainted the whole portrait at each sitting."[8] It is worth noting this radical approach, for it suggests the direction of another path for the artist, an alternate way of working after having searched for a subject's essence by relying on sculpture, or on additional drawn or painted versions of the same dimensions. As an artistic experiment limited to a single canvas and a unique subject, *Portrait of Yvonne Landsberg* dramatically demonstrates how the act of creation itelf became Matisse's true subject at this time. The final image suggests a process of molting, regenerating, and becoming—perhaps even a suggestion of Bergson's *élan vital* (p. 111)—woven into the structure of its reworked layers.[9] While earlier Matisse's reworking was part of his general search for a new path, here we can see that it became that path itself.

We can identify numerous phases in the work's evolution. Matisse started with a lightly painted black contour sketch of Yvonne. It is significant that throughout all of the many subsequent campaigns of scraping, wiping, incising, and repainting, he kept one area of the sketch—her hands—untouched but for a few added darker lines, much like a touchstone to begin each session. Matisse expanded her sketched form and the space surrounding it with thin washes of tan and light black paint, keeping other areas in reserve [**28f**]. He also painted darker lines over the wash, and in some areas of the reserved white ground, he gave a pronounced texture to the surface with white pigment applied in patterned brushstrokes. The sitter's appearance was likely more naturalistic at this time, and we can see the contours of her face, shoulders, and neckline below the present image in the X-radiograph [**28b**]. The artist then built up her form as he might have done with a bas-relief, using thicker applications of pale blue-gray paint to approximate major volumes [**28f**]. Another stage, which may have occurred at about the same time, involved scraping back paint with a wide tool, as a sculptor might reshape with a chisel, in order to adjust the curves of Yvonne's shoulders and hips; this left tracks in the lower layer of black paint and exposed the texture of the canvas weave [**28h**]. To emphasize certain contours, Matisse added strokes of steel gray—for example, on the sides of the nose and inside the left arm, against the torso, adjusting the figure's position and size as well as filling in some of the background. The artist

also applied a thick layer of black paint over some areas of the gray, which enclosed Yvonne's hips and legs in particular. Then, while the paint was still wet, he used a thin, needlelike tool to rapidly sketch long, vertical planes from her hips, scratching right down to the canvas; after that, he wiped across the surface to leave a thin black film on the incised lines. The process of removal and the marks left by the tool recall the monotypes Matisse had begun making by this time [**22**]. Using that same black, the artist painted thick, inky lines over Yvonne's curvy form in a process reminiscent of *Portrait of Olga Merson* [**12.2**]. These straight lines run down and across her torso, geometricizing and challenging the volumes Matisse had earlier established through painting, scraping, and incising. While they were still wet, he shaped these thick lines by further incising [**28e**].

It may have been at about this time that the artist reinforced the scraped and scratched face, adding a thick black curve that runs around the contour of the jaw and chin, and adjusting the position and shape of the eyes. Yvonne's masklike visage is enhanced by this dense, medium-rich paint, which stands out among the other blacks on the canvas and creates the effect of deeper space behind the eyes, chin, and sides of the body.[10] Once this paint dried, Matisse returned to certain areas, including Yvonne's long hair—to score, scratch, and carve away the edges, revealing the gray below and producing a secondary shadowy effect [**28d**]. In other areas, the medium-rich black paint resisted adherence to the canvas, pooling in open, lacelike trails of color from the brush [**28g**]. At this point, the image certainly suggested the demonic, sacral presence described by Matisse's visitor: dramatic in its contrast of darkness and light, and physically marked by literal depth and projection on the surface of the canvas due to the scraping and layering of paint.

It is not known how many sessions Matisse had to make the portrait, but it is clear from physical and archival evidence that in the last one he reworked the scraped areas of the head, cleaning it of nearly all pigment. Most notably, as Albert Landsberg described with surprise, the artist turned his brush around or picked up a palette knife and proceeded to scrape into the surface once again, creating the radiating lines that encircle Yvonne, echoing the curl of her hair and the arms of the green chair in which she sits. Matisse later described these as "lines of construction" that are intended to "give greater amplitude" to the figure in space.[11] Formally, they recall those in the Futurist paintings first exhibited in Paris at Bernheim-Jeune in February 1912. But as striking as these dynamic, repeated lines are, they were made quite delicately.[12] We can see how carefully Matisse incised for different

28r

28q

28s

28q
Yvonne Landsberg, July 1914. Ink on paper; 20 × 17 cm
(7⁷/₈ × 6¹¹/₁₆ in.). Private collection.

28r
Yvonne Landsberg, July 1914. Pencil on paper;
64.7 × 49.5 cm (25¹/₂ × 19¹/₂ in.). Private collection.

28s
Yvonne Landsberg, July 1914. Charcoal on paper;
65.8 × 50.5 cm (25⁷/₈ × 19⁷/₈ in.). Private collection.

28t
Yvonne Landsberg, July 1914. Charcoal on paper;
65.5 × 51 cm (25³/₄ × 20¹/₈ in.). Private collection.

28t

effects, going just below the black to the gray in some areas and completely removing all trace of the painted surface in others. The lines may also suggest the shimmering ethereality and formal dissolution of the Analytical Cubist pictures Picasso had made four years earlier. But Matisse, in his search for new methods of construction, chose a different overall effect—a scaffold of scratched, incised, scraped, and painted lines [**28h**] that together in their final orchestration firmly root the figure in—and project it from—the very ground of the canvas itself.

From Albert Landsberg's accounts, we know that Matisse made numerous sketches and prints of Yvonne during breaks in their sessions [**28i**]. Today we can identify at least twenty-one of these works on paper, half dating to the specific period of the painting's production.[13] They provide a unique opportunity to better appreciate how the artist might have reimagined the use of drawn compositions, especially at a time when he eschewed the benefits he once sought by simultaneously painting and sculpting, or painting and drawing, the same composition in the same scale. Reviewing the drawings together, we can see that some—perhaps those made shortly after the original commissioned drawing—appear more naturalistic [**28j**], while others are more stylized and almost caricatural [**28k**]. Still others seem like casual snapshots of the sitter, viewed from a variety of angles and perspectives and recorded in thick pencil or ink lines [**28l–p**]. An additional group, which depicts Yvonne in a pose close to that in the painting, renders her form in volumes of soft, velvety charcoal [**28r–t**]. Matisse composed a final drawing [**28q**] from a network of wiry lines, repeating many in arching pen strokes around the shoulders and legs. Left undated, this sheet may have been produced during the last sitting, or possibly as an *aide-mémoire* after the painting's completion. Collectively, the drawings suggest concerns that parallel various stages of the canvas but they do not seem to be preparatory works. If we remember that the artist made each of these at a break during painting sessions, we can envision their possible use—as opportunities to capture the sitter's essence with a minimal amount of detail and to refocus and refine his project in the main portrait. The act of laying a line on paper, or incising one into a metal printing plate, could serve to reinforce the challenging method of construction that Matisse envisioned for his painting. With its tangle of lines and forms, his representation of Yvonne would have been difficult to create and even harder for viewers to recognize as it evolved. But its organic production, recorded in the very substance of the image, stands as a record of the artist's unparalleled efforts to challenge himself and his audience at this time.

1. Unidentified commentator, quoted by Matthew Stewart Prichard to Frances Burton-Smith, July 8, 1914; Flam 1986, p. 502 n. 24, who cited Montross 1915. (The catalogue has no reproduction of this letter, but Spurling 2005, p. 155 n. 62, noted that it is included in an addendum to the catalogue.)

2. See Barr 1951, p. 184, whose attempt to grapple with this picture and its associations with various influences, including Marcel Duchamp's *Nude Descending a Staircase* (1912; Philadelphia Museum of Art) and the flower buds Matisse was drawing the morning he first met Yvonne, was the foundation of many subsequent commentaries, including this one. Barr based his thoughts on the information provided in two letters from Albert Clinton Landsberg; these, written on May 30 and June 22, 1951, are in the Alfred H. Barr, Jr., Papers, series 11, folder I A 9, MoMA Archives. For an in-depth study of this painting, see Lavin 1981.

3. Prichard had also arranged for Matisse to draw Mabel Bayard Warren's portrait the previous fall (see n. 4).

4. The commission might have been discussed as early as Jan. 1914; see letters from Félix Fénéon to Matisse, Jan. 29 and Mar. 11, 1914, AHM. The drawing must have been completed sometime around the end of Apr. or the beginning of May, based on an Apr. 25, 1914, account sheet from Bernheim-Jeune to Matisse as well as a May 2, 1914, letter from Prichard to Duthuit, Archives Duthuit, which states: "There has been a meeting at Mrs. K's [Koehler's] today where all our American friends of the N. [North] and S. [South] have gathered to compare the drawings of Mrs. Warren and Miss Landsberg"; see also Labrusse 1996, p. 778. The drawn portrait is in the style of others, including *Portrait of Mrs. Samuel Dennis Warren (Mabel Bayard)* (1913; Museum of Fine Arts, Boston) and *Portrait of a Young Woman (Elsa Glaser)* (1914; Art Institute of Chicago).

5. In a letter to Duthuit of June 8, 1914, Archives Duthuit, Prichard remarked, "Today we, Camille, Schiff, the Tylers, and I, go to Matisse's to see the beginning of the Landsberg portrait"; see also Labrusse 1996, p. 778.

6. Prichard to Duthuit, June 22, 1914, Archives Duthuit. For more on Prichard and other accounts of his time in Matisse's studio, see Labrusse 1996 and Spurling 2005.

7. Prichard to Isabella Stewart Gardner, July 12, 1914, Isabella Stewart Gardner Museum Archives, Boston.

8. Landsberg to Barr, June 26, 1951, Alfred H. Barr, Jr., Papers, series 11, folder I A 9, MoMA Archives. This process is reminiscent of how he described his work on the first state of *Back (I)* (4) to Gelett Burgess in 1908.

9. Bergson developed his concept of the "vital impetus" in *Creative Evolution* (1907). While it is generally understood that Matisse did not read Bergson, he must have felt the philosopher's influence among his young circle of enthusiasts.

10. For more on the issue of masks in Matisse's art, see Klein 2001; Alarcó and Warner 2007; and Rainbird et al. 2008.

11. Matisse to Barr, June 26, 1951, Alfred H. Barr, Jr., Papers, series 11, folder I A 9, MoMA Archives. The lines are also reminiscent of the arabesques the artist used earlier in his career and are especially similar to the curling lines around his *Large Nude* (21f). For similar incised lines used to produce form, see the painting *Seated Nude* (1913–14; Pierre and Tana Matisse Foundation, New York), and the etching *Loulou, Study of the Nape of the Neck* (22m).

12. Although Matisse would have been in Morocco during the time of the exhibition, he would at least have been familiar with the Futurist paintings from illustrations in such contemporary art journals as *Montjoie!* By Mar. 12, Umberto Boccioni's *Pittura scultura furistici (Dinamisco plastico)* (Edizione Futuriste di "Poesia," 1914) had reached Paris, as had Ardengo Soffici's *Cubismo e futurismo* (Libreria della Voce, 1914). Most significantly, Matisse had likely met Gino Severini by this time.

13. Some of the drawings are dated Aug. 1914, when, according to Albert Landsberg's letters to Barr, his family would have already left Paris. The prints are undated and therefore difficult to identify more precisely without documentation from the artist or Landsberg family; a tracing of one (28i), however, was included with Landsberg's 1951 letter, which suggests that it was made before the family's departure.

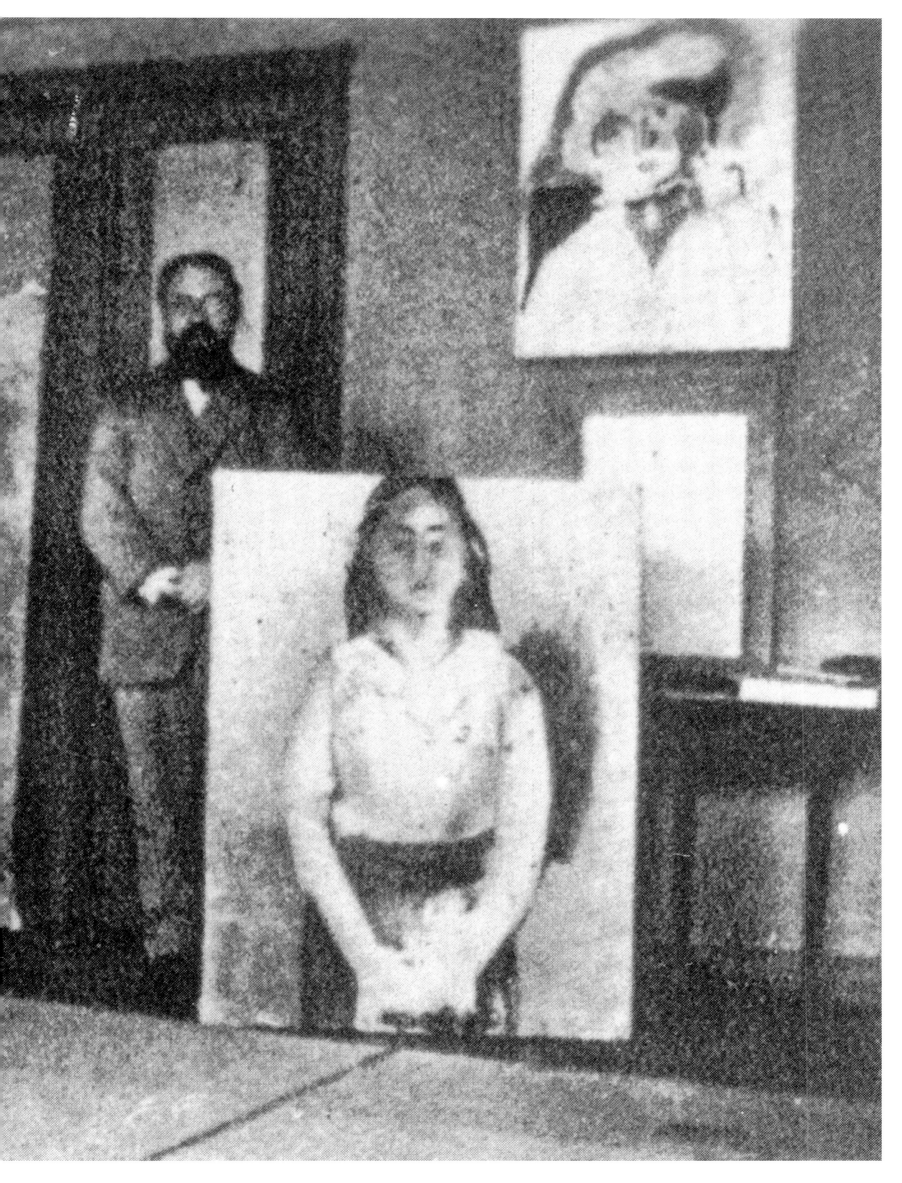

1914

AUGUST 1

Germany, allied to Austria-Hungary by treaty, views Russian mobilization as an act of war and declares war on Russia.

Exhibition at Kunstsalon Fritz Gurlitt, Berlin, closes due to the outbreak of war. The Steins' collection of paintings by Matisse is stranded in Germany.

AUGUST 3

Germany declares war on France.

France, bound by treaty to Russia, finds itself at war against Germany and, by extension, Austria-Hungary.

The Paris art world is quickly decimated: many in the community, including Guillaume Apollinaire, Georges Braque, Charles Camoin, André Derain, Demetrius Galanis, Fernand Léger, Henri Manguin, and Jean Puy, report for service.

Matisse, who is forty-four, tries to enlist but is rejected.

AUGUST 4

Germany invades neutral Belgium.

Britain, allied to France and obligated to defend Belgium, declares war against Germany and Austria-Hungary. Britain's colonies and dominions, including Australia, Canada, India, New Zealand, and the Union of South Africa, offer military and financial assistance.

AUGUST 7

Battle at Mulhouse opens and is quickly followed by those at other frontiers during the month (Lorraine, the Ardennes, Charleroi, and Mons); these mark the collision of both the French and German invasion plans.

AUGUST 20

German troops enter Brussels.

Anna Matisse, the artist's mother, telegraphs to ask that her grandson Pierre join her in Bohain-en-Vermandois; Amélie and Henri do not send him.

AUGUST 23

Japan, in a military agreement with Britain, declares war on Germany.

AUGUST 25

Austria-Hungary declares war on Japan.

The Siege of Maubeuge, a major fort sited on France's northern border with Belgium, takes place; fighting continues until September 7.

AUGUST 26

Battle of Le Cateau opens (at its end there will be nearly 8,000 casualties and losses).

AUGUST 27

Matisse's mother and brother, Auguste, along with his wife and two sons, are in Bohain. The town's citizens prepare to receive the German army with closed shutters and empty streets.

AUGUST 28

By nightfall, Saint-Quentin, where Matisse attended the Lycée Henri Martin, is taken by force.

An officer in the reserves, Auguste Matisse (along with others in Bohain) is taken as a prisoner of war and sent to Germany.

AUGUST 29

Battle of Guise-Saint Quentin launched by the French.

FALL

The Matisses begin sending parcels of food and other necessities to Henri's brother and to Matthew Stewart Prichard, who is also interned in Germany, as well as to friends fighting at the front. This will continue throughout the war.

SEPTEMBER

Ambroise Vollard publishes *Cézanne*, in which Matisse's own Cézanne, *Three Bathers* (p. 45, fig. 3), is reproduced.

SEPTEMBER 1

Barricades are built at the gates of Paris.

The French army officially requisitions the Matisses' Issy home. Henri and Amélie do what they can to safeguard the studio, rolling and storing canvases and burying sculptures in the garden.

SEPTEMBER 2

Germans arrive in Senlis, thirty miles from Notre Dame.

Half a million Parisians follow the government as it flees south to Bordeaux; chaos ensues on the roads and at the railway stations.

SEPTEMBER 6

First Battle of the Marne; by September 12, the Germans are defeated just short of Paris (the French incur 250,000 losses).

SEPTEMBER 10

Accompanied by Albert Marquet, Matisse takes his family to Collioure. Here he will paint *French Window at Collioure* (29).

AFTER SEPTEMBER 11

Matisse becomes friendly with Juan and Josette Gris, who are living in Collioure in a desperate financial situation because his dealer, Kahnweiler, has been forced to leave France.

SEPTEMBER 12

First Battle of the Aisne begins; it continues for sixteen days.

SEPTEMBER 25

First Battle of Albert opens and lasts for four days; together with the Battle of Arras (October 1–4), it comprises the French attempt to outflank the Germans toward the English Channel.

OCTOBER 14

Battle of Ypres begins; it will continue through November 22. French casualties are approximately 50,000.

MID-OCTOBER

Matisse travels with Gris and Marquet to Céret, where they visit the Catalán sculptor Manolo, who offers to help Gris.

OCTOBER 16

Despite the hostilities, Walter Pach arrives in Paris to prepare an exhibition of Matisse's work for the Montross Gallery, New York. The artist will etch his portrait (22v).

OCTOBER 18

Battle of the Yser Canal commences; by its end on October 31, 55,000 French and Belgian troops are wounded or killed.

OCTOBER 22

Matisse leaves Collioure alone, with *French Window at Collioure* unfinished.

BY OCTOBER 25

Inspects his home in Issy, which is still intact after occupation by French officers.

Matisse and Pach work on the exhibition for the Montross Gallery. The artist is involved in the selection process and also prevails upon Sergei Shchukin to lend *Woman on a High Stool* (25), which has not yet shipped to Moscow.

Pach takes Matisse to Puteaux to meet most of the Villon family.

OCTOBER 27
Félix Fénéon writes to Matisse that there are no prospects of advancing funds given the rocky art market and the uncertain outcome of the war.

NOVEMBER 1
Juan and Josette Gris return to Paris; Matisse hires Josette to model for him and goes on to make a drawing and seven etchings of her.

The Matisses care for many wives of artists and critics at the front, including Alice Derain, Fanny Galanis, Greta Prozor, and Germaine Raynal; many appear in Matisse's prints.

NOVEMBER 6
Matisse writes to Amélie about his difficulties in Paris.

C. NOVEMBER 15
Matisse's family returns to Paris from Collioure, leaving their belongings and *French Window at Collioure* behind.

Matisse begins *Head, White and Rose* (30).

Makes monotypes of activities in the studio and a special series of still-life elements (22p–u) related to *Interior with Goldfish* (24) and *Goldfish and Palette* (31).

DECEMBER
Writes to Camoin that he is working on *Goldfish and Palette*, and includes a sketch (31b).

Recommended for auxiliary military service.

DECEMBER 20
First Battle of Champagne, the first significant attack by the Allies against the Germans since the construction of trenches, opens; it will last until March 17, 1915.

LATE 1914
Matisse writes to Marcel Sembat, asking how he might be more engaged in the war; Sembat responds that he should continue painting well.

Makes a portrait drawing of Cocoly Agelasto (33.1).

1915

Matisse acquires a carved wood Bambara figure (42a), adding to a collection of African art that he began to assemble by 1906.

WINTER
Draws and makes prints but does little painting.

Meets violinist Eva Mudocci.

JANUARY
Obtains an official permit as a war artist to visit the ruined quarter of Senlis.

Bernheim-Jeune publishes *Album de la guerre*, which includes works by Pierre Bonnard, Degas, Monet, Pierre-Auguste Renoir, Auguste Rodin, and Édouard Vuillard.

JANUARY 20
Henri Matisse Exhibition opens at the Montross Gallery, New York; it runs through February 27. It is organized by Pach and includes seventy-four works: fourteen paintings, such as *Nude in*

Sunlit Landscape (7c), *Still Life with Lemons* (26), *Woman on a High Stool* (25), *Interior with Goldfish* (24), *Branch of Lilacs* (27), and *Portrait of Yvonne Landsberg* (28); and eleven sculptures, including *Jeannette (I)–(IV)* (11.1–2, 13.1–2). There are also five drawings, twenty-five etchings, two wood engravings, and seventeen lithographs. The catalogue features a color plate of *Interior with Goldfish*.

FEBRUARY
Pach publishes the article "Why Matisse?" in *Century Magazine*.

SPRING
Matisse paints *Composition* (34).

MARCH
Collector John Quinn purchases *The Rose Hat* (30a) from Montross Gallery, along with two drawings, a woodcut, and fourteen lithographs, including *Torso* (22b).

MARCH 17
First Battle of Champagne ends; French casualties number some 90,000.

APRIL 15
Pach writes to Quinn that Matisse has done a new series of etchings and is preparing a new series of lithographs.

Amédée Ozenfant publishes the first issue of *L'Élan*, a periodical to which many artists, at home as well as at the front, send illustrations. Ozenfant hosts weekly gatherings of friends, including Apollinaire, Max Jacob, Picasso, Jacques Lipchitz, and Matisse.

APRIL 22
Second Battle of Ypres begins; fighting is marked by German gas attacks. Allied losses estimated at 69,000 troops by its end on May 15.

MAY 15
Battle of Festubert, part of the French offensive, starts; it will end twelve days later.

MAY 25
Matisse sells *Goldfish and Palette* to Bernheim-Jeune (letter dated May 22); it is sold the following day to Rosenberg.

JUNE 7
Writes to Jacques Doucet about the sale of prints (33) as part of his effort to fundraise for the civil prisoners of Bohain-en-Vermandois.

AUGUST
May have decided to initiate a still-life painting (35) as a variation on his early *La desserte (After Jan Davidsz. de Heem)* (35b).

SEPTEMBER 18
Bernheim-Jeune contract lapses and is left unrenewed until October 1917. Matisse continues to send some works to the gallery, where they are recorded and photographed.

SEPTEMBER 25
Second Battle of Champagne begins; by the time it ends in less than two weeks, 145,000 French soldiers will lose their lives.

OCTOBER 1
Matisse writes to René Jean about working on a still life after his de Heem copy, in which he is "adding to the copy all I have seen since" making the first one.

NOVEMBER 10
Rosenberg writes to Matisse, stating how pleased he is to have acquired *Still Life after Jan Davidsz. de Heem's "La Desserte."*

NOVEMBER 17
Fénéon writes that Rosenberg has asked him about acquiring *Head, White and Rose*.

NOVEMBER 22
Matisse writes to Camoin that he has finished *Still Life after de Heem* and is beginning again another canvas of the same dimensions—*The Moroccans* (36)—for his "souvenir of Morocco."

NOVEMBER 25
Rosenberg writes to Picasso that Matisse came to see Picasso's *Harlequin*: "The Master of the Goldfish was, like me, a little puzzled at first sight. Your *Harlequin* is so revolutionary."

DECEMBER
Exhibition opens on the premises of the couturier Germaine Bongard at 5, rue de Penthièvre; it runs until around December 18. Organized by Ozenfant, the display includes works by Derain, Raoul Dufy, Matisse, and Picasso.

DECEMBER 1
Matisse travels to Marseilles in hopes of curing his bronchitis, this time with Marquet; they will stay for several weeks.

DECEMBER 6
Makes small paintings of the port.

DECEMBER 15
Writes to Rosenberg about Romain Rolland's essay "Above the Fray." The artist remarks, "Did you read it? It is very good and very comforting."

DECEMBER 21
Bernheim-Jeune acquires *Head, White and Rose*.

DECEMBER 24
Matisse writes to Marquet that he has had to suspend work on *The Moroccans* because the canvas is not the right size.

DECEMBER 28
Lottery to benefit Polish artists is held at Bernheim-Jeune; it runs through January 6. Matisse and Georgette Agutte donate watercolors to the effort.

1916

JANUARY 19
Matisse writes to Camoin about his work on *The Moroccans* (44), which will likely continue until the fall.

FEBRUARY
Writes to Derain about Henri Poincaré's *Science and Hypothesis* (1901), which offers "the origins of Cubism." He also mentions that he has seen Picasso's *Harlequin* at Léonce Rosenberg's gallery, remarking that it is in "a new style, without collages and nothing but painting."

Amélie Matisse returns to Collioure to retrieve the family's belongings from 1914; she will also bring *French Window at Collioure*.

FEBRUARY 21
Battle of Verdun is waged 150 miles north of Paris; it will last until December 18.

MARCH 2
La triennale: Exposition d'art français opens at the Jeu de Paume; it runs through April 15. Matisse is represented by drawings and *Interior with Goldfish*.

MARCH 15

Noir et blanc opens at Bongard's salon de couture; it closes on April 15. Organized by Ozenfant, the exhibition features black-and-white drawings by many artists; Matisse likely shows a still life.

APRIL OR MAY

Danish painters Axel Salto and Jens Adolf Jerichau visit Matisse for an article in *Klingen*. They will see many works in process: *The Moroccans, Bathers by a River*, and *Back*, as well as "supernatural interiors" (*The Window*) and still-life paintings "in touch with Cubist theories" (published as "Henri Matisse," April 1918).

APRIL 3

Exhibition of Modern Art: Arranged by a Group of European and American Artists in New York opens at Bourgeois Galleries, New York; it runs through April 29. Matisse is represented by two paintings: *The Leather Hat* (30c) and *Fruits (Zucchini, Bananas, Apples, and Oranges)* (p. 228, fig. 12); three drawings; and seven monotypes.

APRIL 15

Bongard's salon prompts Roger Bissière to announce the "awakening of the cubists" in *L'Opinion*.

APRIL 25

Rosenberg writes to Matisse about *The Moroccans*.

MAY 10

Benefit exhibition at the Galeries Georges Bernheim opens; it closes with an auction on June 1. Matisse donates a painting to be sold for the benefit of the Association for the Blind Soldiers' Home, which will be purchased by the collector Dikran Kélékian.

MID-MAY

Along with Picasso and Diego Rivera, Matisse visits Lipchitz, whose sculptures interest him.

MAY 29

Painting exhibition at the Galerie Bongard opens; it runs through June 15. It includes works by Derain, André Lhote, Matisse, Marguerite Matisse (the artist's daughter, who has become a painter), Picasso, Ozenfant, and others.

SUMMER

Matisse spends much of the summer at Issy, where he works on *The Moroccans, Bathers by a River* (46), *Jeannette (V)* (42), and *Back (III)* (45).

JUNE 1

Matisse writes to Rosenberg that he has finished *The Window* (37), *Bowl of Oranges* (38), and *The Ivy Branch* (p. 265, fig. 4) and is at work again on *Bathers by a River*.

JUNE 8

Concert held in the studio of Émile Lejeune, under the sponsorship of Lyre et Palette, which also organizes exhibitions, *matinées littéraires*, and poetry readings. Under the direction of the Swedish composer H. M. Melchers, the performance includes violinist Gaston Poulet and pianist Walter Morse Rummel.

JUNE 13

Group exhibition at the Galerie des Indépendants opens; it runs through June 30. The presentation includes the work of Derain, Matisse, Picasso, and others.

JUNE 19

Exposition de peinture, serie C opens at Bernheim-Jeune; it runs through June 30. Matisse is represented by *Head, White and Rose; Goldfish and Palette;* and *Still Life with Lemons*.

JULY 1

Battle of the Somme begins; the fighting is seventy-five miles west of Paris and lasts through the fall.

JULY 16

L'Art moderne en France (Salon d'Antin) opens at the Galerie Barbazanges; it runs through July 31. The exhibition is organized by André Salmon and sponsored by Paul Poiret. Matisse is represented by two paintings and a number of drawings; Picasso presents *Les demoiselles d'Avignon* (p. 51, fig. 14) to the public for the first time.

JULY 26

Bernheim-Jeune purchases *Still Life with Plaster Bust* (p. 265, fig. 5).

AUGUST

Bernheim-Jeune photographs *Bowl of Oranges*.

AUGUST 20

Gris writes to Rosenberg that he has visited Matisse's studio and seen a painting of a table in a garden—*The Rose Marble Table* (40).

LATE SUMMER

Begins *Gourds* (41); *Apples* and *Bowl of Apples on a Table* (39.1–2); and *The Piano Lesson* (43).

EARLY FALL

Likely begins portraits of Michael and Sarah Stein (47.2, 47a).

OCTOBER

The Steins purchase *Nude in Sunlit Landscape* from Bernheim-Jeune.

Bernheim-Jeune photographs Matisse's drawings of Eva Mudocci (48.1–2).

OCTOBER 29

Ausstellung französischer Malerei opens at the Kunstverein Winterthur after its presentation in Basel; it runs through November 26.

NOVEMBER

Matisse writes in his notebook about an Italian model, Laurette, recommended by Agutte; she will become the subject of over fifty paintings, including *The Italian Woman* (49), and works on paper over the next several months. She will also be the model pictured in *The Studio, quai Saint-Michel* (51).

Bernheim-Jeune photographs *The Moroccans, Apples, Bowl of Apples on a Table*, and *Still Life with Nutcracker* (p. 265, fig. 7), as well as unfinished versions of *Bathers by a River* and *The Green Pumpkin*.

Matisse paints a commissioned portrait of Auguste Pellerin that will not please the collector (50).

NOVEMBER 6

Writes to Pach that the Steins are packed and "are about to leave for America soon."

NOVEMBER 19
First exhibition of the *Lyre et Palette* opens in the Montmartre studio of Lejeune; it runs through December 5. Erik Satie plays the piano during the opening. Matisse shows *Still Life with Lemons*.

NOVEMBER 22
Den franske utstilling i Kunstnerforbundet opens at Kunstnerforbundet in Christiania (Oslo); it runs through December 10. The exhibition is organized by Walter Halvorsen, whose wife, Greta Prozor, will be the subject of many works by Matisse (48.3, 48i). The catalogue features a drawing by Matisse on the cover and essays by Apollinaire, Salmon, and Jean Cocteau. Matisse is represented by four paintings, including *Interior with Goldfish* (now for sale); ten drawings; and ten etchings.

Prozor writes to Marguerite Matisse about her father's desire that she pose for him.

NOVEMBER 27
Fénéon writes to Matisse about Gustave Courbet's *Young Women on the Banks of the Seine* (p. 312, fig. 3).

NOVEMBER 28
Matisse purchases Courbet's *Source of the Loue* (p. 312, fig. 2) from Bernheim-Jeune.

DECEMBER 1
Ozenfant publishes the tenth issue of *L'Élan* in a unique presentation that contains the poem "Fête" by Apollinaire, drawings by Picasso and Severini, and Ozenfant's "Notes sur le cubisme." Three drawings by Matisse are reproduced: *Still Life with Persian Tile*; *Medina Arab House, Trellis, Figures, Minaret*; and *Seated Moroccan in Three-Quarters, with Arms Crossed*.

DECEMBER 14
Matisse writes to Pach with photographs of paintings he is selling by Agnolo Bronzino, Camille Corot, Jean-Auguste-Dominique Ingres, Claude Lorrain, David Teniers, Tintoretto, Antoine Watteau, and others.

DECEMBER 31
Attends a banquet in honor of Apollinaire's *Le poète assassiné*; it is organized by Gris, Picasso, Paul Dermée, Max Jacob, Pierre Reverdy, and Blaise Cendrars.

1917

Henri Laurens writes to Matisse asking him to contribute a drawing to be sold as a postcard to benefit Russian prisoners and wounded soldiers in France; Matisse agrees.

JANUARY
Bernheim-Jeune photographs *The Italian Woman* and the portraits of Michael and Sarah Stein.

Clément Janin publishes the first of a three-part article on wartime prints in the *Gazette des beaux-arts*, mentioning Matisse's series for the Prisoners of Bohain (33) (published as "Les estampes et la guerre," July and October).

JANUARY 10
Exposition de peinture française opens at the Kunsthalle Basel; it runs through February 4. The presentation is organized to benefit the Fraternité des Artistes de Paris in cooperation with galleries Bernheim-Jeune, Eugène Druet, Durand-Ruel, and Ambroise Vollard. Matisse is represented by *View of Notre Dame* (23d); *Fatma, the Mulatto Woman* (14.2); and *Marguerite with Striped Jacket* (30b).

JANUARY 14
A dinner for Braque is held at the studio of Marie Vassilieff. Among the ten members of the organizing committee are Apollinaire, Gris, Halvorsen, Matisse, Picasso, and Reverdy.

JANUARY 15
Matisse purchases a snowscape by Courbet.

FEBRUARY
Rosenberg purchases *The Moroccans*.

Ameen Rihani visits Matisse in his studio for an article in *The International Studio* and sees *Bathers by a River* (published as "Artists in War-Time," December 1918 and July 1919).

FEBRUARY 3
Bernheim-Jeune purchases *The Italian Woman*.

MARCH 5
Matisse acquires Courbet's *Young Women on the Banks of the Seine* from Bernheim-Jeune.

MARCH 26
Paul Guillaume thanks Matisse for allowing him to publish a Bambara sculpture in his book *Sculptures nègres*, which will accompany an exhibition. Matisse's work is illustrated as "plate V, Collection Henri Matisse, *Idole de la region de Bobo-Dioulasso* (Soudan)."

APRIL 6
The United States enters the war.

APRIL 16
Second Battle of the Aisne (and Third Battle of Champagne) commences; it lasts until May 9, with 187,000 French casualties.

APRIL 25
Exposition d'art français opens at the Palau de les Belles Arts, Barcelona; it runs through July 5. Containing nearly 1,500 works, this is a major exhibition of French art mounted by the Barcelona city council. Matisse exhibits *Still Life with Plaster Bust*.

MAY
Portrait of Auguste Pellerin (II) (50) completed.

MAY 1
Exposition de peinture série D opens at Bernheim-Jeune; it runs through May 11. Matisse is represented by *The Italian Woman* and *Two Sisters*.

C. SECOND WEEK OF MAY
Matisse visits Monet after trying to organize a meeting since fall 1916.

MAY 18
Debut of *Parade*, a ballet with music by Satie and a one-act scenario by Cocteau. The work is composed for Serge Diaghilev's Ballets Russes with costumes and sets designed by Picasso and choreography by Léonide Massine. Organized as a benefit for the wounded veterans of Ardennes, the event has sections of seats reserved for war victims and the Parisian socialites who are its sponsors. *Parade* is intended to be a dazzling and memorable occasion, but it causes a scandal instead.

SUMMER
Matisse writes to Camoin that he has begun a large canvas similar to *The Piano Lesson* but with Amélie and all three of his children: *The*

Music Lesson (p. 316, fig. 11). He also mentions that Jean has left for a regiment in Dijon, serving as an airplane mechanic, and that he has been driving the car he recently purchased to the woods to paint.

Paints *Shaft of Sunlight, the Woods of Trivaux* (52) in the Bois de Meudon, southwest of Issy, and, soon after, *Garden at Issy* (53).

JUNE OR JULY
Visits Chenonceaux with Marquet and the artist Jacqueline Marval; paints two small landscapes.

JUNE 1
Severini's article "La peinture d'avant-garde," which features statements by Matisse, is published in *Mercure de France*.

JUNE 14
Exposition de peinture moderne opens at Bernheim-Jeune; it will run until June 23. Matisse exhibits one painting, *The White Turban*.

JULY 25
Severini writes about Rosenberg's request for a list of all his pictures for his project of an "archive of Cubism." He asks Matisse to remind him of the pictures in his collection.

AUGUST 13
Matisse purchases Courbet's *Sleeping Blonde Woman* and a number of drawings from the artist's sister.

AUGUST 17
Matisse purchases a seascape by Courbet.

OCTOBER 5
Französische Kunst des XIX. und XX. Jahrhunderts opens at the Kunsthaus, Zurich; it runs through November 14. Organized under the auspices of the Service de la Propagande Artistique, supervised by René Jean, the exhibition includes two still-life paintings by Matisse.

OCTOBER 19
Matisse enters a new contract with Bernheim-Jeune. Prices, unchanged in the previous 1912–15 contract, are now more than doubled.

END OF OCTOBER
Travels south.

NOVEMBER 11
Group Show opens at the Bourgeois Galleries, New York; it runs through December 11. Matisse is represented.

DECEMBER
Marquet writes to Matisse: "Coming to the Côte d'Azur is a good idea, here you'll see some sunshine! Every day. Weather never gray. Delightful weather aside from some days where the goddamn mistral blows reminding you of Siberia. Fortunately, this doesn't happen often."

DECEMBER 13
Matisse leaves for Marseilles, where he will visit with Marquet.

DECEMBER 21
Brings his son Jean to Marseilles; makes two paintings of the harbor and a portrait of George Besson.

DECEMBER 25
Matisse arrives in Nice, where he takes a small room overlooking the sea at the Hôtel Beau-Rivage; Pierre joins his father here.

DECEMBER 31
Besson takes Matisse to meet Renoir in Cagnes.

THE UNRIVALLED EXPERIMENTATION AND daring achievement in the first half of 1914 would come to a dramatic and abrupt end for Matisse when he completed *Portrait of Yvonne Landsberg* (28) in mid-July. Just a few weeks before, on June 28—the same day that Curt Glaser visited the artist to discuss an upcoming exhibition of his work in Berlin—Archduke Franz Ferdinand, heir to the Austro-Hungarian throne, was assassinated in Sarajevo. In the ensuing weeks, Austria declared war on Serbia; Russia announced the mobilization of its vast army in Serbia's defense; and Germany, allied to Austria-Hungary, declared war on Russia and then on her ally, France.

By August 3, France was at war (fig. 1), and life was rapidly and radically altered. In Paris, for example, there was pandemonium in the streets as people withdrew their funds from the banks (fig. 2), food prices rose, young men were drafted into service, and public transportation was suspended for military use. Citizens waited in horror as German troops, who had invaded Belgium on August 4, slowly neared the capital; in preparation, they erected makeshift barricades at the city gates. On the evening of August 30, German military aircraft bombed Paris near the quai de Valmy, less than two miles southeast of Matisse's apartment overlooking the Seine. Facing citywide blackouts and nightly bombings, on September 2 the French government, followed by half a million Parisians, left for Bordeaux. As the artist Jules Flandrin reported early in these events, "Nothing is more curious in this Paris that has sacrificed everything, than the feeling that suddenly there no longer exists anything of all that we called work, values, a steady life, ease."[1] Pablo Picasso, putting things more dramatically, recalled to the dealer Daniel-Henry Kahnweiler years later, "On August 2, 1914, I took Braque and Derain to the station in Avignon." Lamenting the end of an era, he commented, "I never saw them again."[2]

Life severely contracted for Matisse as well. In addition to Braque and Derain, fellow artists including Charles Camoin, Fernand Léger, and Jean Metzinger were called up or volunteered; still others, like Picasso and Juan Gris, were exempt from French conscription as Spaniards but initially stayed away from Paris for fear of reprisals against foreigners.[3] Matisse, who was forty-four, reported for service but was rejected. And although he would appeal the verdict, he was unable to overturn it due to his age and weak heart.[4] By the fall, with so many committed to the war effort, artistic life was severely diminished: art journals ceased publication or altered their focus, galleries shortened their programs and sponsored benefits for the war effort, the annual Salons were suspended, and even the Musée du Louvre closed its doors. More personally, at the end of August, the artist's hometown of Bohain-en-Vermandois fell under German control, with hundreds of men, including Matisse's brother, Auguste, deported to a prison camp; the artist could get no news of his ailing mother, who was left behind with his sister-in-law and nephews. To compound his problems, on September 1, the French military requisitioned Matisse's home in Issy-les-Moulineaux.[5] In addition to packing away his family's belongings, he was obliged to close up his studio and delay whatever work plans he might have had, possibly for *Bathers by a River* (21) or *Back* (45). According to Hilary Spurling, Matisse and Amélie hastily rolled up and stowed away paintings and even buried sculptures in the garden before moving to their Paris apartment just as the first nighttime bombings began.[6] Not surprisingly, the months after July 1914 were hardly filled with art making; in more ways than one, the period between August 1914 and the end of 1915 was full of stops and starts, interruptions and returns, as the artist tried to negotiate the dual challenges of attending to the developments of the war and satisfying his own creative ambitions.

Concerned over the increasing danger in Paris, on September 10, while French and British forces were working to defeat the Germans on the outskirts of the city, Matisse and his family left for Collioure. Once there he returned to work after a two-month hiatus and embraced a familiar subject—the open window or door, a motif he had first painted in 1896 and explored frequently thereafter.[7] As the artist explained on many occasions, windows interested him as passageways that could connect exterior and interior, bringing him into the space of a composition so that he might invest it with his own emotion.[8] Since his March 1913 return from Morocco, Matisse had

produced at least five works in which windows feature prominently—*The Blue Window* (18), *Bell Flower (Campanule)* (18c), both versions of *View of Notre Dame* (23, 23d), and *Interior with Goldfish* (24). Now he would initiate *French Window at Collioure* (29), which draws upon elements of many of these earlier window scenes, including the vertical orientation, the banded organization, and the still-prominent use of blue. However, it is also dramatically set apart from these earlier works by its central black band, which has long inspired commentators to interpret its shadowy surface as evidence of Matisse's emotional and psychological withdrawal in the first days of the war. While archival documents attest to his understandably troubled feelings at this moment—at one point, he remarked, "I'd rather be doing something for the defense of the country but I don't even know how to knit socks"—other factors are actually responsible for this painting's appearance.[9] On October 22, the artist left his family and the canvas in Collioure when he took a short trip back to Paris. Almost two weeks later, he lamented his continuing distance, confiding to his wife that he had finally begun "to feel back in my element" in the south (p. 233). When his family returned to Paris later in November, they did so without the painting, and Matisse did not return to it again. Thus, the black band, which was the last element he painted before his departure, represents a frozen step in his working process. Far more than an emblem of the artist's emotional state, *French Window at Collioure* suggests the continuum of Matisse's development from his last canvas, *Portrait of Yvonne Landsberg*, in which he scraped out the sitter's visage from a layer of black paint.

In mid-November, Matisse restarted his work yet again. Surrounded by his family and the familiar atmosphere of his quai Saint-Michel studio, the artist looked once more to familiar themes. He began a new portrait of his daughter, Marguerite, which continued a series he had initiated earlier in the year (30a–d), and also started *Goldfish and Palette* (31), a window painting that followed on *Interior with Goldfish* of January 1914. While both canvases resume earlier motifs, they also demonstrate a significant change of style. Here the artist pursued a more strict, geometric organization, especially in the colored vertical bands; description with alternating positive

223

and negative outlines that he either painted or scraped; and a mixture of naturalistic and more abstracted form. Indeed, these works suggest the influence of Matisse's earlier experience with Gris, who, with his wife, Josette, was living in Collioure at the start of the war. In Gris, the artist found a colleague with whom to explore the possibilities of Cubism for his own developing ambitions and to share the challenges of making modern paintings. By the time Matisse had arrived in the south, the younger painter had already devised a compositional structure in which he arranged planes of bands that were initially gridded (35j) or vertical (fig. 3) but would soon become diagonal (30i) and even fan-shaped; these allowed him to produce tense, dynamic representations of subjects from several vantage points. In the summer of 1914, Gris was also incorporating *papiers collés* into his canvases (fig. 4), which served to further isolate specific parts of objects, emphasizing and juxtaposing their transparency and solidity while unifying the overall composition.[10] In *Head, White and Rose* (30), we can see Matisse's adoption of some of these more doctrinaire Cubist elements, especially the cagelike grid over Marguerite's face. His application, however, was not as strictly measured and organized as Gris's, but rather more intuitive. This difference of approach is at the heart of his later comments to E. Tériade on Cubism: "The Cubists' investigation of the plane depended upon reality. In a lyric painter, it depends upon the imagination. It is the imagination that gives depth and space to the picture. The Cubists forced on the spectator's imagination a rigorously defined space between each object. From another viewpoint, Cubism is a kind of descriptive realism."[11] Matisse was not interested in using Cubist description in a strict way. Rather, he employed it as yet another vehicle in his own development of modern construction, one that began and ended with the subject and his personal feeling for it. As Matthew Stewart Prichard noted during the intensely productive months just preceding the war, "Matisse speaks of space in his pictures. This is not the representation of three dimensions which preoccupies him but the feeling of expansion which the painting produces in him. He projects his feeling into the canvas."[12] *Goldfish and Palette* demonstrates this interest; it also recalls Gris's use of *papier collé* in the transparent effects achieved in areas that were scraped and wiped down from black, particularly at lower right, where the artist's thumb pokes through the palette. Moreover, the central black band, which Matisse scraped into to describe illuminated forms, recalls *French Window at Collioure* and suggests his possible attempt to revive and advance what he had initially undertaken in the south.

At the same time that Matisse was painting these two canvases, he was also working with the American dealer Walter Pach, who had been in Paris since mid-October to organize an exhibition of the artist's work for New York's Montross Gallery.[13] Both men knew the importance of this presentation: the start of the war found Matisse without a steady source of support, as many of his most interested and enthusiastic collectors, who were largely Germans and Russians, were now unable to make acquisitions.[14] Even his still-active patron Michael Stein, who was unable to retrieve his pictures from the Kunstsalon Fritz Gurlitt exhibition in Berlin, was aware of the need for Matisse to attract new collectors from the United States. He implored Pach that, in working with the artist, he must not

fail to impress on him that he must now look to America for a market for his art for some time to come and he might as well send all the things that are at Issy-les-Moulineaux, especially the older and smaller things, black and whites, etc. etc. and not to put the prices too high, as now is the time to have the Americans begin to own Matisse. They have read about him, discussed him, seen him in exhibitions ad infinitum. It is about time he were ranked among the accepted classics and bought freely.[15]

Matisse was especially concerned to show the strongest works possible: he secured Sergei Shchukin's approval to loan *Woman on a High Stool* (25), which he had reserved but could not receive because of the war, and convinced Pach to include *Young Sailor (II)* (1906; Metropolitan Museum of Art, New York) despite its presentation in the 1913 *International Exhibition of Modern Art*, otherwise known as the Armory Show.[16]

In the end, the Montross exhibition comprised seventy-four paintings, sculptures, drawings, and prints that represented both early and later work, but heavily emphasized Matisse's current production. Opened on January 20, 1915, it was installed in three galleries: the first was hung with five recent drawings (fig. 5) and forty-four prints, including two 1906 woodcuts (48j); seventeen lithographs, especially his latest series from 1913–14 (21f, 22b–c); and twenty-five of his most recent etchings and drypoints (fig. 6, 22e, 33j, 33n).[17] A second room contained eleven sculptures, including *The Serf* (1900–04; D6), *Two Women* (4e), and the four states of *Jeannette* (11.1–2, 13.1–2).[18] A final gallery presented paintings: seven earlier works, including *Studio under the Eaves* (1903; Fitzwilliam Museum, Cambridge) and *Nude in Sunlit Landscape* (7c); and the recent canvases *Still Life with Lemons* (26), *The Rose Hat* (30a), *Woman on a High Stool, Interior with Goldfish, Branch of Lilacs* (27), and *Portrait of Yvonne Landsberg*.

In recognition of the event, Pach wrote an article for the *Century Magazine* in which he answered the editor's question about "whether the revolt of Matisse represents genius unfettered or the shrewd play of commonplace talent."[19] Pointing to the artist's interest in both the classic and the modern, Pach quoted from "Notes of a Painter" and stressed Matisse's sincerity and process: "Where the mediocre artist gives up the struggle after a short time and contents himself (and his public) with the copy of an object, Matisse keeps up the search for a month, perhaps for a year, and will not let the work go from his studio until the particular expression he needed has been reached." At the same time, the exhibition also had its detractors, who reminded readers of Matisse's controversial presence in the Armory Show.[20] One critic for *American Art News* saw strength and grace in the artist's works on paper but found that Matisse's paintings and sculptures violated the canons of art; *Woman on a High Stool* and *The Rose Hat*, for instance, were remarkable for their "untruthful color" and "flat, unmodelled features."[21] Matisse, the critic stated, "is a paradox—for with at times his evident love of the beautiful as shown by his grace of line and infrequently his composition and color, he seems to prefer to render the ugly in an ugly way. In fact he may be called 'The Apostle of the Ugly.'"

Despite such public commentaries, even two weeks before the close of the show, *American Art News* reported that over eighty sales had been made, including drawings, prints, and sculptures: indeed, the magazine remarked, "The supply of several of the prints being exhausted, Mr. Montross has sent to Paris for others."[22] In the end, Matisse sold five sculptures, including *Reclining Nude (I) (Aurore)* (1.2); *La serpentine* (1909; D46); *and Jeannette (IV)*.[23] Sales also included three paintings: the great American collector John Quinn acquired *The Purple Cyclamen* (1911; private collection) and *The Rose Hat*, and Walter Arensberg purchased *Portrait of Yvonne Landsberg* sometime after the exhibition closed.[24] Quinn's purchases would also include three drawings, a wood engraving, and at least fifteen lithographs.[25] The presentation and sale of so many of Matisse's prints established a continuing taste, and Pach went on to sell works—monotypes in particular—directly to patrons like Quinn and Arensberg or through other venues such as Bourgeois Gallery in New York.[26]

While Matisse was having some success with the American public, he was finding it increasingly difficult to work back home. Documentation suggests that, once finished with *Goldfish and Palette*, he likely did not pick up a brush again until he painted *Fruits (Zucchini, Bananas, Apples, and Oranges)* (fig. 12) in April–May 1915.[27] Instead, he devoted himself to making drawings and prints—works that in their more intimate nature and humble means may have complemented the wartime atmosphere, suited the confined space of the Paris studio, and been easier to produce in short, interrupted intervals of work. We know that in this period the Matisses became very involved in caring for friends and family at the front or behind enemy lines, as well as the many women and children left at home. The painter Jean Chaurand-Naurac, a neighbor in Issy, entrusted his wife and daughter, Janine, to the Matisses, and the couple also corresponded with and visited Alice Derain in

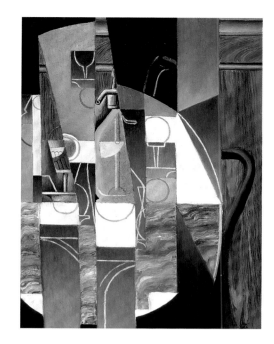

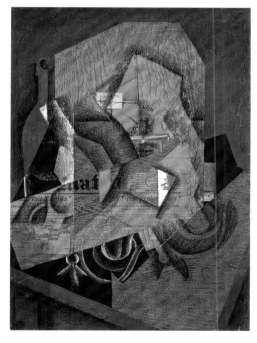

fig. 3
Juan Gris (Spanish, 1887–1927)
The Siphon, April 1913
Oil on canvas
81 × 65 cm (31 7/8 × 25 5/8 in.)
The Rose Art Museum, Brandeis University, Waltham, Mass., gift of Edgar Kaufmann, Jr.

fig. 4
Juan Gris
The Packet of Coffee, June 1914
Papier collé, gouache, and charcoal on canvas
64.8 × 47 cm (25 1/2 × 18 1/2 in.)
Ulmer Museum, Ulm, Eigentum des Landes Baden Wurttemburg

Montfavet. The artist filled time during these trips by making portraits (figs. 7–8, 33i).[28] He also did the same for Fanny Galanis (34e–f), whose husband, Demetrius, enlisted in the foreign legion; Germaine Raynal (fig. 5), wife of critic Maurice Raynal, who was called up; Greta Prozor (48.3), married to the artist Walter Halvorsen, who was a Red Cross skier; as well as many others, including Josette Gris (fig. 9, 34j–n) and Emma La Forge (figs. 10–11).[29] Although not produced with the same complex means as his earlier, more heavily worked paintings, these personal, elegantly spare images share similar compositional traits: for example, the portrait of Cocoly Agelasto (32.1), the daughter of a cousin of Matisse's friends the Rodocanachis, draws upon his portraits of both Janine Chaurand-Naurac and Marguerite (30). Returning to another familiar motif, the artist also made a portrait of his wife (32.2). Rendered in a blend of naturalistic curves and geometric shapes, with a surprising grid pattern over the face, it recalls his 1913 *Portrait of Madame Matisse* (p. 148, fig. 9) and parallels the similar, more personal style that Picasso was also devising for portraiture (p. 315, fig. 8).[30] During 1915, Matisse, who was engaged in auxiliary military service, would use the sales of many of these etchings and monotypes to fund packages for those affected by the war (pp. 249–51); earlier patrons such as Jacques Doucet, as well as newer American collectors including Mabel Bayard Warren of Boston, enthusiastically supported his cause.[31]

During the summer and fall of 1915, this work surely satisfied some of the artist's increasing guilt and disappointment at not being able to directly serve his country. He shared his feelings with the critic René Jean, remarking, "How many things, my God—I, who because of my age and the major's decision, have remained with my brushes, I am often sickened by all of the upheaval to which I am not contributing—and it seems to me that my place is not here. I work as much as I can.

fig. 5

*Head of a Woman
(Germaine Raynal)*, 1914
Pencil on paper
29.8 × 24.4 cm (11 3/4 × 9 5/8 in.)
Phyllis Hattis Fine Arts,
New York

fig. 6

La persane, 1914
Drypoint on paper
Image: 16 × 5.9 cm
(6 1/4 × 2 5/16 in.);
sheet: 31.5 × 22.5 cm
(12 3/8 × 8 13/16 in.)
The Metropolitan Museum of Art,
New York, Harris Brisbane Dick
Fund, 1929.89.6

fig. 7
Janine Chaurand-Naurac, 1915
Charcoal on paper
49 × 31 cm (19 1/4 × 12 3/16 in.)
Private collection

fig. 8
Profile of Madame Derain (II), 1914
Monotype on chine collé
Image: 6.5 × 8.9 cm
(2 9/16 × 3 1/2 in.);
sheet: 14 × 18.5 cm
(5 1/2 × 7 1/4 in.)
Private collection

fig. 10
Emma's Profile, 1915
Monotype on chine collé
Image: 12.7 × 17.7 cm (5 × 7 in.);
sheet: 28 × 36.9 cm (11 × 14 1/2 in.)
Private collection
In exhibition

fig. 9
Portrait of Josette Gris, 1915
Pencil on paper
29.3 × 24 cm (11 1/2 × 9 7/16 in.)
Private collection

fig. 11
Face from the Front, 1915
Monotype on chine collé
Image: 17 × 12.1 cm
(6 11/16 × 4 3/4 in.);
sheet: 37.6 × 28.1 cm
(14 13/16 × 11 1/16 in.)
Private collection
In exhibition

I did what I could to ease the misery of my compatriots who are civilian prisoners."[32] At the same time, his work records a slower and frequently interrupted artistic progress that was equally frustrating. Possibly to offset this, Matisse confined his experiments to familiar motifs from before the war, still-life compositions (fig. 12) and views from windows (34). These do not indicate a lack of imagination, but rather, like his bathers compositions of 1907 to 1909, function as ready-made themes for invention that he could easily set down onto canvas and then push forward.

Perhaps the greatest example of this approach from this moment is *Still Life after Jan Davidsz. de Heem's "La Desserte"* (35), which Matisse painted in Issy during late summer and early fall 1915. Returning to their home after the French military vacated it, the artist and his family had to unpack their household belongings, reorganize the studio, and take artworks out of storage.[33] One can imagine the moment of inspiration that came to Matisse at the renewed sight of his 1893 canvas (35b), copied after the 1640 original in the Louvre (35a). The process of copying was a powerful one for the artist, associated with his very first canvases (2a–b) and especially his time in the studio of Gustave Moreau. As a student, Matisse found copying after an earlier work an important tool that allowed the temporary suspension of concerns about personal style in order to focus on the very basics of constructing a painting.[34] Now, after almost nine months away from the Issy studio, he may have felt the need to start once again, drawing upon his earliest practices to register where he had been for the past several months and methodically acknowledge what he had learned before moving forward. He chose for his composition a substantial canvas—the largest he had painted since reworking *Bathers by a River* in the fall of 1913—and carefully repainted the still-life composition using many of the elements of doctrinaire Cubism that he had absorbed from Picasso's recent work (p. 180, fig. 3), his time with Gris in Collioure, and even visits to Puteaux to meet Raymond Duchamp-Villon with Pach in the fall of 1914.[35] To this, he added his continuing interest in Cézanne as well as recent study of Georges Seurat, which was encouraged by seeing paintings at Bernheim-Jeune in 1915, one of which he acquired (fig. 13).[36] In early September, Matisse reported his thoughts on these works to Camoin while describing his progress on the new still life:

My work goes on. I have already done many things to my painting. It is much more assertive than when you saw it. It has caused me much reflection through its similarities to a second Seurat that Fénéon lent me. But I have already had so many reflections that seemed very important to me and were erased by others without my seeing the light that I was expecting from them, that I no longer believe myself saved as easily as I did ten years ago for example! Even so, things are advancing a bit. What I know, I know better. I know that Seurat is completely the opposite of a romantic, that I myself am a romantic but with a good half of the scientist, the rationalist—this results in a battle

from which I sometimes emerge victorious, but winded. . . . I left Bernheim's, on Friday, with a new Seurat. A replica of the small *panneau* you saw at my house, but more powerful, more precise, more colorful. What is more, at the top and the bottom, it has a band of dark blue dotted with violet, which serves as a frame, or rather a foreground.[37]

Camoin, writing from his post in the northeastern French town of Saint-Dié-des-Vosges, encouraged his friend to continue the painting in order to realize his own ambitions:

And so, after twenty or so years of work, the idea came to you to make a copy of your copy from the Louvre enlarged by all that you have acquired since, the whole of your experiments which now seem to lead back to the tradition of the masters. It is, I suppose, through the quality of the color and the light that your painting resembles Seurat, and also that desire for construction that Seurat was one of the first to feel after impressionism. . . . You yourself are certainly both reflective and lyrical at once, for in the end it is your instinct that wins out.[38]

Matisse's canvas did much for his progress and ultimately freed him to take on a subject he had considered many times before but likely never started. In November 1915, drawing upon sketches from his travels (15a, 15e–j) and possibly even some of the postcards (fig. 14, 20a–b) and other items he collected in 1912–13, he stretched a canvas of the same dimensions as his still life and began to lay in the composition of a painting that he referred to as a "souvenir of Morocco."[39] Although he would soon require a still-larger canvas and postpone work on *The Moroccans* (36) until the beginning of 1916, Matisse's efforts over the last months of 1915 demonstrate a new degree of stability and reconciliation with his circumstances; as he explained to Pach, "Since I haven't yet been drafted I believe it is my duty as a civilian to work as much as possible."[40] His choice of subject was also quite appropriate to the events of the time: just as his copy of de Heem's picture reflected its historical roots in wartime Holland, *The Moroccans* acknowledged his country's own circumstances, which he discussed at length with Camoin at the exact moment he began working on the canvas. On October 7, for instance, Camoin wrote to Matisse:

You said, with some reason, that this war was a disgrace to "*civilization*." It must be admitted that morally, civilization doesn't exist, we confuse it with the words progress, science, etc., which simply provide an occasion for the refinement of barbarity. Pure civilization would be in the worship of Beauty and Taste but it only exists as an exception and this is so among the Moroccans [*les nègres*] as well as ouselves.

Aside from that, the world is a vast battlefield where the battle for the domination of "the strongest" is fought. In this war, we see ourselves in a good light obviously, but what were we doing in Morocco? Teaching them to live with cannon fire! And tragically for their artists,

fig. 13
Georges Seurat
(French, 1859–1891)
Moored Boats and Trees, 1890
Oil on wood
16 × 25 cm (6 5/16 × 9 13/16 in.)
Philadelphia Museum of Art, gift of Jacqueline Matisse Monnier in memory of Anne d'Harnoncourt, 2008, 2008-181–1
(Formerly in Matisse's collection)

fig. 14
Postcard, captioned "View of Tangier," that Matisse acquired during his 1912 or 1913 visits to Morocco and may have used as he restarted work on *The Moroccans* in late 1915. Archives Henri Matisse, Paris.

destroying their most beautiful walls, ancient doors, and putting beautiful corrugated iron over the big market squares.

So as the kingdom of God is decidely not of this world, let us strive to be the strongest: the worship of absolute goodness would perhaps lead to degeneracy, and there is, despite everything, a whole nobility to battle. Conclusion: evil is necessary to the world's moral Beauty, amen![41]

Matisse would likewise worry over the situation of North Africans and other foreigners in France, who he believed were sent to fight a war in which they were involved only by imperialistic association. During a short trip to Marseilles in December, he noted to Camoin, "You can barely get around, it is so overcrowded with soldiers of all races, from the English, Moroccans, and Senegalese, to those Maoris from New Zealand that the English made come here to fight the war. Poor fellows!"[42] His concern, which would continue throughout 1916, may have spurred his desire to unite his personal and artistic imperatives in *The Moroccans*. In doing so, Matisse would transcend the interruptions and returns of his early wartime experience and find a way the following year to make modern pictures under the most difficult of circumstances.

—STEPHANIE D'ALESSANDRO

1. Flandrin to Adèle Flandrin, Aug. 6, 1914; *Jules Flandrin (1871–1947): Un élève de Gustave Moreau, témoin de son temps* (Editions de l'Association Flandrin Deloras, 1992), p. 173. See also Spurling 2005, p. 156.

2. Kahnweiler 1961, p. 59. Kahnweiler acknowledged the meaning of this statement, writing, "This is a metaphor as of course you understand. He did see them again but by this he wanted to say that the friendship was never the same as before." For more on Picasso's statement, see Richardson and McCully 1996, p. 345.

3. Picasso spent most of the months of the war in Avignon. For more on the general atmosphere of Paris at this time, and Picasso's circumstances in particular, see ibid., pp. 343–53.

4. Spurling 2005, pp. 166, 478 n. 88.

5. The house was in the same place where Matisse's distant cousin, Raymond Saunier, would soon design and build the first French fighter planes in the Morane-Saunier workshops; ibid., pp. 159–60.

6. Ibid, p. 160.

7. In 1896 Matisse painted *Open Door, Brittany* (private collection). For more on the theme of windows in Matisse's art, see Stephen Buettner, "The 'Mirrored Interiors' of Henri Matisse," *Apollo* 117 (Feb. 1983), pp. 126–29; Carla Gottlieb, "The Role of the Window in the Art of Matisse," *Journal of Aesthetic and Art Criticism* 22 (Summer 1964), pp. 393–422; Jean Laude, "Autour de la *Porte Fênetre, a Collioure*, de Matisse," in Mousseigne 1978, pp. 53–73; Schneider 2002, pp. 447, 453–56; and Isabelle Monod-Fontaine, "A Question of Windows," in Aagesen 2005, pp. 184–205.

8. "The space," he explained, "is one continuity from the horizon right to the interior of my work room . . . the boat that is going past exists in the same space as the familiar objects around me; and the wall with the window does not create two worlds. This is probably where the charm of these windows . . . comes from." "Matisse's Radio Interviews" (1942); Flam 1995, p. 146. See also Tériade 1929 and 1952, pp. 52, 53, 62; the issue of windows became so important for the 1952 interview, in fact, that it includes a presentation of window-themed paintings by Matisse complemented with photographs taken by Hélène Adant, who was told specifically by the artist which views and angles out of windows to choose for photographs.

9. Matisse to Jean Puy, Oct. 18, 1914, AHM; Spurling 2005, p. 167.

10. For more on Gris, see Daniel-Henry Kahnweiler, *Juan Gris: His Life and Work*, trans. Douglas Cooper (Curt Valentin, 1947); Mark Rosenthal, *Juan Gris*

(Abbeville Press, 1983); and *Juan Gris: Paintings and Drawings 1910–1927*, exh. cat., ed. Paloman Esteban Leal (Museo Nacional Centro de Arte Reina Sofía, 2005).

11. Tériade 1952, p. 50.

12. Undated notes from Matthew Stewart Prichard, Archives Duthuit, Paris; see also Labrusse 1996, p. 770.

13. Barr 1951, p. 179, states that, according to Pierre Matisse, the artist had even worked on the exhibition while in Collioure, receiving a telegram from Shchukin agreeing to lend *Woman on a High Stool* (25).

14. Shchukin, for example, sent a telegram to Matisse stating, "Impossible to send [money] Moscow exchange closed bank and post office refused transfer to France hope send when contacts restored." Shchukin to Matisse, Nov. 2, 1914, AHM; Kostenevich and Semyonova 1993, p. 177. As Spurling 2005, p. 162, noted, Matisse even wrote to Bernheim-Jeune at the end of Oct.; however, Fénéon explained that there were no prospects of advancing anything given the rocky market and uncertain outcome of the war.

15. Stein to Pach, Oct. 1914, Walter Pach Papers, Archives of American Art, Smithsonian Institution, Washington, D.C. See also Pearlman 2002, pp. 387–88.

16. Barr 1951, p. 179.

17. While the subjects of the drawings are not identified by name in the titles, the woman sitter was Germaine Raynal and the male was the violinist Joan Massia, who was also the subject of numerous prints; see Duthuit and de Guébriant 1997, pp. 26–27, cats. 24–26.

18. One critic from the *New York Times* described the busts of *Jeannette* as "one remarkable and rather terrible woman's head . . . presented in four stages of interpretation, the artist gradually getting down to the bare bones of his impression of the sitter." *New York Times*, Jan. 21, 1915, p. 8.

19. Walter Pach, "Current Comment: Why Matisse?" *Century Magazine* 89 (Feb. 1915), pp. 633–36.

20. Even before the exhibition opened, press reminded readers of Matisse's work in the Armory Show, predicting that the Montross exhibition would become "quite a sensation." See *American Art News* 13, 9 (Dec. 5, 1914), p. 1.

21. *American Art News* 13, 16 (Jan. 23, 1915), p. 2.

22. *American Art News* 13, 19 (Feb. 13, 1915), p. 9.

23. See Fénéon to Matisse, Nov. 5, 1914, AHM, confirming the sale price for *Jeannette (IV)*; and Bernheim-Jeune to Matisse, May 22, 1915, AHM, confirming the sale. Barr 1951, p. 180, stated that the collector who purchased *Jeannette (IV)* was William Scranton Pardee and that Arthur B. Davies acquired *La serpentine*.

24. Quinn's purchases are also accounted for in Bernheim-Jeune and Matisse's correspondence; see Barr 1951. For more on Arensberg's acquisition, see Francis Nauman, "Walter Conrad Arensberg: Poet, Patron, and Participant in the New York Avant-Garde, 1915–20," *Philadephia Museum of Art Bulletin* 76, 318 (Spring 1980), pp. 2–32.

25. Many of these prints are today in the collection of the Albright-Knox Art Gallery, Buffalo. For more on Quinn's purchases from the Montross Gallery, see Judith Zilczer, *"The Noble Buyer": John Quinn, Patron of the Avant-Garde* (Smithsonian Institution Press, 1978), esp. pp. 172–74.

26. See Pach to Quinn, Apr. 15, 1915, John Quinn Memorial Collection, Manuscripts and Archives Division, New York Public Library; Arensberg to Pach, July 1915, Arensberg Archives, Philadelphia Museum of Art; and Pach to Quinn, Oct. 5, 1915, John Quinn Memorial Collection (above). For the above letters, see also Pearlman 2002, pp. 34–35, 252–53, 269; Matisse to Pach, Nov. 20, 1915, Walter Pach Papers, Archives of American Art, Smithsonian Institution, Washington, D.C.

27. Josse Bernheim-Jeune to Matisse, Apr. 29, 1915, AHM, and Fénéon to Matisse, May 22, 1915, AHM. See also Dauberville and Dauberville 1995, vol. 1, p. 541, cat. 147. Bernheim-Jeune purchased the painting on May 21, 1915 (stock no. 20465), and photographed it in June 1915 (photo no. 919). The canvas was sold to Pach on June 18, 1915.

28. Matisse's kindness toward Alice Derain helped to restore his friendship with her husband, who wrote from Lisieux on Dec. 31, 1914, to thank Matisse, recognizing that he might be "a little surprised by my letter," since they had fallen out in 1908; Labrusse and Munck 2005, p. 348. In April, Derain visited Matisse while on leave and even had Matisse authorize his works for sale while he was away. Jealous, on Apr. 24, 1915, Picasso reported to Apollinaire in Nîmes, "Derain is in Paris and has been seeing Mattisse [*sic*]. He has not come see me" (Archives, Musée Picasso, Paris). For more on Matisse's portraits made during the war, see Klein 2001, pp. 133–36.

29. Juan and Josette Gris came to Paris on Nov. 1, and Matisse helped them financially by paying Josette to sit for him as a model; he made a drawing and seven etchings of her at the quai Saint-Michel studio. See Gris to Kahnweiler, Nov. 6, 1914, Archives Kahnweiler-Leiris, Paris. Biographical information on Cocoly Agelasto is from Russell 1999, pp. 45–46; and Spurling 2005, pp. 288–89.

30. While the canvas was with Shchukin, Matisse would still have had access to it through its reproduction in *Les soirées de Paris*. For more on Picasso's drawings and the beginnings of a new, more naturalistic style, see Silver 1989 and Richardson and McCully 1996.

31. Spurling 2005, p. 169, recounts Warren's offer to sell works; see Warren to Matisse, Jan. 10, 1916, AHM.

32. Matisse to Jean, Oct. 1, 1915, in the possession of the recipient's daughter, Sylvie Maignan, who generously made it available to the authors.

33. Matisse checked on the Issy house on Oct. 25, 1914, reporting to Amélie that things were generally in good repair; the military vacated the premises on Nov. 1. Based on correspondence, it may be that the family did not return to Issy until Apr. 1915. The photograph of Marguerite with *Back (III)* in process (45d) likely dates from this time.

34. For more on Matisse's copies, see Barr 1951; Tériade 1952; Benjamin 1987 and 1989; Louvre 1993, pp. 72, 147–48, 348–55; and Schneider 2002.

35. See Barr 1951, p. 179; and Pach 1938, pp. 145–46.

36. Matisse likely had *Moored Boats and Trees* at his home in the fall of 1915 but paid for it over a number of installments, finally acquiring it in 1916. Thanks to Joseph Rishel, Philadelphia Museum of Art, for sharing information on Matisse's acquisition of this work.

37. Matisse to Camoin, Sept. 1915, Archives Camoin.

38. Camon to Matisse, Sept. 19, 1915, AHM.

39. Matisse to Camoin, Nov. 22, 1915, Archives Camoin.

40. Matisse to Pach (n. 26); Cauman 1991, p. 5.

41. Camoin to Matisse, Oct. 7, 1915, AHM.

42. Matisse to Camoin, Dec. 6, 1915, Archives Camoin. Archival documents also record that Matisse read pacifist Romain Rolland's *Above the Fray* and encouraged others, including Léonce Rosenberg, to do so as well.

29 **French Window at Collioure**
Collioure, mid-September–October 1914

Oil on canvas; 116.5 × 89 cm (45 7/8 × 35 in.)
Unsigned
Musée National d'Art Moderne/Centre de Création Industrielle, Centre Pompidou, Paris,
gift 1982, AM 1983-508

IN EXHIBITION

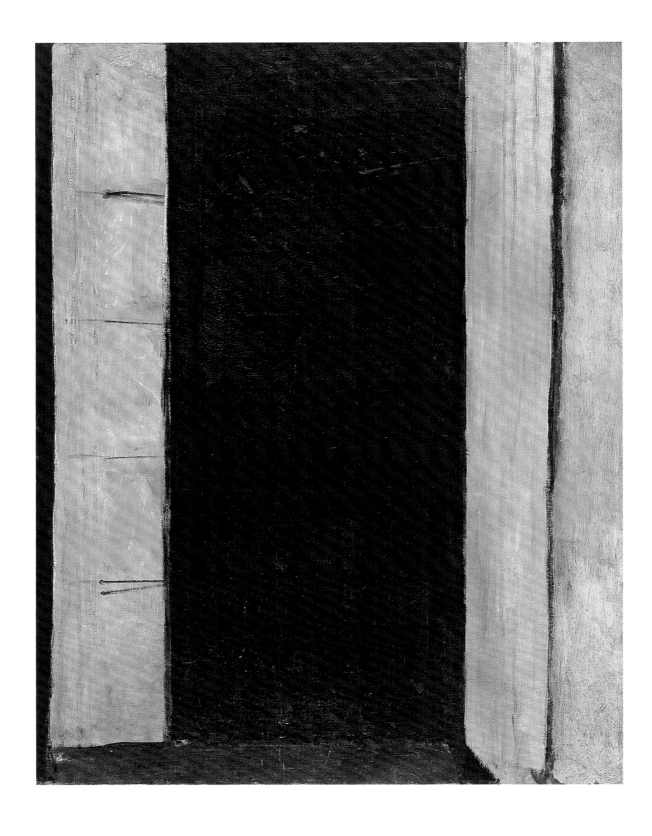

French Window at Collioure
Collioure, mid-September–October 1914

Oil on canvas; 116.5 × 89 cm (45 7/8 × 35 in.)
Unsigned

IMMEDIATELY AFTER MATISSE completed *Portrait of Yvonne Landsberg* [**28**], his personal and creative life changed dramatically. Within a few weeks in August, France was mobilized, his childhood home in the north was occupied, his house in Issy was requisitioned by the military, and he was denied the ability to enlist. Those around him—family as well as friends such as Guillaume Apollinaire, Charles Camoin, and Demetrius Galanis—departed for the front or, like Daniel-Henry Kahnweiler, were identified as enemy aliens. The result was an abrupt end to the unparalleled artistic experimentation he had undertaken during the first half of the year. By August 21, his work, as he reported to his mother, who was living behind enemy lines in Bohain-en-Vermandois, was "going nowhere, inspiration being obviously lacking and I have got other things on my mind."[1] With growing concerns for his family's safety in Paris, on September 10, he and Albert Marquet took them to Collioure, the southern coastal city he had last visited in 1911.[2] As before, they lodged in the home of Marie Astié, away from the fighting that occurred increasingly and more severely further north, although never too far from their minds. It was here, in his familiar studio, that Matisse began the painting known today as *French Window at Collioure* [**29**].

To judge from the title of this work, the artist was pursuing a familiar subject—the open window or door, which he had painted on a number of occasions previously in Collioure, including his last visit three years earlier [**29a**].[3] He had also focused on this theme more recently, as he moved away from exploring color and light with pictures such as *The Blue Window* [**18**] and *Flowers and Ceramic Plate* [**19**], and became interested in transparency, as seen in *Interior with Goldfish* [**24**] and his *View of Notre Dame* [**23**].[4] *French Window at Collioure*, however, is markedly more abstract than any such work Matisse painted before or after, and it has inspired much commentary ever since its first public exhibition in 1966.[5] Its dense black center has led many scholars to identify the canvas with the artist's feelings as he began to grapple with the war, seeing it as "a screen . . . descended" and "overtly despairing."[6] An attention to Matisse's artistic methods and to the historical events of fall 1914, however, suggests another interpretation: that the painting looks the way it does largely because the artist never finished it.

Indeed, Matisse left the canvas in Collioure on October 22, when he traveled alone back to Paris to attend to business; among his concerns were his efforts to raise funds for both his family and for Juan Gris, who along with his wife, Josette, was also in Collioure—and in a desperate financial situation after his dealer and main source of support, Kahnweiler, was forced into exile in Switzerland. While the two

artists had likely met in Paris some time in 1914, they started a friendship in Collioure. In Gris, Matisse had found a companion to keep alive his most recent artistic experimentation. "I see Matisse often," Gris wrote to Kahnweiler that fall. "We talk relentlessly about painting while Marquet listens wearily."[7] Trying to reestablish himself at the quai Saint-Michel, Matisse wrote to Amélie on November 6 about his difficulties:

I still have not gotten used to Paris, and I was so sorry to be here yesterday morning that it would have taken very little for me to telegraph you that I was returning to Collioure....I saw the prospect of enough work there to last me the whole winter. I had already begun the open balcony [*French Window at Collioure*], and I had other things in mind as well, for I was finally beginning to feel back in my element.[8]

Ultimately unable to return, Matisse sent for his family to join him in Paris just weeks later. They left their belongings as well as the painting behind in Collioure.[9]

Given these circumstances and Matisse's own words, it seems clear that *French Window at Collioure* represents an interrupted evolution, even as its present state corresponds to other canvases we have seen. On its surface, the work is mainly composed of a series of vertical bands of blue, black, green, and pale gray with a horizontal band of dark gray running partially along the bottom. Short black horizontals in the blue band break the picture's rigid, nonrepresentational quality, indicating the panels and panes of the open left half of the window. Similarly, on the opposite side, the angled bottoms of the pale gray and continuous green bands describe the partially opened right half, while the dark gray below designates the shallow foreground. We can also see indications of more naturalistic elements just beneath the surface of the painting. For instance, there are sets of closely spaced black verticals on the left side of the blue and throughout the pale gray bands; confirmed by infrared reflectography [**29b**], these suggest the architecture of a threshold or the dense pleats of a curtain. Elsewhere in the blue, there are white arabesques that recall the design of a textile [**29d**].

As in his other works at this time, Matisse was exploring the process of adding and subtracting on the canvas. Aside from the black and white painted lines visible just below the surface, microscopic examination reveals evidence of color changes throughout the picture: at the bottom, the gray covers a terracotta-pink [**29e**], possibly a reference to a tiled floor, as in the 1911 picture that was initially repainted in blue. Varying tones of light and dark blue also lie under the pale gray and green bands on the right side. We can see that the artist worked to remove pigment, alternately carving deeply and incising lightly into the border between the black left edge and the blue band, and marking a shallow

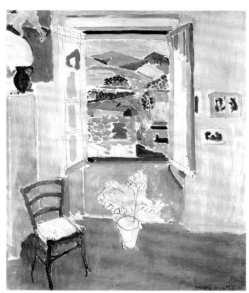

29a

29a
The Window, 1911. Oil on canvas; 73.5 × 60 cm (28 5/16 × 23 5/8 in.). Private collection.

29b

29c

29b
Detail of infrared reflectography of *French Window at Collioure*, showing closely spaced black verticals on the left side; note, too, the short horizontals within the blue and gray bands that represent frames of the window.

29c
The painting seen in raking light.

hatched pattern where the blue band meets the black center. Given Matisse's other ways of working in 1914—especially his incising to indicate shadow and illumination on the buildings in *Interior with Goldfish*, wholesale removal and reshaping of the face in *Portrait of Yvonne Landsberg*, and new work in monotypes [**22**]—his next step might very well have been to work into the black, pulling out some of the composition below. Indeed, examination with both raking light [**29c**] and X-radiography reveals a partial composition under the black: a decorative balcony railing and landscape beyond. (Unaided visual examination shows both blue and green paint within the black field.)[10] The black center, then, represents a step in the thwarted process of this picture's evolution; it remains a *rustine*, as Matisse called it, a patch or palliative before he made his next move.[11] In 1945 the artist explained his early use of black with different words: "Before, when I didn't know what color to put down, I put down black. Black is a force: I use it as a ballast to simplify the construction."[12] The black center of this painting, then, was on its way to becoming something else.

In February 1916, Amélie Matisse traveled back to Collioure to retrieve her family's abandoned belongings, including this canvas. We do not know if her husband saw the work again in Issy or Paris, but he did state that he never forgot any of his paintings.[13] The painting remained in his possession until his death, unfinished, unsigned, and not exhibited or published until fifty years after its arrival at Matisse's Paris studio. Perhaps it was too hard for the artist to return to the work, especially because of the time it represented, or perhaps he was ultimately satisfied enough with its appearance but not ready to show it, as he was other challenging paintings in 1916. What is certain, however, is that it represents an important step in his continuing work during the war, as well as his use of the color black as a sign of light—an approach that found its first full articulation in the late 1914–15 painting *Goldfish and Palette* [**31**].[14]

29d

29e

29d
Detail of the upper portion of the blue band on the left, highlighting vertical and horizontal blacks and curving white lines below the blue.

29e
Detail of the lower-left corner, revealing color below the present gray.

1. Matisse to Anna Matisse, Aug. 21, 1914, AHM; Spurling 2005, p. 157 n. 68.

2. The date of the Matisse family's arrival in Collioure is based on a letter from Juan Gris to Kahnweiler, Sept. 11, 1914, Archives Kahnweiler-Leiris, Paris: "Matisse arrived here yesterday"; Gris 1956, p. 9. See Matisse and Derain 2005 for a detailed chronology of Matisse's 1914 activities related to Collioure.

3. For information on the painting *The Window* and Matisse's time in Collioure in 1911, see ibid., pp. 23–24, 265, 285–87.

4. Pierre Schneider, "La transparence montrée," in Mousseigne 1978, pp. 52–53; Isabelle Monod-Fontaine, "Matisse *Porte-fenêtre à Collioure*," *Cahiers du Musée National d'Art Moderne* 13 (July 1984), pp. 18–25; and Lebovici and Peltier 1994, p. 31. Further discussion of the window as a theme in Matisse's oeuvre can be found in Jean Laude, "Autour de la *Porte-fenétre, à Collioure,* de Matisse," in Mousseigne 1978, pp. 55–73; Schneider

2002, pp. 453–56; and Isabelle Monod-Fontaine, "A Question of Windows," in Aagesen 2005, pp. 184–205.

5. This painting was first shown in the 1966 retrospective exhibition *Henri Matisse* at the University of California–Berkeley, Art Museum, where it engendered much discussion; see the introduction to this publication for more information on this moment in the reception of Matisse's 1914–17 works.

6. See Isabelle Monod-Fontaine, "A Black Light: Matisse (1914–1918)," in Turner and Benjamin 1995, p. 87; and Flam 1986, p. 394, who sees in it Matisse's "most daring evocation of a Mallarméan absence"; and Louis Aragon, *Henri Matisse: A Novel*, trans. Jean Stewart (Harcourt, Brace, Jovanovich, 1971), p. 303, who wrote, "Whether or not the painter intended it, and whatever that French window opens on to, it is still open. It was on to the war then, it's still on to the black future, the 'inhibited silence' of the future, the event to come, which will wreak havoc in the lives of men and women unseen in the darkness."

7. Gris to Kahnweiler, undated letter, Archives Kahnweiler-Leiris, Paris. It is assumed by scholars of Gris's work to be after Sept. 11, 1914; Gris 1956, p. 12.

8. Matisse to Amélie Matisse, Nov. 6, 1914, AHM; see also Claudine Grammont, "Chronologie," in Matisse and Derain 2005, p. 287.

9. This is based, in part, on a letter from Matisse to André Derain, Feb. 1916, Archives André Derain, in which he reported, "My wife is now in Collioure where she is moving us out of the house which we are leaving for good."

10. The X-radiographs of this painting were studied for this project, but not available for publication. There is also evidence of scraping marks visible in the X-radiograph, suggesting that Matisse had already reworked this area. For more on the X-radiograph, see Monod-Fontaine, Baldassari, and Laugier 1989, p. 41.

11. For a thoughtful argument on this matter, see Claudine Grammont's chronology in Matisse and Derain 2005, p. 287 n. 165.

12. Matisse 1946.

13. "Matisse's Radio Interviews" (1942); Flam 1995, p. 146.

14. Monod-Fontaine (n. 6).

30 Head, White and Rose

Quai Saint-Michel, Paris,
mid-November 1914–early 1915 (?)

Oil on canvas; 75 × 47 cm (29 1/2 × 18 1/2 in.)
Signed l.r.: *Henri/Matisse*
Musée National d'Art Moderne/Centre de Création Industrielle, Centre Pompidou, Paris,
purchase 1976, AM 1976-8

IN EXHIBITION

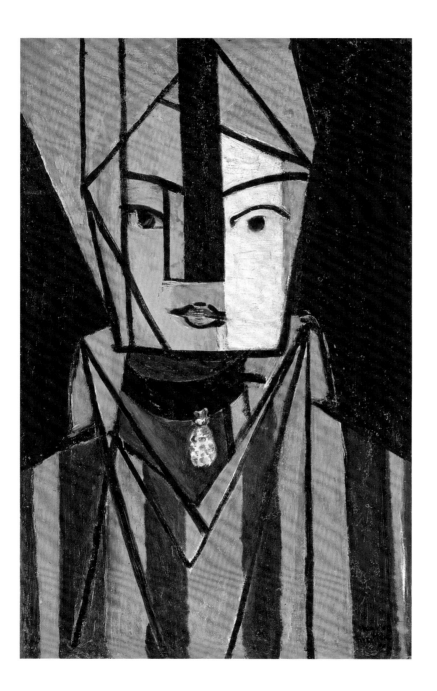

30a
The Rose Hat, 1914. Oil on canvas; 112 × 49 cm
(44 1/8 × 19 1/4 in.). Private collection.

30b
Marguerite with Striped Jacket, 1914. Oil on canvas;
123.6 × 68.4 cm (48 11/16 × 26 13/16 in.). Bridgestone
Museum of Art, Ishibaski Foundation, Japan.

30c
Marguerite with Leather Hat, 1914. Oil on canvas;
97 × 43 cm (38 3/16 × 16 15/16 in.). Private collection.

30d
Marguerite in a Leather Hat, 1914. Oil on canvas;
82 × 65 cm (32 5/16 × 25 9/16 in.). Musée Matisse,
Le Cateau-Cambrésis, gift of Marie Matisse.

30e
Head of Marguerite, 1915. Bronze, cast c. 1952;
31.6 × 11.4 × 14.0 cm (2 7/16 × 4 1/2 × 5 1/2 in.).
The Minneapolis Institute of Arts, gift of the
Dayton-Hudson Corporation, 71.9.2.

"ONE CAN IMAGINE," Daniel-Henry Kahn-weiler wrote, "the sort of discussions that occurred between Gris and Matisse, both of them men inclined to think a great deal about their art, and to talk of it."[1] On the subject of their time together in the fall of 1914, the legendary promoter of Cubism, who was also Juan Gris's dealer, reported:

Both, I am sure, must have benefited by these conversations. It may seem surprising to suggest that Matisse, who was so much older, was somehow influenced by Gris; but if one looks with an unprejudiced eye at the large canvases which Matisse began at Collioure, while he was with Gris, or at those which he painted immediately afterwards, one cannot, I think, fail to notice a certain quality—especially in the structure—which does not appear in his painting either before or after. One might almost call it a new vision [poétique]; and I am convinced that this new vision was the fruit of his conversations with Gris.

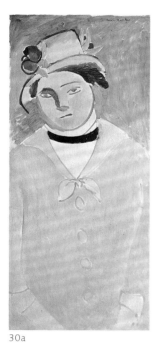 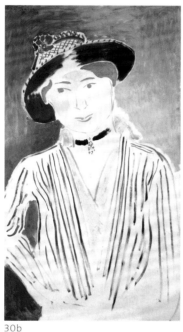 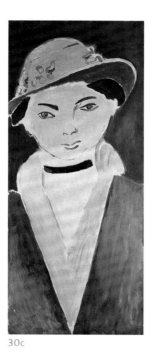

30a 30b 30c

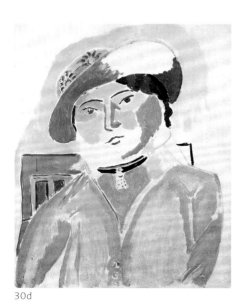 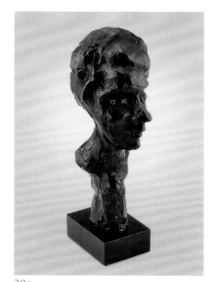

30d 30e

Head, White and Rose [**30**] is perhaps the work by Matisse that is most commonly seen to illustrate his relationship to Cubism—and to Gris.[2] Indeed, the painting's vertical format, abstracted subject, architectonic arrangement of straight lines and angled shapes—and especially its banded composition—suggest a system of divisions and relations inspired by the Spanish artist, who was living in Collioure when Matisse arrived in mid-September, during the early months of the war. However, while their works share certain compositional elements, the artists depended on these for disparate reasons.[3] For Gris, the grid was a way to dissect and examine a subject from different angles, which he could then reassemble into a new, Cubist whole through the use of a vertically banded surface [**25a**; p. 225, fig. 3; **30i**]. For Matisse, in contrast, this particular method paralleled his attempts to simplify and consolidate as a means of describing a specific type of subject. In other words, whereas Gris came with these means to the object, Matisse came to these means from the object. In *Head, White and Rose*, it is likely this difference that accounts for the comparatively informal sense of partitioning and slight asymmetry, which nonetheless follows its own inner logic. Indeed, while this painting may evince "a bit of boldness, found in a friend's picture," as Matisse himself later described his relationship to Cubism, we can best appreciate it not through Gris, but through the context of the artist's Paris studio.[4]

During 1914 Matisse produced at least five representations of his daughter, Marguerite, who served as his occasional model and studio assistant, and was an aspiring artist in her own right.[5] He made what may be the first of these, *The Rose Hat* [**30a**], in early spring, around the time he was working on his commissioned portrait drawing of Yvonne Landsberg [**28a**], and completed it by March.[6] This work, along with *Marguerite with Striped Jacket* [**30b**] and *Marguerite with Leather Hat* [**30c**], both of which probably followed soon after, are

30g

30h

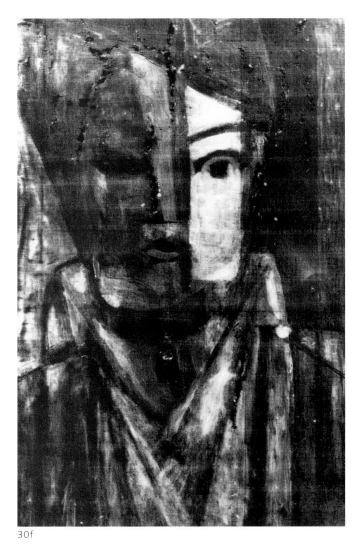

30f

30i

30f
X-radiograph of *Head, White and Rose*, illustrating the original round features, soft hairline, and folds in the jacket.

30g
Detail showing the original ocher color of the face and Matisse's use of incising to emphasize the forms of the nose, lips, and chin.

30h
Detail of the lower right, showing pink under blue bands and light blue below the pink in the jacket.

30i
Juan Gris (Spanish, 1887–1927). *Portrait of Pablo Picasso*, January–February 1912. Oil on canvas; 93.3 × 74.4 cm (36³/₄ × 29⁵/₁₆ in.). The Art Institute of Chicago, gift of Leigh B. Block, 1958.525.

relatively naturalistic representations of this fashionably dressed young woman in the same pose but from different distances.[7] All share the same soft, limpid quality of his first version of *View of Notre Dame* [**23d**], making them consistent with one part of Matisse's artistic experiments that spring. Although their dimensions vary, the paintings are tall and thin; like a number of the artist's etchings at this time (22v), they seem designed to emphasize the verticality of the subject's body.

Matisse also made *Marguerite in a Leather Hat* [**30d**], a version of the earlier work in a different, wider format. While he described his daughter in the same delicate pastel tones and loose brushwork as before, he also made her appear more angular and flat; presenting her against the rectilinear back of a chair, he pushed her closer to the surface of the picture, further flattening her form. He balanced her face with two large areas of reserve and described her features in minimal detail. As in *The Rose Hat*, the artist treated the two sides of Marguerite's face differently, perhaps in order to suggest the effect of light: on the left, her features are minimally rendered, dissolved in an overall shadowy tan color; on the right, the sclera of her eye is painted white, her nose is heavily outlined, and the side of her face is defined by an angled cheekbone. These details parallel the small *Head of Marguerite* [**30e**], which Matisse made around the same time.[8] It is a unique example of his sculpture during this period, representing the only new subject he introduced in that medium; it also recalls his comments about how he had worked with sculpture earlier to clarify his ideas. Given the similarly angled, flattened edge of the nose and asymmetrical face, it is likely that Matisse made the work in close succession to the canvas, perhaps around the time that he was painting the portrait of Yvonne Landsberg. He may also have done so upon his return in the fall, as he prepared to make a new portrait of his daughter. Indeed, distracted by the events around him, the artist may have returned briefly to this earlier practice as he attempted to begin the canvas and push it forward.

Standing apart from this series in its size and style is *Head, White and Rose*, which the artist likely initiated after his family returned to Paris in November, and therefore unlike most of the other works, made after the start of the war.[9] Despite his intense conversations with Gris in Collioure and his work on *French Window at Collioure* [**29**], which he left there unfinished, it is important to recognize that this canvas began as a naturalist image. Indeed, examination of the X-radiograph confirms that Matisse initially painted his daughter with a round chin, jawline, and cheeks; fleshy lips and nose; and a soft hairline, as well as detailing the shadowed folds of her jacket [**30f**].[10] A close look at the paint layers also

reveals that he originally made her face an ocher color [**30g**] and placed her against a green background, possibly even the same chair depicted in *Marguerite in a Leather Hat*.

Soon after commencing the painting, however, Matisse decided to pursue a different path. According to Marguerite herself, her father asked during a working session, "This painting wants to take me somewhere else. Do you feel up to it?"[11] We can chart how the artist transformed the portrait through X-radiographic and microscopic study. First, he likely scraped down dried paint on the contours of the figure's shoulders and collar.[12] Evidence of this scraping can be found in the X-radiograph, where it is visible in the short horizontal marks above the shoulders. Microscopic investigation reveals how Matisse then revised the rounded image of his daughter into one that was more hieratic and geometric. As in *Marguerite in a Leather Hat*, he eliminated extraneous detail by reducing broad areas of his daughter's visage into geometric equivalents, painting these areas light blue. He revised her torso by dividing it into three vertical sections and then painting the two flanking ones the same light blue as the face, while treating the center with equal vertical bands of pink and white, and pink. These intermediary colors can still be seen below the blue and pink colors of the completed painting [**30h**].

Matisse further divided these larger shapes by painting bands of pink and white on the face, suggesting effects of light like those in *Marguerite in a Leather Hat*; he also divided the jacket into pink and blue verticals representing either pleats or stripes.[13] He then scratched along the edges of some of the bands, further defining the lower-left part of the chin as well as the end of the nose [**30g**], creating an equivalent to the flattened edge of the nose on the sculpture. As a final step, the artist used thick black paint to add a network of straight lines and triangulated forms that derive from the original shapes below. To assess the degree of Gris's influence, we must look at the vertical bands, which do not run continuously down the canvas and are not aligned, as they would be in one of his more systematic Cubist compositions. A few lines are parallel, but not obviously so. In addition, Matisse incorporated vestiges of the former, more naturalistic picture—for example, Marguerite's lips, and the pendant on her choker—into this geometricized image. Together, these changes show how he personalized the visual vocabulary of Cubism to meet his own ends and began to forge a new method of pictorial construction at a moment of utter destruction in wartime Paris.

1. Kahnweiler, *Juan Gris: His Life and Work*, trans. Douglas Cooper (Curt Valentin, 1947), p. 11.

2. See, for example, Cooper 1970, p. 206, pl. 234.

3. For more on this, see Golding 1978, p. 15; Elderfield 1984, p. 65; and Isabelle Monod-Fontaine, "Marguerite, Her Father's Model," in Rainbird et al. 2008, pp. 77–78.

4. Tériade 1952, p. 50.

5. Matisse also made a number of monotypes of Marguerite working in the studio; see Duthuit-Matisse and Duthuit 1983, pp. 345–47.

6. Dauberville and Dauberville 1995, vol. 1, p. 536, listed as *Le chapeau de roses,* photograph no. 482, stock no. 20280. *The Rose Hat* was purchased by Bernheim-Jeune on May 8, 1914, and sold to the Montross Gallery on Mar. 4, 1915; this painting was later acquired by the American collector John Quinn.

7. As Pierre Schneider noted, Matisse was "bound to take some interest in fashion" given his wife's earlier career as a milliner and his own background in the textile community of Le Cateau-Cambrésis. In Schneider 2002, p. 520 n. 6, he wrote: "During the First World War Matisse painted his daughter in a series of hats designed by Jeanne, a fashionable milliner in the rue Royale." It is likely, given the economic strain of the war, that the artist purchased these hats before it began. For more on Matisse's relationship to textiles in particular, see Spurling and Dumas 2004. It is noteworthy that the hats worn by Marguerite are also worn by Loulou Brouty and Yvonne Landsberg in a number of contemporaneous prints; see Duthuit-Matisse and Duthuit 1983, pp. 32, 49–56, and possibly 71–72.

8. *Head of Marguerite* (D58) is dated to 1915 but may have been initiated in fall 1914. For further information on the sculpture, see Barr 1951, pp. 213, 217, 401 (ill.); Legg 1972, p. 32; and Mezzatesta 1984, pp. 100–01.

9. A charcoal drawing of Marguerite called *Study for the Leather Hat* (assigned to 1915; private collection) was also made in a geometric style; see Pompidou 1993, p. 115.

10. The painting was transferred to a new canvas and the adhesive used was lead white, which adds a confusing layer to the X-radiograph. For more on the X-radiograph, see Charles de Couëssin, "Le dessin incise d'Henri Matisse," in Verougstraete-Marcq and Van Schoute 1987, p. 76, pl. 52; and Monod-Fontaine, Baldassari, and Laugier 1989, pp. 47–49.

11. Marguerite Duthuit, interview by Jack Flam, Nov. 26, 1979; Flam 1986, p. 403 n. 48.

12. Although there is also evidence that Matisse wiped down some of the still-soft ocher paint in the face, he may have done this earlier in the painting's development; the layers were dry before he began to transform the portrait.

13. In addition to an important survey of this painting in Monod-Fontaine, Baldassari, and Laugier 1989, pp. 46–49, see Klein 2001, pp. 100–01.

31 **Goldfish and Palette**
Quai Saint-Michel, Paris, late November 1914–spring 1915

Oil on canvas; 146.5 × 112.4 cm (57 3/4 × 44 1/4 in.)
Signed l.r.: *Henri-Matisse*
The Museum of Modern Art, New York,
gift and bequest of Florene M. Schoenborn and Samuel A. Marx, 1964

IN EXHIBITION

Goldfish and Palette
Quai Saint-Michel, Paris, late November 1914–spring 1915

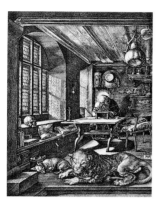

31a

31b

31c

31a–b
Matisse's late 1914 postcard to Charles Camoin, showing on the recto a reproduction of Albrecht Dürer's *Saint Jerome in His Study*, 1514, and, on the reverse, Matisse's sketch for *Goldfish and Palette*. Archives Camoin, Paris.

31c
Interior with Goldfish, 1915. Ink on paper; 31 × 25.4 cm (12 1/4 × 10 in.). Staatliche Graphische Sammlung, Munich.

MATISSE RETURNED FROM Collioure after October 22, 1914, almost two months after the army had requisitioned his property at Issy and German shells had fallen around his studio at the quai Saint-Michel.[1] The American critic Walter Pach, just arrived in Paris despite the war, noticed that Matisse had found himself unable to return to painting but was making a lot of etchings.[2] When he did pick up the brush again, after his family returned from the south in November, it was to revisit two long-standing themes through another portrait of his daughter, Marguerite [**30**]—and another interior with goldfish. The latter was specifically intended as a reprise of his *Interior with Goldfish* [**24**], painted early in 1914. As he explained to Charles Camoin, likely in early December, "I've done a picture. It's my Goldfish picture, which I am redoing with a figure holding a palette and studying (harmony brown-red)."[3] He penned these words on the reverse of a postcard reproducing Albrecht Dürer's *Saint Jerome in His Study*, which includes tall windows with a band of shadow between them [**31a**].[4] Matisse did not detail the setting in the sketch of the goldfish composition that he drew on the postcard [**31b**]. However, he would remember the light-and-dark pattern of Dürer's windows as he brought his painting to conclusion. Given the artist's extensive reworking of the canvas, that must have been sometime the following year. Indeed, it was not until May 22 that Bernheim-Jeune wrote to confirm that it wanted to buy a picture called *Goldfish, Harmony in Blue, Black, and White*. The firm purchased it three days later, selling it immediately to Léonce Rosenberg.[5] As the title suggests, the work's earlier brown-red harmony had been changed.

The subject is a close-up view of the still-life motif at the center of *Interior with Goldfish*, showing the same table with the same bowl and plant; however, the number and arrangement of the objects is somewhat different. The new configuration of the painted still life appears in a naturalistic sketch of the table before the window [**31c**], dated 1915 and therefore drawn after the painting was begun, although it takes the viewpoint of the preceding painting and shows features that had appeared there: the table and window frame tipping down to the right, objects on the wall, and people on the street outside. The buildings across the Seine are a flattened frieze but, even so, hardly anticipate the extremely emphatic frontality of the new painting, from which they would, in fact, be eliminated.[6]

Most critical to this frontality is the wide, vertical black band at the midpoint of the composition. This is the central mullion of the window in *Interior with Goldfish*, broadened and lengthened almost beyond recognition; it is perhaps a reworking of the black panel that runs down the middle of the recent *French Window at Collioure* [**29**]. Deliberation tells us that we look down on the still life, and, therefore, what appears at first to be the lower half of the mullion must in fact be its shadow, cast straight down on the scuffed-up white floor. But, even knowing that, our eyes tell us that the entire band stands upright, a vertical plank in front of the grillwork with the window beyond.

Daniel-Henry Kahnweiler observed that Matisse brought back from Collioure the influence of Juan Gris, with whom he had debated there at length on the subject of painting.[7] The prominence of the vertical plane in *Goldfish and Palette* is reminiscent of certain 1912 paintings by Gris—for example, *Man in a Café* (1912; Philadelphia Museum of Art)—but also of dark planes in 1913–14 paintings by Picasso such as *Card Player* (The Museum of Modern Art, New York). Matisse had become interested in Cubist planarity and would remain so through the completion of the multiplanar *Bathers by a River* [**54**]. In the case of *Goldfish and Palette*, the ambiguity of a plane that may be read as both a horizontal and a vertical is part of a structure where, in Clement Greenberg's words, "Almost every plane is ambiguous and can be seen as on the surface or behind it: thus the transparent wedge of the tabletop lets the background come forward to the actual surface, yet its blue also insists on retreating—in part because it is such a cool, out-of-doors color."[8] Matisse did not learn of this ambiguity from Cubism; much earlier, he had seen it in, and adopted it from, the work of Cézanne. But now his experience of many Cubist variants prompted him to return to it in a more radical form than before.

He did not do so, however, as a Cubist follower. Matisse engaged the ambiguities of Cubism to gain new access to the complexities of perceptual experience. But the Cubists' largest concern was with objects and their relationships to the spaces in which they were located; therefore, as Matisse said, Cubism was "a kind of descriptive realism."[9] In contrast, he was mainly interested in the feelings invoked by persons, places, or things: "To copy the objects in a still life is nothing," he said to Sarah Stein in 1908.[10] "One must render the emotion they awaken in him." With places in particular, and especially in this 1913–17 period, Matisse equated emotion with light and rendered it by using a specific kind of illumination to awaken the appearance of a scene. In particular, his favored effect was of light entering and transforming a darkened interior.

But the version of it in this painting is starker than in its predecessor. This work is unique in the series in that it combines the austere, unadorned contrast of light and dark with many indications of the stages of thought that the artist went through as he constructed

31d

31d
Still Life with with Goldfish (V), 1914–15. Monotype on chine collé; image: 17.5 × 12.5 cm (6⁷/₈ × 4¹⁵/₁₆ in.); sheet: 37.5 × 28 cm (14³/₄ × 11 in.). The Art Institute of Chicago, Mr. and Mrs. Robert O. Delaney Endowment Fund. In exhibition.

31e
X-radiograph of *Goldfish and Palette*, showing multiple compositional changes.

31e

31f

31g

31f
Detail of the leaves of the plant in front of the bowl, shown as refracted through the water.

31g
Detail of the geometric zone at top right, showing extensive scraping and repainting.

31h
Detail of the rectangular palette, showing the hand and arm holding it and the knees beneath.

31h

the final composition. For example, cantilevering out toward us is a tabletop that resembles the raised leaf of a gate-leg table. A close inspection of the painting reveals that the tabletop was originally a very dark, almost brownish purple. Judging by both *Interior with Goldfish* and *The Studio, quai Saint-Michel* [**51**], the table may well have been gray or white. Here Matisse must have begun by conceiving of a brownish wood table for the bowl of very bright red goldfish, to produce the "harmony brown-red" of which he wrote to Camoin. It was originally narrower at the right and extended lower, level with the top of the first of the three C shapes at the left that represent grillwork. Immediately beneath it, rectangular panels of a similar tonality, one at the right still outlined by scratches, appear to record changes in the positions of the legs. Some of these panels are underpainted in blue, which also suggests that Matisse had probably begun with a more naturalistic, narrow mullion dividing the window. It is, in fact, quite likely that he originally conceived of showing the left frame of the window; the blues at the left barely conceal two narrow verticals that had reached down to the area that is now white, and there are salmon pinks around them that recall the color of the buildings in late afternoon light seen in *Interior with Goldfish*. The two brighter table legs at left, glowing with violet and touches of pink, may have originally recorded light entering the room from that side, pushing back into darkness the legs at right, which are overpainted with black and almost invisible. Now they record instead the manual labor of painting, as Matisse scraped and scratched down their length, in part when the paint was still wet, leaving untouched the joint where the stretcher attached to the forward leg.

The goldfish bowl seems originally to have been much smaller, extending in width from the middle of the top fish to outside the right contour of the orange; the upper edge was below what is now the near waterline. Matisse changed the vessel several times before settling on the final dimensions, after which he scratched it back at the right and articulated the volume with incised hatching at the base, very possibly employing the same tools that he used to make monotypes of the motif [**31d**].

The growing luxuriance of the plant across the sequence of monotypes strongly suggests that the artist made them over an extended period, and the placement of the plant and a single piece of fruit on the right tells us that they were at the left as Matisse drew them, the reversal happening in the printing process. This is their position in *Goldfish and Palette* but not in *Interior with Goldfish*, suggesting that they accompanied the creation of the former work and, therefore, may either detail some of the ways that Matisse reconsidered

the subject as he worked on the painting; or they may also represent his need to retain contact with reality as his painting became increasingly abstract.[11] In either case, they cannot be considered studies, but independent works, each done in a single session. As Matisse well knew, going over the same subject time and again enables self-criticism and embeds tacit knowledge. In this case, the process may have facilitated invention in the far more slowly developed painting; it could also have allowed him to follow changes in the appearance of the still life as it became frozen in place in a particularly condensed and synthetic work.

On the left side, enlarging the bowl caused the small earthenware pot to tuck behind it, with the three leaves that had originally touched the bowl's side now appearing nicely refracted through its water. (To gain that effect, the artist overlapped them slightly with the scumbled white paint that describes the water [**31f**].) To the left, the leaves tumble, becoming confused with the grillwork, and on their way down provide shade for the single, very solid orange, which Matisse constructed with zones of yellow, orange, and ocher paint, all of it wiped, scumbled, and scratched. The goldfish themselves are two pieces of bright crimson coddling in their milky liquid. The brightness of this zone draws our attention, reminding us that Matisse told Camoin about an attentive presence within the painting itself, "a figure holding a palette in his hand and studying." He must be at the right.

The right side of the picture, however, is a puzzle. We can see that the artist lowered the top edge of the white floor and moved the grillwork to the right, pushing and compressing the hard-to-decipher zone to its right against the edge of the painting. The postcard sketch reveals that we are being shown a rectangular palette [**31h**] with the thumb showing through, and what appear to be arms rising diagonally toward it. We may, therefore, infer that the forms beneath the palette are derived from the bent legs of a figure seated partially outside the painting. Above, a heavily reworked—indeed, massively attacked—area is divided into a set of angular planes and diagonal lines [**31g**] in a manner reminiscent of *Head, White and Rose* [**30**], and it is possible to discover a bent head within the pentimenti revealed by infrared examination. However, comparison with the similar window view of *The Studio, quai Saint-Michel* [**51**] suggests that these geometric divisions may also refer to the rooftop patterns beneath Sainte Chapelle.

It not unreasonable to discover specific Cubist antecedents for this area in the work of Gris, Jean Metzinger, Gino Severini, and even Raymond Duchamp-Villon.[12] There is a

quality of free invention here, as if Matisse, after focusing his simplifying attention on the still life, allowed himself to move away from the identity of his subject in this area, treating it as if it were seen in peripheral vision and allowing us to do the same.[13] Matisse himself neither affirmed nor denied Cubism's effect on this particular work, but he did speak of this painting's influence on Picasso's Cubism, notably his *Harlequin* of 1915, which Rosenberg acquired in November of that year. Writing to Picasso on the twenty-fifth of the month, the dealer reported: "After having seen and re-seen your picture, [Matisse] honestly recognized that it was superior to everything you've done and that it was the work that he preferred to all those you've created."[14] He then added that Matisse concluded his praises by expressing "the feeling that 'his goldfish' led you to the harlequin." But then Rosenberg concluded: "To sum up, although surprised, he couldn't hide that your picture was very beautiful and that he was obliged to admire it. My feeling is that this work is going to influence his next picture." His feeling was basically right, although it would be a little later, in such 1916 compositions as *The Moroccans* and, especially, *Bathers by a River* that the influence would make itself felt.

1. The biographical material in this paragraph derives from Spurling 2005, pp. 156–59, 167–69.

2. Barr 1951, p. 179; Cauman 1991, pp. 3–4; Spurling 2005, pp. 163–64.

3. Matisse to Camoin, Dec. 1914, Archives Camoin.

4. Matisse to Camoin (n. 3). The date of this critical postcard is uncertain; see Giraudy 1971, p. 19; Elderfield 1978, pp. 100, 205–06; and Grammont 1997, pp. 65–66. Given its contents, it was likely one of the two postcards that Camoin mentioned in his letter to Matisse of Dec. 10, 1914, AHM.

5. Dauberville and Dauberville 1995, vol. 1, pp. 542–43, cat. 148. Since the size of this painting fell outside Matisse's contract with Bernheim-Jeune, as noted in the firm's May 22 letter, he was not obliged to sell it. Whether he knew of Rosenberg's interest in the painting is uncertain; we only know that in Oct. Rosenberg wrote twice to Matisse of his admiration for the painting (undated [Oct.], AHM; Oct. 17, 1915, AHM).

6. While nothing remained on the wall in the completed *Interior with Goldfish*, it originally showed a painting on the wall to the left.

7. Daniel-Henry Kahnweiler, *Juan Gris: His Life and Work*, trans. Douglas Cooper (Curt Valentin, 1947), p. 11. See p. 235 n. 7 in this publication.

8. Greenberg 1953, pl. 13.

9. Tériade 1952, p. 50.

10. "Sarah Stein's Notes" (1908); Flam 1995, p. 51.

11. It is possible, of course, that the monotypes were not done during the creation of this painting or all in the same period. Two of them (22p–q) are tighter and more simplified than the others, and they seem to represent a smaller plant; certainly the first does. In contrast, the remaining four works (22r–u) are more freely treated and show fuller plants.

12. Elderfield 1978, pp. 100, 102; Flam 1986, p. 402.

13. Cowling 2002, p. 133. Greenberg spoke of "free invention" in this area, compared to the "simplification and compression" of the rest of the work (see n. 8).

14. Rosenberg to Picasso, Nov. 25, 1915, Archives Picasso, Musée Picasso, Paris.

32.1 **Cocoly Agelasto**
Quai Saint-Michel, Paris,
late November or December 1914

Charcoal on paper; 35 × 25.4 cm (13 3/4 × 10 in.)
Signed l.r.: *Henri-Matisse*
The Morgan Library and Museum, New York,
Thaw Collection, EVT 113

IN EXHIBITION (CHICAGO)

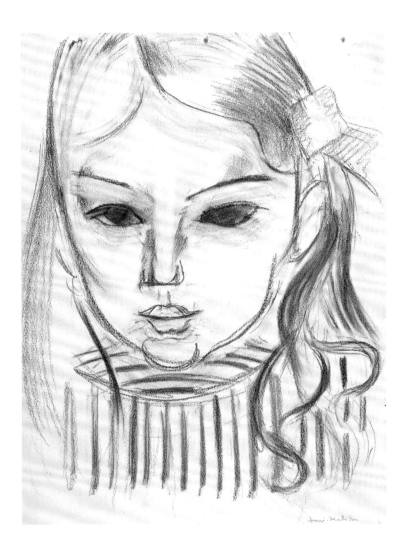

32.2 Madame Matisse

Quai Saint-Michel, Paris
August–October 1915

Graphite on paper; 62.8 × 48.1 cm (24³/₄ × 18⁷/₈ in.)
Signed l.l.: *H. Matisse*
Musée Matisse, Nice, 63.2.48

IN EXHIBITION

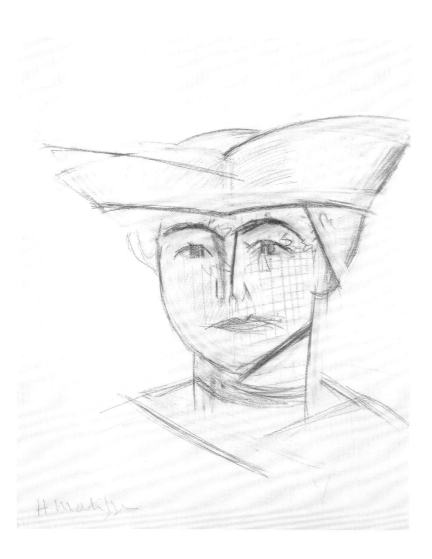

ONE OF THE major changes in Matisse's art at the beginning of World War I was the transformation of his drawings. This occurred from late 1914, when he returned from Collioure to face the daily realities of wartime Paris, through late 1916 or early 1917, when signs of retreat from the experimental began to show themselves in his larger practice. Of course, what occurred in drawing was part of a larger phenomenon that also affected his painting. Nonetheless, for the artist, drawing always had an independent as well as a supportive function; sometimes, in fact, it led the way for his canvases. Throughout this period, Matisse occasionally made study drawings in preparation for his paintings, but he also undertook major independent drawings of unprecedented ambition—some treating the same subjects as his paintings, some not. "Drawing, after all, is concentrated painting," he would say later.[1] It became that, and it grew in concentration, over this three-year period.

Matisse did not date the majority of his independent drawings, and most of the well-known ones have at different times been exhibited or published with all three possible years of their production. There is, however, a reasonably clear stylistic progression across the period. Indeed, while it has long been customary to describe these as Cubist drawings, the earliest have little to do with Cubism, and while the later do bear comparison with drawings by Cubists, that comparison reveals significant differences as well as similarities. Moreover, the grandest of these sheets are portraits, notably of women, and their subjects vary considerably in both appearance and psychological affect. As a group, they are grander, more serious portraits of female sitters than any Matisse had made previously. We know that during the war Henri and Amélie Matisse concerned themselves with the care of women and children whose husbands were away.[2] It is impossible to decide which is the more influential: that the artist became more conscious of the strength of personality of women during the wartime period, or that it was the greater toughness of his drawing that made them appear so strong.[3]

One of the earliest drawings that Matisse made upon his return from Collioure in late 1914 is extremely strong, but it represents a child, Cocoly Agelasto [**32.1**]. This work must date from the same moment as *Head, White and Rose* [**30**], for it resembles that painting as it was originally laid in, with a rounded jaw and cheeks, fleshy lips and nose, and a soft hairline [**30f**].[4] But the drawing is not soft: the claustrophobically muffled girl looms forward, more than filling the sheet. Her hair tumbles in curls that echo the rubbed-back strands beneath the hairline and around the eyes, snaking down to entwine with her strange striped garment. Within all this distraction,

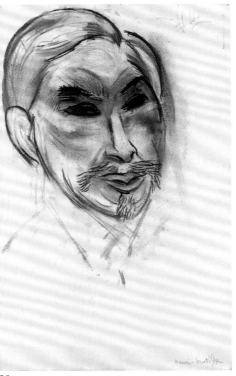

32a

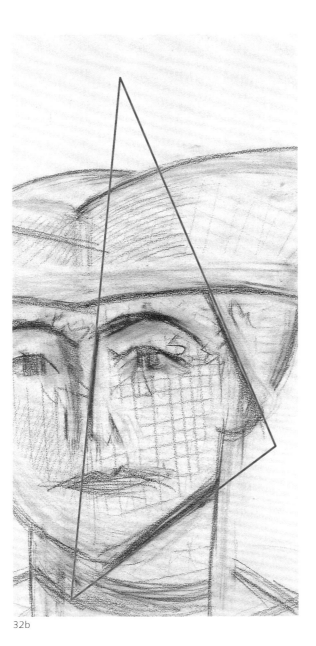

32b

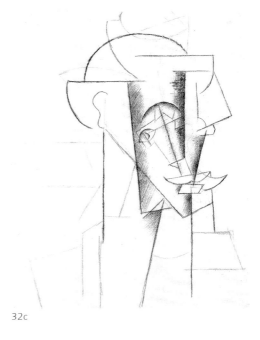

32c

32a
Portrait of Sergei I. Shchukin, 1912. Charcoal on paper; 49.5 × 30.5 cm (19 1/2 × 12 in.). The Metropolitan Museum of Art, New York, The Pierre and Maria-Gaetana Matisse Collection.

32b
Detail of *Madame Matisse* with a diagram showing how Matisse framed the right side of the face with diagonals of the nose, chin, and hairline to form a triangular plane.

32c
Pablo Picasso (Spanish, 1881–1973). *Head of a Man*, summer 1912. Charcoal on paper; 62 × 48 cm (24 3/8 × 18 7/8 in.). Private collection.

the face is elusive: severe in both the flattened, blackened eyes and the nose, which was straightened by erasing; and softer in its overlapping contours, plump lips, and oval chin.[5] Stylistically, the drawing recalls the 1912 portrait of Sergei Shchukin [**32a**], which is to say that there is nothing about it that requires the experience of Cubism. Neither, therefore, is there anything of the harshness and impersonality of *Head, White and Rose*. That picture, the artist remarked, wanted to take him "somewhere else" (p. 239). This drawing, by contrast, did not.

Describing Matisse's attitude toward Cubism, his friend Walter Pach reported that what he feared "was the submerging of every sensuous quality in the rising tide of intellectualism."[6] In the summer of 1915, he exorcized his fears by making the programmatic painting *Still Life after Jan Davidsz. de Heem's "La desserte"* [**35**]. At that very time, he did the same in a drawn portrait of his wife [**32.2**].[7] In both works, he did not entirely transform naturalistic representation, but dissected and embedded it within the severity of a Cubist structure. What is unique about *Madame Matisse*, however, is that, on close inspection, it offers us a unique opportunity to follow in detail how it was created, and to discover how Matisse first addressed Cubism in his drawing practice.

The artist began by making a summary sketch of his wife's chiseled features, the same strongly marked eyebrows, narrow nose, and pursed lips that appear in the great painted portrait of 1913 (p. 148, fig. 9).[8] Then, possibly working without the model, he erased a vertical channel down the nose, as he had done in the Agelasto drawing. This time, however, he added a light guideline that runs from the cleft at the top of the hat to the point of the chin, dividing the portrait into two halves, the left one "primitive" and the right cubistic. On the left of the face, for example, we can see how he ruled a series of parallel verticals, while drawing a rough grid on the right.[9] On the left side of the hat, he erased a falling arc and replaced it with a diagonal that slopes inward; on the right, he eliminated a rising arc, substituting it with one that ascends even higher. He also changed the base of the hat into two very shallow curves that, meeting at the central guideline, appear to be a single dipping-and-rising contour. The left side, however, is actually straighter than the right, echoing the long diagonal above it. This treatment causes the hat shape to rush in from the left and then billow upward and outward to cross the right edge of the drawing.

Matisse also appears to have propelled the face to the right, transforming it from the impassive, masklike left, which recalls the 1913 portrait, to a dissonant area hemmed in by the three bold diagonals of the nose, jaw-

line, and hairline, and pushed toward the triangular shape representing the hair. He repeated this latter feature conspicuously in the neck below, alerting us to how those three main diagonals mark the edges of a transparent triangular plane overlaid on the head, tipping back from the center of the face to beneath the right ear [**32b**].

The drawing is an extraordinary invention: an image of the face as a face divided; a construct of the mind about a mind divided. In it, Matisse combined the convexity of the mask-like "primitivism" of the 1913 portrait with a planarity that testifies to his experience of the high Analytical Cubism of Braque and Picasso [**32c**]. As he worked this sheet, the artist must have been thinking about cubist planes, of which Braque said later, "And, to avoid a recession toward the infinite, I superimpose planes, separating each of them by a slight distance. To make it understood that things stand one in front of the other, instead of being spread around in space."[10] Indeed, it appears that Matisse tried out something like this, imagining how the right side of the face might seem if he constructed it from superimposed planes. We can recognize from *Madame Matisse*—as well as from Picasso's and Braque's drawings of 1911 and 1912—part of what Matisse meant when he said that Cubism was "a kind of descriptive realism," and that "the Cubists forced on the spectator's imagination a rigorously defined space between each object."[11]

And yet the artist found himself fascinated less by overlapping planes than by the way that a line can appear to change in spatial position along its length while remaining in the same plane. Matisse knew that his viewers' experience of the human form would open the necessary space, imaginatively, which is what he meant when he remarked that "the Cubists' investigation of the plane depended upon reality, whereas in a lyric painter, it depends upon the imagination."[12] Late in the creation of this work, he effectively cancelled his Cubist experiment, stemming its rationality by adding the unnerving sparks of matter that fly around the nose and the eyes in a miniature electric storm of emotion. His subsequent drawings would continue to be broadly informed by Cubism, but never again so programmatically.

1. Gotthard Jedlicka, "Begegnung mit Matisse," in *Begegnungen: Künstlernovellen* (B. Schwabe, 1933), p. 118.

2. Schneider 2002, p. 735. See also pp. 226 and 250–53 in this publication.

3. Bock 1990, p. 48.

4. Matisse 1954, pp. 30, 149, listed this drawing as made in 1915, and it was dated to 1916–17 in Duthuit 1997, p. 173, cat. 53. The drawing was photographed by Berhneim-Jeune in Oct. 1916; see Dauberville and Dauberville 1995, vol. 1, p. 580, cat. 176. However, Flam's juxtaposition with *Head, White and Rose* argues eloquently for a late 1914 date. See Flam 1986, pp. 400–01; and for general comments on Matisse's "Cubist"

drawings, see Victor Carlson, "Some Cubist Drawings by Matisse," *Arts Magazine* 45 (Mar. 1971), pp. 37–39; and Elderfield 1984, pp. 64–73.

5. The vertical erasure reinforces the relationship of this work to *Head, White and Rose*. However, this is accompanied by diagonal erasures across each eye, possibly suggesting that they were all intended to represent light cast across the face.

6. Pach 1938, p. 146.

7. The artist made *Madame Matisse* in summer 1915 according to records of the Musée Matisse, Nice, to which Amélie bequeathed it; Carlson 1971, cat. 30, pp. 80–81. It cannot be accidental that the works that Matisse felt wanted to take him into Cubist dissection—these two, plus *Head, White and Rose*—were those whose subjects had an especially strong emotional attachment for him: his wife, his daughter, and the opulent art of the past.

8. A. N. Izerghina reproduced this drawing in the catalogue entry for *Portrait of Madame Matisse*, inviting a visual comparison of the two works; see Izerghina 1978, pp. 180–81. It is also worth noting this drawing's striking resemblance to a photograph of Amélie with Matisse and his mother, taken in Feb. 1913 on their return from Morocco, AHM.

9. The grid has usually been taken as a specifically Cubist device; however, it may well have been motivated by a veil attached to the hat.

10. Jacques Lassaigne, "Entretien avec Braque," in Gilbert Martin-Méry, Jacques Lassaigne, and Bernadette Contensou, *Les cubistes*, exh. cat. (Galerie des Beaux-Arts, Bordeaux/Musée d'Art Moderne de la Ville de Paris, 1973), pp. xvi–xvii.

11. Tériade 1952, p. 50.

12. Ibid.

33 **For the Civil Prisoners of Bohain-en-Vermandois**
Quai Saint-Michel, Paris, December 1914–October 1915

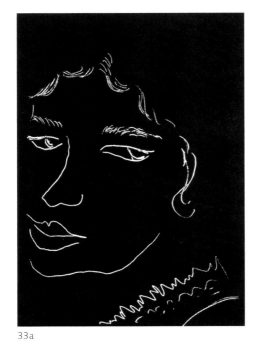

33a

33c

33d

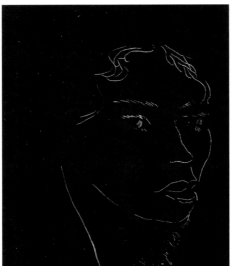

33b

33e 33f

33a
Emma from Three Quarters (II), winter 1915.
Monotype on chine collé; plate: 17.9 × 12.6 cm
(7 1/16 × 4 15/16 in.); sheet: 37.5 × 27 cm
(14 5/8 × 10 5/8 in.). Bibliothèque Nationale de
France, Paris.

33b
Emma's Face Turned to Left (I), 1915. Monotype on
chine collé; plate: 19.7 × 14.7 cm (7 3/4 × 5 3/4 in.);
sheet: 37.3 × 27 cm (14 5/8 × 10 5/8 in.).
Private collection.

33c
Portrait of Bourgeat, Resembling Vassaux, 1914.
Etching on paper; plate: 18 × 12.8 cm (7 1/16 × 5 1/16 in.);
sheet: 37 × 28 cm (14 9/16 × 11 in.). The Museum of
Modern Art, New York, acquired through the Lillie P.
Bliss Bequest, 1948. In exhibition.

33g

33d

Olivarès, 1914. Etching on paper; plate: 16.1 × 6.1 cm (6⁵/₁₆ × 2³/₈ in.); sheet: 27.7 × 18.8 cm (10⁷/₈ × 7³/₈ in.) (INHA); plate: 15.7 × 6 cm (6³/₁₆ × 2³/₈ in.); sheet: 28.1 × 18.7 cm (11¹/₁₆ × 7³/₈ in.) (Met). Chicago venue: Institut National d'Histoire de l'Art, Paris, Bibliothèque, collections Jacques Doucet, EM Matisse 90; New York venue: Lent by The Metropolitan Museum of Art, New York, Harris Brisbane Dick Fund, 1929, 29.89.16. In exhibition.

33e

Fanny from Three-Quarters, 1914. Etching on paper; plate: 15.9 × 6 cm (6¹/₄ × 2³/₈ in.); sheet: 28.1 × 18.7 cm (11¹/₁₆ × 7³/₈ in.). Lent by The Metropolitan Museum of Art, New York, Harris Brisbane Dick Fund, 1929, 29.89.15. In exhibition.

33f

Fanny (Mme. D. G.), 1914. Etching on gray Japanese paper, laid down on white wove paper; plate: 16 × 6.1 cm (6¹/₄ × 2³/₈ in.); sheet: 28 × 18.8 cm (11 × 7³/₈ in.) (AIC/MoMA). Chicago venue: The Art Institute of Chicago, gift of the Albert Roullier Galleries, 1922.4486; New York venue: The Museum of Modern Art, New York, Lillie P. Bliss Collection, 1984. In exhibition.

33g

Large Irène Vignier, 1914. Etching on paper; plate: 18 × 12.7 cm (7¹/₁₆ × 5 in.); sheet: 37.5 × 28 cm (14³/₄ × 11 in.) (INHA); plate: 17.8 × 12.7 cm (7 × 5 in.); sheet: 37.5 × 28.1 cm (14³/₄ × 11¹/₁₆ in.) (Met). Chicago venue: Institut National d'Histoire de l'Art, Paris, Bibliothèque, collections Jacques Doucet, EM Matisse 87; New York venue: Lent by The Metropolitan Museum of Art, New York, Harris Brisbane Dick Fund, 1929, 29.89.35. In exhibition.

WHEN FRANCE ENTERED the war in August 1914, Matisse was prepared to be called up for military duty—he had even purchased boots in anticipation—but when he received his papers, he was sick with the flu and failed his medical examination.[1] Although he appealed to reverse the decision, his application was rejected on the grounds of his age (he was forty-four) and his weak heart. At the same time, he also grew increasingly concerned with the plight of those in his hometown of Bohain-en-Vermandois, which had been under German control and blocked from communications since the early days of France's involvement in the conflict. The artist's brother, Auguste, and hundreds of other men in the town were deported to a prison camp in Havelberg, Germany, and his seventy-year-old mother, Anna, was alone and in failing health. He could get no news of his family for months, and his concern deepened with reports from those, such as Charles Camoin, who directly witnessed the situation of civilians under German occupation:

I understand your worry about those of your family still in Bohain, probably surprised by the rapid advance of the Germans whom no one expected to see so quickly. Around here, it's the same . . . the honest folk having had only the time to make tracks, abandoning everything—livestock, foodstuffs, harvest, and furniture—to the *boches*, who made the most of it. And when they had to pull back, needless to say they left nothing standing, burning what they couldn't take with them.[2]

In December, Matisse was recommended for auxiliary military service.[3] Still wanting to be more engaged, however, he asked his friend Marcel Sembat, who served as minister of public works, how he might help his country. Sembat's response was straightforward: "By continuing, as you do, to paint well."[4]

Matisse took the advice seriously—within months, he found a way to put his art directly in the service of his fellow citizens: with money from the sale of his prints, he began sending weekly shipments of food and necessities to the Bohainois in Havelberg.[5] Two monotypes [**33a–b**] attest to the artist's plan: each is a portrait of Emma Laforge inscribed with the dedication *Pour les Prisonniers civils en Bohain-en-Vermandois*.[6] By their nature, the monotypes exist as single images that cannot be reproduced; from their provenance, we can tell that these simple, elegant works were most likely purchased individually.[7] In at least one instance, however, Matisse sold a group of prints for the cause; on June 7, he wrote to Jacques Doucet, who had earlier acquired *The Blue Window* [**18**]:

I'm endeavoring to make myself useful to the civilian prisoners from back home, four hundred of them taken away to Germany and in captivity in Havelberg, where they are dying of hunger, [since] nothing can be sent to them from their unfortunate invaded hometown. This town . . . is Bohain-en-Vermondois (Aisne). Every week I send them one hundred kilos of bread or soda biscuits with the Society of Prisoners of War as intermediary;

five shipments have already left and to be able to continue, I am selling engravings, monotypes, and etchings, the profit to be used exclusively for them. Knowing your feelings, as well as the interest you have so kindly taken in my work, I shall venture to send you, if you agree, a package of new engravings that at least will interest you, since the monotypes are entirely new. In the hope, Sir, that you will be willing to contribute to this modest task that is so dear to my heart, I send you my most respectful greetings.[8]

Doucet's response, now lost, was surely quick, for just days later Matisse wrote to thank him for his support:

I hesitated for an instant, please forgive me, to appeal to your feelings, knowing all that you are doing for our soldiers; so your response deeply touched me. I thank you in the name of my unfortunate compatriots—deprived of everything, dying of hunger, often beaten (my brother—among them—wrote me of it) and without news of the loved ones who remain in the invaded area. I am sending you the engravings in question; I will find no better recompense for my talent than if it can contribute to lessening their suffering. Again thank you, Sir, for whatever you can do.[9]

In this case, Matisse sent a group of twelve intaglio prints—portraits made, since the start of the war, of friends in Paris. These individuals included the artist Charles Bourgeat [**33c**], Argentine cellist Carlos Olivarès [**33d**], and Emma Laforge [**33h**]; wives and daughters of men called away to serve, such as Fanny Galanis [**33e–f**], Irène Vignier [**33g**], and Alice Derain [**33i**], whom the Matisses visited in Montfavet; and Josette Gris, whom the artist retained as his model after he was unable to secure financial assistance for her and her husband, Juan [**33j–n**].[10] He also included a monotype, *Nude from Back* [**33o**]; all are inscribed for the civil prisoners of Bohain-en-Vermandois. Apart from the monotype, each print in the group is from an edition of fifteen, but those in Doucet's collection are not all the same numbered impression: *Large Irène Vignier*, for example, is inscribed *4/15*; *Portrait of Madame Derain*, *3/15*; and *Josette Gris, Three-Quarters View*, *7/15*. The difference in impressions suggests that Matisse chose the group of prints from a selection of available impressions as opposed to a planned, consistently numbered set of prints organized as a discrete portfolio or album. It is likely that Matisse dedicated and sold earlier single impressions (ones numbered before those in Doucet's set) in a similar fashion to the monotypes of Emma Laforge before he gathered together the group he sent to his patron.[11]

It is worth noting that Matisse did not divert his artistic progress or subvert his style for the war effort, as some artists understandably did.[12] The prints he selected for sale are no different in technique or format than the other spare, intimately scaled drypoints, etchings, and monotypes he was making in this period [**22**]. While some commentators have suggested that the Bohain prints reflect a growing national interest in classicism—indeed, the writer Noël Clément-Janin

33h

33i

33j

33k

33l

33m

33n

33h

Emma L., 1914–15. Etching on paper; plate: 17.5 × 12.4 cm (6⁷⁄₈ × 4⁷⁄₈ in.); sheet: 37.5 × 27.9 cm (14³⁄₄ × 11 in.). Lent by The Metropolitan Museum of Art, New York, Harris Brisbane Dick Fund, 1929, 29.89.13. In exhibition.

33i

Madame Derain, fall 1914. Etching on tan Japanese paper, laid down on white wove paper; plate: 9.2 × 6.5 cm (3⁵⁄₈ × 2⁹⁄₁₆ in.); sheet: 28 × 18.7 cm (11 × 7³⁄₈ in.) (AIC); plate: 9 × 6.5 cm (3⁹⁄₁₆ × 2⁹⁄₁₆ in.); sheet: 28 × 18.7 cm (11 × 7³⁄₈ in.) (MoMA).Chicago venue: The Art Institute of Chicago, given in memory of Charles Barnett Goodspeed by Mrs. Charles B. Goodspeed, 1947.818. New York venue: The Museum of Modern Art, New York, gift of Mrs. W. Murray Crane (by exchange), 1955. In exhibition.

33j

Madame Josette Gris, 1914–15. Etching on paper; plate: 15.8 × 6 cm (6¹⁄₂ × 2³⁄₈ in.); sheet: 25.2 × 16.4 cm (9¹⁵⁄₁₆ × 6⁷⁄₁₆ in.). The Museum of Modern Art, New York, gift of Abby Aldrich Rockefeller, 1940. In exhibition.

33k

Josette Gris, Three-Quarter View, winter 1915. Drypoint and etching on paper; plate: 15 × 11.1 cm (5⁷⁄₈ × 4³⁄₈ in.); sheet: 37.8 × 27.9 cm (14⁷⁄₈ × 11 in.). The Museum of Modern Art, New York, Stephen C. Clark Fund, 1951. In exhibition.

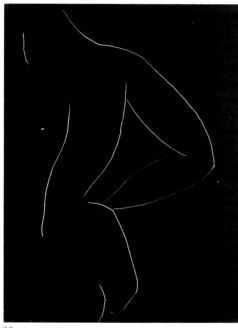

330

33l

Josette Gris ("Séraphique"), winter 1915. Drypoint and etching on paper; plate: 14.9 × 11.2 cm (5⁷/₈ × 4⁷/₁₆ in.); sheet: 37.7 × 27.9 cm (14¹³/₁₆ × 11 in.). The Museum of Modern Art, New York, Stephen C. Clark Fund, 1951. In exhibition.

33m

Josette Gris—Figure in an Armchair, winter 1915. Etching on paper; plate: 8.9 × 6.5 cm (3¹/₂ × 2⁹/₁₆ in.); sheet: 24.8 × 15.9 cm (9³/₄ × 6¹/₄ in.). Lent by The Metropolitan Museum of Art, New York, Harris Brisbane Dick Fund, 1929, 29.89.20. In exhibition.

33n

Double Portrait of Josette Gris, winter 1915. Etching on paper; plate: 12.9 × 17.9 cm (5¹/₁₆ × 7¹/₁₆ in.); sheet: 25 × 32.5 cm (9¹³/₁₆ × 12¹³/₁₆ in.). The Museum of Modern Art, New York, Abby Aldrich Rockefeller Fund, 1949. In exhibition.

33o

Nude from Back, 1915. Monotype on chine collé; plate: 19.8 × 14.8 cm (7¹³/₁₆ × 5¹³/₁₆ in.); sheet: 37.5 × 28 cm (14³/₄ × 11 in.). Institut National d'Histoire de l'Art, Paris.

invoked Jean-Auguste-Dominique Ingres in his appraisal, Matisse's intaglios were on the whole quite linear at this time, with little modeling or chiaroscuro. Their link to the conflict was more personal than stylistic: Matisse made these works during the first months of the war and chose to sell those that depicted people who were affected in one way or another by its circumstances. The sitters' particular situations are not acknowledged in the images, nor do they affect the works' aesthetic identity. For Clément-Janin, in fact, it was their categorization as "les en dehors"— outside of definition, as opposed to more traditional documentary, portrait, or allegorical prints—that made them important to include in his study of wartime printmaking. "These are again certain works made because of the war, for war charities," he wrote to introduce Matisse's Bohain prints, "but absolutely do not represent war subjects. They incontestably belong in our domain, insofar as their inspiration, their purpose, and their process are concerned."[13]

By the early fall of 1915, Matisse's work on behalf of the Bohainois had come to an end. In an October 1 letter to Doucet's former secretary and art advisor, the critic René Jean, who had been recently inducted into the *Commissariat militaire* in the northeastern municipality of Chalindrey (Haute-Marne), he reported that he had done what he could for his compatriots, thanks in large part to Doucet's generosity. But Matisse's disquiet about his art and his purpose during the war had not dissipated. In fact, he remarked, "How many things, my God—I, who because of my age and the major's decisions, have remained with my brushes, am often sickened by all of the upheaval to which I am not contributing—and it seems to me that my place is not here. I work as much as I can."[14] After a relatively long absence, the artist was ready to turn his struggle back to one with his brushes and oil paints.

1. Spurling 2005, pp. 166, 478 n. 88.

2. Camoin to Matisse, Dec. 10, 1914, Archives Camoin. For a history of civilian life under German occupation in France, see McPhail 1999.

3. Matisse to Camoin, Dec. 1914, Archives Camoin.

4. Escholier 1960, pp. 96–97.

5. Matisse's prints for the Bohainois have been little studied; this discussion is shaped by Escholier 1960; Silver 1981 and 1989; Hahnloser-Ingold 1988; Klein 2001, p. 132; Schneider 2002, pp. 735–36; and Spurling 2005, p. 169. Silver's presentation of Matisse's work within the context of the war is especially important for this discussion. Matisse's effort was in addition to the regular packages he and Amélie sent to friends at the front. To Camoin, for example, they sent books, boots, chocolates, gloves, and powdered milk; see Camoin to Matisse, Oct. 28, 1914, and Jan. 1 and Mar. 16, 1915, AHM. To Matthew Stewart Prichard, interned at the Engländer Ruhleben prison in Spandau, they sent food and clothing; Spurling 2005, p. 166; and Labrusse 1996, pp. 755–60. And to Léonce Rosenberg, working as a military translator in 1916, they sent a gramophone and Pathé recordings; see, for example, Rosenberg to Matisse, Oct. 1916, AHM. We also know that Matisse was directly engaged

in assistance for the Bohanois from a May 22 letter from Olivier Deguise, representative of Aisne in the Chamber of Deputies, who wrote to congratulate him for his work. The letter was incorrectly addressed to Auguste Matisse (AHM).

6. Little is known about Emma Laforge: documentation suggests that she might have been the wife of a collector but this cannot be confirmed; materials also locate the production of the two prints in the first half of 1915. Thanks to Wanda de Guébriant, AHM, for providing information about the sitter.

7. Available information does not indicate that the monotypes or other prints of the series were sold as groups. The only known group sale at this time is that to Jacques Doucet.

8. Matisse to Doucet, June 7, 1915, carton XX, dossier, archives, Institut National d'Histoire de l'Art. Thanks to Nathalie Müller and Claudine Grammont.

9. Matisse to Doucet, June 11, 1915, carton 91, dossier, Archives, Institut National d'Histoire de l'Art.

10. Fanny Galanis was married to Demetrios Galanis, a Greek artist who was given French citizenship for his contributions in the war and portrayed by Matisse in at least two prints (D69, 70); Irène Vignier (D18–23, 224–35) was the daughter of Charles Vignier, a gallery owner specializing in Asian art.

11. Efforts to locate as many impressions of the twelve prints in Doucet's collection as possible resulted in the identification of only later examples: none of these have dedications, and many are no longer in their original housings. For their assistance, we are grateful to Nathalie Müller, Institut National d'Histoire de l'Art; Maxime Préaud, Bibliothèque Nationale de France; Mark Pascale, Art Institute of Chicago; Christophe Cherix, The Museum of Modern Art; Samantha Rippner, The Metropolitan Museum of Art; Helen Burnham, Museum of Fine Arts, Boston; Jay Fisher, The Baltimore Museum of Art; John Ittmann, Philadelphia Museum of Art; and Kristin Spangenberg, Cincinnati Art Museum.

12. For more on the activities of French artists during the war, see Green 1976; Baldewicz 1980; Silver 1989; and Cork 1994.

13. Clément-Janin 1917, p. 382. His essay was published in three parts in 1917. See Silver 1989, esp. chap. 2, for more on the context of this appraisal.

14. Matisse to Jean, Oct. 1, 1915. Thanks to Sylvie Maignan, daughter of René Jean, who generously made this document available for our study.

34 Composition
Issy-les-Moulineaux, spring 1915

Oil on canvas; 146 × 97 cm (57 1/2 × 38 1/8 in.)
Signed l.r.: *Henri-Matisse*
The Museum of Modern Art, New York, gift of Jo Carole and Ronald S. Lauder;
Nelson A. Rockefeller bequest, gift of Mr. and Mrs. William H. Weintraub,
and Mary Sisler bequest (all by exchange), 1997

IN EXHIBITION

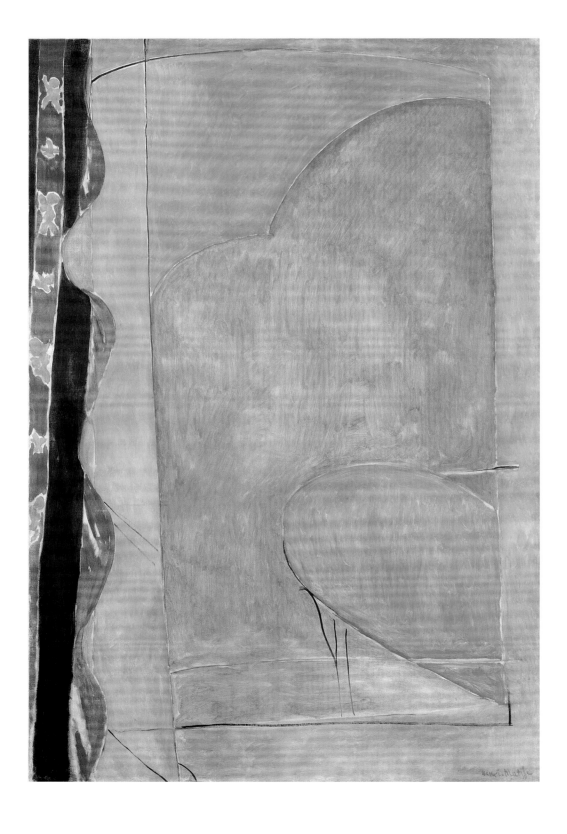

34a

34b

34c

34a
Photograph of the front of the Matisse home in Issy-les-Moulineaux, showing the glass canopy over the doorway. Archives Henri Matisse, Paris.

34b
Detail of *Composition*, showing Matisse's drawing of the post and the angle of the canopy.

34c
Detail showing lines with reserve crossing blue and yellow.

COMPOSITION, MATISSE'S PREFERRED title for this painting [**34**], accentuates its abstractness, which is hardly less radical than that of *View of Notre Dame* [**23**] or *French Window at Collioure* [**29**], its thematic and compositional precedents.[1] Its color is less austere, though, being somewhat reminiscent of Matisse's Moroccan paintings in its limpid, out-of-door harmonies; *Zorah in Yellow* [**14.1**] most obviously comes to mind. So is its language of form, which the artist soon reemployed in another attempt to advance *The Moroccans* [**36**]. However, it was not Tangier but Issy that provided the source for this cryptic image, which in fact records a view from a window above the blue glass canopy over the front door of Matisse's house [**34a**]. In 1931 Margaret Scolari Barr interviewed Matisse and asked him about the painting; her notes read as follows:

On *Rideau Jaune* [*Yellow Curtain*], it has been called this incorrectly. The curtain was red, the color of the yellow [represents its] lining, and the pattern [was] added by the artist. The green frame of the window suggests the green of the trees outside and the cool contrast of the green of the trees and the blue sky necessitated the large mass of yellow which to the artist signifies the vibration and pleasure which he derived from the contrast of trees and sky. It is not therefore a completely abstract picture but a picture which has its roots in reality.[2]

Matisse stated that he made this painting in 1915; however, its manner of creation and strongly decorative appearance have led some scholars to place it earlier.[3] Indeed, the artist employed the same method of construction that had opened his so-called decorative period in 1907: establishing the compositional drawing first and then filling it in with color, transposing the particular hues and densities of pigmentation as necessary until, as he put it, "the color was proportioned to the form."[4] Although he used this technique less frequently after 1911, he did employ it periodically, even in the years from 1913 to 1917, when he reworked and adjusted his paintings extensively. Sometimes he used it to produce what would traditionally be considered *esquisses* for these paintings, as in the two versions of *View of Notre Dame* [**23**, **23d**] or *Portrait of Auguste Pellerin* [**50**, **50a**]; sometimes he carried it to a greater degree of finish, as in the case of *Still Life with Lemons* [**26**] and this canvas.[5] All these works serve to remind us of the continuities that accompanied the changes in his art during the war period.

Even in this context, however, *Composition* is exceptional, seeming a conscious attempt to recover qualities of freshness and immediacy for his painting, though it was tilting definitively to the rugged and revisionary. The artist made his initial compositional drawing in fluid paint and followed it with minor exceptions; he then brought areas of color close to it [**34b**], leaving these unmodified except in a few places, where he strengthened them with a very steady hand. Over this, he set down fragments of dark drawing in order to define the iron post and brace that support the canopy [**34c**]; above it, a short horizontal indicates the far edge of a driveway; running through it, the driveway's near edge is a thin, unreinforced line.[6] The artist used reinforced lines to shape the top, bottom, and left side of the window, while he perhaps used the short diagonals to imagine where the curtain might unfurl along the lower-left side.

Matisse's color infilling is noticeably directional, with brushstrokes following both sides of the contours of the big forms, circling within the yellow center, and moving back and forth within the canopy and the bottom border. In this way, he was able to build space and volume, especially within the flat yellow-blue interior. He may have added the yellow in the curtain not only to record the color of its reverse side but also to make it billow above the green window frame, seeming to lift off the very surface of the painting. Somewhat mystifyingly, however, the artist explained in 1931 that the curtain was initially red and that he painted it yellow "to express his excitement and pleasure at the contrast of trees and sky and to complement their blue and green contrasting tones."[7] Of course, the curtain is still red, and there are no traces of earlier colors beneath the surface, but we cannot dismiss the possibility that Matisse may indeed have altered the colors as he painted.[8]

1. Barr 1951, p. 187; and Barr Questionnaire VII. Barr gave the work the title *Rideau jaune: Composition*. *Composition* is underlined (presumably by Pierre Matisse), indicating either a preference for that title, or that Pierre thought the title should be *Rideau jaune: Composition*.
2. Matisse, interview by Margaret Scolari Barr, 1931, Alfred H. Barr, Jr., Papers, 11.III.S., MoMA Archives.
3. The painting was dated without documentation to Jan. 1915 in Pompidou 1993, p. 362, cat. 124. The artist simply remembered it having been painted in 1915; see Matisse to Fernand C. Graindorge, Oct. 24, 1951, AHM.
4. Tériade 1929.
5. Puzzlingly, though, Gôsta Olson, who visited Matisse's studio sometime during the years of World War I, referred to this painting as the culmination of a series of *esquisses*. Thanks to Claudine Grammont for sharing this information. See Gôsta Olson, *Fran Ling till Picasso* (Albert Bonniers Förlag, 1965).
6. In the left margin, there is a visible underdrawing that originally extended both the yellow-green horizontal division above the base of the picture and the line running across the canopy above that, which describe the near edge of the driveway or the sill of the window. There are also horizontal fragments in both margins (the one at the right reinforced) at around the level of the top of the canopy, which describe the far edge of the driveway. Comparison with *French Window at Collioure* suggests that they may have originally denoted shutters.
7. Barr 1951, p. 542 n.2, using the 1931 interview.
8. Alternatively, Matisse may have been remembering an earlier, presently unknown *esquisse;* see n. 3.

35 Still Life after Jan Davidsz. de Heem's "La desserte"
Issy-les-Moulineaux, August–early November 1915

Oil on canvas; 180.9 × 220.8 cm (71 1/4 × 86 15/16 in.)
Signed l.r.: *Henri-Matisse*
The Museum of Modern Art, New York,
gift and bequest of Florene M. Schoenborn and Samuel A. Marx, 1964

IN EXHIBITION

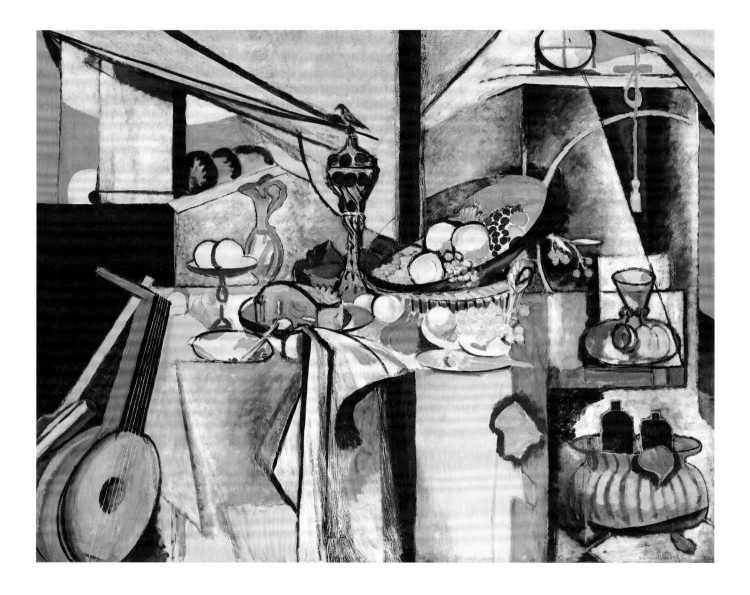

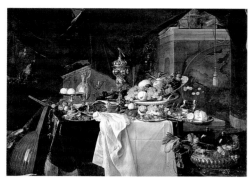

35a

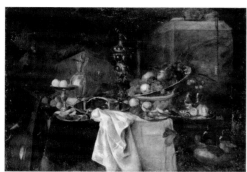

35b

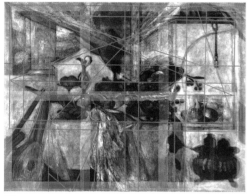

35c

35a
Jan Davidsz. de Heem (Dutch, 1606–1684). *A Table of Desserts*, 1640. Oil on canvas; 149 × 203 cm (58⅝ × 80 in.). Musée du Louvre, Paris, collection of Louis XIV, purchased from Eberhard Jabach, 1662, RF 1321.

35b
La desserte (after Jan Davidsz. de Heem), 1893. Oil on canvas; 72.5 × 100 cm (28½ × 39⅜ in.). Musée Matisse, Nice, 63.2.17. In exhibition.

35c
X-radiograph of *Still Life after Jan Davidsz. de Heem's "La desserte"* with a diagram of the work's geometric composition.

STILL LIFE AFTER Jan Davidz. de Heem's "La desserte" [**35**] looks to the past, for in 1893 Matisse had been sent by his teacher, Gustave Moreau, to copy de Heem's 1640 still life in the Musée du Louvre [**35a**]; the artist based this work both on that earlier copy [**35b**] and on his memory, as the museum was closed in 1914 due to the war. But the painting also looks to the future: Matisse, while reminiscing late in life about his Louvre copies, said, "As for the *Still-Life* by David de Heem, I began it again, some years later, with the methods of modern construction."[1] However, this work is also a synthesis of what preceded its creation. Writing to the critic René Jean on October 1, 1915, he explained that, while making it, he added to his early copy everything he had "seen since."[2] He was exaggerating, but not much, for the 1915 painting looks back to his 1908 *Harmony in Red (The Red Room)* (p. 84, fig. 17), a work of identical proportions that also features an opulent still life on a table beside a window; that canvas, in turn, recalls *Dinner Table* (1897; private collection). Those earlier works were conscious attempts to synthesize his achievements at critical moments in his artistic development, thus accelerating its progress.[3] This painting fulfilled those functions, too.

Matisse may have begun this work as early as August 1915, for he wrote to Charles Camoin in September in a manner that implies that his friend already knew of it.[4] The following month, it was sufficiently advanced for Matisse to write to Jean, "Right now I'm working on a 2.20 × 1.80 canvas representing a large still life that I made after a copy of the large painting by David de Heem that I executed at the Louvre twenty-three years ago. It's interesting for me and I hope it will interest you too; the few people that I see are following its progress with interest."[5] Whereas the 1893 copy was approximately half-size, this still life is larger and slightly squarer than the original, and is of the same format as many of his most ambitious paintings, beginning with *Harmony in Red*. Although Matisse probably finished the canvas in early November, he may have done so even earlier.[6] We know for certain, however, that Léonce Rosenberg wrote to Matisse on November 10 to say that he was delighted to be able to acquire the work; he later called it "a veritable enchantment."[7]

In his letters, Matisse associated his work on this picture with the troubled times in which it was painted. "The war is still with us," he wrote to Camoin. "While not having been called up, I believe I can fulfill my civic duty by working as much as possible."[8] To Jean, he spoke of sharing the sense of helplessness and revulsion about the conflict that everyone was feeling, and it is telling that his reaction was to return to de Heem's affirmation of peace and plenty.[9] Such opulent, baroque paintings were made in a period when the

Dutch were at war much of the time; he would follow de Heem's example, even as the most mechanized campaign in history was in the process of creating the charnel house now called the Second Battle of the Champagne.[10] And yet Matisse painted something more classical than baroque, namely the most methodically, geometrically premeditated work of his career, one that he laid out with carefully ruled lines in an orthogonal grid and energized with diagonals and arcs that project from fixed points in the upper part of the composition [**35e**].[11] These, he had learned from Gris the previous summer, were "the methods of modern construction." In using this phrase, he was indubitably referring to Cubism; nonetheless, it seems permissible to see these methods as more broadly of the times, since they served to constrain the abundance of the Dutch still life. "I am very much a romantic," the artist had written to Camoin in fall 1915, "but with a good half of the scientist, the rationalist."[12] He was mustering the more calculated, sober aspects of his art, and his new version of the de Heem was a testing ground for just how far he could go. Nonetheless, his romanticism could not help but show through, and his earlier, natural tendency toward coloristic and painterly seduction does mitigate the programmatic structure of the work.[13]

In his letter to Jean, Matisse enclosed a sketch [**35e**] that seems to represent the salient features of the 1893 copy, since there is hardly a sign of the geometric framework, except for the lute in the left foreground, which presents its face to the viewer. It is evident from the 1915 painting that the instrument was originally represented in profile, as it appears in the de Heem and in Matisse's early copy. Here, however, the artist turned and enlarged it in such a way that the side view remains visible beside the front one, an approach that is reminiscent of Analytical Cubist works such as Picasso's *Girl with a Mandolin (Fanny Tellier)* [**35h**], also based on an earlier composition, in this case a work by Camille Corot.[14] While Matisse did not record this double view in his sketch, he showed the neck of the lute bent to the left as if in profile. We may therefore assume that the sketch is a notation of the work in process.[15]

Describing de Heem's painting to Jean, Matisse either misremembered or spoke metaphorically when he said that it was composed against a staircase; however, the original work is indeed arranged on stepped planes that climb most conspicuously up the right-hand side, beginning with a pedestal that supports an urn containing bottles, rising to a tabletop and a massive stone pier behind it, and arriving finally at a globe and books on top of the pier.[16] These features are just visible in the chiaroscuro gloom of Matisse's early copy, in which he avoided detail by painting the de Heem from a distance.[17] In this painting,

255

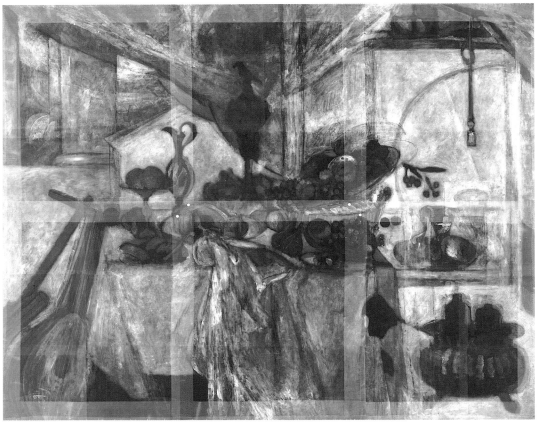

35d

35e

35f

35d
X-radiograph of *Still Life after Jan Davidsz. de Heem's "La desserte."*

35e
Sketch in a letter to René Jean, Oct. 1, 1915. Institut National d'Histoire de l'Art, Paris.

35f
First Study for "Still Life after de Heem," 1915. Graphite on paper; 37.5 × 28 cm (14³/₄ × 11 in.). Musée Matisse, Nice, 63.2-69.

35g
Second Study for "Still Life after de Heem," 1915. Graphite on two sheets of paper; 52.3 × 55.2 cm (20⁵/₈ × 21³/₄ in.). Philadelphia Museum of Art, Walter Arensberg Collection, 50-134-131.

35g

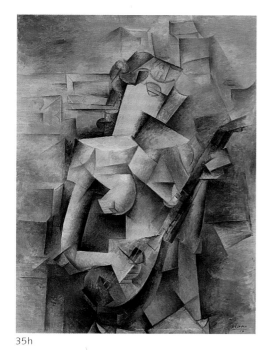

35h

35i

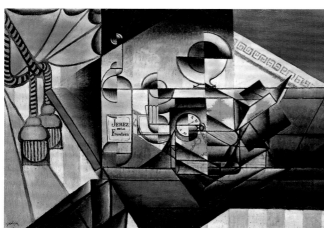

35j

35h
Pablo Picasso (Spanish, 1881–1973). *Girl with a Mandolin (Fanny Tellier)*, 1910. Oil on canvas; 100.3 × 73.6 cm (39 1/2 × 29 in.). The Museum of Modern Art, New York, Nelson A. Rockefeller bequest, 1979.

35i
Table with Basket of Fruit, 1915. Conté crayon on paper; 37 × 54.5 cm (14 5/8 × 21 1/2 in.). Private collection.

35j
Juan Gris (Spanish, 1887–1927). *The Watch*, 1912. Oil and *papier collé* on canvas; 65 × 92 cm (25 5/8 × 36 1/4 in.). Private collection.

however, he avoided it by simplification, piling up the elements at the right side to produce four spatial compartments that are distinct from one another except that the middle two are joined by a big diagonal that extends and lifts the right edge of the tabletop, lending its dramatic black-and-white contrast to all but the top sliver.[18] Matisse scumbled white over black, and vice versa, possibly painting over a masking edge in a pochoir-like technique to produce a misty, metallic setting for the most cubistic of his still-life elements, the glass and fruit on a small tray. He had explored this detail in a separate study [**35i**] before truing and fairing its drawing in a cagelike manner that recalls paintings that he would have known by Juan Gris [**35j**], especially, but also by Jean Metzinger and Gino Severini.[19] This and the lute aside, however, it may be said that the overall geometry of this canvas is indebted to Cubism, though its details are not—indeed, their simplification is an extension of the processes that Matisse had begun to develop shortly after making the 1893 copy and had been refining ever since.

It has frequently been claimed that Matisse used this painting to test out which elements of Cubism might be of use to him.[20] To some extent, this is true, as it is a programmatic work. However, its program was not mainly a matter of borrowing; it was Matisse's way of testing what in his own practice he could sharpen and toughen with the help of Cubism, without sacrificing detail or brilliant color.[21] The artist seemed most interested in how to preserve pockets of lively illustrated incident within the broad geometric banding that he had been using on and off since his early years, most recently in *Goldfish and Palette* [**31**].[22] Here he filled out the austerity of the painting with images of plenty—richly colored food and drink, and the makings of music—confined within and scattered across the rectilinear framed zones.

The still-life elements, which Matisse studied in preliminary drawings [**35f–g**], exhibit an unusual variety of treatment. For example, to the left of the jug with the stuttering, stencil-like outline, the frothy texture of the two lemons, their brightness exaggerated by black outlining [**35l**], contrasts with the vivid, thickly painted red pears, which glow between segments of viridian and black at the center of the picture. Below the lemons, the artist's thin, watercolorist treatment of a Provençal plate is made more fragile by the ocher density of the *pâté en croute* beside it [**35m**]. The delicacy of the fruit in the tipped-up plate, which is improbably pierced by the central vertical, is thrown into relief by the weighty, similarly rounded forms in the bottom corners.

Matisse revised the painting most between the anchored bottom corners, but also wherever else he needed to coax forms into align-

35k

35l

35m

35k
Detail of the area to the right of the vertical at the top in *Still Life after Jan Davidsz. de Heem's "La desserte,"* showing Matisse's reworkings as he narrowed the black band at left and experimented with various contours for the drapery at right.

35l
Detail of the two lemons, which the artist constructed in frothy yellow paint and outlined in black.

35m
Detail of the plate, whose thin treatment contrasts with the densely painted *pâté en croute* to its right.

35o

35n

35n
Detail of the strings of the lute, which Matisse may have produced with the help of a paint-coated string, straight-edge, or mapping pen.

35o
Detail of the drapery at the bottom, which the artist adjusted with numerous scrapings and simplifications.

ment with the geometry of the composition. His changes are clarified by an X-radiograph of the work [**35d**], but he was content to let most of them show. The central black band was obviously broader above the table; the artist incised its edges, scraped back the interior, and repainted the band itself, making it narrower. At its left, compacted brushwork indicates extensive reworking, while areas showing signs of scratched-out paint remain to suggest shadows in folds of drapery. To its immediate right, Matisse tried several contours for the drapery before settling on two diagonals—a bold one separating a pale yellow and whitish gray (and pointing directly to the sound hole of the lute) and another, partially marked one that divides the gray from the scumbled, viridian-white mixture below it [**35k**]. Below the table, through a mass of scrapings and simplifications, he adjusted the drapery so it dropped to the bottom edge of the picture [**35o**]. All of these alterations produced trajectories that align and mesh in patterns that conform to a cogent geometric design, which confirms that the artist began with a freer replica of his earlier copy and then submitted it to the discipline of modern construction. "I have derived constant benefit from my use of the plumb line," Matisse wrote at a later date, and it is quite possible that he used a string, if not even a straightedge, to establish the composition.[23]

The artist associated the use of a plumb line with remaining aware of the actual shape of the canvas, once remarking to a student, "Always use your plumb line. Think of the hard lines of the stretcher or the frame, they affect the lines of your subject."[24] Unquestionably, Matisse intended some of his alterations to echo the wood structure that supported the canvas itself. For instance, the line that he created by scratching back the black band follows the right edge of the central, vertical stretcher bar, even as the top of the table follows the top of its central horizontal bar, and the bars on both sides are noted by flashes of bright brick red at the edges of the painting. Following that red down the length of the lute reveals a technical mystery: how Matisse painted the strings of the instrument so precisely [**35n**]. It is likely that he did not draw them freehand, judging from their parallel precision and uniform treatment (each line doubles slightly along part of its length and tends to taper at each end). It is possible that he used string again, this time snapping paint-coated lines against the canvas. Alternatively, he may have employed a narrow, paint-coated straightedge; or used a mapping pen to create these, the only truly geometrically precise parts of the painting. Regardless, their novel manufacture demonstrates the invention that the artist employed as he returned to painting at this moment.

1. Tériade 1952, p. 42. It has been argued that Matisse must have worked from the painting in the Louvre—or at least had access to it, either through a reproduction or courtesy of his friend Marcel Sembat—but that would not have been possible beginning in Nov. 1914; see Benjamin 1989, p. 194. Moreover, the artist told René Jean explicitly that he was working on the basis of his own early copy. Barr recorded Pierre Matisse's response to a question on this subject: "He worked on the interpretation of a subject he knew well, but had his old copy with him, to which he referred for the placing of the objects"; Barr Questionnaire VII.

2. Matisse to Jean, Oct. 1, 1915, Institut National d'Histoire de l'Art. Thanks to Sylvie Maignan, who generously shared this document with the authors.

3. Elderfield 1978, p. 106; Schneider 2002, p. 486; and Flam 1986, p. 404.

4. Matisse to Camoin, Sept. 1915, Archives Camoin.

5. Matisse to Jean (n. 2).

6. When Matisse wrote to Camoin on Nov. 22 (Archives Camoin), he spoke of having been ill for two weeks. His 1912 contract with Bernheim-Jeune expired on Sept. 15 (see Barr 1951, p. 554), and while this painting was too large to be technically covered by that agreement, so was *Goldfish and Palette* (31), which Matisse had nonetheless sold to Bernheim-Jeune in late May. Since Matisse wanted to continue to sell paintings to Bernheim-Jeune, he may have preferred not to sell the de Heem still life directly to Rosenberg until the contract's expiration date had well passed. He clearly did not want to publicize the name of the purchaser, for in the same letter to Camoin, he told him that the painting was finished and sold in Paris, adding parenthetically, "I can't tell you the name of the art lover."

7. Rosenberg to Matisse, Nov. 10 and Dec. 24, 1915, AHM. Around that date, Matisse wrote to Walter Pach, stating, "I've just finished an important 2.20 × 1.80 painting that I worked on several months—and that I've just sold— fortunately." Matisse to Pach, Nov. 20, 1915, Walter Pach Papers, Archives of American Art, Smithsonian Institution, Washington, D.C.; Cauman 1991, pp. 4–5.

8. Matisse to Camoin (n. 6). Matisse wrote almost identical words in a letter to Walter Pach two days earlier; see Matisse to Pach (n. 7).

9. While Matisse did refer to his sense of helplessness with regard to the war, he did not directly relate this feeling to his decision to return to the de Heem painting. To Jean (n. 2), he wrote, "Sorry for being verbose, I just hoped to distract you for a moment from your preoccupations and your milieu."

10. For more on Dutch painting at this time, see Svetlana Alpers, *The Vexations of Art: Velázquez and Others* (Yale University Press, 2005), pp. 83–94. A vivid account of the battle can be found in E. Alexander Powell's *Vive la France* (Heinemann, 1916).

11. The composition had to have been predrawn, as there are too many alignments to have been created by eye.

12. Matisse to Camoin, Sept. 1915, Archives Camoin.

13. Matisse to Pach (n. 7).

14. See Rubin 1972, p. 205 n. 3.

15. The sketch also helps us to understand that the upper-left zone of the work originally showed a narrow column surrounded by trees; later Matisse broadened the column and transformed the tree at left into a gray-white disk. He mentioned this feature in the short description also included in his letter to Jean (n. 2).

16. Matisse either misremembered or replaced the pedestal with a tiled floor; he represented the globe in the shorthand form of a circle with a cross inside it. The red bar to its right stands for a book.

17. As he recalled to Pierre Courthion, Moreau encouraged him to copy the de Heem as it was "extremely complicated. It looks as if it were painted with a magnifying glass. There are things in the detail that are pursued to infinity. So, I went over to the other side of the gallery, and I worked in the way I would as if painting from nature"; Courthion 1941, p. 17.

18. The artist used a similar color scheme for the left-hand side, introducing a dense black area diagonally bisected by the fingerboard of the lute and the tube of the recorder behind it.

19. In the case of Gris, influence may also have flown in the opposite direction, since the following year that artist made drawings after works by Corot, Diego Velázquez, and Cézanne (the *Three Bathers* that Matisse himself owned), in some cases on the basis of postcards divided by geometric lines of analysis. See Christopher Green, Christian Derouet, and Karin von Maur, *Juan Gris*, exh. cat. (Whitechapel Art Gallery/Yale University Press, 1992), pp. 58–60.

20. See, for example, Jacobus 1973, p. 36; Elderfield 1978, n. 4.

21. When Matisse spoke in 1951 of using the "methods of modern construction" for this painting, he contrasted Cubist art's basis in reality against that of his own in imagination, while insisting, "In those days we didn't feel imprisoned in uniforms, and a bit of boldness, found in a friend's picture, belonged to everybody"; Tériade 1952, p. 50.

22. Structurally, this painting looks back even further to *Carmelina* (p. 47, fig. 7).

23. Matisse 1947b, pp. 75–76.

24. Pierre Dubreuil's recollection of Matisse's teaching, as remembered in a letter to Gaston Diehl; see Escholier 1956, pp. 80–81. The original stretcher is no longer with the painting.

36 The Moroccans, third state
Issy-les-Moulineaux, November–December 1915

Oil on canvas; 180 × 220 cm (70 7/8 × 86 5/8 in.)
No longer extant

Compositional sketch for *The Moroccans* contained in a November 22, 1915,
letter from Henri Matisse to Charles Camoin. Archives Camoin, Paris.

36a

36b

36a
Compositional sketch for *The Moroccans* contained in
a letter from Matisse to Amélie Matisse, October 25,
1912. Archives Henri Matisse, Paris.

36b
Detail of the lower-right edge of *The Moroccans* (44),
showing the line that Matisse drew on the canvas
prior to its stretching.

36c
Group of Trees at L'Estaque, 1916. Charcoal and pencil
on laid paper; 62.1 × 47.5 cm (24 1/2 × 18 3/4 in.).
Musée National d'Art Moderne/Centre de Création
Industrielle, Centre Pompidou, Paris, AM 1984-41.

36c

IN NOVEMBER 1915, after completing and selling his *Still Life after Jan Davidsz. de Heem's "La desserte"* [**35**], Matisse wrote to his friend Charles Camoin, "I am once again starting another canvas of the same dimensions (i.e., 180 by 220 cm). It's a memory from Morocco. It's the terrace of a small café with idlers listlessly chatting toward the end of the day. You can just see a small white marabout at the bottom, this poor sketch [*croquis*] will not tell you much. The bundle is meant to be an Arab lying on his side on his burnoose, the two hooks are his legs."[1] More than three years earlier, in October 1912, Matisse had written to his wife about his plans for two large *panneaux* of Tangier, which became *The Moroccan Café* [**15c**] and *The Moroccans* [**44**], remarking, "I am also hoping to do two large *panneaux* of Tangier…one represents the terrace of the Arab café and the Casbah with Arabs drinking and playing cards near the end of day with the city in the background."[2] He included compositional sketches [**36a, 15b**], and it seems likely that he refreshed his mind about his idea for *The Moroccans* while writing his 1915 letter to Camoin, which includes a strikingly similar sketch [**36**].

Since Matisse was by his own admission "beginning again," he must have started and then suspended work on the painting—possibly while concentrating on the de Heem composition, maybe even since the summer or fall of 1913, when he had stretched a canvas of a size that he judged inappropriate for the subject. A month after returning to *The Moroccans* in 1915, however, he ran into the very same problem again: the canvas size was not right for what he had in mind. On December 24, he wrote to Marquet that he had suspended work on the painting and, having purchased a new stretcher sixty centimeters wider than the old one, was waiting for it to arrive, saying: "In Issy I've drawn the painting of Morocco on a 2m20 × 1m80 canvas, but I need an extra 60 cm to be comfortable, I'm expecting the stretcher today so that I can get back to it. This painting will help me endure the winter which is truly no fun."[3] Rather than enlarging the canvas, it appears that Matisse began again with a new canvas as well as a new stretcher; in other words, he started again from scratch.[4] In fact, he may have attached a canvas to the studio wall and started painting before the stretcher even arrived, for *The Moroccans* is composed within a drawn rectangle [**36b**] that would have substituted for the one the stretcher provided.

In early December, Matisse had been with Albert Marquet in Marseilles, which was full of soldiers; while there, he made a side trip to L'Estaque, where, clearly thinking of Cézanne, he started a beautiful drawing of a group of trees [**36c**].[5] Its boldness may well have prompted him to take more chances in his attempt to make a painting from an anec-

dotal Moroccan sketch. In any event, when he returned to the task in mid-January, he threw himself into a project whose extreme difficulty became more and more evident. Hence, on January 19, 1916, he complained in a letter to Camoin: "My head has been all unsettled for a month, with a picture of Morocco that I am working on at the moment (2.80 m × 1.80 m), it's the terrace of the little café in the Casbah that you know well. I'm hoping to make it work, but what a lot of trouble. I'm not in the trenches, but I worry anyway."[6]

1. Matisse to Camoin, Nov. 22, 1915, Archives Camoin. Matisse's statement that *The Moroccans* was the same size as *Still Life after de Heem* was formerly thought to be an error; see, for example, Cowart 1990, p. 110 n.4. The problem was solved by the 2008 publication of Matisse to Marquet, Dec. 24, 1915, Wildenstein Institute, Paris.
2. Matisse to Amélie Matisse, Oct. 25, 1912, AHM.
3. Matisse to Marquet (n. 1).
4. We can assume that Matisse had returned to a canvas containing the composition sketched in the Nov. 22, 1915, letter to Camoin and had begun to work on it; there are no indications that the discarded canvas was preserved. Since the artist was in Marseilles by Dec. 1 and probably did not return until mid-Dec., it seems unlikely that he had proceeded very far before he realized that its horizontal dimension needed to be enlarged, probably at the left side of the image.
5. In his letter to Camoin of Dec. 6, 1915, Archives Camoin, Matisse said that he had been in Marseilles for a week.
6. Matisse to Camoin, Jan. 19, 1916, Archives Camoin. The letter has an unusual dating in which the letter *J* stands for the month of January; it also contains a rough sketch of Matisse's recent drawing of trees (36c).

THE YEAR 1916 WAS ONE OF THE WORST for France, bracketed by two of the most horrific battles of World War I. From February 21 to December 15, the Battle of Verdun (fig. 1) was waged less than 150 miles north of Paris. It was the longest on the Western Front, and while over 350,000 French soldiers lost their lives, at its end neither side had won any tactical or strategic advantage.[1] This crushing sense of human loss was compounded by the Battle of the Somme (fig. 2), which began on July 1 and was fought approximately seventy-five miles west of the capital. It was one of the bloodiest offensives of the war, owing at least in part to the debut of the armored tank. When it concluded on November 18, French casualties totaled over 200,000.[2] For those in Paris and its environs, these events were very close to home: indeed, on still nights during the summer and fall, the distant thumping of guns could be heard on the Somme River.[3] Even Issy-les-Moulineaux, where Matisse lived and worked for the majority of the year, had been affected by the war, transforming itself into an industrial center for the military aviation industry. The town's factories worked overtime producing fighter planes, while the parade ground was redesigned as an auxiliary airfield.[4]

The year would also mark Matisse's work on some of the most difficult—or, as he termed them, pivotal—works of his career.[5] For most of the first half of the year, he was consumed by *The Moroccans* (44), likely to the exclusion of much else for at least a part of the time. A painting of monumental scale, the final composition is one that the artist ultimately committed to canvas only after considering it on at least three earlier occasions, beginning with his first trip to Morocco in 1912. Now, in the winter of 1916, against the backdrop of the initiation of the Battle of Verdun and the increasing concern for North African soldiers involved in the war and visible on the streets of Paris, he initiated his epic representation of the place that had etched itself so deeply into his mind. The finished canvas is one of dizzying dimensions and shifting perspectives, built upon layers of fine, delicate colors punctuated with thick, rich blacks and whites, and passages of exposed canvas. Heavy geometric forms seem to levitate within the field of banded rosy light and dark shadow, while the seated figure in the lower-right corner is rooted to the earth by its wide sweeping pose as well as Matisse's solid, rhythmic, and form-building application of paint.

Sometime in the spring, the artist also resumed another long-standing project, a canvas of even larger dimensions, his *Bathers by a River* (46)—a work last recorded in November 1913, when it was painted with a Cubist-inspired palette of various steely grays and blacks. Now, two and a half years later, he transformed it yet again, almost entombing the figures in thick layers of scumbled paint and further confining

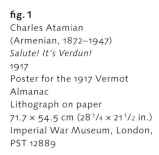

fig. 1
Charles Atamian
(Armenian, 1872–1947)
Salute! It's Verdun!
1917
Poster for the 1917 Vermot Almanac
Lithograph on paper
71.7 × 54.5 cm (28 1/4 × 21 1/2 in.)
Imperial War Museum, London, PST 12889

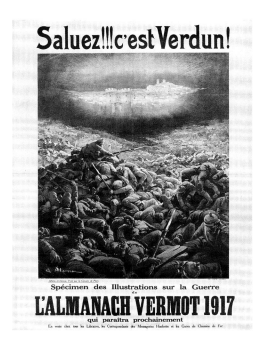

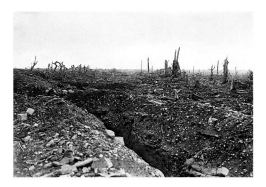

fig. 2
Photograph of a badly shelled main road to Bapaume through Pozières, showing a communication trench and broken trees, during the Battle of the Somme in late summer 1916. Imperial War Museum, London, Q 1086.

them within the rigid structure of a new, geometric composition. Divided vertical bands of black, pale blue, and white contrast with the vital, abstracted zigzags of palms and buoyant rivulets of water to build an austere structure of pulsating planes and forms over the once-idyllic scene. Along with his return to *The Moroccans* and *Bathers by a River*, Matisse resumed two long-standing sculptural projects— his fifth bust of *Jeannette* (42) and third bas-relief state of *Back* (45). Each of these works involved its own complex method of making that built upon and complicated earlier reductive processes of scraping, incising, and elision, as well as additions of fragile medium, to produce fresh distillations of human form through geometric reduction, fragmentation, and abstraction. In all these works—as well as in the equally summative though newly conceived *Piano Lesson* (43) of the late summer and fall—the artist focused on the demanding methods of his "modern construction" on an ambitious physical scale.[6] Matisse required each of these paintings and sculptures, according to Gino Severini, who frequently visited the artist in his studio at this time, to be rigorously "composed, willed, and technically perfect."[7] Reinitiating these paintings and sculptures was a test of skill and conviction, as Matisse told his friend: "One should be able to rework a masterpiece at least once, to be very sure that one has not fallen victim—to one's nerves or to fate." Indeed, the surfaces of his works bear witness to this: they are thick with the trails of repeated reworking and reconsideration, reflection, and adjustment of long-considered, familiar motifs. Together, they function as records of the extraordinary challenge he set for himself and the concrete sign of the great amount of physical effort and time he committed to meet his goals.

While Matisse labored over these works, he chronicled his activities in letters to friends and associates. His words suggest a connection between the challenges facing those at the front and the challenges of his own practice, which he had cast as a struggle of overwhelming dimensions. To his close friend Charles Camoin, who was stationed with a camouflage unit near Amiens, painting portraits of his fellow soldiers, Matisse confided the difficulty of his efforts on *The Moroccans*, allowing, "I'm hoping to make it work, but what a lot of trouble. I'm not in the trenches, but I worry anyway. I congratulate you on being able to work in the confusion where you find yourself."[8] To André Derain, stationed with the Second Heavy Artillery Regiment in Champagne, he equated his overriding sense of tension about his art with larger political circumstances: "Our beautiful, always elusive, profession of painting—which is only beautiful in dreams—the lack of news of my family and the anxiety that comes from the perpetual state of waiting in which we live, the little we know, all they hide from us: with this, you can imagine civilian life during the war."[9] And with Léonce Rosenberg, who had arranged to purchase *The Moroccans* in the late spring and was working as a translator with the Royal Flying Corps, the conflicted artist shared that his paintings were "important things," but:

I can't say that it is not a struggle—but it is not the real one, I know very well, and it is with special respect that I think of the *poilus* who say deprecatingly: "We are forced to do it." This war will have its rewards—what gravity it will lend to the lives even of those who did not participate in it, if they can share the feelings of the simple soldier who gives his life without knowing too well why, but who has an inkling that the gift is necessary. Waste no sympathy on the idle conversation of a man who is not at the front. Painters, and especially me, are not clever at translating their feelings into words—and besides a man not at the front feels good for nothing.[10]

Back in December 1914, when faced with his rejection from military service, Matisse had asked his friend and patron Marcel Sembat how he might still serve his country; the advice he received, which was "to continue to paint well," was more than likely a disappointment.[11] He was nevertheless inspired to put his work—or, more precisely, the profit from sales of his work—in the service of the nation, selling prints in 1915 to support shipments of food and other living essentials to the civilian prisoners of his hometown of Bohain-en-Vermandois (34) as well as small packages

of necessities to fellow artists and friends in combat. In 1916, as the Parisian art market began to reawaken, more opportunities to support the war effort presented themselves. In May, for example, he participated in a benefit exhibition at the Galeries Georges Bernheim (fig. 3), donating a painting to be sold for the Association for the Blind Soldiers' Home, an organization that provided renewable annual allowances to injured servicemen.[12]

In all these instances, Matisse employed existing paintings and prints to support his wartime initiatives without altering his artistic course. While the works he produced in 1916 make no direct reference to the war in their subjects or styles, they were indeed physically and mentally challenging to produce, and thus exist as Matisse's own kind of artistic formulation of response. *The Moroccans, Bathers by a River, The Piano Lesson, Jeannette (V),* and *Back (III)* are unified in their purpose and the seriousness of their demands upon the artist—the same characteristics that the critic Noël Clément-Janin used to describe Matisse's Bohain series in his sweeping 1917 survey on wartime printmaking. In his words, it was precisely their "inspiration, destination, and process" that put Matisse's prints incontestably within the domain of wartime French art.[13] And these same issues, whether self-imposed or inspired in part by the larger national dialogue on cultural production during wartime, were at the center of Matisse's purposeful reengagement with the challenge of continuing to "paint well."[14]

A number of these issues are paralleled in a remarkable group of still-life paintings that Matisse initiated after *The Moroccans* was well underway, probably around the time that he also resumed *Bathers by a River.* The canvases are generally singular in their focus—vases of ivy, a bowl of oranges (38), a table in a garden (40). Matisse might have approached them as a relief from the weight of the long-term paintings and sculptures, or as opportunities, like the monotypes he continued to make (39c–e, 41d–l), to explore a particular formal or compositional idea before returning to his more complicated and larger-scale works.[15] *The Ivy Branch* (fig. 4), for example, is a canvas of modest subject and size that, in its mutually reinforcing contrasts of dark and light color, thick and thin paint, and pattern and emptiness, echoes, on a reduced scale, some elements of *The Moroccans.* This and others canvases made in the summer, expecially *Still Life with Plaster Bust* (fig. 5) and *Sculpture and Vase of Ivy* (fig. 6), are ones that the Danish writer Axel Salto would later identify from his visit to Matisse's studio in 1916 as "supernatural interiors . . . in touch with Cubist theories."[16] In all these works, as well as his fall still-life paintings of apples (39.1–2), *Still Life with Nutcracker* (fig. 7), and *Gourds* (41), Matisse demonstrated his freedom from the more doctrinaire tenets of Cubism that had earlier informed his largest, most complicated still life, *Still Life after*

fig. 3
Lucien Lévy-Dhurmer
(French, 1865–1953)
For the Blind Soldiers' Home
1916
Poster for a benefit exhibition
held May 10–June 1, 1916,
Galeries Georges Bernheim, Paris
Imperial War Museum, London,
IWM PST 11137

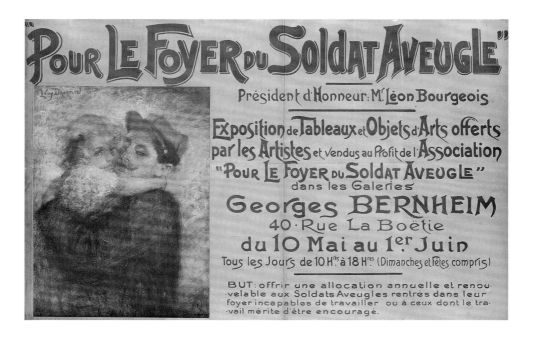

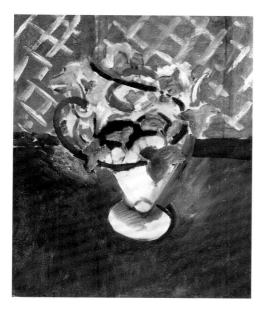

fig. 4
The Ivy Branch,
May 1916
Oil on canvas
60 × 50 cm (2⁵/8 × 19¹¹/₁₆ in.)
Location unknown

fig. 5
Still Life with Plaster Bust,
July 1916
Oil on canvas
100 × 81.3 cm (39³/8 × 32 in.)
The Barnes Foundation,
Merion, Penn., BF313

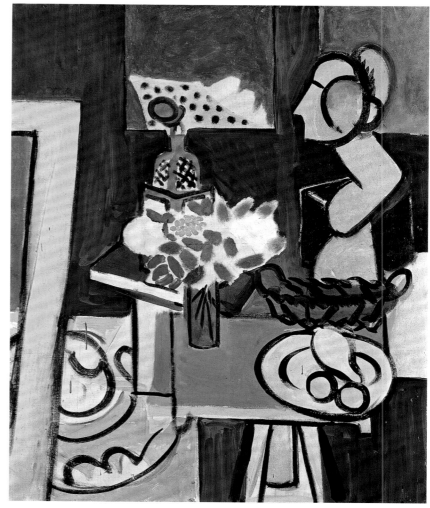

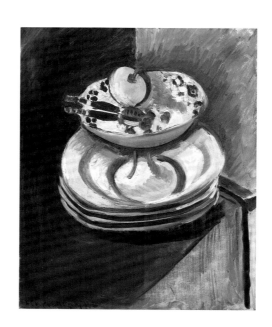

fig. 6
Sculpture and Vase of Ivy,
summer–fall 1916
Oil on canvas
60 × 70 cm (23⁵/8 × 27⁹/₁₆ in.)
Musée des Beaux-Arts et
d'Archéologie, Besançon

fig. 7
Still Life with Nutcracker,
fall 1916
Oil on canvas
61 × 49.5 cm (24 × 19¹/2 in.)
Statens Museum for Kunst,
Copenhagen, Collection J. Rump,
KMSr84

fig. 8
Cover of the catalogue to
Triennale: Exposition of French Art,
March 1–April 15, 1916
Ryerson and Burnham Libraries,
The Art Institute of Chicago

Jan Davidsz. de Heem's "La desserte" (35), in which a compositional grid and heavy outlining of forms produced a solid pictorial structure.[17] In his later still lifes, Matisse loosened his approach and retained some of the heavy outlining of forms and planar structure of his earlier pictures. Within the confines of these smaller-scale works, he contrasted this method—as he did in his large-scale canvases—with open, unbounded forms and a near-sculptural handling of paint that created a sense of movement, depth, and dispersion across the surface.

Matisse's need to paint rigorously and well, despite the war, was not his only artistic obligation in 1916. He was also aware of the necessity to participate in the reinvigoration of France's cultural life.[18] According to their friend Juan Gris, both Matisse and Picasso felt a sincere duty to help support the French art market, especially since so many of their works were in foreign collections.[19] Over the course of 1916, Matisse participated in numerous exhibitions of varying size and character, from large official Salons to small, fraternally organized presentations. Being occupied with a number of large, complicated, and concurrent projects necessarily meant, however, that he had little time, at least during the first half of the year, to make and show new easel-size paintings. And the still lifes he did make beginning in the early summer were either reserved before completion, or quickly purchased by the dealers Bernheim-Jeune, Rosenberg, or Walter Halvorsen, or by such collectors as Alphonse Kann and Dikran Kélékian.[20] All this left Matisse with little if any recent work to present publicly. In the past, the artist often elected to display works from a variety of periods in exhibitions, and while he could have continued this practice now, he chose instead to show available paintings and drawings from his most recent experiments, ones that he made between 1913 and 1915 and that were either still reserved for a particular patron or owned by himself or Bernheim-Jeune.[21] For instance, in March he featured his 1914 *Interior with Goldfish* (24), still reserved for Shchukin, at the *Triennale: Exposition of French Art* (fig. 8).[22] The first major Salon since the beginning of the war, the presentation included contemporary artists such as Pierre Bonnard, Albert Marquet, and Édouard Vuillard, as well as those of the previous generation, such as Degas, Monet, and Auguste Rodin. Later that month, Matisse also took part in a small exhibition at the fashion house of Germaine Bongard, sister of couturier Paul Poiret and a designer herself, who offered her place of business to host cultural events. A display of black-and-white drawings, *Noir et blanc,* was organized by Amédée Ozenfant, artist and editor of the avant-garde journal *L'Élan,* and featured the work of Severini, Max Jacob, Fernand Léger, Jacques Lipchitz, Amedeo Modigliani, and other avant-garde artists. Matisse likely presented a still-life drawing.[23]

These two shows, both from March 1916, also give a sense of the wartime landscape in which Matisse exhibited and produced his work, one characterized by a wide range of artistic identities and stylistic polarities, all of them nationally and ideologically charged. As Kenneth Silver showed, what was underway was a patriotic struggle that produced conflicting critical responses to naturalistic, Cubist, and neo-classical styles.[24] One particularly overt position was represented by the *Triennale.* Its catalogue was written by Clément-Janin, who trumpeted French artists' work as part of a nationalistic imperative: "All have set to work…to prepare one of the noblest victories which is that, in carrying out their masterpieces, they will increase national reputation.…The renewal of artistic preoccupations when Attila's horde is 90 kilometers from the City of Light…has something very noble to it."[25] Bongard's *Noir et blanc,* which was recognized in the press as the "awakening of the cubists," represented another position.[26] In his journal, Ozenfant had formerly ridiculed the worst xenophobic reactions to avant-garde art, such as those represented by Clément-Janin, but was motivated nonetheless in his conviction that art was essential to the nation's morale.[27] Bongard's exhibition reinvigorated the earlier debate about the roots of Modernism, and especially Cubism, which detractors simplistically identified with the German enemy and accused of being *boche,* a pejorative French term for "German" (fig. 9).

Given this polarized environment, it is worth noting that Matisse, regardless of whether he participated in a more conservative or avant-garde Parisian venue, chose to exhibit works that would be considered avant-garde, and more specifically, Cubist. For instance, in June he joined seventeen other avant-garde artists including André Derain, Léger, Jean Metzinger, and Picasso for an exhibition at the Galerie des Indépendants, which was established in December 1915 specifically to present avant-garde art. Later that month, his work was included at Bernheim-Jeune: there, among figurative paintings by Bonnard, Maurice Denis, Kees van Dongen, and others, he presented three works—*Head, White and Rose* (30), *Goldfish and Palette* (31), and *Still Life with Lemons* (26). Vauxcelles singled these paintings out as being "limed in cubism."[28] In July, under the auspices of Poiret and organized by critic André Salmon, the Galeries Barbazanges presented over 150 works in *Modern Art in France*, better known today as the Salon d'Antin. With the clear anti-xenophobic aim of presenting contemporary art by those not necessarily French, but living in France, the exhibition was the venue in which Picasso debuted his *Les demoiselles d'Avignon* (p. 51, fig. 14). Matisse showed two paintings, an unidentified Moroccan female figure and a still life, as well as a number of drawings.[29] Finally, in November, Matisse joined the first presentation of Lyre et Palette, an aptly named association that organized musical and poetry soirées as well as art exhibitions. In this unconventional atmosphere, Matisse presented *Still Life with Lemons* and an unidentified drawing; Picasso showed two paintings; and the rest of the exhibition was given over to the unexpected complement of figurative works by Moïse Kisling, Modigliani, and Manuel Ortiz de Zárate, and the African and Oceanic sculpture collection of Paul Guillaume.[30] An illustration of the opening by Arvid Fougstedt (fig. 10) shows Matisse's work squarely within the company of Picasso and Modigliani, admired by a lively crowd of Parisian intelligentsia and wealthy patrons who gathered in Montparnasse, the area that had replaced Montmartre for younger artists.

While Matisse's feelings about the war and his place within it might have been less emphatically stated than some—he did not, as far as we know, make illustrations for war posters or other official images, though evidence suggests he did make at least one work as an artist in the military auxiliary—his determined participation in all sorts of Paris exhibitions in 1916 does indicate his desire to be part of the national cultural effort.[31] The style and subject of the works presented are also telling: Matisse consistently chose Cubist works for public presentation—a conflicted style during the war, but one nonetheless still associated with youth, modernity, and action. In addition, his decision to exhibit and publish a number of Moroccan-themed paintings and prints throughout the year suggests his desire to call attention

fig. 9
Jacques Nam (French, 1881–1971). "The Cubists! Fortunately we are here to revive ART!"(published in *La baïonette*, November 23, 1916) The artist shown here, a stereotyped French caricature of a German, stands before a canvas with two *k*s, suggesting the vile quality (*kaka*) of his creation.

fig. 10
Arvid Fougstedt
(Swedish, 1888–1949)
Opening of Lyre et Palette,
1916
Ink on paper
22 × 27.7 cm (8 5/8 × 10 15/16 in.)
Statens Konstmuseer, Stockholm
Matisse's *Still Life with Lemons* (26) can be seen on the right in the background, next to Picasso's *Guitare sur un cheminée*, at center, and two paintings by Amedeo Modigliani on the left. Left to right are Max Jacob, Picasso, Manuel Ortiz de Zárate, Gustaf Hellström, Modigliani, Moïse Kisling, Renée Gros, and H. M. Melchers at the piano.

to the circumstances of North African soldiers in the war and their growing visibility in the streets of Paris.[32]

At the same time, however, it should also be noted that almost none of the works Matisse made in 1916 were shown to the public at this time. Whether more modest still lifes or the monumental *The Moroccans*, *Bathers by a River*, *The Piano Lesson*, *Back (III)*, and *Jeannette (V)*, they were all entirely absent from public discourse. The only appearance, however faint, is in the account of Salto's visit to Matisse's studio, which was published in a Danish journal two years later. *The Moroccans*, *Bathers by a River*, and *Back (III)* were presented as if in a sheltered, fragile existence: "Surrounded by the luxuriant nature which serves to rest and renew him. . . . The warm winds blow through the acacias and the green chestnuts. Or perhaps artillery fire has shattered the house and has made large holes in the garden's pathways. It will take a merciful God to protect this place on the day of reckoning, which now seems so near."[33]

It may be that within the polarized field of French art reception, Matisse preferred to protect his most serious and consuming work from undue criticism or misunderstanding, or that he was even still unsure of it himself.[34] Nonetheless, it would be at least another ten years before the public would have the chance to see even a few of these challenging, pivotal works.[35]

—STEPHANIE D'ALESSANDRO

1. Eksteins 1989, p. 144.

2. For a review of the campaigns of Verdun and the Somme, see Robin Prior and Trevor Wilson, "Eastern Front and Western Front, 1916–1917," in *The Oxford Illustrated History of the First World War*, ed. Hew Strachan (Oxford University Press, 1998), esp. chap. 4, pp. 182–87.

3. Eksteins 1989, p. 139; and Spurling 1998, p. 189.

4. Ibid., p. 180.

5. Matisse, as quoted by Katharine Kuh to Courtney Donnell, typescript dated May 23, 1985, curatorial files, Art Institute of Chicago.

6. For a discussion of *The Piano Lesson* within the context of the national debate on Cubism and Naturalism, see Silver 1989, pp. 34–36.

7. Severini, "La peinture d'avant-garde," *Mercure de France* 121 (June 1, 1917), p. 456. Matisse's words are quoted in Severini's article.

8. Matisse to Camoin, Jan. 19, 1916, Archives Camoin.

9. Matisse to Derain, Feb. 1916, Archives André Derain. For a synopsis of how censorship and propaganda affected and even confused civilian life, see Eksteins 1989, pp. 233–38.

10. Matisse to Rosenberg, June 1, 1916, manuscript department, Musée National d'Arte Moderne, Paris; a copy of the letter also resides in the Alfred H. Barr, Jr., Papers, MoMA Archives. *Poilu* is a French term meaning "hairy one," which by 1916 had become a term of affection for the mud-caked, bearded French soldier; see Eksteins 1989, p. 146. For a related discussion focused on American authors, see Kenneth Gandal, *The Gun and the Pen: Hemingway, Fitzgerald, Faulkner and the Fiction of Mobilization* (Oxford University Press, 2008).

11. Escholier 1960, pp. 96–97.

12. Picasso participated in the exhibition as well. Matisse's painting would be purchased by the collector Dikran Kélékian, who, just weeks later, would also acquire *The Window* (37) and, on Nov. 25, *The Green Pumpkin* (1916; Museum of Art, Rhode Island School of Design). The closeness of dates between the Bernheim benefit and the additional purchase by Kélékian suggests the influence of one acquisition on the other. See Matisse to Rosenberg (n. 10).

13. Clément-Janin 1917; Silver 1989, p. 60 see also entry 33.

14. In this context, there should be noted a June 6, 1916, letter from Léonce Rosenberg (AHM) that is perhaps surprising for its nationalistic, emotional content: "You should not blush, dear friend, for not being among us, by making beautiful things, you are doing more for France than the most heroic of *poilus*! In a century or two—maybe even less—our obscure work will be forgotten, but what you will have done will belong to France's heritage of glory, to that glory that lasts longer than that of battle. You are a soldier of Ideas, incessantly firing from the barricades on the . . . shirkers for Peace, and your paintings are the ramparts of a Verdun of which you are the heroic defender! Yes, war will have widened Life, and swept away—oh, how many—impurities! We shall live again the age of cathedrals, and by the simplicity, nobility and serenity that we will experience once more, we too shall know the path of the Good and the Beautiful!"

15. The still-life paintings that Matisse made beginning in May 1916 are generally smaller-scaled canvases: *The Ivy Branch* and *Still Life with Nutcracker* are both standard size 12; *Bowl of Oranges* number 15; *Sculpture and Vase of Ivy* number 20; *The Green Pumpkin* and *Gourds* number 25. Four paintings are larger: *Still Life with Plaster Bust* is a size 40 canvas; both still lifes of apples (39.1–2) are size 50; and *The Rose Marble Table* (40) is the largest, at size 80.

16. Salto 1918.

17. Bois 1998a, p. 15.

18. For more on the activities of the revived Parisian art market, see Gee 1981, pp. 221–24 ; and Silver 1989.

19. Picasso, as quoted by Gris in a letter to Rosenberg, June 11, 1916, Fonds Léonce Rosenberg, Musée National d'Arte Moderne, Paris, "replied 'that during the war he had not turned down any French art shows lest people thought badly of him. For him, as for Matisse, given their celebrity, this is a plausible reason enough. To refuse to take part in shows here after having so many pictures abroad would look odd.'" Christian Derouet, ed., *Juan Gris: Correspondances avec Léonce Rosenberg, 1915–1927* (Éditions du Centre Pompidou, 1999), p. 30; Cowling 2002, p. 369.

20. See correspondence between Matisse and these dealers in AHM and Dauberville and Dauberville 1995, vol. 1.

21. As a demonstration of Matisse's specific exhibition plan for Parisian shows, in Nov. 1916 he also

participated in *Den franske utstilling I Kunsterborbundet*, organized by Halvorsen. There the artist presented a wider chronological span of his work: in addition to *Interior with Goldfish* (24), he showed *Lemons and Bottle of Dutch Gin* (1896; The Museum of Modern Art, New York); *The Young Sailor (I)* (1906–07; private collection); *Joaquina* (1911; National Gallery, Prague); and *Portrait of Marquet* (1905–06; Nasjonalgaleriet, Oslo); as well as a number of drawings. For more, see Klüver and Martin 1989, pp. 76, 221 n. 3; and Halvorsen, "Utstilling av moderne fransk Kunst 1916, I–IV," *Aftenposten*, Dec. 11–12, 14–15, 1959.

22. The *Triennale* was held from Mar. 1 to Apr. 15, 1916, at the Jeu de Paume and presented the work of 110 artists; the catalogue listed *Interior with Goldfish* (no. 87) as being in the collection of S.I.S. (Sergei Shchukin), whom the war prevented from formally acquiring the work.

23. According to correspondence between Matisse and Félix Fénéon, it is likely that the artist only presented a still-life drawing, although a number of prints were mentioned in relation to the drawings exhibition. Given the connection between Bongard's salon and *L'Élan*, it is possible that the still life Matisse exhibited is the same later published in the journal—*Still Life with Persian Tile* (1915; private collection).

24. Silver 1989. For more on wartime French art, see Shapiro 1976, pp. 138–44; Baldewicz 1980; Green 1987; and Dagen 1996. For a discussion that puts *Bathers by a River* in this context, see Bock 1990.

25. Clément-Janin, "Foreword," in *La catalogue illustré des ouvrages de peinture, sculpture, dessin, gravure, architecture, et art décoratif* (Ilya Lapina, 1916), pp. 15, 17. In this chauvinistic atmosphere, Matisse's *Interior with Goldfish* was singled out by the conservative review *S.I.C.*, which derisively identified it as a mistaken painting of carrots within the otherwise solemn "salon of war"; unsigned note, "Peinture—La Triennale—," *S.I.C.* 3 (Mar. 1916), p. 23. The painting was also resolutely praised by Gustave Kahn, who recognized it from the last Salon but admired nonetheless how its "impression of unity and softness is perfect"; Kahn, "Art," *Mercure de France* 114, 426 (Mar. 16, 1916), pp. 321–22. Rosenberg wrote to Picasso on Mar. 2, 1916 (Archives Picasso, Paris), "Apart from Matisse and a picture by Degas, what is there to make you fall asleep on your feet!"; Cowling 2002, p. 369.

26. Roger Bissière, "Le réveil des cubistes," *L'Opinion* 9, 16 (Apr. 15, 1916), p. 382.

27. See Silver 1989, pp. 50–59, for an in-depth review of *L'Élan*'s position during the war. Conservative critic Louis Vauxcelles accused the exhibiting artists of a weak and insincere presentation that amounted to "avant-garde *pompier* art"; Vauxcelles, Mar. 1916. See also Gee 1981, p. 221. *L'art pompier* is a pejorative late-nineteenth-century term for academic paintings made by such artists as Adolphe-William Bouguereau, which focused especially on large historical or allegorical subjects. For more on the term, see Albert Boime, *Art pompier: Anti-Impressionism, 19th Century French Salon Painting*, exh. cat. (Emily Lowe Gallery, 1974); James Harding, *Artistes pompiers: French Academic Art in the 19th Century* (Rizzoli, 1979); and Pierpaolo Luderin, *L'art pompier: Immagini, significati, presenze dell'altro Ottocento francese, 1860–1890* (Leo S. Olschki, 1997).

28. Vauxcelles, "La vie artistique," *L'Événement* (June 22, 1916).

29. The exact Moroccan paintings exhibited remain difficult to identify. An anonymous review from July 30, 1916, in *Le cri de Paris* opens with a description of a work by Matisse, but the information does not correspond with known works and appears unreliable given the tone: "A young Cubist was looking at an odalisque with an apple-green face, no nose, no mouth, and with hands like rakes, a daring masterpiece by the famous Matisse, the leader, the prince of the Fauves"; see Cow-

ling 2002, p. 369. Still, a critic from *L'Intransigeant* could not help but share nationalistic pride despite the stated goal of the show: "This man Picasso! . . . I am drawn to this large canvas; it overwhelms me, you might say. And Matisse? He is seductive. How could anyone have said of art such as this that it is not French?" "Nos échos," *L'Intransigeant* (July 16, 1916), p. 3.

30. The exhibition was complemented by literary and musical events, and the catalogue included an homage to Erik Satie written by Jean Cocteau and "Le Musickissme" by Blaise Cendrars, dedicated to Satie. See *1er Exposition: Kisling, Matisse, Modigliani, Ortiz de Zárate, Picasso* (Lyre et Palette, 1916); see also Klüver and Martin 1989, pp. 76–77, 222 n. 4.

31. Matisse apparently made a painting of a ruined aqueduct; Stephanie D'Alessandro, conversation with Hilary Spurling, June 26, 2009.

32. In addition to the exhibited works discussed here, *Still Life with Persian Tile*; *Medina Arab House*; *Trellis, Figures, Minaret*; and *Seated Moroccan, Three-Quarter View, with Arms Crossed* were published in *L'Élan* 10 (Dec. 1916). For more on the issue of North African involvement in the war and Matisse's reactions, see pp. 229–30 in this publication; and Silver 1989, pp. 259–60, 263–64.

33. Salto 1918.

34. While we know Matisse had numerous visitors in Issy, few eyewitness accounts mention these works in detail, or at all. One noteworthy exception is Severini (n. 7). Matisse's presentation of these works ten or more years later parallels the decision of other artists of his generation, such as Georges Rouault and Otto Dix, who either exhibited or even produced works on the war in the 1920s. For more on these issues, see Winter 1995, esp. pp. 171–76; and Cork 1994, chap. 10.

35. *Bathers by a River* and *The Piano Lesson* were exhibited in fall 1926. See pp. 351–55 in this publication for more on the reception of these works.

The Window
Issy-les-Moulineaux, late April–May 1916

Oil on canvas; 146.1 × 116.8 cm (57 1/2 × 46 in.)
Signed u.l.: *Henri-Matisse*
The Detroit Institute of Arts, City of Detroit Purchase, 22.14

IN EXHIBITION

ON JUNE 1, 1916, Matisse wrote to the dealer Léonce Rosenberg, reporting that he had recently completed the painting known today as *The Window* [**37**]. He sent along a sketch [**37a**] and description of the work: "Through the window of the drawing room you see the green garden and a black tree trunk—basket of forget-me-nots on the table—a garden chair—a rug . . . red. The picture is green and white with some accents, blue for the forget-me-nots, and red—the painting is as big as the one of goldfish [*Goldfish and Palette*] that you have."[1] The artist was right to compare the painting to Rosenberg's own picture: in addition to dimensions (both were made on standard-size number 80 portrait canvases), the two compositions share one of the artist's favorite subjects, the interior with an open window. Matisse changed the location from his Paris studio to his Issy parlor and carefully recast the familiar objects around the window; we see the small pedestal table, still-life elements, a chair on the right turned toward the room, and a wrought-iron grille that marks the boundary between interior and exterior space. In 1942 Matisse explained his interest in the open window: "My feeling is that from the horizon right into the interior of my workroom only one space exists, and that the boat that is passing by exists in the same space as the familiar objects around me, and the wall with the window does not create two different worlds."[2] In *The Window*, as in *Goldfish and Palette* [**31**], the atmosphere and light from the outside powerfully enters the darkened spaces, merging floors and walls, and flattening deep space and solid forms into single planes. In *Goldfish and Palette*, the artist suggested this effect with the central black band that extends through the entire length of the composition; here he substituted the black with a thick band of white paint, which he adopted as a new physical sign of the powerful, dematerializing nature of light.[3]

Just a month or two earlier, the Danish painters Axel Salto and Jens Adolf Jerichau called on Matisse in Issy, and Salto later published an account of their visit.[4] While *The Window* may not have been fully finished at the time, it surely matches the description of the paintings noted in his account of a group of "supernatural interiors," works that were "stronger, more pure in style, and in touch with Cubist theories."[5] The artist, reported Salto, "experiments here with larger and larger 'displays of force' while surrounded by the luxuriant nature which serves to rest and renew him." The vibrating interplay between vertical bands of light and shadow; solid and empty forms; opaque layers and thinner washes of pigment; and painted and incised lines demonstrates the complex compositional challenges that Matisse set for himself at this time. A remarkable example of his methods of modern construction and process

of reworking, *The Window* is directly connected to a number of works mentioned by Salto and underway at this moment—most particularly, *The Moroccans* [**44**] and *Bathers by a River* [**46**], as well as *The Piano Lesson* [**43**], which the artist began later that summer in the same room.

It is no wonder that Matisse described *The Window*'s palette to Rosenberg, as it is significantly different from many of his earlier canvases, which were composed predominantly of blues, grays, and blacks. Here the artist introduced on a large scale the colors with which he had been experimenting in localized areas of *Still Life after Jan Davidsz. de Heem's "La desserte"* [**35**] and *The Moroccans*: dusky, warm ocher; turquoise; pink; and red-brown. In tandem and in contrast, these earthy colors produce almost hallucinogenic visual effects, especially as counterpoints to the light-filled and vibrant green, bright white, and clear blue of the forget-me-nots, which offer a hopeful note to this canvas, painted during the height of the Battle of Verdun.

To create these impressions, Matisse carefully organized the composition into a series of mutually reinforcing contrasts. He divided it into approximate halves: the left side consists primarily of dominant horizontal lines, and the right side of verticals. This separation parallels the effect of light: the left side (and right foreground) are cast in shadow and composed mainly of turquoise, black, ocher, red-brown, and pink, which the artist carefully applied in layers so that the colors below would show through. The wastebasket [**37f**], for instance, which is strikingly similar to the containers in *Interior with Goldfish* [**24**] and *Branch of Lilacs* [**27**], was made from contours of gray for the sides and top, and black on the bottom. This simple form, reminiscent of the isolated objects in Matisse's monotypes [**22**], rests atop opaque layers of ocher and pink. As a final step, the artist filled the outlined form with turquoise that he brought close to—but never overlapped with—the contours. This open style of construction recalls the optical effect of forms in shadow, where edges appear indistinct and volumes merge and flatten. At the bottom of the canvas, he painted turquoise over black and red-brown over white to suggest the contrast of light and shadow upon the carpet [**37e**]. In contrast to objects in shadow on the left, on the right side and in light areas that exist in close proximity to the viewer, forms are painted more solidly; Matisse added contour lines that generally touch, if not overlap, the colors they contain. In this light-filled area, there is a marked sense of physicality in the tighter, more compressed organization.

The same is true of color: where on the left, he painted thin, open veils of earthy hues, on the right Matisse heavily worked the paint, adjusting media, scraping, and scratching to

37a
Detail of a letter from Matisse to Léonce Rosenberg, with a drawing of *The Window*, June 1, 1916. Archives, Musée National d'Art Moderne/Centre de Création Industrielle, Centre Pompidou, Paris.

37b

37c

37f

37d

37e

37b

Detail of *The Window*, showing a sun-filled area of the window where Matisse experimented with paint and brushwork to suggest the dematerializing visual effects of light.

37c

Detail of the armchair and radiator, highlighting how Matisse applied the paint in layers, working it with numerous tools.

37d

Detail of the chair's armrest, made from various applications of thinned and thick paint, and a network of incised lines employed in order to adjust its position and shape.

37e

Detail of the lower right, where the artist brushed turquoise over black to produce a greater depth and shadow, in contrast to the red-brown over the white.

37f

Detail of the wastebasket, revealing the careful orchestration of ocher, pink, turquoise, gray, and black.

suggest depth and form. In the heavily illuminated grille, for example, he applied thinned, vibrant green directly onto the white ground, running the brush over the canvas to deposit the color in liquid pools as well as in dry strokes reminiscent of a watercolor painting [**37b**].[6] He also experimented with black paint, which he likewise thinned and dried to produce alternatingly dense, velvety, translucent, and resistlike effects as the brush moved across the white ground. In contrast, the radiator and armchair, which are less intensely illuminated than the objects outside the window, are more heavily worked with denser layers of paint [**37c**]. Here the artist added substance to the light, working thick paint with the end of his brush, palette knife, and perhaps other tools that he had on hand in his Issy studio.[7] Under magnification, we can see how he repeatedly adjusted the placement and position of objects, completely recycling the traces of former contours into shadows and other compositional elements. Just above this, he scraped and incised away the original armrest, painted white over some of the area, and scraped into it again while it was wet. He then added black into the wet pigment, blending the color as he moved his brush; after this was dry, he painted the new armrest with more black [**37d**].

There are, in fact, many adjustments throughout the painting, which can be viewed with infrared reflectography and when the canvas is illuminated with transmitted light from behind. We can see, for instance, that the chair back was repositioned and shifted to the right, as were the arm rests and seat; a rectangular form was painted over the middle of the wall on the upper left; and window details (panes, mullions, and the landscape beyond) were scraped away and repainted. Also visible with infrared examination is an X-shaped support under the chair, which links the seat with the contours of the rug. It is clear from these revisions, and from others that can be seen in natural light, that Matisse continually worked the composition, moving one element and then readjusting others, allowing previous contours to generate new elements in an organic way.[8] The artist focused all these efforts on his goal of constructing a painterly approximation of the visual effects that are created when light and matter interact. It was these effects, which Salto may have been describing as "displays of force," that Matisse would continue to pursue on both a small and large scale during the summer and fall.

1. Matisse to Rosenberg, June 1, 1916, manuscript department, Musée National d'Art Moderne; a copy of this letter also resides in the Alfred H. Barr, Jr., Papers, MoMA Archives. *The Window* is likely the first new canvas (as opposed to the long-standing *Bathers by a River*) that Matisse made after a significant period of work on *The Moroccans*.

2. Schneider and Préaud 1970, p. 37.

3. A thoughtful discussion of the use of black as a source of illumination can be found in Isabelle Monod-Fontaine, "A Black Light: Matisse (1914–1918)," in Turner and Benjamin 1995, pp. 85–95; and John Gage, *Color and Meaning: Art, Science and Symbolism* (University of California Press, 1999), pp. 228–40.

4. Salto 1918.

5. Salto's article was translated from the Danish by Scott de Francesco.

6. This style of painting can also be seen more fully in the greens of the melons in the left foreground of *The Moroccans* (44).

7. Under magnification, a variety of widths from scraping and incising were detected; these may represent tools for painting, sculpting, or printmaking. The application of such tools suggests that Matisse borrowed from a number of areas of artistic exploration, much as he did with the other canvases he made at this time.

8. This process recalls the artist's Apr. 1908 comments to Gelett Burgess on the first state of *Back (I)* (4) but is also seen in *Gourds* (41), which he made over the summer. See Inez Haynes Irwin, typescript of diary, Apr. 20, 1908, A-25, box 2, vol. 22, folder 1, p. 107. Inez Haynes Gilmore Papers, 1872–1945, Schlesinger Library, Radcliffe Institute, Harvard University, Cambridge, Mass.

38 **Bowl of Oranges**
Issy-les-Moulineaux, May 1916

Oil on canvas; 54 × 65 cm (21 1/4 × 25 5/8 in.)
Signed l.r.: *Henri-Matisse*
Private collection

IN EXHIBITION

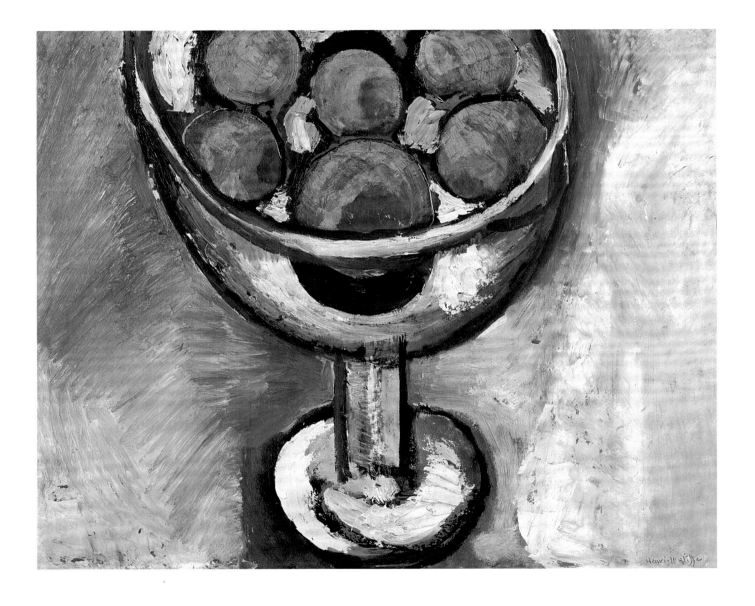

ON JUNE 1, 1916, Matisse wrote to Léonce Rosenberg, recounting a number of canvases that he was working on and had recently completed, stating, "the still life with oranges that you had asked me to reserve for you is finished."[1] It is possible, however, that the art-ist returned to the canvas [38], for its surface reveals a lot of reworking, including the application of new pigment over that which had already dried. The painting would not leave Matisse's studio until late August, going to Bernheim-Jeune, which had outmaneuvered Rosenberg to acquire it.[2] Matisse's second three-year contract with the gallery had expired the previous September—at a bad time for the artist, given the state of the art market during the war. Rosenberg was clearly keen to step into the breach, and Matisse, although remaining friendly with Félix Fénéon at Bernheim-Jeune, was smart enough to try to work both sides.[3]

Painted in the same period as *The Moroccans* [44], *Bowl of Oranges* echoes the dense, compacted parts of that painting's surface, as well as its vivid yellow melons and other circular motifs, existing as another, more compressed remembrance of an idealized, distant place. Here Matisse also drew, as he did in *Still Life after Jan Davidsz. de Heem's "La desserte"* [35], upon his early works. In this case, he borrowed a particular still-life element from the foreground of his *Dinner Table* (1897; private collection), a highly controversial painting that he had used to fulfill a student's traditional graduation requirement of creating an ambitious composition.[4] After painting that work, the artist recalled, "The love of materials for their own sake came to me like a revelation. I felt a passion for color developing within me."[5] This process was reflected in future treatments of this same motif, includ-

ing *Still Life with Oranges (II)* of 1899 (p. 47, fig. 6); *Basket of Oranges* of 1912, "an important" Moroccan still life that was purchased by Picasso [38a]; and this composition.[6] However, *Bowl of Oranges* is far more austere than any of these and also surpasses in gravity all the other still lifes that the artist would create in the same year.

This canvas possesses an effect of colossal size and monumental dignity that results from Matisse's decision to eliminate any details of the setting or background that might establish a sense of scale.[7] The darker area around the foot of the bowl suggests that it may originally have been shown standing on a table, while the dense background pigment that overlaps it at the left gives the impression of having been put there to eradicate as well as to construct. However, the impression of an overall weightiness—of thick pigment seeming to entirely fill a relatively small surface—may disguise the fact that Matisse carefully used different densities of paint to articulate the composition. Most notable, perhaps, is how he reserved the heaviest paint for areas of reflected light while employing a thinner application for dense, dark shadow. This approach, a far cry from the use of a similar facture for light and shadow in the 1914 *Branch of Lilacs* [27], follows traditional practice but in an exaggerated manner, producing a solidified light that fills up the empty spaces between the fruit, whose contours are incised in two instances. The two highlights around the foot of the cup are overlapping crescents, one with the surface of gypsum and the other of mortar. The left side of the painting, hatched with a coarse brush, contrasts with the seemingly troweled right side, whose layering of viscous over dry areas of pigment reminds us that Matisse was concurrently doing the same with plaster, as he was at work on his bas-relief *Back (III)* [45].

Apollinaire, who had found sensuality in the equally severe *Portrait of Madame Matisse* (p. 148, fig. 9), saw a radiance in *Bowl of Oranges* that inspired his famous pronouncement, "If the work of Henri Matisse had to be compared to something, it would have to be the orange. Like the orange, his work is the fruit of dazzling light."[8] The reason that these fruit dazzle is that they are embedded within areas of modulated silver-gray pigment that, through the process of optical assimilation, is slightly tinted by their orange and yellow hues. The cup itself recalls a silver Byzantine chalice admired by Matisse, who had proclaimed that he understood Byzantine painting after he stood "in front of the icons in Moscow."[9] The chalice had been acquired in 1912 by Royall Tyler, a collector of Byzantine art and friend of Matthew Stewart Prichard, who saw much of the artist during World War I.[10] Matisse would have fully understood that it was a sacred object, pursuing that

association in his painting. However, the gritty gray pigment also gains a contemporary, martial significance when we remember that the Battle of Verdun was in progress while it was being applied. The color gray, which had been in abeyance since Matisse's canvases of 1913–14, would soon give way to bright, prismatic color in two still lifes of apples [39.1–2], only to return with even greater force in two of the great canvases of the summer and early fall, *The Piano Lesson* [43] and *Bathers by a River* [54]. If Matisse did return to *Bowl of Oranges* after June, he would have been revising it while at work on these two paintings, as well as *The Moroccans* and *Back (III)*. Despite its modest size, it possesses the monumentality of these much larger works.

1. Matisse to Rosenberg, June 1, 1916, manuscript department, Musée National d'Art Moderne; a copy of this letter also resides in the Alfred H. Barr, Jr., Papers, MoMA Archives.

2. On Aug. 24, 1916, Félix Fénéon wrote to Matisse (AHM): "We'll purchase your *Coupe d'oranges* 15 fig. (0,54 × 0,62) n°20612 from you for 900f, keeping for you 1/4 of the potential profit. The photographs for you and for us have arrived. Would you pick yours up when you have a chance. My sincere congratulations on this new painting." The work was photographed in Oct. 1916, and on Nov. 10 Bernheim-Jeune sold it to Matisse's former pupil Walter Halvorsen (Dauberville and Dauberville 1995, vol. 1, pp. 554–55, cat. 157).

3. Matisse signed a third contract with Bernheim-Jeune, in the form of a letter of Oct. 19, 1917, in which he agreed not to sell in-process paintings to any third party but gained the right to sell completed works to other dealers provided they were sold at the agreed Bernheim-Jeune prices plus 30 percent. Barr 1951, pp. 553–55, reprinted all five contracts between Matisse and Bernheim-Jeune, while Spurling 2005, p. 163, briefly touched upon this sensitive situation. See also Dauberville and Dauberville 1995, vol. 1, pp. 34–36.

4. Matisse recalled the controversy over this painting in Guenne 1925, pp. 4–5.

5. Ibid., p. 5.

6. Matisse to Pierre Matisse, Feb. 1945; Cowart 1990, p. 66 n. 8. The fruit bowl from *The Dinner Table* also reappears in *Harmony in Red (The Red Room)* (p. 84, fig. 17), while a bowl closer to—and perhaps identical to—that in the 1916 painting appears in at least three early paintings made around 1900; see *Sideboard and Table* (1899; private collection) and *Still Life with Blue Tablecloth* (1900/02; The State Hermitage Museum, St. Petersburg).

7. Barr 1951, p. 189.

8. Apollinaire, "Henri Matisse," in *Matisse Picasso*, exh. cat. (Galerie Paul Guillaume, 1918), n.pag.

9. Matisse 1947a, p. 23.

10. Labrusse 1996, pp. 299–309; and Cowling 2002, pp. 208, 354 n. 3.

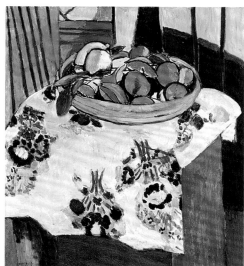

38a

38a
Basket of Oranges, 1912. Oil on canvas; 94 × 83 cm (37 × 32 5/8 in.). Musée Picasso, Paris.

39.1 Apples

Issy-les-Moulineaux, late July–November 1916

Oil on canvas; 116.9 × 88.9 cm (46 × 35 in.)
Signed l.r.: *Henri-Matisse*
The Art Institute of Chicago, gift of Florene May Schoenborn
and Samuel A. Marx, 1948.563

IN EXHIBITION

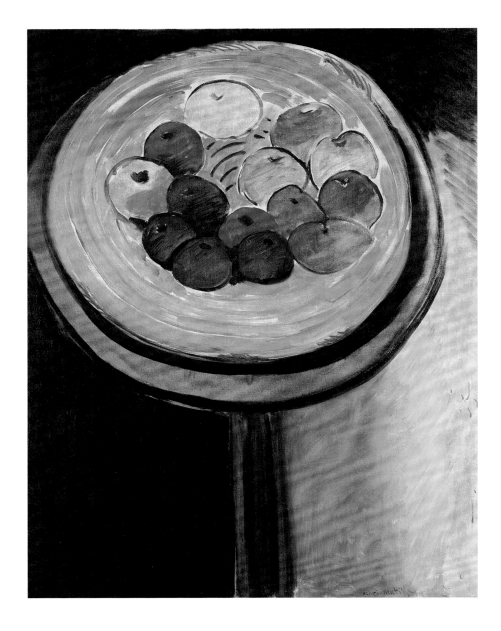

39.2 Bowl of Apples on a Table
Issy-les-Moulineaux,
late July–November 1916

Oil on canvas; 114.9 × 89.5 cm (45¼ × 35¼ in.)
Signed l.l.: *Henri-Matisse*
Chrysler Museum, Norfolk, Virginia;
gift of Walter P. Chrysler, Jr., 71.515

IN EXHIBITION

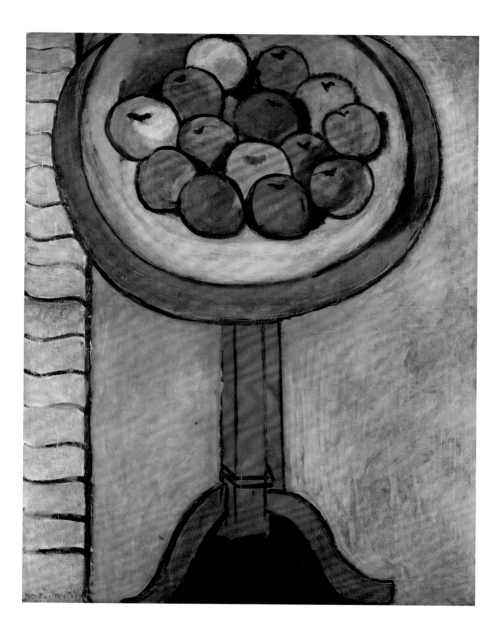

THE LOUIS XVI table in this pair of still lifes [**39.1–2**] also appears in *The Window* [**37**], where it supports not a large terracotta bowl of apples but a delicate basket of forget-me-nots. That painting was completed by the end of May 1916, by which time Matisse had made considerable progress on—and possibly also completed—*Bowl of Oranges* [**38**]. By mid-August, he had painted *The Rose Marble Table* [**40**], with three green apples, and was probably still working on *The Moroccans* [**44**], to which he had added a still-life section with melons early in the year. Since *Apples* and *Bowl of Apples on a Table* were not photographed until November, it seems reasonable to infer that they were made in the late summer or fall of 1916.[1] *Gourds* [**41**] was painted in the fall, but there were other still lifes besides, including *Sculpture and Vase of Ivy* (p. 265, fig. 6). Moreover, Matisse made many monotypes of fruit during the war years, including two that share features with the two still lifes with apples.

Not since 1911 and 1912 had the artist pursued still-life painting in this way. Perhaps it was the large and intricate Cubist *Still Life after Jan Davidsz. de Heem's "La desserte"* [**35**], painted late the previous year, that prompted him to persist with this subject in a less doctrinaire manner. Possibly, these images of plenty offered a palliative during the dark days of World War I. If that was Matisse's aim, the paintings of apples were particularly successful, for they are the most vivid and luminous of all. These two canvases are identical in size as well as subject and form a pair. Like Matisse's earlier companion works, one canvas is more immediate and quickly painted, and the other is more considered and slowly revised. Yet the forms taken by the immediate and the considered vary in each pair of works that the artist made. Hence, what we find here is not the contrast of fresh naturalism and severe abstraction—seen, for example, in the Notre Dame pictures [**23, 23d**] or the portraits of Marguerite from 1914 [**30, 30a–d**]. It seems to be, rather, the contrast of alternative modes of perception and realization that characterizes his treatments of imaginary subjects such as *Le luxe* [**2.1–2**]. It may be this association that translates the two still lifes from the world of quotidian reality to something fantastic and apparitional.

As infrared examination [**39a**] reveals, Matisse painted *Apples* directly, without changes, on top of a simple multicolored sketch that he had drawn with a brush. He set down a thin brown circle for the table and presumably another for the bowl that is now covered by a black shadow; both fade away at the distant edge. The artist used purple-brown lines for the fruit and for the concentric circles on the bottom of the bowl. He later covered this area with turquoise and reinforced the lines

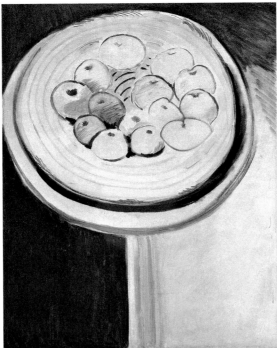

39a

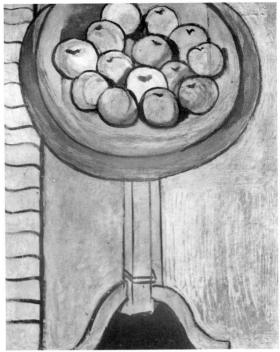

39b

39c

39d

39e

39a
Infrared reflectogram of *Apples*, showing how Matisse laid the composition down directly onto a painted sketch, without making changes.

39b
Infrared reflectogram of *Bowl of Apples on a Table*, revealing the substantial changes made to the position of the bowl.

39c
Fruits on a Moroccan Plate, 1914/15. Monotype on chine collé; image: 5.7 × 15.7 cm (2 1/4 × 6 3/16 in.); sheet: 17.8 × 27.5 cm (7 × 10 13/16 in.). The Museum of Modern Art, New York, Abby Aldrich Fund, 1954. In exhibition.

39d
Three Apples, 1914/15. Monotype on chine collé; image: 9.9 × 14.7 cm (3 7/8 × 5 3/4 in.); sheet: 23.7 × 28 cm (9 5/16 × 11 in.). Private collection.

39e
Three Apples and Bowl, 1914/15. Monotype on chine collé; image: 6.5 × 9 cm (2 9/16 × 3 9/16 in.); sheet: 27.9 × 19 cm (11 × 7 1/2 in.). The Allen Memorial Art Museum, Oberlin College Friends of Art Fund, 1949, AMAM 1949.76. In exhibition.

39f

39f
Detail of the upper-left edge of
Bowl of Apples on a Table, show-
ing the tracks left by Matisse's
stiff-bristled brush as he pulled it
through the paint.

with black, as he did for the contours of
the apples.

Starting at the rim of the bowl, Matisse
sketched an ocher line spiraling inward and
then filled in most of its interstices with con-
centric circles of pinkish ocher, using more
of his liquid paint for the long strokes than the
shorter ones. He appears to have laid in the
fruit in a simple, straightforward way, using
single, subtly mixed colors. The superimposed
shadows on some of the apples are heavier
layers of the same color, but there are occa-
sionally highlights in hues borrowed from
adjacent pieces of fruit. It is worth noting that
Matisse may have painted the three red
apples at bottom center before sketching in
the rest of the fruit, as they do not appear to
have preliminary outlines. If so, he likely
worked his way up from that point, which may
account for the manner in which the compo-
sition seems to disperse as it moves outward,
with the apples appearing increasingly less
round and substantial.

The artist also introduced small clusters
of hatched, directional marks at the top
and bottom of the bowl, which heighten
the sense of spinning introduced by the
concentric ocher bands. These marks bear
comparison with those in two monotypes
of apples on a Moroccan plate, one of them
shown here [**39c**]; this suggests that they
may have been made at the same time as
Apples.[2] This possibility is especially intrigu-
ing because Matisse was concurrently
working on *The Moroccans* and may also
have conceived of these paintings as
"souvenir[s] of Morocco."[3]

Beneath the bowl in *Apples*, a blotchy red
stain falls down the painting, partially dis-
guising the pedestal of the table. To its right,
the red changes into ocher, yellow, and black,
producing green as the latter two colors mix
at the upper right; together, these shifting
hues offer a sense of golden light entering the
picture from the lower right, casting a spot-
light on a table surrounded by a black as
dense as that which Édouard Manet frequently
used in the 1860s. Manet's black, Rainer
Maria Rilke wrote in 1907, "has the effect of a
light being switched off and yet still stands
opposed to the other colors as if coming from
some other place."[4] That is precisely the effect
of Matisse's painting, whose switch from
warm yellow to pitch darkness, mediated by
a strip of more intense color, recalls the
bisected background of such works by Manet
as *Portrait of Zacharie Astruc* (1866; Kunsthalle
Bremen). Matisse compared *The Moroccans*
to that canvas, commenting on its "blunt lumi-
nous black," and saying, "Doesn't my paint-
ing . . . use a grand black, which is as luminous
as the other colors in the painting."[5]

Infrared examination also reveals that there
was at some point a lot of black, among other
colors, around the table in *Bowl of Apples on
a Table* [**39b**]. Later the artist condensed it into
a small glossy pyramidal shape between the
legs that registers almost as a hole or cavern.
Matisse needed this element to offset the
greater visual weight at the top edge, which
was caused by the heavier treatment of the
bowl of fruit. (Speaking generally, he said:
"I used black as ballast to simplify the con-
struction."[6]) Indeed, the work encourages us
to move our vision up and down between
these negative and positive poles, even pro-
viding a ladder at the left edge in the form
of an abstracted louvered door.

That left edge itself has a rough, distressed
quality that Matisse created by building up a
heavy layer of thick white paint beneath the
turquoise and vigorously scratching it with
the stiff bristles of his brush [**39f**]. While it is
possible that something was obliterated here,
that was surely the case on both sides of the
table, especially the right. There vertical marks
of wiping and scraping are ubiquitous, but
even scientific examination does not tell us
what precisely was erased. One exception,
however, is visible to the naked eye: Matisse
painted over his signature in the bottom-
right corner, tucking it into the bottom left.
However, we can see multiple traces of earlier
color applications, notably areas of black,
green, and ocher, which suggest that the art-
ist may have first attempted a background
treatment similar to that of *Apples*. It is clear
that he repeatedly reconsidered the shape of
the bowl, especially its position in respect to
the top edge of the painting. In fact, both
visual inspection and infrared examination
indicate that the vessel was initially smaller

and positioned higher in the painting, with a
larger segment sliced away: the red flash of
color in the top-left corner conceals the
change. We can also notice that Matisse
brought the bowl down, enlarging it at the
base and narrowing it at the top. But he did
not adjust it on the table, so that it appears to
protrude beyond the invisible upper edge,
giving a crescent shape to the exposed table-
top that balances the arched spread of the legs.

What that flash of red at the upper left
originally denoted is impossible to tell. The
dark verticals within the bowl, however,
present an easier challenge. Since they fall
over as well as behind the outermost fruit
on both sides, we can deduce that they are
almost certainly not traces of an earlier motif,
but rather compositional guides that helped
Matisse shape the depth of the bowl and
orchestrate the placement of the circle of
apples within the vertical geometry of his
painting. The result is that Matisse replaced the
casualness of the arrangement of fruit in *Apples*
with orderly compression. Just as that casual-
ness may follow his own earlier monotypes
[**39c–e**], this compression perhaps responds to
that of the crowded Cézanne still life that he
owned (p. 147, fig. 7). Even the small, open
space of *Apples* has been surrendered, filled in
with a dark turquoise apple. It hardly needs
saying that apples were especially associated
with Cézanne and, therefore, that there may
be here an element of homage to the artist
whom Matisse esteemed above all others. But
soon after completing these paintings, he
would turn from Cézanne the colorist to the
more somber Cézanne of works dominated
by steel grays, as he painted *Gourds* and car-
ried *Bathers by a River* closer to its conclusion.

1. One of the still lifes, at least, was seen in the Issy
studio by Albert Huyot, who wrote to Matisse, "How
are you and are you still working a lot; how is painting
going? The still life with apples impressed me with its
beauty and how are you coming with the large painting?"
Unfortunately, this letter cannot be dated more pre-
cisely than somewhere between July 23 and Dec. 13, 1916,
AHM.
2. These are customarily assigned to 1914 (D342–43)
but are not dated, and show a similiar vessel. The mono-
types were made in Paris, the paintings at Issy.
Therefore, the Moroccan plate would have had to be
transported across Paris, unless Matisse owned more
than one of them.
3. Matisse to Charles Camoin, Nov. 22, 1915,
Archives Camoin.
4. Rilke to Clara Westhoff, Oct. 14, 1907; Rilke,
Letters on Cézanne, ed. Clara Rilke, trans. Joel Agee
(North Point Press, 2002), p. 77.
5. Matisse 1946.
6. Ibid.

40 **The Rose Marble Table**
Issy-les-Moulineaux, August 1916

Oil on canvas; 146 × 97 cm (57 1/2 × 38 1/4 in.)
Signed l.r.: *Henri Matisse*
The Museum of Modern Art, New York, Mrs. Simon Guggenheim Fund, 1956

IN EXHIBITION

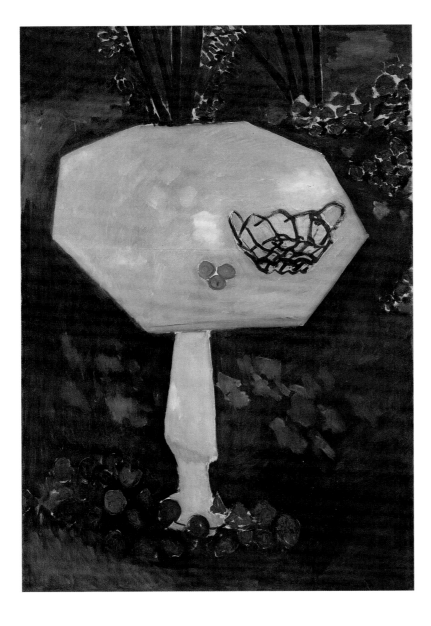

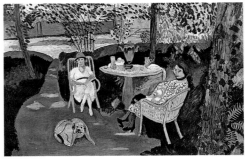

40a

40b

40c

40a
Tea in the Garden, 1919. Oil on canvas; 140.3 × 211.5 cm (55 1/4 × 83 1/4 in.). Los Angeles County Museum of Art, bequest of David L. Loew in memory of his father, Marcus Loew.

40b
Juan Gris (Spanish, 1887–1927). *Still Life with Fruit Bowl*, 1916. Oil on canvas; 60.3 × 73.3 cm (23 3/4 × 28 7/8 in.). Private collection. (Formerly in Matisse's collection).

40c
Detail of the apples in *The Rose Marble Table*, illustrating the area between them that the artist left unpainted.

MATISSE HIMSELF SOLD *The Rose Marble Table* [**40**] to Alphonse Kann in 1917, and it has traditionally borne that date.[1] However, on August 20, 1916, Juan Gris reported in a letter to Léonce Rosenberg: "I received your note (sent by pneumatic dispatch) the day of your departure but I haven't heard since if you arrived safely. I went to Matisse's and I saw a very beautiful painting, the *guéridon* in the garden. It's solid and sensitive and much more human than other things he has done."[2] It is difficult to know what other painting this could possibly have been; therefore, *The Rose Marble Table* turns out to be not an example of the softer naturalism that began to infuse Matisse's art in 1917, but a precursor to it. As a consequence, it belongs to the series of great 1916 paintings of fruit on tables, preceded by *Bowl of Oranges* [**38**], completed in May, and contemporary with *Apples* [**39.1**], *Bowl of Apples on a Table* [**39.2**], and *Gourds* [**41**], made in the late summer and fall.

The table illustrated in this painting sat in the garden at Issy, most likely on a path not far from the studio, as we see it in *Tea in the Garden* [**40a**]. The comparative lack of foliage in *The Rose Marble Table* suggests that Matisse wished to focus sharply on the central motif, as he did even more stringently in the two still lifes with apples. Compared to those vibrantly colored works, *The Rose Marble Table* is an ode to melancholy. Recent cleaning has improved its previously somber mood, yet it retains a muted tone that contributes to its qualities of silence and isolation. It may be a rare instance of Matisse's art reflecting the impotence he felt, as the Battle of Verdun came to a climax in July, at not being a participant.[3] But if we find more respite than resignation in this painting, we will welcome the coincidence that a similar tipped-up table with a geometric top appears in a fifteenth-century representation of a paradisal garden.[4]

The artist, however, had another painting of a table much closer at hand. Gris, who so admired this canvas in August 1916, decided to give Matisse *Still Life with Fruit Bowl* [**40b**], which he had painted that year.[5] Whether this was before or after seeing *The Rose Marble Table* we do not know, but the two small circles in the foreground, which represent fruit, do correspond to the tiny apples in Matisse's painting. The recipient, however, was less than thrilled: he apparently thought little of the painting and had cooled toward the artist as well.[6] He certainly had cooled toward Gris's brand of Cubism, which had so engaged his interest in earlier works such as *Head, White and Rose* [**30**] and *Still Life after Jan Davidsz. de Heem's "La desserte"* [**35**], and had thoroughly digested Cubism in his monumental 1916 works, *Bathers by a River* and *The Moroccans*. Indeed, *The Rose Marble Table* and its companion still lifes of apples are his least Cubist works of that year.

The picture, painted on a tall canvas, is significantly larger than any other 1916 still life.[7] It is identical in size to *Composition* [**34**], whose clarity and reticence it shares, making the two works seem almost a pair. Like that work, it was largely drawn in before paint was applied to the surface of the canvas. It is evident that Matisse introduced the table with charcoal, for the medium remains visible around its edges, most conspicuously in the line that separates the narrow front from the top surface. The artist also allowed his preliminary charcoal drawing to indicate the shadows cast by the openwork basket, smudging it to tone the bare canvas; however, that basket and the three apples beside it sit neither on the table nor on the surface. Rather, these elements retreat to become part of—or, better, interruptions in—a membrane that is simultaneously a horizontal table and a vertical canvas.

To this end, ever attentive to detail, Matisse did not tone the sliver of ground visible between the apples [**40c**], which gives them space to expand visually; instead, he used the charcoal to slightly darken their green color so that they occupy the same plane as the complementary pink of the table. The darker, turquoise leaves of the ivy seem similarly impressed into openings in the rich, Van Dyck brown earth. The artist variegated both the table and the surrounding garden with loose daubs and patches of paint, adding white to the pink and brown, joining them as recipients of the thin, dappled sunlight that falls through the surrounding trees. Even more striking, however, is the visual separation of these elements: the solid table seems less substantial than the earth around it. Just as the basket and apples occupy absences in the surface of the table, the table itself appears to be an intangible, cutout shape, almost an absence within the dense, dark ground. And yet these qualities of simplification and condensation are bonded to the painting's evocative representation of a real table in a real garden, the abstraction and the naturalism seeming indivisible.

They were to be divided, though. After painting this picture, Matisse gradually pushed naturalism aside in the still lifes that followed in 1916, giving yet greater rein to formal grandeur. It would not be until a year later that, embarking upon a program of landscape painting, he began to turn the balance in the opposite direction, with enormous consequences for the future of his art.

1. The 1917 date goes back to Matisse's first retrospective of 1931 (Georges Petit 1931, cat. 39), an exhibition with which the artist was not much involved. Amélie Matisse told Alfred H. Barr, Jr., that she remembered the painting having been taken to the quai Saint-Michel studio after the summer of 1917, and it appears on the wall there in the right panel of the Three Sisters Triptych (1917; Barnes Foundation, Merion, Penn.);

see Barr 1951, p. 193 n. 6. This information reinforced the acceptance of a 1917 date, although there could have been a good reason for moving the painting more than a year after it had been painted, and despite Diehl 1954, cat. 78, subsequently having dated it to 1916.

2. Gris to Rosenberg, Aug. 20, 1916, Fonds Léonce Rosenberg, Musée National d'Art Moderne. Although Gris used the term *guéridon*, which is now commonly used to refer to a circular pedestal table, it can denote a table with a top of any shape. In any case, Gris, as a Spaniard, may not have been precise in his French furniture vocabulary.

3. Matisse to Rosenberg, June 1, 1916, Fonds Léonce Rosenberg, Musée National d'Art Moderne. See Spurling 2005, pp. 175–82, for more on Matisse's low mood in this period.

4. See Elderfield 1978, p. 213, fig. 100. It is not known whether Matisse would have been familiar with the c. 1410/20 painting by the Upper Rhenish Master now in the Städel Museum, Frankfurt am Main, or with a comparable work, but it is by no means out of the question, especially given his northern background.

5. The painting, known to Matisse as *La pipe sur la table*, is dedicated "A Henri Matisse, Juan Gris 1916."

6. This information comes from a Nov. 8, 1957, letter from Pierre Matisse to Joseph Pulitzer; many thanks to Emily Rauh Pulitzer for sharing this document and to Camran Mani for bringing it to the attention of the authors. For Gris, *Still Life with Fruit Bowl* may have been something of an homage and, more probably, a token of thanks for Matisse's attempts to help him financially in 1914–15. See Spurling 2005, pp. 160–65.

7. The canvas was extended in size at the top but the join is crenellated, a professional technique that Matisse would hardly have attempted himself. Moreover, the commercially applied ground would have concealed it; its present visibility, in raking light, seems to be a result of the canvas having been relined.

41 Gourds
Issy-les-Moulineaux, summer–fall 1916

Oil on canvas; 65.1 × 80.9 cm (25 5/8 × 31 7/8 in.)
Signed and dated l.l.: *Henri-Matisse 1916*
The Museum of Modern Art, New York, Mrs. Simon Guggenheim Fund, 1935

IN EXHIBITION

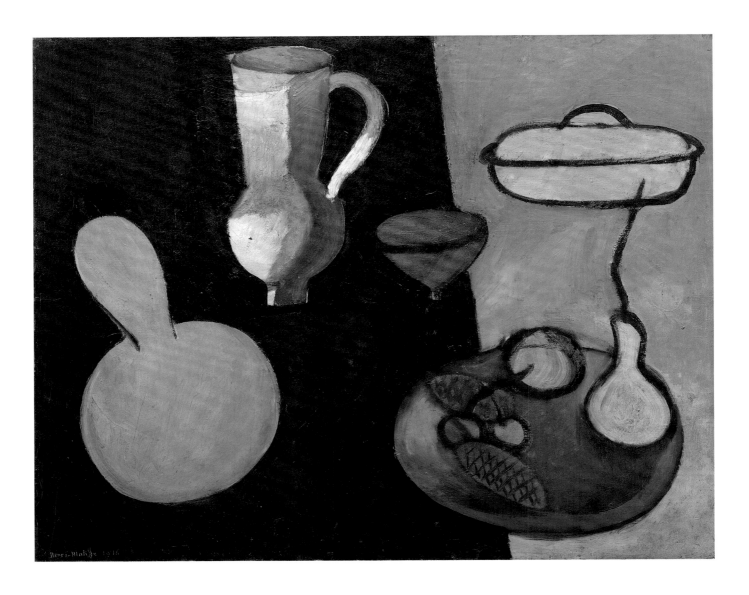

41a

41b

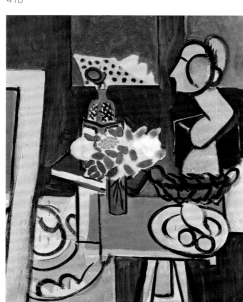

41c

41a
X-radiograph of *Gourds*, illustrating the outlines of the original, more naturalistic composition.

41b
X-radiograph of *Gourds* with a diagram showing the final composition.

41c
Still Life with Plaster Bust, July 1916. Oil on canvas; 100 × 81.3 cm (39³/₈ × 32 in.). The Barnes Foundation, Merion, Penn., BF 313.

AT THE LOWER left of *Gourds* [**41**], Matisse scratched the date *1916* into the black paint next to his signature; in 1945 he told Alfred H. Barr, Jr., that he recalled having painted the work in the summer of that year.[1] However, we know that it was not photographed until it was purchased by Bernheim-Jeune on February 22, 1917. Therefore, it may well date to fall 1916, which would make it the last of the great still lifes Matisse painted that year. Its austerity is complementary to—and even a consequence of—the artist's monumental *The Moroccans* [**44**] and *Bathers by a River* [**46**], which he was working on during this period.[2] It may even have aided the development of the former work, for as Matisse said of *Gourds*, "In this work I began to use pure black as a color of light and not as a color of darkness."[3] Moreover, in both paintings, he divided the ground into a black left side and pale-colored right side, and placed circular elements across the common boundary. Describing *Gourds* in 1945, Matisse stated that he created "a composition of objects that do not touch—but nonetheless participate in the same intimacy."[4]

This description has, since its publication, appeared obvious, but as close visual inspection and an X-radiograph of *Gourds* demonstrate [**41a–b**], the artist labored to produce what seems like such a simple work. Indeed, the painting was originally a far more naturalistic composition of objects overlapping in space, and its complex evolution offers a condensed primer in Matisse's methods of advancing a painting by adjusting and transposing the shape, size, position, or color of the forms it depicts. The artist was presumably taking note of lessons learned in the development of *The Moroccans* while refining this work, and vice versa. Nonetheless, a close look at the painting reveals that, when he began altering his initial, more naturalistic composition, he proceeded by instinct rather than with a clear notion of his goal. The result was that *Gourds* evolved in a slow, incremental manner, with changes to any one object or area leading to changes to neighboring ones, until the entire composition was transformed.

The coarsely modeled pitcher—along with the shallow plate, the only object painted to invoke touch—was originally much flatter, and its chalky white was quite dry before the graduated darks were scumbled over it to afford a sense of volume. It was also about half again as broad and positioned lower down and further to the left in the composition, reaching from the top of the white band below the spout to well behind the right side of the gourd below; its contour fell where we now see the division of light and dark down the pitcher. At some point in the evolution of the painting, Matisse painted the right side of the background black and the left gray-blue; then he reversed them so that the

41f

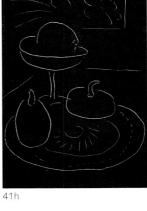

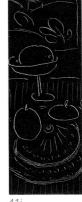

41h

41i

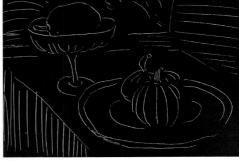

41g

41j

41d

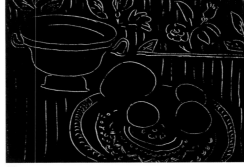

41k

41e

41l

41d
Small Bowl (II), 1914–15. Monotype on chine collé;
image: 6.5 × 9 cm (2 9/16 × 3 9/16 in.); sheet:
18.7 × 28 cm (7 1/4 × 11 in.). Location unknown (D350).

41e
Small Bowl (I), 1914–15. Monotype on chine collé;
image: 9 × 6.5 cm (3 1/2 × 2 9/16 in.); sheet:
28 × 18.7 cm (11 × 7 3/8 in.). Location unknown (D349).

41f
Still Life with Soup Tureen (I), 1916/17. Monotype on
chine collé; image: 6 × 15.9 cm (2 3/8 × 6 1/4 in.);
sheet: 23.3 × 27.6 cm (9 3/16 × 10 7/8 in.). Courtesy of
the Pierre and Tana Matisse Foundation.
In exhibition.

41g
Still Life with Soup Tureen (II), 1916/17. Monotype on
chine collé; image: 12.8 × 18 cm (5 × 7 1/16 in.);
sheet: 28 × 37.5 cm (11 × 14 3/4 in.). Location unknown
(D389).

41h
Fruit Dish and Gourds (I), 1916. Monotype on chine
collé; image: 18 × 12.9 cm (7 1/16 × 5 1/16 in.);
sheet: 37.3 × 27.2 cm (4 7/16 × 10 11/16 in.). Private
collection. In exhibition.

41i
Fruit Dish and Gourds (II), 1916. Monotype on chine
collé; image: 15.8 × 6.1 cm (6 3/16 × 2 3/8 in.);
sheet: 28 × 18 cm (11 × 7 1/16 in.). Private collection.
In exhibition.

41j
Three Gourds, 1916. Monotype on chine collé;
image: 12.7 × 8 cm (5 × 7 1/16 in.); sheet: 28 × 36 cm
(11 1/16 × 14 7/16 in.). Museum of Fine Arts, Boston,
Katherine E. Bullard Fund in memory of Francis
Bullard, 1990, 1990.245.

41k
Gourds and Moroccan Plate, 1916. Monotype on
chine collé; image: 17.9 × 13 cm (7 × 5 1/8 in.);
sheet: 37.5 × 28 cm (14 3/4 × 11 in.). Private collection,
Germany. In exhibition.

41l
The Gourds, 1916. Monotype on chine collé;
image: 17.7 × 12.6 cm (7 × 4 15/16 in.). Bibliothèque
Nationale de France, Paris, Department of Prints and
Photographs, 81 C 105. In exhibition (Chicago).

field of dense black was carried across the majority of the composition. This decision enabled him to give the pitcher a much more compact, graspable shape. It also produced the intense, complementary contrast of whites and grays against the black ground. This effect is incandescent within what would otherwise be a subdued group of still-life objects; perhaps this is why, in February 1917, the painting was first titled, by Bernheim-Jeune, *La nature morte (Noir et blanc)*.[5]

The contrast not only adds illumination to the painting; it also causes the pitcher to hover in space. Matisse enhanced this effect by incising lines down its right side and along its handle, which lift it away from the ground. Having thus transformed this object from a flat form to a modeled one, the artist appears to have taken the large gourd below it in the opposite direction. Initially, he shaped the neck with a range of greens, starting with lime at the top, moving through darker shades in the middle, and ending up with passages of primary green and turquoise near the body. The gourd was also higher in the composition and more vertical in orientation until the artist pulled it down and away from the pitcher, flattening it with gray-blues close to those of the ground at the right. He also moved the small bowl at center away from the pitcher, changing its form from the broad oval seen in one contemporaneous monotype [**41d**] to the more vertical shape in another [**41e**]. It was originally a paler blue than the covered dish to its right. Now its reddish color helps it separate that dish from the pitcher even as its shape mediates between them.

Two additional monotypes tell us that the covered dish was, in reality, a soup tureen [**41f–g**]; it became something different, which resembles a fish poacher. Although close in color and value to the large gourd, it possesses a harder, metallic surface that Matisse invoked with bold black outlining and paint that he whipped into a lively texture. The snaking stem of the smaller gourd beneath is the exception that proves Matisse's rule of objects not touching, alleviating any programmatic quality that the painting might otherwise have had. By explicitly connecting one object to another, it also reminds us that we are expected to associate them through their analogous forms, not merely their locations.

This gourd manages to simultaneously hang from the dish behind it and sit firmly on a shallow plate with an apple, two pinecones, and two cherries. The plate was probably first blue and then red before the artist gave it a brownish earthenware look. He had originally placed another gourd between the apple and pinecone, and there are circular shapes that indicate the former presence of fruit near the top of the small gourd. Most intriguingly, where the stem of that gourd bends first left and then right, there are signs of two

suppressed horizontals that stretch across the picture—one to the bottom of the larger gourd's stem, the other to its top. Perhaps these horizontals were trial positions for the back edge of a table or maybe a sculpture stand where the still life was arranged, as in the related *Still Life with Plaster Bust* [**41c**], which depicts a covered dish on another, higher surface behind it. What these lines reveal, however, is the most wonderful transposition of all, one in which Matisse turned the compositional division from a horizontal to a raking vertical. Barr spoke of objects that neither stand nor hang but simply exist.[6] In the many contemporaneous monotypes [**41h–l**], we see objects that do all of these things; seen together as a group, they recapitulate the movement of objects that is now hidden behind the surface of the painting. They also draw out links between *Gourds* and other compositions, most notably the Moroccan plate in the monotypes: indeed, this plate is the one that we see in the monotypes of apples and, therefore, in *Apples* and *Bowl of Apples on a Table* [**39.1–2**]. Matisse insisted in 1951, "The object is not so interesting in itself. It's the environment that creates the object."[7] Explaining this, he spoke of the objects he used as "actors," saying "an object can play a different role in ten different pictures. The object is not taken alone, it evokes an ensemble of elements." These items move from place to place within pictures and from picture to picture, changing identity along with their contexts. Additionally, the artist claimed, working time and again with the same things "gave me the force of reality by making my mind engage with everything that these objects had gone through for me and with me." His objects, Matisse implied, speak of the changing environments and mental states to which they belong, as they float across time, as across a canvas, rather like the separated temporal incidents that Henri Bergson described:

Discontinuous though they may appear, however, in point of fact they stand out against the continuity of a background on which they are designed, and to which indeed they owe the intervals that separate them . . . Our attention fixes on them because they interest it more, but each of them is borne by the fluid mass of our whole psychical existence. Each is only the best-illuminated point of a moving zone . . . which in reality makes up our state.[8]

1. Barr Questionnaire VII.

2. The clear relationship of *Gourds* to the drawing *Still Life with Persian Tile* (1915; private collection), which was exhibited in winter 1915–16, led Flam 1986, p. 405, to suggest that it was made at the same time. However, *Still Life with Plaster Bust* (41c), which is also closely related to the drawing, was photographed in late Aug. 1916, when it was acquired by Bernheim-Jeune (Dauberville and Dauberville 1995, vol. 1, pp. 550–51, cat. no. 155). That work, therefore, must have followed the group of still lifes—among them the just-completed *The Window* (37) and the in-progress *Bowl of Oranges* (38), of which Matisse wrote to Rosenberg on June 1,

1916 (see pp. 271, 275 in this publication). These works were photographed in June and late Aug., respectively. Flam 1986, p. 422, erroneously suggested that *Still Life with a Plaster Bust* was mentioned in that letter; it must have been painted later, but in time for the Aug. photography session, to be followed by additional still lifes, among them *Apples* (39.1) and *Bowl of Apples on a Table* (39.2), which would be photographed in Nov. along with *Bathers by a River* and *The Moroccans*. *Gourds* was not photographed until Feb. 1917, when it was purchased by Bernheim-Jeune.

3. Barr Questionnaire I.

4. Ibid.

5. On Mar. 15, 1916, Germaine Bongarde, sister of the couturier Paul Poiret, organized at her salon an exhibition on the theme of black and white, which suggests that the theme was popular enough for Bernheim-Jeune to draw upon it for the title.

6. Barr 1951, p. 190.

7. Luz 1952, p. 66. He added, "You remind me of the table I painted isolated in a garden? [Presumably, he refers to *The Rose Marble Table* (40)] . . . Well, it was representative of a whole open-air atmosphere in which I had lived."

8. Bergson 1911, p. 3.

42 **Jeannette (V)**
Issy-les-Moulineaux, summer 1916

Plaster, cast in bronze 1954 (LACMA), c. 1930 (MoMA)
58.1 × 21.5 × 23.5 cm (22⁷/₈ × 8¹/₂ × 9¹/₄ in.) (LACMA);
58.1 × 21.3 × 27.1 cm (22⁷/₈ × 8³/₈ × 10⁵/₈ in.) (MoMA)
Signed and numbered: *HM 1/10* (LACMA); *5/10 HM* (MoMA)
Inscribed on the base: *C. Valsuani–perdue* (LACMA, MoMA)
Chicago venue: Los Angeles County Museum of Art,
gift of the Art Museum Council in memory of Penelope Rigby, M. 68.48.3
New York venue: The Museum of Modern Art, New York,
acquired through the Lillie P. Bliss Bequest, 1952

IN EXHIBITION

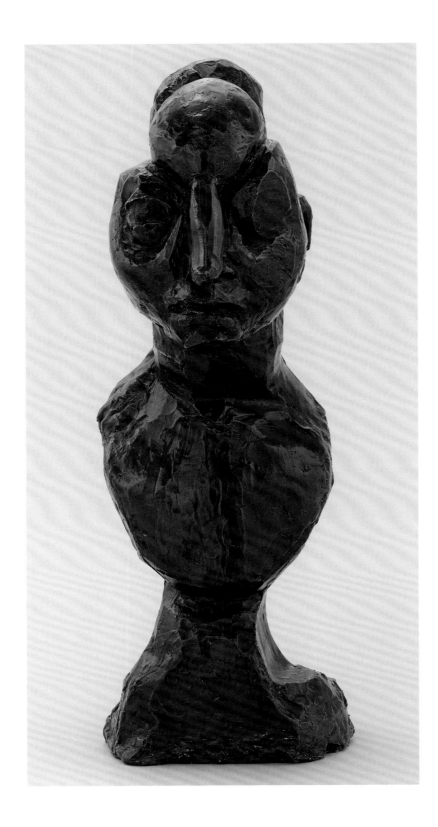

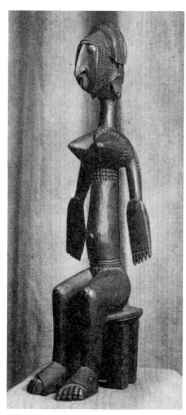

42a

Seated Figure. Bambara; Mali. Wood; h. 61 cm (24 in.). Private collection. (Formerly in Matisse's collection). As published in Paul Guillaume, *Sculptures nègres: 24 photographies* (1917), plate 5.

JEANNETTE (V) [**42**] is depicted in the painting *Still Life with Plaster Bust* of 1916 [**41c**], photographed by Bernheim-Jeune in August of that year.[1] The sculpture's striking left profile view shows its long, pointed nose and the huge volumes of its orbital zone and clump of hair; the latter exaggerates the break between nose and brow and minimizes the size of the ear. These features associate the work with a wooden Bambara figure [**42a**] from West Africa that Matisse purchased in 1915 for the collection of such pieces that he began to acquire almost a decade earlier.[2] Years later, speaking to Pierre Courthion of his first encounter with artworks like these, he recalled: "I was astonished to see how they were conceived from the point of view of sculptural language, how close it was to the Egyptian. That is, compared to European sculptures, which always depend upon musculature, primarily on the description of the object, these Negro statues were made in terms of their material, according to invented planes and proportions."[3]

Years before, in 1910 or 1911, Matisse had advanced his series of portrait busts to the point that we first notice the material, and then see that it has been worked into a semblance of a figure. Now, in summer 1916, he returned to the series and carried this process still further with *Jeannette (V)* [**42b–f**]. This was a moment of culmination for Matisse. His son Pierre recalled that his father worked concurrently on *Jeannette (V)* and *Back (III)* [**45**].[4] In the extremely productive summer and fall, the artist brought his most ambitious works of the war years to—or near to—conclusion. Among these, he had started the *Backs* and *Bathers by a River* [**46**] around 1909; the *Jeannette* series in 1910; and *The Moroccans* [**44**] in 1912, although he did not put paint to canvas until later. The sense of finally finding an ending in one work must have affected the others: for all of them, ending meant condensation, and this was never more explicitly the case than in *Jeannette (V)*.

The first pair of *Jeannettes*, made in 1910, comprised sculptures that are, respectively, more restrained and more animated [**11.1–2**]; the second pair, made in 1910 or 1911, is the same [**13.1–2**]. These four pieces were included in Matisse's early 1915 exhibition at the Montross Gallery, New York, which featured the first and third in plaster, the other two in bronze. While the bronze cast of *Jeannette (IV)* was sold, Matisse must have retained the plaster since casts were made later; the other three *Jeannettes* were returned to him in April.[5] As he was able to consider these works afresh, and pondered why *Jeannette (IV)* sold at the exhibition, that sculpture must still have seemed what it was at its creation: an extraordinarily inventive, dynamic work that itself comprised the culmination of the series. It was probably for this reason that he chose

not to start *Jeannette (V)* from a cast of its predecessor, which was his usual practice, but instead to go back and initiate his new work from a cast of the more sober *Jeannette (III)*.[6] The less flamboyant structure of the earlier piece would have afforded a more settled base on which to rework. By building on what had been the penultimate work, Matisse could shape an alternative, very different ending to his serial story.

In *Jeannette (V)*, like *Back (III)*, the artist stabilized a previously animated pose and clarified in a sharp, linear fashion his division of the subject into separate parts. But while he radically disjointed the forms in *Back (III)* in order to join the body to the slab of the relief, here he penetrated deep beneath the surface of a freestanding volume. Yet Matisse also worked the subject so that it appeared to be more of a solid thing than in any previous state, as if he had compacted mass and weight to produce something that is visually denser and heavier.

The previous year, the artist had made the small *Head of Marguerite* [**30e**], achieving density through compression, squeezing the form inward with his hands. With *Jeannette (V)*, he condensed the head, following the "invented planes and proportions" he saw in African art.[7] Matisse described this work as "the same as 3rd and 4th, but with the hair reduced to simple volumes; an ovoid forehead." Indeed, the simplification of the hair and the forehead are particularly noteworthy traits. To start his work, Matisse likely chopped away the hair, except for a single tear-shaped volume that tapers backward from the top of the crown to the top of the neck [**42g**]. There, after removing the clump of hair that falls down the neck in *Jeannette (III)* and later smoothing the area with clay or wet plaster, he cut a vertical plane that drops from the nape of the neck, recalling the conflation of hair and spine in *Back (III)*. At the front, he made the brow more massive and straightened the nose; together, these features resemble the bowl and handle of a rough-hewn spoon. The artist separated this compound form from the adjacent cheeks and orbital zones by creating a fissure that runs down from the hairline to the top of the nose and then descends its full length. In this reorganization of features, there is a strong sense of addition and dissection of form and part-to-part composition that can be associated with Cubist sculpture. Nonetheless, the effect of overall wholeness is even stronger.

The artist more or less preserved the profile of the mouth and chin from *Jeannette (III)* but lengthened the neck, cutting sharply downward at the front; he formed the facet beneath the figure's left ear by spreading clay or plaster upward to overlap the lobe, as we can see from the directional marks of his tool that remain on the surface. Above

42b

42c

42d

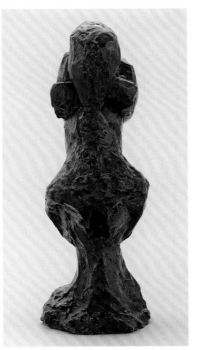

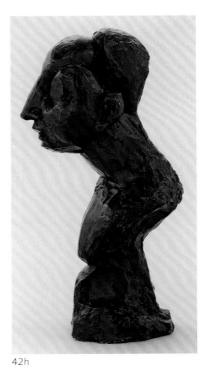

42g

42h

42i

42e

42f

42b–f

Matisse's schematic drawings of his *Jeannette* sculptures in an undated notebook in which he recorded his sculptures and their casting histories. Archives Henri Matisse, Paris.

42g

Back view of *Jeannette (V)*, showing the tear-shaped volume as it tapers backward from the top of the crown to the top of the neck; the volume that combies the left ear and cheek; and the barely attached right ear.

42h

View of the sculpture in left profile, showing the simplified ear cupped by a slanting facet of hair.

42i

Detail of the left profile, showing the hole above the sculpture's ear.

and in front of that ear, Matisse added a large volume of material, carrying it from cheekbone to hairline, obliterating the eye, and then slicing off the front of it, leaving a broad, almond-shaped facet where the eye should be. It is as if this side of the face is in shadow, much like the triangular facet that covers Pierre Matisse's right eye in *The Piano Lesson* [**43**]. However, the shock of the asymmetry is even greater in the sculpture, which seems blinded.

Yet further shocks await. Seen directly from the front, the left ear is occluded by the mass of material that the artist added in front of it. By thus removing the ear from sight, he enhanced the blankness of that side of the face. In contrast, the other side seems animated. Matisse retained the orbital structure of *Jeannette (III)* but enlarged and simplified it so that the lidded right eye is set within a hollowed-out compartment. (This feature also recalls *Head of Marguerite*, in which the eyes are set as if in a shallow tray.) Above the eyebrow, though, the artist cut away the side of the face so that we can see, above, a rising facet of a volume that is obviously attached to both the face and the brow, yet falls back separately from them. On the reverse side of the sculpture [**42g**], we can see that this volume is the cap of hair. But something else is puzzling now. The right ear has disappeared into a composite twin-peaked volume that joins the higher cheekbone beyond. In contrast, from this back view, the left ear seems hardly attached. From the left profile view, however, it is clear that Matisse, in his remaking of *Jeannette (III)*, did not replace the ear but simplified it somewhat, excavating behind it, chiseling away and replacing the earlier hair in the process; indeed, he shaped the bottom of the hair into a slanting facet that runs sideways to cup over the ear [**42h**]. Within the darkness beneath its projecting ledge, Matisse made a three-inch-deep hole above the ear [**42i**]. This astonishing feature allows us to imagine a head built not only within space but also around it.

Jeannette (V) is not only the most radical of the series but also the most unsettling. Its formal and psychological concentration alone sets it apart from its predecessors, but these qualities open onto something more extreme —a primal, atavistic power well beyond the protocols of portraiture. In 1916 Matisse was carrying his painting to its most intense— "To what I wanted to be," he explained, "an unprecedented level of creation."[8] With this work, he carried his sculpture to a point no less unprecedented, and perhaps more: it was not until 1930 that Matisse exhibited *Jeannette (V)*, suggesting that he was either unsure of what he had created or, more likely, of its reception.[9]

1. Dauberville and Dauberville 1995, vol. 1, pp. 550–51, cat. 155.

2. He represented an early acquisition in an unfinished still life of 1906–07; see Flam 1986, pp. 420–21. For more on Matisse and African sculpture, see Flam, "Matisse and the Fauves," in Rubin 1984, vol. 1, pp. 211–40; and Gill Perry, "Primitivism and the 'Modern,'" in Harrison, Frascina, and Perry 1993, esp. pp. 55–61.

3. Matisse's recollections about the experience are recorded in Courthion 1941. The one mentioned here is from Courthion, as interviewed by Jack Flam in Dec. 1979; Flam 1986, pp. 173–74.

4. Pierre Matisse, in conversation with Flam, Mar. 30, 1982; ibid., pp. 503–04 n. 25.

5. *Henri Matisse Exhibition* was held from Jan. 2 to Feb. 27, 1915. See Montross 1915 and pp. 224–25 in this publication for more on the exhibition, its reception, and sales. Correspondence between Bernheim-Jeune and Matisse regarding the return of works can be found in AHM.

6. For further discussion about Matisse's return to *Jeannette (III)* for *Jeannette (V)*, see Barr 1951, pp. 141–42; and Kosinski, Fisher, and Nash 2007, pp. 198–99.

7. Undated manuscript notes in Duthuit and de Guébriant 1997, pp. 260, 385.

8. Verdet 1978, p. 124.

9. *Jeannette (V)* was exhibited in Berlin; Galerie Thanhauser, *Henri Matisse*, Feb. 15–Mar. 19, 1930, cat. 95.

43 **The Piano Lesson**
Issy-les-Moulineaux, summer–fall 1916

Oil on canvas; 245.1 × 212.7 cm (96 1/2 × 83 3/4 in.)
Signed l.l. of center: *Henri-Matisse*
The Museum of Modern Art, New York, Mrs. Simon Guggenheim Fund, 1946

IN EXHIBITION

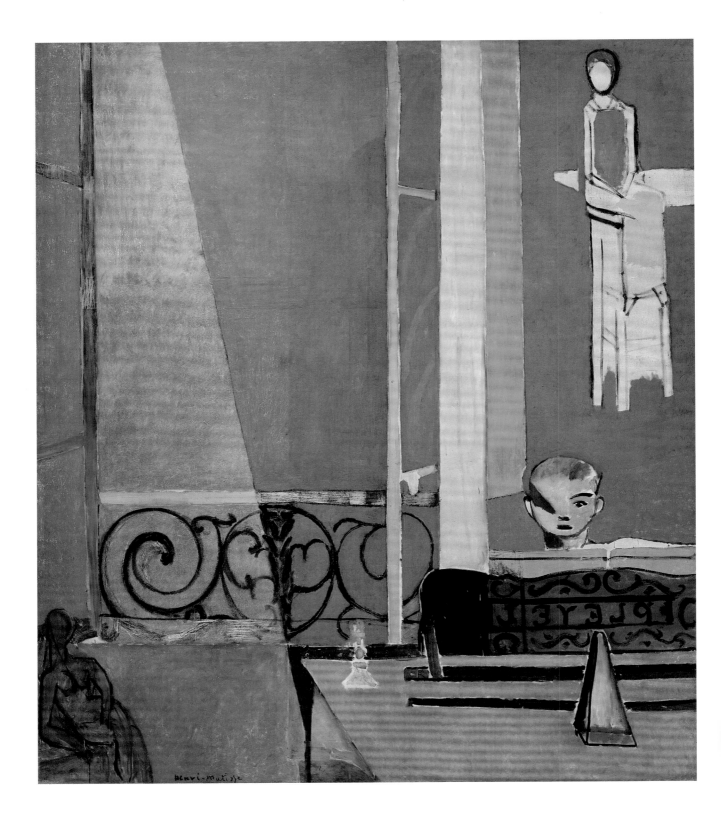

43a

43b

43a
Drawing for "The Piano Lesson," 1916.
Graphite on paper. Private collection.

43b
X-radiograph of *The Piano Lesson*.

MATISSE PAINTED *THE Piano Lesson* [**43**] in the late summer and probably the fall of 1916, while he was working on *Bathers by a River* [**46**] and *The Moroccans* [**44**].[1] It separates itself, however, from these other large, commanding paintings in two critical respects: it is not an imagination of a distant place, but rather a record of the living room of the artist's house at Issy; and it is not a uniformly abstracted composition, but rather contains carefully disposed, highly legible imagery that requires very specific iconographical analysis.

It was only to be expected, perhaps, that Matisse's depictions of home and studio in both Paris and Issy should call for a summative work — one in which he might play out more fully their frequent theme of contemplation in an interior, elaborate their invocation of time and place, advance their exploration of allusion and metaphor, and invigorate their pictorial structures in the process. Nonetheless, *The Piano Lesson* entwines all these threads in a manner that cannot be disentangled. In the painting, Matisse reimagined an observed, temporal moment in a composition that seems concrete and specific to it. The objects and figures are our guides through the picture, and our perception of its method of construction unfolds as a temporal narrative of its own.

The most obvious element is the artist's younger son, Pierre, who faces us lost in concentration, practicing on a Pleyel piano beside an open French door; this is the same room seen in *The Window* [**37**], which was painted in the spring. Pierre was then sixteen years old, although his father made him seem much younger. Since he and Matisse were the musicians of the family, we might consider him a surrogate for the painter. To the left is Matisse's *Decorative Figure* of 1908 [**4f–g**], arguably the most sexual of his sculptures, and on the wall behind him hangs *Woman on a High Stool* [**25**], which registers as a severe, supervisory presence. (This figure also resembles the faceless form at the right of *Bathers by a River* [**54**]). On the rose cloth over the piano, a candle and a metronome stress the measuring of time; the scrollwork on the piano stand appears to continue into the grillwork of the window, flowing across time and space like music.

Matisse began the painting from observation, as he had done with earlier interiors such as *View of Notre Dame* [**23**] and *Goldfish and Palette* [**31**], which became more abstract as he worked on them. As these canvases also demonstrate, he was attracted to scenes viewed in fading late-afternoon light; this was the case for *The Piano Lesson,* which takes place within a very narrow, highly poetic temporal envelope, a moment of twilight on a summer night.[2] An unseen light to the right traverses the scene, striking the boy's forehead and shadowing a triangle on his far cheek [**43g**]; brightening the salmon-orange curtain

43c

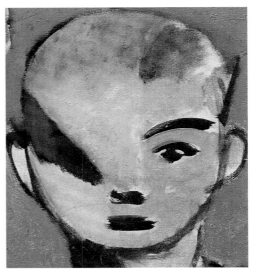

43e

43d

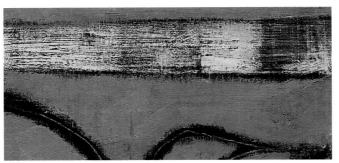

43f

43g

43h

and the pale blue-gray of the partially closed right door; and illuminating a big triangular patch of lawn that Matisse may have remembered from Cézanne's *Bathers at Rest* (p. 45, fig. 4).[3] The colors themselves, meanwhile, complement one another in ways that activate the stillness of the scene. The orange resonates with the pale blue, and the rose with the green; these are interrupted by yellow and black, all of them reconciled by the surrounding soft gray, which they tint. The colors also resist being fully incorporated into the work of depiction, both because they occupy such stark, autonomous shapes and because Matisse applied them in a manner that at times reveals earlier shapes and hues, continually reminding us of his incursions upon the surface of the painting.

An initial drawing of the composition [**43a**], coupled with an X-radiograph of the canvas [**43b**], allows us to see how Matisse proceeded. From the start, he appears to have rejected the music scattered on top of the piano, the patterned cloth beneath it, and the leftward slope of the instrument's edge, instead dropping it vertically from the precise point it meets the triangle of lawn. He tried out and eliminated a radiator and also raised the grillwork and transom from the level of the music stand to that of Pierre's ear. Curvilinear verticals, still just visible in the pale blue stripe rising above the piano, reveal that Matisse began with the loosely draped curtain shown in the drawing. And the garden view had at least some of the profusion of plant life that he had drawn with such attention, placing it in three parallel zones. He eliminated the bottom of these when he added the grillwork and transom. Contours of earlier, bushlike shapes may be seen when the painting is viewed in raking light, and a set of three green arcs is visible beneath the gray of the middle pane of the right window [**43e**].

What are harder to gauge are the changes that differ from both the drawing and the completed canvas. However, judging from pentimenti in the window area that take the shape of a grid, the window was probably shown closed in an earlier state. Sets of incised lines in the interior of the left door frame and transom [**43f**] show where Matisse located the panes. Incising midway between the two casement bars may also indicate where he removed the upper zone of the old garden view. He originally painted the right half of that vista the same salmon-orange as the curtain that rises behind the pianist's head, and likely did the same to much of the right section of the work; he also carried the shallow angle at the base of the curtain to the right edge of the painting, exploring and ultimately rejecting the possibility of a larger form in that area.

Discussing *The Piano Lesson* in 1978, Pierre Matisse said that his father scraped down large areas of the composition two or three times before arriving at the final painting.[4] Some parts obviously never changed, as witnessed by the presence of untouched ground at the right side, notably in the image of *Woman on a High Stool*. But usually both the final marks and the results of compositional changes were critical to the appearance and thematic effect of the result. This is true not only of the scratching and incising, which we see especially on the window frame, but also in the marks of stippling and cutting, particularly down the left side, which give the picture a pitted quality [**43c**]. If the former were indeed the result of modifications to the shape of the window, as suggested above, Matisse may have retained them to describe the effect of light catching the edge of the frame. The pitting, however, is harder to read but might be seen as a weakening or erosion—of light or of time, perhaps—on a solid form. Additionally, Matisse accepted the cracks that he had produced by painting over surfaces that were not fully dry [**43d**] and the broken paint film that resulted from the use of a resist technique [**43h**]. These, too, speak of atrophy and temporality. Given the artist's statements about the challenges he faced in painting at this time, it is difficult—and, we suspect, meant to be difficult—to distinguish between the intended and the accidental. The painting's contrasts of stillness and finality, duration and continuity, were reinforced by Matisse's own acceptance of the accidental and unfinished that he found and willingly incorporated into the process of making the work.

1. For justifications of this dating, see Elderfield 1978, p. 211 n. 1. The garden, as shown in the preliminary drawing, looks summery and overgrown. However, Pierre Matisse remembered *The Piano Lesson* as having been painted in the fall of 1916 (Barr 1951, p. 174). Since the canvas was extensively worked, it is reasonable to suppose that it was not finished until then.

2. At this moment of his career, Matisse distinctly preferred views with fading light over those with full sunlight. It seems reasonable to ascribe some of this to the wartime period in which these works were made, but the wider cause was the artist's attraction to the temporal and transitional.

3. That painting was as much a sensation at the 1905 Salon d'Automne as Matisse's own Fauve canvases; see the spread on the Salon in *L'Illustration* 3271 (Nov. 4, 1905), pp. 294–95, reproduced in Elderfield 1976, p. 44. This is neither to dispute the certainty that the sharpness of this triangle responds to others in the painting, nor to disallow the possibility that it was also motivated in part by Constantin Brâncusi's *Head of a Child* (1913–15; Musée National d'Art Moderne, Paris; Monod-Fontaine 1984, p. 32.

4. In conversation with John Elderfield, June 1978; Elderfield 1978, p. 212 n. 8.

44 **The Moroccans, fourth state**
Issy-les-Moulineaux, January–November 1916

Oil on canvas; 181.3 × 279.4 cm (71³/₈ × 110 in.)
Signed l.r.: *Henri-Matisse*
The Museum of Modern Art, New York, gift of Mr. and Mrs. Samuel A. Marx, 1955

IN EXHIBITION

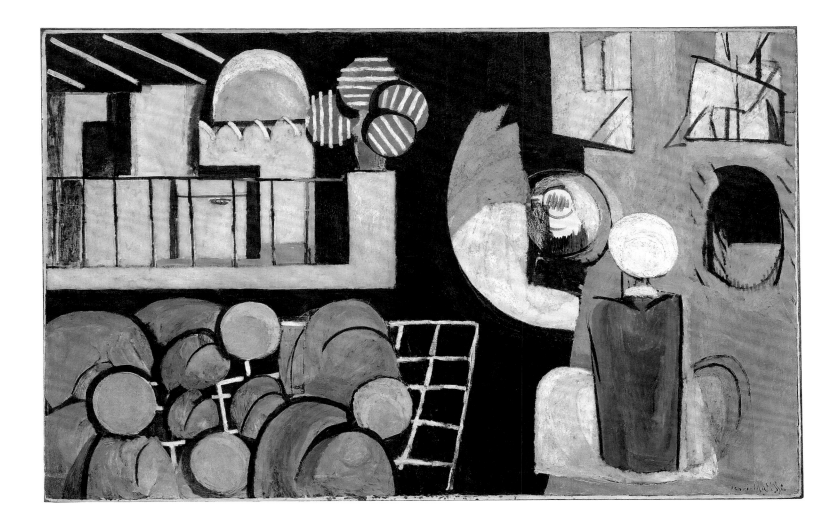

MATISSE CONCEIVED *The Moroccans* [**44**] in spring through fall 1912 [**15**]; stretched a canvas for the work in summer 1913 [**20**]; returned to it in autumn 1915; and began working on the final canvas early in 1916, after lengthening it by sixty centimeters [**36**]. His two known compositional sketches, from 1912 and 1915 [**44a–b**] correspond to the proportions of the painting prior to its enlargement. In both, the artist placed the left side of the marabout dome, with the steps onto the terrace beneath it, at the furthest left edge. In the completed painting, the left side of the dome falls sixty centimeters inside, while below it an anomalous directional shift in the gridded pavement indicates where the steps were first placed [**44l**]. Both of these factors suggest that Matisse enlarged the composition on the left side, as do the golden melons and green leaves spread out on the pavement, which do not appear in the compositional sketches. Matisse saw them during his second visit to Tangier and drew them in one of his many topographical sketches [**44g**], which he may have referred to as he painted the picture. In fact, he transferred nearly everything from an on-site sketch to a compositional drawing and again to the final painting. Elements were simplified, truncated, and rearranged, but rarely lost entirely. The artist himself emphasized this point when he spoke with two young painters who came to his studio in the spring of 1916 and saw *The Moroccans* in process. One of them, Axel Salto, published a report of the visit two years later, which reproduced the painting for the first time:

Moroccans stood on an easel in the middle of the room. The painting was conceived around North African motifs, landscapes with minarets, café and street scenes, all painted as directly as possible from life. The painter showed us how the different parts were assembled, transformed, and reworked to form a whole new totality whose effect was purely decorative yet at the same time solidly based on observation and studies from life. The result was a decorative, synthetic style of great beauty and simplicity. As I remember them, the colors were green, black, light blue, and light brown.[1]

The artist described this approach himself when he discussed the painting during a studio visit with Gino Severini, who recalled, "Matisse said rightly that everything that did not contribute to the balance and rhythm of the work, being of no use and therefore harmful, had to be eliminated. That was his way of working: constantly stripping the work down, as you would prune a tree."[2] He had shown his friend a painting made in Tangier—probably *The Marabout* [**15d**]—in which he had allowed the blue of the near wall to dominate all yet "had to admit that he had only partially succeeded in rendering the intensity of its sensory impact." Then came *The Moroccans*, in which Severini said he "achieved that degree of intensity...by replacing the real structure of the landscape with a structure which he himself decided, yet one which nevertheless remained experiential."[3] Together, these accounts speak of transformation through transposition, of assembly aided by elimination, and of reduction leading to reworking, all of which brought about a new synthesis that was both decorative and firmly lodged in the perceptual world.

Matisse had long emphasized that he painted out as much as he added.[4] Here black is the principal agent of elimination, at once simplifying, dividing, and joining the work as a composition of three distinct parts. At the same time, it represents color that has been "put to sleep," as one contemporary observer described the effect of brilliant light on a landscape not far south of Tangier.[5] It is fair to say that, when the artist added the large black area of *The Moroccans*, he set the painting on the path to its realization. However, black was also the first color that he applied to the canvas as he laid out the composition in a thin wash. This can be seen in the fragments of forms that are still visible, surrounded by areas of unpainted ground; the most prominent of these describe the railing at the left [**44o**] and the large coiled motif at the center [**44k**]. In both zones, Matisse shaped forms in extended lines until his brush was depleted of pigment. He also blocked out areas in different ways, using summary, uneven infilling between the railings and hatched lines of varying density within the coiled motif. He later returned to these zones, scraping down particular spots, adding emphasis to some lines and obliterating others. However, he did not revisit every part of the canvas.

In creating this painting, the artist also drew upon his memories of Morocco as included in the Moroccan Triptych [**44c–e**]. As in those works, he gradually built up a layered, scumbled surface, allowing the process of painting to show in the presence of one thin layer of pigment above another, the color and value of the underlying layers modifying those of the one on top. Matisse began to add color around and over the early compositional lines and areas of very liquid paint, generally following the traditional practice of proceeding from thinner, leaner layers of paint to thicker, richer ones. Two areas in particular invoke the watercolor technique of Cézanne, which Matisse knew well from his own collection of the artist's works. One is the sliver of space between the four round, striped forms of the potted plant at top center [**44j**], which reveals a celadon green overlapped by touches of pink; both colors look almost stained into the canvas, which was left bare beside them. The other is at lower left, where many of the melon leaves also contain watery greens: some stained [**44m**]; others thinned and then blotted [**44n**]; and yet others painted in a medium-rich pigment. In the latter case, the brush created a hatched effect that allows the white ground (plus compositional lines

44a

44b

44a
Matisse's compositional sketch of *The Moroccans* in his letter to Charles Camoin, November 22, 1915. Archives Camoin, Paris.

44b
Letter from Matisse to Amélie Matisse, October 25, 1912, showing a compositional sketch of *The Moroccans*. Archives Henri Matisse, Paris.

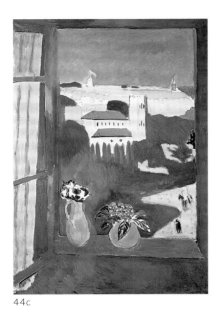

44c

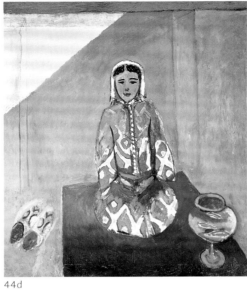

44d

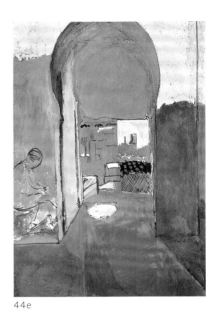

44e

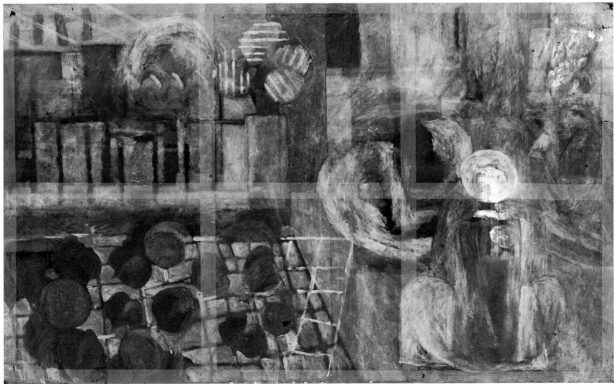

44f

44g 44h

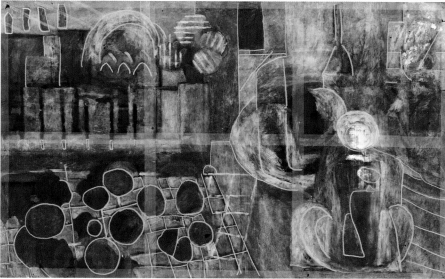

44i

44c

Landscape Viewed from a Window, 1912/13. Oil on canvas; 115 × 80 cm (45 1/4 × 31 1/2 in.). The State Pushkin Museum of Fine Arts, Moscow.

44d

On the Terrace, 1912/13. Oil on canvas; 115 × 100 cm (45 1/2 × 39 3/8 in.). The State Pushkin Museum of Fine Arts, Moscow.

44e

The Casbah Gate, 1912/13. Oil on canvas; 116 × 80 cm (45 5/8 × 31 1/2 in.). The State Pushkin Museum of Fine Arts, Moscow.

44f

X-radiograph of *The Moroccans*, showing the state of the composition before Matisse's final adjustments to the dome, the trellis, and the melons.

44g

Medina Terrace and Dome, 1912/13. Pencil on paper; 16.2 × 9.5 cm (6 3/8 × 3 3/4 in.). Courtesy of the Pierre and Tana Matisse Foundation. In exhibition.

44h

Medina: Door, Seated Moroccan, 1912/13. Pen and ink on paper; 19 × 25.7 (7 1/2 × 10 1/8 in.). Private collection.

44i

X-radiograph of *The Moroccans* with a diagram of the principal changes to the composition.

and flashes of previously applied color) to show through, hinting at the veining of leaves without specifically picturing it [**44l**]. Thus, in facture as well as form, this area of the composition draws on a fragment of Cézanne's *Fruits and Foliage* (p. 147, fig. 7), which Matisse acquired in 1911. Like Cézanne, Matisse set the subject in tension with his representation of it, ratcheting up the effect by emphasizing the shaping and materiality of the latter while creating a structure that, as Severini said, "nevertheless remained experiential." Unlike Cézanne, however, he adopted from Islamic art the convention of separate spatial cells within a work. This enabled him to draw attention to materiality in different ways in different areas of one painting—and never more so than in the three parts of *The Moroccans*: the still-life zone at bottom left, the architectural zone at top left, and the figural zone at right.

An X-radiograph of the first of these zones [**44f**] suggests that Matisse may have originally followed his on-site sketch and painted a scattering of about a dozen smaller melons before reducing them to four larger fruits and adding the leaves. With this revision, the artist turned the melons into rough, flat disks; this enabled him to create a formal analogy between this still-life zone and the architectural and figural areas, which contain their own large, round shapes. At the same time, he distinguished this section with the liquid treatment of the leaves of the melons.

In contrast, the architecture above is the most luminous zone in the composition. It is surmounted by a visibly enlarged dome; above that and to the left is a trellis or awning that, the X-radiograph indicates, replaced the figures from the original sketches. He brushed the area as a whole in accumulated layers of pale blues and grays over pinks, darker blues, and touches of ocher, affording a plausible illustration of warm-colored light falling on plaster walls. There the disruption of the surface by incising, scraping, and other traces of reworking enhances the illusion of something built and used. In contrast, the potted plant on the end of the parapet defies definition as much for its materiality as for the extra-botanical appearance of its white-on-blue stripes, which seem almost squeezed from the paint tube.

The pink-violet platform and wall, combined in one tall plane at the right—and the figures within and beside it—must at one point have been as luminous and placid as the zone of architecture; they, too, are richly layered, but to a point of dry opacity, massively distressed by Matisse's scratchings, scrapings, repaintings, and drawn revisions. The circular form that overlaps the edge of the pink area [**44k**] corresponds, in the compositional sketch, to a turbaned figure seen from above, next to another sprawled out on the ground.

44j

44o

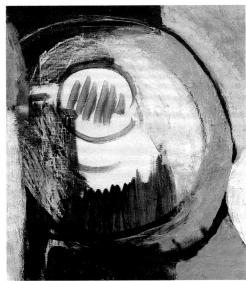

44k

44n

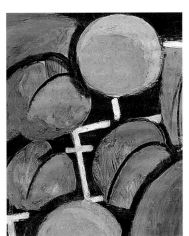

44l

44m

44j
Detail of the space between the striped leaves on the parapet in *The Moroccans*, showing different layers and effects of paint.

44k
Detail of the circular form.

44l
Detail showing both the break in the pavement where the steps were originally placed and the hatched effect on the melon leaves.

44m
Detail of the stained melon leaves.

44n
Detail of the blotted melon leaves.

44o
Detail of the railing, showing fragments of Matisse's original drawing.

Matisse transformed this into a large, irregular crescent of white and ocher, so simplified as to be unrecognizable without reference to the drawing. To the right, he replaced two small seated figures in the sketch with one seen from the back, enlarging it to monumental size in at least three stages, much as he did Zorah's body in the central panel of the Moroccan Triptych [**44d**].[6] At the same time, he reduced the remaining two figures in the compositional sketch to linear glyphs, placing them in windowlike compartments at the top right of the painting, probably remembering similar motifs that he had drawn in Tangier [**44h**]. The left compartment contains the figure with binoculars, who is pruned down to a sign for raised forearms and a sloping upper leg. To the right is the seated figure, who appears above a new feature: a horseshoe-arched doorway that recalls one in the right-hand panel of the Moroccan Triptych [**44e**]. The dense black drawing, which shapes the final definition of these and similar features, sometimes reinscribes an underdrawing that remains just visible. At other moments, it defines forms that have now expanded or shrunk, or imposes an entirely new invention on the summary, fragmented elements that remain from the original drawn layout.

The drawing's staccato, interrupted sequences also speak to the dense black, which, warmed by the pinks, violets, and ochers beneath it, ranges in facture from thin film to rubbery membrane to coarse and scabrous skin. Matisse used black, he later said, as "a force . . . to simplify the construction," and as a way of not representing, but creating, light.[7] "Doesn't my painting [*panneau*] of *The Moroccans*," he asked, "use a grand black which is as luminous as the other colors in the painting [*tableau*]?" He admired Édouard Manet's use of black and had, in 1916, also seen two paintings in which black was prominent: at Léonce Rosenberg's gallery, Picasso's recently completed *Harlequin*

(1915; The Museum of Modern Art, New York), and at the Pellerin collection, Cézanne's *The Black Clock* of 1867–69 [**44p**]. *The Moroccans* is closer to the Cézanne, with its sensual pinks, where black and white define the limits of the palette, behave like colors, and act as receptors, offering a silent response to the louder hues.[8]

On April 25, 1916, Rosenberg wrote to Matisse to confirm his purchase of his "last painting, *Terrasse au Maroc*," which suggests that the artist had finished it by that time.[9] However, it was not until November that Bernheim-Jeune photographed *The Moroccans*, producing the first known image of the painting in its present state.[10] So perhaps Matisse continued to work on the canvas: Rosenberg did not actually acquire it until February 1917, but that may have been owing to a dispute with Bernheim-Jeune about who should have it.[11] As it happened, he did not have it for long, because the artist repurchased it a little over a year later, on April 2, 1918—the very month that Salto's article appeared. It would not be reproduced again until 1926, the same year that *Bathers by a River* [**54**] and *The Piano Lesson* [**43**] were first exhibited, published, and sold.[12] However, *The Moroccans* was not exhibited until 1927, after which Matisse took it back. He retained it until two years before his death, when he spoke of it, saying, "*The Moroccans*—I find it difficult to describe this painting of mine with words. It is the beginning of my expression with color, with blacks and their contrasts."[13]

1. Salto 1918. The painting came close to being reproduced in a far more prominent place, *Burlington Magazine*, for on Apr. 4, 1917, Roger Fry wrote from London to Rose Vildrac in Paris: "Among other things let's talk of the *Burlington* . . . we must absolutely bring in new material. Now I am trying to introduce articles on modern art —serious art, of course. We need you to look for people who would write articles from time to time. If you can find someone who would write in English, so much the better; but it's not necessary. For a long time I have been looking out for a well-illustrated article on Negro sculpture. . . . Also, I need an article on the most recent things of Matisse—with photographs/ 1. of his big painting of Morocco, at his home/ 2. of the portrait bought by Kevorkian"; *Letters of Roger Fry*, ed. Denys Sutton (Random House, 1972), p. 407.

2. Severini, *Matisse* (Libreria Fratelli Bocca, 1944), p. 9.

3. Severini, "La peinture d'avant-garde," *Mercure de France* (June 1, 1917), pp. 456–57; Turner and Benjamin 1995, p. 90.

4. Matisse 1908, p. 734.

5. T. E. Lawrence, recalling entering the Red Sea port of Jeddah in Oct. 1916, wrote of how "[t]he noon sun . . . like moonlight, put to sleep the colors. There were only lights and shadows, the white houses and black gaps of streets." Lawrence, *Seven Pillars of Wisdom* (1922; repr., Wordsworth Editions, 1997), p. 49.

6. For more on the painting *On the Terrace*, including its X-radiograph, see Cowart 1990, pp. 84–85, 278. It is tempting to view this turned-away figure as a reaction to a figure in the same location of Picasso's *Les demoiselles d'Avignon* (p. 51, fig. 14), publicly exhibited for the first time in July 1916. However, this would require certainty that Matisse was still working on *The Moroccans*

at this point and wanting to respond to the painting in this work.

7. Matisse 1946.

8. Rainer Maria Rilke to Clara Westhoff, Oct. 14, 1907; Rilke, *Letters on Cézanne*, ed. Clara Rilke, trans. Joel Agee (North Point Press, 2002), p. 77.

9. Rosenberg to Matisse, Apr. 25, 1916, AHM.

10. See Dauberville and Dauberville 1995, vol. 1, pp. 570–71, cat. 167.

11. See pp. 259 n. 6 and 275 n.3 in this publication on tension between the two parties. Rosenberg wrote in his Apr. 25, 1916, letter (AHM): "I saw Fénéon this morning who asked me if I was thinking of buying your 'Maroc,' I said yes without saying that I already had, since I feared causing a misunderstanding between the two of you."

12. Carl Einstein, *Die Kunst des 20. Jahrhunderts* (Propyläen-Verlag, 1926), no. 244, p. 635.

13. Tériade 1952, p. 47.

44p

44p
Paul Cézanne (French, 1839–1906). *The Black Clock*, 1867–69. Oil on canvas; 54 × 74 cm (21 1/4 × 29 1/8 in.). Private collection.

45 Back (III)
Issy-les-Moulineaux, by May 13, 1913–early fall 1916

Plaster, cast in bronze c. 1950; 189.2 × 112.4 × 15.2 cm (74 1/2 × 44 × 6 in.)
Signed l.l.: *Henri Mat* [...]; inscribed at bottom: *HM / 1/10*;
inscribed l.r.: *Cire–C. Valsuani–perdue*
The Museum of Modern Art, New York, Mrs. Solomon Guggenheim Fund, 1952

IN EXHIBITION

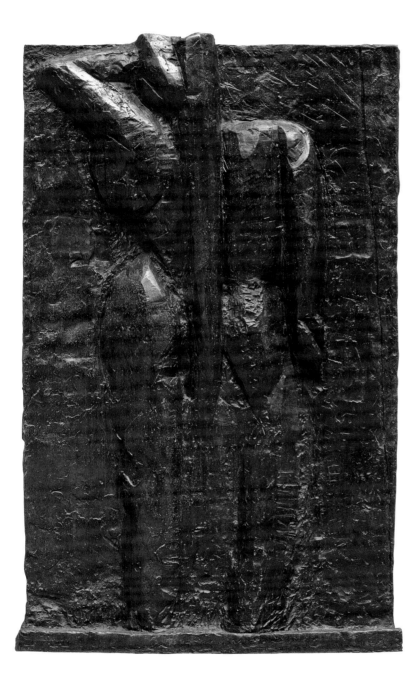

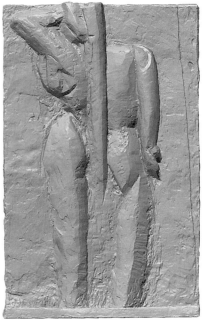

45a

45a
Grayscale three-dimensional digital model of *Back (III)*.

45b
Matisse working from *Back (II)* to *Back (III)*,
May 13, 1913, photograph by Alvin Langdon Coburn.
Archives, International Museum of Photography at
George Eastman House, Rochester, New York.

45c
Matisse working from *Back (II)* to *Back (III)*,
May 13, 1913, photograph by Alvin Langdon Coburn.

45d
Marguerite Matisse standing in the garden at Issy,
c. 1915 or 1916, with *Back (III)* in process in
the background. Archives Henri Matisse, Paris.

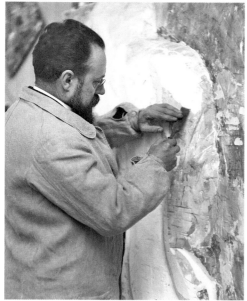

45b

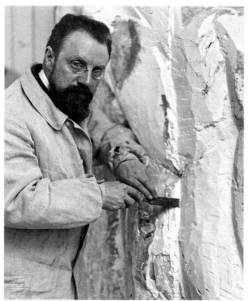

45c

45d

WHEN MATISSE RETURNED from Morocco in early March 1913, he resumed two long-term projects, his painting *Bathers by a River* [**16**] and his bas-relief *Back* [**17**]. Just about two months later, on May 13, Alvin Langdon Coburn photographed the artist working on a *Back* sculpture. Since these images were first published in 1992, this work has been identified variously as *Back (I)* or *Back (II)*.[1] However, careful study of the images, along with the two bronzes and their three-dimensional laser-scanned models [**45a**], suggests that we are looking at neither of these, but instead a cast of *Back (II)* on its way to becoming *Back (III)*. In both photos, we see the artist at work, having covered the surface with varying intensities of slip (a thin mix of clay and water), or possibly tint or varnish, in order to better distinguish the marks he made into the white plaster with his knife and chisels; this could be reapplied as he continued to carve down and reshape the figure. The picture of Matisse looking at the bas-relief [**45b**] shows his recent removals, which register as white shapes on the surface of the figure's shoulder. At the bottom right, we see the hand: it appears without the fingers of *Back (I)* and *Back (II)*, and with the dark inverted triangular notch that would become the joint between the thumb and fingers of *Back (III)*.[2] In the second photograph [**45c**], the artist looks out to the viewer while his chisel rests just below the V-shaped lines connected to the hips of *Back (II)*, now under transformation into the vertical channel of *Back (III)*.

This new identification also suggests a longer period of production for *Back (III)* than the traditionally held date of 1916. Indeed, as mentioned earlier, Marguerite Duthuit suggested that the *Backs* are in fact one sculpture that passed through several states, and that her father made a cast when he felt he had worked it to a point of progress that satisfied him.[3] A drawing from his second trip to Morocco demonstrates his continuing consideration of his bas-relief [**16k**], and it is likely, given what we have seen in Coburn's photographs, that upon his return to Issy the artist quickly completed—or decided that he was already satisfied with how he had left—his bas-relief. He proceeded to cast what would become *Back (II)* in order to move forward with his work.[4] He surely discussed his plans with his friend Charles Camoin while they were together in Tangier, for around mid-August 1913, Camoin wrote to Matisse inquiring about his progress on the sculpture; the artist responded in September, stating that he had "advanced on my large painting of Bathers [**21**], the Portrait of my wife, as well as my Bas-relief."[5]

In December of that year, a month before Henri and Amélie Matisse's move to Paris, Robert Rey visited the Issy home and studio, where he noted "the vast Neo-Assyrian bas-reliefs, which Matisse carves into enormous slabs of plaster."[6] While this account gives us little to document the progress of *Back*, a photograph of Marguerite from c. 1915–16 [**45d**] provides more specific information. This image was presumably taken when the family returned to Issy after the French military's occupation of their home, and the studio and its contents were reassembled. We can see a bas-relief in the background that no longer resembles the one documented in Coburn's photograph; instead, it is far more vertically structured, more like stone than flesh and closer to the final form of *Back (III)*. This state is most likely one of those that Axel Salto noted during his visit to Matisse's studio in spring 1916, describing "reliefs of a powerful man's back in motion."[7] Like *Back (II)*, therefore, the period of production for the third state was long: Matisse started, paused, and restarted the project over three years' time.

A digital overlay of *Back (II)* and *Back (III)* [**45e**] confirms the general nature of Matisse's work on this state: he further straightened the figure's spine, eliminating details like fingers and the musculature of limbs; emphasized vertical elements in the pose; and widened the overall form. Another comparison of relative depths with a difference of up to ten centimeters [**45f**] identifies areas of blue and purple where the artist added between six and ten centimeters of material. Areas of yellow and orange indicate where he carved away between three and six centimeters of the surface of the cast of *Back (II)* to make the new work.[8] The main thrust of this process, as evidenced in superimposed cross sections of *Back (II)* (in yellow) and *Back (III)* (in red), was the reduction of depth and expansion across the surface. In a vertical cross section [**45g**] that runs from the split at the head down to the inside of the left leg, we can see the overall removal of mass from the figure as well as the one area of exception: the addition of material to the squared-off head. A horizontal cross section at the level of the right wrist [**45h**] also demonstrates the repositioning of the figure's hip to the left, the pronounced removal of material, and the generally more shallow forms of the third state.

While it possesses a more shallow effect, *Back (III)* gives the sense of deepening structure, which is especially apparent in the solid, trunklike legs and repeated verticals across the figure's body. The most pronounced element is the prominent spine or column of hair, which seems to clamp the figure onto the surface and press it into and across the ground. In many ways, this flattening and sectioning of form is reminiscent of the effect of the Cubist grid that Matisse adopted in such paintings as *Head, White and Rose* [**30**] or the vertical bands he devised for *Goldfish and Palette* [**31**], *The Moroccans* [**44**], and *Bathers by a River* [**46**]. The artist very likely worked

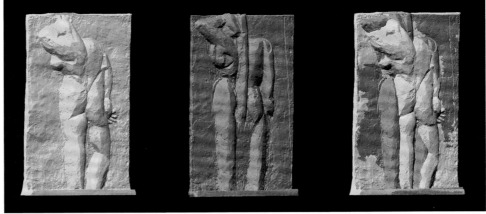

45e

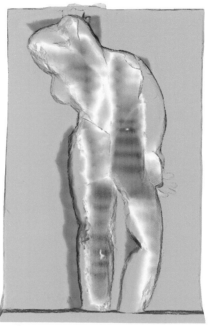

45f

45e
Three-dimensional digital models of *Back (II)*, in yellow, and *Back (III)*, in red, separately and, at right, overlaid.

45f
Overlay of *Back (II)* and *Back (III)* with differences of up to 6 centimeters identified; yellow-orange areas are lower in *Back (III)*.

45g
Vertical cross section of superimposed *Back (II)* and *Back (III)*, running from the split at the head down to the inside of the left leg; this shows both the addition of material at the head and the overall removal of mass.

45h
Horizontal cross section of superimposed *Back (II)*, yellow, and *Back (III)*, red, at the level of the right wrist; this demonstrates both the repositioning and addition of material on the left and the general effort to reduce materials.

45i
Detail from the laser-scanned *Back (III)*, revealing parallel chisel marks inside the incised line.

45g

45h

on *Back (III)* after he had been occupied with *The Moroccans* for a number of months in 1916, and the bas-relief figure shares some of the weight and sense of construction of the great back-turned figure at the center of that canvas. An even deeper connection can be seen between *Back (III)* and *Bathers by a River*, which was painted in the Issy studio just to the right of the bas-relief, according to the artist's son Pierre.[9] The left-hand bather shares many characteristics with this figure, from the pose and the rounded, heavy hips to the thick, vertically sectioned torso and the deep central structure running down the back. In *Bathers by a River*, this hair or spine is underscored by its thickness and dark black color; in *Back (III)*, it is emphasized by the deep carving on either side of the column and its pronounced profile at top.[10] Both *The Moroccans* and *Bathers by a River*, as well as *The Piano Lesson* [**43**], which Matisse also painted during the summer while he worked on *Back (III)*, are constructed with strong vertical lines and sectioning that produces a kind of rhythm and balance. Matisse suggested the same for *Back (III)*: on the right, we can see a thin line that runs along the ground from the bottom to the top edge. Through laser-scanning technology, we can identify parallel chisel marks that run down the inside of the line [**45i**]. Just as his paintings influenced his bas-relief at this time, so too did Matisse's sculpture—its process of removal and structure of deep recesses—affect his paintings, none more significantly than *Bathers by a River* [**46**, **54**].

45i

marks and occlusion of details from the original as it was subjected to numerous castings and reworkings.

9. See Barr Questionnaire VII; and Elderfield 1978, p. 198, fig. 62, also based on conversations with Pierre Matisse.

10. The strong vertical center of *Back (III)* also points to the possibility that due to Matisse's heavy reworking, the plaster cracked at some point in the process. Both sides of the spine are deeply carved from a relatively flat but bulky upper back. The lower end of the spine stops at the thickest part of the standing left thigh on *Back (II)*, which was all cut away to make the next state. Matisse removed as much as four inches of materials, which would have weakened the remaining plaster and could have caused a crack, and the area between the legs on *Back (III)* looks as if it might include filler material, which would compensate for the thinning out of the plaster.

1. These photographs were discovered by Sharon Dec, The Museum of Modern Art, New York, in preparation for Elderfield's 1992 retrospective exhibition and were first published in that catalogue.

2. Comparison of the computer-generated models of *Back (I)* and *Back (II)* show that the fingers are identical in the two states; this supports the idea that they were retained from one cast to another and not re-sculpted for *Back (II)*. Given this, the fingerless hand in Coburn's photograph must be one of *Back (II)* in transition to *Back (III)*.

3. Marguerite Duthuit to John Elderfield, Apr. 26, 1978; Elderfield 1978, p. 194 nn. 6, 13. In 1936 Matisse explained the importance of this method to E. Tériade: "My reaction to a state [*étape*]—said Matisse— is as important as the subject. For this reaction originates from me and not from the subject. Starting with my interpretation I react continually until I find the work in agreement with me. Like someone putting together a sentence—reworking it, rediscovering it. At each state, I have a balance, a conclusion"; Tériade 1936, p. 3.

4. It may also be possible that the work was completed earlier, in 1911 or 1912, and that Matisse simply made a new cast at this time to begin his work.

5. Matisse to Camoin, Sept. 15, 1913, Archives Camoin. According to Grammont 1997, p. 49, this undated letter was written by Camoin in Cassis to Matisse on Aug. 14, 1913.

6. Rey 1914, p. 60.

7. Salto 1918.

8. Like the previous state, there are generally minimal changes to the background; many of these, including the signature, demonstrate the continued softening of

46 **Bathers by a River, fifth state**
Issy-les-Moulineaux, early spring–November 1916

Oil on canvas; 260 × 392 cm (102 1/2 × 154 3/16 in.)

Photograph of *Bathers by a River* by Galerie Bernheim-Jeune, showing the painting
as it was in November 1916.

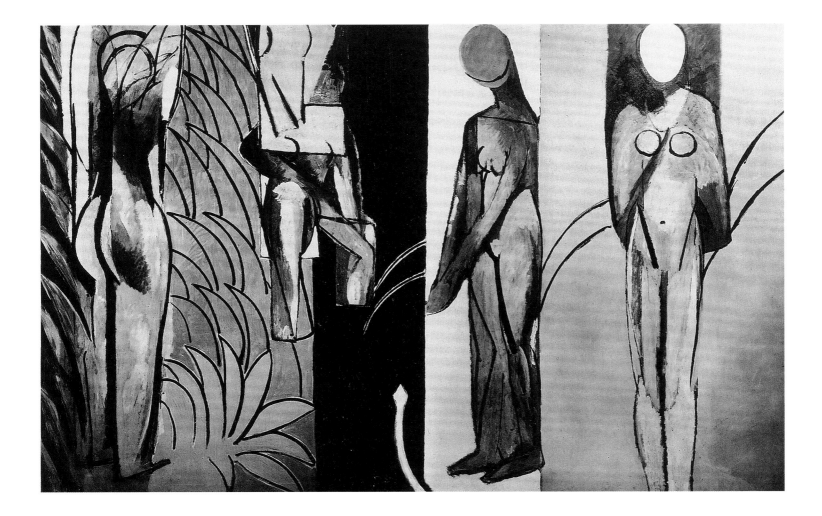

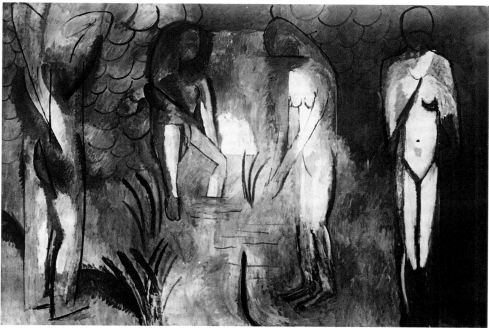

46a

46a
Bathers by a River, November 1913, photograph by Eugène Druet.

IN NOVEMBER 1913, Eugène Druet photographed *Bathers by a River* as *Femmes nues, décoration* [**46a**], capturing a somber, abstracted image of four figures in a landscape painted in a predominantly gray palette.[1] Soon afterward, Matisse left the canvas in Issy when he moved to Paris, where he worked on an ambitious set of paintings in a new studio. In August 1914, he was confronted by the outbreak of war and did not return to work in Issy until some time in 1915, slowly rebuilding his painting practice after a long absence. Since the beginning of 1916, the artist had been working on *The Moroccans* [**44**], but at some point, probably in early spring, he turned again to his monumental bathers scene. The Danish artist Axel Salto visited Issy in April or May and saw the canvas in progress, remarking, "Matisse was in the seventh year of working on an enormous painting that presented a row of figures placed next to each other in separate squares."[2] A month or so later, on June 1, Matisse wrote to Léonce Rosenberg to report that he had "taken up again a five-meter-wide painting showing bathing women."[3]

By November 1916, the canvas was photographed by Bernheim-Jeune [**46**], looking markedly different from the state documented by Druet just three years earlier and very much like the version we know today.[4] Comparing the 1913 and 1916 photographs reveals the great amount of work that Matisse must have done to transform the monumental painting.[5] Gone was the monochromatic tonality and the narrative background of forested landscape and flowing waterfall; gone, too, was the method of modeling primarily with passages of pinks and grays. Instead, we see a far more animated and rigorously constructed composition distinguished on the one hand by a pronounced definition of constituent parts and, on the other, by a complex integration. No longer informed by the look of Analytical Cubism, the canvas now showed a greater resemblance to the dynamic work of Juan Gris and Gino Severini, as well as the continuing experiments of Braque and Picasso, including their *papiers collés* as well as Synthetic Cubist paintings.

Comparing the 1913 and 1916 states also reveals the nature of Matisse's work and its connections to other canvases he was making around this time. Looking at *Bathers by a River* in 1916, we can see elements of the grid in *Head, White and Rose* [**30**], the vertical registers of *Goldfish and Palette* [**31**], the divided forms of *Still Life after Jan Davidz. de Heem's "La desserte"* [**35**], the structured space of *The Moroccans* [**44**], and the distinct use of black in all of these. Perhaps most noteworthy are many formal connections between *Bathers* and the second and third states of *Back* [**17, 45**]; Matisse made *Back (III)* in the stretch of time between the 1913 and 1916 photographs. Indeed, according to the artist's son Pierre,

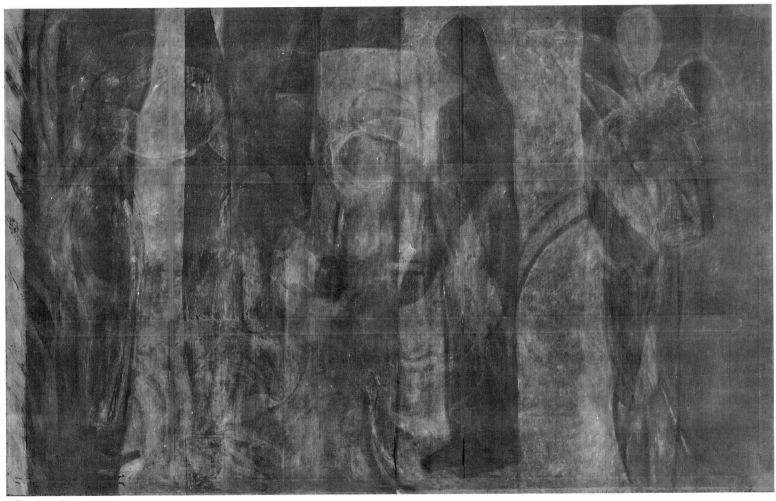

46b

the painting and bas-relief share a deep affinity, as both were produced in stages, side by side, in the Issy studio [**10b**].

A review of Matisse's changes to the figures in the 1916 state of *Bathers* reveals many shared issues of construction with *Back (III)*. For instance, the artist made the standing bather on the left wider as well as more vertical, adding passages of gray, pink, and pale blue to fill the form; he also segmented her torso with dark vertical lines that are reminiscent of the deeply carved structure of *Back (III)*. As a complement to the central axis of the sculpture, Matisse painted a shadowy hollow down her center.[6] Likewise, he made her hips fuller and her stance more rigid, emphasizing a sense of weight with thick, trunklike legs that share a pose similar to those in the bas-relief. While Matisse built mass with paint, he also reduced it on the rear of the left thigh, scraping away layers just as he removed plaster on *Back (III)*.

To revise the second figure, Matisse scraped back the previous hoodlike form of the head, exposing green and blue paint from the earliest, lowest level of the canvas [**5**] and working this removal in a way that still suggests the shape of a head. Above this, he held a few of the earlier tree forms in reserve and incorporated them in the elongated blue and gray forms that rise over the torso. While the trees overlapping recalls the kind of faceting seen in Futurist works, their rounded, angled shape also echoes the head and enveloping left arm of *Back (II)*. Matisse framed this bather with black lines that both divide and reinforce its construction. In addition, he positioned a set of rectangular planes at different depths in order to push parts of the figure forward while holding its center firmly to the ground.[7] This likewise recalls the play of figure and ground in *Back (III)*.

The third bather also sustained change: Matisse raised the head, elongated the neck, straightened the body, and extended the left side, seemingly encasing it all within a narrow geometric niche. Thick black lines divide and solidify the formerly soft figure, which is now anchored to a black vertical line that runs the height of the painting. The legs, filled with various scumbled shades of gray, play with transparency and opacity, as does the right hip, which is surrounded with dark gray paint. The sturdy black contour lines of the thighs contrast with the thinner overlapping forms of the lower half of the legs. Matisse gave this bather, too, a weighty permanence.

The artist subjected the standing figure on the right to some of the same types of changes, but she is far less segmented and geometrically constructed than her companions. Matisse defined the breasts clearly with black outlines, scraping the right one and repainting it with a darker pink. He widened the hips with black contours and filled out the legs with

a lighter tone of gray, as if adding sculpting medium to the earlier state, which we can see just below the present layers. In addition, he lightened the lower legs by adding white over dark gray, doing the same on the head; in this way, he extended the figure across the length of the canvas with a far greater weight than before.

While all these changes demonstrate Matisse's deep, evolving concern with the construction of form, one of the most remarkable occurred in the background, as Salto suggested when he described the figures "separated in squares." By examining the X-radiograph [**46b**] and cross sections of the painting, together with information gleaned through analysis of the pigment, paint extenders, and fillers, we can chart the numerous combinations of background colors and bands that the artist considered while he was adjusting the figures.[8] A series of illustrations [**46c–s**] represents the likely evolution of his work. Research demonstrates that the artist repainted some vertical strips as many as six times, adjusting widths and altering colors; his most intense work, however, occurred on the left edge.[9] Here we can see that he changed the band from light blue to white, black, and white again before painting it in pale blue with a black leaf pattern. Later he colored over the blue with green, holding the pattern in reserve; still not satisfied, he then filled the inside of the leaves with gray and the space between them with black, producing a dramatic, shadowy depth between the forms. In an inspired final step, pushing further the brush technique he deployed on the left edge of *Bowl of Apples on a Table* [**39f**], Matisse incised the contours of the leaves into the still-wet gray paint, much as he had in his monotypes. As he did for *Back*, he scraped down earlier layers of medium in order to reinforce the reserved silhouettes. His removals uncovered greens from the original composition [**5**] along with colors closer to the top layer, which blended with the wet gray paint from the surface, producing a kind of marbleized effect.

The sheer effort required to transform this large-scale picture so radically—and at the same time evoke the history of its production through its layered surface—is a clear indication of Matisse's great desire to challenge himself at the height of the war. In August 1916, even before the work was photographed, Rosenberg recognized what Matisse would achieve with the painting and asked to put it on reserve.[10] The artist, however, was not yet ready to finalize the picture, and in the end, the November photograph came to serve as a document of yet another stage in its ongoing evolution.

1. Curatorial files, Art Institute of Chicago.
2. Salto 1918.

46c

46d

46e

46f

46g

46h

46i

46j

46k

46l

46c–s
Digitial re-creation of Matisse's revisions of *Bathers by a River* from early spring to November 1916.

46m

46n

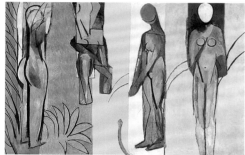

46o

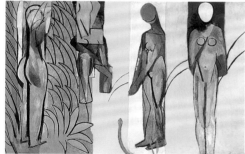

46p

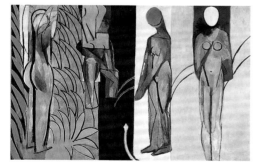

46q

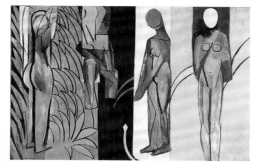

46r

46s

3. Matisse to Rosenberg, June 1, 1916, manuscript department, Musée National d'Art Moderne; a copy of the letter also resides in the Alfred H. Barr, Jr., Papers, MoMA Archives.

4. Over the years many scholars, including Alfred H. Barr, Jr., have identified this photograph as that of the completed work, although it is not. Matisse's continuing changes to the painting are detailed in entry 54.

5. An additional indication of the painting's transformation can be seen in its title at this time, which, according Dauberville and Dauberville 1995, vol. 1, pp. 568–69, cat. 166, was *Trois personnages debout*, demonstrating a move to a much more abstracted concept.

6. For more on this particular aspect of the work, see Elsen 1968d; Elderfield 1978, p. 78; and Flam 1986, pp. 416–19, who also made note of the telling connection between the 1916 version of the figure and Matisse's *Three Bathers* by Cézanne (p. 45, fig. 3).

7. Matisse played with this newly constructed space—for example, in the the bather's right knee. Here it is pushed so far forward into the viewer's space that it is literally painted out of focus.

8. The material composition of the bands was determined to be frequently different than those of the pigments Matisse used for earlier states of the composition. The paint in the bands contains elements most likely added as inexpensive extenders or fillers during World War I, when raw materials may have been hard to come by. It is also possible that the artist added the materials himself in order to extend the paint or adjust its qualities, making it more matte and stiff or giving it a more textured tooth. It might have resulted in a more opaque paint or a more transparent one, depending on the ratio of oil binder to pigment and extender. For example, the pale blue and white bands on the right side are stiff but relatively transparent; the bright green band on the right is more smooth, fluid, and transparent.

9. In July 1916, Camoin wrote to Matisse (AHM), "Your painting staggered me a little, [I was] disconcerted probably because I did not have the time to really understand it, I understand the logic of the big black area with bands of white, and yet it leaves me somewhat anxious, still a bit of leftover prejudice perhaps." Grammont 1997, p. 102, suggested that this may be a reference to *Bathers by a River*. Indeed, at one point in the process of evolution, the bands produced a stable pattern of green, black, white, and blue; however, this comment may be too soon in Matisse's many months of work on the painting to actually be about this canvas, and not, perhaps, *The Moroccans*.

10. On this date, Matisse wrote in his personal notebook, "Saw Rosenberg in Chatou. Had a visit from him the next day. Asked to be #1 for the canvas of bathers." Thanks to the AHM for sharing this information for this publication.

LOOKING BACK ON THE YEAR 1917, Matisse would recognize it as a major period of change:

I was coming out of long and wearying years of searching, during which I had given the best of myself, after many inner conflicts, in order to bring those researches to the point of achieving what I hoped would be an unprecedented creation. In addition, I had been strongly engaged by the requirements of important mural and monumental compositions. After having started out with some exuberance, my painting had evolved toward decantation and simplicity. A synthesis both pictorial and moral, governed always by the laws of harmony, held strict dominion over my work. A will to rhythmic abstraction was battling with my natural, innate desire for rich, warm, generous colors and forms, in which the arabesque strove to establish its supremacy. From this duality [later] issued works that, overcoming my inner constraints, were realized in the union of [these two] poles.[1]

The artist must have felt pleased that such "important mural and monumental compositions" as *Bathers by a River* (46) and *The Moroccans* (44) had finally come to (or were nearing) fruition and, therefore, must have been anticipating—if not actively encouraging—the likelihood of an artistic shift in direction. Change did indeed occur and, as Matisse himself suggested, the shape it took was a return to "rich, warm, generous colors and forms," giving "the arabesque . . . its supremacy" after an era of increasing austerity and geometry. What Matisse did not mention, however, is that this took place within the context of a move to naturalistic representation; this development began early in 1917 and dominated his practice by the end of that year, even while he was continuing to paint severe and abstracted pictures.

The naturalist paintings surprised and at times dismayed his supporters with their conservatism, and have continued to do so. It bears remembering, though, that even the most abstract paintings of the 1913 to 1917 period were a consequence of Matisse's desire to "discover in nature how my sensations should come" after a time of producing highly synthetic, imaginative compositions that culminated in *Dance (II)* and *Music* (p. 77, figs. 1–2).[2] Indeed, he made nearly all of these paintings from nature, and those that were made from the imagination, notably the "mural and monumental compositions," followed the principle, laid down in his 1908 "Notes of a Painter," that "even when [the artist] departs from nature, he must do so with the conviction that it is only to interpret her more fully."[3] In that text, the artist had also observed that while paintings by Impressionists "register fleeting impressions," he sought to represent the "essential character" of a landscape rather than "only one moment of its existence [*durée*]."[4] He did make some small impressionistic studies after nature in 1917, but all his ambitious paintings held to that principle of capturing the flux of duration in a single image. And his single largest project of 1917, more than fifty paintings of the model Laurette, was entirely consistent with the Bergsonian principle that he had been using for the past several years: that duration, given its fluid nature, cannot finally be grasped in a single image, but that "many diverse images . . . may, by the convergence of their action, direct the consciousness to the precise point where there is an intuition [of duration] to be seized."[5]

Matisse had, in fact, regularly shifted direction to preserve his artistic momentum, also arguing in "Notes of a Painter," "My destination is always the same, but I work out a different route to get there."[6] In this case, the new route may have been predicated by external as well as internal reasons. Among these was the painful progress of the war, which reached a critical moment at the end of the horrendous Battle of the Somme on November 18; less than a month later, Germany offered a compromise peace that was rejected as unacceptable. The conflict continued with renewed force, to the dismay of soldiers and civilians alike: in April the Second Battle of Aisne, in Matisse's home region, was an unmitigated failure for the French army, which lost 187,000 of its troops, 40,000 on a single day; the Germans razed villages as they advanced, and even the town of Saint-Quentin, where the artist had gone to school, was forcibly evacuated and pillaged. For France the continuing, systematic destruction of its young male population and its landscape, as the war

moved through its third year, must have seemed never-ending. We know from Matisse's 1916 letters to friends and colleagues that his anguish and sense of impotence had increased as the war advanced.[7] These sentiments were matched by his conscious engagement with a parallel struggle on his monumental compositions, although he knew that his own strivings were nothing compared to those of the soldiers at the front. When he no longer had most of his big projects to worry over, it must have been even harder for him to be a civilian in wartime.

In Paris one response was to make the best of a bad situation. This meant throwing banquets for returning war heroes such as Guillaume Apollinaire and Braque, both of whom had displayed great bravery, been seriously wounded, and been highly decorated.[8] It also meant going to benefits for war victims, like the Ballets Russes's performance of *Parade* with Picasso's Cubist costumes and romantically naturalistic curtain; and simply participating in the increasing number of art-world events. By the end of 1916, the cultural life of Paris was continuing to improve as dealers sought to promote new art to haute bourgeois and aristocratic clients, who mingled socially with artists in a way unknown before the war.[9]

Matisse's main dealer, Bernheim-Jeune, continued to be extremely active, and the artist's correspondence through 1917 is full of exchanges with the gallery about sales, frames, commissions, and payments.[10] The principal competitor for his paintings, Léonce Rosenberg, still courted the artist, but with lessening success. Rosenberg's access to his work was facilitated by the expiration of the artist's second contract with Bernheim-Jeune on September 15, 1915; it was made more difficult again when Matisse signed a new agreement with the firm on October 19, 1917. But even before then, Rosenberg recalled, Matisse had stopped offering him paintings owing to "the entry into the action of the Scandinavians."[11] He was referring to Walter Halvorsen (fig. 1), Matisse's friend and former student, and the husband of his occasional model, the actress Greta Prozor (48.3). Having previously worked with the Paris dealers (for example, buying Matisse's *Bowl of Oranges* [38] through Bernheim-Jeune), Halvorsen was now going directly to Matisse, or to those who owned his work, for both old and new examples to offer to a burgeoning audience of Scandinavian collectors.[12]

Matisse himself was not doing at all badly. In fact, he had begun to augment his income by engaging in some dealing himself. We know that he served as an agent for a Swiss buyer who wanted someone to assemble an early modern collection and that he recommended to the critic Walter Pach a dozen paintings—including

fig. 1
Henri Matisse (at right) and his family sitting on the steps of his studio in Issy-les-Moulineaux with Walter Halvorsen (front) and Greta Prozor (back right), c. 1916. Archives Henri Matisse, Paris.

works by John Constable, Camille Corot, Jacques-Louis David, Jean-Auguste-Dominique Ingres, Claude Lorrain, and Antoine Watteau—that eminent Parisians were willing to release into the thriving American market.[13] Additionally, as the exchanges with Bernheim-Jeune and Halvorsen's activities testify, his own work was selling well. It helped that he took on a commission in the winter of 1916 to paint a portrait of Auguste Pellerin, which required making two versions (50, 50a). The second canvas turned out to be his final great portrait of a period that was now winding to a close.[14] According to Pierre Matisse, early in 1915 his father had felt so strapped for funds that he considered selling his treasured Cézanne *Three Bathers* (p. 45, fig. 3). Now, however, he had enough discretionary income to purchase a great landscape by Gustave Courbet, *The Source of the Loue* (fig. 2); he added four more Courbets in 1917, including a study for *Young Women on the Banks of the Seine* (fig. 3) and *Sleeping Blonde Woman* (1849; private collection).[15] The influence of these highly sensual figure paintings would be reflected in his series of usually small, and therefore more easily saleable, naturalistic portraits of Laurette, "an Italian model recommended by Mme. Sembat [Georgette Agutte]," as Matisse described her.[16] He engaged her in November 1916, and the two worked together into the following summer.

Yet even as he reengaged with naturalism, he continued to make toughly formalized works, among them a pair of paintings of the quai Saint-Michel studio with Laurette. Viewed in retrospect, they have a valedictory tone. The earliest of the pair, *The Painter in His Studio* of winter 1916–17 (51a), became the final canvas in which Matisse used broad dark and light bands to make the foreground and background into one plane, a practice he had initiated in his first painting of this studio, the early 1914 *Interior with Goldfish* (24), and which had become ubiquitous over the intervening three years. This was also the very first canvas in which the artist presented himself painting a model. However, he transformed himself into something close to a small wooden marionette sold to teach rudimentary poses to art students, and Laurette into a decal pasted onto the back wall. The artist is absent from the second painting, *The Studio, quai Saint-Michel* (51), only temporarily, we presume. Nonetheless, the theme of unfinish that resounds in the interior—from the incomplete drawing on the chair to the ghosts of drawings on the walls; from the rudimentary outlines of the model to the sketchy forms of the furniture—comprises the final great example, in this severe vocabulary, of Matisse's expression of duration as something in flux, deconstructing and reconstituting form.

But while Matisse was still making such compositions, and despite his changing relationship with Rosenberg, he appears to have remained in touch with some of the increasingly large group of younger Cubists whom the dealer was attracting to his fold; among these were Juan Gris, André Lhote, Amédée Ozenfant, Diego Rivera, and Gino Severini, who in early 1917 visited Matisse's studio to see him paint. The elder artist sent collectors to Severini, whose works Halvorsen also bought for his clients.[17] Another regular visitor to Matisse's atelier was the poet Pierre Reverdy, who played a crucial role in defining a new, stricter role for Cubism; his attempt to reconsider Cubism in its eighth year may well have interested Matisse for its rigor but must also have increased his skepticism about the style's usefulness to him. Much later, he conceded to having been bothered by its success and left out by "not joining the direction that was acquiring more and more followers and whose prestige was becoming increasingly widespread."[18] But he could not be a part of it: "Of course, Cubism interested me," Matisse remarked, "but it did not speak to my deeply sensory nature." In 1917 this became especially obvious.

In March of that year, Reverdy had published the manifesto-like article "On Cubism" in the first issue of the magazine *Nord-sud*, which he edited. After criticizing the followers of the original Cubists for simply working "*in the Cubist manner,* while laying claim to the making of a new art of their own," he explained what he felt was the true lesson of the style: "Just as perspective is a means of representing objects in accordance with their visual appearance, so Cubism now offers a way

fig. 2
Gustave Courbet
(French, 1819–1877)
The Source of the Loue, c. 1864
Oil on canvas
107.3 × 137.5 cm (42 1/4 × 54 1/8 in.)
Albright-Knox Art Gallery,
Buffalo, George B. and Jenny R.
Matthews Fund, 1959
(Formerly in Matisse's collection)

fig. 3
Gustave Courbet
Young Women on the Banks of the Seine, 1856
Oil on canvas
174 × 206 cm (68 1/2 × 81 1/8 in.)
Musée du Petit Palais, Musée des Beaux-Arts de la Ville de Paris
(Formerly in Matisse's collection)

of constructing the picture which takes account of objects only as picture elements and not as anecdotal elements."[19] Although specious in its description of what Cubism originally was—in fact, it was very much a new way of retaining references to quotidian, anecdotal objects—Reverdy's article succinctly argued for a new, purified Cubism that was to feature prominently in Rosenberg's Galerie de l'Effort Moderne.[20] Those artists who had participated in the war, notably Fernand Léger and Braque, not only felt contempt for those who qualified to serve but managed to avoid doing so—including Robert Delaunay, Marcel Duchamp, and Albert Gleizes—but also felt compelled to continue to advance Cubism down the path of external reference, Braque picking up where he had left off and Léger finding in its idioms an analogy to the anonymity of modern, mechanized warfare. However, the majority of the new avant-garde, who had not been in uniform or demobilized, turned their back on contemporary horrors, seeking to distill Cubism to its purest, most hermetic form.

Part of the justification for doing this was to return the movement to its essence of classic, "Latin" clarity and order—a traditional defense not dissimilar to that offered for certain kinds of representational art, including Matisse's, and for a larger development that came to be known as the "return to order," which was taking root in France at this time.[21] This idea, in fact, had never been the essence of Cubism, but it was reassuring for artists to believe so after the horrors of the war made extreme avant-gardism seem as distant from present realities as the most hedonistic of decorations. This meant that the new Cubist aesthetic was not only averse to the privileging of representation, but also utterly uninterested in the older, highly experimental concerns that centered on condensed descriptive reference and the evocation of the simultaneity of experience, the very human things that had attracted Matisse and, indeed, led Picasso and Braque to invent Cubism in the first place. Therefore, it is of special interest that it was human representation at its most unequivocal, namely portraiture, that took both Matisse and Picasso away from the orbit of the younger Cubists.

Toward the end of 1916, Matisse's portraits reached their most extreme level of abstraction in the medium of drawing, notably in the massively erased and revised images of Eva Mudocci (48.1–2), Greta Prozor (48.3), and Sarah Stein (47.1), the latter two even more radical than his paintings of these subjects. That year he had been impressed by reading the mathematician Henri Poincaré's *Science and Hypothesis* (1901)—"such daring hypotheses, one feels quite dizzy," he wrote to Derain.[22] It contained the claim, reminiscent of Bergson, that "movement exists only by means of the destruction and reconstruction of matter." With their many erasures, these drawings seem literally to have been constructed from destroyed matter. It was while working on them that the artist engaged his new model, Laurette. His first painting of her, *The Italian Woman* (49), is fully as formalized as his painted *Portrait of Sarah Stein* (47.2). But Matisse continued, making almost fifty canvases that utterly altered his practice of portraiture, for they are likenesses of a young woman in different roles, as expressed in a particular costume, deportment, mood, or artistic mode. This is to say that the difference between one painting and the next reads more as a change in identity assumed by the model than an alteration in the way that Matisse represented her. Many of these works are, in fact, rather similar in treatment, executed in the highly sympathetic realist style that he adopted for *Portrait of Michael Stein* (47a) and other small portraits of the period (fig. 5). Others are very diverse: decorative (fig. 6), sensual (fig. 7), formalized (fig. 4), and so on.[23] The very existence of alternatives suggests not stylistic eclecticism as such, but that the artist imagined alternative existences for his model and that his style followed that imagining. In short, thematic exploration now drove formal construction: an art-for-theme's-sake resurfaced in Matisse's practice, having been expelled from it for twenty years.[24]

The sheer number of these naturalistic paintings must have come as a shock to those who were familiar with the artist's recent production. The bare fact of their

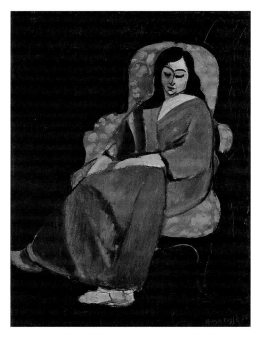

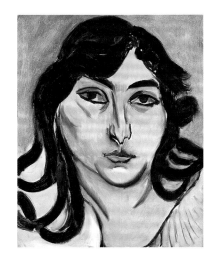

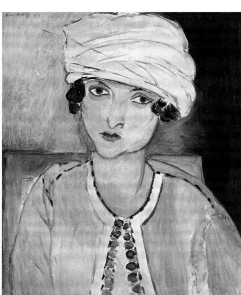

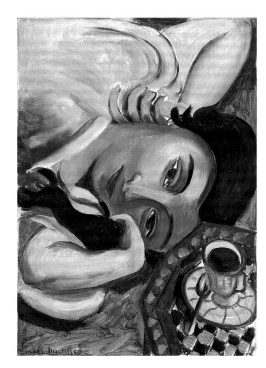

fig. 4

Laurette in a Green Robe, 1916
Oil on canvas
73 × 54.3 cm (28 3/4 × 21 3/8 in.)
The Metropolitan Museum of
Art, New York, Jacques and
Natasha Gelman Collection,
1999.363.43

fig. 5

Laurette with Long Locks, 1917
Oil on wood
35.2 × 26.7 cm (13 7/8 × 10 1/2 in.)
Norton Museum of Art, West
Palm Beach, Bequest of R. H.
Norton, 53.124

fig. 6

*Laurette with Turban, Yellow
Jacket*, 1917
Oil on wood
61.3 × 49.4 cm (24 1/8 × 19 7/16 in.)
National Gallery of Art,
Washington, D.C., Chester Dale
Collection, 1963.10.39

fig. 7

Laurette with Cup of Coffee, 1917
Oil on canvas
57.8 × 40 cm (22 3/4 × 15 3/4 in.)
The Art Institute of Chicago,
estate of Marguerita S. Ritman;
Marion and Samuel Klasstorner
Endowment; through prior gift of
Philip D. Armour; through prior
bequests of Dorothy C. Morris
and Marguerita S. Ritman,
1993.186

naturalism, however, would not: he had continued to create occasional canvases, as well as a number of prints and drawings, that did not reflect the abstracting tendencies of the past few years. In Picasso's case, however, the neoclassical, Ingres-influenced portrait drawings that he began making in 1915 came almost out of the blue and created a furor. In December 1916, when his *Portrait of Max Jacob* (fig. 8) was published in the journal *L'Élan*, attacks began from the new purist Cubist faction, among them highly sarcastic remarks from the truculent Francis Picabia.[25] Reverdy laid out the party line regarding portraiture in his *Nord-sud* article: "Cubism is an eminently plastic art; but an art of creation, not of reproduction or interpretation. . . . After the foregoing, it will be understood that no cubist painter should execute a [realist] portrait."[26]

If, as Jean Cocteau remarked, "A [Cubist] dictatorship hung heavy over Montmartre and Montparnasse," Rosenberg was in many ways its chief promoter.[27] Matisse's increasing unwillingness to offer him paintings for sale probably came less from a desire to use Halvorsen than from his discomfort with the aesthetic orthodoxy that Rosenberg was endorsing.[28] Similarly, Picasso's escape from this dogmatic climate by withdrawing from the Parisian avant-garde scene in fall 1916, initially to work with Sergei Diaghilev's Ballets Russes, was paralleled by Matisse's

own escape and withdrawal to Nice a year later. After his brief experimentation in 1914 and 1915 with the doctrinaire Cubism of Gris, Metzinger, and others, which had most notably produced his *Still Life after Jan Davidsz. de Heem's "La desserte"* (35), Matisse had pulled back to create his far more personal canvases of 1916. Seeing how much more rigid the conception of Cubism was becoming in early 1917 must have made him realize its usefulness for him was waning.

And yet even while the young Cubists produced work that Matisse and Picasso found unsympathetic, these distinguished elders shared their interest in traditional French virtues, an interest that increased as the war continued. One important commonality was an admiration of Cézanne and Corot as exemplary French painters, which is evident in the propaganda exhibitions organized for foreign venues in 1917. In January, for instance, a large display of French painting opened at the Kunsthalle Basel; coordinated by four Paris galleries to benefit the Fraternity of Parisian Artists, and therefore their dealers, it was conceived to show the indebtedness of younger practitioners (Matisse included) to those of the late nineteenth century, Cézanne in particular.[29] This shared debt also served to connect Cubist paintings as diverse as those by the purist Gris and the antipurist Picasso, notably the former's *Woman with a Mandolin (After Corot)* of 1916 (fig. 9) and the latter's *The Italian Girl* (fig. 10), painted in April 1917 in Rome, where Cocteau declared, "Long live Corot! Picasso speaks only of this master."[30]

For Matisse, *The Music Lesson* (fig. 11), which he painted in the summer of 1917 at Issy, seemed to mark a point of no return. In this reprise of *The Piano Lesson* (43) of the previous summer, the artist reversed his customary approach to working in pairs, in which he produced the naturalistic canvas first and the experimental one second.[31] As a result, *The Music Lesson* resembles the meticulously representational drawing that Matisse used to plan the composition of the earlier work (43a) and then stripped of detail as he created the large geometric planes of the 1916

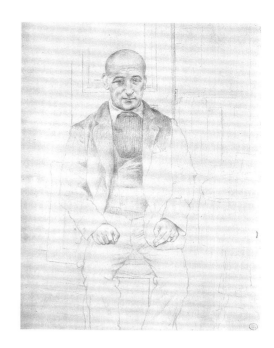

fig. 8
Pablo Picasso
(Spanish, 1881–1973)
Portrait of Max Jacob, 1915
Pencil on paper
33 × 24.8 cm (13 × 9 3/4 in.)
Private collection

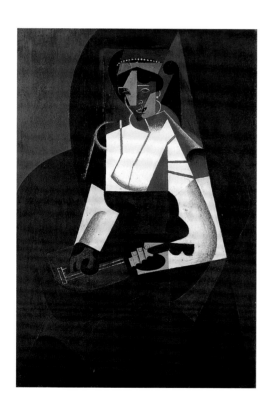

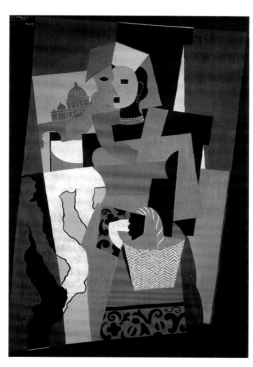

fig. 9
Juan Gris (Spanish, 1887–1927)
*Woman with a Mandolin
(After Corot)*, 1916
Oil on plywood
92 × 60 cm (36 1/4 × 23 5/8 in.)
Kunstmuseum, Basel, gift of
Dr. H. C. Raoul La Roche

fig. 10
Pablo Picasso
The Italian Girl, 1917
Oil on canvas
149 × 101 cm (58 3/4 × 39 3/4 in.)
Foundation E. G. Bührle
Collection, Zurich

painting. There are a few broad planes in *The Music Lesson*, but its surface is unified not by these but rather by the "rich, warm, generous colors and forms," loosely applied in a manner previously thought more appropriate to an *esquisse* than to a finished *tableau*. And the theme changed, too: the large, gray-green geometric rectangle behind the window was replaced by a lush and seductive garden. At the far side of it, beyond a circular pool, what looks like a theatrical backdrop shows a monumental statue surrounded by foliage that has more than a passing resemblance to Matisse's *Reclining Nude (I) (Aurore)* (1.2) of 1906–07 as re-represented in *Blue Nude (Memory of Biskra)* (1.3). The wishfulness of the evocation is unmistakable, speaking as it does of the imaginary Arcadia that held sway in Matisse's art prior to the devaluation of such dreaming during the war.

This cannot be irrelevant to the next development in Matisse's art: his return to landscape painting. Announcing to his friend Charles Camoin that he had reprised the previous year's picture of his son Pierre at the piano, the artist added that he had also produced "many other canvases of lesser importance—I can travel around the neighborhood, thanks to a small car that I have purchased and that allows me to easily transport myself and my materials into the forest."[32] Matisse had become interested in the works of the great Impressionist landscape painter Monet, with whom he had been in regular contact since November 1916, visiting him with Marquet in May.[33] However, most of the landscapes that he painted in the Bois de Meudon and elsewhere near his home in Issy are small, unpretentious, straightforwardly naturalistic works (fig. 12), created with improvisatory daubs and strokes of pigment

fig. 11
The Music Lesson, 1917
Oil on canvas
243 × 209.5 cm (96 × 82 1/2 in.)
The Barnes Foundation,
Merion, Penn.

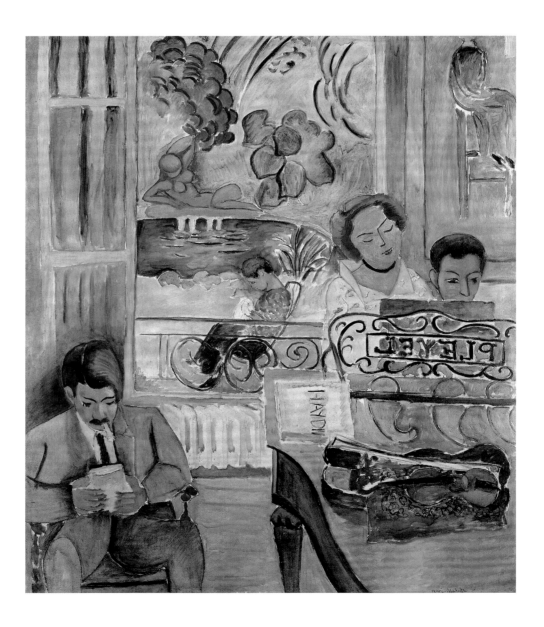

that reveal a generic affinity with at once the loosely painted landscapes of Cézanne, modest works by the proto-Impressionist Édouard Manet, and the earlier landscapes of Corot. A few of Matisse's canvases, such as *The Windshield on the Road to Villacoublay* (fig. 13), are spatially more complex, looking onto the landscape through the windshield of the artist's 1911 Renault. But they were not intended as major statements: "Those little things are relaxations, recreations," Matisse wrote to Camoin of similar works made the following year.[34]

Matisse did paint some more ambitious landscapes, one of which, *Trivaux Pond* (fig. 14), reads virtually as an homage to the bold simplifications of such decorative Cézanne paintings as *Large Pine Tree and Red Earth* (fig. 15), which he would have known from Ivan Morosov's collection in Moscow. Others, including *Crossroads at Malabai (Carrefour de Malabai)* (fig. 16), with its broken brushwork indicating patterns of light on a forest floor, suggest his interest in Corot's lyrical landscapes. In December 1916, Matisse had written glowingly to Walter Pach of such a landscape, *View of the Forest of Fontainebleau* (1834; National Gallery of Art, Washington, D.C), saying, "The effect of the painting is very decorative— the figure of the young woman reading, lying on a flowery patch of grass by the side of the river, is delightful."[35] In 1913 he had said that Corot's work expresses "a finished perceptive act" in the realization of its subject, whereas his own "was meant to be felt and submitted to" in order to appreciate its meaning.[36] But he now moved in Corot's direction, as is indicated by the contrast that he subsequently made between this artist's traditional use of half-tones and Gauguin's use of contours and

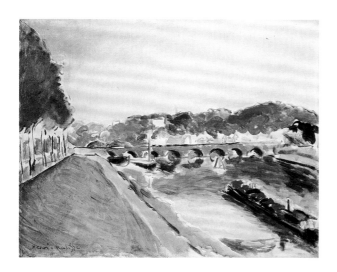

fig. 12
The Pont de Sèvres, 1917
Oil on canvas
26.7 × 34.7 cm (10 ¹/₂ × 13 ⁵/₈ in.)
Private collection

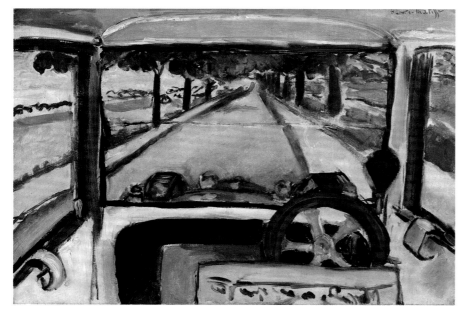

fig. 13
The Windshield on the Road to Villacoublay, 1917
Oil on canvas
38 × 55.9 cm (15 × 22 in.)
The Cleveland Museum of Art, bequest of Lucia McCurdy McBride in memory of John Harris McBride II

317

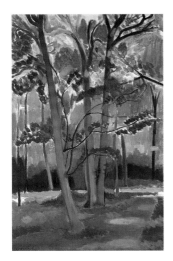

fig. 14
Trivaux Pond, 1916 or 1917
Oil on canvas
92.7 × 74.3 cm (36 1/2 × 29 1/4 in.)
Tate Modern, London,
bequeathed by C. Frank Stoop,
1933, NO4717

fig. 15
Paul Cézanne
(French, 1839–1906)
Large Pine Tree and Red Earth,
1890–95
Oil on canvas
72 × 91 cm (28 3/8 × 35 7/8 in.)
The State Hermitage Museum,
St. Petersburg

fig. 16
*Crossroads at Malabai (Carrefour
de Malabai)*, 1917
Oil on canvas
61.3 × 38.4 cm (24 1/8 × 15 1/8 in.)
Brooklyn Museum, bequest of
Laura L. Barnes, 67.24.16

very shallow spaces.[37] "Contour gives grand style (while in proceeding by half-tones one is closer to the truth)," he wrote to Camoin. "But don't you find that is seeing things a bit superficially, and that one can use contour to create a semblance of grand style and half-tone to create true grand style? Which was the greater style, Gauguin's or Corot's?"[38] The fact that Matisse could even ask this question is a demonstration of how he was now ready to challenge the modernist conventions on which his mature art had been based. Whereas previously he had regularly turned to Cézanne to sustain his moves forward to a more advanced position, now he appeared to be looking back through Cézanne to recover contact with the realism and naturalism of the nineteenth century. Whereas the Cubists' concurrent interest in Corot was in his iconic figural images, too, as emblematic of the French tradition, Matisse's interest was essentially a stylistic one, part of a new search to recover the truth of naturalistic representation.

We might also consider the Bois de Meudon landscapes and the garden of *The Music Lesson* to be another kind of recovery, as they show scenes untouched by a war that was more destructive of nature than any previous such conflict, and their surfaces are created by paint built and coaxed into shape rather than more brutally imposed and incised.[39] If so, however, the sudden illumination that cuts dissonantly through *Shaft of Sunlight, the Woods of Trivaux* (52), the single abstracted landscape that Matisse painted at this time, reminds us that the war was still perilously near.[40] *Shaft of Sunlight* may be Matisse's final, truly radical work of 1917 and, therefore, of the whole period of radical invention to which it belongs. However, it could have been after making the landscape that the artist returned again to *Bathers by a River* (54) to make more revisions, as if wishing to be free of it yet unable to let go, "like an unlaid ghost."[41]

However, on October 19, he signed a new three-year contract with Bernheim-Jeune and then set off for Nice, where, except for summer visits, he would live and work apart from his wife and family for a decade. There, in 1919, the artist spoke about his aims for his painting to a studio visitor who was surprised at its "softer and more impressionistic" appearance:

When you have achieved what you want in a certain area, when you have exploited the possibilities that lie in one direction, you must, when the time comes, change course, search for something new. For the time being, I am working predominantly in black and gray, with neutral, subdued tones, because I felt this was necessary for me right now. It was quite simply a matter of hygiene. If I had continued down the other road, which I knew so well, I would have ended up as a mannerist. One must always keep one's eye, one's feeling fresh; one must follow one's instincts. Besides, I am seeking a new synthesis. . . . I first worked as an impressionist, directly from nature; I later sought concentration and more intense expression both in line and color, and then, of course, I had to sacrifice other values to a certain degree, corporeality and spatial depth, the richness of detail. Now I want to combine it all, and I believe I will be able to, in time. . . . I want to depict the typical and the individual at the same time, a distillation of all I see and feel in a motif.[42]

—JOHN ELDERFIELD

1. Verdet 1978, p. 124.

2. Matisse 1947a, p. 23.

3. Matisse 1908, pp. 736, 742.

4. Ibid., p. 736.

5. Henri Bergson, *Introduction to Metaphysics*, trans. T. E. Hulme (G. P. Putnam's Sons, Knickerbocker Press, 1912), p. 16.

6. Matisse 1908.

7. See pp. 262–69 in this publication.

8. On Braque's wartime experience and his banquet, see Danchev 2005, pp. 122–46; for Apollinaire's, see Louis Faure-Favier, "Le banquet Guillaume Apollinaire," *Mercure de France* 446, 119 (Jan. 16, 1917), pp. 378–79; Cecily Mackworth, *Guillaume Apollinaire and the*

Cubist Life (John Murray, 1961), esp. chap. 13, pp. 182–204; and Shattuck 1961, pp. 287–93.

9. For the resurgence of artistic life in Paris, see ibid.

10. Dauberville and Dauberville 1995, vol. 1, pp. 587–627.

11. E. Tériade, "Nos enquêtes: Entretien avec M. Léonce Rosenberg," *Feuilles volantes*, supplement to *Cahiers d'art* 6 (1927), pp. 1–3. It appears that Matisse was also working with the exiled Daniel-Henry Kahnweiler through an agent in Paris, Eugène Reignier, since Rosenberg wrote to Gris on May 19, 1916, warning him against Reignier as "very dangerous because *totally unscrupulous*" and saying that Matisse had "*many illusions*" about him (Archives Georges González Gris).

12. For more on Halvorsen's purchase of *Bowl of Oranges*, see p. 275 of this publication. On Nov. 22, he opened a major exhibition of modern French art in Oslo that included five paintings, eleven drawings, and ten etchings by Matisse, all but one for sale. For more on Halvorsen, see Klüver and Martin 1989, pp. 76–77, 221 n. 3.

13. Silver 1989, p. 86 n. 11. Matisse to Walter Pach, Dec. 14, 1916, Walter Pach Papers, Archives of American Art, Smithsonian Institution, Washington, D.C.

14. He also made portraits of Michael and Sarah Stein (47.2, 47a) in 1916. However, he declined Félix Fénéon's suggestion that he make a double portrait of his dealers, Josse and Gaston Bernheim, whom Pierre Bonnard had painted together a decade earlier; Fénéon to Matisse, Mar. 12, 1917, AHM.

15. For Pierre Matisse's recollections, see p. 54 n. 11 in this publication. The specific influence of these works may be seen in some of the Laurette paintings, notably his *Laurette with Coffee Cup* of 1917, which he never exhibited, retaining it for the rest of his life; and in some later paintings, among them *Marguerite Sleeping* of 1920 (see Elderfield 1995, pp. 46–47). Matisse would speak of Courbet as the very artist who too strongly influenced Cézanne, limiting his expression. See Matisse 1950, p. 5. Now, beginning to disengage from Cézanne's own influence, he turned specifically to the earlier artist who had constrained that once and future "god of painting"; see Guenne 1925, p. 5.

16. This is Matisse's 1916 notebook description of the model; Flam 2006, p. 9. Flam 2006 is an indispensible account of the period covered by the present essay, to which it is indebted.

17. See Severini 1983, pp. 198–99; and Spurling 2005, p. 186.

18. Verdet 1978, p. 127; Flam 1995, 299 n. 13.

19. Pierre Reverdy, "Sur le cubisme," *Nord-sud* 1 (Mar. 15, 1917), pp. 5–7; Daix 1982, p. 137. Such objections had been voiced months earlier: for example, in spring 1916, Roger Bissière had detected a "reawakening of the Cubists" but said that for him the movement "ceased to have any point." Bissière, "Le réveil des cubistes," *L'Opinion* (Apr. 15, 1916). See Etienne-Alain Hubert, "Pierre Reverdy et le cubisme en mars 1917," *Revue de l'art* (1979), p. 66 n. 23. This is when Matisse had set aside his previous year's experiments with doctrinaire Cubism.

20. Reverdy (n. 19).

21. Matisse's Bohain etchings, while not depicting wartime subjects, were praised for their sobriety and simplicity, which was appropriate to wartime art (Silver 1989, pp. 417–18 n. 63). Matisse himself obviously believed this, and he accepted a proposal transmitted by Henri Lauren to provide drawings suitable for reproduction on postcards from a committee that proposed to sell such postcards at matinees to benefit prisoners and wounded Russian soldiers in France. For more on this subject, see Lauren to Matisse, n.d. [1917], AHM.

22. Matisse to Derain, Feb. 1916, Archives André Derain; Escholier 1960, p. 98.

23. This play-acting far exceeded the few earlier occasions when the artist had dressed his wife in exotic costumes—for example, in 1911, in the shawl he had brought back from Spain. He did, however, dress Laurette in a black lace mantilla. It must have recalled the enjoyment he received from painting models in Morocco, especially once Laurette had assumed harem roles. Years later, when asked about his use of the odalisque theme, Matisse defensively replied, "I had seen them in Morocco, and so was able to put them in my pictures back in France without playing make-believe"; Tériade 1952, pp. 53, 62. This is obviously untrue.

24. This is to say, since the maturity of his art in 1897, the same year that he met Amélie Parayre, his soon-to-be wife. This regression raises a question unmentioned by Flam 2006 in his discussion of Matisse's midlife-crisis representations of Laurette: whether they may be thought to reimagine his earliest regular model, Caroline (Camille) Joblaud, the young woman with long dark hair and dark eyes—"the eyes of a true odalisque," Matisse said (this was repeated by Joblaud, whose Parisian reminiscences, confided to her friend Mme Richard, were preserved and passed on to Spurling by Mme Richard's grandson, Michel Gueguen; Spurling 1998, p. 77 n. 74). Matisse was very conscious of how a model he was representing might resemble someone else, as evidenced by how in 1914, while making a print of the painter Charles Bourgeat (33c), he realized that the image was also a portrait of a childhood friend, Léon Vassaux; see Duthuit-Matisse and Duthuit 1983, vol. 1, pp. 36–37, cat. 40.

25. Daix 1982, p. 134.

26. Reverdy (n. 19); Edward Fry, ed., *Cubism* (Thames and Hudson, 1966), pp. 144–45.

27. Cocteau, *Oeuvres complètes*, vol. 9 (Marguerat, 1946–51), pp. 244–45; Billy Klüver, *A Day with Picasso* (MIT Press, 1997), p. 82.

28. Moreover, through 1916, the dealer had been pressing Picasso, to his annoyance, to help him bring all the Cubists together under his wing, a project that continued in 1917.

29. This goal was explained in the catalogue by René Jean; see René Jean, "Preface," in *Exposition de peinture française: Organisé au profit de la "Fraternité des Artistes de Paris,"* exh. cat. (Emil Birkhäuser, 1917), pp. 5–7 (pamphlet provided by the library of Kunstmuseum, Basel). The exhibition was held at the Kunsthalle Basel, Jan. 10–Feb. 14, 1917. Other such exhibitions included a large but conservative display of French art in late Apr. at the Palau de les Belles Arts in Barcelona, and a show of French art of the nineteenth and twentieth centuries at the Zurich Kunsthaus in the fall, organized by the Service of Artistic Propaganda, of which Jean was then in charge. For Barcelona, see Robert S. Lubar, "Joan Miro before 'The Farm,' 1915–1922: Catalan Nationalism and the Avant-Garde" (Ph.D. diss., New York University, 1988), pp. 81–83, 86–87; for Zurich, see Maignan 1979, pp. 131–32.

30. Cowling 2002, p. 309. Cocteau was with Picasso to work on the ballet *Parade*. Picasso's continuing interest in a traditional realism occasionally produced results somewhat similar to some of Matisse's depictions of Laurette; among them is *Portrait of Olga in Spanish Costume* (private collection), influenced by Catalan Noucentista painting, that he made in summer 1917 of his new paramour, the Ballets Russes dancer Olga Khokhlova in Spanish costume. However, Picasso's meticulous realism was never of interest to Matisse; nor was his overt neoclassicism. Both were as confining to him as the new Cubist classicism.

31. Barr 1951, pp. 193–94, first made this point, which has since been repeated by many scholars.

32. Matisse to Camoin, summer 1917, Archives Camoin.

33. Cowart and Fourcade 1986, pp. 19, 42 n. 14; Wildenstein 1985, pp. 395, 397. Cowart explained: "Letters from Monet to Bernheim-Jeune brothers mention the planning in response to Matisse's wish to visit Monet. It seems clear that the May 1917 rendezvous, which also included Albert Marquet, did take place"; see letters nos. 2205, Nov. 28, 1916; 2205a, Dec. 12, 1916; and 2229, May 1, 1917, AHM. Fénéon relayed Monet's message to Matisse on May 2, 1917; Monet asked Matisse and Marquet to pick a day in the coming week.

34. Matisse to Camoin, May 2, 1918, Archives Camoin; Flam 1986, p. 474.

35. Matisse to Pach (n. 13).

36. Matthew Stewart Prichard and Matisse in conversation, June 30, 1913, Isabella Stewart Gardner Museum Archives, Boston, and Archives Duthuit.

37. Halftones are values halfway between the lightest and darkest in a picture, to which all other values are adjusted to shape space and volume.

38. Matisse to Camoin, May 2, 1918, Archives Camoin; in the first part of his statement, Matisse repeated the common understanding of this artist.

39. For more on war as a demonic antipastoral, see Fussell 1975, p. 231.

40. It is perhaps more than merely a coincidence that on June 7, 1917, while Matisse was probably painting landscapes in the Meudon woods, he would have actually heard the loudest explosion yet produced (it was heard as far away as Dublin), the product of 600 tons of explosives at the Battle of Messines, which blew off the entire length of the Messines Ridge. "Gentlemen," said General Sir Herbert Plumer before ordering the offensive, "we may not make history tomorrow, but we shall certainly change the geography"; see Peter Barton et al., *Flanders Field: The Tunellers' War, 1914–18* (McGill-Queen's University Press, 2005), pp. 162–83. This is not to suggest, of course, that *Shaft of Sunlight* records the flash of this explosion, only that the war was never very far away.

41. Sigmund Freud, "Compulsion to Repeat," in J. Laplanche and J.-B. Pontalis, *The Language of Psycho-Analysis* (Norton, 1973), p. 79.

42. Hoppe 1931, p. 196.

47.1 **Study of "Portrait of Sarah Stein"**
Quai Saint-Michel, Paris, September–October 1916

Graphite on paper; 48.5 × 32 cm (19 1/8 × 12 5/8 in.)
Inscribed, signed, and dated l.r.: *a Mad*e *Michel Stein/*
homage respecteux/Henri-Matisse 1916–
San Francisco Museum of Modern Art,
gift of Mr. and Mrs. Walter A. Haas, 62.1158

IN EXHIBITION

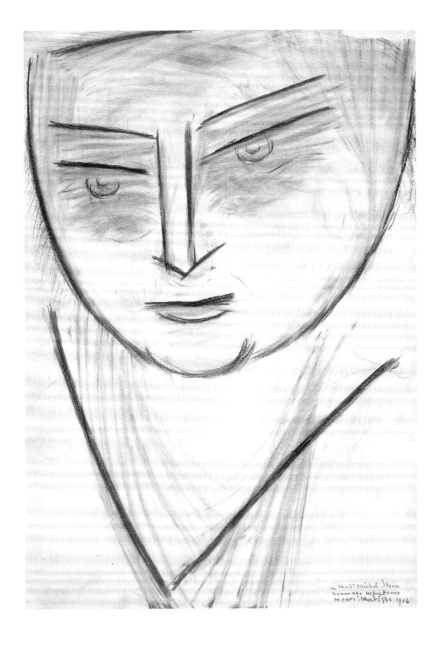

47.2 Portrait of Sarah Stein
Quai Saint-Michel, Paris, September–October 1916

Oil on canvas; 72.3 × 56.5 cm (28 1/2 × 22 1/4 in.)
Signed l.r.: *Henri-Matisse 1916.*
San Francisco Museum of Modern Art,
Sarah and Michael Stein Memorial Collection, gift of Elise S. Haas, 54.1117

IN EXHIBITION

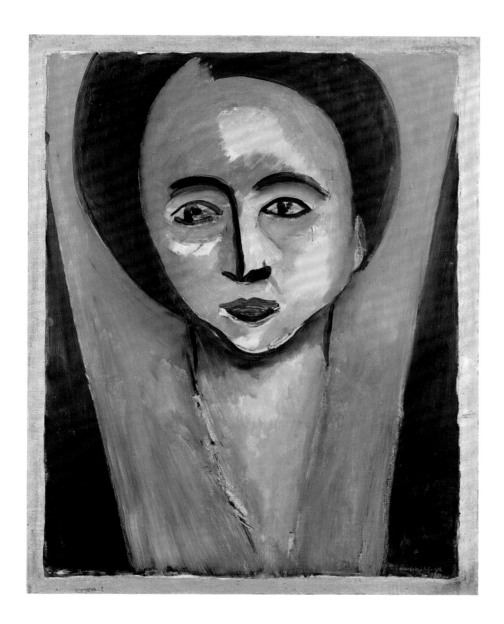

THE PORTRAITS OF Sarah and Michael Stein [**47.2, 47a**] not only commemorate two of Matisse's important early patrons but, together with the related drawing of Sarah Stein [**47.1**], also represent a noteworthy example of the artist's evolving practice of drawing and painting the same subject. In 1916 the expatriate art collectors were probably the artist's oldest, most serious and still-active supporters from before the period of the war.[1] Beginning with their group purchase (with Leo and Gertrude Stein) of *Woman with a Hat* (p. 49, fig. 10) at the 1905 Salon d'Automne, they quickly became enthusiastic patrons, gathering a unique representation of canvases, including *Portrait of Madame Matisse* (*The Green Line*) (1905; Statens Museum for Kunst, Copenhagen) and *The Red Madras Headdress* (1907; Barnes Collection, Marion, Penn.); sculptures such as *The Serf* (1900–04; D6); works on paper; and ceramics. In 1907 the couple had even hoped to acquire *Le luxe (I)* [**2.1**], although the artist ultimately could not part with the picture and offered to loan it to them instead.[2] They also established a close friendship, encouraging him to open the Académie Matisse in January 1908.[3] Sarah attended classes at the school, and her notes remain a critical document of Matisse's early practices and concerns.[4] In addition, the couple tirelessly promoted the artist's work to visitors at their Saturday evening salons; it was here that Matisse met Camille Schuwer and probably also Matthew Stewart Prichard.[5] In February 1914, the *New York Sun* boasted that the Steins' collection was surpassed only by that of Sergei Shchukin.[6]

In late June 1914, the Berlin curator Curt Glaser traveled to Paris to organize an exhibition of Matisse's work for the Kunstsalon Fritz Gurlitt. He turned to the Steins for help, and with the artist's encouragement, they agreed to lend nineteen canvases from their collection "out of kindness" for their friend.[7] When the war broke out just a few weeks later, the works were unfortunately stranded in Germany.[8] In spite of their ongoing struggles to secure the return of their paintings, the Steins remained supportive of Matisse: in 1914 they purchased at least seven prints; in February 1915, they acquired Leo Stein's interest in *Woman with a Hat*; and in October 1916, they bought *Nude in Sunlit Landscape* [**7c**] from Bernheim-Jeune.[9] Their painted portraits—the single example of double portraiture in Matisse's career—were also in their possession sometime in November 1916, but no documents have yet been located to suggest that they were commissioned.[10] The dedication of this drawing, in "respectful homage" to Sarah, suggests that it might have been made for a special occasion—and indeed, on November 6, 1916, Matisse wrote to Walter Pach that the Steins were "about to leave for America...packed and ready to

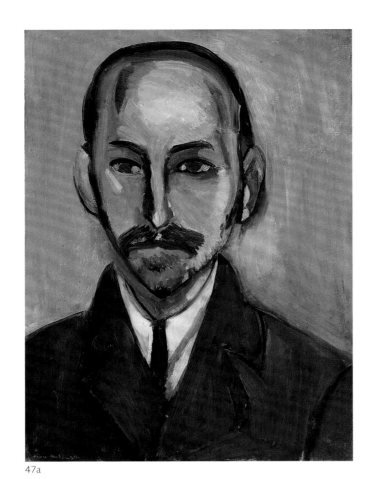

47a

47c

47f

47d

47e

47b

47a
Portrait of Michael Stein, early fall 1916. Oil on canvas; 67.3 × 50.5 cm (26 1/2 × 19 7/8 in.). San Francisco Museum of Modern Art, Sarah and Michael Stein Memorial Collection, gift of Nathan Cummings, 55.3546.

47b
Detail of *Study of "Portrait of Sarah Stein,"* revealing earlier placements of the right eye as well as Matisse's process of moving and removing medium with an eraser and stump, especially in the area of the brow.

47c
Detail of the forehead of *Portrait of Sarah Stein*, showing the patterned directional brushstrokes used to model and shape the face.

47d
Detail of the right eye, highlighting the eye's former position in red-earth and black paints.

47e
Detail of the mouth and chin, showing the lighter ground that Matisse exposed by scraping into the wet paint.

47f
Detail of the left eye; note the deposits of wet black paint at the end of the horizontal scraping left by a tool.

go, they still do not know when they will leave—the events will decide for them."[11] It may be that he made the works in special recognition of their friendship, to commemorate their imminent departure, or even, as John Klein suggested, as a measure of compensation for their still-unreturned treasures, though there is no documentation to confirm that the works were gifts to the Steins either.[12]

Unlike Matisse's other related drawings and paintings of this period, *Study for "Portrait of Sarah Stein,"* with its high degree of finish, and *Portrait of Sarah Stein* are particularly notable for the strongly similar methods Matisse used to create them. The study is characterized by a pattern of rhythmically moving features that the artist slid up and down as he expanded and refined their overall forms. We can see how he started with a smaller, more naturalistic face: the initial placement of Stein's right eye is recorded in the middle of her present cheek [**47b**], and at the end of her angular nose, we can see the fleshy remains of the first one he sketched. Matisse continued to revise her image, continually raising the eyes, deepening the neckline, and expanding the crown of the head beyond the top edge. He not only added more medium—dark, soft graphite that left a dense trail on the sheet—but also eliminated it with an eraser and moved it with a stump, repositioning material in additional lighter lines. The varying densities of black, balanced by the white of erasure, give Stein's face a sense of modeling and volume. Light and ethereal, she looks down from above, her head almost floating, yet held within the niche of her angled neckline.

When he began the canvas, Matisse reenacted his process with the drawing. He started with the eyes, setting them down with a red-earth sketch that he scraped back after it dried; he painted them again in black, which he also scraped back [**47d**]. Another pass brought the artist to a different technique, one akin to his method of moving graphite on the sheet: on top of the right cheekbone, we can see where he painted another position for the eye, but he scraped it back when it was still wet, leaving a deposit of oil paint at the end of his tool marks [**47f**]. Magnification reveals earlier positions of the lips, chin, and neckline, showing how Matisse likewise applied thick layers of paint, into which he used his tool to push wet medium away; this produced an effect similar to the inky ends of the lines of his monotypes [**47e**]. He also built Stein's face through a rhythmic pattern of brushwork, densely layering and overlapping hatched strokes of brown, ocher, and gray in varying directions to suggest its volume and planes [**47c**]. As in the drawing, the artist arrived slowly at the reduced, geometric presentation, which incorporates the dark, disconnected halo of hair, achieved by scrap-

ing off a lower hairline, and the exaggerated lines of the collar that cover an earlier green version and now run along the sides of the canvas, nestling Stein's corporeal form firmly within the space they define. The blue strokes of paint over the ocher of the background re-create the same sense of surface energy and atmosphere that Matisse produced in the sheet. This consistency of approach between the two works is also conveyed by the continued repetition of contour lines, the presence of medium moved across the surface, and the glimpses of light-colored support or ground.

In 1954, the last year of his life, Matisse wrote an introduction to a folio entitled *Portraits*, which included a reproduction of his painting of Sarah Stein; his description of his process echoes the method of making we can trace between the sheet and canvas:

At the end of a half hour or an hour, I am surprised to see appear on the paper little by little, a more or less precise likeness of the person I am with. The image becomes visible to me as if each line in charcoal was clearing mist from a mirror, mist that up to that point had prevented me from seeing the person. . . . During this time, a certain unconscious fermentation takes place . . . I reconstitute my drawing mentally with greater clarity. . . . Linked to my impressions of the session, a linear construction generally appears. . . . The sessions follow one another in the same spirit. . . . At the same time, something is born of an interpenetration of feelings that makes us feel the warmth of the other's heart, and this ends in the conclusion of the painted portrait.[13]

As much as they are related, the drawing and painting are also independent: the drawn portrait is less a study for the composition of the painting than, as Matisse suggested, a study of the process he used to summon it forth.[14]

1. Sergei Shchukin was a major early collector of Matisse's work, but the outbreak of World War I and the subsequent revolution in Russia impeded his continued support; see pp. 76–87 of this publication.

2. Pompidou 1993, p. 80. For a photograph of the painting in the Steins' Paris home, see Elderfield 1992, p. 137 (lower right).

3. The school was partially financed by Michael Stein.

4. "Sarah Stein's Notes" (1908); Flam 1995, pp. 44–52.

5. Han Purrmann, "Über Henri Matisse," *Das Werk* 33, 6 (June 1946), p. 187; and Schneider 2002, p. 360. Michael and Sarah, as well as Leo and Gertrude Stein, were also responsible for introducing Matisse's work to Etta and Claribel Cone on Oct. 18, 1905, at the Salon d'Automne. Etta lived in an apartment in the same building as Michael and Sarah during the winter of 1905–06, and Sarah took Etta to meet Matisse at his studio on Jan. 15, 1906, where she purchased two drawings, one of which she gave to Sarah. See Museum of Modern Art 1970, p. 76 n. 6; Brenda Richardson, "Dr. Claribel and Miss Etta," in *Dr. Claribel and Miss Etta: The Cone Collection* (The Baltimore Museum of Art, 1985), pp. 85, 93; and Ellen B. Hirschland and Nancy Hirschland Ramage, *The Cone Sisters of Baltimore: Collecting at Full Tilt* (Northwestern University Press, 2008), pp. 46, 244 n. 27.

6. "Paris to Lose Fine Art Collection," *New York Sun*, Feb. 1, 1914.

7. In 1916 Curt Glaser was curator of the Kaiser-Frederick Museum (now the Bode Museum). For Matisse's explanation of the events of 1914, see Courthion 1941, pp. 111–12. The catalogue for the Gurlitt exhibition is reproduced in Monrad 1999, p. 144.

8. Oskar and Greta Moll, the latter a student at the Académie Matisse then living in Germany, took the paintings into safekeeping for the Steins. In 1917, when the United States entered the war, the German government confiscated the works as enemy property. The Steins succeeded in getting pictures back only after prolonged negotiations. See Courthion 1941, pp. 111–12; Fiske Kimball, "Matisse: Recognition, Patronage, Collecting," *Philadelphia Museum Bulletin* 43, 217 (Mar. 1948), p. 35; Barr 1951, pp. 177–78; Monrad 1999; and Schneider 2002, p. 185.

9. On the 1915 purchase from Leo Stein, see Museum of Modern Art 1970, p. 49 n. 38; and Donald Clifford Gallup, ed., *The Flowers of Friendship: Letters Written to Gertrude Stein* (Knopf, 1953), p. 106. For the 1916 sale from Bernheim-Jeune, see Dauberville and Dauberville 1995, vol. 1, pp. 476–77, cat. 103.

10. The only information comes from ibid., p. 586, cat. 182: "*Portrait*, dessin, photographie Bernheim-Jeune no. 1530, Novembre 1916."

11. Matisse to Pach, Nov. 6, 1916, Walter Pach Papers, Archives of American Art, Smithsonian Institution, Washington, D.C.; Cauman 1991, p. 7.

12. Klein, "Objects of Desire and Irresistible Forces: Matisse between Patrons, Collectors, and War," in Monrad 1999, pp. 18–19; and Klein 2001. Given the level of finish and dedication of the drawing, it may also be possible that Matisse made it as a gift and asked the Steins to simply sit for the portraits in a sequence of events somewhat reminiscent of those surrounding *Portrait of Yvonne Landsberg* (28).

13. Matisse 1954, pp. 15–16.

14. Matisse's approach is strikingly similar to the working process devised by Wassily Kandinsky as he made his abstract *Improvisations*. The connection between the work of these two artists is a little-studied area that deserves more attention.

48.1 **Eva Mudocci**
Paris or Issy-les-Moulineaux,
September–October 1916

Charcoal and graphite on wove paper;
37.5 × 28.2 cm (14 13/16 × 11 1/16 in.)
The Morgan Library and Museum, New York,
Thaw Collection, EVT 313

IN EXHIBITION

48.2 **Eva Mudocci**
Paris or Issy-les-Moulineaux,
September–October 1916

Graphite on three pieces of paper, mounted to canvas;
92.7 × 71.1 cm (36 1/2 × 28 in.)
Lent by The Metropolitan Museum of Art, New York,
The Pierre and Maria-Gaetana Matisse Collection, 2002, 2002.456.41

IN EXHIBITION

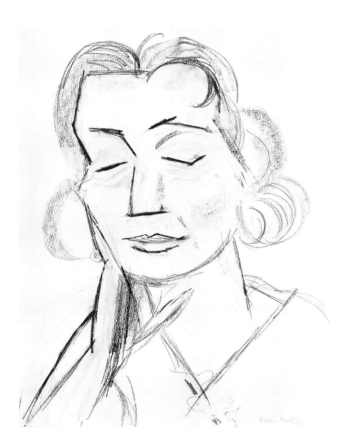

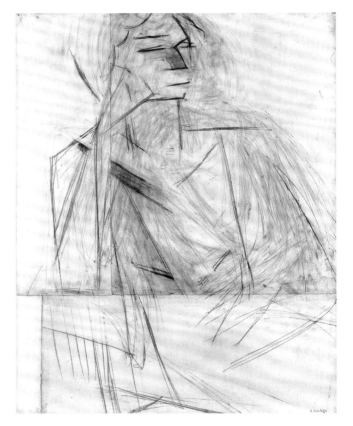

48.3 Greta Prozor
Paris or Issy-les-Moulineaux, November–December 1916

Graphite on paper; 55.5 × 37 cm (21⁷/₈ × 14⁹/₁₆ in.)
Private collection

IN EXHIBITION

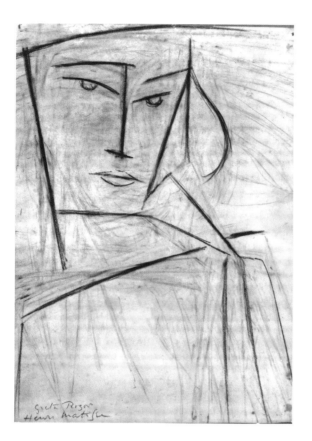

IN LATE 1916, Matisse created a number of drawings of the striking English-born violinist Eva Mudocci, who had posed for Edvard Munch more than a decade earlier [48a–b].¹ He had come to know her in the winter of 1914–15, when his family returned to Paris from the south, and he had arranged lessons for himself and his son Pierre from the Belgian violinist Armand Parent. At that time, Matisse surrounded himself with young string players of whom he made etchings; these include action poses of Mudocci [48c].² The drawings of 1916, however, with their closer perspective, reveal a new draftsman: neither the pre-Cubist Matisse of *Cocoly Agelasto* [32.1] nor the programmatically Cubist Matisse of *Madame Matisse* [32.2], but someone who had come out on the far side of these endeavors to produce works of great strength and severity, some of which seem, at first sight, as much Expressionist as Cubist.

In these sheets, Matisse mapped Mudocci's face [48.1, 48d] with dense, hard-pressed charcoal, depicting it as an island with rugged, angular coastlines; he then surrounded it with velvety shading, which he made by turning the stick on its side. This shading abates her face's harshness, as does the sense of mobility and substance provided by Matisse's rubbing, stumping, and erasure of earlier lines. Mudocci had a long neck, broad mouth, and unusually large, wide eyes that Munch had described as seeming "two thousand years old"; in these works, we recognize the younger woman that Munch had drawn.³ In both sheets, Matisse rhymed the closed lids of her eyes with her arched eyebrows, repeating the gesture in the dreamy smile below. Pierre Matisse said that the withdrawn, introspective mood invoked by his father was very like Mudocci's expression while performing.⁴ However, in both works, her closed-eyed face, supported by a strange claw of a hand, tells us that she is absorbed in listening—to music, her thoughts, or both. In the first sheet [48.1], her eyes are closed by the multiple contours that mark their changed positions, and in its companion [48d] by the sheer density of the marking. In both cases, it is hard to think of eyes in any of Matisse's other drawings that are so definitively shut.

With the large drawing that surely followed these [48.2], Matisse maintained that same sense of the world shut out. Now, however, he condensed the eyes to slits. Munch's Mudocci has retreated so far into the woman shown here as only to be discovered by the width of the features, the length of the neck, and the linear quality that permeates both the figure and the sheet—or rather sheets—that it occupies. Indeed, Matisse presumably began with a close-up study and then enlarged it by adding broad strips of paper at the left and bottom of the original drawing. He incorporated the visible seams into the composition,

325

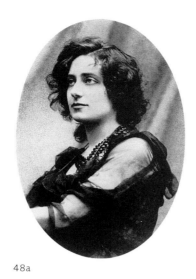

48a

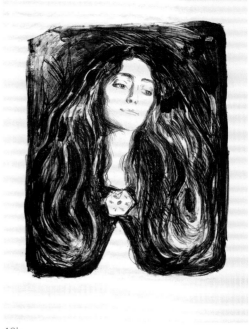

48b

48c

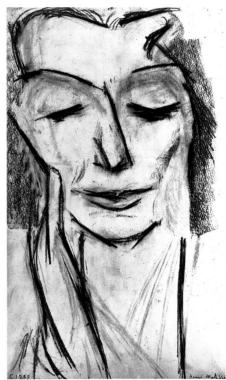

48d

48a
Eva Mudocci, c. 1910.

48b
Edvard Munch (Norwegian, 1863–1944). *The Brooch: Eva Mudocci,* 1903. Lithograph on paper; image: 60.8 × 47.0 cm (23⁷/₈ × 18¹/₂ in.); sheet: 78.2 × 56.5 cm (30³/₄ × 22¹/₄ in.). The Art Institute of Chicago, John H. Wrenn Memorial Collection, 1947.689.

48c
Eva Mudocci, 1915. Drypoint on paper; image: 6.5 × 8.9 cm (2⁹/₁₆ × 3⁵/₈ in.); sheet: 18.8 × 28 cm (7⁷/₁₆ × 11 in.). Private collection.

48d
Eva Mudocci, 1915. Charcoal on paper; 38.1 × 21 cm (15 × 8¹/₄ in.). Private collection.

48e

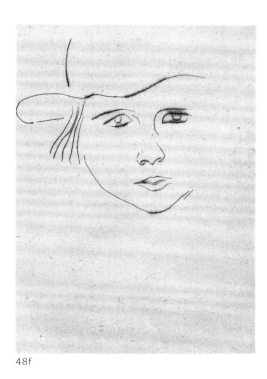

48f

48e
Greta Prozor, c. 1916.

48f
Greta Prozor, 1916. Drypoint on paper; image: 15 × 11 cm (5 7/8 × 4 5/16 in.); sheet: 37.8 × 28.3 cm (14 7/8 × 11 1/8 in.). The Museum of Modern Art, New York, Stephen C. Clark Fund, 1951. In exhibition.

using the vertical to help settle the weight of the figure and the horizontal to suggest a table on which her elbow rests.

The figure itself is a web of alterations. To the right of the present head are the erased traces of an earlier, more naturalistic one, showing full lips, open eyes, and indications of wavy hair. Below it, sheaves of rubbed-down contours wrap around Mudocci's shoulders and arms, speaking of versions of the figure that have faded from visibility.[5] In the years between 1910 and 1912, Matisse had made drawings in which he clearly added and subtracted, allowing traces of earlier imagery to remain.[6] But he had created nothing like this. In "Notes of a Painter," he had written of his desire to condense "a truer, more essential character" from the "succession of moments which constitutes the superficial existence of beings and things, and that constantly modifies their appearance."[7] Now he arrived at that essential character by condensing a succession of representational moments, each one superseding the one before. In 1916 the artist wrote to André Derain, saying that he had read Henri Poincaré's *Science and Hypothesis* and was impressed by its discussion of the destruction of matter.[8] "Movement," he explained, "exists only through the destruction and reconstruction of matter." Here we may imagine movements in time and space as Mudocci's body, resting head against hand, settles under its own weight.

A similar quality of metamorphosis is expressed in Matisse's portrait of another high-spirited performer, Greta Prozor [**48.3**], which he seems to have drawn in the late fall of 1916.[9] Prozor [**48e**] was a young, intense, dark-haired actress, the daughter of a Lithuanian diplomat and the wife of Matisse's former pupil Walter Halvorsen. The artist made beautifully light etchings and drawings of Prozor [**48f–g**], as well as an extremely stately study for a painting [**48h–i**]. Matisse apparently executed numerous drawings prior to taking up the canvas. The sitter recalled that he encouraged her to talk about the theater, which she would do in an animated manner; then, suddenly, he stopped her with a movement of his hand and began to draw.[10] Clearly Matisse did not want her to pose but rather aimed to catch her in mid-thought, and his more casual drawings and etchings have that arrested quality. But not this drawing, in which he swerved away from the process that led to the painting, choosing instead to refine the method he used for Mudocci.

Here, as in the large Mudocci drawing, a mass of destructions and reconstructions fade behind the final image. But whereas Mudocci appears in a web of lines of varying density, as if the figure were emerging from the ground, the final image of Prozor is denser and more definitive. We can recognize the earlier positions of the eyes, cheeks, chin,

shoulders, and arms; and we can wonder whether Matisse thought of showing her hair streaming to the right. Yet these ghosts of features merge into a more continuous substrate, and the effect is flatter: the figure seems inscribed within a tablet as much as within a space.

Additionally, the more uniformly dense lines in the foreground place greater emphasis on the spatial compartments they enclose. In this respect, Matisse used this drawing— and the related *Study for "Portrait of Sarah Stein"* [**47.1**]—to retrieve the approach he used in his woodcuts of 1906 [**48j**]. There he enclosed compartments of different sizes with dense black lines in order to optically elicit whites of varied intensities, all from the same white paper.[11] As he wrote of later drawings made with a similar method, "Despite the absence of cross-hatching, shadows or half-tints, I do not deny myself the interplay of values, of modulations. I modulate with variations in the thickness of my line and above all with the areas it delimits on the white paper. I modulate the different parts of the white of my paper without touching them, but by what I put near them."[12] In this sheet, Matisse modulated with the shadows and half-tones created both by erasures and by the size of the compartments they occupy.

In the 1906 woodcuts, the artist used patterned backgrounds to grade the areas around the figures; here the continuous web of adjustments grades the entire sheet, and the dark foreground lines seem the result of forces generated in the substrate. In this respect, they recall what the Futurist artists gathered around Umberto Boccioni called "force-lines." "Each object," they claimed, "by means of its lines, reveals how it will be decomposed according to the direction of its forces . . . which follow the emotional law dominant in the painting."[13] Matisse would have known of Futurist theories through the Paris-based Gino Severini, and the celebrated statement "everything moves, is in flux" would have complemented the Bergsonian ideas to which Matisse was also exposed; besides, the exhibition of Futurist painting at Matisse's own gallery, Bernheim-Jeune, in February 1912 had been a huge sensation.[14] The Prozor drawing, however, is far from Futurist, for the foreground lines seem not only generated in the substrate but also willfully imposed upon it, their fixity in control of its fluidity. They give the front-facing figure an immobile quality that is aided by its arresting eyes.

If this portrait of Prozor and the large sheet of Mudocci are not Futurist drawings, they are, in a broad sense, Cubist. Albert Gleizes and Jean Metzinger, who lodged in Matisse's house for a while in this period, had offered a very basic definition of Cubist draftmanship in their 1912 book on Cubism: "The art of drawing consists of creating rela-

48h

48g

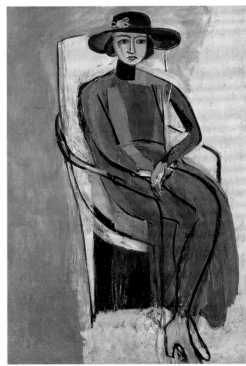

48i

48g
Greta Prozor, 1916. Drypoint on paper; image:
17.9 × 12.8 cm (7 × 5 in.); sheet: 38 × 28.5 cm
(12 13/16 × 9 5/8 in.). Private collection.

48h
Greta Prozor, 1915–16. Graphite on paper; 55.5 × 37
cm (21 5/8 × 14 5/8 in.). Musée National d'Art
Moderne/Centre de Création Industrielle, Centre
Pompidou, Paris, AM 1976-282.

48i
Portrait of Greta Prozor, 1916. Oil on canvas;
146 × 96 cm (57 1/2 × 37 3/4 in.). Musée National d'Art
Moderne/Centre de Création Industrielle, Centre
Pompidou, Paris, gift of the Scaler Foundation, 1982,
with the support of an anonymous donor, AM
1982-426.

48j

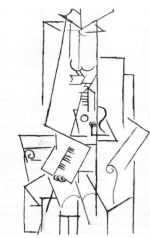

48k

48l

48j
Small Light Woodcut (Petit Bois Clair), 1906. Woodcut print; image: 34.2 × 26.9 cm (13⁷⁄₁₆ × 10⁹⁄₁₆ in.); sheet: 46 × 29 cm (18¹⁄₈ × 11⁷⁄₁₆ in.). The Museum of Modern Art, New York, Abby Aldrich Rockefeller Fund, 1954.

48k
Pablo Picasso (Spanish, 1881–1973). *Seated Woman with Violin*, 1912. Black ink and graphite on graph-paper page from notebook; 13 × 8.5 cm (5¹⁄₈ × 3³⁄₈ in.). Musée Picasso, Paris.

48l
Piet Mondrian (Dutch, 1872–1944). *Composition Trees 2*, 1912–13. Oil on canvas; 98 × 65 cm (38⁵⁄₈ × 25⁵⁄₈ in.). Gemeentemuseum, The Hague. © 2010 Mondrian/Holtzman Trust c/o HCR International Virginia USA.

tionships between curves and straight lines."[15] Matisse's 1916 drawings are exemplary in this respect. However, they are also representational drawings, and this fact calls for a more sophisticated characterization of Cubist methods. As Pepe Karmel summarized the issue, the representational system used in the most advanced Cubism of 1912—that of Picasso and Braque—comprised two kinds of marks: large, generalized geometric elements and smaller ideograms. "The larger geometric forms . . . provide a kind of material substrate, indicating that there is something there, and giving a rough idea of its proportions. But they are too ambiguous—either individually or as an overall configuration—to complete the job of figuration."[16] For, as Daniel-Henry Kahnweiler observed, "It would be impossible to see . . . the 'representation' of things from the outer world. One would only see an arrangement of planes, cylinders, quadrangles, etc. . . . [But] when 'real details' are thus introduced, the result is a stimulus which carries with it memory images. Combining the 'real' stimulus and the scheme of forms, these images construct the finished object in the [viewer's] mind."[17]

In these terms, Matisse rejected ideograms that recalled "real details." If Picasso had drawn Mudocci, he indubitably would have put in signs for a violin, as he did in a 1912 drawing of an anonymous woman with a violin [**48k**]. For Matisse to have done so is unthinkable; he did not want a two-part system, the second part of which made reference to what was patently absent from the drawing. But neither did he prefer a first part that only gave a rough idea of the subject or, worse, gave viewers only cylinders, planes, quadrangles, and so on. He wanted it both ways: he desired a generalized system that made the subject vivid and present in a way that ideograms could not. In this respect, his Cubism is closest to that of Piet Mondrian, whose work Matisse surely would have known.[18] The tree paintings that Mondrian exhibited at the Salon des Indépendants in 1912 and 1913 have not been securely identified, but they were certainly like *Composition Trees 2, 1912–13* [**48l**]. Matisse's Cubist production does not require the example of Mondrian, but there is indeed an affinity between his work and that of this other northerner, who had been transformed by the experience of Cézanne and went on to explore the possibilities of Cubism.

1. Two of the drawings shown here (48.1, 48d) were photographed by Bernheim-Jeune in Oct. 1916; see Dauberville and Dauberville 1995, vol. 1, pp. 578–79, cats. 174–75. Barr 1951, p. 401, dated 48d to early 1915, but given the regular pattern of the firm's photography, it is hard to believe they were not recorded for a year and a half. Nonetheless, issues of the war and Matisse's lapsed contract may have played a part in their documentation.

2. For the etching and two drypoints of 1915, see D65–67. Born Evangeline Hope Muddock, Mudocci met Munch in Paris in 1903; see Patricia G. Berman and Jane Van Nimmen, *Munch and Women: Image and Myth*, exh. cat. (Art Services International, 1997), p. 196.

3. Ibid., p. 199.

4. Carlson 1971, p. 74, cat. 27.

5. As Schneider 2002, p. 594, put it, "The almost tragic grandeur of some of the drawings of this period stems from the tension between categorical geometry and tentative approximations that are more than half effaced."

6. Notable among these are *Girl with Tulips* (11c) and *Sergei I. Shchukin* (32a).

7. Matisse 1908, p. 736.

8. Matisse to Derain, Feb. 1916, Archives André Derain.

9. In a letter of around Nov. 22, 1916, AHM, Prozor wrote to Marguerite Matisse to say that her husband had told her that Matisse wanted her to pose for him. There is also a photograph of Matisse's studio, probably dating to Nov. 1916, that shows the painting of Prozor in process; see pp. 216–17.

10. Dominique Fourcade, "Henri Matisse: Greta Prozor," *Cahiers du Musée National d'Art Moderne* 11 (1983), pp. 100–07, in which portions of a radio interview with Prozor are transcribed.

11. Yve-Alain Bois, "Matisse Redrawn," *Art in America* 73, 9 (Sept. 1985), pp. 128–30; and "Matisse and Arche-drawing," in Bois 1990, pp. 29–35.

12. Matisse, "Notes d'un peintre sur son dessin," *Le point* 21 (July 1939), p. 110.

13. Umberto Boccioni, Carlo Carrà, Luigi Russolo, Giacomo Bella, and Gino Severini, "Les exposant au public," in Boccioni et al. 1912, pp. 1–14; *Archivi del futurismo*, vol. 1 (De Luca, 1958), p. 106; Green 1976, p. 42.

14. The Futurists' "Technical Manifesto of Futurist Painting," from which this phrase derives, was published in French in *Comoedia* on May 18, 1910; ibid., p. 41. This was probably too early to have interested Matisse, but he would surely have heard this phrase, or words to this effect, from Severini.

15. Gleizes and Metzinger 1912, p. 20. On Matisse's lodgers, see Spurling 2005, p. 188.

16. Karmel 2003, p. 122.

17. Kahnweiler 1949, p. 12.

18. See Bois and Rudenstine 1994, pp. 29–32, for the Mondrian exhibition record for these years. Flam 1986, pp. 396–97, compared the Mudocci drawing to a Mondrian self-portrait drawing (c. 1912; private collection); it is a very striking juxtaposition, but we cannot document whether Matisse could have seen a work like this. While he did not exhibit at the Salon des Indépendants in 1912 or 1913, he would certainly have made a point of seeing both exhibitions and would likely have noticed that Apollinaire praised Mondrian's work in the 1913 Salon.

49 **The Italian Woman**
Quai Saint-Michel, Paris, November–December 1916

Oil on canvas; 116.7 × 89.5 cm (45 15/16 × 35 1/4 in.)
Signed l.r.: *Henri-Matisse*
Solomon R. Guggenheim Museum, New York, by exchange, 1982, 82.2946

IN EXHIBITION

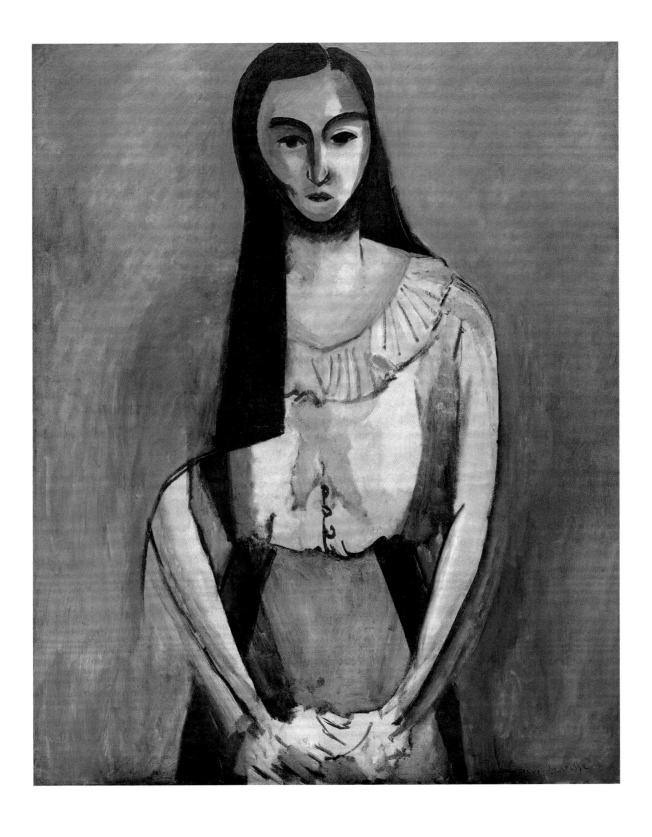

EVEN IN MATISSE'S most daring and austere paintings of this period, he continued his practice of reusing and repeating themes. Whether painting a single subject in quick succession, as in *Apples* and *Bowl of Apples on a Table* [**39.1–2**], or more independently over a longer span of time, as in *The Window* [**37**], he refined his ideas and explored different artistic paths through familiar subjects. *The Italian Woman* [**49**] represents a significant example of this practice. First, as a portrait of a subject facing forward with hands held together, it is one of the motifs Matisse repeated most consistently during the 1913 to 1917 period. He used this format for *Marguerite with Striped Jacket* [**30b**] and would do so again for both portraits of Auguste Pellerin [**50, 50a**]. In these works, and especially in *The Italian Woman*, the hands root the sitter at the base of the canvas, acting as the very foundation on which the figure is built and by which it is held together. To this initial group, we can also add full-length seated figures such as *Greta Prozor* [**48i**], *Woman on a High Stool* [**25**], *Portrait of Yvonne Landsberg* [**28**], and numerous prints [**22**]. We can even include Amélie Matisse (p. 148, fig. 9), held within the confines of her chair and shawl, and Sarah Stein [**47.2**], nestled within the diagonal bands that emanate from below her neck. In all these instances, Matisse's sitters are grounded, their bodies seemingly fused with the canvas. *The Italian Woman*, made near the end of Matisse's period of great experimentation and invention, is the most austere and architectonic of the group.

The second way the painting functions in Matisse's practice of reuse and repetition is through its model: an Italian woman named Laurette (or Lorette), whom the artist met some time near the end of 1916.[1] She became the subject of his focus for almost a year; together, they produced over fifty paintings and works on paper.[2] As a whole, the images of Laurette demonstrate a shift from abstraction to naturalism, as Matisse grew increasingly interested in the organic description of her fleshy volumes and curves. *The Italian Woman* was the first painting in the series; with its stiff pose and radical reduction of form, the canvas stands apart from its more naturalistic counterparts but was initially far less severe than it looks now. Although the work is undated and was not recorded by Bernheim-Jeune until January 1917, we can begin to assign a time to its production with a photograph likely taken in Matisse's Paris studio in November 1916 [**49a**].[3] There, among other paintings, are the two finished Stein portraits (probably completed in early November) and the portrait of Greta Prozor, which was still underway.[4] To the artist's left is an early version of *The Italian Woman*. We can see that it is markedly different from its final state: Laurette stands like a thick column, cut off at the top and resting her hands just above the

49a

49b

49a
Detail of the November 1916 photograph of Matisse's studio (pp. 216–17), showing an early stage of *The Italian Woman*.

49b
X-radiograph of *The Italian Woman*, revealing numerous reworkings of the form.

49c

49d

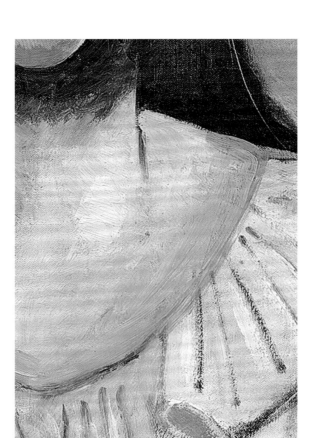

49e

49f

49g

49h

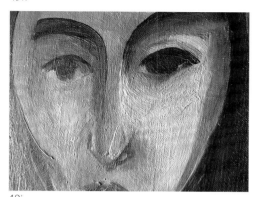

49i

49c
Detail of the forehead of *The Italian Woman*, showing how Matisse constructed the face by overlapping hatching brushwork to suggest different facets.

49d
Detail of the dark hair and the crisp incised line within it, echoing the painted slice on the other side of the canvas.

49e
Detail of the neck and chest; note the various applications of flesh colors to produce a new sense of modeling.

49f
Detail of the sitter's left shoulder, pared down and constructed with vertical bands and lines of color.

49g
Detail of forearm, showing Matisse's reuse of the former limb, now entombed and reenlivened with scumbles of light color reminiscent of *Bathers by a River* at this time.

49h
Photograph of the head in raking light, highlighting the ridges of paint produced by Matisse's paint-laden brush.

49i
Photograph of the face in raking light, demonstrating the pronounced ridge of Laurette's nose defined with paint.

bottom edge of the canvas. She has a full face, enhanced by a wide neck and set off against dark hair that falls behind her sloping shoulders. Her thick arms hang down against her heavy, trunklike core. We can see that Matisse has added shading in the background, which contrasts with her pale shirt and imparts some depth to the image. A gentle shadow also runs across the top of the sitter's forehead and down both sides of her neck.

The Italian Woman demonstrates Matisse's initial search for a new style and method near the end of 1916. An X-radiograph of the painting [**49b**] documents the many changes he made to the figure's contours as he proceeded to carve the volume, scooping flesh away from her initially thicker form. He refined the curve of her chin, slimmed and elongated her neck, narrowed her shoulders, nipped in her torso, and thinned her arms. Throughout these changes, the artist retained his original sketch for Laurette's hands, which he painted in a light black wash on the ground and supplemented with only a few additional dark lines as he adjusted and recontoured the arms. As in the Landsberg portrait, the hands acted as a kind of touchstone for Matisse's repeated reworkings, but here, rather than creating Laurette's form through a series of scrapings, repaintings, and incisings, he did so by repeatedly applying paint in crisp, incisive brushstrokes. We are witnessing the beginning of a new process—of paring down what had previously been painted without destroying it through scraping and full removal. Instead, paint itself does the work, taking the form of a skin that covers and reshapes what is below. For instance, examination of the canvas in raking light [**49h**] demonstrates how Matisse defined the top and side of Laurette's head with ocher-green paint, running his brush in a smooth contour. A thick defining edge of paint can also be seen on the top of her eyebrows, along the bridge of her nose and cheekbone, and under her left eye [**49i**]. In other areas, the artist structured his brushwork in hatched, overlapping strokes to define a flatter form [**49c**]; on the neck and chest, he varied the direction, applying short, square, and swirling strokes of medium to cover the former neckline of the dress [**49e**].

Matisse still worked toward concision, however. He whittled down Laurette's arms by reshaping earlier forms with directional bands of color [**49f**] and paler combinations, adding black with a dry brush [**49g**]. This approach recalls his treatment of the figures' limbs in *Bathers by a River*, which he reshaped and modeled in the summer and fall of 1916 by applying layers of paint over and around the contours. And while the artist might have begun to alter his use of black at this time, he still employed it here to stand in for a more literal removal on the surface, at once a continuation of the hair over Laurette's right

shoulder and an elision that submerges her form below the canvas surface (we can discern the presence of her arm just below the green and ocher paint of the background). On the right, nestled within the black expanse of her hair, is an incised line [**49d**] that acts as a boundary edge, echoing the work of the paint on the left but existing as a more fragile demarcation than those of canvases past.

1. The date is based on a Nov. 1916 entry in Matisse's daybook about a potential new model; this was at a time when models were difficult to find in Paris because of the war. Matisse wrote, "Italian model recommended by Mme [Georgette Agutte] Sembat"; see pp. 312, 319 n.6 in this publication; Flam 2006, p. 9.

2. For an in-depth study of Matisse's paintings of Laurette, see Isabelle Monod-Fontaine, "A Black Light: Matisse (1914–1918)," in Turner and Benjamin 1995, pp. 92–93; Isabelle Monod-Fontaine in Cowling 2002, pp. 95–101; and Flam 2006.

3. Bernheim-Jeune photographed the painting (no. 1663) in Jan. 1917 and purchased it from the artist on Feb. 3, 1917 (no. 20834); Dauberville and Dauberville 1995, vol. 1, p. 589, cat. 185.

4. In addition, we can identify on the wall to the left of Matisse an unfinished state of *Georges Besson (I)* (1917; Musée Albert-André, Bagnols-sur-Cèze) and *Seated Nude* (1913–14; Pierre and Tana Matisse Foundation, New York); *Marguerite in a Leather Hat* (30d) hangs on the wall to the right.

50 **Portrait of Auguste Pellerin (II)**
Quai Saint-Michel, Paris, winter–May 1917

Oil on canvas; 150.2 × 96.2 cm (59 × 37 7/8 in.)
Signed and dated l.l.: *Henri-Matisse mai 1917*
Musée National d'Art Moderne/Centre de Création Industrielle, Centre Pompidou, Paris,
gift 1982, AM 1982-97

IN EXHIBITION

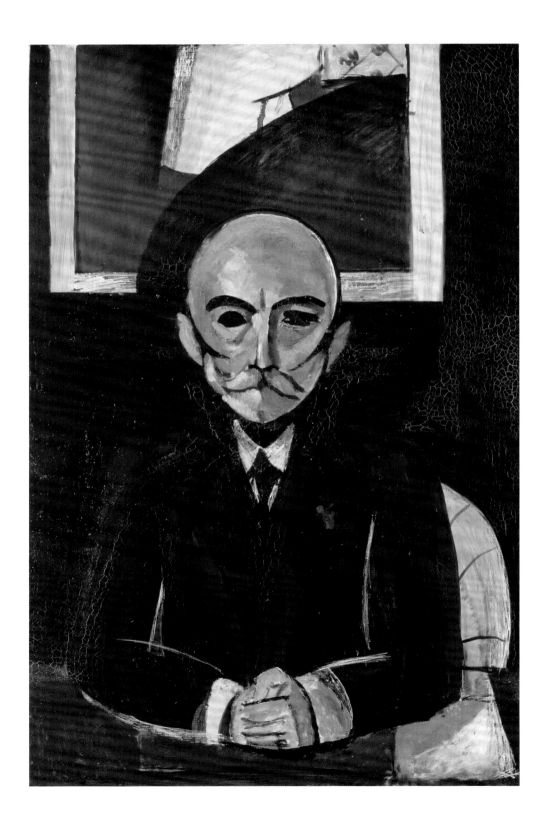

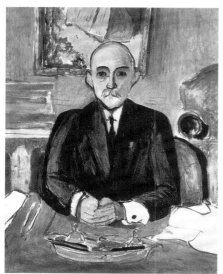

50a

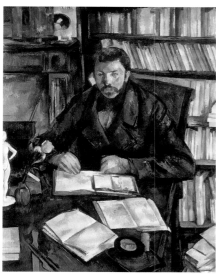

50b

50a

Portrait of Auguste Pellerin (I), 1916. Oil on canvas; 92.4 × 78.7 cm (36 3/8 × 31 in.). Private collection.

50b

Paul Cézanne (French, 1839–1906). *Portrait of Gustave Geffroy*, 1895–96. Oil on canvas; 110 × 89 cm (43 1/4 × 35 in.). Musée d'Orsay, Paris, RF 1969 29.

PORTRAIT OF AUGUSTE PELLERIN (II) [**50**], which has been described as "arguably the greatest portrait to have been produced in [the twentieth] century," was dated May 1917 upon its completion.[1] Therefore, Matisse would have finished it after *Portrait of Michael Stein* [**47a**] and *The Italian Woman* [**49**], on which it draws stylistically, and around the same time as *The Studio, quai Saint-Michel* [**51**], whose interdictive authority it shares. Both works fully succeed at keeping the viewer at a distance.

Pellerin was a Parisian businessman who made his fortune in margarine but is better known today as a great art collector, having owned over fifty works by Édouard Manet and more than 150 by Cézanne. Matisse, who was continuing to develop his own far more modest collection of the latter artist's work, had visited Pellerin from time to time for at least a decade.[2] Probably late in 1916, Matisse accepted and fulfilled a commission to paint Pellerin's portrait [**50a**]; in doing so, he may well have looked at Cézanne's *Portrait of Gustave Geffroy* [**50b**], which the collector owned. That work also places a serious but affable subject in a colorful, thinly painted setting of books and *objets d'art*.[3] However, the sitter rejected the finished work as too daring, "too much of a mask" to hang on his office wall.[4] Matisse, who had never before offered to make a second version of a commissioned portrait, did just that. Perhaps he was determined to have one of his paintings in such an esteemed collection; perhaps he wanted to show his client what a portrait that was truly a mask would look like.[5] Effectively, Matisse began the portrait commission in his new casual and naturalistic style and then returned to his older, more formal and radical style for the second version. As it happened, the sitter ended up acquiring both.[6]

The pose of the second painting repeats that of the first, only in such severe terms as to recall Jean-Auguste-Dominique Ingres' famous portrait of the eminent newspaperman Louis-François Bertin in the Musée du Louvre, as well as a famous photograph of Cézanne, thereby emphasizing Pellerin's identity as a cultural magnate.[7] It also recalls *Portrait of Gertrude Stein* (1905–06; Metropolitan Museum of Art, New York), with which Picasso had sought to reconcile Ingres and Cézanne, and thereby stand up against Matisse, whose *Le bonheur de vivre* (p. 49, fig. 12) had drawn on these same sources. Matisse could well have been thinking of Picasso's canvas, since he himself had just painted portraits of Sarah and Michael Stein [**47.2, 47a**]. The masklike face that Matisse gave Pellerin recalls the one that Picasso famously painted from memory after some sixty frustrating sessions sitting in front of Gertrude Stein. But it could also have been motivated by his continuing interest in African tribal art, a subject

on which Paul Guillaume published a book in 1917, organizing an exhibition that included Matisse's Bambara figure [**42a**].[8] Moreover, in his sculpture *Jeannette (V)* [**42**], made the previous year, he had drawn upon such art to produce a head that is as much a rounded, compressed mask as Pellerin's appears in the second portrait.

Prior to taking up a larger, more vertical canvas for the second portrait, Matisse made two drawings of Pellerin: one showed a reserved but not unfriendly figure [**50c**] as in the first painting, the other someone more stern [**50d**], as in the second. Nevertheless, an X-radiograph [**50h**] suggests that the second painting started out resembling the first, only with the subject more heavily rendered, less mild, and with a smaller, narrower head not unlike that in *Portrait of Michael Stein*.[9] The black ground conceals most of the incised contours that mark the artist's revisions of the head, but their results can be seen in a rough oval of drying cracks beneath the ears. Close visual inspection confirms that at one stage the top of the head reached as low as the midpoint of the present vertical crease between the eyebrows, while bits of scraped-off paint from earlier contours found their way into the pasty surface of the crown [**50e**]. An earlier location of the bottom of the beard remains just visible as a dark zone across the upper part of the white collar, and a touch of flesh tone at the right of the collar suggests that the beard was once even further down [**50f**]. As Matisse elevated the head, bringing up the frame of the picture in the background with it, he shaped the face into two overlapping, broad ovals, and he loaded it with pigment in a variety of ways, ranging from discrete patches of paint around the left eye to the parallel, hatched strokes on that side of the beard and the somewhat desiccated paste spread broadly over the dome of the head. He then added the ears and sharpened the features with black lines, reducing one eye to a slit and blocking out the other entirely.[10] No neck is shown, yet the head seems to break from its moorings, shift left, and float forward, as if this grave patriarch is leaning toward the viewer.

The black ground from which Pellerin emerges is actually composed of many colors, most especially in the area of the suit. There Matisse blended, reworked, and darkened the blue, brown, dark gray, and green as he advanced the picture. He wiped areas away; dragged a finger through the paint to clear space on the collar for the necessary flickering distraction of his subject's Légion d'Honneur rosette; enlarged the arms (which led to drying cracks); reincised contours to shape the forearms, cuffs, and hands; and dragged black paint through a grayish pink to describe the knuckles and fingers.[11] He used the same coloration for the chair at the right, then

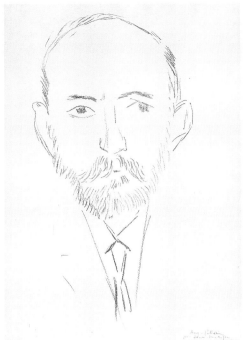

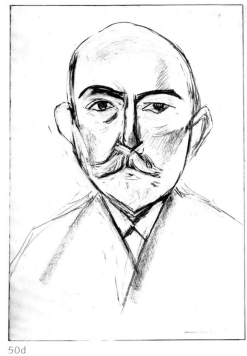

50c

50d

50c

Auguste Pellerin, 1917. Graphite on vellum; 56 × 37.5 cm
(22 × 14 3/4 in.). Musée National d'Art Moderne,
Centre Georges Pompidou, Paris, AM 1984-47.

50d

Auguste Pellerin, 1916. Charcoal on paper. Private
collection.

50e

Detail of the crown of the head in *Portrait of Auguste
Pellerin (II)*, showing the presence of scraped-off
paint.

50f

Detail of the collar, with the dark zone across the
upper part indicating an earlier location of the
bottom of the beard; at right, the flesh tone suggests
that the beard was once even further down.

50g

Detail of the chair, revealing where the artist
scratched and scraped through the black ground.

50e

50f

50g

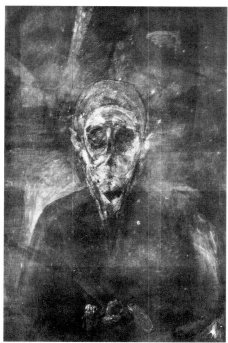

50h

50i

50h

X-radiograph of *Portrait of Auguste Pellerin (II)*, showing the original composition, which resembled that of *Portrait of Auguste Pellerin (I)*.

50i

Pierre-Auguste Renoir (French, 1841–1919). *Rapha Maître*, 1871. Oil on canvas; 130 × 83.1 cm (51³/₁₆ × 32³/₄ in.). Private collection.

scraped and scratched to produce a strange noncolor [**50g**] that resembles that in similarly worked areas on the right side of *The Moroccans*. Speaking much later of that painting, Matisse expressed his admiration for how Édouard Manet painted the black jackets worn by figures in his portraits.[12] While the results are equally dense, Manet's continuous membrane of dark liquid pigment seems very distant from Matisse's rugged, sculptural, distressed surfaces. He treated the chair almost as if he was painting an actual piece of furniture: he scraped its surface down, stained the canvas with a brown liquid paint, and then scraped it back again, as if waiting for a finish that would never be applied.

The light that shines on Pellerin's face flattens it, casting a big, curving shadow that connects the figure to the wall in a way that recalls *The Italian Woman*. Here, however, the wall behind the sitter contains a painting in a gold frame, its sides marked by the artist's stiff brush; the right seems to catch more light than the left, and the bottom displays long marks that capture the effect of flickering illumination on its surface. Matisse allowed the shadow to obliterate the frame just to the left of the sitter's head, then feathered it into the painting's Indian red ground, stopping it at the inside edge of the frame at right. At the center left of the framed painting, he repeatedly scratched down the side of an incised strip, removing dark paint from the edge of an illegible pale yellow form. This corresponds, in fact, to the edge of a long gown worn by the fashionable socialite Rapha Maître in a painting by Pierre-Auguste Renoir that Pellerin had just acquired [**50i**]. Matisse and his patron must have discussed the work; we have to wonder whether they spoke of the fact that Renoir painted it during the Paris Commune, working to the sound of cannon fire and bombing, while Paris was under siege.[13]

1. Golding 1992, p. 833.

2. Matisse had been visiting Pellerin's collection since at least the time of the great 1907 Cézanne retrospective, to which Pellerin was the biggest lender, and he had been there three or four times in 1916. See Spurling 2005, pp. 193, 479 n. 510

3. Barr 1951, p. 189, placed the commission and both portraits in 1916. Although the inscribed date of May 1917 on the second portrait has led it to be reassigned, the commission and the first work are still reasonably dated to 1916, although no supporting documents have yet been uncovered.

4. Schneider 2002, pp. 406, 718.

5. A confused story tells of Pellerin folding back areas of the painting he did not like, to Matisse's great discomfort; if this is true, it is reasonable that he would have wanted to make another work that Pellerin would like. See Elderfield in Cowling 2002, p. 349 n. 28.

6. The most thorough account of Matisse's transaction with Pellerin appears in Monod-Fontaine, Baldassari, and Laugier 1989, pp. 58–59, cat. 14: "Then, changing his mind, he proposed keeping both paintings for the price of one. Matisse stood firm: Monsieur Pellerin was obliged to buy both his paintings." Evidence of Matisse's stylistic flexibility in this period is demonstrated by the

fact that, precisely when he was making the radical *Portrait of Auguste Pellerin (II)* in May 1917, he was also making for Pellerin *The Three Sisters* (Musée de l'Orangerie) in the more illustrational style that he had adopted for images of his model Laurette, whom he featured in that work. On May 24, 1917, Félix Fénéon wrote to Matisse (AHM), saying, "On the 22nd of the month you told us that you had sold: 1) a not-yet-completed size 30 canvas (without frame) representing *Les trois sœurs* for 7000f to Mr. Auguste Pellerin."

7 See Elderfield in Cowling 2002, pp. 109–13.

8. Guillaume wrote to Matisse in Issy: "Dear Monsieur Matisse, You were so good as to take the trouble of bringing to Paris a Negro statue and allowing me to reproduce its photograph in my book. [Paul Guillaume, *Sculpture nègre, 24 photographies* (Paul Guillaume, 1917)]. I thank you. I have before my eyes the print which perfectly renders this truly very beautiful piece. I am happy to have it figure in the work, where it contributes greatly not only its own qualities but also the name of the collection to which it belongs. [Thanks]"; Guillaume to Matisse, Mar. 26, 1917, AHM.

9. Charles de Couëssin, "Le dessin incisé d'Henri Matisse," in *Le dessin sous-jacent dans la peinture: Colloque 6/Infrarouge et autres techniques d'examen* (Louvain-la-Neuve, 1987), pl. 57. It is worth noting that the image as recorded in the X-radiograph recalls Amedeo Modigliani's strange *Portrait of Max Jacob* (1916; Cincinnati Art Museum).

10. Scholars have often compared these eyes to West African masks and the early Cubist paintings influenced by them; see Elderfield (n. 7), p. 112.

11. On the role of the rosette on the jacket and its distracting quality, see ibid.

12. See p. 279 in this publication.

13. Colin B. Bailey, *Renoir's Portraits: Impressions of an Age*, exh. cat. (Yale University Press/National Gallery of Canada, Ottawa, 1997), cat. no. 11.

51 The Studio, quai Saint-Michel
Quai Saint-Michel, Paris, March–April 1917

Oil on canvas; 147.9 × 116.8 cm (58 1/4 × 46 in.)
The Phillips Collection, Washington, D.C., 1307

IN EXHIBITION

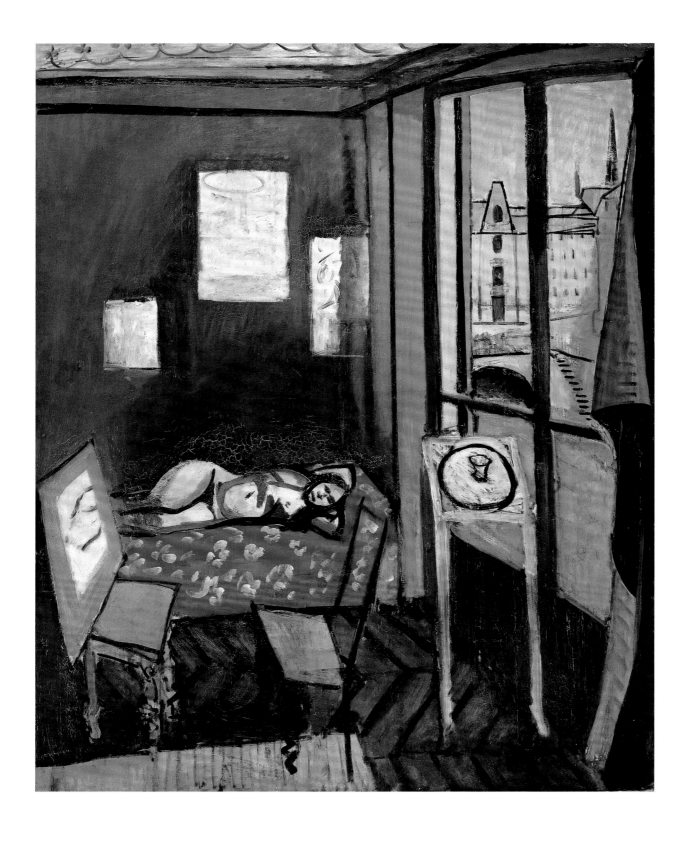

THE STUDIO, QUAI Saint-Michel [**51**] is the last and most affecting of Matisse's four paintings of his atelier overlooking the Seine. It forms a pair with *The Painter in His Studio* [**51a**] in its subject of making art with a model; in contrast, the first set of canvases, *Interior with Goldfish* [**24**] and *Goldfish and Palette* [**31**], turns our focus to a window and a bowl of goldfish placed before it. However, the view here, and the manner in which it is painted, returns us to *Interior with Goldfish*, although offering a narrower, more foreshortened vista over the river. On the table by the window, the tiny vessel recalls the plant pot of the earlier work and the circular plate on which it sits, the area formerly occupied by the goldfish bowl. By completing the second pair of quai Saint-Michel interiors and recalling the first in them, this canvas functions like Matisse's fourth *Jeannette* sculpture [**13.2**] did with respect to its predecessors: closing, albeit temporarily, a series of like works. But whereas the artist revisited the sculptural series to make a single additional work in 1916, he would subsequently make many studio paintings with the subject of *The Studio, quai Saint-Michel* in mind. It is different from its three predecessors in depicting a female model in the studio, a theme that Matisse would pursue for the next forty years. Therefore, it is at once the culmination of the 1914–17 quai Saint-Michel interiors and an announcement of a major change to come.

In *The Painter in His Studio*, Matisse, for the very first time, depicted himself painting a model.[1] He began working with Laurette in November 1916; judging by the bleak scene outside the window, this canvas was made in the winter.[2] The scene inside is bleak, too, as both artist and model appear more like mannequins than real people. In *The Studio, quai Saint-Michel*, however, Matisse did not include himself but left the empty chair. We also see Laurette, a stylized but nonetheless vivid presence, who appears as she does in *Laurette Reclining (I)* [**51c**], for which the drawing on the chair in the present painting is presumably a study. Given the date of another related canvas, it seems fair to conclude that Matisse painted *Laurette Reclining (I)* and the larger *Studio, quai Saint-Michel* in spring 1917.[3]

The window view of *The Studio, quai Saint-Michel* [**51e**] suggests a more even, northern light than that of *Interior with Goldfish*—the pale sunlight of a late morning rather than the multicolored late-afternoon light of the earlier work. The buildings across the Seine are flatter here and would have merged with the sky if Matisse had not redrawn the intersecting rooftop patterns below the spire of Sainte Chapelle, working with heavy lines of black paint, some of which appear to have been ruled.[4] This area has been extensively revised: we can see how the artist scraped

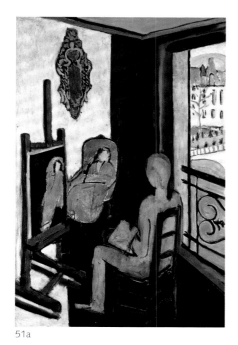
51a

51b

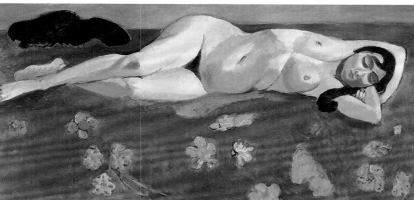
51c

51a
The Painter in His Studio, 1916–17. Oil on canvas; 146.5 × 97 cm (57 11/16 × 38 3/16 in.). Musée National d'Art Moderne/Centre de Création Industrielle, Centre Pompidou, Paris, AM 2585 P.

51b
Drawing for "The Studio, quai Saint-Michel," 1917. Graphite on paper; 73.6 × 55.9 cm (37 3/8 × 22 in.). Private collection.

51c
Laurette Reclining (I), 1917. Oil on canvas; 95 × 196 cm (37 1/2 × 77 1/8 in.). Private collection.

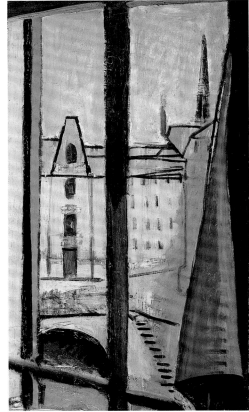

51e

51d

51f

51d
X-radiograph of *The Studio, quai Saint-Michel*, show-ing changes in the composition, notably the repeated repositioning of the three pictures on the wall.

51e
Detail of the view out the window, displaying Matisse's adjustments to the buildings on the opposite side of the Seine.

51f
Detail of the tabletop, showing the original far edge of the plate and the presence of scraping at the lower-right corner.

away the roofline of the corner tower, lowered it a fraction, and scraped paint from above the window, door, and base of the building; he then shifted the whole structure down. He drew the roofs over the pale mauve of the sky, which has pink beneath it, and later dragged a thin wash of the mauve over the facades, exposing in places the white ground and the finely textured canvas. He then extended a darker mauve yet further down, scratching and scraping it to set the plane of the roadway behind the vertical surface of the bridge. At the right, in an opposite movement, he used a thinned wash to carry the pink of the bridge upward, almost to the top of the buildings. Here it serves to buffer the original pale mauve against the harsh, dark orange of the oddly shaped curtain. In a drawing for the work [51b], this element appears as a saggy drape. Visual inspection of the painting shows us that the curtain's black middle area was, at one point, a watery green color, indicating that it was originally part of the Seine. This strange invention, curled like the peeling bark of a tree in a northern Renaissance painting, would therefore have come quite late in the painting process. A drooping blackout curtain may have motivated it, but Matisse may also have wanted to add something puzzling to the eye to close the edge of his composition and distract attention from all that is happening on the other side.

Originally, the artist had tried, then rejected, grillwork behind the window. An X-radiograph [51d] clearly shows its curvilinear forms, as does the drawing. Dark, sloping lines along the water are visible remnants of this feature in the painting, while an indentation in the gray-turquoise vertical edge of the opened external shutter, just where the transom crosses it, suggests that the upper rail of the balcony was once located there. This arrangement was obviously too fussy, attracting attention outside the room rather than distracting attention inside it.

Within the studio, the figure of Laurette is outlined in black (except for her hip) and framed by the vividly colored divan, while five pale rectangles appear to orbit around her in the composition. Three of them, hanging behind her on the wall, are pictures that may have been paintings before coming to resemble drawings. Matisse may have toned down what was previously more colorful, since turquoise lies under the surface of the center one, and the wall itself was originally ocher. Matisse changed *Interior with Goldfish* in a similar way, painting over a picture that appeared on the studio wall. The X-radiograph of *The Studio, quai Saint-Michel* indicates that the artist labored over the size and position of the three works, likely changing the one at the right four times; he also removed the back of the divan and brought Laurette down lower in order to create more space beneath the

pale rectangles. As a result of these changes, drying cracks developed, most noticeably above the model's body and the drawing board to her left, and above the right-hand painting. In 1951 Pierre Matisse stated that his father was "baffled" at the appearance of these cracks "after all the care he had taken to avoid them."[5] And yet he accepted them: they give uncertain edges to the shapes that, together with their implied—and sometimes actual—transparency, intensify this painting's fluid, Cézannist interchange between objects and their surroundings. Without firm spatial mooring, they tremble in the plane of the wall, advancing from and receding within it in an uncanny, mysterious way.

The three pictures on the wall also speak to the two other, more grounded rectangles in the vicinity. One of these is the drawing board, which is propped against the chair back. The sheet looks almost like a mirror, reflecting Laurette's body and receiving gray light from outside and a reflection of turquoise from the window frame across the room. The other rectangle is the tabletop, which holds a glass and a plate [51f]. Matisse revised this feature considerably. First, he scraped down to the white ground, which is visible in the lower-right corner, not quite eliminating his first attempt at the plate, whose original far edge remains. Then he scumbled the surface with citron and finished by inscribing the shiny black circle. The table itself is a preposterous, ramshackle structure, very different from its solid counterpart in *Interior with Goldfish*.

The two chairs to its left are not quite as flimsy, but the pentimenti within and around them introduce an undecided, provisional quality, particularly to the alternative versions of the seats. These pieces stand on a modified herringbone parquet with brown and red beneath the marks of the boards, and next to a patch of light that does for the bottom of the painting what the curtain does for the right side—distract vision and keep it moving. Laurette is barricaded by both furniture and the built structure of the room: it is hard to find another painting in Matisse's work up to this point in which the full and crowded so poignantly evoke the empty and isolated— nor one in which the viewer's captivation by, and of, the depiction is so bound to an acknowledgment of its separateness.

In 1917 Matisse purchased Gustave Courbet's *Sleeping Blonde Woman* from the artist's sister and then painted his own *Sleeping Nude* (1917; private collection) based on it. In its sensuous approach, that work marked a change from the few nudes he had made between 1913 and 1916. However, his series of almost fifty paintings of Laurette—which he had been working on for some six months prior to making *The Studio, quai Saint-Michel*—also explored the influence of Courbet and another way of

painting; this is evident from the intimate *Laurette Reclining* and its companion, *Laurette with Cup of Coffee* (p. 314, fig. 7). *The Studio, quai Saint-Michel*, coming toward the end of the series of Laurettes, was painted as if by an artist who had stepped back from these recent canvases. The model is remote and unreachable, and the studio is cold with anxiety. Matisse was truly pulling back, torn between his repeated recordings of a new subject and his unwillingness to abandon the methods of modern construction that he had been developing for the previous four years.

1. See Flam 2006, p. 18.

2. No documentation has yet confirmed which winter, however; see Flam 1986, pp. 441, 505 n. 9, who placed *The Painter in His Studio* after *The Studio, quai Saint-Michel*, but not as late as 1917.

3. Dauberville and Dauberville 1995, vol. 1, pp. 608–09, cat. 199; and Flam 2006, p. 32 n. 35.

4. Although the rooftop patterns recall Piet Mondrian's Paris paintings of 1914, it seems impossible for Matisse to have seen these, although he would presumably have known the two slightly earlier paintings that Mondrian exhibited at the Salon des Indépendants in spring 1914; see Bois and Rudenstine 1994, p. 32.

5. The changes of position are detailed in The Phillips Collection technical study, which also records Pierre Matisse's Dec. 1, 1951, comments to Duncan Phillips.

52 **Shaft of Sunlight, the Woods of Trivaux**
Environs of Issy-les-Moulineaux, June–August 1917

Oil on canvas; 91 × 74 cm (36 × 29 1/8 in.)
Signed l.c.: *H. Matisse*
Private collection

IN EXHIBITION

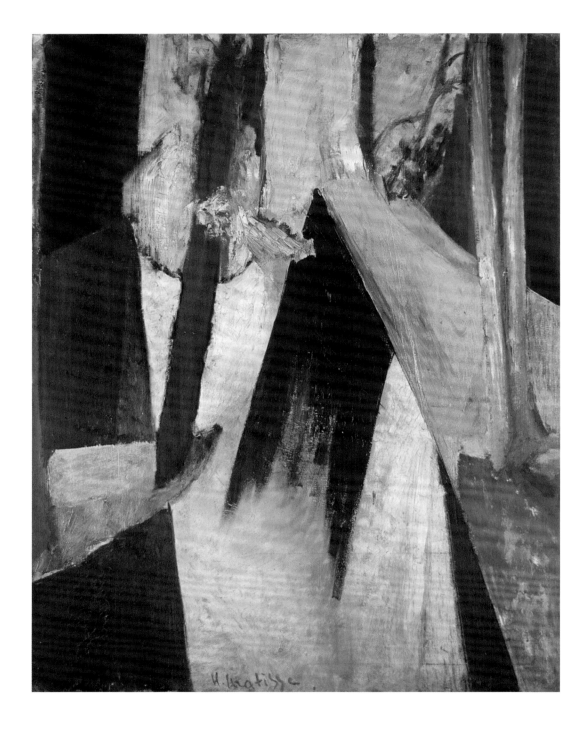

SHAFT OF SUNLIGHT, the Woods of Trivaux [52] belongs to a group of landscapes that Matisse made in the summer of 1917, working southwest of his Issy home in the large, parklike Bois de Meudon, which contains the tiny pond of Trivaux.[1] These works reflect his rediscovered nineteenth-century interests, most evidently the influence of Camille Corot, as well as his longstanding preoccupation with Cézanne.[2] Working out-of-doors, he could both learn from earlier French landscapists and recover qualities that his recent, highly formalized art made impossible.[3] While making this painting, however, he returned to as extreme an abstraction as he had ever attempted.

This canvas forms a pair with *Walk at Trivaux* [52a], a Cézannist scene of the same size, also showing a path receding through the woods. Available archival information does not confirm which work came first: whether, as had typically been the artist's practice in paired

works, the more formalized painting followed the more naturalistic one, or whether he had painted them in the reverse order just as, around the same time, *The Music Lesson* (p. 316, fig. 11) reprised the previous year's *The Piano Lesson* [43]. In any event, *Shaft of Sunlight* depicts not the typical appearance of a part of the Trivaux forest, as the companion canvas does, but a sudden, dramatic flash of illumination piercing the trees. This associates it with the interiors that Matisse painted between 1914 and 1917, works in which he depicted the effects of late-afternoon light, doing so not merely as a matter of record but in order to use unexpected illumination as an emotive vehicle.[4] As with those canvases, the artist remembered the poet Stéphane Mallarmé's dictum, "Paint not the thing but the effect it produces."[5] But here the effect is a veritable explosion.[6] Responding to a question from Alfred H. Barr, Jr., Matisse stated that he thought he made the work in 1912.[7] He must have recalled a similar shock in a path through the woods in Tangier that led him to produce *The Palm* [52b], which he had made "all in one blow, like a flame," in his most recent period of landscape painting.[8] Both canvases share a downward view on a densely wooded landscape, more naturalistic at the top, with a more abstract lower part flattened and simplified in response to the flash of light.

Shaft of Sunlight, however, reveals a distinctly different treatment of these zones. At top center, visual examination reveals that Matisse quickly set in the distant tree trunks and tangled branches, leaving slivers of exposed canvas between them; he did the same with the earth, grass, and two trees enclosed by the diagonal that falls close to the bottom-right corner. Here he quickly brushed out the pigment, even to transparency; below and around this, though, the surface is much denser, suggesting that it covers a more naturalistic first effort. Beneath the white of the foreground, there are visible arched and vertical forms in a pinkish tone that indicate the original presence of plants; traces of a similar tone within the dark shape at left suggest that it may have been a patch of reddish earth like the one at bottom right. The similar dark patch at upper left, however, looks like polished leather and obscures everything beneath it. Below the adjacent, roughly circular cluster of foliage, drying cracks indicate that this element was either moved up or originally extended lower. Most visible to the naked eye are the incised lines of varying degrees of definition that fan from the meeting of black and green at lower right. These reveal that Matisse tried out several possibilities for the path going into the distance. For the path coming forward, he overpainted with gray the left half of the black triangle that sits near the bottom-right edge, bringing it into dialogue with its reversed twin, which sits on the

top edge of the green wedge at the left. The angle and mooring of the tree at the right end of that wedge look especially precarious, as the sides of the path seem to shift and shudder in position, and the huge, blinding black shadow falls down between them.

Shaft of Sunlight's palette and big geometric shapes recall *The Piano Lesson*, made the summer before. But the settled calm of that work breaks apart in the violent optical contrasts of this painting. In October 1917, Matisse sent a group of his recent landscapes to Bernheim-Jeune.[9] This canvas, however, he kept for himself, choosing not to present it to the public until Barr's 1951 exhibition of his work at The Museum of Modern Art, New York.[10] That same year, he spoke of having used "the methods of modern construction" in making his *Still Life after Jan Davidsz. de Heem's "La desserte"* [35] in 1915, also included in that presentation. It was apt that this landscape was there, too, since it may well have been one of the very last pictures he painted using these methods.

1. See pp. 317–18 in this publication.

2. It is noteworthy that Cézanne's role as a connecting element backward to earlier nineteenth-century painters, rather than forward, the more common interpretation, was one of the focuses of a Bernheim-Jeune exhibition in Jan. 1917.

3. See also Flam 1986, pp. 456–62, for a discussion of these and related landscapes of this period.

4. See entries 24 and 43 in this publication.

5. Mallarmé to Henri Cazalis, Oct. 30, 1864; *Stéphane Mallarmé: Correspondance complète (1862–1871) suivi de lettres sur la poesie (1872–1898)*, ed. Bertrand Marchal and Yves Bonnefoy (Gallimard, 1995), p. 206; Rosemary Lloyd, *Mallarmé: The Poet and His Circle* (Cornell University Press, 1999), p. 70. Matisse's notion of "equivalences" is effectively his own recasting of Mallarmé's dictum. See his earliest clear version of this in "Sarah Stein's Notes" (1908); Flam 1995, pp. 45, 50. See, however, the gloss on this statement, referring to Matisse's earlier Fauve landscapes, in Gowing 1979, p. 51.

6. See ibid., p. 137.

7. Barr 1951, pp. 157, 540 n. 1, recorded that Pierre Matisse dated the work to 1915–16.

8. However, Isabelle Monod-Fontaine in Cowling 2002, p. 90, rightly referred to a Cézannist prelude to the 1917 landscapes in the form of a drawing of trees that Matisse made, appropriately at L'Estaque, in Dec. 1915. For "all in one blow, like a flame," see Barr 1951, pp. 156, 540 n. 1. Barr translated this passage as "in a burst of creation, like a flame." Margaret Scolari Barr recollected that Matisse had said, "Je l'ai fait tout d'un coup, comme une flamme," or as she translated it, "all in one bang." Margaret Scolari Barr to Trinkett Clark, June 27, 1981, curatorial files, National Gallery of Art, Washington, D.C.

9. Dauberville and Dauberville 1995, vol. 1, pp. 616–25, cat. 203–09.

10. Barr 1951, p. 540 n. 1. It was reproduced in this book (p. 381), which accompanied the exhibition, albeit bearing the date "1912? 1914–16?"

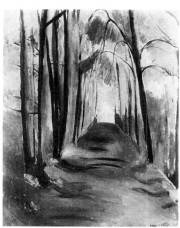

52a

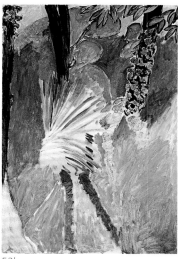

52b

52a

Walk at Trivaux, 1917. Oil on canvas; 92 × 73 cm (36 1/4 × 28 3/4 in.). Private collection.

52b

The Palm, 1912. Oil on canvas; 117.5 × 81.9 cm (46 1/4 × 32 1/4 in.). National Gallery of Art, Washington, D.C., 1971.73.1.

53 Garden at Issy
Issy-les-Moulineaux, June–October 1917

Oil on canvas; 130.5 × 89.5 cm (51³/₈ × 35¹/₄ in.)
Signed l.l.: *H Matisse*
Fondation Beyeler, Riehen/Basel, 88.3

IN EXHIBITION

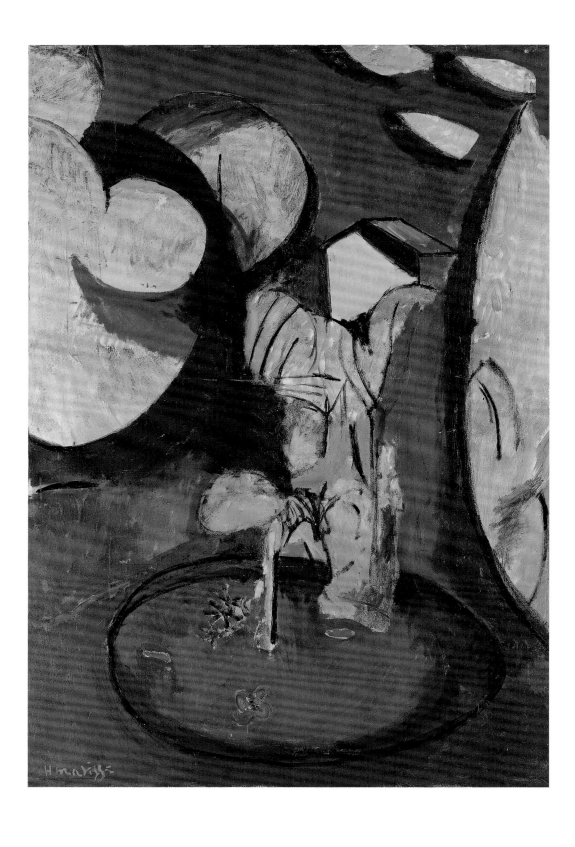

THE VIEW REPRESENTED in *Garden at Issy* [**53**], which Matisse made in early fall 1917, is from his living room; this same vista appears at the far side of *The Music Lesson* (p. 316, fig. 11), which was painted that summer.[1] The massive dark green bush at the left of the garden in that painting produced the overlapping disks at the left of this one; likewise, the rhyming, curved lines in the upper-right corner of the window there describe the lower part of the tree that is seen at its full height here. Matisse now brings us much nearer to the garden, and we look down onto the circular pool, which appears as a broader ellipse. Within the pool, there are fragments of drawing in and to the left of the upright green mass that suggests Matisse may have considered adding a figure or figural sculpture there [**53a**]. What may be mistaken for a small plume of water rising from the pool is in fact a stream projected from a wall fountain behind it, arching down amidst foliage. In *The Music Lesson,* this fountain is concealed by the sculpture *Reclining Nude (I) (Aurore)* [**1.2**], which appears life size, with water dripping from beneath it.[2]

Woman at the Fountain [**53a**], another painting made that summer (if not later), confirms these features. However, the small shed or distant building in *Garden at Issy* is absent from both of its companions. It may be that, as he painted the big disks, Matisse remembered *The Blue Window* [**18**], with its far-off studio and a halo of cloud floating above it; in response, he may have added this toy house, crowning it with a pattern of dappled light that resembles three peach-colored shells flying across the sky. Or perhaps he simply felt that a painting of rhyming, natural curves required a geometric, architectural focus.

Visual inspection reveals traces of charcoal drawing over the green leaves at the upper left; these, together with horizontal marks that seem to change angle, suggest that the artist may have considered and then rejected the idea of including the side of the French window to stabilize the composition, as he did in *Woman at the Fountain.* The repainted area further down on the left, just above and beside the pool, indicates that Matisse not only decided against the window but that he also obliterated what may have been a boundary wall or an earlier position of the edge of the pool; all that remains of this feature are arching forms with blue hatching behind and, most prominently, a strong black line over a hint of blue, which Matisse must have decided he needed to retain in order to prevent that area from passively receding. The pool was blue at first: since we can follow the black line across the center of the composition, this suggests that it was the original far boundary of the pool, which Matisse had originally placed too far back and off-center. Such a change is confirmed by his use of a blue wash

that stained through to the reverse of the canvas, indicating that the entire bottom-left quadrant of the picture was originally taken up by an elliptical, vertically oriented pool.

The artist continued the painting by laying in the landscape in greens that extend far beyond their brown boundaries, moving his brush vigorously in strokes that include directional hatchings, zigzags, pouncing, and broad, sweeping marks. Blues were also present early on, visible through the foliage and sometimes denoting sky, as in the fragments that remain at the center and upper right. While the blue behind the pool can be explained if the pool once occupied that area, the sliver of blue at the lower-right edge is simply willful, and it reveals Matisse's typical attention to detail. He was clearly bothered by a black line that looped around to meet the inside contour of the tree, so he scratched away the top of the loop. Enjoying the effect, he scratched to soften the blue above it and then came back to overpaint the entire reverse curve with green. In a similar vein, he scratched back the blues beyond the pool; incised lines to describe the falling water; and then reinforced this sense of movement with white and blue paint and black contours. After he had repainted the pool with Venetian red and left in reserve places for the fountain, two goldfish, and floating plants, he added those elements, reshaping the nearest plant into a prominent quatrefoil form rotating in the foreground.

All these details, however, are subsumed by the graphic clarity of the whole, which affords a sense of big cutout shapes that glow like bright windows against the rich, dark red ground. These shapes cast shadows that not only open space in the landscape but also fall flatly on the surface of the painting. Indeed, the round forms at left cast shadows that recall one that falls across the dark red surface of the background painting in Matisse's *Portrait of Auguste Pellerin (II)* [**50**], made that spring. *Garden at Issy* demonstrates Matisse's continuing interest in paring down his compositions, although by means that were in the process of transformation.

1. This painting has been dated c. 1917–19; see Schneider and Préaud 1970, cat. 162; Finsen 1970, cat. 45; and Tokyo 1981, cat. 47. Its present dating is based on its relationship to *The Music Lesson* and *Woman at the Fountain,* as well as on reasons of style and method.

2. Matisse's preliminary drawing for *The Piano Lesson* (43) does not show a wall fountain, unless it is obscured by the large ornamental urn; see 43a.

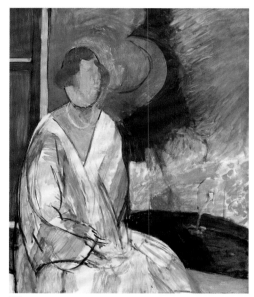

53a

53b

53a
Woman at the Fountain, c. 1917. Oil on canvas; 81 × 65 cm (31³/4 × 25¹/2 in.). Private collection.

53b
Detail of the far side of the pool, showing fragments of black drawing in the shape of a reclining figure or sculpture.

54 Bathers by a River, sixth state
Issy-les-Moulineaux, January–October (?) 1917

Oil on canvas; 260 × 392 cm (102 1/2 × 154 3/16 in.)
Signed l.l.: *Henri-Matisse*
The Art Institute of Chicago, Charles H. and Mary F. S. Worcester Collection, 1953.158

IN EXHIBITION

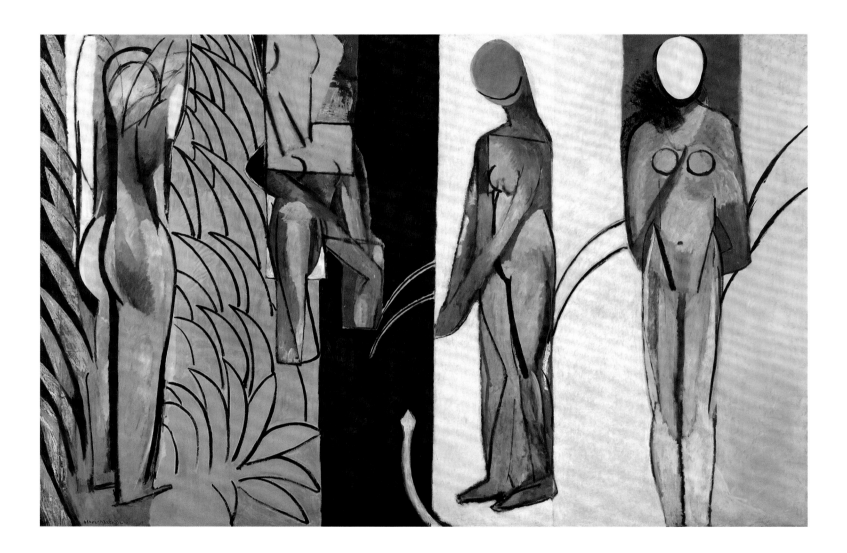

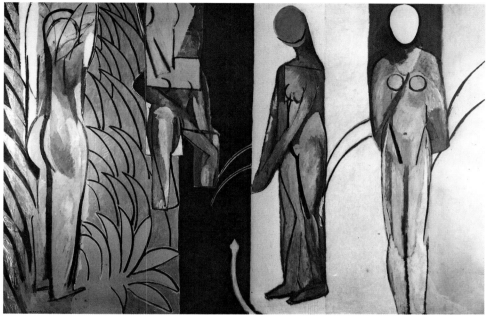

54a
Bathers by a River, fall 1926, photograph
by Paul Guillaume. Archives of The Barnes
Foundation, Merion, Penn.

OVER THE YEARS, commentators have questioned whether Matisse ever really finished his large-scale bathers composition, citing a 1978 statement by his daughter, Marguerite, that he did not consider it truly complete.[1] *Bathers by a River* was indeed a picture with a long gestation and one to which the artist returned over numerous painting campaigns: this publication acknowledges at least six separate occasions including the present final state, although others not yet documented by physical or archival evidence could certainly exist.[2] What is clear is that the artist, freed early in this work's genesis from the obligation to tailor it to the needs of a donor or dealer, employed it as central vehicle for his ambitious experiments. Given the painting's continual presence in his studio for so many years as well as its connections with numerous works from 1909 through 1917 and beyond, we should consider Marguerite's statement as an indication not of the picture's lack of completion, but rather of Matisse's enduring relationship with it.

That said, there are no extant historical records that securely document Matisse's completion of the painting. The only firm date we have, in fact, is September 14, 1926, when he sold the canvas—along with *The Piano Lesson* [**43**], *The Lorrain Chair* [**54b**], and probably *Bather* [**8**]—to the dealer Paul Guillaume.[3] It was at this time that the canvas was also photographed by Guillaume [**54a**], who in turn offered it to the American collector Albert Barnes, praising it as "very large and sumptuous."[4] Guillaume's photograph shows the painting as we know it today, signed in the lower-left corner.[5]

Although *Bathers by a River* was sold in 1926, Matisse's departure for Nice in October 1917 makes it rather more likely that he completed the canvas sometime during that year.[6] In February 1917, in fact, the Lebanese writer Ameen Rihani visited the Issy studio, where he witnessed the painting still in process and the artist still unsure about it himself. Rihani later wrote of his experience in an article about artists in wartime:

A footpath from the door-steps leads to another house, half-concealed by the trees, which is his studio. He would have been glad if it were in the Sahara that winter. He warned us, when we expressed a desire to see it, against its North-Pole atmosphere. *Mettez votre pardessus, Monsieur.* And he slipped on a sleeveless overcoat, a contrivance of his own, to overcome, while working, the cold and coalless winter. He was right. We shivered for ten minutes amidst a confusion of unfinished tableaux on which we could not warm even our imagination. Only when the North wind subsides and the sun shines does he come here to while away a few hours at an old tableau, on which he had been working spasmodically for the last six years and which promised to be a masterpiece of—Cubism, Futurism, Fauvism?—he himself does not know. And there it stood, a huge canvas in greys, which baffles the understanding. And the Master, to add to our perplexity and embarrassment, asked us if we thought it had anything in it of Cubism. Alas, Monsieur

54b

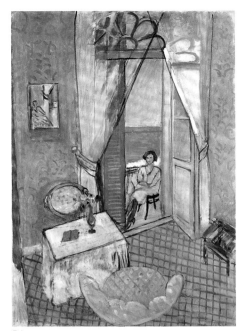

54c

54d

54e

54b
The Lorrain Chair, 1919. Oil on canvas; 130 × 89 cm
(51 5/8 × 35 3/16 in.). Private collection.

54c
Interior at Nice, 1919 or 1920. Oil on canvas;
132.1 × 88.9 cm (52 × 35 in.). The Art Institute of
Chicago, gift of Mrs. Gilbert W. Chapman, 1956.339.

54d
Detail of lower-left edge of the leaf forms in *Bathers
by a River*, showing deep scraping and incising in
a second painting campaign that took place after
November 1916.

54e
Detail of the area behind the third figure's knees,
showing stiff brushwork patterns over the formerly
pale blue band.

Matisse is afraid, I think, of becoming a Cubist and he is just as much afraid, alas! alas! of *not becoming* a Cubist. He would make up his mind, I suppose, if he could foresee the ultimate course of the destiny of Cubism. Meanwhile, he will go on doing his best to overcome the perplexity within him. And if he had hauled down the flag of the revolution, he continues to experiment on what he believes to be a new expression of art.[7]

Rihani's account poignantly documents the artist's continued work over the winter of 1917, and we can identify further changes that date to this time, which are corroborated by physical examination and bolstered by comparison of the November 1916 Bernheim-Jeune [46] and September 1926 Guillaume photographs. Evidence points to a much more subtle reworking at this time that was focused less on deep structure than on surface and light.

Unlike his bold, large-scale transformations in 1916, Matisse now attended more slowly to two specific areas where he made subtle adjustments. The first was the left edge: here he continued to work on the leaves, lightly scraping back prominent black paint strokes within the forms, reshaping contours, and cleaning the lines.[8] Inside the leaves, he also incised over the scraped areas, revealing more color—especially white—from the lower layers [54d]. These changes, complementing the zigzagging brushwork in the green paint on the other side of the first figure, gave the left edge a greater sense of depth and soft volume, bringing more cohesion to the whole. The artist also revised the band between the third and fourth figures: he added white over the blue in a thin brushy scumble [54e], a combination that prefigures some of the pictures from his early Nice period, including *The Lorrain Chair*, *Plaster Figure with Bouquet of Flowers* (1919; Museu de Arte de São Paulo), and especially *Interior at Nice* [54c], with its ethereal effects of light.[9] Here the stiff, frothy texture produced by Matisse's brush through the white paint contrasts with the denser band of white in front of the third bather; it also echoes the patterns in the blue band behind the fourth figure, where he moved his brush quickly through still-wet paint to reveal passages of the earlier gray color. These adjustments, at once additive and reductive, allowed him to bring greater unity to the painting's composition and surface. The changes are different than the structural emphasis of much of his work in 1916 and suggest the shift that Matisse would begin to execute in his transition to Nice.

In 1953 the Art Institute of Chicago's director, Daniel Catton Rich, wrote to the artist to inform him that the museum had acquired *Bathers by a River*. Matisse replied in his congratulations that the painting was one of the five most pivotal works in his career; this should be no surprise, given his many changes to the canvas between 1909 and 1917 and its critical place within the period of his most radical invention.[10] The painting reflects on a grand scale the many sources of his inspiration, from Arcadian images by artists ranging from the Old Masters to Cézanne and avant-garde developments of Cubism and Futurism, to his own inventive approaches to construction and abstraction, and concentration on specific subjects and forms of expression.[11] *Bathers by a River*, it can be said, became the vehicle through which Matisse discovered his methods of modern construction.

1. See Elderfield 1978, p. 189.

2. He might, for example, have returned to the canvas in summer 1911, when he could have been working on *Back (II)*; he was also pursuing other large compositions at the time.

3. Guillaume to Matisse, Sept. 14, 1926, AHM. Included with this sale was another canvas, which Guillaume referred to as "the nude done with Brouty which was hung on the wall of the large studio, 30 canvas." This is very likely *Bather*, which is a standard size 30 canvas and for which Loulou Brouty was the model. If this is indeed the case, this reinforces the relationship between *Bathers by a River* and *Bather* for the artist. Guillaume would exhibit *Bathers by a River*, *The Piano Lesson* (43), and *Branch of Lilacs* (27) together in a small exhibition that ran from Oct. 1 to 14, 1926, and was inaugurated with a special lecture by Georges Duthuit and a musical performance by pianist Marcelle Meyer. For more on the exhibition, see pp. 351–53.

4. Guillaume described the work to Barnes as "a very large and sumptuous painting—rather abstract—representing four figures by the side of a river." The collector declined the offer, stating that both *Bathers by a River* and *The Piano Lesson* "look like very important ones and one of them is the largest Matisse I ever heard of. The two large ones should go into a public museum and I fear that you will have trouble in selling them to a private collector." See Guillaume to Barnes, Sept. 14, 1926, and Barnes to Guillaume, Oct. 6, 1926, President's Files, Albert C. Barnes Correspondence, The Barnes Foundation Archives, Merion, Penn. Thanks to Karen Butler and Katy Rawdon, archivist and librarian, for bringing these materials to our attention.

5. This photograph was critical in the recent treatment of the painting, providing important historical confirmation of what researchers and conservators' examinations pointed to as the work's original look. For issues related to the treatment, see pp. 26–29.

6. The earliest publications of the painting date the work to 1918 and 1917; see Sylvain Bonmariage, "Henri Matisse et la penture pure," *Cahiers d'art* 9 (1926), pp. 239–40; and Florant Fels, *XXe siècle: Henri Matisse* (Éditions des "Chronique du jour," 1929), n.pag., respectively.

7. Rihani's visit was published in the second section of a two-part article in *International Studio*, Dec. 1918 and July 1919. In the first part, Rihani discussed visiting Paris at the time of the deaths of the artist Carolus-Duran (Feb. 17, 1917) and the writer Octave Mirabeau (Feb. 16, 1917). Based on this, and the season clearly described in his interview with Matisse, Rihani must have seen the artist in the winter of that same year, despite the much later publication dates. See "Artists in War-Time," *International Studio* 66, 262 (Dec. 1918), pp. xxix–xxxvii; and 68, 269 (July 1919), pp. iii–viii.

8. Some of these marks might have been made with a special palette knife that Pierre Matisse told Nicolas Watkins his father had used to rework the layers of *The Piano Lesson*; see Watkins 1984, p. 138.

9. This white over blue combination recalls Picasso's *Les demoiselles d'Avignon* (p. 51, fig. 14), which Matisse had seen on several occasions, including the 1916 Salon d'Antin.

10. According to a May 23, 1985, interview between Katharine Kuh and Courtney Donnell, then-director Daniel Catton Rich wrote to Matisse about the acquisition and asked about its place within his oeuvre; the artist responded that he "considered it one of his five key…no, pivotal works.…That was when we acquired this, which was in 1953…so that was everything up to 1953. Among others, he said that there was another work that belonged to that group and that was the…painting that Sam Marx owned—*The Moroccans*, which has subsequently been given to The Museum of Modern Art" (curatorial files, Art Institute of Chicago). See also John Rewald to Matisse, Mar. 1, 1953, informing him of the acquisition by an "American public collection" (AHM).

11. Despite its dramatic transformations, the canvas, according to Matisse, still retained its narrative quality; in 1926, for example, he identified the bather on the left as the one "removing her shirt." See Matisse to Georges Duthuit, Oct. 21, 1926, AHM. For other interpretations of the final state of *Bathers by a River*, see Bock 1990; and Werth 2002, esp. pp. 223–38.

Coda: The Experiment Remembered

STEPHANIE D'ALESSANDRO and JOHN ELDERFIELD

STEPHANIE D'ALESSANDRO and JOHN ELDERFIELD

AT THE END OF 1917, shortly before his forty-eighth birthday, Matisse settled in Nice, where he would live for the larger part of each year for the remainder of his life. He had chosen not to have a solo exhibition in Paris since 1913, but after World War I ended, he agreed to hold one featuring his most recent paintings at Bernheim-Jeune in May 1919.[1] It revealed such a dramatic break with his earlier work that Jean Cocteau remarked, "What is happening to him?"[2]

The artist's move to the south of France is still commonly perceived as marking a sudden shift both in style and subject matter, a turn to more traditional methods grounded in Impressionism and naturalism.[3] It is true that Matisse's art became very different from what it had been in 1913–17: he courted change, explaining in 1919, that "when you have achieved what you want in a certain area, when you have exploited the possibilities that lie in one direction, you must, when the time comes, change course, search for something new."[4] This "question of hygiene" as he termed it, manifested itself in numerous images of contemplative women in interiors (fig. 1) or by windows (54c), sometimes looking to the sea. At the same time, he hardly forgot his period of more sustained and focused radical invention. We know that both traditional and experimental modes coexisted in his art for at least a year before his move to the south (see pp. 310–18), and so it should be no surprise that they continued to do so for a year or two after his arrival.[5] To be sure, some of Matisse's early works in Nice reprise those made in Paris or Issy during the war: for example, *Interior with a Violin* (fig. 2) recasts *Interior with Goldfish Bowl* (24) down to the foreground table with a circular form, while *Violinist at the Window* (1918; Musée National d'Art Moderne, Paris) introduces a figure reminiscent of *Bathers by a River* (54) before a window scarcely less severe than that in *French Window at Collioure* (29).

By 1920, however, works of this sort disappeared from Matisse's repertory, and paintings of odalisques dominated his production for the next several years. But in May 1926, when he debuted his *Decorative Figure on an Ornamental Ground*

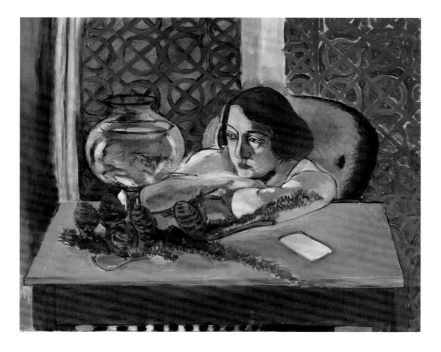

(fig. 3) at the Salon des Tuileries, it startled critics with its audacity and connections to his earlier work.[6] In October of that year, the artist provided an even greater surprise to his viewers by agreeing to the first presentation of two of his greatest paintings from the period of radical invention at Paul Guillaume's gallery (fig. 4) —the "celebrated" *Bathers by a River* (54) and *The Piano Lesson* (43)—as well as *Branch of Lilacs* (27).[7] This occasion was hastened by the dealer's purchase, just a month before, of the first two works and two others (p. 347) directly from the artist.[8]

The opening reception of this small but pivotal exhibition was marked by a lecture by the artist's son-in-law, Georges Duthuit, an art historian and member of Matthew Stewart Prichard's circle who had married Marguerite just three years before. He inaugurated the event by speaking eloquently about modern art, and Matisse's work in particular, questioning how it should be understood at a time when "everything—or just about—amuses us, or then again that nothing amuses us much" and "our eyes—worn out by the glare of fireworks and blasé after too much dazzle—are never quite sure if some new burst of light is going to prove painful or enchanting."[9] In order to recover some of the original aims of one modern artist, he turned his attention to the works presented in the gallery: "For men of my generation," Duthuit admitted,

and those older by fifteen to twenty years, the paintings surrounding us this evening take us back in time. Then, they were the subject of passionate attacks. They also aroused ardent enthusiasm. The quarrel has since calmed down. Their influence on the alternating periods of advancement and retreat is such that these canvases are always discussed with reverence, if not always with admiration. But is anything really discussed today? Have times changed so much that this is where we find ourselves?

Seeking to set aside the misunderstandings about such works, he argued for a true appreciation, freed from the typical emotional uproar over modern art, the obligatory effort to pronounce it as necessarily different than the art of earlier periods, or the temptation to identify it as commodity without human or emotional values. Instead, Duthuit sought to restore "the broad lines of the artist's method at the same time as the rules of his mode of expression." He turned to *Bathers by a River* to demonstrate this, first identifying in the painting what he called "the moment, the event, the pretext" of its origin:

A road in the Rousillon, on a hot afternoon. At a bend on the mountain, a shadowy recess carpeted with grass and fed by a flowing stream. The intimate nature of the spot, cut off above by a narrow gleaming waterfall, its thriving plant life nourished and ruffled by the stream, the coolness of the whole scene with the full brilliance of the sky overhead, held up by three slopes of dark greenery—all suggest simultaneously the idea for a painting and the idea of bathers relaxing in this retreat, one drying herself perhaps, the second teasing a garden snake, two others doing nothing but looking on.[10]

In this canvas, he continued, the specific event was only the beginning of a very long process. Afterward, "the performance" begins: both that of the painter—as he responded to the motif, to his memory of it, and to his artistic materials—and of the viewers, as they followed the signs of the painter's activity. Duthuit located meaning in Matisse's process, likening his artist's activity to that of a board game: "once begun, play moves ahead as a whole, and many a piece that has been moved will leave no trace of that movement once the game is finished. Of how many states

fig. 3
Decorative Figure on an Ornamental Ground, 1925–26
Oil on canvas
130 × 98 cm (51 1/8 × 38 5/8 in.)
Musée National d'Art Moderne, Paris

EXPOSITION
des deux célèbres tableaux
Les Demoiselles à la Rivière
et
La Leçon de piano
par
HENRI-MATISSE
du 1er au 14 Octobre 1926
chez Paul Guillaume, 59, rue La Boëtie Paris
INVITATION au Vernissage le Vendredi 1er Octobre à 15 heures

— Le Vendredi 8 Octobre à 21 heures à la même adresse, M. Georges Duthuit fera une conférence sur Henri-Matisse. Cette conférence sera suivie d'une audition d'œuvres musicales modernistes.

fig. 4
Announcement of the "Exhibition of two celebrated paintings, *Bathers by a River* and *The Piano Lesson*," at the gallery of Paul Guillaume, Paris, October 1–14, 1926. Archives of The Barnes Foundation, Merion, Penn.

each pushing the previous one out of the way and then disappearing to leave room for the next, is a painting composed?"

Duthuit recognized that we "cannot speak of the 'stages' [*étapes*] of a composition's progress except by artificially marking pauses along this path of purely interior growth, for example, at a moment when it seems to hesitate between two directions, or even to go backward." Nonetheless, he identified two such crises in the production of *Bathers*, one of which was documented by a photograph. In the first, the canvas was painted in "a bright shower of madder, of azure blue, of pink and of cream" like an immense Persian miniature (see 5 and 10), the grand scale of which weakened its effect. In the second, curvilinear forms related to the female figure dominated the canvas (see 16 and 21), but Matisse found that these did not suffice either. A "prisoner" of his reworked composition, he needed to step back, Duthuit explained, "passing the sponge of monochrome across both canvas and mind." The artist eventually found resolution in his painting through acts of "violence" (46, 54):

Sculpted by ample hatchet blows, these figures are deprived of faces, gigantic, fleshless, and not even anchored to the ground; these plates of greenery and this block of sky, ragged, broken into an unexpected order, and projected onto the flat surface of the canvas, as if solely at the impetus of their own internal pressure; this vegetation carved out of iron; this equilibrium not resting on a central point—nothing here has spoken to us of truth, of beauty, and of harmony.

It was here, the speaker proposed, in the careful appreciation of the modern artist's process—the "thorough originality, the unmitigated purity of the current passing through the senses before all the images and signs were annihilated in the single explosion of joy"—that resulted a finished work. From all accounts, Duthuit's lecture and the exhibition were "a great success."[11]

Living in Nice, Matisse received news of the exhibition and had the opportunity to read Duthuit's manuscript. Grateful for the fine comments, he nonetheless highlighted the speaker's remarks on the final process of reworking *Bathers by a River*, writing,

Please allow me to draw your attention to a passage which may lend itself to misunderstanding. Your desire was to indicate my scorn for the easy methods so as to arrive at a spiritual meeting between viewers and my canvas. But the sentence in question may lead to the belief that I take away things that should exist in some way or another in my painting. While these figures are formed of wide, simple planes, one cannot say that they are *sculpted with hatchet blows*—an expression which is often used with the words "*rough draft*" [*ébauche*] (almost the synonym for "*rough out*" [*d'ébaucher*]). Particularly notice the suppleness, the delicacy of form, particularly visible in the outline of the woman on the left who is taking her shift off. The feeling of verticality throughout the painting can't prevent one seeing the meticulous work on form. The same for *fleshless*: for all that I didn't get attached to giving the idea of flesh, skin and all that goes with it, can one say that these women are fleshless? And especially: *who are not even anchored to the ground*. Their equilibrium, their solidity—doesn't that imply the idea of the ground? So much so that it would be repetitive to represent it otherwise in the canvas. In the case in point, the lower edge of the painting constitutes the ground in the mind: because the feeling of verticality is very emphatic. If these women were not attached to the ground, they would be suspended. Either that or, by adding wings, they would appear to be flying.[12]

In other words, Duthuit was right to stress the artist's practice of extended revisions but wrong to suggest that it concluded in an act of impetuous, uncontrolled, raw creativity. At the same time, the critic Sylvain Bonmariage registered quite another impression of the painting in his review of the exhibition for the *Cahiers d'art*:

We find ourselves here in the presence of pure technique, and this is nothing to frighten us. The two works exhibited: *La leçon de piano* and *Les jeunes filles au bain* have the coldness and the synthetic precision of certain studies by Delacroix. Never have we been more charmed nor more troubled, for we find ourselves here before the talent, I will even say the genius, of the master,

completely rid of all the anecdotal details, all of the artifices that, in many of his works, prevent us from going straight to him.[13]

While we have no record of Matisse's opinion about Bonmariage's comments, which are focused on the pure and formal qualities of the paintings and divorced from their making, the fact that the artist's work allowed such contrary responses from two sympathetic critics is significant. It speaks of the capacity for *Bathers by a River* specifically—and his works from the period of radical invention in general— to evade definitive summary in the years that followed their production.

Prior to the 1926 exhibition, a dozen or so of such works had been seen in group shows, but both the large compositions and the most experimental of the smaller works had remained unknown. In New York in 1926 and 1927, the other two large paintings, *Still Life after Jan Davidsz. de Heem's "La desserte"* (35) and *The Moroccans* (44), were shown for the first time; but the exhibitions and publications on Matisse that culminated in 1930 in celebration of his sixtieth birthday emphasized the artist's recent work, leaving the 1913–17 rarely seen or discussed.[14] Moreover, it was little noticed that his most current artworks engaged with the issues of Matisse's earlier experimentation, producing canvases such as the heavily scored *Woman with a Veil* (fig. 5), the flat-patterned, compartmentalized interior *Harmony in Yellow* (1927–28; private collection), and the overtly Cézannist *Still Life on a Green Sideboard* (1928; Musée National d'Art Moderne/Centre de Création Industrielle, Centre Pompidou, Paris), which combined geometry and improvisational qualities.

It was in the 1930s, however, that Matisse more consistently summoned the lessons of his years of radical invention, albeit for very different ends. He recovered the clarity of design of his earlier paintings and reprised his interest in serial images in order to achieve "a certain formal perfection," and the quality "of a well-executed, finished object."[15] In 1935, for example, he painted *Large Reclining Nude (The Pink Nude)* (fig. 6), a reprise of *Blue Nude (Memory of Biskra)* [1.3], by reworking the composition on at least twenty different occasions: for each state, after documenting his work with a photograph, he washed away the composition with turpentine and began again on the same blank canvas (fig. 7).[16] Thus,

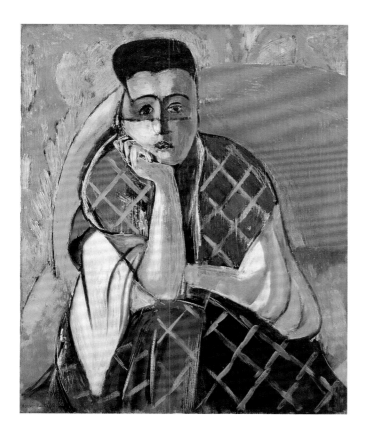

fig. 5.
Woman with a Veil, 1927
Oil on canvas
61.6 × 50.2 cm (24 1/4 × 19 3/4 in.)
The Museum of Modern Art, New York, The William S. Paley Collection, 1990

fig. 6
*Large Reclining Nude (The Pink
Nude)*, 1935
Oil on canvas
66 × 92.7 cm (26 × 36 1/2 in.)
The Baltimore Museum of Art,
The Cone Collection, formed by
Dr. Claribel Cone and Miss Etta
Cone of Baltimore, Maryland,
1950.258

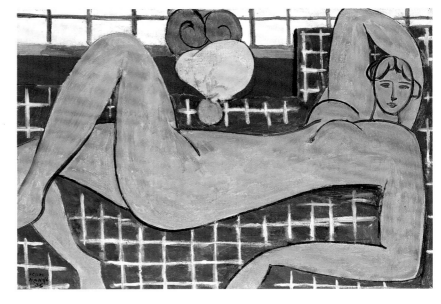

fig. 7
Photographs of *Large Reclining
Nude (The Pink Nude)* in process,
The Baltimore Museum of Art.

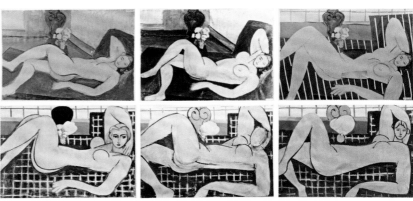

fig. 8
Back (IV), c. 1931
Plaster, cast in bronze c. 1950
188 × 112.4 × 15.2 cm
(74 × 44 1/4 × 6 in.)
The Museum of Modern Art, New
York, Mrs. Solomon Guggenheim
Fund, 1956
In exhibition

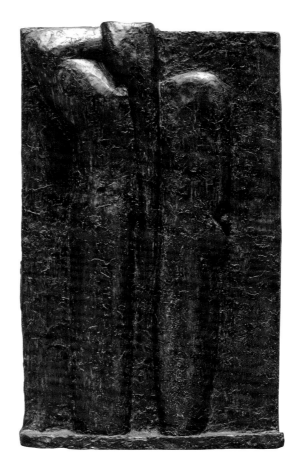

he reprised the serial processes that he developed in the 1913–17 period but avoided producing similarly heavily reworked surfaces wrought with the means of their making. He also revived his bathers motif for a new decorative commission, the greatly simplified *Dance* (1932–33; Barnes Collection, Merion, Penn.), and returned to his *Back* bas-relief (fig. 8), producing a fourth state that is a stark but refined, highly architectural monolith, in which he smoothed away the struggles of its earlier states. Matisse kept a plaster of it in his studio for the remainder of his life surrounded by examples of his last works, in which the influence of the 1913-17 period still resonates. His boldly abstracted and reduced drawings and monumental paper cut-outs mediate between painting and sculpture, carved from color in a palpably physical way (fig. 9).

Despite these continuing connections to his great earlier experiments, it would take his audiences time to catch up: while several more canvases of 1913–17 became known in the 1930s, World War II interrupted this process. It would not be until the later 1940s that the public would have the chance to experience Matisse's large compositions again, and many that had never been shown would still not be seen until after the artist's death in 1954, or even later.[17] From the time of Barr's 1951 retrospective, the importance of the period of radical invention has slowly become evident, while accelerating a debate initiated by the works themselves, their characteristics and "methods of modern construction." This debate, evident even in the first exhibition of *Piano Lesson* and *Bathers by a River* in 1926, is critical to an understanding of the paintings, sculptures, and works on paper from this moment, is indispensable to an appreciation of their place within Matisse's oeuvre as well as the history of Modernism itself, and has been the subject of this volume as well as the exhibition that it accompanies.

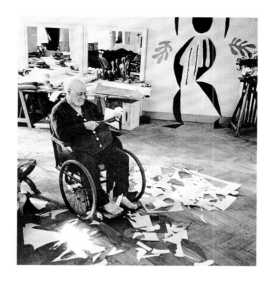

fig. 9
Matisse in his studio at the Hôtel Régina, Nice-Cimiez, 1953, working on a paper cut out. Photograph by Hélène Adant.

1. This is evident from a letter from Guillaume to Matisse, Jan. 16, 1918, AHM; the dealer asked Matisse if he would agree to show jointly with Picasso, arguing that it would not be "a special [Matisse] exhibition, which could look as if it had been organized by you and might therefore appear to be a show that you have mounted personally—which no doubt you do not care to do during time of war."

2. Jean Cocteau, "Déformation professionelle," *Parismidi*, May 12, 1919. The exhibition *Henri Matisse* was held at the Galerie Bernheim-Jeune, *Oeuvres récentes de Henri Matisse*, May 2–16, 1919.

3. For more on the Nice period, see Cowart and Fourcade 1986; Bock 1996, pp. xxxii–xliv, lxxxviii, offers a useful review of contemporaneous literature on the Nice period and of the hostile responses that followed the 1970 exhibition, most of them focusing on Matisse's representation of female models.

4. Hoppe 1931, p. 196.

5. A few later writers have acknowledged this, notably Dominique Fourcade, whose "An Uninterrupted Story," in Cowart and Fourcade 1986, pp. 47–57, remains the best introduction to this period.

6. See Monod-Fontaine, Baldassari, and Laugier 1989, pp. 79–82, for a survey of responses to the painting's exhibition in 1926.

7. The announcement for the exhibition refers to the first of these works as *Bathers by a River* (*Les demoiselles à la rivière*); in Duthuit's lecture, he called it *Bathers by a Stream* (*Les demoiselles au ruisseau*); see Duthuit, "'Les tableaux qui nous entourent ce soir' Conférence au vernissage d'une exposition Matisse à la Galerie Paul Guillaume, le 8 octobre 1926," in Labrusse 1993, p. 55.

8. Documents related to the sale can be found in the AHM; Guillaume also wished to acquire *Branch of Lilacs*, but Matisse apparently wanted to keep the work for himself. According to Spurling 2005, p. 285, the sale was made in order to finance repairs and repainting at the Issy home and to purchase a new apartment on the boulevard Montparnasse.

9. Duthuit (n. 7), pp. 47–69.

10. It is noteworthy that Duthuit specifically identified "a road in the Roussillon" and we must assume that Matisse suggested it, wanting to firmly connect the canvas to an event that had happened more than a quarter century earlier: Toulouse, the old capital of the Rousillon region, was where in 1899 he had seen local boys swimming in the river Garonne; decided to buy *Three Bathers* by Cézanne, which he had recently encountered at the Galerie Vollard in Paris; and thereby begun his longstanding interest in bathers, which produced this culminating composition. The scene invoked in 1926 is one of female bathers, but the bathers in the river Garonne and in Cézanne's painting possibly merged in the artist's memory.

11. Guillaume to Barnes, Oct. 7, 1926, President's Files, Albert C. Barnes Correspondence. The Barnes Collection, Merion, Penn. To Matisse, on October 14, 1926 (AHM), Guillaume reported "The exhibition ends today after awakening interest, curiosity and admiration, as I predicted. Almost all the artists who keep on top of important events came to see it." Guillaume, who was "Foreign Secretary" for the Barnes Foundation, wrote at length to Barnes about the two large works, but the collector did not buy them; documents relating to these exchanges can be found in the Archives of the Barnes Foundation. Neither work was sold, and on Oct. 29, 1926 (AHM), Guillaume wrote to Matisse to say that he was keeping both of them for his own collection.

12. Matisse to Duthuit, Oct. 21, 1926, AHM.

13. Sylvain Bonmariage, "Henri Matisse et la peinture pure," *Cahiers d'art* 1, 9 (1926), p. 240.

14. *Still Life after Jan Davidsz. de Heem's "La desserte"* was shown in *Memorial Exhibition of Representative Works Selected from the John Quinn Collection*, Art Center, New York, Jan. 7–30, 1926, and *The Moroccans* in *Henri Matisse* at Valentine-Dudensing Gallery, New York, Jan. 3–31, 1927, which was organized by Pierre Matisse.

15. Tériade 1929.

16. See Brenda Richardson, *Dr. Claribel and Miss Etta: The Cone Collection of the Baltimore Museum of Art* (Baltimore Museum of Art, 1985), pp. 134–37; for more on this method of working at the time, see Jeffrey Weiss, "The Matisse Grid," in Kahng 2007, pp. 173–93.

17. *Bathers by a River*, for example, was presented at Valentine-Dudensing Gallery in the 1930s, when it had a profound influence on new American painting; see Clement Greenberg, "Influences of Matisse," *Art International* 17, 9 (Nov. 1973), p. 28, and letter from Greenberg to Courtney Donnell, May 3, 1975, curatorial files, Art Institute of Chicago. *Bathers by a River* would not appear again until the 1948 Matisse exhibition at the Philadelphia Museum of Art, along with *Still Life after Jan Davidsz. de Heem's "La desserte."* The *Piano Lesson* was not shown until an exhibition at the Arts Club of Chicago in 1940 and *Back (I)* not until a presentation in Lucerne in 1949. There was, in fact, a twenty-year gap between the first appearance of these monumental canvases, in 1926–31, and their second appearance, in 1946–51, which brought them definitively into the canon of Matisse's art. Still, other critical works would take longer to be introduced to the public: for instance, *Garden at Issy* not until 1958 (Musée des Beaux-Arts, Liège) and *French Window at Collioure* in 1966 (University of California Art Galleries, Los Angeles). Finally, *Portrait of Auguste Pellerin (II)* was hardly known prior to its acquisition by the Musée National d'Art Moderne/Centre de Création Industrielle, Centre Pompidou, Paris, in 1982.

Selected Bibliography

Published Matisse Correspondence

Giraudy 1971
Giraudy, Danièle. 1971. "Correspondance Henri Matisse–Charles Camoin." *Revue de l'art* 12, pp. 7–34.

Grammont 1997
Grammont, Claudine, ed. 1997. *Correspondance entre Charles Camoin et Henri Matisse*. Bibliothèque des Arts.

Grammont 2008
Grammont, Claudine, ed. 2008. *Matisse-Marquet: Correspondance, 1898–1947*. Bibliothèque des Arts.

Phéline and Baréty 2004
Phéline, Christian, and Marc Baréty, eds. 2004. *Matisse-Sembat correspondance: Une amitié artistique et politique, 1904–1922*. Bibliothèque des Arts.

Writings by Matisse

Matisse 1908
Matisse. 1908. "Notes d'un peintre." *La grande revue* 2, 24 (Dec. 25), pp. 731–45.

Matisse 1935
Matisse. 1935. "On Modernism and Tradition." *The Studio* 9, 50 (May), pp. 236–39.

Matisse 1946
Matisse. 1946. "Témoignages de peintures: Le noir est une couleur." *Derrière le miroir* (Dec.), pp. 2, 6, 7.

Matisse 1947a
Matisse. 1947. "Le chemin de la couleur: Propos de Henri Matisse." *Art présent* 2 (1947), p. 23.

Matisse 1947b
Matisse. 1947. *Jazz*. Tériade.

Matisse 1950
Matisse. 1950. "Henri Matisse vous parle." *Traits* 8 (Mar.), p. 5.

Matisse 1954
Matisse. 1954. *Portraits*. A. Sauret.

Unpublished Interviews with Matisse

Barr Questionnaire I
Alfred H. Barr, Jr., Questionnaire I, 1945, facilitated by Mrs. Bertha Slattery Lieberman, The Museum of Modern Art Archives, New York, AHB 11.l.B.1a.ii.

Barr Questionnaire II
Alfred H. Barr, Jr., Questionnaire II, Mar. 1950, facilitated by Monrow Wheeler, The Museum of Modern Art Archives, New York, AHB 11.l.B.1a.ii.

Barr Questionnaire III
Alfred H. Barr, Jr., Questionnaire III, Apr. 1950, facilitated by Mrs. George Duthuit (Marguerite Matisse), The Museum of Modern Art Archives, New York, AHB 11.l.B.1a.ii.

Barr Questionnaire IV
Alfred H. Barr, Jr., Questionnaire IV, July–Sept. 1950, facilitated by Pierre Matisse, The Museum of Modern Art Archives, New York, AHB 11.l.B.1a.ii.

Barr Questionnaire V
Alfred H. Barr, Jr., Questionnaire V, Aug. 1950, facilitated by John Rewald, The Museum of Modern Art Archives, New York, AHB 11.l.B.1a.ii.

Barr Questionnaire VI
Alfred H. Barr, Jr., Questionnaire VI, Mar.–Apr. 1951, facilitated by John Rewald, The Museum of Modern Art Archives, New York, AHB 11.l.B.1a.ii.

Barr Questionnaire VII
Alfred H. Barr, Jr., Questionnaire VII, July 1951, facilitated by Pierre Matisse, The Museum of Modern Art Archives, New York, AHB 11.l.B.1a.ii.

Courthion 1941
Courthion, Pierre. 1941. "Conversations avec Henri Matisse." Typescript. Getty Center for the History of Art and the Humanities, Archives of the History of Art, Santa Monica, Calif.

Published Interviews with Matisse

Apollinaire 1907
Apollinaire, Guillaume. 1907. "Henri Matisse." *La phalange* 11, 18 (Dec.), pp. 481–85.

Estienne 1909
Estienne, Charles. 1909. "Des tendances de la peinture moderne: Entretien avec M. Henri Matisse." *Les nouvelles* 2, 106 (Apr. 12), p. 4.

Goldschmidt 1913
Goldschmidt, Ernst. 1913. "Strejftog i Kunsten: Henry Matisse." *Politiken* (Jan. 5), pp. 13–14.

Guenne 1925
Guenne, Jacques. 1925. "Entretien avec Henri Matisse." *L'Art vivant* 18 (Sept. 15), pp. 1–6.

Hoppe 1931
Hoppe, Ragnar. 1931. "På visit hos Matisse." In *Städer och Konstnärer, resebrev och essäer om Konst*. Albert Bonniers Förlag.

MacChesney 1913
Clara MacChesney, "A Talk with Matisse, Leader of Post-Impressionists," *New York Times*, Mar. 9, 1913, p. 64.

Rey 1914
Rey, Robert. 1914. "Une heure chez." *L'Opinion* 7, 2 (Jan. 10), pp. 59–60.

Sacs 1919
Sacs, J. (Felius Elies). 1919. "Enric Matisse i la critica, part 2." *Vell i nou* (Nov. 1), pp. 399–404.

Tériade 1952
Tériade, E. 1952. "Matisse Speaks, Part II." *Art News Annual* 21, pp. 40–71.

Verdet 1952
Verdet, André. 1952. "Entretiens avec Henri Matisse." In *Prestiges de Matisse*. Éditions Émile-Paul.

Matisse Catalogues Raisonnés

Duthuit and de Guébriant 1997
Duthuit, Claude, and Wanda de Guébriant. 1997. *Henri Matisse: Catalogue raisonné de l'oeuvre sculpté*. Claude Duthuit.

Duthuit-Matisse and Duthuit 1983
Duthuit-Matisse, Marguerite, and Claude Duthuit. 1983. *Henri Matisse: Catalogue raisonné de l'oeuvre gravé*. 2 vols. Imprimerie Union á Paris.

Selected Secondary Sources

Aagesen 2005
Aagesen, Dorthe, ed. 2005. *Matisse: Masterpieces at Statens Museum for Kunst*. Translated by René Lauritsen. Statens Museum for Kunst.

Alarcó and Warner 2007
Alarcó, Paloma, and Malcolm Warner. 2007. *The Mirror and the Mask: Portraiture in the Age of Picasso*. Exh. cat. Yale University Press.

Alpatov 1969
Alpatov, M. 1969. *Matisse: Peinture, sculpture, oeuvre graphique, lettres*. Exh. cat. Pushkin State Museum of Fine Arts/State Hermitage Museum.

Antliff 1993
Antliff, Mark. 1993. *Inventing Bergson: Cultural Politics and the Parisian Avant-Garde*. Princeton University Press.

Antliff 1999
Antliff, Mark. 1999. *The Rhythms of Duration: Bergson and the Art of Matisse*. Edited by John Mullarkey. Manchester University Press.

Apollinaire 1913a
Apollinaire, Guillaume. 1913. *Les peintres cubistes*. Eugène Figuière.

Apollinaire 1913b
Apollinaire, Guillaume. 1913. "Le Salon d'Automne: Henri Matisse." *Les soirées de Paris* 18 (Nov. 15), pp. 6–10.

Apollinaire 1914
Apollinaire, Guillaume. 1914. "Les arts: Henri Matisse." *Paris-journal* (May 15), p. 3.

Apollinaire 1972
Apollinaire, Guillaume. 1972. *Apollinaire on Art: Essays and Reviews, 1902–1918*. Edited by Leroy C. Breunig, translated by Susan Suleiman. Viking Press.

Apollinaire 1991
Apollinaire, Guillaume. 1991. *Oeuvres en prose complètes*. Edited by Pierre Caizergues and Michel Décaudin. 2 vols. Gallimard.

Apollinaire 2004
Apollinaire, Guillaume. 2004. *The Cubist Painters*. Translated by Peter Read. 1913. Repr., University of California Press.

Baldewicz 1980
Baldewicz, Elizabeth Kahn. 1980. "Les camoufleurs: The Mobilization of Art and the Artist in Wartime France, 1914–1918." Ph.D. diss., University of California, Los Angeles.

Barr 1931
Barr, Alfred H. 1931. *Henri-Matisse*. Exh. cat. Museum of Modern Art/W. W. Norton and Company.

Barr 1951
Barr, Alfred H. 1951. *Matisse: His Art and His Public*. Museum of Modern Art.

Benjamin 1985
Benjamin, Roger. 1985. "Une copie par Matisse du *Balthazar Castiglione* du Raphael." *Revue du Louvre et des musées de France* 35, 4, pp. 275–77.

Benjamin 1987
Benjamin, Roger. 1987. *Matisse's "Notes of a Painter": Criticism, Theory, and Context, 1891–1908*. UMI Research Press.

Benjamin 1989
Benjamin, Roger. 1989. "Recovering Authors: The Modern Copy, Copy Exhibitions and Matisse." *Art History* 12, 2 (June), pp. 176–201.

Benjamin 2003
Benjamin, Roger. 2003. *Oriental Aesthetics: Art, Colonialism, and French North Africa, 1880–1930*. University of California Press.

Bergson 1911
Bergson, Henri. 1911. *Creative Evolution*. Translated by Arthur Mitchell. Henry Holt and Company.

Bismarck and Gallwitz 1991
Bismark, Beatrice von, and Klaus Gallwitz. 1991. *ReVision: Die Moderne im Städel, 1906–1937*. G. Hatje.

Boccioni et al. 1912
Boccioni, Umberto, Carlo Carrà, Luigi Russolo, Giacomo Bella, and Gino Severini. 1912. *Les peintres futuristes italiens*. Exh. cat. Bernheim-Jeune.

Bock 1981
Bock, Catherine C. 1981. *Henri Matisse and Neo-Impressionism, 1898–1908*. UMI Research Press.

Bock 1990
Bock, Catherine C. 1990. "Henri Matisse's *Bathers by a River*." *Art Institute of Chicago Museum Studies* 16, 1, pp. 44–55.

Bock-Weiss 1996
Bock-Weiss, Catherine. 1996. *Henri Matisse: A Guide to Research*. Garland.

Bois 1990
Bois, Yve-Alain. 1990. *Painting as Model*. MIT Press.

Bois 1998a
Bois, Yve-Alain. 1998. *Matisse and Picasso*. Flammarion.

Bois 1998b
Bois, Yve-Alain. 1998. "Matisse's *Bathers with a Turtle*." *Saint Louis Art Museum Bulletin* 22, 3 (Fall), pp. 8–19.

Bois and Rudenstine 1994
Bois, Yve-Alain, Angelica Zander Rudenstine, eds. 1994. *Piet Mondriaan, 1872–1944*. Exh. cat. translated by Silvia Bonucci. Leonardo Arte.

Briggs 2007
Briggs, Patricia. 2007. "Matisse's Odalisques and the Photographic *Académie*." *History of Photography* 31, 4 (Winter), pp. 365–83.

Carlson 1971
Carlson, Victor I. 1971. *Matisse as a Draughtsman*. Exh. cat. Baltimore Museum of Art/New York Graphic Society.

Cauman 1991
Cauman, John. 1991. "Henri Matisse's Letters to Walter Pach." *Archives of American Art Journal* 31, 3, pp. 2–14.

Cherix 2007
Cherix, Christophe. 2007. *Henri Matisse: Traits essentiels, gravures et monotypes, 1906–1952*. Exh. cat. Cabinet des Estampes.

Chicha 2003–04
Chicha, Céline. 2003–04. "Les monotypes de Matisse: Le noir et la ligne." *Nouvelles l'estampe* 191–92 (Dec.–Feb.), pp. 41–48.

Clément-Janin 1917
Clément-Janin, Nöel. 1917. "Les estampes et la guerre, part 2." *Gazette des beaux-arts* 692 (July–Sept.), pp. 366–83.

Clouzot 1922
Clouzot, Henri. 1922. *André Metthey, décorateur et céramiste*. Librairie des arts décoratifs.

Coburn 1913
Coburn, Alvin Langdon. 1913. *Men of Mark*. Duckworth and Co./M. Kennerley.

Cooper 1970
Cooper, Douglas. 1970. *The Cubist Epoch*. Exh. cat. Phaidon/E. P. Dutton.

Cork 1994
Cork, Richard. 1994. *A Bitter Truth: Avant-Garde Art and the Great War*. Barbican Art Gallery/Yale University Press.

Courthion 1934
Courthion, Pierre. 1934. *Henri-Matisse*. Rieder.

Cowart 1990
Cowart, Jack. 1990. *Matisse in Morocco: The Paintings and Drawings, 1912–1913*. Exh. cat. National Gallery of Art.

Cowart and Fourcade 1986
Cowart, Jack, and Dominique Fourcade. 1986. *Henri Matisse: The Early Years in Nice, 1916–1930*. Exh. cat. National Gallery of Art/H. N. Abrams.

Cowling 2002
Cowling, Elizabeth. 2002. *Matisse Picasso*. Exh. cat. Tate Publishing/Réunion des Musées Nationaux/Museum of Modern Art.

Cuno 1980
Cuno, James. 1980. "Matisse and Agostino Carracci: A Source for the *Bonheur de Vivre*." *Burlington Magazine* 122, 928 (July), pp. 503–05.

Dagen 1996
Dagen, Philippe. 1996. *Le silence des peintres: Les artistes face à la Grande Guerre*. Fayard.

Daix 1982
Daix, Pierre. 1982. *Cubists and Cubism*. Skira/Rizzoli.

Daix and Rosselet 1979
Daix, Pierre, and Joan Rosselet. 1979. *Picasso: The Cubist Years, 1907–1916; A Catalogue Raisonné of the Paintings and Related Works*. Translated by Dorothy S. Blair. Thames and Hudson.

Danchev 2005
Danchev, Alex. 2005. *Georges Braque: A Life*. Hamish Hamilton.

Dauberville and Dauberville 1995
Dauberville, Guy-Patrice, and Michel Dauberville. 1995. *Matisse: Henri Matisse chez Bernheim-Jeune*. 2 vols. Bernheim-Jeune.

Diehl 1945
Diehl, Gaston. 1945. "Les nourritures terrestres de Matisse." *XXe siècle* 2 (Nov. 18).

Diehl 1954
Diehl, Gaston. 1954. *Henri Matisse*. P. Tisné.

Diehl 1958
Diehl, Gaston. 1958. *Henri Matisse*. P. Tisné/Universe Books.

Dittman 2008
Dittmann, Lorenz. 2008. *Matisse begegnet Bergson: Reflexionen zu Kunst und Philosophie*. Böhlau Verlag.

Doran 2001
Doran, Michael, ed. 2001. *Conversations with Cézanne*. Translated by Julie Lawrence Cochran. University of California Press.

Duthuit 1984
Duthuit, Claude, ed. 1984. *Henri Matisse: Oeuvres gravées*. Exh. cat. Galerie Maeght Lelong.

Duthuit 1997
Duthuit, Claude. 1997. *Matisse: "La Révélation m'est venue de l'Orient."* Exh. cat. Artificio.

Eksteins 1989
Eksteins, Modris. 1989. *Rites of Spring: The Great War and the Birth of the Modern Age*. Houghton Mifflin.

Elderfield 1976
Elderfield, John. 1976. *The "Wild Beasts": Fauvism and Its Affinities*. Exh. cat. Museum of Modern Art/Oxford University Press.

Elderfield 1978
Elderfield, John. 1978. *Matisse in the Collection of the Museum of Modern Art*. Museum of Modern Art.

Elderfield 1984
Elderfield, John. 1984. *The Drawings of Henri Matisse*. Exh. cat. Arts Council of Great Britain.

Elderfield 1992
Elderfield, John. 1992. *Henri Matisse: A Retrospective*. Exh. cat. Museum of Modern Art.

Elderfield 1995
Elderfield, John. 1995. *Pleasuring Painting: Matisse's Feminine Representations*. Thames and Hudson.

Elderfield 1998
Elderfield, John. 1998. "Moving Aphrodite: On the Genesis of *Bathers with a Turtle* by Henri Matisse." *Saint Louis Art Museum Bulletin* 22, 3 (Fall), pp. 20–49.

Elsen 1968a
Elsen, Albert. 1968. "The Sculpture of Matisse, Part I." *Artforum* 7, 1 (Sept.), pp. 20–29.

Elsen 1968b
Elsen, Albert. 1968. "The Sculpture of Matisse, Part II." *Artforum* 7, 2 (Oct.), pp. 22–33.

Elsen 1968c
Elsen, Albert. 1968. "The Sculpture of Matisse, Part III." *Artforum* 7, 3 (Nov.), pp. 26–35.

Elsen 1968d
Elsen, Albert. 1968. "The Sculpture of Matisse, Part IV." *Artforum* 7, 4 (Dec.), pp. 24–32.

Elsen 1972
Elsen, Albert. 1972. *The Sculpture of Henri Matisse*. Harry N. Abrams.

Escholier 1937
Escholier, Raymond. 1937. *Henri Matisse*. Libraire Floury.

Escholier 1956
Escholier, Raymond. 1956. *Matisse, ce vivant*. A. Fayard.

Escholier 1960
Escholier, Raymond. 1960. *Matisse, from the Life*. Translated by Geraldine and H. M. Colvile. Faber and Faber.

Faure et al. 1920
Faure, Élie, Jules Romains, Charles Vildrac, and Léon Werth. 1920. *Henri Matisse*. G. Crès et Cie.

Finsen 1970
Finsen, Hanne. 1970. *Matisse: En retrospektiv udstilling*. Exh. cat. Ministeriet for Kulturelle Anliggender.

Flam 1971
Flam, Jack D. 1971. "Matisse's Backs and the Development of His Painting." *Art Journal* 30, 4 (Summer), pp. 352–61.

Flam 1986
Flam, Jack D. 1986. *Matisse: The Man and His Art, 1869–1918*. Cornell University Press.

Flam 1988
Flam, Jack D., ed. 1988. *Matisse: A Retrospective*. Hugh Lauter Levin Associates/Macmillan Publishing Company.

Flam 1995
Flam, Jack D., ed. 1995. *Matisse on Art*. University of California Press.

Flam 1998
Flam, Jack D. 1998. *Henri Matisse, Sculpture*. Exh. cat. C and M Arts.

Flam 2001
Flam, Jack D. 2001. *Matisse in the Cone Collection: The Poetics of Vision*. Baltimore Museum of Art.

Flam 2003
Flam, Jack D. 2003. *Matisse and Picasso: The Story of Their Rivalry and Friendship*. Westview Press.

Flam 2006
Flam, Jack D. 2006. *Matisse in Transition: Around Laurette*. Exh. cat. Norton Museum of Art.

Fourcade 2005
Fourcade, Dominique. 2005. *Écrits et propos sur l'art*. 1972. Rev. ed., Hermann.

Freyer 1912
Freyer, Kurt. 1912. *Moderne Kunst: Plastik, Malerei, Graphik*. Museum Folkwang 1. Selbstverl. d. Museums.

Fussell 1975
Fussell, Paul. 1975. *The Great War and Modern Memory*. Oxford University Press.

Gee 1981
Gee, Malcolm. 1981. *Dealers, Critics, and Collectors of Modern Painting: Aspects of the Parisian Art Market between 1910 and 1930*. Garland.

Georges Petit 1931
Galerie Georges Petit. 1931. *Henri-Matisse, exposition organisée au profit de l'Orphelinat des arts*. Exh. cat. Galeries G. Petit.

Gleizes and Metzinger 1912
Gleizes, Albert, and Jean Metzinger. 1912. *Du "cubisme."* E. Figuère.

Golding 1978
Golding, John. 1978. *Matisse and Cubism*. University of Glasgow Press.

Golding 1992
Golding, John. 1992. "Henri Matisse: A Retrospective, New York." *Burlington Magazine* 134, 1077 (Dec.), pp. 833–36.

Gowing 1979
Gowing, Lawrence. 1979. *Matisse*. Thames and Hudson.

Green 1976
Green, Christopher. 1976. *Léger and the Avant-Garde*. Yale University Press.

Green 1987
Green, Christopher. 1987. *Cubism and Its Enemies: Modern Movements and Reaction in French Art, 1916–1928*. Yale University Press.

Greenberg 1953
Greenberg, Clement. 1953. *Henri Matisse*. Harry N. Abrams.

Gris 1956
Gris, Juan. 1956. *Letters (1913–1927)*. Collected by Daniel-Henry Kahnweiler, translated and edited by Douglas Cooper. Lund, Humphries.

Groom 2001
Groom, Gloria. 2001. *Beyond the Easel: Decorative Painting by Bonnard, Vuillard, Denis, and Roussel, 1890–1930*. Exh. cat. Art Institute of Chicago/ Yale University Press.

Hahnloser-Ingold 1982
Hahnloser-Ingold, Margrit. 1982. *Henri Matisse, 1869–1954: Gravures et lithographies*. Exh. cat. Musée d'Art et d'Histoire Fribourg.

Hahnloser-Ingold 1988
Hahnloser-Ingold, Margrit. 1988. *Matisse, the Graphic Work*. Translated by Simon Nye. Rizzoli.

Harrison, Frascina, and Perry 1993
Harrison, Charles, Francis Frascina, and Gill Perry. 1993. *Primitivism, Cubism, Abstraction: The Early Twentieth Century*. Yale University Press.

Institut du Monde Arabe 1999
Institut du Monde Arabe. 1999. *Le Maroc de Matisse*. Exh. cat. Institut du Monde Arabe/ Gallimard.

Izerghina 1978
Izerghina, A. N. 1978. *Henri Matisse: Painting and Sculpture in Soviet Museums*. Aurora Art Publishers.

Jacobus 1973
Jacobus, John. 1973. *Henri Matisse*. Harry N. Abrams.

Kahng 2007
Kahng, Eik, ed. 2007. *The Repeating Image: Multiples in French Painting from David to Matisse*. Exh. cat. Walters Art Museum/Yale University Press.

Kahnweiler 1949
Kahnweiler, Daniel-Henry. 1949. *The Rise of Cubism*. Wittenborn, Schulz.

Kahnweiler 1961
Kahnweiler, Daniel-Henry. 1961. *Mes galeries et mes peintures, entretiens avec Francis Crémieux*. Gallimard.

Karmel 2003
Karmel, Pepe. 2003. *Picasso and the Invention of Cubism*. Yale University Press.

Kean 1983
Kean, Beverly Whitney. 1983. *All the Empty Palaces: The Merchant Patrons of Modern Art in Pre-Revolutionary Russia*. Universe Books.

Klein 2001
Klein, John. 2001. *Matisse Portraits*. Yale University Press.

Klüver and Martin 1989
Klüver, Billy, and Julie Martin. 1989. *Kiki's Paris: Artists and Lovers, 1900–1930*. Abrams.

Kosinski, Fisher, and Nash 2007
Kosinski, Dorothy M., Jay McKean Fisher, and Steven Nash. 2007. *Matisse: Painter as Sculptor*. Exh. cat. Dallas Museum of Art/Yale University Press.

Kostenevich 1990
Kostenevich, Albert. 1990. "Matisse and Shchukin: A Collector's Choice." *Art Institute of Chicago Museum Studies* 16, 1, pp. 26–43.

Kostenevich and Semyonova 1993
Kostenevich, Albert, and Natalia Semyonova. 1993. *Collecting Matisse*. Flammarion.

Krumrine 1990
Krumrine, Mary Louise. 1990. *Paul Cézanne: The Bathers*. Exh. cat. Museum of Fine Arts/Eidolon/ Harry N. Abrams.

Labrusse 1993
Labrusse, Rémi, ed. 1993. *Georges Duthuit, écrits sur Matisse*. Ecole Nationale Superieure des Beaux-Arts.

Labrusse 1996
Labrusse, Rémi. 1996. "Esthétique décorative et expérience critique: Matisse, Byzance et la notion d'Orient." Ph.D. diss., Université de Paris I, Panthéon-Sorbonne.

Labrusse 1999
Labrusse, Rémi. 1999. *Matisse: La condition de l'image*. Gallimard.

Labrusse and Munck 2005
Labrusse, Rémi, and Jacqueline Munck. 2005. *Matisse, Derain: La verité du Fauvisme*. Hazan.

Lacambre 1999
Lacambre, Geneviève. 1999. *Gustave Moreau: Between Epic and Dream*. Exh. cat. Réunion des Musées Nationaux/Art Institute of Chicago.

Lavin 1981
Lavin, Maud. 1981. "Portrait of Yvonne Landsberg." M.A. thesis, University of Pennsylvania.

Lebovici and Peltier 1994
Lebovici, Elisabeth, and Philippe Peltier. 1994. "Lithophanies de Matisse." *Les Cahiers du Musée National d'Art Moderne* 49 (Autumn), pp. 5–39.

Legg 1972
Legg, Alicia. 1972. *The Sculpture of Matisse*. Exh. cat. Museum of Modern Art.

Louvre 1993
Musée du Louvre. 1993. *Copier Créer: de Turner à Picasso: 300 oeuvres inspirées par les maîtres du Louvre*. Exh. cat. Réunion des Musées Nationaux.

Luz 1952
Luz, Maria. 1952. "Témoignages: Henri Matisse." *XXe siècle* 2 (Jan.), pp. 55–57.

Lyons 1975
Lyons, Lisa. 1975. "Matisse: Work, 1914–17." *Arts Magazine* 49, 9 (May), pp. 74–75.

Maignan 1979
Maignan, Sylvie. 1979. "Un critique d'art parisien: Rene-Jean, 1879–1951." Ph.D. diss., École du Louvre, Paris.

Matisse and Derain 2005
Matisse, Henri, and Andrè Derain. 2005. *Matisse-Derain: Collioure 1905, un été fauve*. Exh. cat. Gallimard.

McBreen 2007
McBreen, Ellen. 2007. "The Pinup and the Primitive: Eros and Africa in the Sculpture of Henri Matisse (1906–1909)." Ph.D. diss., New York University.

McPhail 1999
McPhail, Helen. 1999. *The Long Silence: Civilian Life under German Occupation of Northern France, 1914–1918*. I. B. Tauris and Co.

Mezzatesta 1984
Mezzatesta, Michael P. 1984. *Henri Matisse: Sculptor/Painter: A Formal Analysis of Selected Works*. Exh. cat. Kimbell Art Museum.

Monery 2002
Monery, Jean-Paul. 2002. *La céramique fauve dans l'atelier d'André Metthey*. Exh. cat. Musée de l'Annonciade.

Monod-Fontaine 1979
Monod-Fontaine, Isabelle. 1979. *Matisse: Oeuvres de Henri Matisse, 1869–1954: Catalogue*. Centre Georges Pompidou.

Monod-Fontaine 1984
Monod-Fontaine, Isabelle. 1984. *The Sculpture of Henri Matisse*. Exh. cat. edited by Catherine Lampert, translated by David Macey. Thames and Hudson.

Monod-Fontaine, Baldassari, and Laugier 1989
Monod-Fontaine, Isabelle, Anne Baldassari, and Claude Laugier. 1989. *Matisse: Oeuvres de Henri Matisse*. Centre Georges Pompidou.

Monod-Fontaine and Durey 1998
Monod-Fontaine, Isabelle, and Phillipe Durey. 1989. *Matisse: La collection du Centre Georges Pompidou, Musée national d'art moderne*. Éditions du Centre Pompidou/Réunion des Musées Nationaux.

Monrad 1999
Monrad, Kasper, ed. 1999. *Henri Matisse: Four Great Collectors*. Exh. cat. Statens Museum for Kunst.

Montross 1915
Montross Gallery. 1915. *Henri Matisse, Paintings, Drawings, Etchings, Lithographs, and Sculpture*. Exh. cat. Montross Gallery.

Moorman 1986
Moorman, David, ed. 1986. *Matisse Prints from the Museum of Modern Art*. Exh. cat. Fort Worth Art Museum/Museum of Modern Art.

Mousseigne 1978
Mousseigne, Alain. 1978. *D'un espace a l'autre: La fenêtre, oeuvres du XXe siècle*. Exh. cat. Musée de l'Annonciade.

Mullarkey 1999
Mullarkey, John, ed. 1999. *The New Bergson*. Manchester University Press.

Musée Matisse 1996
Musée Matisse and Fondation Saint-Jean. 1996. *La céramique fauve: André Metthey et les peintres*. Exh. cat. Musée Matisse/Réunion des Musées Nationaux.

Museum of Modern Art 1970
Museum of Modern Art. 1970. *Four Americans in Paris: The Collections of Gertrude Stein and Her Family*. Museum of Modern Art.

Neff 1974
Neff, John Hallmark. 1974. "Matisse and Decoration, 1906–1914: Studies of the Ceramics and the Commissions for Paintings and Stained Glass." Ph.D. diss., Harvard University.

Neff 1975
Neff, John Hallmark. 1975. "Matisse and Decoration: The Shchukin Panels." *Art in America* 63, 4 (July–Aug.), pp. 38–48.

Pach 1938
Pach, Walter. 1938. *Queer Thing, Painting: Forty Years in the World of Art*. Harper and Brothers.

Pearlman 2002
Pearlman, Bennard B. 2002. *American Artists, Authors, and Collectors: The Walter Pach Papers 1906–1958*. State University of New York Press.

Pompidou 1993
Centre Georges Pompidou. 1993. *Henri Matisse, 1904–1917*. Exh. cat. Le Centre.

Puttfarken 1982
Puttfarken, Thomas. 1982. "Mutual Love and Golden Age: Matisse and 'gli Amori de' Carracci." *Burlington Magazine* 124, 949 (Apr.), pp. 203–08.

Rabinow 2006
Rabinow, Rebecca A., ed. 2006. *Cézanne to Picasso: Ambroise Vollard, Patron of the Avant-Garde*. Exh. cat. Metropolitan Museum of Art/Yale University Press.

Rainbird et al. 2008
Rainbird, Sean, Ina Conzen, Ortrud Westheider, Michael Philipp, Dorothee Böhm, and Frank-Thomas Ziegler. 2008. *Matisse: People, Masks, Models*. Exh. cat. Hirmer.

Rewald, Feilchenfeldt, and Warman 1996
Rewald, John, Walter Feilchenfeldt, and Jayne Warman. 1996. *The Paintings of Paul Cézanne: A Catalogue Raisonné*. 2 vols. Harry N. Abrams.

Richardson and McCully 1996
Richardson, John, and Marilyn McCully. 1996. *A Life of Picasso: Volume II, 1907–1917*. Random House.

Rishel and Sachs 2009
Rishel, Joseph J., and Katherine Sachs. 2009. *Cézanne and Beyond*. Exh. cat. Philadelphia Museum of Art/Yale University Press.

Rousseau 1991
Rousseau, Claudia. 1991. "'Une femme s'honore par son silence': Sources et significations de *Baigneuses à la tortue* de Matisse." *Revue de l'art* 92, pp. 79–86.

Rubin 1972
Rubin, William Stanley. 1972. *Picasso in the Collection of the Museum of Modern Art*. Museum of Modern Art/New York Graphic Society.

Rubin 1984
Rubin, William Stanley. 1984. *"Primitivism" in 20th Century Art: Affinity of the Tribal and the Modern*. Museum of Modern Art/New York Graphic Society Books.

Rubin 1989
Rubin, William Stanley. 1989. *Picasso and Braque: Pioneering Cubism*. Museum of Modern Art/Bulfinch Press.

Russell 1999
Russell, John. 1999. *Matisse: Father and Son*. Harry N. Abrams.

Salmon 1912
Salmon, André. 1912. *La jeune peinture française*. Société des Trente, Albert Messein.

Salto 1918
Salto, Axel. 1918. "Henri Matisse." *Klingen* 1, 7 (Apr.), n.pag.

Schneider 2002
Schneider, Pierre. 2002. *Matisse*. Translated by Michael Taylor and Bridget Strevens Romer. Flammarion.

Schneider and Préaud 1970
Schneider, Pierre, and Tamara Préaud. 1970. *Henri Matisse: Exposition du centenaire*. Exh. cat. Ministère d'État, Affaires Culturelles.

Sembat 1913
Sembat, Marcel. 1913. "Henri Matisse." *Les cahiers d'aujourd'hui* 4 (Apr.), pp. 185–94.

Sembat 1920
Sembat, Marcel. 1920. *Henri Matisse*. Les peintres français nouveaux 1. Éditions de la Nouvelle Revue Française.

Sembat 1985
Sembat, Marcel. 1985. "Les cahiers noirs, Part 4: 1911–15." *Cahier et revue de l'OURS* 157, 50 (Jan.), pp. 3–49.

Severini 1917
Severini, Gino. 1917. "La peinture d'avant-garde." *Mercure de France* 121 (June 1), pp. 451–68.

Severini 1983
Severini, Gino. 1983. *La vita di un pittore*. 1946. Repr., Feltrinelli.

Shapiro 1976
Shapiro, Theda. 1976. *Painters and Politics: The European Avant-Garde and Society, 1900–1925*. Elsevier.

Shattuck 1961
Shattuck, Roger. 1961. *The Banquet Years: The Arts in France, 1885–1918*. Doubleday.

Silver 1981
Silver, Kenneth E. 1981. "Esprit de corps: The Great War and French Art, 1914–1925." Ph.D. diss., Yale University.

Silver 1989
Silver, Kenneth E. 1989. *Esprit de corps: The Art of the Parisian Avant-Garde and the First World War, 1914–1925*. Princeton University Press.

Spurling 1998
Spurling, Hilary. 1998. *The Unknown Matisse: A Life of Henri Matisse, the Early Years, 1869–1908*. Alfred A. Knopf.

Spurling 2005
Spurling, Hilary. 2005. *Matisse the Master: A Life of Henri Matisse, the Conquest of Colour, 1909–1954*. Alfred A. Knopf.

Spurling and Dumas 2004
Spurling, Hilary, and Ann Dumas. 2004. *Matisse, His Art and His Textiles: The Fabric of Dreams*. Exh. cat. Royal Academy of Arts.

Stein 1947
Stein, Leo. 1947. *Appreciation: Painting, Poetry and Prose*. Crown.

Stein 1950
Stein, Leo. 1950. *Journey into the Self: Being the Letters, Papers, and Journals of Leo Stein*. Edited by Edmund Fuller. Crown Publishers.

Stein 1998
Stein, Laurie A. 1998. "The History and Reception of Matisse's *Bathers with a Turtle*, 1908–1939." *Saint Louis Art Museum Bulletin* 22, 3 (Fall), pp. 50–73.

Tanaka and Amano 2004
Tanaka, Masayuki, and Chika Amano. 2004. *Henri Matisse: Processus, Variation*. Exh. cat. Yomiuri Shinbun Tokyo Honsha Bunka/NHK.

Tériade 1929
Tériade, E. 1929. "Visite à Henri Matisse." *L'Intransigeant* (Jan. 14 and 22).

Tériade 1936
Tériade, E. 1936. "Constance du fauvisme." *Minotaure* 2, 9 (Oct. 15), p. 3.

Tokyo 1981
National Museum of Modern Art, Tokyo. 1981. *Matisse*. Exh. cat. National Museum of Modern Art, Tokyo.

Tucker 1969
Tucker, William. 1969. *Henri Matisse, 1869–1954, Sculpture*. Exh. cat. Victor Waddington Galleries.

Tucker 1974
Tucker, William. 1974. *Early Modern Sculpture: Rodin, Degas, Matisse, Brancusi, Picasso, Gonzalez*. Oxford University Press.

Tucker 1975
Tucker, William. 1975. "Matisse's Sculpture: The Grasped and the Seen." *Art in America* 63, 4 (July–Aug.), pp. 62–65.

Turner and Benjamin 1995
Turner, Caroline, and Roger Benjamin, eds. 1995. *Matisse*. Exh. cat. Queensland Art Gallery/Art Exhibitions Australia.

Vauxcelles 1907a
Vauxcelles, Louis. 1907. "Les Salons des Indépendants." *Gil Blas* (Mar. 20).

Vauxcelles 1907b
Vauxcelles, Louis. 1907. "Le Salon d'Automne." *Gil Blas* (Sept. 30).

Verdet 1978
Verdet, André. 1978. *Entretiens, notes et écrits sur la peinture: Braque, Léger, Matisse, Picasso*. Éditions Galilée.

Verougstraete-Marcq and Van Schoute 1987
Verougstraete-Marcq, Hélène, and Roger van Schoute. 1987. *Le dessin sous-jacent dans la peinture: Colloque VI, 12–14 septembre 1985; Infrarouge et autres techniques d'examen*. Collège Erasme.

Vollard 1937
Vollard, Ambroise. 1937. *Degas, an Intimate Portrait*. Translated by Randolph T. Weaver. Crown Publishers.

Watkins 1984
Watkins, Nicholas. 1984. *Matisse*. Phaidon.

Wattenmaker and Distel 1993
Wattenmaker, Richard J., and Anne Distel, eds. 1993. *Great French Paintings from the Barnes Foundation: Impressionist, Post-Impressionist, and Early Modern*. Knopf/Lincoln University Press.

Weiss 1994
Weiss, Jeffrey S. 1994. *The Popular Culture of Modern Art: Picasso, Duchamp, and Avant-Gardism*. Yale University Press.

Werth 2002
Werth, Margaret. 2002. *The Joy of Life: The Idyllic in French Art, circa 1900*. University of California Press.

Wildenstein 1985
Wildenstein, Daniel. 1985. *Claude Monet: Tome IV, 1899–1926, Peintures*. Bibliothèque des Arts.

Winter 1995
Winter, Jay. 1995. *Sites of Memory, Sites of Mourning: The Great War in European Cultural History*. Cambridge University Press.

Woimant and Guichard-Meili 1970
Woimant, Françoise, and Jean Guichard-Meili. 1970. *Matisse, l'oeuvre gravé, Paris, 1970*. Exh. cat. Bibliothéque Nationale.

Wright 2004
Wright, Alastair. 2004. *Matisse and the Subject of Modernism*. Princeton University Press.

Zervos 1928
Zervos, Christian. 1928. "Sculptures des peintures d'aujourd'hui." *Cahiers d'art* 4, 5–6, pp. 276–89.

Zervos 1931
Zervos, Christian. 1931. "Notes sur la formation et le développement de l'oeuvre de Henri-Matisse." *Cahiers d'art* 5–6, pp. 229–52.

Index

Numbers in **bold** refer to pages with illustrations. Works of art by Matisse are indexed by title; those by other artists are listed under the name of the artist.

Photography Credits